ENACTMENTS

EDITED BY RICHARD SCHECHNER

To perform is to imagine, represent, live and enact present circumstances, past events and future possibilities. Performance takes place across a very broad range of venues from city streets to the countryside, in theatres and in offices, on battlefields and in hospital operating rooms. The genres of performance are many, from the arts to the myriad performances of everyday life, from courtrooms to legislative chambers, from theatres to wars to circuses.

ENACTMENTS encompasses performance in as many of its aspects and realities as there are authors able to write about them.

ENACTMENTS includes active scholarship, readable thought and engaged analysis across the broad spectrum of performance studies.

BeiJING XIngWEI

Contemporary Chinese Time-Based Art

MeiLING CheNG

Seagull
BOOKS

LONDON NEW YORK CALCUTTA

This volume is published with support from
the USC School of Dramatic Arts, Los Angeles, California.

Seagull Books, 2013

© Meiling Cheng, 2013

ISBN 978 0 8574 2 087 9

British Library Cataloguing-in-Publication Data
A catalogue record for this book is available from the British Library.

Book designed by Bishan Samaddar, Seagull Books, Calcutta, India
Printed and bound by Hyam Enterprises, Calcutta, India

For Ashtin Natshi Wang

给王納虛

So you know why your parents want you to learn Chinese

所以你知道為什麼你的父母要你學中文

How Do I Pursue This Book?

My consciousness makes time;
My will woos it.
Chance is time's sculpture;
Time is my teacher.
My intention swallows time; and
Brings you to me.

M. Cheng
6 September 2010

我如何寫這本書？

我微思造時間
我意志它追求
機緣是時間的雕塑
時間是我的帥父
我心念吞嗜流時，而
帶你見我。

鄭美玲
9 / 9 / 2010

IMAGE 0.1 'Skin Poetry; Surface Rain' (2010) by M. Cheng; photograph by Rolf Hoefer, Rishikesh, India, on the bank of the River Ganges.

CONtenTS

ACKnowLEDgeMENtS

I have had the privilege of receiving several grants in support of the research and writing of *Beijing Xingwei*. I am indebted to the GuggenheimFoundation for a 2008 Guggenheim Fellowship, which was complemented by a special sabbatical from the University of Southern California, Los Angeles. My teaching leave came at a crucial point in the early difficult phase of conceptualizing my book. I am grateful to Martin Levine, vice provost of Faculty Affairs, for making the special sabbatical funding available, and to my dean, Madeline Puzo, of the USC School of Theater, now renamed the USC School of Dramatic Arts, for granting my leave. I owe my thanks to Stanley Rosen and Grace Ryu, director and associate director respectively of the USC-UCLA East Asian Studies Center, for supporting my quest for a 2006 Zumberge Research and Innovation Fund from USC, which made possible my initial fieldwork in Beijing.

I am fortunate to work among a group of talented artists and scholars at the USC School of Dramatic Arts. Many of these colleagues have become great friends. For *Beijing Xingwei*, I wish to acknowledge especially Madeline Puzo who is not only my gracious boss but also a friend, a mentor and an ardent supporter of my line of inquiry into extreme performances; and Angus Fletcher who, during his own tension-filled year of tenure review, had read my entire manuscript and offered me brilliant suggestions, eloquent analysis and timely encouragement, which kept my hazardous experiment going. In an era of Internet-assisted research, I still depended much on printed books and archival video documents. I thank Ruth Wallach, head of the USC Architecture and Fine Arts Library, for always providing what I requested with courtesy and expediency.

During my over-a-decade-long work on performance art, I have befriended many inspiring artists, art writers, historians and performance scholars. They have taught me what art-making means and what friendships in time will yield. To Moira Roth, Suzanne Lacy, Claudia Bucher, Amelia Jones, Carolee Schneemann, Toti M. O'Brien, Barbara T. Smith, Gabrielle Cody, Brighde Mullins, Velina Hasu Houston, Luis Alfaro, Una Chaudhuri, Susan Jonas, Adrienne Weiss, Joyce Devlin, Yong Soon Min, Peter Bleszynski, Gloria Orenstein, Charlotte Furth, Sonya Lee, Janie Geiser, Gayle Baizer, Nicole Hodges Persley, Garson Yu, Benrei Huang, Shida Kuo, Yeh Tzu-Chi, Xin Yi and Winnie Wong I owe a field of daffodils, tulips and sunflowers—like the

one Moira conjured up for me to celebrate the finishing line of my introductory chapter. To this list of radiant peers I wish to add my professors Wang Wen-hsing, Chen Chuyun and Leon Katz, for whom my prose ever aspires to reach baroque heights.

As an immigrant to the beautiful language of English, I have taken advantage of continuous schooling by learning from the many reviewers and editors with whom I worked on my perform-ance journal submissions. For those preliminary articles that have expanded into chapters in *Beijing Xingwei*, I thank Jack Becker of *Public Art Review*; Richard Gough, Ric Allsopp, Mick Wallis and Laurie Beth Clark of *Performance Research*; John Rouse, Theodore Shank and Adele Shank of *TheatreForum*; Peter Eckersall of *Performance Paradigm*; Amelia Jones and Adrian Heathfield of the anthology, *Perform, Repeat, Record*. In many ways, my autodidactic performance studies education has been intertwined with my on-the-job training through reading and writing for *TDR*. I particularly value the extensive editorial processes through which I strove to become a better thinker and writer, with the help of Richard Schechner's incisive comments and Mariellen R. Sandford's judicious and elegant editing.

There are a few people who deserve recognition here for helping me find my paths towards Chinese time-based art in the autumn of 2003, when I had yet to learn how to type in Chinese. I thank Zhang Huan's wife Hu Junjun for introducing me to independent curator Gu Zhenqing and art magazine editor Yang Li, who gave me numerous leads and recommendations for con-tacting artists in Beijing. I thank my much more capable younger sister Judy Cheng and younger brother Kai Cheng for facilitating my initial online Chinese research. I also thank my sister-in-law Assya Wang, who has settled in Beijing, for her hospitality during my several research trips. I am grateful to artist Wang Qingsong, whose one personal phone call enabled me to meet Li Xianting, an eminent curator and a key figure in my quest to understand the deceased artist Zhang Shengquan. I thank Qingyun Ma, dean of the USC School of Architecture, for connecting me with San Francisco–based curator Hou Hanru who first translated 'performance art' into 'xingwei yishu' in Beijing. My deepest gratitude goes to all the artists featured in this book for the time, trust, memories and data they shared with me. Especially, I owe a debt of friendship to Qiu Zhijie for collaborating with me to create a conceptual gestalt for *Beijing Xingwei*, enacting his light-calligraphy to make the empty-fullness of the book's Chinese spirit visible.

For more than a third of his time on earth to date, my 11-year-old son Ashtin Wang has lived with *Beijing Xingwei*. I give him a million hugs—a number he favours—for his compassion and understanding that Mommy had to finish her book before she could spend more time with him. For their generous support in overseeing my son and his close friends' playdate 'village', I thank my fellow parents: Cynthia Hier; Debora Vrana; Pamela Daukayev; Coley Laffoon; Anne Heche; Diane Stewart and Mike Yusi; Tiffany Wright; Eva Quiroz; Marcia Tillman; Angela Toiya and Eric Portegies; Courtney Behrenhausen; Sharon Wollaston; Jan Weiss. For taking care of my son and me in Los Angeles, especially when his father travelled in China for his architectural projects, I thank our nanny, cook and housekeeper Amy Deng and her resourceful husband Webster Feng.

At the heart of *Beijing Xingwei* flow the blessings and creative energies of three individuals: Nonchi Hwafong Wang, Mariellen R. Sandford and Rolf Lorenz Hoefer. I am indebted to Nonchi, the co-author of my life, for ever lending his ears and brain to accompany my urgent talking-thinking expeditions and for inspiring me with his devotion to his own architectural vision. I thank

Nonchi's support for me to continue working with Mariellen whose editorial sanity saved me countless times from my rhetorical extravagance. Since March 2010, Rolf, a former student-turned-de-facto-teacher, has volunteered to be my research assistant and first reader for *Beijing Xingwei*. My manuscript has become so much stronger because of Rolf's astute questions, persistent prodding, business insights and enabling witnessing.

I am delighted to have *Beijing Xingwei* participate in Richard Schechner's Enactments series for Seagull Books. I give thanks to Seagull's assistant editor and compositor Bishan Samaddar, the brilliant word-and-image artist who has designed the pages of *Beijing Xingwei* and offered the book its visual incarnation. Many thanks are due to Seagull's publisher Naveen Kishore for his passionate idealism for books. I am indebted too to Naveen for teaching me multicentricity in praxis.

Two days before I wrote the first version of this text on 22 July 2011, my mother accidentally slipped in her kitchen and fractured three of her ribs. My father tried to help her up and also fell, hurting his back. During their convalescence, my parents came to live with Nonchi, Ashtin and me, which gave their grandson the joyful opportunity to know his grandparents better. Sadly, soon after their recoveries, my father passed away from a sudden cardiac arrest on 30 January 2012. I dedicate the completion of *Beijing Xingwei* to my mother's mental strength and good health and to the loving memories of my father.

Beijing Xingwei is a challenging and illuminating book. I am honoured to have been its disciple and messenger.

Los Angeles, 25 February 2013

NOTes ON TRAnslaTION and IMagE CAPtioNS

1. TRANSLATION SYSTEMS | Mainland China and Taiwan use different romanization systems of translating Chinese into English—the former uses the Hanyu Pinyin; the latter the Wade-Giles. I adopt the local conventions. Thus, I use the Pinyin system throughout most of the book but I follow the Wade-Giles system for the names of individuals from Taiwan. I also adopt the most common translations for ancient masters, such as Confucius (for Kongzi).

2. CHINESE NAMES AND PHRASES | For Chinese names, I follow the local convention of listing the surname before the given name—unless the individuals, having moved overseas, have adopted the Westernized convention of placing the family name last. There are also different ways of translating a Chinese name into English. I treat a Chinese individual's given name as one unit, even though it might include two characters. For example, I translate the name of the artist 何云昌 as 'He Yunchang' while his British producers translate it as 'He Yun Chang'. Beginning in the 1950s, the People's Republic of China adopted simplified Chinese characters. Taiwan continues to use traditional Chinese characters. I include the ideograms within the text when they are essential to my analysis. I supply the ideograms for the Chinese names, titles and phrases in a separate glossary of Chinese Terms, following the local conventions for simplified or traditional characters.

3. THE TITLES OF ARTWORKS AND CITED PASSAGES | Unless otherwise stated, all translations from Chinese into English are mine, including the titles of artworks and cited passages from artists' interviews and texts. Although I follow the artworks' original Chinese titles in my Pinyin versions, my English translations at times differ from those publicized by the artists and by earlier critics. Some citations of Chinese texts are excerpts from bilingually published exhibition catalogues. I retranslate most citations into English based on their original Chinese versions. As a rule, I provide Chinese titles for those artworks that I analyse based on primary research. For a few Chinese artworks cited from the press, I only refer to their translated English titles.

4. BILINGUAL TITLES OF ARTWORKS AND EXHIBITIONS | For bilingual titles, I cite the original Chinese (in Pinyin)/English titles. When the original Chinese title differs significantly from its English counterpart, I provide a literal translation of the Chinese title in parentheses.

5. DENOTATIONS OF CHINESE WORDS | For all denotations of Chinese words that I decipher in my ideographic critique, I have consulted the book *Guoyu ribao cidian* (He Rong ed.) (Taipei: Guoyu riboashe, 1981).

6. PHOTO CREDITS FOR IMAGE CAPTIONS | Most of the images given to me by the Chinese artists list no photo credits. Because of past conflicts regarding authorship between xingwei artists and photographers who documented their artworks, most Chinese artists nowadays own the rights to their performance photographs by hiring trade photographers for documentation. Because of the controversial nature of certain artworks, some photographers also decline from being identified by name.

TO YOu wHO READ and HELP me BUILD THIS boOK— TIme ARCS in FIVE FLIghtS

Beijing Xingwei tells the story of several arcs.

FLIGHT FIVE: IN WHICH
A WRITER PROFESSES

Some of them began in Los Angeles, landed in Beijing and, after some time, reversed their courses to Los Angeles. These arcs reflect the research trajectories of my past few years as an academic fieldworker, aided by economy-class air travel, a grant-supported local driver/informant/personal assistant, many Beijing artists who welcomed or rejected my interview requests and three generations of recording devices common in their tendencies to malfunction.

A few more arcs entered my time zone as staccato stimulators, accidental persuasions and sweeps of compulsion, when chance and desire—urged by the scent of sweet osmanthus from my backyard, certain indelible images that played on my nerves, the 'Call for Proposal' notices from my favourite journals, the annual rhythms of professional conference presentations and the occupational hazard of needing to articulate my thoughts and to see them on the screen and across the page—led me to write a series of articles like successive endurance 'happenings'.

Those articles, each an arc arching towards the next, do not form circles, for they are not complete within themselves. Instead, they are curved steps that make for a twisted ladder, extending towards a larger inchoate, non-Euclidean structure, floating out there somewhere near the horizon. Like an aerial castle made of cumulous clouds, the stuff of memories, reveries, half-logical speculations and barely digested dream-theories drew me on, inching towards what I would now call *Beijing Xingwei*.

Beijing Xingwei—literally meaning Beijing behaviours or behaving in Beijing—recounts my movement via these arcs. Arcs throw mobile patterns through space, creating motions that imply the passage of time. But I prefer to subsume space within time, framing a given three-dimensional expanse within a temporal process.[1] I see my arcs as durational fluctuations in time/space, during which something in me changed. By prioritizing the experience of time in my arcs, I link them with acts of remembering.

1 I am indebted to Nonchi Wang for reminding me of the intertwinement of time and space and to Rolf Hoefer for differentiating between a state and a process.

Remembrances infused with divergent temporalities flow in my consciousness, enfolding me in an existential continuum. Like waves, my time arcs curve towards each other, splashing against the perceptual rupture of space and the shrinkage of distance intensified by technological globalization. I often wake up on the land of tomorrow while the watch on my wrist lingers at the edge of yesterday. I have to adjust my watch and my internalized time perception to arrive at today. My time arcs move, then, both outward and inward, charting my physical relations with the world and opening fluid paths on my neural sea.

Among the arcs of time that have reformed my memory, the most elongated is perhaps the one that passed through my cognitive circuit again yesterday. It began its tendril-like thrust decades ago, as I laboured, with a brush pen in hand, an ink stick and an ink well nearby, to compose my tentative *ba gu wen* (eight-part essay) in Taipei.

By 1972, rumours about the 'dreadful and horrendous Cultural Revolution' within 'our pitiful, iron-clad territory' had reached my elementary school.[2] Salacious for their whiff of scandal, these allegations about the unmentionable devilry just across the Taiwan Strait turned my classmates and me into precocious patriots. In class, we translated our anti-communist zeal into propagandistic eight-part essays about our sacred mission to 'fangong dalu, zhengjiu Zhongguo'

2 All quotations in the Preface without specific citations are my recollections, translated into English. I do not provide original Chinese phrases unless they strongly evoke collective memories among people who share my cultural background.

(counterattack the Mainland and save China). Moving our heads rhythmically in unison to better intone our phonetic lessons, we recited classical poems from the Tang and Song dynasties while lamenting the devastation of a lyrical homeland that we had never seen but from which we had been, as our teacher said, 'exiled'. We deeply felt the responsibility to retrieve, reclaim, redeem, restore and rebuild that lost—and once glorious—'five-thousand-year-old' homeland. For extra-curricular activities during recess, we contrived outlandish plans to rescue our Mainland brothers and sisters from their fate of 'eating banana peels for breakfast'; we kneaded our pinkies together for a good-luck pledge and vowed to touch the next big belly of the Buddha statue we saw, perhaps in a neighbourhood temple, for keeping us together with our parents instead of living like 'starving Mainland orphans' in the 'roach-infested' Red Guard communes!

Absorbed as we were in our indoctrinated hallucination about an imminent political redemption, few of us wondered aloud why our school principal, Mr Chen, failed to show up one day to an early-morning student assembly and then simply disappeared. Principal Chen was a Mainlander who came to Taiwan with the Kuomintang (KMT, Chinese Nationalist Party) in 1949, after the communist takeover of China. To my child's eyes, Principal Chen's face resembled another face—one similarly bald but much older—that I had seen and heard a few times on TV—the face of President Chiang Chung-cheng (also known as Chiang Kai-shek) of the Republic of China (ROC). Principal Chen spoke with a Mainlander accent, reminding me of President Chiang's even heavier Mainlander accent that made his public speech often incomprehensible to my ears. The two men were alike also in the way they held their silence, for both preferred to purse their lips tightly in between sentences, as if to inflect their pauses with significance. Principal Chen and President Chiang might have come from different Chinese provinces but, to me, they were both *waishengren* (other-province people or Mainlanders, as were their Taiwan-born children), a category that appeared—according to the implicit cultural hierarchy of the time—to be somewhat superior to *benshengren* (native-province people or Taiwanese and their children), a category to which my family and I belonged.

What I perceived as the resemblance between Principal Chen and President Chiang, however, proved to be a superficial analogy, subliminally made perhaps by a Taiwanese girl's confused identification of authority figures. Years later, I heard through the grapevine that Principal Chen disappeared because he fell prey to the 'White Terror', the brutal suppression

of political dissidents during the period of martial law (1949–87) imposed on Taiwan by the KMT regime.[3] One day Principal Chen went out for tea with a friend from his home province in China; the next day he was arraigned for his alleged 'thought crime' as a *fei-die* (a 'communist subversive' bandit-spy). Imprisoned for more than a decade, Principal Chen was forced to study daily the political treatise *San Min Zhu Yi* (known in English as *Three Principles of the People*), which was developed by Sun Zhongshan (also known as Sun Yat-sen), our 'national father', and upheld by the KMT regime as its ideological foundation.

3 Because of a confidentiality agreement with my source, I cannot be more explicit than acknowledging that I learnt of Principal Chen's fate 'through the grapevine'.

'Whatever you do, never touch politics!' This principle of self-preservation under martial law—incessantly reinforced and interpreted by family, television and teachers— as an inevitable and protective condition of our existence trained me to excel in my 'political unconscious'.[4] I was unable to make any connection, for example, between what had happened to Principal Chen and to my mother Su Yu-Jen in 1947, when she was still a little elementary schoolgirl like me.

4 Although our usages are different, I borrow this phrase from Fredric Jameson (1982).

I listened to this autobiographical incident from my mother's childhood as a bedtime story between 'Snow White' and 'Cinderella'. One day, she was left alone at her home in a little northern Taiwanese town called Xizhi when her mother went out to a fabric shop. (Her other family members were away somewhere else.) Suddenly, armed men in shabby cotton overcoats intruded into her house and ordered her to go and wait on the town's main street that was already crowded with people as far as she could see. Some of them were kneeling on the ground and bowing repeatedly to the armed men, saying 'thank you, thank you' and 'please, please, please'; others were frightened and huddled together. She hovered among her neighbours and strangers and decided to go and find her mother, who was ordered to come to the street together with all the people in the fabric shop.

The men in shabby cotton overcoats set up machine guns. My mother turned to my younger sister Nailing and me, her captive audience of two in pyjamas, and commented that those Chinese Mainlanders, the armed men, did not look as well groomed and presentable as the Japanese colonial policemen and soldiers who occupied Taiwan when she was even younger. Did my mother try to heighten our expectations with this narrative digression or did her memory, tampered with by time, drift towards the most trivial impressions? The humour of trauma! People were waiting in different states of anxiety—my mother picked up her story again—but nothing happened for six hours. Then, without any explanation, they were released. My mother later heard that the people of Xizhi were spared because of an emergency phone call from a high-ranking KMT official. The official's mistress happened to be in the crowd but apparently the caller didn't know her name and couldn't help the armed men identify her. The second day, my mother's whole town escaped on ferries to a mountain on a nearby island.

'I owe my life to that anonymous mistress, so you owe your lives to her too,' concluded my mother matter-of-factly to my sister and me, before she transitioned to her sensational rendition of a pathetic girl tortured by her cruel stepmother. My mother's sentimental logic equated the miraculous salvation credited to the mistress in Xizhi with the eleventh-hour rescue of Cinderella by her fairy godmother, who appeared out of the blue to give the obedient and

virtuous Cinderella a beautiful gown, a pair of dainty glass slippers and a fancy pumpkin coach to attend the ball where she would meet the prince who would save her from her unjust thraldom at home. In her coincidentally linked bedtime stories, my mother emphasized the moral of optimistic outcomes rather than the disturbing parallels between sundry oppressors—be they the KMT soldiers retreating from the Mainland to occupy Taiwan or the wicked stepmother and stepsisters usurping what once belonged to Cinderella, the rightful daughter of the house.

Most probably, my mother's motivation was the gendered enculturation of my sister and me rather than the politicization of us girls being taught to recognize our unfair subaltern status as benshengren. For I didn't register until decades later—after I came to the US and watched Hou Hsiao-hsien's film, *Beiqing chengshi* (known in English as *A City of Sadness*, 1989)—that my mother's personal anecdote was actually part of the '228 Incident' that referred to the brutal suppression and massacre of Taiwanese rebels and civilians by KMT forces.[5] On 28 February (2/28) 1947, the 228 Incident inscribed a bloody page in the history of the ROC and ushered in the period of White Terror in Taiwan.

5 See an excellent rendition of the 228 Incident in Chen Ruoxi (2008: 31–3).

| FLIGHT TWO: IN WHICH A TEENAGER DESPAIRS | Before I left Taiwan, I didn't know enough to ever shed a tear over the White Terror—something else induced my sorrow. One morning in 1979, during my high-school assembly, I burst out crying among my weeping (all-female) |

classmates when we sang our ROC national anthem. Right before this daily school ritual, our principal, Ms Deng Yuxiang, solemnly announced that US President Jimmy Carter had formally broken his country's official ties with the ROC in order to normalize its diplomatic relations with the People's Republic of China (PRC). Henceforth, the US would only recognize the PRC as the sole government of China. 'Fear not. Our friend Senator Goldwater made sure that President Carter signed the Taiwan Relations Act that authorized the American Institute in Taiwan [a nongovernmental agency] to facilitate continuous civilian relations between our two nations,' added Principal Deng to quell the general panic surging in the morning air.

I no longer remember how Principal Deng explained the Taiwan Relations Act but the following wording I borrow from Carter's public statement, dated 10 April 1979, regarding 'H. R. 2479, the Taiwan Relations Act' should suffice: 'This legislation will enable the American people and the people on Taiwan to maintain commercial, cultural, and other relations without official Government representation and without diplomatic relations' (Carter 1979). In other words, as interpreted by Principal Deng, the message from Carter implied that the world—with the US as its symbolic representative—had rejected the ROC as the legitimate government of China. The humiliation of our country being unseated by the PRC from the UN membership in 1971 suddenly hit home in 1979 with the politically ambiguous Taiwan Relations Act. The tears that welled up in my eyes at that moment had little to do with fear: How could the 'backward—poor and weak and totalitarian' China attack us, its supposed saviours? Instead, I sobbed from the bitterness of being denied, abandoned and betrayed by the world: Oh my poor orphaned country! Doesn't the good world hate evil communism?

I recall that moment of communal distress as the incipience of my political consciousness, when politics ceased to be forbidden cognitive territory—the mere crossing of which meant

immediate self-endangerment—and emerged as a field of emotional wilderness, eliciting shame, indignation, bafflement, frustration and, most crucially, doubt. No longer taboo, politics became a tangible source of affect and action, when that which had moved me to tears demanded attention, whether through thinking, telling, writing or doing. As a naive and ill-informed high-school student, I was incapable of sorting out these complex emotional responses beyond interpreting them from my perspective of oxymoronic, melodramatic moralism. In retrospect, I realize that my early inculcation as an apolitical citizen in a martial law–controlled Taiwan was itself a highly politicized ideological conditioning.

This conditioning made me assume without contest, for example, the tacit cultural and political hierarchy akin to a colonial system in which *waishengren*, the powerful minority of Chinese refugees who retreated to Taiwan with the KMT army after 1949, dominated the *benshengren*, those whose ancestors migrated generations earlier from China to this island. The de facto colonial value system insinuated that a Taiwanese, especially one who could not 'pass' as *waishengren* by pronouncing Mandarin without a Taiwanese accent, was less intelligent, less urbane and less worthy of respect than a person of a (more recent) Mainland or other provincial descent. The same system fed me the absurdist dogma that citizens of the ROC—whether or not from the Mainland—were all obliged to fight communism by studiously avoiding it and to reclaim a homeland lost to communism by endlessly reiterating relevant anti-communist slogans. It taught me that my words were my weapons but also that, as the fine print revealed, they were either impotent, like the empty rhetoric of the eight-part essays, or suicidal, as nonconformist chitchat overheard by the KMT's hired ears, the clandestine 'professional students' on the government's payroll.[6]

6 The novelist Chen Ruoxi mentioned this alleged historical fact of KMT-hired 'professional students' (2008: 53–7). I often heard about this rumour when growing up. Chen belongs to my parents' generation but the Taiwan she portrays is not that different from the one I knew. The imposition of martial law, I suppose, had contributed to the stagnant sociopolitical state of Taiwan before 1987.

My next moment of political awakening did not occur until years later, when I came to the US. In June 1989, my fiancé Nonchi Wang (a second-generation Taiwan-born *waishengren*) and I (an eighth-generation benshengren of Chinese descent) watched—with an emotional mixture of fear, loathing, dismay and sadness—a televized broadcast of the military crackdown ordered by the Chinese government's hardliners against the pro-democratic student protesters gathering on Tiananmen Square. We had been following on and off news about the Chinese college students' pro-democratic demonstrations; we were anxious about their hunger strikes and suspected that some bloodshed was inevitable. We didn't expect, however, to actually see—in the US, on TV and at such a massive scale—troops and tanks rolling into Beijing and firing at the crowd to suppress the demonstration. Were we shocked by the Chinese government's violence or by our sudden witnessing, via Western media coverage, of communist China's capricious cruelty against its people?

As international students from Taiwan trying to survive graduate school at Yale University, Nonchi and I had few opportunities to cross paths with our counterparts from China. The Tiananmen incident compelled us to heed the strength of a united front and the necessity of expressing our political voice. We decided to join a group of Chinese students who were caravanning to protest in front of the PRC embassy in Washington DC.

FLIGHT THREE: IN WHICH A GRADUATE STUDENT FALTERS

There were about 20 students in that caravan. Nonchi and I were the only two from Taiwan. I remember being bewildered by the atmosphere in the group. All of the Chinese students were talking but they mentioned neither the pro-democratic movement in China nor the purpose of our trip. Whereas Nonchi and I were burdened with gloom and sorrow for the fallen students in Beijing, the others appeared animated and rambunctious, even festive, as if we were going to a picnic on the beach. Perhaps noting our silence, one person asked, 'So you are from Taiwan. What is it to you that you are joining us to protest about something that happened in Beijing?' Was that a genuine question that I misheard as a snide dismissal at the time? Did I reply feebly: 'But are we not, after all, all Chinese?'

We arrived at our destination in Washington DC. Just before we departed from the caravan, a Chinese student cautioned us, 'There will be people who will try to use this occasion to protest for Tibetan independence. You should stay away from them. Don't be used.' Considering that President Chiang Ching-kuo, who succeeded his father Chiang Kai-shek to lead the ROC, had only lifted martial law from Taiwan two years earlier (in 1987), the issue regarding Taiwanese independence was not yet on the international horizon. I wonder if the same Chinese student might have warned us against demonstrating for Taiwanese independence had we attempted to rally round a 'united front' a decade later—when the first Taiwan-born KMT President, Lee Teng-hui, would be leading the ROC?

That caravan ride was my first close encounter with Chinese intellectuals as an overseas social group in the post-Deng era. Much of what transpired during our marching and chanting has blurred in my memory but I remain stung by the subtexts of the two remarks from the trip. One was a question raised behind a mask of innocence: Do the Taiwanese care about the Chinese? The other was a command coming from a mask of sophistication: Do not stray from our political agenda that you signed up to follow. The experience taught me that politics was not just an emergent source of crisis that needed remedial action but also a crisis-inducing emotional maelstrom, whirling with transient, impersonal energies, trapping less-than-autonomous actors in its turbulence of conflicting causes.

FLIGHT FOUR: IN WHICH A WORKING MOTHER PRETENDS These time arcs, each linking a younger me and mine (country, mother, lover) with someone or something from China, probably would not have formed the twisted ladder which I climbed on my way to *Beijing Xingwei* were it not for the chance formation of a time sculpture—a dialogue I had years later with another overseas Chinese intellectual.

On 1 August 2003, I had just finished presenting a paper entitled 'Somagraphs: The Laughing Medusa'—on the French writer Hélène Cixous's call for 'writing the body' and its inspiration for feminist artists to enact 'body writing' (1994)—in the 'Fresh Print series', a panel featuring emergent and distinguished theatre scholars organized by my colleague and friend David Roman for the Association of Theatre in Higher Education's annual conference held that year in New York (Meiling Cheng 2010a and 2010b). Prior to that moment, I had published a book entitled *In Other Los Angeleses: Multicentric Performance Art* (2002) that taught me about endurance life art. I had also given birth to a boy named Ashtin Natshi Wang who taught

me about motherhood as an extreme strain of feminist body art. A long-haired woman in the audience approached me and introduced herself as Haiping Yan, a theatre professor just hired by UCLA—which to me, as a theatre professor at USC, was 'the other school'—and an upcoming guest editor for the academic journal, *Modern Drama*. 'I am intrigued by your concept of somagraph,' Yan told me. 'It can be related to Chinese calligraphy. Have you considered using the concept to write about performance art in China?'

As a working mother who had barely emerged from exhaustion and anxiety-induced postpartum serial sick spells, I could only fumble for an optimistic answer. 'Yes, of course, I used the calligraphic critique to analyse performance art in my book on LA, although the idea of somagraph is new. I coined the term from reading Cixous's "Medusa" and I haven't yet explicitly linked it with the Chinese calligraphy. But I'd love to write more about somagraphs and performance art. As for China, I need to do some research and to find a suitable subject.'[7] Yan appeared puzzled but then she kindly reassured me, 'Send me a proposal if you are interested in writing for *Modern Drama*.' She did not stop at what I feared was an obvious deduction—I knew nothing about Chinese performance art.

[7] My exchange with Haiping Yan was in English, although the citations are my paraphrases based on memory.

Yan's invitation prompted me to search online for Chinese performance art. To my utter amazement, in the fall of 2003, I chanced upon a vibrant website called 'Chinese Type Contemporary Art' at Chinese-art.com and found a series of radical and strangely beautiful images there: a naked man bursting out of a cow carcase; a pair of human figures fully wrapped in bandages; the back of a man in a jacket pasted with a sign that read *ciren chusho* (This man is for sale); an ink-smeared imp-like face fused with an inky fabric triangle—is it a deflated parachute or a skirt with train?[8]

> O wonder!
> How many goodly creatures are there here!
> How beauteous mankind is! O brave new world,
> That has such people in't!

Discovering Alonso and his company alighted on her isle, Miranda in Shakespeare's *Tempest* (c.1610; 5.1.181–4) exclaims her joyful surprise: 'O brave new world'! With a smile, her father Prospero says, ''Tis new to thee.' Without chiding her innocence, I suggest that Miranda's joy comes not from having spotted a spectacle that she had never seen but from seeing that which is both noble and lately becoming familiar redoubled. She sees, like the person of Ferdinand—with whom she has been playing chess—also Alonso and others, standing next to her dear sire Prospero. Miranda cannot yet distinguish friends from foes but she discerns the consistency of their well-garbed male human forms, those she perceives as more 'goodly' than the aggressive non-human physique of Caliban: 'How beauteous mankind is!'

FLIGHT FOUR AND A HALF: IN WHICH A CRITIC MARVELS

[8] The webpage is no longer extant. In 2004, when the entire website disappeared, I emailed a query to its publisher and editor, Robert Bernel, who told me that he couldn't sustain the website for lack of funding. In 2011, however, I found traces of the website in different versions. See Chinese Type Contemporary Art (2011) and Chinese-art.com (2011). I have a main-page printout of the website, with an image of Wu Gaozhong and the cow in *Born on 28 May* (2000; see Chapter 4) but I can no longer retrieve all the images. What I describe here are then memory collages—although all these pieces are iconic and have appeared in other publications. In addition to Wu's piece, the other three I recount here are: *Wrapping Up—King and Queen* (1986) by Zhang Peili and Geng Jianyi; *This Person is for Sale (Negotiate Price on the Spot)* (1994) by Zhu Fadong; *May 8, 1999* by Zhu Ming. The first two appear, for example, in Thomas J. Berghuis (2006: 50, 112); and the third in Zhu Ming (2007: 43).

Miranda's iconic phrase—which centuries later inspired Aldous Huxley's dystopic novel, *Brave New World* (1932)—did ring in my ears when I discovered Chinese performance art in autumn 2003. Revisiting that moment now through the lens of Shakespeare's play brings into relief the oblique analogy between our two initiation stories. Like Ferdinand for Miranda, performance art in China was for me, a recent author focusing on this intermedial genre in Los Angeles, also something both new and old. Thanks to my prolonged acculturation within a more open sociopolitical environment—reflected in my changed legal identity from a Taiwanese-American immigrant to a naturalized US citizen—I no longer regarded the Mainland across the Taiwan Strait as purely an authoritarian state oppressing its people with compulsory communism. But I did grow up imagining 'China' largely in the monstrous role in which Prospero, or Shakespeare, casts Caliban in *The Tempest*. Unlike the guilelessly hyperbolic Miranda, I have never judged performance art to be solely 'goodly'; yet, in my journey to *Beijing Xingwei*, I have found that Chinese performance art indeed functions as a source of human wonder to break the monotony, orthodoxy and intransigence of a sociocultural system operating under enforced ethical and political conformity. The artists whose works enrich this book are the 'beauteous mankind' that has guided me through a 'brave new world', ever-shifting in its multicentric manifestations.

FLIGHT FIVE AGAIN: IN WHICH A POET PAINTS; A PAINTER READS; A READER NARRATES; A NARRATOR PHILOSOPHIZES; A PHILOSOPHER WHILES AWAY TIME

9 I am alluding to a sign allegedly used on old European maps to mark the land beyond generally known territory. 'Here be dragons' is the English translation of the original Latin phrase Hic sunt dracones. See Erin C. Blake (2011).

10 I am paraphrasing from Prospero's exchange with Ariel. Ariel says, referring to those bound by Prospero's charmed circle, 'That if you now beheld them, your affections/Would become tender'. Prospero: 'Dost thou think so, spirit?' Ariel: 'Mine would, sir, were I human' (*The Tempest*, 5.1.18–20).

I did not manage to send a proposal to Haiping Yan; the initial learning curve for climbing my twisted ladder was steep. Her gracious invitation, however, functioned as an enabler for my launch into a China series. Like Prospero's charm, my de/politicized enculturation in Taiwan bound me unwittingly inside an illusory, but no less constricting and befuddling, circle, beyond which crouched the 'here-be-dragons' China.[9] An Ariel, this one unaware of her full import to an enchanted being, appeared in my version of *The Tempest* (c.2003) as an emissary from time. She moved the Prospero in me to 'tenderness',[10] henceforth freeing me from the charmed circle to walk beyond my limit zone: to eye the dragon for myself.

Beijing Xingwei is a sketchbook for my dragon. 'Shenlong jian sho bujian wei' (one can see a divine dragon by its head but not its tail). A mighty dragon is ever half-hidden—in the clouds, the waves, the caves, the chasms—and the one I seek spits fire in a humongous puddle inside my opaque rain-forest heart. I try approaching this dragon scale by scale, from beard to torso to tail, yet the more I draw, the more I become aware of its elusive nature. Like a poem made of, from and in time, the dragon demands my full visual concentration to follow its stanzas -in-motion; but there are always movements faster or slower than the speed of my pen: beyond my rhythms and rhymes, I am blind to the gleam of dragon claws in flight.

Such a partial vision is what time has taught me through *Beijing Xingwei*. Knowing my limits as a fallible, enfleshed and typically encultured human subject of perception, consciousness,

imagination, memory and action, I make the best use of my time with courage and persistence, the pair of enabling soft-systems that have nudged me forward despite my constant struggles with fear, inhibition, inadequacy and failure. The joy of intellectual liberation and the pursuit of political empowerment are not foreign to these struggles. I hold fast in my mind's eye the exhilaration of my father Shu-king Cheng, when he, as a seventh-generation *benshengren*, could vote for Chen Shui-bian, the first Taiwanese non-KMT politician to win the ROC presidential election on 18 March 2000. As Taiwanese American immigrants making their home in Hacienda Heights, California, my parents flew back to Taiwan in order to vote for Chen again in 2004, putting aside their disappointment at President Chen's lacklustre performance during his first term. I also understand the choice of my little brother Kaiyi Cheng, nearly a generation younger than my sister and me, to speak Mandarin with a Taiwanese accent. But my choice differs from theirs.

If 'politics' per se revolves round the expression of one's fixed ideological allegiance, which dichotomizes my others into comrades and enemies, then I am inclined towards a noncommittal political consciousness, declaring allegiance to all and none. My political consciousness changes with time and keeps a critical distance from its object of scrutiny; it acts as a dynamic and constantly self-modifying impetus for doubt, agreement, dissent, ambivalence, alienation, affinity, compassion and complexity—to enumerate but a few potential emotive/proactive responses. This political consciousness, akin to my philosophy of multicentricity, informs my performance inquiry in *Beijing Xingwei*.

Power—articulated variously in political, ethical and cultural contexts—enters this ostensibly neutral picture of my intellectual/creative pursuits. A central object scanned by my political consciousness, this power at work may be subtle, incessant, intractable and as comprehensive as ideological indoctrination from without and internalized oppression from within the self. It may be gentle, casual and as nuanced as fleeting interpersonal events between a parent and a child during bedtime stories or an editor and a prospective contributor during a manuscript solicitation. It may also be capricious, complicit and as contingent as a temporary bond between a performance critic and a xingwei artist during an interview or an author and her readers during a series of drawn-out virtual dialogues through the pages of a book. With words and images— recalled, borrowed, assembled—tangling in stillness, I choose to fight, appreciate, understand, expose, support, celebrate and document power, experienced as temporal points of condensation in which the flow of life stagnates, suddenly freezes to form toxic memories and infirm scabs or pools up into jubilant lucidity, buoyant and tranquil.

My political consciousness resists the dominance of one ideological centre and aspires to simultaneously transcend and include a binary model. As such, it reflects my multicentric epistemology.

FLIGHT FIVE AND FIVE AGAIN: IN WHICH A MULTICENTRIC TIME-TRAVELLER BECKONS

Inspired by what Guillermo Gómez-Peña promulgates as 'a multicentric perspective', I coined an abstract noun, 'multicentricity', in my first book to describe the centrifugal urban geography of Los Angeles and to analyse the performance artworks produced there (see Meiling Cheng 2002: xv–xxix and Gómez-Peña 1993: 49). Taking 'centre' physically as a converging point, metaphorically as a sentient unit and conceptually as an idea or a position,

multicentricity acknowledges the coexistence of multiple—and multiscaled—centres as a palpable phenomenon of our cosmic, terrestrial, social and individual existence. To recognize the coexisting multiple centres, however, implies dealing with each centre/unit/construct. Multicentricity therefore necessitates a theory of centricity.

I conceptualize my model of centricity in a multicentric world along two paradoxical postulates: the irreducible presence and provisional validity of each centre; the fundamental inadequacy of any one centre. To practise these propositions as an epistemology, the first urges the subject—who knows through observing, learning, experiencing, remembering and signifying—to embrace a conditional centricity while the second obligates the subject's self-critique.

IMAGE **0.2** Taijitu, a neologistic ideogram for multicentric centricity. Image from the public domain.

We may visualize the joining of these two premises within a cognitive schema by borrowing from the pictorial representation of the Daoist Taijitu, which comprises five emblematic components: an outer circle; a black hemisphere; a tiny white circle within the black hemisphere; a white hemisphere; a tiny black circle within the white hemisphere. The curved linkage between the black and white hemispheres, respectively containing within each a white and a black centre, represents the complementary, dialectical and reciprocally implicating relationship between these two opposites within one larger, outer circle. Let us translate this diagram back into the multicentric paradigm: to claim a provisional centricity is the *yang* (positive) half of the equation; to conduct self-critique is the *yin* (negative) half. By adding a circumference to encircle these two dynamic, mutually giving-and-taking halves, we may present the Taijitu as a neologistic ideogram for the 'multicentric centricity' I propose. Shorthand for 'decentered centricity in a multicentric world', multicentric centricity is the point of departure for my epistemology.

Being the default learning/experiencing/signifying subject here, I will use my 'knowing' process as an example. When I assess an artwork, attempt an analysis or recall a lived encounter, I cannot proceed without asserting my subjectivity as the temporary grounding of my perception, cognition, intuition and memory. My subjectivity is then the provisional centre on which I base my knowledge production.

Now, what is my so-called subjectivity? Lest it be purely speculative, I search for external supporting evidence to articulate my 'subjectivity'—with its ever-shifting characteristics—by delineating my time arcs. These time arcs, all unforgettable transitions in life when my self was remade, constitute the specific biographical path that brings me to this moment of writing to you. But can I see, think, feel, dream and speak for you? Insofar as our biographies are not identical, my subjectivity, like yours, is unique and partially impossible to share. Since I cannot help but deploy my subjectivity in analysing the artworks collected in *Beijing Xingwei*, inevitably there will be places where I fail to convince you. My way of overcoming this certainty of our (partial) incompatibility—in addition to my incomplete, faulty vision—is through self-reflexive critique.

I may critique, for example, this thesis of our epistemic incompatibility by challenging the supposed uniqueness of my subjectivity. To the extent that my biography represents the cross-national acculturation, migration and glocalization of a cosmopolitan individual, my distinctiveness as a subject is by no means absolute. Given my gender, ethnic, class and generational particularities, my subjectivity is nonetheless typical—hence partially shareable—among many

other typically unique individuals in the early twenty-first century, including probably you. Although I still cannot speak for you in this book, you might hear yourself speak in following how I talk through these pages, interweaving my words with those borrowed from others, perhaps also from you.

Thus, while you are reading me and, through me, reading the artworks I describe, analyse and contextualize, you are already reading yourself, interjecting your subjectivity into my text. Perhaps a particular moment of my vulnerability textualized on this page might give you pause. While pausing, your imagination might wander away to brood over or even to begin creating—instantaneously or in a slightly syncopated tempo—your blogs, poems, articles and reviews; your paintings, sculptures, dances, designs, photographs and films; your bedtime stories, premeditated dreams, flash mob events and vegan recipes; your live-art exhibitions and manuscripts about Chinese performance art and other generative mutations. My task is then to tell you where I am coming from, to critique my shortcomings and to stay out of your way. I shall allow my subjectivity—however imperfectly imprinted onto my performance journey documented here—to be absorbed into this book, to initiate a self-reflexive critical dialogue with it and then to leave *Beijing Xingwei* at your disposal.

The sequence of reasoning that I pursued in the preceding three paragraphs reflects what I take as the greatest gift from performance art—its public service as an enabler for both the artist/self and the receiver/other. A hybrid art form that thrives on the 'in-between', performance art obscures the boundaries between numerous presumably contradictory entities: life and art; artist and artwork; subject and object; practice and theory; process and product; performer and spectator; performing and documenting; memory and history; experience and imagination; witchcraft and technology; time-based and static media; creative and critical inventions; the actual and the virtual; the real and the fantastic; the authentic and the simulated; the phenomenal and the metaphysical; sensorial and conceptual modalities. These entities on my list—and more—constitute performance art's multiple centres. To recall the Taijitu with which I represent the multicentric centricity, performance art is the elastic circle that contains these co-dependent binaries. Minimally, the politics of performance art is pivoted on the dynamic of power, need, fantasy, confrontation, conspiracy, negotiation and symbiosis at work between its modal pair—two sentient subjects, the artist and the receiving/responsive other, each existing for the other.

Admittedly, any number of performance art's multiple coexisting centres may serve as inspirations for a book about this intermedial mode of expression. Why does *Beijing Xingwei* focus on time?

Beijing Xingwei began with my quest to find and understand Chinese performance art. What intrigued me the most on my journey were the local permutations of this global live art medium as *xingwei yishu* (behaviour art) and its related genre, *xingwei-zhuangzhi yishu* (performance-installation or performative installation art). I consider 'time-based art' an apt label for these two glocalized genres because it features a pre-eminent common trait—time.

In the past three decades, 'change' has been the most conspicuous phenomenon discernible across reformist China's social, cultural, artistic, intellectual, technological, economic and commercial spheres. Although both the temporality and the spatiality of contemporary China

have been subject to drastic transformation, I have chosen time as the encompassing entity to mark the prevalent sense of transience, mutability, uncertainty, nostalgia, amnesia, efficiency, anticipation and prescience that both xingwei yishu and xingwei-zhuangzhi have explored, revealed and produced.

As the paradigmatic subject who is invested in her Chinese cultural heritage and who has gone through a protracted, durational and devotional process of studying xingwei yishu and xingwei-zhuangzhi from the PRC, I claim both 'Chinese' and 'time-based art'—however Americanized as they are in my case—as descriptors for *my own labours* borne by *Beijing Xingwei*. My critical and creative endeavours—coexisting, simultaneous, complementary and dialectical—form the reciprocally implicating hemispheres within the elastic circle I name *Beijing Xingwei*, itself an ephemeral centre energized by my multicentric centricity.

Hybrid scholarship, homoeopathic critique, literalist analysis, ideographic interpretation, self-reflexive meta/discourse and performative writing—call my book by whatever name you please, these are the concurrent media-cum-messages of *Beijing Xingwei*.[11] My central goal with this book or, rather, my most consistent behaviour within its covers, is to practise and theorize 'Chinese' time-based art—mine, enriched, challenged, qualified, humbled and fostered by its illuminating multicentric samples collected here for you.

11 I am referring to Marshall McLuhan's famous coinage, 'the medium is the message'. See Marshall McLuhan and Quentin Fiore (1967).

FLIGHT FIVE AND ECHOES: | Given my biographical particularity and scholarly intent, my stakes in
IN WHICH A FALLIBLE WORD LINGERS | writing this book are high. But what is this book to you? Are we not, after all, human, sharing this globalized twenty-first-century moment?

To me, the ultimate gift of performance art is its reversal of the temporal sequence of gifting. A gift without a receiver cannot be called a gift. Gifted receivers are those capable of rewrapping an ordinary box—with a sob, a sigh, a scorn, a smile, three tears and multiple time arcs in it—into a gift. Readers are those who create an author—I am therefore your issue.[12] Today you read me; tomorrow you might remember me; the day after tomorrow you might write about you/(me). I presume to be the enabling Virgil/Dante for your *Divine Comedy* (c.2013).

12 As far as my inspiration goes, this idea—the death of an author and the birth of a reader—has been simmering in my mind ever since I read Roland Barthes's 'The Death of the Author' (1968): 'Here we discern the total being of writing: a text consists of multiple writings, proceeding from several cultures and entering into dialogue, into parody, into contestation: but there is a site where this multiplicity is collected, and this site is not the author, as has hitherto been claimed, but the reader' (1989: 54). I am merely slanting the same concept towards the logic of performance art in multicentricity.

Los Angeles, 1 May 2011
Revisited, 25 February 2012, with loving memories of
my father Shu-king Cheng (1934–2012)

CROss-MILLEnnIAL CHRonICLE

In the past three decades, China has transformed from an impoverished communist state, closed to the democratic and capitalist West for more than a quarter of the twentieth

century, into a rising global superpower. Indeed, to many Western observers, including me, China's epochal transformation was a most astounding phenomenon as we entered the third millennium. The socialist nation's contemporary advances, however, would not have been possible without Deng Xiaoping's 1979 *gaige kaifang* (reform and opening up) policy, reconnecting China to the international community—a policy that the ruling Chinese Communist Party (CCP) continues to sanction, sustain and expand. Recent statistics on the country's rapid economic growth attest to the success of the CCP's reformist rule. China surpassed Japan, for example, as the world's second-largest economy (after the US) in the second quarter of 2010, when most of the developed countries were still reeling from the worst economic crisis in decades.

In addition to its current status as a formidable economic, military and diplomatic force, China inspires awe for its complexity and unpredictability. Several features characterize China's transformation: the extraordinary speed of its change; the comprehensive scale of its internal sociocultural, agricultural, commercial, industrial, scientific and technological restructuring; and the magnitude of its international influence. Yet, at the same time, due to state-enforced restrictions, certain aspects in China's body politic remain relatively unchanged, most notably its political system of authoritarian socialism. Thus, China's model of economic and political development both resembles and differs from that of the West. While China's prosperous market economy reflects its successful emulation of capitalism, which has long been practised in the West, the nation-state's persistent one-party political rule defies Western expectations for a democratic China. If the Asian country's current economic boom suggests that it has benefited from globalization, then its oft-noted 'Chinese exceptionalism', manifested in its particular economic, political and cultural combination, exemplifies the inevitability of glocalization—the regional adaptation, modification and reinvention of global trends.[1]

With China's ascending international stature, its highly prized cultural product, contemporary art, has also attained global prominence. According to Wu Hung, the term 'contemporary Chinese art'—in the Chinese context—

[1] One specific usage of the phrase 'Chinese exceptionalism' is related to the country's manipulation of its currency. See Philip Bowring (2009). My usage here is a broader indication of China's difference from the West. See Chapter 1 for an extensive discussion of globalization and glocalization in relation to Chinese time-based art.

refers to 'a broad artistic sphere that began to take shape in the 1970s and has undergone continuous development over the past thirty years'. It encompasses a variety of styles, trends and media common in their conscious differentiation from, if also constant interaction with, 'official art, mainstream academic art, and traditional art' (Wu Hung 2010: xiv). In the global context, nevertheless, the term may well indicate a recent popular and critical crescendo. As we exit the first decade of our current century, contemporary Chinese art has become not only an object of international journalistic, curatorial, popular and academic fascination but also a coveted cultural commodity and financial investment. According to a European Fine Art Foundation report released in March 2011, for example, China has overtaken the UK to become the world's second-largest fine-art market after the US—with Chinese modern and contemporary art representing 58 per cent of the world's auction and gallery sales in 2010 (see Reyburn 2011). A robust auction in April 2011 at Sotheby's Hong Kong verified the perceived value of contemporary Chinese art—a new world record for the art category was set by Zhang Xiaogang's triptych oil painting, *Forever Lasting Love* (1988), which sold for US$10 million, topping the 2008 record set by Zeng Fanzhi's diptych oil painting, *Mask Series 1996 No. 6* (1996), sold for US$9.7 million at Christie's Hong Kong (see Ehrmann 2011).

The monetary success of contemporary Chinese art serves, at the very least, to index the emergent global confidence in a rising China, whose latest economic performance has radically remodelled its international image and given all things Chinese—from its ancient philosophical ideas to its contemporary creative products—a distinctive, even distinguished, brand. Yet, just as reports of its economic progress might obscure the fact that China remains a largely developing country with low per capita income, so too do the record-breaking sales of contemporary Chinese artworks paint a lopsided picture, overstressing the pecuniary motivation of Chinese artists in pursuing art-making. To be sure, not all Chinese artists attain financial success; nor do most of them—not unlike artists in other countries—make art solely for a single purpose. I find it untenable to generalize either the motivation or the ability of individual artists. Nevertheless, we may surmise several reasons why contemporary Chinese art—as a cultural and fine-art category—has garnered so much attention in global art exhibitions, collections, art markets and specialized research circuits.

Why Is Contemporary Chinese Art Popular? | *Four Suppositions*

One, there is a perceived connection between contemporary Chinese art and the power and mystery of an ascending China. As such, the country itself is often taken to guarantee the value of its contemporary artworks while the artworks are regarded as ciphers for their country. Along with security concerns, the world's fascination with the nation-state spills over to its contemporary art, which in turn sheds light on the nation-state. As Carol Yinghua Lu succinctly comments, 'In no time, Chinese contemporary art was embraced by the international art market as a hot item—not particularly for its artistic value, but for its ideological and sociological revelations. In this way, the label of Chinese art became extremely crucial to works that would command international recognition' (2009).

Two, the current fame and fortune of contemporary Chinese art have much to do with the pioneering and persistent efforts of numerous Western curators, collectors, art critics and

historians, including both Westerners who have lived in China for years and overseas Chinese. Britta Erickson has meticulously traced the Western reception of contemporary Chinese art in the 1990s—the first decade when this art category began receiving international notice—through a string of pivotal exhibitions, informative catalogues, archival collections and bibliographic compilations, in addition to a handful of art historical accounts (2002). Among these earliest efforts, the trend-setting cultural sensibility and ambition of Swiss collector Uli Sigg provided a most stimulating paradigm. As 'vice president of the first joint venture between China and the West', Sigg moved to China in 1980 and later served as Swiss ambassador to China (1995–98). He began collecting exclusively Chinese artworks in the early 1990s and, in 1997, established the Chinese Contemporary Art Awards (CCAA) for which he invited international curators to China to serve as judges. Sigg was also instrumental in advising the Swiss curator, Harald Szeemann, to feature 20 Chinese artists—20 per cent of all participating artists—in the forty-eighth Venice Biennale (1999), the first time this prestigious international exhibition placed Chinese art at its centre (see Sigg and Frehner 2005: 17). More recently, in 2005, Sigg helped underwrite a global touring exhibition, *Mahjong: Contemporary Chinese Art from the Sigg Collections*. In this light, we may consider contemporary Chinese art an effective supplier of highly selective transcultural products, 'created in China' but bearing multiple types of Western blessings.[2]

Three, similar to the Chinese regime's syncretic combination of a market economy and socialist authoritarianism, contemporary Chinese art represents its practitioners' assimilation of Western art modes

2 I adopted this new catch phrase from Michael Keane (2007). See Chapter 1 of this volume for an elaboration of the emergent relevance of this phrase.

and stylistic conventions and their subsequent sinified/sinocentric innovations. To Westernized eyes—like mine—seeing a contemporary Chinese artwork resembles encountering a spectacle at once familiar and novel, comprehensible and eccentric. If we don't dismiss its overly familiar qualities as derivative, then these recognizable traits may serve to validate the productive influence of (our) Western models while giving us entry points to this new Chinese art. And, if we don't feel alienated by its unknown, even unknowable, aesthetics, then the tantalizing challenge of this art may seduce us.

Four, the individual drama of cross-cultural appreciation of art indicates a current macrophenomenon that makes such an encounter increasingly prevalent—'globalization', succinctly defined by Roland Robertson as 'the compression of the world and the intensification of consciousness of the world as a whole' (1992: 8). Concomitant with globalization is the process of 'glocalization', a portmanteau coinage that Robertson adopts from Japanese business practice to highlight the extent to which the globalizing/universalizing and localizing/particularizing trends are intertwined.[3] As contemporary Chinese art selects, combines, contrasts, juxtaposes and/or synthesizes exogenous influences with indigenous modification, it brings into relief the production, dissemination, circulation, consumption and histori-

3 According to Roland Robertson, he found the term 'glocalization' in *The Oxford Dictionary of New Words* (1991), which says the word is borrowed from the Japanese notion of *dochakuka*, originally 'an agricultural principle of adapting farming techniques to local conditions' (1995: 28). See also Chapter 1.

cization of *glocalized* cultural expressions—those that are traceable to some diffused and generic global/foreign origins but that are created through specific methods of regionalization. For those of us who live outside China but who are experiencing similar pressures of globalization and

glocalization, to study how contemporary Chinese art represents these pressures is to consider how we ourselves can negotiate with these ineluctable trends.

CONTEMPORARY CHINESE TIME-BASED ART | My four suppositions regarding the overseas audience's attraction to contemporary Chinese art delineate the perspectives of this group as consumers; but these hypotheses may also address the other side of the equation, the creative producers (artists, curators, critics, historians) of contemporary Chinese art, implying the advantages and problems affecting them up to this historical moment. Similar forces confront the practitioners of contemporary Chinese time-based art which is the focus of *Beijing Xingwei*. 'Time-based art' is the term I use to encompass two ephemeral art genres: 'xingwei yishu' (behaviour/performance art); and 'xingwei-zhuangzhi yishu' (performance-installation, or performative installation), both developed in China since the 1980s. Given that time-based art is a highly experimental, even extreme, strain within contemporary Chinese art, the four thematic rubrics that have mapped out the glocal circumstances for the mainstream also concern, if in a different fashion, its tributary.

The major distinction between conventional types of contemporary artworks and their experimental time-based varieties lies in how their creators respectively express the nature and material of art. For the former, artworks are unique, refined and relatively static objects—including paintings, sculptures and, more recently, photographs and video artworks; for the latter, an artwork may be a mere idea, shifting or accumulating its connotations in diverse temporal/spatial contexts; it may be a customary ritual in life, intentionally doubled as a durational artwork, such as punching a time-card, keeping a diary, partaking of a family meal or collectively mourning a departed friend in a funeral; it may be an artist's body, deployed as time-bound materiality, conceptually framed as a temporary singing sculpture; it may be a site-specific installation made of perishable matter, here today and gone tomorrow, leaving only mediated traces in documentary photographs. Accordingly, while the object-based artworks may be routinely shown as artefacts in museums and directly supplied as singular commodities to the art market, time-based artworks are displayed and consumed via more indirect, diffused, fleeting, incidental and contingent channels of transmission: a photograph; a digital recording; a textual document; an Internet site; a performance festival; or an evanescent exhibition. Further, since a time-based artwork seldom yields a permanent artefact—other than a few documentary photographs—it is harder to commodify it for exorbitant profits.

There is much historical overlap between contemporary Chinese object-based and time-based art. Nevertheless, due to its peculiar ephemeral and/or embodied nature, Chinese time-based art tends to encounter the variously capricious, encouraging, coercive or manipulating forces affecting contemporary Chinese art with a heightened degree of intensity. For clarity, we may track both their similarities and their differences by revisiting these four rubrics.

Four Suppositions

One, 'Brand China'. In *Beijing Xingwei*, I call the global enthusiasm for China the 'Brand China syndrome'.[4] Above all, the Brand China syndrome establishes the commodity value of all Chinese-made artworks; as such, it has benefited Chinese artists across the board. The inflated price for certain con-temporary Chinese paintings is a welcome symptom of this syndrome, which has also led to more commissions and exhibition opportunities for Chinese practitioners of time-

[4] For a detailed analysis of the Brand China syndrome, see Chapter 1; see also Jing Wang (2008).

based art. Few artists would complain about their enhanced professional prospects. The tangible benefits reaped from Brand China as an underwriter of commodity value, however, may exert more pressure on those artists who desire to resist or evade the blatant commodification of art. The more readily Brand China acts as a direct link to increased commodity value, the more difficult it becomes for an artist to prevail against what the brand implicitly requires with other less tangible values. Time-based art typically embraces ephemerality and thrives on continuous experimentation—neither propensity is particularly conducive to commodification. In the long run, therefore, Brand China may be more detrimental than beneficial to the field of time-based art because it tends to lure artists away from unremitting experimentation towards producing profitable art objects.

The Brand China syndrome also manifests itself as discursive values, which may become reified to be stereotypical criteria—as, for example, a set of allegedly ethnocentric formal traits some critics have described as 'Chineseness'[5]—which may in turn dictate and limit the range of responses for both the creators and receivers of contemporary Chinese art. Since a brand draws attention to itself, an artwork made by a Chi-

[5] See Allen Chun (1996) and Rey Chow (1998). See also Chapter 1 for an extensive analysis of Chineseness as performative identity politics.

nese artist may become secondary to its country of origin; what 'China' is would then supersede what an artwork thus branded otherwise aspires to do. The Brand China syndrome may then potentially have adverse effects—creatively and critically—on all 'Chinese' artworks, especially on those object-less artworks that depend on discursive accretions to establish their public relevance. Certain time-based art practitioners may claim that they have chosen this durational art form only for personal experiences, which need not be shared with a public. Some others pursue solitary actions—such as inscribing inkless calligraphy in the sky, or setting adrift ten pounds of apples on a pond—merely for the existential thrill or to lightly note the transience of time. Nevertheless, most of these experimental artists do have other purposes. They may want to exert social influence, form public culture, challenge ethical prohibition, probe political corruption and/or develop medium-specific innovations—none of these is feasible without registering their contributions in various receptacles of public memories. Given that these potential objectives for practising time-based art all require documentary assistance, they bring further complications vis-à-vis Brand China.

A time-based artwork characteristically expends itself during the presentation process. For an ephemeral artwork to exist for posterity, it depends on supplementary material archives (photographs, videotapes, documents and other remnants) prepared by the artist as well as those discursive responses (eyewitness accounts, performance reviews, artist interviews, critiques based on archival analysis, etc.) added by the spectators/art receivers, those who share

the artist's cultural investment in the given piece. A remote/subsequent viewer who has not seen the artwork onsite may still have access to the transpired action by assembling the available material and discursive fragments that have accrued throughout the given piece's cultural afterlife. The prevalent clichés affixed to Brand China add one more interpretive layer for the remote viewer-respondent to consider—suppose an artist used these presumptions surrounding Brand China to shape a time-based piece, the stereotypical framework would actually help the viewer-respondent to better understand the piece. Yet, Brand China stereotypes may just as well function to constrict a viewer-respondent's conceptual scope in assessing the piece, in turn triggering a discursive process that might end up diminishing the piece's multivalence in history.

Two, the indispensable and now prestigious 'foreign sponsorship'. For roughly two decades, since its inception in the early 1980s, contemporary Chinese art was primarily viewed, exhibited, circulated, collected and critically evaluated abroad. The sponsorship of a foreign benefactor like Sigg and the crucial overseas professional connections for Chinese artists inversely exposed the deficiencies of the indigenous support network for contemporary, non-traditional art in the 1980s and 90s. While all contemporary artists struggled with an inadequate domestic exhibition infrastructure, time-based art practitioners frequently encountered additional public obstacles to pursuing their process-oriented art production. These experimental artists were typically more inclined than their fellow painters and sculptors to jettison the safe distance between art and life, artifice and artist, while pushing against prevailing ethical, sociocultural and even political boundaries. Without extrinsic art objects to shield them, these artists risked being viewed as 'real-life' advocates for their artistically framed extreme actions, such as nudity, self-mutilation, animal torture, cadaver manipulation, pornographic simulation and cannibalism. As a result, throughout the post-Tiananmen decade and into the early years of the twenty-first century, more artists who practised time-based art than those working in other genres suffered from public condemnation, government censorship and other civil and official interference, including dismissal by the press, funding withdrawal, exhibition cancellations, passport confiscation, police harassment, arraignment and arrest, etc.

In the twenty-first century, the general condition for practising experimental art in China has improved, especially after 2003, the year of the first Beijing International Art Biennale.[6] The biennale's inclusive programming revealed China's changed attitude towards its contemporary art. Both the international cachet attained by contemporary Chinese art and the Chinese leadership's increasing emphasis on 'soft power'[7]—which promotes the country's cultural and other nonmilitary assets—helped shift the government's stance from suspicion to suppression to approbation to occasional patronage of contemporary Chinese art, including its time-based fringe. Nevertheless, a recent case involving the prominent artist Ai Weiwei reveals just how fragile and unpredictable the official tolerance for controversial art in China can be. On 3 April 2011, Ai was prevented from boarding a plane to Hong Kong, where he was to join his friend Sigg to attend the Sotheby's auction in which Zhang Xiaogang's painting, *Forever Lasting Love*, would set a new world record (see Leybold-Johnson 2011). According to the Chinese government,

6 For an analysis of the Chinese government's changed attitude as revealed by the first Beijing Biennale, see Chapter 2.

7 'Soft power' is a term coined by Joseph S. Nye (2005). See also Carola McGiffert (2009).

Ai was arrested on suspicion of 'economic crimes'. But Ai's family and friends and most overseas observers believe that Ai's detention was actually an official reprisal for his series of activist—and time-based—artworks on behalf of students crushed by shoddily constructed school buildings during the 2008 Sichuan earthquake.[8]

8 For a detailed assessment of the Weiwei incident, see Appendix.

Three, the 'assimilation of Western models' by contemporary Chinese art producers. There is no denying that contemporary Chinese art owes much to Western models rapidly absorbed during the country's first reformist decade by creative individuals suddenly awash in an information deluge of visual, intellectual, literary, spiritual and technological stimuli from abroad. What had taken a long time to accumulate culturally in other parts of the world was compressed into randomly accessible bits of data, available for Chinese artists and other intellectuals (who had been reinstated as elites) through reproduced images, translated texts, catalogues and magazines brought back from overseas (see, for example, Wu Hung 2008). The tragic 1989 Tiananmen incident, however, stalled this exuberant incorporation of imported knowledge and behavioural modes by a whole society newly opened to the outside world. As many critics have observed, the ensuing political repression in the early 1990s diverted most Chinese artists from their idealistic creative quest towards a pragmatic pursuit for revenues (see, for example, Gao Minglu 1998b; Li Xianting 1993b). A cursory survey of contemporary Chinese art history in subsequent decades seemingly corroborates this observation. Indeed, most of the art objects that achieved global visibility and turned in astronomical profits for their creators and earliest collectors belonged to the two painterly genres of 'political pop' and 'cynical realism', as dubbed by Beijing-based critic Li Xianting.

These two popular genres of contemporary Chinese art were introduced to the Western audiences primarily through the organizational effort of Hong Kong's Hanart TZ Gallery, run by curator and gallerist Chang Tsong-zung. Chang invited Li Xianting to co-curate the exhibition, *China's New Art, Post-1989* (1993–97), which then toured Hong Kong, Australia, Canada and the US for five years. Most crucially, Chang and Li arranged for the exhibition to be accompanied by a voluminous catalogue—with nearly 20 essays, published in English and authored by both Chinese and foreign art critics, extensively historicizing the development of contemporary Chinese art throughout the twentieth century (ibid.). Chang and Li's influential joint venture—an internationally touring exhibition and a catalogue that itself has become a collectible—perhaps explains why political pop and cynical realism have remained the favourites among contemporary Chinese art collectors, now including both Chinese and foreigners in their rank. Nevertheless, we may use the same project—*China's New Art, Post-1989*—to simultaneously confirm and repudiate the argument that Chinese artists traded their cultural aspirations for financial gains in the post-Tiananmen era. Granted that Chang and Li's project originated outside the Mainland and mainly addressed an overseas audience, it was nonetheless a significant curatorial/historical project that also achieved popular and financial success. The effort to reach financial security therefore does not necessarily negate an artist's continuous cultural endeavours. Although numerous Chinese artists are known to have churned out semi-replicas from their most profitable product lines for collectors from various financial brackets,

some of them do so in order to self-subsidize further experimental artworks. In the meantime, the critical, journalistic and curatorial responses contributed to the gradual formation of a local lineage of contemporary Chinese art—however Westernized it may turn out to be.

Although Chang and Li's pivotal catalogue for *China's New Art, Post-1989* covers mostly the object-based genres, it does include 'A Documentary Record of Performance Art in China, Post-1989', which selects 15 examples, each with a few photographic documents, an artist biography and a brief performance description (see Xu Bing et al. 1993). Many other artists represented for their paintings or installations in this catalogue have also engaged with time-based art. Although Chang and Li do not include substantiated critical analysis of their performance art samples, the 15 selected, produced from 1989 to 1993 (when the catalogue was published) hint at the prevalence of time-based activities even during that politically repressive period. To me, the performance art featured in *China's New Art, Post-1989* suggest that time-based art has almost always been part of the indigenous contemporary Chinese art heritage. Moreover, most experimental artists regarded it as one among many imported art modes; they would at least try it once or twice, perhaps for fun, for controversy or for other unquantifiable rewards. Further, as I discovered in my fieldwork, very few contemporary Chinese artists—if any—have devoted their careers exclusively to time-based art.

The nearly synchronic development of time-based art with other static contemporary art media in China appears quite extraordinary, especially when its genealogy is compared with the international (European, North and South American, Australian and Japanese) modern and contemporary art history of the twentieth century. RoseLee Goldberg traces performance art to the numerous waves of European avant-garde movements in the first three decades of the twentieth century (1996). None of these movements, however, focused solely on live art. Indeed, performance art and other time-based varieties (ritual, earth art, action painting, mail art, experimental music, kinetic theatre, postmodern dance, body art, social sculpture, happenings, Fluxus, interactive installation, etc.) did not appear en masse until the late 1950s; most did not become art-historically visible until the 1970s. Of course, we may attribute this historical factor to the tragic interruptions of the two world wars that devastated European nations and forced the exodus of many artists and intellectuals from Europe to the US, where time-based artworks bourgeoned in tandem with the civil rights, anti-war and feminist movements in the late 1960s and 70s. Still, *non-Chinese* time-based art took a while to mature into a ubiquitous, internationally practised art medium.

In contrast, time-based art activities emerged in China as early as 1985, barely six years after *Xingxing meizhan* (the *Stars Art Exhibition*, 1979), an 'underground' or 'unofficial' exhibition of paintings that purportedly marked the beginning of contemporary avant-garde Chinese art (see, for example, Li Xiangting 1993a; Noth, Pöhlmann and Reschke 1994; and Wu Hung 2010: 7). These ephemeral activities—workshops, debates, village-factory visits, unofficial exhibitions, guerilla performances—suddenly proliferated all over China amid what Gao Minglu coined 'the 1985 New Wave Art Movement' or the attempted renewal of Chinese modern art and culture through 'importism': 'the borrowing, copying and outright theft of ideas from Western art' (1993). According to Li Xiangting, 'the first appearance of performance art in China

was in December 1985, when the Beijing artist Wu Guangyao wrapped himself up in cloth' (1993b: lxxx).[9] Yet, performance art seemed so 'unidentifiable' and so at odds with other visual art forms that Lu Hong and Sun Zhenhua —the two Chinese art historians who coauthored the first book on performance art in China—describe the medium as a *zao chan er* (premature infant) (2006: 2).[10]

Lu and Sun published their book, *Yi hua de ro shen: Zhongguo xingwei yishu / China Performance Art (Alienated Body/Flesh: Chinese Performance Art)* in 2006, more than two decades after the first occurrence of performance art in Beijing.[11] They list several reasons why xingwei yishu has endured a difficult history and faces an uncertain future in China. One, it is non-commercial, which is hard to survive in China's present market economy; Two, it is self-marginalized and conceptual, in antipodal tension with mainstream society and its traditional notion of art; Three, it prefers shock, controversy and sensationalism, which contradicts its professed desire for public participation; Four, it is distinguished by its *yicixing* (one-time quality), which compels most of its audience to experience it through documentation, whereas common spectators want the excitement of *zai xianchang* (live/onsite participation); Five, some of its most extreme, violent, bloody pieces disturbed *jiben daode* (basic morality) and initiated a crisis for the medium.[12]

In fact, we can use the same explication that Lu and Sun offer for the lingering general suspicion of performance art in the West. But I am attracted to xingwei yishu precisely for some of these 'notorious' reasons, especially for its transience— or its 'onceness'—which makes the medium a mirror to the elusive twinkles of time. Lu and Sun's analysis exposes, even as it explains, what I read as an odd discrepancy in the role of time-based art (as xingwei yishu here) within contemporary Chinese art history—it burst onto the local scene 'prematurely' but was formally named in art history belatedly. Both factors derived from China's specific history.

On the one hand, we may attribute performance art's speedy arrival in Beijing—its prematurity—to China's three-decade communist isolation from the democratic, industrialized world. The sudden opening up of communist China in the 1980s meant that a broad range of art and information—accrued diachronically in the West for a century—poured in, compressed and juxtaposed. Chinese artists assimilated performance art concurrently with other contemporary art modes, even though its deviant sensibility and lifelike temerity might have made it less intelligible to the Chinese populace than a well-made composition of multicolour paint layered on a canvas. On the other hand, the great imbalance between the amount of xingwei artworks and critical discourse on them—its belated naming—reveals time-based art's sensitive, even vulnerable, cultural position in China. It occupies the edge of a local art lineage that has at once been severely condemned for its appalling, brutal iconoclasm and blithely ignored for being incomprehensible, elitist, antisocial, scandalous, extreme, amateurish and unable to be sold.

9 The catalogue does not provide a Chinese name for Wu Guangyao but Li Xiangting mentioned this case again in a recent interview. See Wang Pinpin (2011).

10 The book is written in Chinese but with Chinese and English titles. All citations from this book are in my translation.

11 According to as-yet-unconfirmed confidential news given to me, Lu Hong and Sun Zhenhau finished the manuscript by 2004 but they hesitated to publish it until 2006—quite a big delay in China's super-fast publishing world. The authors' hesitation probably had nothing to do with worries about xingwei yishu's unpopularity, for the first printing of *China Performance Art* was sold out in two weeks.

12 I translate and paraphrase these reasons from Lu and Sun, but I provide original Chinese phrases only for jargon. See 'Preface' in Lu and Sun (2006).

Four, 'the glocalization of contemporary Chinese art under globalization'—I use this awkward thesis phrase to suggest the relationship between contemporary Chinese art and the two constant, interwoven and interacting forces surrounding its creation, transmission, commodification and historicization. Globalization—as a term denoting the transnational movement of capital, information, commerce, people and leisure activities—signifies both the historical circumstance and the ongoing trend that have constituted the condition of production and consumption for contemporary Chinese art. Globalization also provides an impetus for the nearly concurrent process of glocalization that each creative agent has to undergo in order to reinvent the exogenous stimuli as domesticated hybrid-originals. If globalization is *why* that contemporary Chinese artists must take into account the presence of a foreign viewership, then glocalization explains *how* artists have engaged in producing artworks of interest—whether relatively permanent or outright ephemeral—for the consumption of this viewership.

'The 1990s witnessed both rapid globalization and the artistic result of China's policy of "striding to the world." This confluence of circumstances implied an interest on the part of the West in other cultures and the production in China of art intended for consumption overseas' (Erickson 2002: 1). This comment by Britta Erickson echoes many others in maintaining that contemporary Chinese art has become globalized since the 1990s. Wu Hung, for example, states that contemporary Chinese art 'was "discovered" by Hong Kong, Taiwan, and Western curators and dealers in the early 1990s'; moreover, because of several global indicators, including the blockbuster *China's New Art, Post-1989* exhibition, from '1993 onward', the 'network of biennales and triennials around the world' and various prominent (US) art journals with international circulation, such as *Flash Art*, *Art in America* and the *New York Times Magazine*, have regularly included and reported on this art (see Wu Hung 2010: 356; 2008: 39).

Art historical surveys such as Erickson's and Wu's demonstrate the progression of contemporary Chinese art into the global cultural and economic marketplaces. While there is irrefutable evidence to support this diachronic mapping of decisive stages, I would also highlight a coexisting picture. Globalization has always been part of the DNA of contemporary Chinese art, because its inception both coincided with and stemmed from the institution of Deng's reform and opening-up policy. As Liu Kang explains, globalization is 'both a historical condition in which China's *gaige kaifang* has unfolded and a set of values or ideologies by which China and the rest of the globe are judged' (2004: 2). In other words, the reformist policy spearheaded by Deng and implemented by the CCP had redirected the PRC to embrace what was already happening in the advanced industrialized and capitalized countries in the late 1970s— globalization. The ensuing transformation of China was a direct result of its integration into the globalized international community, which has in turn imposed a set of principles and expectations (for example, human rights, equitable trade, environmental impact, democratic rule of law, military-security concerns) on this post–Cold War socialist nation.

Globalization, as the burdensome gift that China has accepted to facilitate its reform, instigated in this non-Western country an almost simultaneous movement towards glocalization. From among globalization's encompassing programmes, for example, the 'Dengist' regime firmly chose economic development as the nation's central goal while targeting four specific

areas for modernization: industry; agriculture; national defence; and science and technology.[13] In his address to the CCP in March 1979, Deng proclaimed 'Four Cardinal Principles'—to uphold socialism; the proletarian power; the CCP leadership; the Marxism-Leninism and Mao Zedong Thought—as the ideological filter for the country's various reforms, so as to 'act in accordance with [China's] own situation and find a Chinese path to modernization' (Deng 1979). Five years later, claiming that China's 'national construction' project was set on a 'correct' path and had achieved 'satisfactory results', Deng delivered a talk—'Building Socialism with Chinese Characteristics' (1984)—that summarized the central thesis of his reformist policy. Above all, he emphasized the importance of adapting imported foreign thought—such as Marxist socialism—for explicit Chinese concerns: '[B]y socialism we mean a socialism that is tailored to Chinese conditions and has a specific Chinese character' (ibid.).

[13] As Jack Linchuan Qiu cautions, the 'Deng Xiaoping Theory' is not the fruit of Deng's solitary vision but includes the 'actual work of many others, including Hu Yaobang and Zhao Ziyang' (2000: 251). Thus, I adopted his suggested term, 'Dengist', to acknowledge this fact.

Without overstressing the rhetorical influence of China's body politic on its creative individuals, I contend that an equivalent process of glocalization has been occurring within the field of contemporary Chinese art. The conceptual principles extractable from Deng's discursive performance inform us about the particular method of glocalization 'with Chinese characteristics'. Deng's cognitive scheme revolves round 'sinification', which I define in *Beijing Xingwei* as an epistemic propensity *to make Chinese*—in whatever manner delineated by the individual maker—any stimuli and information that the individual encounters, recognizes as 'foreign' and studiously acquires and internalizes as his/her own. Aligning the qualifier 'Chinese' more with culture than with ethnicity, I posit sinification as an acculturated tendency in 'Chinese' epistemology, which has oriented how the process of glocalization has transpired in disparate fields within China, from its political decisions, as exemplified by Deng's public statements, to its development of contemporary art.

While I consider it a legitimate creative methodology, sinification, like other epistemic systems, has both constructive and destructive implications. Deng's sinification, revealed in his 'socialism with Chinese characteristics', for example, borders on a sinocentrism that determines how the statesman selects, rejects, modifies and alters foreign thoughts to fit 'Chinese conditions'. In my present usage, sinocentrism signifies a tacit political stance that protects self-interest at the expense of others; it exists as a potentially aggressive version of sinification. Because of their shared cultural roots in Chinese history, the two analytical terms—sinocentrism and sinification—have been used interchangeably. But I am interested in differentiating sinocentrism from sinification or, rather, in subsuming the former within the latter, in order to recuperate the latter as a multivalent/multicentric epistemic procedure, one that does not necessarily have to be sinocentric.

My theorization of sinification departs from Jing Wang's inspiring critique of the same term. According to Wang, sinification refers to 'the recurrent collective impulse of Chinese intellectuals to invoke a historical past in which China positioned itself as the cultural and spiritual center of the world. [. . . N]o matter how humiliating China's encounter with the West has been throughout modern history,' Chinese intellectuals were capable of drawing on their fatherland's glorious premodern history to both admit and reverse 'the symmetrical superior

versus subordinate binary configuration by which the West mapped its hierarchical relationship to China,' thereby 'illogically' turning the West into 'a margin to be annexed and homogenized' (1996: 238). By way of supporting evidence, Wang cites Deng's 'socialism with Chinese characteristics'—the same edict I have cited—to expose its underlying political agenda as 'nationalistic defence mechanism that seeks to neutralize and eventually to dissolve the alien' (ibid.: 239).

To me, Wang's critique offers not a comprehensive summary of sinification but a classical definition of sinocentrism. Wang focuses especially on what I've discussed elsewhere as the assertion of centricity that the geopolitical and cultural entity Zhongguo (the Middle/Central Kingdom) has inculcated in its subjects throughout its long-lasting dynastic and nationalistic histories.[14] This imaginary centricity tends to saturate a Chinese psyche because of its incessant enculturation. Deng's rhetoric, for example, reminds me of my numerous interviews with Chinese artists, especially with male xingwei artists, who would mention 'Chinese conditions' or 'the peculiarities of Chinese society and Chinese people' as the rationale for their art—even though most of their funded performance opportunities came from abroad.[15] But I've also encountered many Chinese artists who repudiated any connection between their national/ethnic identity and their art, despite the probable advantage of associating with Brand China.[16] In either group, the tendency towards 'self-positioning' is evident—to cite a term that both Wu Hung and Jing Wang have used, drawing from a popular Chinese phrase, *ziwo dingwei* (self-positioning) (Wu Hung 2000a: 155; Jing Wang 1996: 239). I suggest that such self-positioning—variously through, against, indifferent to, or flexible with sinification—was and has remained the first step taken by a Chinese artist in glocalizing/converting Western contemporary art models into his/her art language, however impure this language is.

[14] See my analysis of this Central Kingdom complex in Meiling Cheng (2002: xvii).

[15] Based on the my interviews in Beijing with the following artists: Ai Weiwei, 5 July 2005; Yang Zhichao, 3 July 2005; Wang Chuyu, 3 July 2005; He Yunchang, 4 July 2005.

[16] Most notably, Liu Ding. Based on my interview with Liu, 23 March 2009, Beijing.

If what Wang calls (in her book title) 'high culture fever' infected Chinese artists in the 1980s, then their symptoms—the passionate absorption and appropriation of imported data and the subsequent adaptation of the same via tactics of sinification—demonstrated the palpable features of glocalization with Chinese characteristics. The ceaseless momentum of globalization that accelerated in the 1990s gave these artists the real opportunity to test out their glocalized products among global consumers. We can tell how these global (Western) art patrons became increasingly receptive of contemporary Chinese art by comparing the numbers of Chinese artists chosen for two international shows organized by the same French curator—Jean-Hubert Martin. In 1989, on the advice of Chinese curator Fei Dawei, then living in France, Martin introduced three Chinese artists—Huang Yong Ping, Gu Dexin and Yang Jiechang—to an international crowd at the Centre Georges Pompidou through his controversial but also monumental exhibition *Magiciens de la terre* (Magicians of the Earth, 1989), designed to feature 'Third World' artists (see Carol Yinghua Lu 2009). About a decade later, more than five times as many Chinese artists—including several who used animal and human body parts in their experimental artworks—were shown in Martin's Partage d'Exotismes: The Fifth Lyon Biennial of Contemporary Art (2000) (see Erickson 2002: 5).

Although the journey towards a global distribution of glocalized contemporary Chinese art was relatively swift, it was fraught with complications. The migration of world populations—hastened by globalization, and compounded by the political crisis of the 1989 Tiananmen incident—caused a split within contemporary Chinese art of the late 1980s. A case in point involves the divergent paths taken by the three Chinese artists included in the *Magiciens de la terre* show, whose exhibition period (May–August 1989) coincided with the 4 June massacre in Beijing. Only Gu, the Beijing native, returned home right away; Huang and Yang defected to France, joining the worldwide growing rank of Chinese expatriate artists. Together with Huang and Yang, some of these most renowned émigré artists, such as Chen Zhen, Wenda Gu, Xu Bing, Cai Guoqiang, Wang Du and Wu Shanzhuan, became the faces of contemporary 'Chinese' (overseas) art through countless China-themed solo and group exhibitions beginning in the 1990s. Some other emigrants, such as Ai Weiwei, Wang Gongxin, Lin Tianmiao and Zhang Dali, however, did not produce their best-known artworks until they returned to China—a trend of repatriation that has been gaining force in the twenty-first century (see Wu Hung 2010: 401). If globalization increased the mobility of Chinese artists two decades ago and enabled them to seek better working conditions abroad, China's recent improved socioeconomic environment has persuaded some expatriates to reverse the trend, bringing back to the local art scene their hybrid, glocalized products.

The Impact of Overseas Chinese Art on Glocalized Time-Based Art in China: Subplots

Almost all of the Chinese artists who have made their careers overseas have practised time-based art as one medium among many; they also tend to be more experimental than many of the China-based contemporary painters who have achieved global fame and enjoy record-breaking auction sales. Except for Xu Bing, Ai Weiwei and Gu Dexin, most artists I study in *Beijing Xingwei* belong to a younger generation. While all of them also practise in multiple art media, time-based art appears to be much more prominent in their careers. This complex scenario activated by globalization initiated several motifs in the evolving glocalization of Chinese time-based art round the turn of the millennium, in the last half-decade before the Chinese leadership changed its attitude towards local experimental art:

1. SENIOR-PEER PRESSURE | Since the overseas Chinese artists represent the geocultural bifurcation —or multiplication—of the contemporary Chinese experimental art heritage, their global success has become a source of envy, emulation and rivalry among some of the younger experimental artists who have remained in China.

2. EXTREME MANIFESTATION | Many of these younger artists who have chosen to work mainly in time-based art have dealt with their aversion to being unduly influenced by their overseas seniors by pushing their art to the sensorial/conceptual edge. Various ethically, even legally, ambiguous acts—anthropophagy, suicide, animal torture, cadaver exploitation, etc.—that could not be committed overseas as performance artworks without severe consequences were employed in extreme xingwei and xingwei-zhuangzhi pieces in China, especially at the apocalyptic *fin de siècle* moment. For these cool-headed time-based art practitioners, sinification may well signify excessive sensation, experienced discretely in semiprivate settings.

3. BELATED EXPOSURE | Because of the generational differences, most of the time-based artworks that these younger artists produced did not attract the attention of the overseas popular media until the late 1990s. This historical coincidence projected the impression that Chinese time-based art began to circulate globally later than object-based art and that it has produced mostly extreme artworks. Contemporary Chinese paintings first became internationally prominent through *China's New Art, Post-1989*; Chinese time-based art—as performance art—became widely known in the West through another blockbuster show, *Inside Out: New Chinese Art* (1998), which toured New York, San Francisco, Seattle and Monterrey (in Mexico). Since its curator Gao Minglu included artists from three broadly construed 'Chinese' cultural regions—the PRC, Hong Kong and Taiwan—*Inside Out* both affirmed the participants' cultural commonality identified by the descriptor 'Chinese', and problematized the term's conventional alignment with ethnicity/nationality (see Gao Minglu 1998a). Under this expanded identity label, which avows the dispersal of regional culture through historical circumstances and current globalization, *Inside Out* brought a diverse range of Chinese experimental artworks to US and Mexican viewers.

4. GLOCAL PRODIGY | More pertinent to time-based art, *Inside Out* facilitated the diffusion of knowledge about Chinese performance art by bringing to Western audiences two strong xing-wei artists, Zhang Huan and Ma Liuming. Following their well-received live performances in the *Inside Out* show, Zhang decided to settle in New York while Ma returned to Beijing. Zhang soon launched his prolific and highly visible performance art career in the US and was invited to create live performances in museums and galleries all over the world (except China). Zhang's endurance body art struck a balance among formalistic beauty, conceptual acuity, ethnocentric resonance and communal interactivity. His stylistic signature was so appealing internationally that the name 'Zhang Huan' became virtually synonymous in the West with Chinese performance art in the beginning of the twenty-first century.

5. GLOBALIZED ART | Zhang Huan's career path is paradigmatic of the mobility, hybridity and variety of contemporary art-making under globalization. Between 1993 (when Zhang began enacting his xingwei yishu in the eastern outskirts of Beijing) and 2005 (when Zhang resettled in Shanghai), his practice focused almost exclusively on xingwei yishu.[17] Whereas his Chinese expatriate predecessors would occasionally produce time-based artworks in the mode of performative installation, Zhang confronted critical issues shared by overseas Chinese artists—such as the colonial–postcolonial/centre–periphery dichotomy; minoritarian vs sinocentric identities; diasporic consciousness; and multiculturalism—in a time-based art mode centring on the artist's body.[18] For over a decade, Zhang's artist's body was a glocalized ephemeral artwork sporadically displayed at dispersed global high-cultural sites. After Zhang returned to China in 2005, however, he shifted his focus from performance art to realizing numerous large-scale object-based artworks centring on Buddhist themes, employing a team of artisans, craftsmen, technicians and student workers in his huge Shanghai studio (see Barboza 2007b). He continues to turn his performance art stardom into a singular brand for his behemoth glocal cultural commodities. However superb his art objects are, Zhang's move towards static media corroborates my argument of Brand China's detrimental impact on the field of time-based art.

[17] For an analysis of Zhang Huan's career, see Chapter 3.

[18] All the enumerated issues have been addressed in the contexts of multiculturalism and multicentricity in Meiling Cheng (2002). See also Hou Hanru (2002: 24–101).

IMAGE **0.3** *Peace* (2003), a performance artwork by Zhang Huan, presented by Creative Time, Inc., as part of *Art on the Plaza*, Ritz-Carlton New York, Battery Park, New York. Image courtesy of Zhang Huan Studio.

6. SINIFICATION REDUX | As Wu Hung points out, the mode of art production and exhibition exemplified by Zhang Huan's recent move back to China 'is shared by many other *"hai gui"* (slang for "returnees" from abroad) artists, who use cheap Chinese labor and materials to produce works for an international audience' (2010: 402). I suggest, however, that Zhang's reversed career trajectory may also reflect the rising global status of Brand China, which has convinced many of its contemporary artists that practising art in Shanghai or in Beijing is just as international, cosmopolitan and noteworthy as doing so in New York, Paris, London, Berlin, Tokyo or Sydney. Moreover, for a Chinese art producer, Brand China is not only a source of material gain but also a matter of cultural subjectivity and historical responsibility—two traditional ethical values embraced by Chinese intellectuals. The latter principle seems to have prompted the 2008 repatriation of another eminent overseas Chinese artist, Xu Bing, who became the vice president of his alma mater, Beijing's Central Academy of Fine Arts. Regardless of individual motivation, such migratory patterns indicate the normalization of China's position within the global art world. This normalization process is itself a temporary historical condition that may eventually render sinification as one global style among many—for Chinese and non-Chinese artists alike—rather than a self-referential identity proclamation during glocalization.

China + Contemporary Chinese Art + Chinese Time-Based Art

The four thematic rubrics—Brand China; the art support, creation, transmission and sustainability networks; the indigenous heritage of internationally practised contemporary art; the globalization/glocalization imbrications with contemporary art-making—that I have assessed as suppositions from both ends of the consumption-and-production chain delineate two immediate macrocosmic contexts for my central object of research: contemporary Chinese time-based art. If I may compare 'China' to a large, elastic circle and 'contemporary Chinese art' to a smaller and equally flexible circle within China, then 'Chinese time-based art' would constitute an even smaller but likewise supple and permeable circle within the two larger overlapped circles. This diagram of multiple circles, or multiple centres, sketches out what I see as the external structural relations among the three entities. I place my conceptual emphasis, however, on their dynamic, dialectical, reciprocally implicating and ever-shifting interconnections. In other words, how China changes—both internally and in its international relations—will affect how contemporary Chinese artists construct their creative sphere, which comprises the ever-changing sum total of all individual output.

VERSION 1 VERSION 2 VERSION 3

IMAGE **0.4** China + Contemporary Chinese Art + Chinese Time-Based Art. Conceptual design by Meiling Cheng; drawings by Claire Frykman. Image courtesy of amphibianArc Design Studio.

While Chinese time-based art occupies only a small sector within the sphere of contemporary art, how its individual creators shape their practices to remain vital, in sync with or deliberately detached from the tempos of its two macrocosmic circles will simultaneously affect the composition and relationship of all three circles.

Since change, dynamism and interactive malleability are how I perceive the impingement of time on my narrative quest, my book typically treats the aforementioned three circles in a scrambled order, making the world of Chinese time-based art my largest circle, as if the whole universe is filled with its convoluted diversity and attention-grabbing urgency, while turning contemporary Chinese art and China into two companion circles that from time to time assert themselves on my time-based art circle.

VERSION 1 VERSION 2

VERSION 3 VERSION 4 VERSION 5

IMAGE 0.5 Chinese time-based art and two companion circles—contemporary Chinese art and China. Conceptual design by Meiling Cheng; drawings by Claire Frykman. Image courtesy of amphibianArc Design Studio.

I have three justifications for this scrambled order. One, perceptual priority, which compels me to hold the immediate object of my analysis closest to my field of vision; Two, redressive deliberation, which urges me to counter the prevalent reading of contemporary Chinese artworks as covert codes for the country by engaging with the artworks themselves in depth; Three, interpretive self-permission, which allows me to seize from the two macrocosms surrounding my central object of inquiry only those parts needed to sustain my argument. All three analytical procedures serve to downsize, or to render temporarily peripheral, my companion circles, regardless of their actual volume and external relationship to my time-based art circle.

My subjective prioritization of the three coexisting major centres in this book—Chinese time-based art; contemporary Chinese art; China—follows my multicentric methodology that grants provisional centricity to my object of inquiry at any given moment while acknowledging the object's constant interactions with other thematic centres. Within the centre of time-based art, there are of course coexisting multiple centres: selected artists, artworks, art modes, genres, concepts, sites, etc. To make this book possible, however, I am compelled to draw a circle within the vast field of Chinese time-based art to limit my research scope. The book's title, *Beijing Xingwei*, represents this necessary framing act.

Beijing Xingwei includes four Chinese characters, converted through the Pinyin romanization system into a neologistic English phrase. I evoke Beijing (北京, northern capital)—China's present capital—to identify my investigation's major geocultural site; the city also serves as a metonymy for the country to which all the selected artists in this book belong. I choose *xingwei* (行为, behaviour)—part of xingwei yishu—to indicate a major target of my time-based art research. The term also characterizes my scholarly behaviour. The words that take up residence

in these pages therefore chronicle my process of re/tracing certain artistic behaviour—seen, heard, recollected, imagined and documented—in Beijing.

As symbolic shorthand, 'Beijing' is the minimum common denominator among the three centres profiled here. But my choice of the city is not arbitrary—even though it means excluding from consideration other prolific 'Chinese' contemporary art sites, both in the Mainland and the diaspora (including Shanghai, Chengdu, Guangzhou, Hong Kong, Taipei, Singapore, Tokyo, Paris, New York). As Wu Hung notes, since the 1990s, Beijing has become the centre of experimental art in China (2008: 29–42). My research trajectory confirms Wu's claim by induction, through the incessant guidance of particular artworks that would not let go of my memory until I brooded over them patiently. Out of my successive attempts to inhabit the unforgettable, 'Beijing' emerged as the metropolis where the makers of certain evanescent actions and transient monuments have scarred my mnemonic skin with indelible cuts.

| NAMING 'XINGWEI' IN MULTICENTRICITY: A SYSTEM OF READING TIME | *Beijing Xingwei*, coined from a bilingual convergence, marks this book as an intercultural product emblematic of the trend of glocalization as experienced by a single player, |

through movement, behaviour, speech and interaction. Corresponding to the diagrams I devised to position time-based art in relations to contemporary Chinese art and China, I've designed an ideogram to capture at a glance the confluence of desires that have motivated my glocal movement and excavation. This ideographic neologism is an as-yet unpronounceable

IMAGE **0.6** A square in a circle. Conceptual design by Nonchi Wang; drawing by Claire Frykman. Image courtesy of amphibianArc Design Studio.

character consisting of a small square set within a larger circle. The small square occupying the interior of a circle indicates the relationship between a viewpoint (mine) and a volitionally isolated cultural landscape (that of Chinese time-based art); the viewpoint enables my act of enunciation which sets out to describe the encircling landscape that inspires, sustains, resists and intersects with my speech act. The small square mirrors the Chinese ideogram for the mouth, *ko* (口), a bodily vehicle for utterance. The outer circle exaggerates the Chinese punctuation mark for the period, which is a tiny circle, suggesting simultaneously emptiness and fullness in contained cohabitation. Their juxtaposition joins the presence/absence of a pregnant circle with the absence/presence of an alien square, providing an aperture from which the content residing in the circle may appear, leak out, burst forth or mutate and become a square. This ideogram epitomizes the nature of my cross-continental inquiry by making visible my conditional analytical centricity in dealing with the encircled sphere of my research. It verbalizes my critical subjectivity—a decentered centre, a square whose existence and sustenance depend on a co-present external circle—as a glocalized intercultural reader/writer in a multicentric terrain.

Coincidentally, this ideogram resembles the shape of an ancient Chinese copper coin, a small round piece of metal with an empty square at its centre. The colloquial term for the coin is a three-word phrase, *kongfangxiong*, which may be translated as 'hole', 'square', 'brother', aka 'brother square hole', a Chinese counterpart to the American 'buck'. In retrospect, this likeness

between my square-in-a-circle ideogram and brother square hole astonishes me for its serendipity, because the sign of 'money' was one of the conundrums that drew me to Chinese time-based art. When increasing numbers of Chinese painters joined the rank of multimillionaires and the entire Chinese society was rife with lucrative opportunities, I became interested in those who had seemingly pursued a minority model. I sought to understand why certain visual artists, trained as they were with superb skills in painting, would choose instead to create time-based artworks that evaded straight-forward commodification and popular appreciation. Chinese time-based art

IMAGE **0.7** The traditional shape of a Chinese coin called *kongfangxiong* (brother square hole). Image courtesy of amphibianArc Design Studio.

had incited public suspicion, academic ridicule and official condemnation on its home turf. If external incentives (monetary reward, critical recognition, cultural distinction) were not likely to be forthcoming, then what urged these xingwei and xingwei-zhuangzhi practitioners to produce ephemeral art? What mental resources and intellectual satisfaction sustained these artists in their divergence from the prevailing ethos of quick profits and instant fame?

The longer I worked on my research, however, the less certain I felt about either the idealism of Chinese time-based artists or their uniqueness in relation to the performance artists I met in the West. In fact, all of the artists I interviewed for my books—whether in Los Angeles or in Beijing—aspired to promising and financially secure professional lives. Similarly, many of them would not hesitate to overspend their personal funds to create meaningful artworks. These artists often laid claim to the pleasure, necessity or perversity of pursuing imaginative alternatives to the capitalist zeitgeist and mainstream consumerism. Thanks to the speed of glocalization in China, the Beijing artists I encountered were no different from their Los Angeles counterparts in either their medium-specific artistic languages or their excitement for inhabiting the experiential and cognitive limit zones. Ironically, what made the two cities' time-based artists different from each other was their native environments, especially due to the relative rate of change for each country—nearly static in the routinized, overdeveloped US vs dynamic in the capricious, developing China.

To my amazement, I discovered that the opposite of what I assumed had been true as well. The square-in-a-circle ideogram I designed specifically for my transcultural critical intervention would also serve to epitomize my previous inquiry about performance art where I reside. My diasporic identity—as an immigrant from Taiwan in Los Angeles and as an American of Taiwanese ancestry in Beijing—had only complicated my critical acts but did not fundamentally singularize my performance studies projects. Other similarly trained performance scholars may well offer something comparable. In the same light, the three multicentric circles with which I schematize the fluid relationship among China, its contemporary art and its time-based art coexist to oppose and compliment each other and assert their respective validity, exigency and pertinence in various moments and contexts. Thus, to push this reasoning sequence to its two multicentric conclusions: One, what makes Chinese time-based art unique is the very fact that I cannot claim the same intimate interconnections among the US, its contemporary art and its time-based art at this historical moment. Two, in contrast, I can ascertain an almost direct lineage between performance art in Los Angeles and time-based art in Beijing. *Beijing Xingwei* is then a sequel to *In Other Los Angeleses*, which is also a prequel to *Beijing Xingwei*.

Time-Based Art | Because of the close tie between China and its contemporary artistic expressions, I designate xingwei yishu and xingwei-zhuangzhi yishu as time-based art to underscore these two ephemeral art modes' perceptual proximity to as well as critical distance from the coeval Chinese experiences with transience, mutability, commercialism, instant obsolescence, historical amnesia and virtuosic adaptability. Yet, before we proceed to substantiate these two Chinese art modes that have sinified/glocalized performance art, we must pause to ask: What is time-based art?

Or, to break down this abstract question into more specific ones: What is the purpose of creating time-based artworks in a postmodernist, late-capitalist period when any temporal duration, if not registered sensuously as speed, is guarded as a resource for generating assets? If time-based art is an expressive medium associated with evanescent art-making, then how does its resulting non-permanent products relate to the capitalist utilitarian reflex to commodify labour and to profit from one's commodity? How does time-based art, via its embodied, live, sited, clandestine, public or virtual guises, intervene in China's contemporary art scene? How does time-based art, an established international live art medium, become reconfigured when it is cast as xingwei yishu, which frames an artist's deliberate behaviour within a durational structure? How does xingwei-zhuangzhi, which combines the temporal volatility of xingwei with the spatial fabrication of zhuangzhi, activate the cognitive patterns inculcated by an ideographic language? How do xingwei and xingwei-zhuangzhi tap into, reproduce or reinvent their practitioners' enculturated way of accessing and representing the material world—in what I've demonstrated, via my compulsion for imagistic-semantic coinages—as an ideographic phenomenology? How do these two time-based art modes, sharing their ethical and existential quest via xingwei, open heuristic windows into fast-paced present-day China? How do the Chinese practitioners of time-based art—many of whom told me that they are 'post-painting'—relate their object-less artworks to other types of contemporary art forms, experimental or otherwise? How do they contextualize their concept-initiated transient events within a socio-cultural environment in the throes of unprecedented changes? How do these artists appreciate their works' contributions to their national history and to the human chronicle in general? And, lastly, how do I project my voice as an interlocutor to that distant scene where some site-specific, temporally energized and spatially charged performative actions took place beyond my physical presence?

All these questions, in one form or another, appear throughout the following chapters, especially in Chapter 1 where I theorize time-based art amid a set of overarching conceptual issues, from globalization, Chineseness and multicentricity to glocalization and sinification. Instead of answering these questions here, I offer an interim definition of time-based art as a visual art form that pivots itself on the interplay between temporality and materiality. Time-based art exhibits the effect of time on assorted 'bodies', including those of the artist, the artwork, the viewer and the viewing environment.

My book uses 'time-based art' as the summative taxonomic term for the diverse ephemeral artworks produced by a number of Beijing-based artists. But none of the selected artists has used this term. Song Dong, for example, remarked that he has covered such a variety of media, including performance, installation, photography, video and new media, that he can at best call

his work simply 'art'.[19] Qiu Zhijie, who also works in multiple media, names his evolving syncretic art practise 'total art' (see Meiling Cheng 2009). Their antitheses exist too. As Ai Weiwei professed, he doesn't care whether what he does is art. Wang Jin avoids defining his art. Gu Dexin, working primarily in xingwei-zhuangzhi, shares Ai's and Wang's attitudes but in the manner of what I would call 'negative resistance': 'Whether what I do is art or not doesn't matter. It's something I do.'[20] He Yunchang has favoured using 'xingwei yishu' to describe the majority of his art actions.[21] So do some of the other artists who have worked mostly in xingwei yishu, including Zhu Ming, Yang Zhichao, Wang Chuyu and He Chengyao. In contrast, a few pioneering xingwei artists, such as Ma Liuming, Zhang Huan and Cang Xin, have either ceased performing for the time being or have shifted their emphases to producing relatively more permanent artworks in sculpture, photography and painting. Zhu Yu, who enacted numerous controversial xingwei pieces round the turn of the millennium, also moved away from action back to painting. Other artists identify mainly with xingwei-zhuangzhi or simply with zhuangzhi, as do Yin Xiuzhen, Xiao Yu, Wang Wei, Liang Shaoji, Liu Ding, Sun Yuan and Peng Yu.

19 My interviews with Song Dong, 5 July 2006 and 24 March 2009, Beijing.

20 My interview with Gu Dexin, 10 July 2006, Beijing.

21 My interview with He Yunchang, 4 July 2005, Beijing.

Despite such plurality, three things are constant. One, all of these artists are visual artists by training (formal or autodidactic)—unlike the interdisciplinary mix (from visual arts, theatre, puppetry, music and dance to urban design, architecture and literature) of performance artists I met in Los Angeles. Two, none of these Chinese artists focuses exclusively on one art medium or genre; they traverse transient and nontransient means and often combine their art practices with exhibition curation, writing, teaching, comic-book drawing, graphic design, photojournalism and other commercial work. Three, when I mentioned the term *shijian yishu* (time art, or time-based art), all of these Beijing artists seemed to know instantly what I meant without explanation and thought the term fairly appropriate for their work.

Time-Based Art as Performance Art

In accentuating the actual irreversible changes to the bodies brought together—across space and time—by a given time-based artwork, my take on this art form extends from the conceptual and corporeal synergy of performance art. As a mode of time-based art and a resourceful life/live art vehicle, performance art enables a practitioner to externalize—through embodied, hence evanescent, means—a certain perceptual, cognitive, sensual, existential, meditative, or even hermetic, engagement with the world. While not all time-based art modes are performance art, the latter—with its nominal focus on 'performance'—supplies a multisensory vocabulary available for constructing a time-based artwork.

In *In Other Los Angeleses*, I define performance art as an intermedial visual art form that incorporates theatrical elements in its presentation. The definition highlights that performance art borrowed from theatre in order to constitute its creative language for composition and presentation, when visual art moved from a static two-dimensional (2D) or three-dimensional (3D) medium to a live medium, adding to its consideration the fourth dimension (4D)—time. While the theatrical elements in performance art may be deliberately antitheatrical, they still derive

from a dynamic, interwoven and interactive time–space–action–performer–audience matrix of theatricality. Simply put, the 'time' is the duration within which a performance artwork occurs, whether it's a real-time enactment or an elastic sense of time constructed by the performance; the 'space' is the actual, virtual or imaginary site wherein a performance takes place, as well as the spatial quality designed and projected by the performance; the 'action' is the sequence of acts, movements, images and/or texts scored by the artist for execution; the 'performer' is the entity that implements the action score, often but not necessarily including the artist; the 'audience' is the spectatorial unit which may or may not occupy the same site where the performance transpires. These five components are multicentric in their structural functionality and interdependent in their relationship; each may be singularly privileged, constructed and treated but still call on all others—however refashioned, reduced or inflated in their roles—to constitute a performance piece.

By privileging performance art's 4D language as the consistent creative ecology surrounding its presentation, I have sought to elucidate the joint heritage between performance art and experimental theatre in the twentieth century. Yet, this emphasis may obscure performance art's other lineage from conceptual art, which distinguishes it from theatre art's communal basis and allows it to redefine, in particular, the element of the audience in the theatrical matrix. The 'audience' in performance art therefore shifts from its position as an event participant to a conceptual partner, from its role as a testimonial 'eye' that verifies the presence of an art action to that of an embodied consciousness which, through sensory recall and data collection, extends the impact of the original action.

Mixing its conceptual art heritage with tactics for cultural survival, performance art thrives on the implicit contract and mnemonic co-agency between the artist/self and the viewers/others. Performance art's tendency to remain incomplete and multivalent permits its conceptual ownership to be dispersed and shared among spectatorial others, thereby offering incentives for its experiential shareholders—those touched by the work's presence or traces—to disseminate its affectability. By avowing its radical lack of self-sufficiency, performance art, though impermanent, engenders its posthumous returns as a reusable cultural reservoir for posterity. A performance artist may be the sentient body experiencing a certain action in its first occurrence, yet the performed piece requires other people's investments (cognitive, emotive, visual, imaginative, etc.) to register its public interest in written memories. Thus, for a performance artwork to last in history, it has to inspire at least two present-tense actions: one endured by the artist's body; and one other—as its echoes and supplements—borne by another body, the one who *re-members*.

Performance Art as Live Art as Time-Based Art

Since I place a premium on theorizing performance art via its expanded 'present tenses'—the first time related to a performance piece's original unfolding and the subsequent times to the piece's recollection/reenactment/re-creation through the agency of others—my approach to performance art veers towards the ambiguous conceptual territory of another time-based art mode signified by the term 'live art'.

RoseLee Goldberg, a pioneering theorist of performance art, considers live art the logical next step from environments and assemblages (1996). Nevertheless—as was the wont of initial

critical work on performance art—Goldberg does not specifically define the term, leading to the often-interchangeable usage of 'live art' and 'performance art' in performance scholarship. From Goldberg's implicit connection of live art with 4D art-making, I regard the 'live' in live art as a condition of production. In live art, the processes of making art and presenting art overlap. A live artwork is created during its sharing with a witnessing entity other than the artist. This premise entails three resultant suppositions, applicable also to other time-based art modes. One, the live artwork's production and presentation are integral to its composition; Two, the artist cannot fully control the creation of a live artwork; Three, the interactive dynamics between the artist and the witnessing entity would significantly affect not only the making but also the reception and interpretation of a given live artwork.

Based on this conceptual articulation, I argue that the 'live' in a live artwork presupposes the co-presence of two entities: the creator of an art production/presentation process; and a witness to the same. Whereas the live artist more often than not assumes the role of the creator, what constitutes a witness is open to debate. Theoretically, a witness to a (time-based) live artwork includes at least three types: a witness with intention, such as a human spectator who recognizes or is willing to share the temporal duration in which a live artwork transpires; a witness without intention, such as the lens of a camera/video recorder; an accidental witness, such as a stray cat or a passer-by, who may or may not have the capacity to recognize an artwork being made.

My proposed typology of live art witnesses leaves unanswered the artist's potential status as his/her own witness. Nevertheless, it does respond to the general assumption that a live art viewer cannot be remote—that is, not onsite, distant in both space and time. In fact, the ubiquity of cameras in a live art event both admits to the desirability of remote viewers and makes provisions for them to appreciate the artwork offsite. Understanding the 'live' in live art as a condition of its production, therefore, leads to neither the notion that there must be a community of live bodies congregating to experience an artwork in its present-tense happening, nor that a critic/respondent of a live art piece must be physically present onsite. These postulations, I believe, apply more to the evaluation of a theatre piece, which depends on a live audience for its appreciation, than to a concept-based live artwork. Thus, like performance art, live art depends not on an onsite audience for its reception but on providing access (via documentation, artist interviews, critical review, etc.) to interested others for appraisal.

The shared conceptual kinship between performance art and live art makes these two time-based art modes alike, but regional preferences may dictate the prevalence of each term. 'Live art', for example, is favoured in the UK whereas 'performance art' is more often used in the US. A coincidental glocal procedure, however, renders the two terms more distinct in Chinese. The most popular Chinese translation for 'live art' is *xianchang yishu* (literally 'present-site art') and that for 'performance art' is xingwei yishu (behaviour art). The connotation of *xianchang* (the present site) affiliates live art in its Chinese rendition to what Adrian Heathfield theorizes as the immediate, the immersive and the interactive qualities of a live art event, one engaging an onsite audience (even just a single intentional witness) (2004). In fact, Beijing has hosted quite a few international live art festivals in the past decade in its attempts to accommodate and encourage a global public culture. Conversely, the connotation of *xingwei*

(behaviour) in the sinified version of performance art stresses its individualistic, if not solitary, aspect; it prioritizes the artist's volition and experience in undertaking a sequence of acts while drastically diminishing the relevance of an onsite witness to the time-based artwork.

Multicentric Temporality | Because of my geographical and temporal distance, my inquiry into Chinese time-based art focuses on performance art–derived xingwei yishu and its spatial kin xingwei-zhuangzhi, rather than on the live art equivalent, xianchang yishu. Ironically, following my restrictive definitions, I am theoretically capable of critiquing a live artwork as a performance art piece but I am not equipped to analyse its Chinese counterpart, a xianchang yishu piece, without having witnessed it live, at its original present-site.

My previous work on performance art, a globally practised 4D art medium, therefore serves as both my theoretical grounding and point of departure for this new inquiry into its glocalization in China. But, when I enacted the naming rite for my book's launch into the world, I chose yet another term—Chinese time-based art. Why?

First, there is the practical reason of finding a common term for both xingwei yishu and xingwei-zhuangzhi. Beyond the logistical necessity, the naming of Chinese time-based art implies an authorial intention, enunciating my theoretical/literary intervention into this scene. This intention is expressed in the formal linkage between my book's title and subtitle. I've earlier performed what I consider a loosely ideographic critique of the book's main title, centring on the significance of Beijing. Now, to illustrate how information changes in time with the shifting of thematic centres and the accretion of details, I shall read the book's title again together with the subtitle to offer a conceptual snapshot of this book as time-based art.

I see the relationship between the book's interrelated titles as analogous to the square-in-a-circle ideogram I created for my project: *Beijing Xingwei* epitomizes my provisional critical centricity symbolized by the square; *Contemporary Chinese Time-Based Art* delimits my circumscribed sphere of inquiry represented by the circle. In their neo-symmetrical structure, 'Beijing' in the main title corresponds to 'contemporary' in the subtitle, and 'xingwei' becomes equivalent to 'Chinese time-based art'. If the main title delineates my authorial critical action (my 'xingwei' in 'Beijing'), then the subtitle proclaims this action itself as being 'contemporary' with 'Chinese time-based art', which I take as both the quest and the product of my critical action.

A further step. While I use 'xingwei' in the main title to evoke performance art via its sinified alias, xingwei yishu, I also drop yishu (art) from its nomenclature. This elision defines the nature of my critical action by pronouncing the continuum between my artistically framed writerly performance and my expediency-emergency-contingency-bound daily behaviour. Thus, I mark the entire temporal duration through which I accomplish my critical action as a piece of Chinese time-based art, foregrounding my conditional centricity as the multicentric body/mind that has experienced and called forth the myriad temporalities—mine as well as those I borrow—compacted in these pages.

Finally, seen from this book's impersonal perspective, my time-based art is nothing but the dramatization of its author's function. Therefore, to imagine this reasoning sequence again in the third-person voice of *Beijing Xingwei*, the book, as its title and subtitle forecast, features

a direct connection among multiple time-bound entities: its author's extended verbal labour in composing the book; the span of time she spent on and round its composition; her claiming of this durational project as her 'Chinese' time-based art; a selection of ephemeral artworks by Beijing artists who showed her their 'Chinese' time-based art; and, Chinese time-based art as verbalized in *Beijing Xingwei*.

How do I practise my authorial time-based art? Making Time

> My consciousness makes time;
> My will woos it.

Perhaps an author's consciousness creates time in the span of an intention, when an inchoate thought, having soaked up a type of invisible ink called time, tallies the seconds/minutes/hours/days/weeks/months/years it will take for the words that tentatively match its 'thoughtfulness' to become manifest under the ultraviolet light of extreme duress. Writing makes time because it takes time to write.

This passage about an author's writerly performance evokes at least three kinds of temporality. Creative time—belonging to the present tense, intrinsic to and linked with a subject's consciousness, of flexible duration and uncertain consequence. Mysterious time—having no tense or full of it, extrinsic to the subject, attractive to theoretical physicists, artists and other philosophers, of infinite or infinitesimal duration. And artificial/consensus time—matched with various tenses, extrinsic to yet able to be internalized by the subject, regularized by candles, sundials, hourglasses, watches, clocks, calendars and scheduling software, of measurable duration. There are, of course, other types of time hidden in the passage: natural time; physiological time; sick time; self-maintenance time; family time; love time; panic time; chores time; traffic time; work time; teaching time; social time; meal time; play time; sleep time; dream time. The authorial will that woos time as a species of interest, knowledge and imagination —a taxonomic conglomerate of pain and pleasure, sterility and productivity—can do nothing but persevere through the multicentric proliferation of temporal phyla to search for their shareable names.

Thus, the most frequent way that I, as the author, have practised my time-based art with/in this book is by accumulating hours of pondering and then waiting for their sudden transmutation into comprehensible prose. Aside from such private agony, however, I've built this critical inquiry upon my prior system of performance research—call it my once-tested professional time—which consists of a fluid synthesis of live art critique, archival analysis, theoretical contextualization and affective interactions (via face-to-face, phone and email interviews) with artists, curators and critics. I've used several concepts to characterize this performance research system, including multicentricity, prosthetic performance and ideographic critique. These analytical concepts, in more elaborate shapes and slanted towards an engagement with temporality, inform this book.

Multicentricity is effectively the genius loci of *Beijing Xingwei*. In the Preface, I've rehearsed the implications of multicentricity as a mode of subjectivity. Here I shall briefly reiterate its relevance as a descriptive epistemology. Multicentricity simultaneously affirms an embodied

knowing subject's ineluctable experiential/evaluative centricity and qualifies the subject's potential projection of solipsism and omnipotence when exercising such centricity. By holding in view the coexistence of multiple (epistemic/knowledge-making) centres, a multicentric subject avers the fundamental inadequacy of any one centre, even as s/he also asserts a certain provisional autonomy and strategic competence in generating knowledge and impressions about the world. Accordingly, a multicentric author—as I strive to be—concedes to the inevitability of perceptual centricity and the impossibility of absolute knowing by discursively vacillating between self-affirmation and self-critique.

As the 'central' methodology that governs my interpretive regime, multicentricity coordinates my critical quest because it charts the structural operation of performance art, which is the paradigmatic model for my study of time-based art. Not only is performance art's constituent time–space–action–performer–audience matrix multicentric but the ephemeral art form has also evolved multicentric solutions to preserve its post-mortem cultural vitality. Counteracting time's power of erasure, which ultimately dissolves any claim to centricity, performance art propagates by entrusting its memory to the re/creative insemination of spectatorial others. This time-based art form resorts to its 'renaissance' technology by generating and making available multimedia traces: texts, photographs, videotapes, recordings, performance scores, artist interviews, websites, referential documentation, peripheral testimonies, transcribed or embellished eyewitness accounts—each source acting as an imaginary centre to entice/enable its subsequent re/creation. I call an issue of such re/creative labour a prosthetic performance. Although a prosthetic performance cannot fully restore, replicate or supersede the source performance, it may extend in time and space the efficacy of the originary performance in the global culture-at-large. An emergent centre that heeds its multicentric germination and emplacement, a prosthetic performance—as is this book—is the artificial adaptation of time-based art.

I have sifted most of the prosthetic performances collected in *Beijing Xingwei* through an ideographic critique I demonstrated earlier with my readings of this book's title and subtitle. Multicentricity and ideographic critique mutually inform each other because I've developed both concepts under the influence of an ideographic language—Chinese. Based on my admittedly eccentric and literate class–specific understanding, Chinese writing is a sense-infused yet visually oriented linguistic system that tends to inculcate in its users the habit of reading images from the phenomenal world as ideograms remade in calligraphy. Multicentric in its composition, a Chinese ideogram typically consists of numerous independent and semantically self-coherent parts; each part—or linguistic centre—has particular denotations; combined as a multicentric sign, this committee of all-functioning parts registers a range of meanings for the ideogram whose discursive resonance coincides with its cumulative visual complexity. Sight and sense are figurally conjoined and complemented by a conventionalized sound to create an ideogram's sensuous and meaningful ecosystem. With my ideographic critique, I often hover over a performance and alight on an installation as if I were a hypersensitive, genetically modified insect, extending my enculturated antennae to sniff coded nectar from the air. Within the ideographic scripto-zone, a durational xingwei piece unfolds for me like stanzas of visual poetry while a spatialized xingwei-zhuangzhi reads like a neologistic ideograph.

There are multiple ways of reading a time-based artwork, just as there are many different ways of spending one's day. While my study of time-based art extends from my performance research, what makes *Beijing Xingwei* most different from *In Other Los Angeleses* is my insistence on bringing into relief a temporal dimension that appears at once inherent to the artworks I scrutinize and extrinsic to them. By subsuming a variety of ephemeral artworks under one label, I have interpolated a thematic layer—time—into my reading, essentially treating these diverse artworks as global cultural 'readymades' to illustrate my theory of time-based art (see Duchamp 1989: 141). An expected drawback of such an interpolation is thematic monotony, for temporality becomes a perennial analytical topic. But a more glaring danger with this approach is imperialist over-reading, when I, as an American performance theorist, appropriate numerous artworks made by Chinese artists as examples to support my argument.

I readily admit that critiquing time-based artworks created by others as my practice of authorial time-based art does verge on two potentially insidious acts: domination, if I assess my objects of scrutiny from a higher/imperialist stance; or usurpation, if I access them from a lower/ambitious standpoint. Both acts are parasitic to my unwitting hosts. These negative possibilities are undeniably present, for power struggles between two subjects (creators and their viewers, artists and their critics, etc.) are a dimension of any intersubjective/interpersonal exchange. My approach merely acknowledges this usually tacit dimension as part of the liabilities assumed by two parties linked through an act of cultural transaction: the creator who issues an artistic product to the public risks being misread, appropriated and critiqued; the critic who considers such a product risks sounding presumptuous or myopic, condescending or sycophantic. In my view, spelling out these liabilities does not make them worse; rather, it enhances my understanding, if not appreciation, of the coexisting hazards and opportunities in any attempt at (public) communication. Disclosing my critical act as a self-reflexive time-based artwork actually doubles my liabilities as simultaneously a critic and an artist.

My tendency towards self-referential critique is nothing new in the broader tradition of conceptual art; Marcel Duchamp, wishing to pursue 'the idea of inventing', shifted the orientation of art from morphological to conceptual concerns in the early twentieth century. Joseph Kosuth, in 'Art After Philosophy' (1969), self-reflexively articulates Duchamp's line of inquiry to declare, 'A work of art is a tautology in that it is a presentation of the artist's intention [. . .] that a particular work of art is art [. . .] is a *definition* of art' (Kosuth 1999: 165). My humble relay in the chain of ideas set off by Duchamp, à la Kosuth, is to study time-based art alongside my contemplation of time. In addition, I employ a particular lens—my multicentric methodology —in observing time together with the use of time in art. 'The idea becomes a machine that makes the art,' as Sol LeWitt succinctly stated in 1967 (1999: 13). Multicentricity is the machine that makes the hybrid time-based art/scholarship of *Beijing Xingwei*.

With the caveat that my book might be no more than the self-referential delusion of an inventive tautology, I offer my meditation on time via multicentricity as a central contribution of this inquiry into Chinese time-based art. In short, my main message is that there is always more than one way of reading a time-based artwork and that every way of reading it presents a certain combination of validity, aporia, deficiency, acuity, cliché and insight. My interpolation

of an embodied temporal dimension into wide-ranging transient artworks is indeed a peculiar aspect of my durational reading/writing project chronicled in *Beijing Xingwei*. Nevertheless, this imposition on my part does not necessarily contradict my scholarly objectives of bringing a set of Chinese artworks to international public attention, situating them as splendid samples in the global lineage of time-based art and evaluating them with the contextual complexity they deserve. In this light, there is no conflict of interest in practising my time-based art while critiquing that of others. My multicentric notations of time actually enrich my research on (other) Chinese practitioners of time-based art, because I demonstrate the effects of their creativity on a single receiver/consumer even as I point out the built-in problem with this demonstration.

Multicentricity, along with the other related analytical procedures delineated here, presents *one* system of reading and writing about the creative products of an expressive medium that emulates our relationship to time. How do we, as mortal beings, relate to time? Both an element and the entirety of our existence, time is at once too familiar (for all of us have it, use it, lose it, enjoy it, waste it and profit from it), too pressing (for it changes our bodies towards their own vanishing) and too elusive (like our shape-shifting memories, preventing us from re-accessing a vanished event without changing it). Precisely because of time's obdurate, uncontrollable otherness, my attempt at making time through my consciousness is no more than an act of a transient being chasing after her own bliss. Time is still out there, changing me/her/him/us, without being changed by me/her/him/us. Thus, the other side of my proactive claim to making time is to let myself be made by time.

Chance is time's sculpture;
Time is my teacher.

As Gertrude Stein and John Cage have demonstrated in their respective time-based art— landscape drama and experimental music—chance is a fantastic, often humorous, compositional impetus. I take my cues from them—much more than I do from *I Ching* (*The Book of Changes*, mid-fourth century BCE)—to admit chance into my compositional process. Traces of these chance digressions, expansions or asides are recorded in my text primarily through my copious use of em dashes. But I've also incorporated plenty of life's fortuitous input that has changed me as a time- sensitive perceiver, even though these temporal sculptures remain somewhat unmarked in my main text.[22] To respect the accidental offerings from chance confirms the actuality of time beyond me.

Nevertheless, there is also an intrinsic dimension of temporality overlapping my embodiment, affecting my cells, metabolism, cognition, imagination and memory, in addition to the somatic ecology of the microbial communities within my body. All these interacting factors daily change my ability to write. To observe, follow and remain critical of these changes in me is to learn from time; to manifest these time-lessons in my writing is to mirror time. Peering through the multicentric lens, I've transferred these lessons into my text by experimenting consistently with a set of conceptual/rhetorical time-tricks: catalogue; definition; repetition with reversal; self-reflexive critique; the perceptual present.

22 The input from life and art-in-life have come to me primarily through the agency of my family, Nonchi Wang and Ashtin Wang, and my manuscript's multicentric reading/writing team: my consistent first respondent, Rolf Hoefer, and my in-house reader/editor, Mariellen R. Sandford, in addition to many others listed in the Acknowledgements.

A catalogue is a discursive expression of multicentricity, for it displays a list of items as coexisting centres of equivalent or variable thematic values. Making catalogues (for example, typology; numbered lists; classification of genres; taxonomy of artworks; a string of nouns, adjectives or verbs) is my way of interweaving a cluster of related but differentiated ideas into the perpetual present, allowing them to share the same expansive moment.

A definition embodies the provisional centricity as a necessary evil of multicentricity. I've provided many interim definitions throughout this book like a constellation of motionless moments, crystallized not for eternal/citational wisdom but as stellar memoranda of relentless struggles.

A reversed repetition of an afore-proved thematic statement is the discursive counterpart to the Taijitu diagram with which I illustrate—in the Preface—the concept of decentred centricity essential to multicentricity. If the first appearance of a thematic statement represents the positive half within the Taijitu circle, then the recurrence of the same statement, pursued from the opposite perspective, represents the negative half. In temporal terms, the repeated but reversed statement recycles a past moment for its present use in order to complete the (future) promise of this present-past moment.

A self-reflexive critique follows the self-critical imperative of multicentricity. Similar to a reversed repetition, a self-reflexive critique exposes the aporia of a prior thesis by reviewing the same thesis from a different perspective. A self-critical reassessment demonstrates the change that I, as the authorial subject, activate when I challenge my cognitive blind spot by inhabiting the hypothetical perspectives of other centres. This self-contesting rhetorical device joins a flashback (a recursion of a past thesis) with an instant replay (a playback of the past thesis for present scrutiny) to serve the dialectical purpose of self-revision (a temporal double-take).

The perceptual present pays homage to the multicentric 'now', the creative time during which an authorial subject stretches past all temporal limits in search of stimuli for creativity. I adopt the perceptual present—formalistically marked by an alternative typeface and the present tense, as shown here—to conceptually frame my description of a time-based artwork that has long since vanished.

There are multiple reasons for this narrative/typographical conceit:

1. IMMERSIVE RECALL | When I recount a time-based artwork, I immerse myself so fully in its multisensory ambience that I become perceptually present with what I recall.

2. DATA COLLAGE | Although I strive to describe a temporal artwork as closely as possible to what I believe originally transpired, the perceptual present discloses the basis of my description as a composite reconstruction from data collected for assessing the artwork.

3. PROSTHETIC PERFORMANCE | The grammatical discordance triggered by the perceptual present accentuates the disconnect between the description of an artwork—its prosthetic regeneration —and the thing itself—the originary performance.

4. INVERSE MARKING | At times, when other considerations take precedence, I opt not to use the perceptual present in describing a performance. For example, the convention of using the past tense to tell a fairytale; the artist's initial undecided slippage between an improvised life event and an intentional artwork; the retelling of historical performances based not on my primary

23 I thank Dévan Bratton, a photography student at USC, for a stimulating discussion about this experimental feature. Dévan felt that the past tense will do the trick of recall although the present tense works well too.

research; or my psychic resistance to 'reliving'—by becoming perceptually merged with—certain artworks towards which I remain ambivalent.[23]

Verbalizing Temporality | To sum up these temporal contrivances—*Beijing Xingwei* is a multicentric time-based art book about time-based art. 'The medium is the message,' goes Marshall McLuhan's famous meme (McLuhan and Fiore 1967). Or, as Ludwig Wittgenstein puts it, 'The meaning is the use' (cited in Kosuth 1999: 161). The doubling of art and art criticism as my verbal medium, the useful/methodological slant in my scholarly inquiry and the splicing of my changes as a writer into my writing all make my book different from and complimentary to other books dealing with the use and idea of time in contemporary art.

Take, for example, Pamela M. Lee's elegant art historical study of time in *Chronophobia*, a term she coins to describe the 'pervasive anxiety' registered in 'the art and art criticism of the sixties' as 'an almost obsessional uneasiness with time and its measure' (2004: xii).[24] Lee tracks chronophobia to the

24 I thank Winnie Wong for bringing Lee's book to my attention.

emergence of computer technologies following the Second World War, when 'the rise of the Information Age and its emphasis on speed and accelerated models of communication [served] as the cultural index against which many artists and critics gestured' (ibid.: xiii). I've observed a similar chronophobic anxiety in some of the time-based artworks I study, probably because the current epochal transformation of China is comparable to that of the West (primarily the US and the UK in Lee's book) as a result of the technological paradigm shift that Lee analyses. But I have equally observed Daoist resilience, Confucian pragmatism, Buddhist detachment, Dionysian revelry and Midas-like abundance in the Chinese artists' relationship with time. Indeed, in Chinese time-based art, I've encountered what we might call the chronophiliac, chronoblivious, chronosensitive, chrononeutral and chronodefiant attitudes existing adjacent to chronophobia. My mobilization of a multicentric system, then, sets my critique apart from Lee's.

Lee's approach in *Chronophobia* centres on the representations of time in art and art criticism; mine, on the presence and impact of time on temporary artistic representations (ultimately, this book included). Of course, another crucial distinction derives from the glocalization of time-based art in China, which brings us to its reincarnations as xingwei yishu and xingwei-zhuangzhi in Beijing.

XINGWEI IN BEIJING: SINIFYING TIME-BASED ART | Like time, *Beijing Xingwei* is simultaneously within and beyond me. It joins my discourse about time (my being-and-becoming in time) with my meta-discourse on those time-based artworks that have taught me about their durational, fortuitous, improvisational and embodied medium. Chronologically, however, my meta-discourse came much earlier than my discourse on time which grew out of my writing on contemporary Chinese ephemeral artworks. In other words, I learnt about xingwei

25 I am alluding to Marcel Duchamp's comment on his first 'readymade': 'In 1913 I had the happy idea to fasten a bicycle wheel to a kitchen stool and watch it turn' (1989: 141–2).

yishu and xingwei-zhuangzhi long before I 'had the happy idea to fasten' the label of time-based art to these two sinified modes of performance art and performative installation.[25]

Because of that happy idea, I now have the felicitous task of demonstrating how these Chinese performative art forms are time-based art.

As mentioned earlier, the most popular Chinese translation of performance art is Xingwei Yishu xingwei yishu (behaviour art), which emerged in Beijing amid the 1985 New Wave art movement. Other translations include *biaoyan yishu* (performing art), *xingdong yishu* (action art, a preferred translation in Taiwan), *shenti yishu* (body art) and xianchang yishu (live/present-site art), with the last becoming more associated with live art activities held at public sites. Whereas each translation prioritizes a particular element of performance art, I argue that xingwei yishu, as the dominant translation, signals the beginning of performance art's glocalization in China. The phrase, 'xingwei', for example, includes two Chinese characters: *xing* (行) means 'to walk, to move, to circulate or to approve'; *wei* (为) denotes 'to act with intention'. *Xingwei* (行为), as a verb phrase, signifies 'to behave'. It may also appear as a noun phrase, meaning 'a behaviour, a legally recognized manifest conduct or a deliberate action'. Semantically linking xingwei with *yishu* (艺术, fine arts) therefore identifies an experimental art mode that probes the accepted boundary of premeditated behaviours enacted by an artist.

To a student of performance studies, my definition of xingwei yishu would most probably evoke Richard Schechner's famous theorization of performance as 'twice-behaved behavior' (2002: 22). Schechner's definition covers a spectrum of performative possibilities, from the everyday to the theatrical. The majority of those restored behaviours, however, imply a performer's intention to demonstrate in public or to a public. In contrast, many xingwei artists appear ambivalent, if not phobic, towards actual public showings (despite their eventual addressing of the public via documentation). Moreover, the connotation of ethical appropriateness in the Chinese noun phrase 'xingwei' paradoxically pronounces the art form's recalcitrant intent. Often, xingwei yishu produces instead twice-mutated behaviour, twice-removed routine conduct or, simply, twice-behaved misbehaviour, legally precarious and morally scandalous. Less frequently, xingwei yishu takes the alternative route of framing a quotidian (need-not-think-twice) behaviour as an experimental artwork, igniting the sensation of 'onceness' that perceptually turns monotony into eventfulness.

As behaviour art, xingwei yishu underscores its affiliations with a behavioural arena at once broader and more down to earth than the specialized theoretical concerns (for example, modernism, postmodernism, conceptualism, minimalism, etc.) affecting the international art world. Its expanded art-making sphere, however, may well extend from performance art's challenge to the reified division between life and art. Although a xingwei artist may claim otherwise, I suggest that the nuance of behaviour in xingwei yishu does not so much mutate as exacerbate the genes it inherits from performance art and thereby releases more genetic possibilities. What's the difference between 'to perform' and 'to behave'? Perhaps the former stresses expressive intentionality while the latter compulsory compliance. While an artist has the ability to create, any individual can behave—indeed cannot *not* behave—at any given moment of the day. Although not all behaviour is art, xingwei yishu may draw from any readymade-behaviour in the realm of habits and reframe it as art. Xingwei yishu may also invent impossible behaviour (misbehaviour) within the context of art and contribute hitherto-untenable behavioural patterns

to disrupt highly prescribed social life. In a nutshell, xingwei yishu contemplates not only *how to behave and why* but also *what to behave and how and why not*. To me, what has sinified performance art in Beijing is not xingwei yishu's conceptual innovation but its revised target of critique. Contrary to performance art's defiance of the canonized Western art history, xingwei yishu's object of contention is the even longer history of China's indigenous ethical tradition, which has been making a triumphant comeback in the nation's postreformist era.

Xingwei-Zhuangzhi | While 'xingwei yishu' is one among many translations for 'performance art', there is only one available Chinese translation for 'installation art': zhuangzhi yishu. The phrase 'zhuangzhi' consists of two words: *zhuang* (装, to instal, to decorate) and *zhi* (置, to set in a place). Placing the phrase 'xingwei' with 'zhuangzhi' for the compound phrase 'xingwei-zhuangzhi'—already a specialized art term, hence oft-used without 'yishu'—signifies an installation art that highlights its transient nature.

Xingwei-zhuangzhi encompasses two subtypes. One, a performance-installation joining a xingwei piece with a zhuangzhi, and linking an artist's volitional movement with an objective structure. Two, a performative installation projecting a xingwei effect as an ever-shifting state within a zhuangzhi, exposing the entropic process during which an impermanent object is dissipated. Xingwei-zhuangzhi as performance-installation appeared in Beijing in the late 1980s. In the mid-1990s, through the use of organic matter and natural elements as art material by several zhuangzhi practitioners (including Gu Dexin, Song Dong, Yin Xiuzhen and Wang Jin), xingwei-zhuangzhi as performative installation debuted in the city. Since the late 1990s, this time-based art mode, in both subtypes, has become ubiquitous in Beijing, yielding some of the most notorious and memorable pieces in contemporary Chinese art history.

Risking cultural essentialism, I attribute xingwei-zhuangzhi's popularity in China to the same source that has inspired my ideographic critique. Chinese culture—steeped, as it were, in an ideographic epistemology—tends to persuade its literate learning subjects to perceive and portray worldly phenomena in terms of pictorial-symbolic entities, like ideograms. The semantics of an ideogram often stems from an imagistic and hermeneutic montage of interlocked multicentric parts. To demonstrate again this imagistic meaning-making process—the word *xing* (行, to walk), for example, is composed of the word *chi* (彳, the left step) and *chu* (亍, the right step). The phrase *chi chu* (彳亍) denotes 'walking slowly, taking a step here, pausing a moment there'. Putting together these two ideographic entities to form another ideogram brings us to walk, *xing* (行), either fast or leisurely. Adding in the middle of *xing* (行) another ideographic unit *tu* (土, mud or earth) and packing it on top of yet another *tu* (土) lets us walk on a paved ground called *jie* (街), a street.

My epigrammatic linguistic game illustrates how an ideogram is made through the discursive association and semantic accretion of cumulative ideographic units. An analogous procedure happens in a xingwei-zhuangzhi artwork. Xingwei, as a performative action, intersects a temporal dimension with the spatial matterness of a (3D) zhuangzhi. The presence of time inferred by tangible changes—either through an artist's movement or through an art object's involuntary response to time—thematizes an installation's mutable architectural structure which continually alters the space. The layering of picture and concept, of object, body,

space, time and the perceiver who interacts with the xingwei-zhuangzhi approximates the making and deciphering of an ideogram.

I consider both xingwei yishu and xingwei-zhuangzhi to be paradig- matic time-based art modes because they treat temporality as an ever- | ## Glocalizing Time-Based Art

fluctuating condition that implicates all sentient beings in a process of eventual irreversible decay. As behaviour art, xingwei yishu connotes a direct intervention in the realm of ethics, construed as a comprehensive mapping of moral codes guarding an individual's speech, con- duct and social relationships, constantly taught and reinforced through family, school, media and societal inculcation. The joining of xingwei with zhuangzhi—as performance-installation— potentially reinforces this ethical significance. I understand how artistic inquisition into ethics serves a crucial role in a Chinese society, especially when the realm of ethics may function as a stand-in for the untouchable domain of politics. Nevertheless, I submit 'time-based art' as a nimbler conceptual vehicle to recognize the multicentric diversity within xingwei yishu and xingwei-zhuangzhi.

The quarter century–plus tenure (c.1985–) of these two transient art modes as part of contemporary Chinese art history (c.1979–) provides the general chronological framework for studying Chinese time-based art. Although plenty of historical contexts appear in the following pages, my aim with *Beijing Xingwei* is not to present a comprehensive historiography of Chinese time-based art. Instead, I have striven to allow time—in the multicentric way it taught me—to impinge on every aspect of my study. I have chosen six major thematic centres for the ensuing chapters, which have in turn dictated how I picked the artworks to organize my argument. The selected artworks then determined the artists and any relevant exhibitions featured in each chap- ter—a structural process that partially resulted in the recurrence of certain artists across chapters.

My criteria of selection are multiple. Several of the chapters appeared in their embryonic forms as published articles in my response to editorial calls. I interpret this kind of circum- stances as objective and temporal, because the themes selected by various editors reflected topical public interest, such as animal studies and art objecthood in late capitalism. Other themes reflect my perennial research interest, which I see as subjective and randomly bound up with chance in personal time: extreme performances and other transgressions against experiential limits, manifested here as cannibalism, death, cadaver display, flesh manipulation, monastic endurance, etc. Yet others I judge to be indispensable to understanding Chinese time-based art: globalization; glocalization; Chineseness; sinification; commoditization; and documentation—besides a supernatural longing for transmutation (surpassing one's temporal s/lot in a life span). Joining these introspective momentums and extrospective mechanisms, I believe, brings time into play with my multicentric centricity at the same time as it covers a broad and diverse range of Chinese time-based artworks.

To some readers, the prioritizing of artworks over their creators might smack of antihumanist 'artefact' fetishism, if not outright animism.[26] I admit that my proclivity in treating art objects as subjects in their own right and my almost pseudo-deification of time are potential pitfalls in my inquiry. I would nevertheless argue that my antihumanist—or

26 My phrase is inspired by Karl Marx's famous 'commod- ity fetishism'. See Marx (1993b).

'extra'-humanist—approach echoes the Daoist vision of the universe as an impersonal entity that has profound influence on human existence. Time in *Beijing Xingwei* is somewhat equivalent to, for example, the notion of *tian di* (sky earth, nature/the universe) in *Daodejing* (*The Classic of the Way and the Virtue, c.*sixth century BCE), the Daoist philosophy's founding text ascribed to the sage Laozi. The only difference is that I extract merely one element from the grand elegant universe for my prolonged scrutiny. Considering my theatre training, I may well attribute this d/alliance with time to the subliminal rhyming spells from Shakespeare. But, more importantly, I believe that my method emulates the 'spirit' of most time-based artists in producing ostensibly self-expiring yet multiply accessible (conceptual) artifices for the global commonwealth of the human imagination. Time-based artworks take most viewers' familiarity with transience as their interpretive given; the ordinary existential basis shared by these works encourages the other-enabling propensity of performance art and the self-empowering multiplicity of xingwei yishu.

The majority of artworks I investigate in depth were produced in the late 1990s and the early twenty-first century. While a historical survey is not feasible at this juncture, I will elaborate upon six transitional moments in the sinification of time-based art in Beijing as a road map for the multicentric trails to come. In concert with my intensive focus on time-based artworks, a main part of my inquiry into their transient objecthood manifests itself as a taxonomy of genres which will be integrated into this genealogical mapping. How Chinese time-based art practitioners (artists, critics, curators) jointly developed various modes of transmission for their 'dematerialized'[27] artworks since the 1990s is another crucial segment in my genealogical tracing.

27 I am borrowing from Lucy R. Lippard's term for conceptual art (1999).

Sinification of Time-Based Art

Similar to a typical exploratory process, the glocalization of time-based art in Beijing as xingwei yishu and xingwei-zhuangzhi went through three phases in which its practitioners scouted the terrain of sociocultural limits, charted the territory of creative possibilities and finally attempted to stake their claim to artistic ownership. In more specific terms—roughly corresponding to this medium's quarter-century-plus history, these artists began their tentative forays just underneath the official radar in the late 1980s, moved towards their collaborative and competitive push for domestic legitimacy and international appreciation in the 1990s, and arrived at their more overt strategies for sinification in the new millennium.

1. XINGWEI PRECURSORS | The three exploratory stages that I tracked as diachronic developmental phases for Beijing's time-based art are actually all discernible as synchronic impulses in an early example of xingwei yishu—*Concept 21–Art Before Your Eyes* (23 December 1986), a collective action that took place on the campus of Beijing University:

In −8°C weather, a group of artists, including Sheng Qi, Kang Mu, Zheng Yuke, Zhao Jianhai and Zhang Jianjun, undressed, wrapped their bodies in white linens, poured various-coloured paint on one another and then engaged in simultaneous random actions. Some rode bicycles while others climbed on the roof and called out the names of iconographic sites, such as 'The Great Wall' and 'Yangzi River' (see Berghuis 2006: 232).

This campus happening vaguely resembles the random juxtaposition of simultaneous actions in the untitled event enacted by John Cage, David Tudor, Robert Rauschenberg, Charles Olsen, Mary Caroline Richards and Merce Cunningham—plus an excited stray dog—at the Black Mountain College in North Carolina (1952) (see Goldberg 1996: 126–7). The Beijing artists nevertheless declared their cultural subjectivity by calling out Chinese historical sites— in a manner divergent from their US predecessors' Zen Buddhist/Dadaist non-order. If we take the binding of the Chinese artists' bodies as a mimetic representation of their sociocultural restriction, then the coloured paints disrupting the oppressive uniformity of their white bondage is their knock on the door of artistic legitimacy.

Although the *Concept 21* collective xingwei piece took place on a public site, most people know of it as an art historical record. A much more visible public moment for xingwei yishu occurred in the major 1989 exhibition in Beijing—*Zhong-guo xiandai yishuzhan* (literally 'China Modern Art Exhibi-tion', known in English as *China/Avant-Garde*).[28] Within hours of its opening, authorities shut down the exhibition because of an unexpected xingwei event known as *Qiangji shijian* (*Pistol Shot Event*, 1989), staged by two then little-known artists Xiao Lu and Tang Song.

28 See Marianne Brouwer and Chris Driessen (1997); Wu Hung (1999: 17–22); Thomas J. Berghuis (2006: 77–94).

Following Tang's shout of 'Da!' (Shoot!), Xiao fired two pistol shots at her sculptural zhuangzhi entitled *Duihua* (Dialogue, 1989). Originally Xiao's art-school thesis project, it com-prised two public telephone booths occupied by a male and a female mannequin respectively, showing only their backs. Xiao fled the scene afterwards while Tang, as her vocal accomplice, was arrested onsite. Later in the day, Xiao turned herself in. Both artists were released after only three days, allegedly for their social connections as children of high-ranking cadres and for the specific 'patriotic' source of the incriminating pistol—it belonged to a decorated member of the People's Liberation Army, the grandmother of a student Xiao tutored (see Li Xianting 2006).

The *Pistol Shot Event* betrayed undue political privileges that few enjoyed and inadvertently demonstrated xingwei yishu's seditious power in exposing official corruption. Xiao's two bullets transformed her static zhuangzhi into a xingwei-zhuangzhi; the subsequent arrests of Tang and Xiao ironically ensured their apotheosis in contemporary Chinese art history. This incident, which caused the premature closure of the *China/Avant-Garde* show on its opening day, resulted in xingwei yishu's entanglement with violence and subversion in public perception. Yet, for Xiao and Tang's peers and followers, it appeared to have also established the power of contro-versy in ephemeral art production.

2. SOCIALISM WITH CHINESE CHARACTERISTICS IN THE POST-TIANANMEN BEIJING | The *China/Avant-Garde* exhibition prompted a temporal convergence of artistic experimentation and political mobilization because it effectively became the inaugural ceremony for the nationwide pro-democratic demonstrations by college students in April–June 1989. The ruthless suppression of protesters by government hardliners both on and following the 4 June Tiananmen Square massacre, however, revealed the intellectual elite's political impotence and dashed their hopes of applying a variety of Western theories and practices to regenerate Chinese culture (see Li Xianting 1993b: xix).

The Tiananmen tragedy left Beijing's contemporary art world spent and paranoid; its vibrancy and vigour evident in the exemplar 1985 New Wave Art Movement stagnated under repression. Those artists who had chosen to stay in Beijing went into semi-hibernation to deflect political attention. Information about contemporary art was exchanged furtively, in contrast to the ecstatic engagement of artists with the international modern art scene in the first post-Mao decade. In January 1992, both to boost national morale and to buttress his political legacy, Deng Xiaoping undertook a much-publicized 'Southern Tour' to inspect the special economic zones of Shenzhen and Zhuhai (Kraus 2004: 21).[29] The tour became the basis of the so-called Deng Theory, which, as Elizabeth Perry observes, was crystallized in the title of Jiang Zemin's keynote address to the Fourteen Communist Party Congress (October 1992): 'Accelerating the Reform, the Opening to the Outside World and the Drive for Modernization, so as to Achieve Greater Successes in Building Socialism with Chinese Characteristics' (Perry 1993).

29 I thank Richard Kraus for bringing my attention to the annual review of Chinese politics in the *Asian Survey*.

I have earlier used Deng's talks to illustrate the procedure of sinification. To sum it up for this different context—the Deng Theory joins two seemingly incompatible platforms, endorsing expanded economic reform but suppressing any challenge to the CCP's political monopoly. Despite the ostensible ideological contradiction, the pragmatic theory managed to serve its theorist's purpose. Deng's renewed economic-political directives set off a national frenzy for commercialization, marketization and consumerism while compelling a general depoliticization among intellectuals. Their erstwhile fervour for what Zhang Xudong describes as 'universalistic high culture of humanism and modernism' seemed increasingly irrelevant in a mercantile society with myriad opportunities for anyone to 'make a buck'; their philosophical inquiries appeared anachronistic in the face of a bourgeoning mass movement towards popular entertainment and hedonistic pursuits (2008: 103). China since 1992 has entered—to use Zhang's apt term—a 'postsocialist' period, characterized by 'the historical overlap between the socialist state-form and the era of capitalist globalization' (ibid.: 16).

China's initial postsocialist reforms enabled several noteworthy changes in the country's contemporary art world, including, based on Wu Hung's analysis, the emergence of independent artists; the migration of experimental artists from various provinces to the capital Beijing; the formation of residential communities known as artists' villages, where those out-of-towners temporarily settled; and the internationalization of contemporary Chinese art (2008: 29–42). Thanks to increased job opportunities in advertising, graphic arts and interior design, independent artists were able to jettison institutional affiliations with the official art system and subsidized their unprofitable art experiments with commercial projects. Such economic independence brought geographic mobility and ambitious young artists throughout the country amassed in Beijing, transforming the city from 'a stronghold of official art and academic art' in the 1980s into China's 'unquestionable center of experimental art' (ibid.: 37).

In 1992, a hotbed of time-based art sprang up in Dongcun (East Village), an ephemeral artists' village in the dilapidated, garbage-polluted region originally called Dashanzhuang (Big Mountain Village) and later renamed East Village by its artists-residents for its location on the eastern outskirts of Beijing and to evoke its Manhattan namesake.[30] Owing to low rental rates, East Village attracted many young migrant artists and the place soon became a

30 Ma Liuming related this history of naming Dongcun in his interview with Tang Xin (2004). The police demolished East Village in 1994.

vigorous artist community known for its push against the aesthetic status quo. Divergent from the previous decade's collective tendency—as exemplified by *Concept 21*'s group performances—the majority of time-based pieces that xingwei artists such as Ma Liuming, Zhang Huan, Zhu Ming and Cang Xin produced in East Village were individual pieces with apparently depoliticized 'personal' themes.[31] Whether to pursue a sharper experiential impact; to mirror the hostility of their existential condition; to vent their pent-up rage at being young, poor and misunderstood in a society that prized seniority, familial support and moral concord; to defy a domestic art-making environment at once indifferent to and censorious of their creative output; or to impress their invited audience of fellow artists, curators, foreign students and reporters from Beijing, East Village artists staged a series of (by now world-renowned) xingwei artworks distinguished by their physically intense execution which explicitly linked xingwei yishu with violence, nudity, endurance and self-harming behaviour.

[31] I am referring to the feminist adage—'the personal is the political'—here. See my elaboration in Chapter 2.

3. BODYWORKS; ANIMALWORKS; CONSUMABLEWORKS; DOCUMENTARYWORKS | East Village artists deserve the credit for establishing striking precedents for Chinese time-based art, even though their extreme performances reinforced xingwei yishu's early reputation as risky, radical and counter-cultural—hence deserving also of public suspicion. Despite the lack of social acceptance, these pioneering artists formed their own audience and began developing two distinctive time-based art genres that I will call, by virtue of the performer/s involved, bodywork and animalwork.[32]

Bodywork treats the artist's body as the basis, perimeter, material, subject and object of a performance action. Animalwork involves the artist's interaction with or manipulation of another body, that of an animal—human or otherwise—in its various guises as a concept, a somatic mass, a sensorial stimulus, a material symbol or an alien spectacle. Both genres share a strong interest in the concurrence of corporeality and temporality—that is, in the nature and attributes of a mortal body. With violence as a common tendency, both genres thrive on presenting unexpected, grotesque or grossly visceral spectacles. While most xingwei pieces in East Village were bodyworks, Ma and Zhang also enacted some prototypical animalworks—a genre that would become a favourite among time-based artists with the increasing popularity of xingwei-zhuangzhi at the turn of the millennium.

[32] I adopt the term 'bodywork' from the title of a pioneering exhibition *Bodyworks: [exhibition]: March 8 to April 27, 1975* (Museum of Contemporary Art, Chicago, 1975). For 'animalwork', see Meiling Cheng (2008).

In the mid-1990s, another time-based art genre emerged in Beijing—consumablework, a term I use to designate a xingwei-zhuangzhi artwork made of consumable material or a xingwei artist engaged in the behaviour of self-commodification. Sharing the temporal basis of bodywork and animalwork, consumablework differs in its use of art materials strongly evocative of commercialism and its theoretical focus on economic exchange. Above all, consumablework conceptually intervenes in a mode of perception so saturated with the idea and experience of consumption that it generates an ever-insatiable craving for expenditure.

The act of consumption, in its guise as consumerism, has enjoyed a long history and an inquisitive body of scholarship in the capitalist West.[33] This was not the case in China in the 1990s. As Sigg commented, China's long isolation by Mao caused a 'time lag', leaving the consumer society that began

[33] For a survey of this literature, see Alan Aldridge (2003).

IMAGE **0.8** *Yu hai* (*Fish Child*, 1996), an animalwork performed by Ma Liuming. Image courtesy of the artist.

in Deng's era about three decades behind its Western counterparts (Sigg and Frehner 2005: 15–16). The emergence of consumable-works at this juncture in Beijing, then, responded to a suddenly dominant yet unexamined contemporary experience with economic Westernization. Even more crucially, unlike the politicized ideological discussions forbidden after the failed pro-democratic student movement, the artistic inquiry into socio-economic changes that a consumablework galvanizes benefits from their alignment with the official economic policy, which was itself testing out de facto postsocialist capitalism with 'Chinese characteristics'. Thus, consumablework arose as a paradigmatic postsocialist genre and has attracted many time-based artists over the past two decades. Their pointedly transient artworks reflect, challenge, exacerbate and offer alternatives to the mainstream pursuit of consumption and the common attitude towards consumerism as unproblematic, even enviable and socially prestigious in China's ever-more commercialized society.

Also in the 1990s, a hybrid time-based art genre developed in Beijing—documentarywork. Similar to consumablework's alignment with the official economic policy,

IMAGE **0.9** *00 10 29 (29 October 2000)*, a consumablework installed by Gu Dexin in the exhibition *Buhezuo fangshi/Fuck Off* (2000), Eastlink Gallery, Shanghai. The piece features a sofa filled with raw meat, placed on a red carpet, facing a red painting. Image courtesy of the artist.

IMAGE **0.10** *Yihu kaishui* (*A Teapot of Hot Water*, 1994), a documentarywork by Song Dong, pouring hot water on his neighborhood hutong (the traditional alleyway) in Beijing. Image courtesy of the artist.

documentarywork may be deemed politically noncontroversial because part of its presentational mode assumes a literary guise, affiliating the genre with the Chinese literati tradition. Documentaryworks emerged in relation to an experimental art exhibition format called *Wenxian zhan* (document exhibition), first introduced by Sichuan art critic Wang Lin in 1991. Wang used 'the name of academic research' to support his exhibition of experimental artworks via their documentation, effectively circumventing the intensified official supervision of contemporary art events in the immediate post-Tiananmen period (see Zhang Qingwen 2010). Documentarywork, however, pushes Wang's emphasis on evidentiary art documents further by actively incorporating documentation as integral to its art-making-and-presenting process. In this aspect, documentaryworks are impure time-based artworks, for they fuse transient durational actions with relatively more permanent documentary objects, construed as intrinsic to, rather than merely supplementary to, the enacted xingwei events. Documentaryworks bring to the fore the paradox of preserving ephemeral artworks because they integrate verbal and visual texts, blending literature with visual arts. Understandably, some of the artists attracted to this genre, such as Qiu Zhijie, Song Dong, Yang Zhichao and Wang Chuyu, are also calligraphers and art writers.

Except for bodywork, I have coined all the genre names. Nevertheless, time-based artworks similar to what I have described have ample Western precedents, if under different taxonomic labels. At any rate, Beijing artists have been presenting ephemeral pieces relatively corresponding to my proposed genres since the early 1990s to initiate a glocal lexicon for the globally evolving language of time-based art.

4. EVOLVING MODES OF TRANSMISSION FOR TIME-BASED ART IN BEIJING | During the 1990s, before international exhibitions became a regular possibility for Chinese artists, transmission of time-based art occurred through four channels: photography; publication; exhibitions; and the Internet. Actively complementing one another, each channel has experienced technological advances in recent years that have enhanced their collective capacity to reach a larger and more diversified audience. Since all four channels emerged in response to both regional intolerance and international receptivity of experimental Chinese art, their use attests to the practitioners' ingenuity and ability to jointly invent a more sustainable professional future for all.

Drawing on photographic documents to disseminate live artworks among offsite or future viewers has been a common method of transmission in the global practice of performance art. Many of the earliest xingwei artists initially learnt about performance art through photographic images in exhibition catalogues acquired from overseas, so they were predisposed to using photography as the pre-eminent means of documenting their xingwei yishu. The censorious local circumstances in the 1990s also induced many xingwei artists to adopt photographs as proxies for live action. Further, documentary photographs could be collected in printed form and thus could more easily dodge official interference, compensate for a deficient exhibition infrastructure and function as residual art objects for extended display, publicity and sale.

Photographic documents, however, depend on other transmission channels for wider dissemination. In the early 1990s, there were only a few art magazines in China, limiting the opportunities for artists to gain public exposure and legitimacy (see Qiu Zhijie 2004: 118). This situation exaggerated the power of the local art critics who acted as the authoritative filters for

the art market, charged fees to comment on artists' works and published the artworks they commented on in the magazines they edited. These official critics were nevertheless ill-equipped to evaluate the proliferating new genres of what Qiu Zhijie called 'non-easel' art (performance, installation, video, new media art, etc) (ibid.) and experimental artists had to take the initiative of organizing 'printed exhibitions' by publishing postcards, booklets and archival collections (see Tang Di 1997).

The format of printed exhibitions, however, has different implications for xingwei yishu and xingwei-zhuangzhi. Theoretically, I argue, publication functions as a passable means of displaying xingwei yishu because this conceptual art form, in its basic structure, revolves round a human body; the artist's body therefore serves as a surrogate for the viewer's body in imaginary identification. The intersubjective exchange between an acting body in durational engagement and a viewing subject in empathetic participation is made possible by the commensurable human sensory perception and cognition. Given that the enacted task solely depends on the artist's individual agency, xingwei yishu can be appreciated offsite by stimulating a remote viewer's conceptual reenactment through photographic images, supplemented by other documents. Indeed, certain xingwei pieces, such as most documentaryworks, can *only* be appreciated via documentation.[34]

34 See an extensive discussion of audience experience vis-à-vis documentaryworks in Chapter 6.

In contrast, I cannot make the same argument for xingwei-zhuangzhi. Whereas xingwei yishu may begin with an artist's action and end with a photograph, xingwei-zhuangzhi, like temporary architecture that shelters and surrounds its inhabitants, requires at least an actual space coordinated with a given temporal duration for its creation, if to a lesser degree for its appreciation. That a xingwei-zhuangzhi artwork is often grander than the human scale also makes it more difficult for a viewer to appreciate it in absentia. Publication cannot substitute for its real-time actual site. This ephemeral medium demands live exhibition in the same way that xingwei yishu doesn't—even if both expressive modes in due course use photographs for documentation and dissemination.

The eventual prevalence of xingwei-zhuangzhi in Beijing, then, hinged on the formation of an alternative art exhibition system. Gao Minglu calls this trend 'apartment art' and Wu Hung names it 'experimental exhibition', but they point to the same phenomenon beginning in the mid-1990s—artist-organized exhibitions at affordable and available spaces, from apartments to abandoned warehouses and construction sites, from street alleys, factories and restaurants to supermarkets, universities and the basements of residential compounds (Gao Minglu 1998c). Experimental artists solicited progressive critics or turned themselves into independent curators to create a parallel—underground—exhibition system, offering public exposure to those non-easel art media that suffered from various undisguised—aboveground—obstacles, including denunciation by the orthodox official art system, disregard by the purveyors of the rising popular culture and surveillance by capricious control measures of the government.

Since its official launch in China in 1995, the Internet has emerged as a popular, decentralized and high-capacity communication platform, reflecting the country's widening

globalization.[35] In the twenty-first century, the Internet, together with other electronic social media, provides relatively available channels for the transmission of time-based art. Resembling publication as a means of 2D display, the Internet surpasses print in its capacity to more efficiently reach a trans-regional online crowd. While the Internet does not offer an artist the kind of professional distinction that a live exhibition or a print publication does, it exceeds both traditional venues in its flexibility as a potentially viral vehicle for easily transferable data. In recent years, however, the Chinese government—with technological prowess purchased from numerous US firms—has adopted a sophisticated Internet filtering and censorship system known as 'the Golden Shield' (see Erping Zhang 2005). The Internet is therefore a highly unstable art-transmission channel. Nevertheless, for certain technologically savvy Chinese artists, the Internet promises more opportunity for information about contentious artworks to slip through the official firewall.

35 China 'officially joined the Internet on 20 March 1994 and, in June 1995, the Internet was opened to the public'. Since the mid-1990s, 'hundreds of thousands of Chinese-language Internet websites have emerged in China, and the number of Internet users has increased dramatically'. See He Qinglian (2006: 31); Christopher J. Berry et al. (2003); and Liu Kang (2004: 127).

5. EXTREME CHINESE TIME-BASED ART | Among the four channels of transmission, experimental exhibition most actively instigated the types of time-based artworks being produced in Beijing. The surfacing of an unofficial, if initially precarious, art-exhibition system introduced several dynamics in the late 1990s: it effectively transferred the legitimizing power from publication's print display to live exhibitions (Qiu Zhijie 2004: 118); and it fostered a mutually supportive yet deeply fraught relationship between organizers and participants of experimental exhibitions. This co-dependent comradeship not only enhanced a curator's intellectual power to generate a given thematic fashion but also allowed participating artists to move in unexpected directions;[36] and by virtue of their underground mystique, experimental exhibitions frequently attracted both a domestic crowd and foreign aficionados of new Chinese art, including students, reporters, curators and collectors. This increasingly prevalent phenomenon of globalization turned an experimental exhibition into a highly competitive international showcase for marginalized Chinese artists.

36 The exhibition *Post-Sense Sensibility* (1999, Beijing), curated by Qiu Zhijie and Wu Meichun, provides a paradigmatic case study for the complex relationships between an artist-curator and fellow artist-participants. See Chapter 2.

These new dynamics in turn-of-the-millennium Beijing evolved into more aggressive contests among time-based artists for domestic legitimacy and wider international recognition. Perhaps to refract, deflect or outdo the cut-throat ethos in an encroaching mercantile society, a great number of Beijing artists produced in a roughly five-year period (1998–2002) a string of controversial xingwei and xingwei-zhuangzhi pieces that delved into the violence of consumption. Reconceptualizing consumption as an element innate to all organic and social existences, these time-based artworks presented the concept as an insatiable greed that ignores the depletion of resources or an insurmountable force that exacerbates, exhausts, fragments, even terminates, a material being. The majority of animalworks revolved round the former idea, bringing to light the frequent subjugation of nonhuman animals by humans in an unequal relation of dominance and exploitation. An array of extreme consumableworks—in varying combinations with bodyworks and animalworks—tackled the latter theme, pursuing ever-more perilous and ethically dubious acts.

Unlike earlier xingwei artworks, which often became known through photographic documents, most of Beijing's brutal time-based pieces appeared in experimental exhibitions, including, among the most influential/controversial, *Hou ganxing/Post-Sense Sensibility* (1999), curated by Qiu Zhijie and Wu Meichun; *Dui shanghai de milian* (*Infatuation with Injury*, 2000), curated by Li Xianting; *Ren•Dongwu* (*Human•Animal*, 2000), curated by Gu Zhenqing; and *Buhezuo fangshi/Fuck Off* (2000), curated by Ai Weiwei and Feng Boyi. These well-attended and extensively reported exhibitions brought tremendous domestic and international media attention to their participating artists, making such names as Zhu Yu, Sun Yuan, Peng Yu, Xiao Yu, Qin Ga, He Yunchang, Yang Zhichao, Wang Chuyu, Wu Gaozhong and Yu Ji temporarily synonymous with extreme performance in China.

In April 2001, China's Department of Cultural Affairs issued a 'notice', banning all performances that displayed 'bloody, violent and obscene' material, thereby practically identifying xingwei yishu and xingwei-zhuangzhi with these infectious adjectives in the popular imagination (see Lu Hong and Sun Zhenhua 2006: 218–19). According to most xingwei practitioners in Beijing, however, this cultural-policy 'notice' managed only to curb the Chinese media's often spotty and salacious coverage of controversial time-based art events; it failed to exert any lasting impact on the field.[37] Nevertheless, a moment of potential danger flashed by during the National People's Congress (NPC) meeting in March 2002, when the CCP hardliners (cadres associated with the then NPC Chairman Li Peng) denounced the aggressive 'avant-garde art' as a 'social evil' comparable with the Falungong cult, severely suppressed by the government since 1999.[38] Although none of the xingwei and xingwei-zhuangzhi artists were officially prosecuted for their extreme art right after the 2002 NPC meeting, some of them experienced unexplained government censorship of particular artworks. So far, the most visible case of a probable official persecution of 'extreme art' has been the nearly three-month arrest of Ai Weiwei, detained for his alleged 'economic crimes' by the Chinese government in 2011. Ironically, prior to his arrest, Ai's most recent time-based art, made in response to the 2008 Sichuan earthquake, was a far cry from those brutal artworks denounced by the 2001 'notice'. Instead, Ai was probably punished for daring to encroach upon politics, the as-yet-untouchable realm of public interest in China.

37 My interview with Qiu Zhijie, 11 November 2007, New York.

38 See Jonathan Napack (2004a). On the brutal suppression of the Falungong, see Vivienne Shue (2004).

6. RECENT PERMUTATIONS | The medium's notoriety notwithstanding, extremity characterizes only a portion of xingwei yishu and xingwei-zhuangzhi. Over the past few years, Chinese time-based art has moved away from its more aggressive sensorial fringe towards a panorama of great diversity. Some transient artworks wrestle with the vacuity, extravagance and fickleness of the dissembling middle ground, the *terra mercatura* of present-day Beijing. Others investigate how ephemeral art production may be conjoined with the long-term project of building society and making history. Yet others attempt to present novel artistic experiences by fusing time-based art with other visual art forms (photography, new media, printmaking, painting, calligraphy) or more broadly with non-art forms (tourism, camping, fine cuisine, organ trafficking, prostitution, city planning, pedagogy for cultural literacy, even the piracy-counterfeit industry). No longer solely infamous, time-based art now participates in expanding the glocal lexicon of

IMAGE **0.12** *Day 64*, a photograph of Ai Weiwei by the art critic Jeff Kelley, who released the image on the Internet on the sixty-fourth day of Ai's incarceration by the Chinese government. Kelley wrote in his documentary text, 'Waiting for Weiwei' (2012), that his act of uploading one photo of Ai per day during the artist's absence resembled 'lighting a daily candle' for a missing friend, so that the world would not forget Ai's disappearance. The photo shows Ai standing inside his Caochangdi office. In the background is a large printout listing the names of the student victims who were crushed to death by collapsed school buildings during the 2008 Sichuan earthquake. The printout is part of Ai's *Sichuan Earthquake Names Project* (2008–09). Image courtesy of the photographer.

contemporary Chinese art; even sinification has become part of its multicentric stylistic acts, rallying round Brand China.

Multicentric Notations | Xingwei yishu supplies a malleable vessel for an artist to embody, endure, propose and demonstrate unconventional modes of conduct; it allows an artist—as an ordinary, if highly alert and trained, individual—to try out certain event-catalysed behaviours that agitate against China's long-standing ethical boundaries for quotidian conduct. Xingwei-zhuangzhi constructs an unfamiliar site to expose, evoke, accommodate and/or conceal such repurposed behaviour in a momentary interface with the viewing public. Placing xingwei with zhuangzhi formalizes in space the artist's phenomenological explorations, approximating an ideographic epistemology—one that organizes the universe of elements, creatures, things and landscapes as interactive, mutually affecting and cumulatively meaningful entities. Both

time-based art modes function as sensitive barometers to measure and record the epochal sociocultural changes resulting from China's state-promoted fusion between socialist market economy and authoritarian communist politics. From one perspective, studying Chinese time-based art within its diverse glocal contexts—both domestic and overseas—provides an intriguing critical angle to observe Beijing's current historical moment, suspended, as it were, between broken memories from a fast-receding past and the moral vacuum of an impatient present. From the other perspective, considering the country's global emergence as a newly minted Brand China adds an indispensable layer of complexity to the analysis of Chinese time-based art.

Without making any claim about the immediate sociopolitical efficacy of art, I hold that Chinese time-based art probes the nation's collective psyche and consciousness, testing its ethical phobias, historical traumas, ideological quandaries, sociocultural shifts and popular obsessions. Because of its adaptability, time-based art can be easily transferred to diverse existential contexts, which may be as private as an artists' bedchamber, as monumental as the Great Wall of China, as desolate as an insane asylum, as random as a deserted demolition site or as public as an academic research studio. This art medium is flexible enough to comprehensibly reach various dark, unduly opaque or fashionably over-lit corners of public habits, permitting it to assemble and represent wide-ranging phenomena in an ultra-naturalistic fashion, even as it simultaneously invents behavioural patterns that verge on the absurd, the futile or the fantastic. Collectively as xingwei and xingwei-zhuangzhi pieces, time-based art succeeds in compiling an ongoing *ye shi* (wild/untamed history or colloquial history) which emulates, exposes, questions and chronicles the specific time-space that has inspired the production of these projects. Time-based art may not prescribe a panacea to poorly digested postsocialist capitalism but it does strive to serve up an antidote. For some of its practitioners, the dedication to enact individually designed behavioural sequences or to construct some fleeting architectonic enclosures perhaps resembles a transcendental experience, an act of grace that substitutes the erstwhile dominance of state politics and the current lack of metaphysics with art.

While I approach Chinese time-based art as a heuristic window into its changing homeland, I also seek the opposite—to read the selected artworks closely on their own terms as art. This objective does not solely spring from my self-critical multicentric perversity but also responds to a major tendency in existing accounts of contemporary Chinese art. A remark by Sigg illustrates this tendency: 'Through encounters with hundreds of artists, my ultimate object of study is China' (Sigg and Frehner 2005: 18). If even a passionate contemporary Chinese art collector regards the artworks he has judiciously acquired for decades as an 'access to China', then, I reason, the means of access itself also compels contemplation beyond its presence as a passage to elsewhere. I linger on this passage—a flowing span of temporality—as worthy of a searching rendezvous. In this light, my book extends an access to an access.

INTO *BEIJING XINGWEI*: WRITING TIME

As a multicentric experiment that has less to do with chronological progression than with structural diversity, I organize the following six chapters as coexisting centres; each revolves round a larger theme that may be studied in relative isolation but all six also compose an interrelated whole, with crisscrossing echoes and

references. In a rough summation, these six major themes are: Chineseness; violence; limit; animality; objecthood; and historicity. My inquiry begins with Chinese time-based art's relationships to the sweeping braided phenomena of globalization and glocalization in tandem with the rising Brand China. It moves on to examine Beijing artists' symbolic evisceration of humanity through terminal acts that not only challenge the existential and ethical limits but also expose the intercultural, interpersonal and interspecies predicaments. It then covers the selected artists' variegated responses to commercialism, ecological crises, entropic disintegration, class retrenchment, appropriated labour and transient communion and ends with assorted documentary performances that partially salvage the perishable oneness of time-based art. Unexpectedly, a disturbing annotation of the vicissitude of time closes my *Beijing Xingwei* with an Appendix that briefly comments on the recent detainment and release of Ai Weiwei whose time-based art opens the first chapter.

Chapter 1, 'Multicentric Repasts', explores the current global status of Chinese time-based art with two contrasting case studies: Ai Weiwei's collective xingwei-zhuangzhi piece, *Tonghua* (*Fairytale*, 2007), which brought 1,001 Chinese individuals and the same number of antique chairs as artworks to the *Documenta* exhibition in Germany; and He Yunchang's solo xingwei artwork, *Shito Yingguo manyou ji* (*A Rock Tours Round Great Britain*, 2006–07), which involved the artist carrying a rock as he walked for three and a half months round the UK coastline. The case studies open onto the analysis of numerous thematic nexuses, such as the resurgence of (the long-lasting) China as a country brand; foreign sponsorship for sinified ephemeral artworks; multicentricity as a type of Chinese subjectivity; Chineseness as a performative identity politics; and the global circulation and dispersal of glocalized creative commodities. In addition, these debatable axioms are pitted against the seemingly borderless, imperceptible, at once still and ever-moving, commonly shared and measurable temporality—global time/art, glocally consumed.

Chapter 2, 'Violent Capital', considers the millennial brutal strain of Chinese time-based art by tracking four critical moments when visceral aggression threatened to implode this art medium. Observing that violence has become performative capital, my analysis foregrounds how the aesthetic of symbolic and real-time ferocity interacts with transnational cultural-economic forces. The chapter moves from an overseas Internet rumour about Zhu Yu's xingwei piece, *Shi ren* (*Eating People*, 2000), to the piece's virtual transmigrations via *Beijing Swings* (2003), the Channel 4 documentary, and Saatchi Gallery's blockbuster exhibition, *The Revolution Continues* (2008). My narrative then returns to Beijing to examine the provocative underground exhibition, *Post-Sense Sensibility* (1999), which inaugurated Zhu's rivalry with his 'cadaver school' peers. A genealogy follows to elucidate an indigenous 'violent' art lineage via four significant contributions: the East Village (1993–94) bodyworks and animalworks by Ma Liuming and Zhang Huan respectively; the pioneering consumableworks (1995–98) by Gu Dexin; and a series of excruciating consumableworks (1998–2002) by Zhu Yu, who pivots his art on the conceptual edge where violence intertwines with sacrifice and creativity with annihilation.

Chapter 3, 'Limit Zones', departs from two classical Chinese proverbs cited by Zhang Huan as sources of his xingwei yishu to query the medium's multifarious confrontations with ethical, sociocultural and biological limits. I structure the chapter in line with the dual existential

limits—birth and death—identified by a Confucian adage ('Weizhi sheng yan zhi si', If [one] doesn't yet know life, how does [one] know death?) and a Daoist one ('Si sheng ming yeh', Death, birth, [but] life). The 'birth' section proceeds with several metaphorical scenarios—abortion, adaptation, manifestation and rebirth—and moves from two time-based artworks (2005 and 2006) staged overseas, by He Yunchang and by Sun Yuan and Peng Yu respectively, to selected xingwei pieces (1994–2005) by Yang Zhichao with Ai Weiwei, He Chengyao and Wang Chuyu. The 'death' section grapples with wide-ranging acts (1994–2005) from recurrent burials, memory erasure, suicide and cadaver display to self-entombment and displaced bereavement. Artists covered include Qi Li via Wang Xiaoshuai, Qiu Zhijie, Qin Ga, Zhang Shengquan, Sun Yuan and Peng Yu and He Yunchang. All selected works approach birth and death as dissimilar yet intertwined limit-events, ironically pointing to our experience of life as that which transpires between limits—a fluctuating duration.

Chapter 4, 'Animalworks', studies an array of time-based artworks (1994–2008) that employ live animals or animal bodies as involuntary performers and manipulated art objects. I explore various performative encounters and power dynamics (use and abuse, collaboration and incorporation, homage and subjugation, merging and hybridization) between human artists and nonhuman animals. Artworks treated include intriguing xingwei-zhuangzhi pieces by Xu Bing, Liang Shaoji, Wang Jin and Zhang Shengquan; several controversial, even sadistic, animalworks by Zhu Yu, Xu Zhen, Xiao Yu, Sun Yuan, Peng Yu; and a sampling by Liu Ding, Zhu Ming, Jin Le, Wang Chuyu, Liu Jin, He Yunchang, Yu Ji, Cang Xin, Gu Xiaoping and Wu Gaozhong from the multipart, multiregion exhibition, *Human•Animal* (2000). The chapter also looks into more recent output (2000–06) from the Sun and Peng duo, who have broken free of their previously assumed human-animal hierarchy, as well as at what I call 'trans-animalworks' (2005–08) by the Manchurian Cang Xin, who has engendered hybridized floras, faunas and deities through his Siberian shamanistic alchemy.

Chapter 5, 'Indigestible Commodities', investigates how objects operate in miscellaneous consumableworks in China's fast-paced postsocialist era through a method of inquiry that I call the Analytical Positioning System (APS, modelled after the Global Positioning System, GPS). 'Objects' in my usage are material entities that can be seen, touched, assembled, inflated, broken, redone, eaten, bought, sold or otherwise experienced. The chapter probes the functions of chosen art objects under several major categories—catalyst, praxis, habitat and simulation—which, in varying combinations, constitute a typology of transient objecthood in my inventory of xingwei and xingwei-zhuangzhi pieces. I apply the APS to treat these consumableworks through four constant thematic dimensions like spatial coordinates, comparing my typology of transient objecthood to the GPS latitude, the objects' region-specific sociocultural particularities to the longitude, their artists' creative subjectivity to the altitude and their shared postsocialist climate to the local time. My complex, dynamic, but also consistent, analytical system positions these artworks in a spectrum of commodification potentials while underscoring the tensions and blurred boundaries between 'commodities', those made for delectable consumption, and 'odd products', those that resist, subvert, critique, exaggerate and ostentatiously celebrate the logic of consumption. Evoking a shopping list, the chapter enumerates 15 time-based objects (1995–2006) by Wang Jin, Yin Xiuzhen, Gu Dexin, He Chengyao, Wang Chuyu, Song

Dong, Cang Xin, Zhu Ming, Wang Wei and Liu Ding. These artists contribute ingenious solutions to the problem of reconceptualizing material objects in palpably self-expiring artworks while bringing into sharper focus unbridled commercialism in globalized China.

Chapter 6, 'Keepsake Morsels', looks into documentation as a common act/theme in the *oeuvre* of several Chinese artists and self-reflexively interrogates my engagement with documentation in writing the chapter. Such a double move mirrors my desire to query the status of documentation vis-à-vis time-based art and to question my validity in appraising some originary events that I, as an interpretive critical subject, have not experienced live. This two-pronged inquiry hinges on my concept of prosthetic performance as an archival source, a mediating agent, an enabling mechanism and the very issue of a re/creative endeavour. Troubling the presumed relations between live performance and documentation, the chapter reconsiders their supposed sequentiality and contrasting standings as producers of primary/originary and secondary/prosthetic materials. The assessed documentaryworks (1994–2008), culled from Qiu Zhijie, Yang Zhichao, Wang Chuyu and Wang Hong, Song Dong and Zhao Xiangyuan, have integrated documentation into both art-making and exhibiting processes, further complicating my argument. Read as shared gestures towards sinification, the documentation of these artists links ephemeral art with colloquial history compilation, paradoxically bringing attention to the live. Documentation as live art encourages the existential relish for the here and now, extending a simple gift that time-based art keeps on giving.

Ingesting *Beijing Xingwei*

A deliberate, yet tenuous, metaphorical thread centring on the behaviour of eating appears throughout these chapters. In a quick rendition: 'Multicentric Repasts' savours a banquet spread; 'Violent Capital' ponders eating the dead; 'Limit Zones' contemplates chewing on the inedible living and dead; 'Animalworks' exposes the complexity of eating other flesh; 'Indigestible Commodities' displays an array of processed food too odious, noxious, elusive or scarce to eat; 'Keepsake Morsels' ruminates over how one remembers what one ate so as to cook up a new dish according to a reconstructed recipe.

Despite the imagery, *Beijing Xingwei* offers no ethnography of eating in China. In fact, the metaphorical thread that I trace here did not assert itself until long after I conceived of this book. Nevertheless, I do wonder what the emergence of this thread tells me/us about the subliminal psychic effect derived from the pervasive behavioural patterns, embodied dispositions and interpersonal relations that have inspired contemporary Chinese time-based art. Besides, how is eating implicated in my act of serving up plate after plate of prosthetic performances for my readers' delectation or indigestion?

Then again, a metaphor remains shy of coinciding with 'the real'. As Judith Farquhar cautions, China is not 'a totality that can be seen as having a special relationship to food', nor is there anything 'essentially Chinese about the unequal social relations that have produced a world economy of food maldistribution' (2005: 44), resulting in the coexistence of starvation and surplus in different populations of our contemporary world. Neither *Beijing Xingwei* nor time-based art can fully explain, let alone resolve, this global problem of our time. My time 'here', as I gaze into the gathering steam of a protracted 'now', merely allows me to dream up multicentric flavours of susceptibility which certain Beijing artists have prepared and shared,

like serving cups of jasmine tea to a guest from afar. Their porcelain tea sets are aged but the virtuosic ways they serve tea—by tossing the cups like juggling balls, by smashing the cups against their bamboo tea trays, by stacking the cups so high that they topple, by composing non-Euclidean teacup geometry with drenched tea leaves, by clinking their silver spoons against the painted cups, by hiding the cups away in random drawers so that no one can find them again—become imaginable only in their postsocialist country.

But, haven't we, as sentient beings, experienced much of what they have imagined here—pots, steam, teacups and all—since time immemorial? Don't we at various moments enjoy, forget, dread, cherish, curse and appreciate our time-bound lot? Are we not minnows all, caught—slightly blind—in the stomach of time, swimming towards each other for company?

My intention swallows time, and
Brings you to me.

IMAGE **1.1** *Tonghua* (*Fairytale*, 12 June–14 July 2007) by Ai Weiwei. Image courtesy of the artist.

CHAPTER **1**

MULtiCENTRic rePASTS

FAIRYTALES | Once upon a time, a Chinese artist named Ai Weiwei was invited to present his work in Documenta, a contemporary art exhibition in Kassel, Germany. Mulling over Documenta's receptivity to unusual art forms during a mountainside promenade with his Swiss friend Uli Sigg, Ai expressed his desire to bring 1,001 Chinese visitors to Kassel as his art project. Sigg enthusiastically encouraged the idea. Thus began Ai's ambitious quest. In honour of Kassel's history as the city where the folklore writer-collectors Brothers Grimm received their education, Ai named his project *Tonghua*, which translates as *Fairytale*. And so it happened: 1,001 antique Qing-dynasty wooden chairs were transported to Kassel and arranged

as temporary installations throughout the numerous exhibition sites for Documenta; the sculptural chairs were followed by five waves of Chinese visitors (201 + 200 + 200 + 200 + 200), who flew into this German town, stayed in their dormitories (built by the artistic team inside a renovated factory, with custom-made bed sheets and pillowcases on single beds), ate their group meals (prepared fresh daily by Ai-imported Chinese cooks) and wandered all over Documenta. Individually equipped with artist-supplied sound recorders and digital cameras, the Chinese visitors took snapshots of Kassel at dusk and dawn, exchanged greetings in sign language with their German hosts and entertained themselves in a converted karaoke bar. After a little more than a week, each group of visitors left for home, carrying in their artist-designed matching suitcases photographic and oral memories of their brief experiences as living artworks in a foreign city.[1]

Once upon another time, on another continent, a Chinese artist named He Yunchang chanced upon a bright idea while smoking a cigarette at a sidewalk cafe in New York: What if he randomly picked up a stone from a street corner and walked with it round Manhattan's coastline until he returned it to its place? Finding no sympathy for his idea in the US, He transferred his plan to another site—the UK—where he won a commission from amino, a Newcastle-based independent arts production company. Ben Ponton and Lee Callaghan, amino's two directors, helped He chart out a route, roughly circumnavigating the island of Great Britain, and volunteered to be his native guides. Thus began the artist's 113-day

1 My description of *Fairytale* is based on my interview with the artist on 23 March 2009 in Beijing and my viewing of a documentary film for *Fairytale* (June 2008). I've also consulted Ai Weiwei (2011); Nataline Colonnello (2007); David Coggins (2007); Galerie Urs Meile (2007); Ma Qian (2007); and Ruth Sacks (2009).

IMAGE **1.2** *Shito Yingguo manyou ji* (*A Rock Tours Round Great Britain*, 24 September 2006–14 January 2007) by He Yunchang. amino producers charted out the artist's route on the map. Image courtesy of the artist.

tour. On a beach in Boulmer, He picked up a house-brick-size basalt rock weighing 3.5 kg, walked counterclockwise through beaches, grass fields, forests and farmlands; through swamps, high mountains, biking lanes and some highways; through late summer breezes, through autumn rain, fog and wind, through winter hail and snow and eventually returned the rock to its original spot on the beach. The rock endured one fracture on Day 17 of the walk, was repaired with epoxy resin and was gradually worn smooth by He's touch. The rock-carrying artist wore out four pairs of boots and lost 7 kg of his body weight.[2]

Told in conventional narrative forms, both Ai Weiwei's *Tonghua* (*Fairytale*, 12 June–14 July 2007) and He Yunchang's *Shito Yingguo manyou ji* (*A Rock Tours Round Great Britain*, 24 September 2006–14 January 2007) are akin to fairytales.[3] While both were actual events recorded as having taken place in a specific period according to their exhibition calendars, I believe I am poetically justified in drawing on a folkloric genre to register their incongruous historicity: to exclaim simultaneously the *wonder* that they happened at all—*once*—and the *fact* that they could very well still be imaginary—upon *a time*—since much of what happened in the journeys now exists solely in their participants' private memories. The characters in these two stories are human; they travel much slower than the speed of light. Yet both events, like mythic yarns, pursue a simple but extraordinary idea to its adventurous extreme; both feature protagonists miraculously blessed by external forces that have helped them

2 My description of *A Rock Tours Round Great Britain* is based on my interviews with He Yunchang, 10 July 2006, Tongzhou, Beijing; and 23 March 2009, Beijing; and a phone interview on 9 May 2009, Los Angeles to Beijing. I also consulted the following: amino (2009); amino and Spacex (2009); and Vanessa Art Link (2008).

3 The team in amino translated the title as *Touring Round Great Britain with a Rock*. I chose a more direct translation. The reason for our difference will be analysed later in the chapter.

IMAGE **1.3** He picked up a rock from a beach in Boulmer on 24 September 2006, in *A Rock Tours Round Great Britain* (2006–07). Image courtesy of the artist.

IMAGES **1.4.1–3** He performing *A Rock Tours Round Great Britain* (2006–07). Image courtesy of the artist.

accomplish their quests in far-off lands. And their co-players, by virtue of the joy and hardship experienced during the events, perhaps will indeed live happily ever after.

Shifting back to their original art-world context, I propose to see *Fairytale* and *A Rock Tours Round Great Britain* as time-based artworks. Both artists went through an arduous and protracted course to execute their projects. This temporal dimension first unfolded in both pieces as a practical problem. For *Fairytale*, Ai resolved the logistics of accommodating and distributing the 1,001 participants within his self-designated 33-day period, roughly coinciding with the first month of Documenta 12 (16 June–23 September 2007), by dividing the visitors into five groups and by charting out on a master calendar each group's precise visiting schedule. For his rock-touring project, He considered the problem of time in relation to the amount of funding he obtained. His commission could only support his basic touring team—which would include the artist, two guides and two assistants on a rotating basis, plus alternate drivers of a motorhome trailer that would provide most meals and nightly lodging—for about three and a half months. This temporal-financial restriction determined the entire distance the artist could cover on his tour—about 4,800 km—and the average distance he needed to tread every day—35 to 40 km. These spatial measurements in turn determined the route he took to approximate the UK coastline, the average hours he spent daily on walking—about 10 hours, initially with a five-minute break every hour, progressing to a brief stop every four hours—and the number

of rest days he had—20 days (including seven 'compulsory' Christmas and New Year holidays) out of a total of 113 days.[4]

Once Ai and He solved their respective space-time confluence problems, they confronted the temporal challenge of duration. Ai's role evolved during the long span of time it took to make *Fairytale*. Initially, he was fully responsible for the project's conception, representation and production; then he moved on to managing the necessities and contingencies resulting from the project's enormous scale, which included at the very least Ai's 40-people work team and 1,001 participants. Because of the qualitative division of his artistic labour, Ai's durational experience with *Fairytale* fluctuated in its intensity and unpredictability. Conceptually, with more Chinese visitors arriving in and departing from Kassel, Ai became less in control of *Fairytale*, for the artwork's other constitutive players— the 1,001 individuals, with their diversity in age, gender, class, profession, ethnic and provincial origin—were composing their own scripts along the way. As the most substantial and expanding corpus of *Fairytale*, these players' physiological functions; their imaginations and desires; their cerebral, sensory and psychic flows; their itinerant and random actions—all transformed the temporal duration Ai spent on *Fairytale* into a spatialized

[4] All these numbers, charting distance and time, are provided by the artist in an interview. See Jiang Ming (2008: 116–39). When I interviewed He Yunchang on 23 March 2009, he said he had to take longer rest periods (four days for Christmas and three days for the New Year) out of consideration of his British sponsors and guides who went home for the holidays.

existential drama, so varied, interwoven and expansive that it was impossible for Ai to even glimpse into most of its unfurling. There is then a split and a simultaneous multiplication of *Fairytale*'s temporal duration. The split turned the artist, Ai, into his project's partial observer and enactor, even though he also experienced the entire process of making *Fairytale*. This very split, however, multiplied *Fairytale*'s duration into a mathematical mystery that could not be fully measured, for its 1,001 participants—at once artworks and vicarious art-makers—lived through their separate existences during *Fairytale* as parts of the artwork and continue indefinitely to re-experience their 'time' of being (in) *Fairytale*. This piece's audacious scale translates as unfathomable temporality.

He Yunchang's process of incrementally presenting *A Rock Tours Round Great Britain* likewise required him to go through an extended, but by no means solitary, temporal duration. Albeit on a much smaller scale than Ai, He also employed a team of helpers who served as his guides, photographers, video documenters, caretakers and cooks. While Ai's role evolved during the making of *Fairytale*, He's identity remained constant throughout *A Rock*: he occupied the project's artistic centre as a Beijing-based performance artist conducting an endurance art project in the UK. Because of his role's continuity, He experienced the duration of transporting the rock as an extended, physically demanding and uniformly, if not increasingly, laborious task, one that only he as the artist had endured in its entirety.[5] The difficult time the Chinese artist spent in realizing his three-and-a-half-month-long trek proved to his British sponsors that they had indeed supported a worthy artistic cause, distinguished precisely by its quixotic heroism, an onerous much-ado-about-nothing for an anonymous rock. This element of

5 The four assistants took shifts, two at a time, cutting their participation time nearly in half.

interpersonal and institutional investment in upholding a (male) artist's absolute dedication to an artistic—useless, disinterested and pure, hence, neomodernist—gesture complicates the duration He suffered from transporting the rock. We may imagine the scene in geometric abstraction as the conjoining of two lines—before the path He walked in the UK stretched another path, nebulous, glistening and made of time, a decade-plus 'pre-duration' in which the artist had, by conducting equally taxing and futile actions, established a reputation as a xingwei yishu practitioner endowed with, in his own epithet, 'an iron will'.[6] Iron against flesh-constituted will—He's fierce endurancework inevitably ushers in a 'post-duration', compelling his traumatized body to recuperate in order to regain its capacity as a producer.

6 This particular phrase appears in the proposal He sent to his British producers in amino, a long excerpt of which is cited on amino's website.

Neither the notion of time, nor its particular incarnation as duration, is a theme addressed by *Fairytale* or *A Rock*. If there is a purpose to their art, it lies plainly in Ai's and He's respective initial ideas—to bring 1,001 Chinese visitors to Kassel for Documenta 12; to pick up a rock, take a walk, and return the rock to where it was found.[7] Instead of approaching 'time' as a novel creative entity, Ai and He regarded the temporality in which their live art-works inhabited as a given, a pre-existing or ever-existing dynamic with which they must interact. The artists exerted a measure of control by adopting the normative procedure that industrialized societies follow in relation to time—they used watches, clocks and calendars to regulate the otherwise indivisible time into blocks of activities interspersed with intervals of rest. Even so, time was hardly a mere existential environment interweaving and wrapping round the two projects, for both *Fairytale* and *A Rock* were also temporal 'process-products'. Both Ai and He conflate their art-making *process* (that is, a span intertwined with time) with their resulting *product* (the moment-to-moment happenings within a preset duration). In this sense, time appeared as integral to their compositions. Yet, insofar as time is neither an object nor an embryo that is ready to be engendered, how could the two artists use such a non-entity as a compositional element?

7 In 2011, there was an allegation that Ai had plagiarized the idea of *Fairytale* from Professor Yue Luqing, who in 2006 had sent 1,001 people from Shanghai to Xian as part of a project funded by the British Arts Council. Yue, however, stated that he had never accused Ai of plagiarism and that the resemblance of the two projects was merely 'a collision of ideas'. See Adam Clark Estes (2011).

FABULATING CHINESE TIME-BASED ART

Of course the question regarding how to configure temporality in an artistic composition goes beyond our immediate concern with *Fairytale* and *A Rock* to touch upon the conundrum of creating time-based art. Arguably the least controllable aspect of time as an expressive element is its ungraspable visuality, for temporality cannot manifest itself visibly unless it borrows the bodies of those it affects. I cannot see how time has furrowed my brow, for example, unless I look at my face in the mirror. Yet are those wrinkles I see on my mirror reflection time's little curves? Or are they my body's scars from time, a shaping but shapeless force in my being?

I shall take my improvised phenomenological sketch as a fable about time-based art. Suppose I occupy a viewer's position in this fable, then time-based art is the mirror that, in its unforgiving and reflexive visibility, tells me, 'While you are not the fairest of them all, at least

you are more than whom you assume to be—a passive viewer. In this visual drama, you are always-already an actor, a painter and a narrator!' In other words, the mirror consoles me even as it presents my unflattering self-reflection, promising me the gift of a double agency—I can choose to look at the mirror and choose again, with a sheer cognitive shift, to interpret the perceived sight (my furrowed brow) as a sign of my intellectual maturity. Thus I gain pleasure from appreciating a time-based artwork by adopting the re-creative licence consigned to me, an active viewer-cum-critical subject, because much of what's given to be seen—as fleeting spectacles on my mirror—depends on my conscious composition to make it a story, a narrative melody.

My fable about time-based art contains two main episodes. The first addresses how an artist engages with time as a compositional element by incorporating in the artwork certain bodies capable of being changed by/in time; the second outlines the potential appeal of time-based art as a creative vehicle for a viewer's hermeneutic reiteration. In *Fairytale*, Ai displays traces of time by borrowing the bodies of those 1,001 visitors, assembling their lived experiences during a specially marked artistic occasion to uncover his project's evolving configurations. In He's *A Rock*, the changing transient vistas of time are not only the artist's labouring body and the rock he carries but also the British weather and landscape encompassing his journey. The expansive temporal-spatiality probably prevented any viewer from witnessing the successive unfolding of either piece live/onsite. Both Ai and He chose to document their durational engagements with exhaustive photographs and videotapes, so as to reconcile the real-time improbability and the cultural necessity of communicating their work to potential viewers/receivers. By producing along the way plentiful traces, which are simultaneously mementoes, testimonies, relics and partial products from their localized actions, Ai and He proactively ensure an interested viewer's continuous, if future and piecemeal, access to their expired artworks. In this light, documentation is both the last step taken to complete a time-based artwork and the first step towards enabling the artwork's cultural afterlife which begins its posthumous discursive circulation through another person's retelling.

The archival imperative to preserve the traces of a dematerialized artwork has long shadowed the practice of time-based art. By extensively documenting their live artworks, Ai and He resort to a tactic commonly used by contemporary time-based art practitioners. What makes the current moment different from, say, the time when Carolee Schneemann had herself photographed in *Eye Body* (1963) as she enacted a ritualistic sequence in an environment constructed in her painting studio, is the enhanced variety of technological tools for documentation (see Schneemann 1997: 52–3). Aside from the conventional documentary apparatus (copiers, recorders, cameras, camcorders, etc.), the more recent prevalence of Internet use allows the simultaneous streaming broadcast of actions and near-immediate distribution via digital documents. Thus, documentation exceeds its prior function as a means of preserving remnants from a vanished event to become part of an ongoing performance. The Internet has played such a dual role in both *Fairytale* and *A Rock*.

Ai began recruiting his potential participants by posting an announcement regarding his plan for *Fairytale* on his personal blog on 26 February 2007. Within three days, he received 3,000 applications. Subsequently, Ai's team conducted much of the screening, selection and organization process online. During *Fairytale*, Ai's blog posted photographs of his 1,001

IMAGE **1.6** *Eye Body—36 Transformative Actions* (1963) by Carolee Schneemann. Action for camera. Photograph by Erro. © Carolee Schneemann. Image courtesy of the artist.

participants-in-action. These participants, each with a digital camera, could also multiply the project's optical reach by eventually downloading their 'photographic memories' to the artist's electronic archive. Up until the summer of 2009—before the government shut down Ai's blog —Web users from round the world could still access much of *Fairytale*'s archive via Ai's blog.[8]

8 My research experience reveals that the Internet access to Chinese websites is rather inconsistent and subject to deletion and termination. Because of Ai's attempts to list the names of the 2008 Sichuan's earthquake victims, his blogsite has been indefinitely closed by authorities since the autumn of 2009. See Appendix for details.

In *Fairytale*—at least per the artist's design—the live relates to the virtual in reciprocity and relay—the live first gave a reason for the virtual to exist but then virtual technology took over to sustain, for as long as possible, the cultural tenure of a no-longer-extant live event.

Although the Internet played a less essential role in the planning process for *A Rock*, He's producers at amino similarly used the virtual to augment the live. Refashioning He's solo performance as a potentially communal project, amino created

a blog to post the daily itinerary of He's walk, inviting people to join the artist live at his mobile performance site. The amino website also became—at least temporarily—He's publicity portal, providing links to another roughly concurrent exhibition, *He Yun Chang: Works*,[9] which took place as part of the Liverpool Biennial (16 September–26 November 2006) and as a solo show (7 October–2 December 2006) in Spacex, an international contemporary art space in Exeter. He's rock-carrying route passed through both places. Viewers at

9 There are different ways of translating a Chinese name into English. I have followed the way of treating a Chinese person's given name as one unit, even though it might include two characters; hence, my translation of '何云昌' as He Yunchang. He's British producers have chosen to translate his name as three independent characters; hence, He Yun Chang.

He Yun Chang: Works could see displayed photographic documents and films of He's past extreme performances; they could also catch the Chinese artist carrying out *A Rock Tours Round Great Britain* live. In this joint context, the documentary authenticates the live even as the live corroborates the documentary.

Perhaps the most fairytale-like similarity between *Fairytale* and *A Rock* is the extents and sources of support the two artists have received from their respective sponsors. These projects, made by Chinese artists in overseas locations over an extended period, involved substantial intercultural negotiation, cooperation and patronage—in a scope unprecedented in China's experimental art world. With a budget of US$3.1 million, *Fairytale* was the most expensive project to be presented in Documenta 12; *A Rock* received a commission of £200,000, which was in 2006 'the highest amount ever granted to an individual xingwei artist'.[10] These behind-the-scene financial matters indicate the degree to which economics and culture intertwine within the current globalized contemporary art system of production, exhibition, circulation, consumption,

10 My interviews with Ai Weiwei, 23 March 2009, Beijing; my interview with He Yunchang, 10 July 2006, Tongzhou, Beijing. I confirmed with He again in a phone interview on 7 May 2009, Los Angeles to Beijing.

evaluation and collection (see Ratnam 2004; Stallabrass 2004). In particular, they imply the prospect of bankability that Chinese contemporary artists—including those who produce unretainable artworks—have inspired in the first decade of the twenty-first century. Moving beyond its status as the transnational manufacturing outpost for cheap disposable goods, China can now flaunt its latest image as a global centre for desirable high-end cultural exports. A perceptual makeover has transformed the term 'Made in China' from a ubiquitous commercial label inviting dismissal, mockery and suspicion to a blue-chip label in the realm of international diplomatic relations. Indeed, as championed by the country's advertising industry, the new catchphrase in the new century for Chinese-made luxury goods—contemporary art included— is 'Created in China' (Keane 2007, cited in Jing Wang 2008: 3)!

That the world's recent fascination with new Chinese art could so fluidly translate into monetary and symbolic capital surprised even the artists. Ai expressed his astonishment at how receptive and encouraging other people were towards his idea for *Fairytale*. Urs Meile, the owner of Ai's representing gallery, Galerie Urs Meile, Beijing–Lucerne, approved his proposal in a heartbeat and, after a week, raised Ai's proposed budget from two Swiss Foundations, the Leister Foundation and the Erlenmeyer Foundation (see Hu Zhen and He Jingfang 2007; Colonnello 2007; Coggins 2007). In addition to official endorsements from the directors of Documenta 12, Roger M. Buergel and Ruth Noack, and the German Ministry of Foreign Affairs,

Ai's friend Uli Sigg made a special trip from Switzerland to Beijing to lend moral support for Ai's meeting with German ambassador Volker Stanzel who in turn facilitated the acquisition of visa permits for *Fairytale* participants."

11 According to Ai in our interview on 23 March 2009 in Beijing, among all selected *Fairytale* participants, only two Chinese men (a poet and a former policeman), for undisclosed reasons, were denied German visas to enter Kassel. All those Chinese who went to Kassel as part of *Fairytale* returned to China.

Whereas *Fairytale* became a major media event for Documenta 12 in both Europe and China, *A Rock* evinced the generous financial backing, high visibility and coordinated museum and gallery exposure given to any single Chinese artist's performance works. Prior to his UK rock-touring action, He had done most of his performances in various remote locations in China; those live actions were semi-private, self-subsidized and often only observed by the artist's locally hired photographers and assistants. In contrast, *A Rock* was well publicized, commissioned and co-produced by British independent art organizations with major funding from Arts Council England.

I began writing this chapter in the midst of a global financial crisis which became increasingly inexorable towards the end of 2008. So I could not help but wonder whether projects like *A Rock* and *Fairytale* would have been funded in 2009. He's rock-touring UK project happened across late 2006 and early 2007. Ai's *Fairytale* began shortly afterwards, running through roughly the first three quarters of 2007. I believe the years of production for the two pieces are fortunate and noteworthy—2006 marked a high point in contemporary Chinese art history, energized, as it were, by the record-setting sale of Zhang Xiaogang's painting *Bloodline Series: Comrade No. 120* (1998; acquired by a Chinese-Singaporean bidder for US$979,200) in the inaugural sale of contemporary Asian art at Sotheby's in New York (Napack and Picard 2006). Zhang's success was by no means an exception. According to David Barboza:

> Globally, the recent rise in Chinese artists' fortune was unparalleled. Only one Chinese artist—Zao Wouki, a traditional painter who lives in France—ranked among the Top 10 best-selling living artists in 2004 [. . .] By 2007, 5 of the 10 best-selling living artists at auction were Chinese-born, led by Zhang Xiaogang, who trailed only Gerhard Richter and Damien Hirst (2009).

The booming art sales for contemporary Chinese paintings continued unabated up to May 2008—just three months short of the Beijing 2008 Olympic Games Opening Ceremony—when Zeng Fanzhi's *Mask Series 1996 No. 6* (purchased for US$9.7 million) became the most expensive Asian contemporary artwork sold at an auction (Huei 2008).

Fairytale and *A Rock* cannot be sold at auction blocks. Yet, isn't it plausible to assume that the capitalist imprint on an object-based genre might have inflated across the board the value —monetary or otherwise—of all types of contemporary Chinese art? Since neither *Fairytale* nor *A Rock* can yield a product that might rise in its exchange value through ownership transfers, both projects' sponsors must have realized that their one-time investment would bring only intangible returns. Is it possible that those returns include the international prestige of being visionary agents for a global art trend? Might not that prestige be enhanced by the civic satisfaction of becoming enablers for those Chinese art forms that find little support from their home country and that cannot be auctioned off at Sotheby's or at Christie's or at Phillips de Pury? Do the privileges given to *Fairytale* and *A Rock* indicate the post–Cold War

global recognition enjoyed by what I would call Brand China, a perceived cultural distinction coinciding with the country's international ascendance as the most dynamic emerging economy in the twenty-first century? Can Brand China retain its value independent of the world's current attraction to the country of its origin?

BRAND CHINA

Fairytale and *A Rock* share the distinction of being contemporary experimental artworks produced in the West by Beijing-based Chinese artists. This statement of Ai and He's common national, ethnic, regional and professional identity is nevertheless complicated by Western perceptions regarding Brand China, with its implied access to the mystery of the country's meteoric rise. 'A brand is an asset of differentiating promises that links a product to its customers,' goes Stuart Agres' well-honed advertising principle (cited in Thakare 2009).[12] Rubbing off on the glory and prosperity promised by Brand China, *Fairytale* and *A Rock* have unwittingly acquired a shimmering double status—they are contemporary time-based artworks created by *Chinese* artists. Even more importantly, to those seekers and movers of global power circuits, they are cultural ciphers coded with information about *China*'s quantum leap into modernity!

[12] See also Michael L. Rothschild (2001). I thank Rolf Hoefer for the reference.

In *Brand New China*, Jing Wang analyses Chinese corporate, media and government advertisers' recent craze to adapt and reinvent American branding techniques in their attempts to develop domestic as well as international markets and to compete with transnational ad agencies which have made their aggressive overtures into the Chinese markets, especially since the country joined the World Trade Organization in 2001 (see Jing Wang 2008: 3). As ordinary Chinese buyers quickly learn from all stripes of marketers to become targeted consumers in the post-Deng era, the branding trend is just one among a plethora of capitalist mechanisms emerging in the country's growing economy. Departing from this actual trend, I use the term Brand China metaphorically to indicate the changing international attitude towards the country's status as an economic, political, military, cultural and diplomatic power, together with China's increasing efforts to enhance its global image as a formidable international presence. The strength of Brand China—a projection colluding perceived qualities and statistical factors —I submit, directly contributes to the world's admiration for contemporary Chinese art. My usage is therefore closest to what Wang calls 'the country brand of China', following 'the Saatchi & Saatchi vision of turning the nation into a brand' (ibid.: 32, 293). As many of us witnessed on TV, 'Brand China' enjoyed a shining moment in the globally telecast Opening Ceremony for the 2008 Beijing Olympic Games—showcasing '15,000 performers', 'grand pyrotechnics, [a] huge spinning globe, and the incredible sight of gymnast Li Ning doing a lap of the stadium while suspended in mid-air' and attended live by 91,000 fans, including hundreds of world leaders (Blecher 2009: 82). While Chinese artists, as cultural producers, are partially responsible for creating novel images of contemporary China, I name the Brand China syndrome in order to connote global dynamics beyond individual control.

Related to the Brand China syndrome is the troublesome notion of 'Chineseness', understood variously as a unique philosophical outlook of life (Daoism, Confucianism, Chan

Buddhism, etc.); a near-mythic evocation of the supposed Chinese cultural 'essence' (being filial, frugal, diligent, restrained, wise, cunning, naive, gastronomic, etc.), as distinct from the alleged hedonistic, egotistical and over-rational West; or as a self-Orientalizing strategy putatively adopted by most overseas Chinese artists (using traditional Chinese signs and inventions, such as calligraphy, ideograms, gunpowder, herbal medicine, feng shui, t'ai chi, etc.). Existing long before the recent rise of Brand China, 'Chineseness' has been an ideational abstraction collectively coined by the institutional, intellectual, creative and social agents with vested interests in the historical, ethnic, political, economic and cultural entity called 'China'. As Allen Chun observes, Chineseness is characterized not so much by a set of definitive values, ethnic and linguistic traits, cultural discourses, everyday rituals and customs as it is by 'a multitude of expressions' used 'to denote different aspects of China' and what it means to be Chinese (1996: 111). These expressions generalized under the rubric of Chineseness, moreover, have

changed throughout history, evolving from 'a sinocentric core' associated with Zhongguo[13] as a geoculturally bounded civilizing centre; through its politicized construction as patriotic sentiments with the founding of the nation-state China in the twentieth century; to its current multivocal and polysemous representations created by mainland as well as diasporic Chinese communities (ibid.: 119–31).

13 Zhongguo (中国, China) is usually translated as 'the Middle Kingdom', but the word *zhong* (中) also means 'central'. For an analysis of the distinction, see Meiling Cheng (2002: xvii).

Therefore, in contrast to Brand China, which has its material basis in the rise of Mainland China as an exceptional economic and political global player, Chineseness is an ambiguous, fluid and potentially deterritorialized concept which may be employed by individual subjects—native, diasporic, sinophonic or affiliated by choice—as a multivalent identity marker. This voluntary dimension of Chineseness, however, has a slippery relationship with its compulsory dimension. Institutional agents of the nation-state may proclaim Chineseness to inculcate in its subjects what it means to be 'Chinese', thereby reifying an abstract concept into a disciplinary measure to validate some people while excluding others. Sinologists—Chinese or non-Chinese—may treat Chineseness according to their own deductive thematization or assume Chineseness to be an a priori criterion as the legacy of a Eurocentric hegemony inflecting this 'Area Studies'. Chun's analysis of Chineseness as a cultural construction pivoting on one's ethnicity, language and history elucidates the state imperative, 'Because it is constructed, culture is not just imagined but authorized and institutionalized [. . .] to rationalize a particular utopian vision of the polity' (1996: 115). Rey Chow's argument for Chineseness to be 'a theoretical problem' that must be dissected along with 'a concurrent problematization of whiteness within the broad frameworks of China and Asia studies' exposes the reputed neutrality of intellectual inquiries which would eventually infiltrate global popular culture to become established standards in understanding China (1998: 10).

Perhaps because of such theoretical agitations as Chun's and Chow's, the Swiss collector Sigg felt compelled to send a letter to all Chinese artists participating in the touring exhibition *Mahjong: Contemporary Chinese Art from the Sigg Collection* (touring internationally since 2005) to ask how each defines Chineseness. Based on the 37 entries published in the *Mahjong* catalogue, these responses range from the incredulous and the allegorical to the ambivalent,

from the quizzically speculative and the absolutely dismissive to the parodic. A most penetrating and hilarious response from Xu Zhen turns the table round to ask Sigg if his collecting activity is affected by 'Swissness' (see Fibicher and Frehner 2005: 49–58). Xu's rhetorical question sheds light on the enduring power imbalance between a wealthy Western patron—presumed, beyond doubt, to exercise a universal good taste—and the elite group of Chinese artists who made it onto his exhibition roster. To me, such a power imbalance, which symbolically implicates the capitalist West and the economically developing China, makes Sigg's query about Chineseness—however mercurial its disposition—current, especially in situations when contemporary Chinese artworks must encounter the Western gaze. *Fairytale* and *A Rock* both fit into this scenario. We may then ask: Is Chineseness, in any of its potential manifestations, a critical element in these two pieces? Or is it, like a background tint, merely an aspect among their multiple colourations?

Since Chineseness is partly a collective mythology, partly a set of inherited stereotypes and partly conceptual distillations from sociohistorical circumstances surrounding international power contests, I suggest that we understand it as a performative assemblage of ideas, images, rhetorical forms, ritualistic practices and behavioural modes available to be appropriated and regenerated by creative agents. In other words, if there is indeed an articulation of Chineseness in *Fairytale* and *A Rock*, we might most productively approach it in the way Arjun Appadurai defines 'culturalism' in *Modernity at Large*—as 'identity politics mobilized at the level of the nation-state' (1996: 15). Culturalism, being a political affirmation of one's sense of cultural belonging, stresses the deliberate claiming of group identities based on 'certain attributes (material, linguistic, or territorial)' traditionally associated with nation-states as well as 'the consciousness of these attributes and their naturalization as essential to group identity' (ibid.: 13–14). Appadurai illuminates people's persistent affiliations with particular nation-states (through nationalism, ethnic separatism, diasporic extremism, etc.) at a moment when globalization purportedly homogenizes the whole world under the influence of mass media, communication technology, transnational commerce, human migration and the triumphant capitalist ideology. He restores individual agency to his picture of fractal hybridity by redefining one's acquired and imagined cultural heritage as a choice to mobilize group identity.

In the light of Appaudurai's proactive theory, we may regard Chineseness as a culturalism that rallies round the imagined totality called China; 'Chineseness' as a predetermined *signified* for certain inalienable inborn traits then shifts to become an elastic *signifier*, which may well be politicized and strategically deployed to enunciate one's consciously evoked Chinese identity. This redefinition deconstructs Chineseness as an ontological cause of detectable attributes and opens it up to an artist's mindful demonstration of the Chinese cultural subjectivity as embodied by the work. Accordingly, we would reverse the cause and effect sequence to read what we might have habitually taken to be the 'effect'—an artwork—as the 'cause', a heuristic instance wherein a self-identified Chinese artistic subject performs 'Chineseness' in response to an exigent local context. My hermeneutic reversal takes its cue from Judith Butler's similar analysis of gender as an effect of performativity—precisely because we cannot transcribe Chineseness into a definitive taxonomy of essential qualities, we encounter it as an expandable archive of collectively iterated and reiterated tendencies. Chineseness, as articulated alongside

Brand China, however, differs tactically from Butler's gender performativity (see Butler 1990). Whereas Butler's conceptual coinage seeks to counter the punitive implications of binaristic gender assumptions and compulsory heterosexuality, Chineseness, when manoeuvred to deepen the mystique of Chinese contemporary art, serves the function of an authenticating watermark that one may—subtly but assuredly—stamp on one's product to call attention to Brand China.

Doubtlessly, some of the expressions resulting from Chineseness as identity politics might look indistinguishable from those produced by auto-exoticization—which is itself an arguably legitimate choice to commodify one's artwork.[14] To me, what distinguishes a self-avowed Chineseness from a self-Orientalizing gesture is the artistic subject's motivation and priority. The former is engaged not to cater to the Other's desire but to affirm an individual subject's political agency by self-identifying with an ethnically, culturally or otherwise affiliated group. To translate this thesis into a blunt declaration is to say 'Whether or not you want me to be different from you, I am, in any case, *very* interesting because I am *Chinese*!' As culturalism-in-action, Chineseness might still titillate the Other's fantasy about the Chinese self, yet its impetus lies in acknowledging the self's Chinese identity with confidence and pride of ownership.

14 See Arif Dirlik's analysis of Asian subjects' voluntary participation in constructing the Orient, making orientalism an aspect in Asian modernities as well (1996).

CHINESENESS AND GLOBALIZATION | As Chinese-created artworks that took place in foreign environments, both *Fairytale* and *A Rock* set in motion the conceptual nexus between Chineseness and globalization. Ai and He nonetheless treat this thematic conjunction differently. *Fairytale* comments openly on the intersection between Chineseness and globalization, which both remain implicit in *A Rock*. The two artists reveal divergent assumptions concerning the artist's role in China through this period of drastic change—one actively changes with time, even setting out to change the time; the other circumvents the changing time. Whereas Ai adopts an entrepreneurial flexibility to expand, diversify and publicize his professional and civic voice, He maintains a more self-reliant approach, constructing a devotional art practice to insulate himself from the mercantile mainstream.

Ai Weiwei: Cultural Mediation | In his study of contemporary Chinese art under Deng Xiaoping, Emmanuel Lincot describes the arrival of a new professional—the cultural mediator—who serves an evolving art world's emergent needs in the reformist era:

> The cultural mediator is a freelance professional who combines several functions. He is the obligatory intermediary between the Ministry of Culture, its *éminences grises*, the exhibition commissioner, the artists, the public, and the potential consumers. He 'manufactures' opinion, describes current trends, travels, and negotiates between the parties concerned, in particular with [the] collector who, by means of his financial assets and social position—he is often a diplomat or an industrialist—spreads rumours,

destroys reputations, drapes himself in the prestigious role of patron, of defender—on occasion—of human rights, of freedom of expression in a country where, it is true, society does not much appreciate independence or the right to be different (2004: *n.p.*).

The consummate cultural mediator who inspired Lincot's profile is Ai Weiwei, along with Ai's crucial long-term friend and associate Uli Sigg, who was indeed an 'industrialist'-turned-diplomat. Before his sudden detention by the Chinese government in 2011, Ai has been a celebrity in Beijing's experimental art circles, having the cultural pedigree of being the famous poet Ai Qing's son and the valued credentials of practising art in New York for 12 years (1981–93).[15] Versatile, enterprising, bold and intellectually agile, Ai appeared receptive to globalization's impacts, in tune with the Chinese art world's resulting economic boom and ready to adjust his professional practice accordingly. Without Ai's capacity and experience as a cultural mediator, a complex multilayered piece like *Fairytale* would not have been made.

15 For Ai's well-known biographical information, see, for example, David Coggins (2007). More recently, Ai added to his international acclaim as the consultant to the Swiss architectural firm, Herzog and De Meuron, in designing Beijing's Olympic Stadium, known as the 'Bird's Nest'. Ai later disowned his connection with the project for political reasons.

As a time-based artwork built round effervescent human subjects, *Fairytale* represents a departure from Ai's previous praxis in *guannian yishu* (conceptual art) and *zhuangzhi yishu* (installation art). *Fairytale*'s mode of operation, however, typifies the professional habitus Ai has developed for his art career which branches out to include architecture, publishing and dealing in antiques. Inspired by Andy Warhol's 'business art' established at Warhol's 'Factory', Ai's professional mode, in turn, exemplifies a recent development in Beijing's contemporary art world.[16] Like Ai —and not unlike many of their Western minimalist predecessors such as Robert Morris and Donald Judd and eclectic contemporaries such as Jeff Koons and Damien Hirst —an increasing number of more successful (wealthier) Beijing artists have incorporated what might be considered a conventional architectural model to art practice: the artist, as the principal designer, conceptualizes, blueprints and raises funds for a project; a team of assistants help organize construction documents in detail; a lower tier of hired hands, under close supervision, construct the final material product. This mode of operation espouses a proto-capitalist hierarchical division of intellectual, technical and manual labour, privileging art concept over craft and blurring the distance between fine art products and brand-name commodities. This industrial model used by a conceptualist like Ai also finds its way to the more technique-and-craft-intensive fields. Nowadays in Beijing, many painters, especially those who command astronomical prices in international auctions, adopt this operative model to turn their studios into assembly lines, with recent art-school graduates (their 'apprentices' perhaps) ghost-painting their most popular works for direct sale from their art 'factories'. They virtually mass produce Brand China.

16 See Andy Warhol (1975: 87–104). Ai has acknowledged Warhol's influence on him in numerous interviews. *Heipi shu* (known as 'The Black Cover Book', 1994), an untitled book in a black cover, coedited by Ai, includes a translated interview of Warhol by an unnamed author. See Ai Weiwei et al. (1994: 134–40).

From one perspective, *Fairytale* was a massive showcase for Brand China on the global stage of Documenta 12. Because of its scope, time frame and complicated procedures in getting more than 1,001 Chinese to travel and stay abroad, *Fairytale* required tremendous organizational teamwork, including setting up a temporary travel agency inside Ai's company, Fake (original

name in English), transporting the Qing-dynasty antique chairs and manufacturing numerous *Fairytale* trademark products, such as custom-made luggage, jackets, utensils, bedsheets, pillowcases and blankets for its 1,001 participants. In concert with globalized trends, the *Fairytale* process involved international tourism, intercultural exchange by taking part in a major world arts exhibition and the production of event-related memorabilia.

From another perspective, *Fairytale*, as a display of 1,001 living Chinese individuals, presents quite an anomalous brand, even an anti-brand, and it conflicts with the criteria of standardization, quality control and maximum profits generally associated with mass-produced brand-name commodities distributed for sale worldwide. A contradiction exists, then, between its branding process and anti-branding heterogeneity, between its citation of globalization and its multiple glosses on a singular nationality. This contradiction is captured in Ai's comment in an 'insider' interview with Fu Xiaodong, a *Fairytale* participant, 'Although *Fairytale* is a huge project, it still demonstrates the individual will and individual existential circumstance of a particular region. In this sense, it is against internationalism. Most participants in *Fairytale* do not understand the English-German linguistic systems. Nor do they have any understanding of contemporary art.'[17]

17 Fu Xiaodong with Ai Weiwei, 'Zuowei zuopin de *Tonghua*', posted on Ai's blog and given to me as a PDF text.

IMAGE **1.7** Custom-made luggage for Ai's *Fairytale* (2007). Image courtesy of the artist.

If Ai is ambivalent about addressing issues related to globalization in *Fairytale*, he seems more certain about wanting to articulate Chineseness. In the same interview, responding to Fu's question about the number 1,001, Ai explains his intention to show 'a slice from a cake, including particular characteristics from all positions of the cake. [. . .] This is why it's not 50 or 100 people. It has to include this kind of large quantity, consisting of so many people's identity traits, age traits and diverse provincial traits.' Put otherwise, Ai wants his slice of Chineseness to be large enough so that its plurality will shine through its nominal singularity. Indeed, to ensure that his representation of Chineseness would be dynamic, varied and atypical, Ai urged some of his selected candidates to recruit for the project.

Two striking instances involved a farming community located in the northwestern Gansu Province and an ethnic minority group called Dong zu from Guangxi, an autonomous region in the southern Chinese inland province. Ai asked Beijing-based artist Jin Le to invite four people from his hometown in Gansu's Xinlian Village. The villagers felt so honoured that they convened a town meeting to select four villagers representing different age groups. Wu Hongfe, a rock singer and writer of the Dong ethnicity, brought 19 of her family members and relatives to the project by convincing them that their pigs would survive their short absence, that the Germans would not prevent them from returning to China and, finally, that 'Germany is as good as Beijing' (Ma Qian 2007). Wu's successful recruitment revealed a startling fact—some of the Dong women never had a fixed name and 'were out of the public register before starting the bureaucratic procedures connected with *Fairytale*' (Colonnello 2007). Eventually, *Fairytale* included participants ranging from 2 to 70 years old: students, artists, laid-off workers, writers, policemen, designers, housewives, farmers and those women who had newly emerged from their gender-based anonymity.

Chineseness in *Fairytale*, therefore, displays the dialectic tension between one and many that the piece's logo, designed by Ai, embodies: 1=1,001. More than a thousand individual human specimens travelled from the same continental land mass subsumed under the name 'China', each an emanation of that selfsame national identity; from a single project entitled *Fairytale* (the graphic 1= approximating the uppercase letter 'F') came 1,001 'Fairytalers'—most of whom had never seen any contemporary art, never mind lacking the financial, social and political wherewithal to go abroad. As Ai explains, '[The logo] means that in this project 1,001 is not represented by one project, but by 1,001 projects, as each individual will have his or her independent experience' (ibid.). While Ai equates his numbers with 'projects' here, I would anthropomorphize these numbers to add three more possibilities. The 1 in 1=1,001 may signify: (1) the artist (the one) who assembles (as many as) 1,001 Chinese citizens to become one constantly varying artwork; (2) a participant (the one) who perceives his/her mobile relations with those (many) compatriots who are also fellow tourists and artworks; (3) a viewer (the one, either onsite or after the fact) who contemplates the intricacy and significance of a performative event composed of (so many) heterogeneous bodies with similar physiognomic features. All three subjects—the artist; the participant/artwork; the interested viewer—enact their experiential subjectivity in relation to *Fairytale* through their time-based perceptual, cognitive, existential and imaginary involvement with a fable-like event interconnecting so many diverse subjects.

Multicentricity in *Fairytale* | This dialectic tension and correlation between one and many constitute my concept of multicentricity (Meiling Cheng 2002: xix). I posit multicentricity as a descriptive methodology rather than a prescriptive politics (explicitly differentiating it from multiculturalism), and maintain its link with the idea of centricity (hence, implicitly challenging the poststructuralist notion of decentring). I further theorize multicentricity that is, multiple centres) along three postulates, taking 'centre' as both a converging point and a sentient unit: the inevitability of perceptual centricity; the coexistence of multiple (and multiscaled) centres; and the fundamental inadequacy of any one centre. This theoretical modality supports my observation of multicentricity as a (prominent) type of Chinese subjectivity embodied in *Fairytale*.

A transcendental vision with commonplace applicability, multicentricity incorporates the philosophy of coexisting, complementary and mutually inclusive opposites crystallized in Taijitu (the Daoist cosmological symbol for the 'Supreme Ultimate') but relocates its philosophical grounding from the realm of natural phenomena to that of sociocultural histories. Thus I translate the natural principles of yin (darkness/negativity) and yang (brightness/positivity) into the ethical units of *one* (self/an individual subject) and *many* (others/all those other subjects with whom the self interacts) in multicentricity. As a finite being among a multitude of other finite beings in this universe, the one is always-already implicated in relation to the many that surround, sustain, challenge and give meaning to his/her existence. Centricity is inseparable from multicentricity, even as multicentricity, derived literally from coexisting and aggregating multiple centres, refers back to centricity.

The story of the cosmic genesis according to Daoism draws from the mystery of numbers. *Yi sheng er* (one birthed two)—the cosmos first differentiated to create two opposing and complementary principles; *er sheng san* (two birthed three)—the two joined to create a third—the process of cosmic differentiation intensified; *san sheng wanwu* (three birthed the multitude)—fast-forward zillions of years and the universe is alive with multitudinous animate and inanimate beings. Transferring this natural paradigm to human societies, we may take the 'one' as an individual subject, the 'two' as a modal pair in interpersonal/intersubjective relations, and the 'three' as a subject negotiating with two other subjects to form a basic interrelated kinship/social unit which may be further extended to a multitude (multiple families, societies, nation-states, life-sustainable planets, etc.). Multicentricity is then intersubjectivity multiplied, extending the interpersonal to the intersocietal, the international and the interglocal and perhaps, one day, when extraterrestrials decide to join us earthlings, to the interglobal and the intergalactic.

Only the spirit of a fairytale can justify my mythic relapse into sedimentary Chineseness. Yet, assuming the allegorical as the negative half of the plausible, a fairytale might well bring into being a complementary scholarly argument. For me, Ai's *Fairytale* offers a representation of Chinese subjectivity as multicentric, a conception that Ai's *Fairytale* logo captures. 1=1,001 resembles the Daoist yin-yang emblem in Taijitu by visually registering the opposition/complementarity of two different and co-dependent entities. Configured in a circular structure, the Daoist emblem presupposes a timeless eternity—it projects a cosmology that is cyclical, dialectic, tense-less and ceaselessly turning. In contrast, Ai's logo is designed as a linear structure, inserting a time-based mathematical equivalence for the two entities—there is a beginning

and an end, which may be construed variously as a cause and an effect, a basis and its manifestation, an initiation and its purpose. If we follow the English linguistic order to read the sign 1=1,001 from left to right, then the 1 may signify an individual subject versus other 1,001 significant others. Yet, if we follow the traditional Chinese linguistic order to read the sign from right to•left, we will see the 1,001 energetic individual bodies becoming/yielding 1—the all-encompassing and ever-changing body of *Fairytale*. This larger body also coincides with the entire portion of Ai's selected slice of the Chinese pie. The Chineseness as represented by *Fairytale* is therefore poised between the centricity of a totalizing entity and its constituent multicentricity.

The dynamic interplay between centricity and multicentricity in the *Fairytale* logo engenders two clear emphases—on individual participants and on collective portraits—in Ai's mediated representations of the project. In the documentary film (a 150-minute version edited from 1,500 hours of film), which I viewed in Ai's Beijing studio, the footage fluctuates between close-ups of individual participants, including the artist, responding to interviews, and more distant shots of these participants leaving their hometowns for Kassel.[18] Most photographic documents for *Fairytale* stress collectivity, featuring diverse groupings of people and things, from participants to beds, from suitcases and dining tables to antique chairs, as if they were all parts of a huge xingwei-zhuangzhi seen at different moments. Since the creator of *Fairytale* receives no 'star' photographic treatment, Ai's authorial subjectivity, perceived as a mobile centre among many, becomes dispersed amid his living installation's multicentric components. A different approach characterizes Ai's textual representation which maintains an acute focus on the individual: 'Ultimately *Fairytale* is concerned with individual experiences and individual understandings,' said Ai, 'What's most important and irreplaceable in this project is every individual's personal background, personal identity and personal imagination.' While Ai elevated his individual participants as the cumulative existential centres of *Fairytale*, he simultaneously displaced his central authorial position to the sideline, 'My role in *Fairytale* is that of an uncertain producer [. . .] not a leader, but an observer and a learner.'[19]

[18] Ai hired about 20 Chinese and foreign documentary film directors to interview his recruits and to document their daily life circumstances on location in different parts of China; the compiled 1,500-hour film-footage was edited into an eight-hour film and was screened at Documenta 12 long after the Chinese visitors had left Kassel. I saw the latest and shortest version (150 minutes, 2008) at Ai's Beijing studio on 23 March 2009.

[19] Fu Xiaodong with Ai Weiwei, 'Zuowei zuopin de *Tonghua*', given to me as a PDF.

We may regard Ai's privileging of *Fairytale*'s individual participants over himself as his way of allowing his artwork—in its multicentric vitality—to take precedence over his singular authorship. He might be expressing his postmodernist scepticism regarding the myth of originality, as attested by the name of his art company, Fake. Nevertheless, when we take into account his intent to present a slice of contemporary China, the artist's move to obscure his authorial centricity and to highlight his ordinary participants acquires a different meaning. In this cultural context, I contend that Ai's intensive focus on the participants undermines a traditional limit affecting most Chinese subjects—the subjugating power of the One over many.

Throughout Chinese history, the power of this One has remained dominant, authoritative and often deified as absolute law; it persists in political and sociocultural principles of punishing

disobedience and rewarding compliance. The One has had many names: the Emperor in dynastic China; various fathers in the Confucian familial patriarchy; the '5,000-year Chinese civilization' oft-cited by the Republic government to resist foreign imperialist incursions, culminating in the Second Sino-Japanese War (1937–45); Chairman Mao during the revolutionary years; and economic developmentalism in the Dengist reform era. This patriarchal principle would surely insist on paying due respect to the creator of a contemporary Chinese artwork, such as Ai Weiwei. We might call the perennial sign unifying these disciplinary figures, ideologies and ethical codes 'sinocentrism', or the belief in the centrality of 'being Chinese'— however it is defined. I argue that this belief, in its multifarious embodiments, exists as an overbearing centre within a typical multicentric Chinese subject, radically reducing, if not utterly abrogating, the weight of his/her other existential centres. In *Fairytale*, Ai challenges this restrictive limit of Chineseness by breaking down the superstitious homogeneity of 'being Chinese' into heterogeneous Chinese bodies.

'In China, there are many obstacles to individual development,' states Ai. 'It is difficult to become active, to engage in independent pursuit of individual consciousness. There isn't even an opportunity to experience one's failure, let alone one's success' (Hu Zhen and He Jingfang 2007). What Ai identifies here is a long-standing problem under China's traditional and socialist collectivism—a problem diametrically opposed to the excessive individualism symptomatic of most Western late-capitalist societies. Ai sets out to redress his country's pervasive indifference towards the individual by making each participant an indispensable part of *Fairytale*. So thorough was Ai's individualistic turn that he even required all 3,000 applicants, as an initiation ritual of sorts, to respond to a 99-question survey, covering topics from fairytales to religion, from dream to geography and tourism.[20] His art project then sent a third of these voluntary, curious and committed applicants abroad, far beyond their well-kept boundaries of quotidian routine, leading their imaginations 'astray' on a sensorial holiday. By locating the central significance of *Fairytale* in its individual Chinese subjects, Ai turned his piece, with its explicit intercultural veneer of transnational patronage, into an intracultural inquiry for himself and an educational opportunity for his participants. While Ai benefited from his interactions with his fellow Chinese citizens who trusted him enough to become his artworks, these same individuals got to experience variegated trials and pleasures of becoming twenty-first-century globalized subjects, even if just this *once* in their lifetimes.

20 These completed questionnaires are saved in Ai's private archive for *Fairytale*. He allowed me to read five samples.

He Yunchang: Noncommittal Chineseness

A global audience was given multiple points of access to Chineseness through Ai's living collage of multitudinous Chinese individuals in *Fairytale*. *A Rock* shares *Fairytale*'s ethical emphasis on the individual but it eschews the latter's tactic of comprehensive sampling. Instead, He's piece throws a spotlight on a single Chinese individual immersed in a durational partnership with an alien rock, passing through an unfamiliar landscape.

A person, a rock and a landscape—*A Rock* comprises many regional particularities garnered from its three main characters, including the person's national identity as Chinese, ethnic classification as Han, native residency in Beijing; the rock's former placement at the

Boulmer beach; and the British landscape's demarcation into urban and rural districts with searchable names. Yet the question remains: Did any of these details thematically affect the piece? Indeed *A Rock* draws just as much, if not more, of its visual and existential content from its characters' non-region-specific traits, such as the person's gender and physiological type; the rock's size, shape and weight; the landscape's shifting light, moisture and temperature. We may then read this juxtaposition of a person, a rock and a landscape in two ways: as an intercultural, even globalized, scenario wherein a Chinese male artist/tourist with a Northumbrian rock circumnavigates the island of Great Britain; or as simply the given circumstance that brings together a human subject, a sedimentary object and a terrestrial environment. Since both interpretations are equally persuasive, I see He's piece revealing a sense of ambivalence, or a noncommittanl stance, towards the thematic nexus of Chineseness and globalization which Ai's *Fairytale* both evokes and undercuts.

Perhaps the open-ended multivalence underscoring *A Rock* justifies the different representations of the piece put forth by its producer and artist.

'Beijing-based artist He Yun Chang is arguably the leading performance artist presently working in China', begins the promotional blurb on He's British producers' website, which identifies He's rock-carrying action with a different translated title—*Touring Round Great Britain with a Rock*. The blurb by the production company, amino, proceeds to describe He's performance career, praising the artist's extraordinary capacity to meet his live art's 'exceptional physical demands upon himself both in terms of his strength and endurance. These works, mostly performed in public, though occasionally only observed by a camera operator, commonly astound audiences with their simple ambition combined with the difficulty of their implementation and, ultimately, their apparent futility.' The blurb also compliments the careful elegance of He's photographic and videotaped performance documentation to highlight amino's joint venture with Spacex in exhibiting *He Yun Chang: Works* in Liverpool and in Exeter. A selling point for both the live event and the documentation exhibition is that this Chinese artist's 'extreme physical performances' based on 'Chinese mythology and ideas deeply ingrained in Chinese aesthetics' have been 'rarely seen outside China' and this will be 'the first exhibition of the artist's work in the UK'! So, sums up amino, 'The combination of all of the elements of this project and the specific timing of all its aspects have been planned to attract the highest audience figures and maximise media attention' (2009). In amino's roundly orchestrated publicity narrative, the rising Brand China is more than a subtext.

The press release from amino for *A Rock* is interspersed with several key promises: contemporary Chinese; extremity; rarity; live art; and maximum audience appeal. In my reading, the first three promises reflect general British perceptions about performance art from China and the last two betray regional preoccupations, including the popularity of live art and its assumed effects on fostering a public cultural sphere in a media-saturated society through immediate human interaction. (I will detail the British take on Chinese performance art in the next chapter.)[21] With respect to the local expectations about live art, let me cite these incisive descriptions from London's Live Art Development Agency's website: 'Live Art is now recognised as

21 In Chapter 2, I substantiate my assertion about the British take on Chinese performance art through a detailed analysis of the media furores surrounding a controversial British documentary, *Beijing Swings* (2003), broadcast once as a late-night television programme on Channel 4.

one of the most vital and influential creative spaces in the UK.' Further, 'Wherever they may take place or whatever shape they may be, Live Art practices are concerned with all kinds of interventions in the public sphere and all kinds of encounters with an audience' (2009).

Given the regional background and assumptions underlying amino's publicity narrative, I find it humorous to read in the same document the following artist statement, which, except for a few ellipses to avoid redundancy, I shall reproduce—without my editorial interference—from the amino website:

> motive and concept: The work will make an attempt to represent the iron will of an individual and the living conditions of his being with simple and pure methods, and criticize the current trend of mass culture and the mainstream of its values excessively pursuing physical benefits in worship. In a global view, the current mainstream of values has engendered a solo of so called 'healthy values' [. . .] shown as the compromise between autocracy and instincts in some areas and the compromise between habits of custom and instinct in the other areas. An artist may provide the other possibilities of individual interests and a wide space of imagination [. . .] even though it may not change the mainstream of society rapidly. Intention: (1) The living condition of individual: Challenging the mainstream of current values such as efficiency, health, etc. with a performance of invalidity. (2) Lessening the element of technique: A work of perform art should be the natural reflections of body and psyche of an artist while he set himself in a specific condition. it is different from movie. drama.dance.music and other performance (2009).

Before explaining why I am amused by the juxtaposition of amino's and He's texts, I shall first address the typographical drama of global etiquette hovering above my citation. As the excerpt demonstrates, the amino team has refrained from correcting even some spelling and punctuation errors in He's original translated proposal.[22]

22 As I confirmed with the artist in our phone interview on 9 May 2009, He wrote the proposal in Chinese and had a friend translate it into English before he sent it to amino. I also contacted amino but received no response.

Since other texts published on the website are grammatically fastidious, I have to assume that the British producers tried to respect the linguistic difference of an artist whose native language is not English. Does the sense of tolerance shown by amino to a foreign individual demonstrate the heightened sensitivity among globalized cosmopolitan denizens towards their cultural others? Does it imply the producers' fetishization of the artist's spontaneous output—even though He had hired someone else to translate his Chinese statement into English? Or was the amino team charmed by the magic of Brand China?

What interests me about the British producers' deferential citation from the artist is the incongruity between their practically sinocentric representation of the work and the artist's assumed universalism. amino and Spacex are promoting an artist specifically Chinese but the artist himself speaks as a global intellectual or, more exactly, as an autonomous and boundaryless individual. Noticeably, not only does He's proposal for *A Rock* make no mention of 'China' but also He conveys no desire to interact with an audience. Instead, the statement evinces a set of loosely related values to define the artistic subject: individual will and consciousness;

existentialist outlook; anti-mainstream attitude; alternative values; simplicity and purity; imagination and instinct; disregard for technical sophistication; aversion to mediation and simulation; counter-hegemony. In my view, they reflect a hybrid gamut of largely Western intellectual sources from premodern romanticism, early-twentieth-century avant-gardism, modernism, existentialism, postmodernism and the latest postcolonial critique of hegemonic globalization. The subjectivity textually constructed by the artist's proposal resembles more a 'Cartesian subject'—one characterized by 'identity to self, positionality, property, personality, ego, consciousness, will, intentionality, freedom, humanity, etc.'—than the free-floating 'subjectless self' that has populated classical Chinese poetry and prose.[23] Ironically, if there is anything particularly Chinese in He's discursive articulation of his art, then it is a sinocentrism at once so ingrained and cosmic that he perceives no need to identify his always-already centred subject position.

23 See Jing Wang (1996: 195). The description of the 'Cartesian subject' is cited by Wang from Jacques Derrida (1991: 109).

No matter its longer duration and more extensive spatial reach, *A Rock* epitomizes He's ongoing xingwei practice which is sustained by a modus operandi quite different from Ai's. As *Fairytale* exemplifies, Ai conceptualizes the artist's role as a principal designer whose leadership is both defined by the scope of his following and dispersed among his followers. Conversely, He has chosen to present himself throughout his career as a lone thinker and worker, a clear-sighted individual distinguished by his 'iron will'. It is his iron will that steels his self-reliant ego against changing tides, reinforces his work with volitional timbers and fuels his commitment to whatever task he decides to pursue as art. 'I will therefore I am; I am therefore I will.' My mutated Cartesian maxim suggests how He conceives of the interlocked spaces of his being, his time in being here and the will-ful doing of his timed being. He sings the gospel of xingwei yishu but primarily as a song of himself willing to sing.

In establishing a devotional relation to his (self-in-)art, He's xingwei practice typifies the monastic xingwei artists of Beijing. In contrast to Ai's hierarchical teamwork model, these xingwei artists—such as He's peers Zhu Ming, Yang Zhichao, Wang Chuyu, Zhu Yu and He Chengyao—usually work alone, developing their art projects independent from institutional (official or commercial) affiliation. Should they be invited to exhibitions, they tend to select from their existing plans to match the exhibition themes rather than generate projects in reaction to emergent opportunities. To me, the mindset behind such an independent—and essentially isolated—practice is more existential and self-contained than interactive or site-and-occasion-specific, as is customary among zhuangzhi artists. It is a way of working more typically resembling that of a traditional painter.

Like most xingwei practitioners, what motivates He to choose this embodied durational medium is the sense of individual freedom derived from experiencing a consciously chosen and timed behavioural sequence as art. Nevertheless, whether or not He admits it, the coveted Brand China phenomenon—itself inextricably bound up with the nation's economic growth—has financially improved almost all Chinese artists' lives. I personally observed these changes—most of the xingwei artists I interviewed in my first trip to Beijing in 2005 had, by my third trip in 2008, moved from their tiny apartments to spacious studios-cum-private exhibition spaces. Moreover, since roughly 2006, the Brand China syndrome has given rise to a different

permutation of Ai's 'factory' model among xingwei artists, with some of them dividing their studios into two sections: one for serious art; another for profit. He's case is again paradigmatic. After more than a decade of solo practice, selling some documentary photographs to sustain a frugal life, He can now afford to hire assistants to construct large-scale saleable objects, mostly paintings and sculptures derived from his live performances. This transition in He's professional mode offers us a heuristic moment to ponder several implications.

First, the transmutation of ephemeral art. He's career in dematerialized art adds symbolic currency to his name, which in turn brands his subsidiary material products, raising their monetary value and collectibility.

Second, the artist's negative resistance to changing circumstances. By diversifying and increasing his income sources when he is capable of doing so, He refuses to romanticize the putative spiritual worth of poverty. Nor does he reject the commodification of his performance-derived residual output—those he calls *shougong zhipin* (handmade products)—as a sell-out.[24] While he does not consider financial reward contradictory to his serious art pursuit, neither does he purposely design an extreme action to hype his marketability. He's lack of interest in displaying Chineseness in *A Rock* conveys the semblance of inaction but actually results from an act of negative resistance.

24 My phone interview with He Yunchang, 9 May 2009, Los Angeles to Beijing.

Third, the artist's positive identification of an artistic rationale. He prioritizes his live action's intent over its consequence which he accepts as a side effect. Whether or not he profits from his xingwei yishu is secondary to this total equation. The artist's foremost concern is his unwavering adherence to his 'individual interest' which includes, as he told me in our first interview, 'systematically damaging the physical health of his body' and 'engaging in pointless actions'—such as picking up a stone and walking beyond exhaustion for months, so as to put it back again.[25] We might recall He's comments about challenging the global mainstream's 'healthy values' with a 'performance of invalidity' in his proposal to the British producers.

25 My interview with He Yunchang, 4 July 2005, Tongzhou, Beijing.

Existential thrill; pragmatism; individualism; idealism; heroic endurance; suicidal self-impairment; missionary zeal for impotent actions—such are the characteristics of He's xingwei practice. I find it intriguing that these diverse and seemingly contradictory descriptors don't seem to converge into one energetic central essence that propels He's art—even though the artist proclaims that his 'iron will' is his sole driving force. Instead, I submit, these various focal points coexist as enfleshed perceptual and epistemic tendencies in He's multicentric subjectivity. Perhaps it is in the artist's multicentricity that his British producers may locate He's Chineseness.

Admittedly, my reading of He's work runs against the grain of how the artist has chosen to represent *A Rock*. I proffer 'multicentricity' as a method of reading He's project rather than using an inductive logic to prove his essential Chinese attributes. Likewise, I approach Chineseness not as a fixed set of intrinsic Chinese traits but as a conscious representational mode which, when deployed by artists from Beijing, implies a largely nation-based identity politics mobilized round the centrality of being Chinese. In contrast to the Chineseness Ai

pronounces for *Fairytale*, He steers away from an explicit reference to Chineseness in *A Rock*—in the manner that I've described as his *negative resistance*, best expressed in a *neither–nor* syntax. The artist neither accentuates nor repudiates his Chinese identity in enacting his British 'rock'-tour. It would be inaccurate, however, to generalize He's attitude towards Chineseness as always in a mode of negative resistance. Consider, for example, the very xingwei piece that won He the commission to *A Rock*—*Long yu* (*Dragon Fish*, 11 March 2006), a live art piece enacted in the Newcastle Art Centre, UK.

IMAGE **1.8** He Yunchang performing *Long yu* (*Dragon Fish*, 11 March 2006), in the Newcastle Art Centre, UK. Image courtesy of the artist.

Dragon Fish revolves round 24-hour endurance running. Naked except for a pair of boots, He has the flesh underneath his left collarbone pierced with a metal hook made of surgical steel; a long red thread connects the hook to the ceiling, leashing the artist to the exhibition hall.[26] He kneels on the floor to write with a red crayon the phrase *Long yu* (龙鱼) in simplified Chinese characters and then starts running in circles until the next day.

26 I based my description of *Dragon Fish* on two interviews with He on 14 July 2008 and 23 March 2009, Beijing. I also consulted He's photographic documents and his interview with Jiang Ming (2008: 106–13).

Dragon, an ancient Chinese totem; *dragon fish*, a common Chinese-restaurant and corporate pet favoured for its supposedly auspicious *feng shui* properties; the colour *red*, associated with both traditional and revolutionary China; and the large Chinese *ideograms* inscribed at the centre of the circumference marked by the artist's marathon. Through all these unmistakable and globally recognized ingredients of Chinese culture, He has clearly enunciated his Chineseness in *Dragon Fish*.

The Brand China syndrome has encouraged the amino producers to play up He's Chinese identity in promoting *A Rock*, even though their strategy finds little corroboration in the artist's statement. Inversely, *Dragon Fish* reflects He's typical practice of evoking a Chinese legend to entitle his xingwei piece and inspire its action score. We may then surmise that He has no predetermined stance towards Chineseness but simply does whatever he feels fit for a given project. With *Dragon Fish* in mind, we may understand He's ambivalence towards Chineseness in his follow-up UK piece as a tactic to preserve his freedom. What his producers take as a brand-name allure the artist might perceive as niche-market confinement. A further

complication—He's choice not to highlight any politicized culturalism (that is, Chineseness) in *A Rock* does not mean that the piece contains no untranslatable cross-cultural differences, those deeper than the superficial opposition between the producers' promotional logic and the artist's reluctance to be boxed into representing his ethnic identity.

A concise example of this kind of mismatched intercultural communication is He's project title, itself a linguistic artifact under cultural translation.

I've translated He's piece as *A Rock Tours Round Great Britain*, closely following—in my American English way—the artist's Chinese title, *Shitou* (stone or rock) *Yingguo* (the UK) *Manyou* (wandering or touring) *Ji* (a record or a narrative account). I keep the rock as the subject intended by the artist's original title but I take the liberty of changing 'Yingguo'—a common Chinese name for the British Isles—to 'Great Britain' to reflect the actual route. I also insert the verb between the two originally contiguous nouns to make syntactic sense in English. The artist's British producers have translated the title as *Touring Round Great Britain with a Rock*. This British translation, while introducing ear-catching alliterations as a gift of the English language, transfers the rock from its former subject position to being an object accompanying an implied subject, the human artist. In my view, the divergence in translation betrays two cultural presuppositions which are simultaneously constructed and mirrored by their different languages. The most crucial difference lies in the presumed subject.

In *Touring Round Great Britain with a Rock*, the subject is linguistically veiled but grammatically preordained to come before 'touring'. The artist, as the human subject, is assigned the agency of touring with a rock. The man and the rock are linked by a voluntary artistic action but they remain divided by the boundary between a subject and an object. In *Shitou Yingguo Manyou Ji*, the subject is the rock and is grammatically implied to have the agency to wander round the UK. How does a legless rock do so? There are several possibilities according to the Chinese imagination, mine as its proxy at the moment. First, the rock's agency comes from its linguistically unidentified human carrier who has outsourced his subjectivity to a chosen host. Second, the rock has absorbed its human carriage into part of its rocky materiality; hence, it's now a human-rock. Third, the rock finds a prosthetic extension in the artist who supplies it with arms and legs. These are multicentric existential scenarios for the rock whose subjectivity is not denied but supported by its objecthood, its ability to be held by a human palm. As for the palm's owner—his (human) subjectivity is not undone but fulfilled by the temporary succession of his centricity as a sentient, animate and motile being, letting himself become his other's other, the negative complement of an inanimate central character.

I raise the case of a doubly translated title not to demonstrate my superior knowledge of the Chinese language nor to celebrate my performance studies–trained clairvoyance in better deciphering the cultural unconscious. The fact that *Touring Round Great Britain with a Rock* is a perfectly legitimate and stylish translation for *Shitou Yingguo Manyou Ji* speaks to my conviction that multicentricity, or the dynamic coexistence of multiple epistemic and experiential centres as hermeneutic possibilities, *enlivens* the universe of time-based art. A creative medium that absorbs the entropic fury of being, time-based art relies much on the kindness of strangers —each a discursive circle and extension—in framing, retracing and re/inventing each artwork's temporal passage in narratives; the more contagious the narrative the better, enabling the

artwork's conceptual and imagistic memes to be grasped and passed round in global cultural spheres as randomly accessible information.

The moral of the moment may be consumed in two easily digestible lessons. My narrative for *A Rock Tours Round Great Britain* does not replace but adds to the one composed by He's British producers for *Touring Round Great Britain with a Rock*. As interested others who tell stories about the project, the British producers and I, a diasporic Taiwanese American critical subject, have entered into an imaginary conspiracy with the Chinese artist in pursuit of a shared agenda—to extend the mnemonic vitality of an artwork transpiring *somewhere-when else*, in a no longer physically accessible time-space, a site where a rock once walked on the shoulder of a man.

A rock resting on the shoulder of a man who walks within a changing landscape—this variant riff on 'a rock once walked on the shoulder of a man' succinctly relates the visual motif recurring in the photographic documents He selected to represent *A Rock Tours Round Great Britain*. I am looking at these coloured photographs published in a catalogue for a solo exhibition bilingually entitled, *Cunzai de chidu*: *He Yunchang zuopi* / *The Ability to Exist*: *He Yunchang Art Works* (5–14 March 2008), at Vanessa Art Link in Jakarta, Indonesia. At first glance, these documentary photographs reinforce the 'orthodox' image of xingwei yishu as a solitary and volitional behavioural sequence enacted by an individual artist. Despite the fact that at least a guide and an assistant had always accompanied He, these images have an exclusive focus—a lone man against a vast landscape or a protagonist on a mission, crystallized by the object of his devotion, a rock roughly the size of his two fists. By rendering invisible the supporting players, these photographs highlight the autonomy and self-determination of an artistic subject who will pursue a transcendental goal at all costs—the rock, for all its ordinariness, becomes both an index to and a material emblem of this goal. Indeed, the less remarkable the rock the more transcendent is the artist's service to it. Decoding the 'rock' as a randomly selected signifier for its signified 'art' elucidates the metaphysical dimension in He's xingwei discipline.

Examining the photographs again and against the grain, we might reverse the normative order of figure and ground to direct our gaze instead at the landscape. Frame after frame, the exquisite and always changing landscape—with fluffy clouds, dappled slopes, curvaceous coastlines, majestic trees, snowy crags and grazing cows—becomes the central character, through which pass a miniature profile of a man with a tiny lump sitting on his shoulder. *Shitou Yingguo Manyou Ji—Rock England Wandering Record*! Ah, now I see again, there have always been three characters there to begin with—the rock, the land and the one who wandered so as to remember. But, I would stress, there were surely more than three characters there—behind the three leading actors walked a few supernumeraries excluded from the photographic frame, including a guide anxiously tracing the map and a photographer quickly snapping away while taking care not to trip on an errant stone. Somewhere in the distance, a driver waited and a cook chopped cabbage in a motorhome kitchenette.

Three birthed the multitude; another world begins.

My case studies of *Fairytale* and *A Rock* delineate the lay of the land for contemporary Chinese time-based art. I regard Beijing's evolving time-based art-'land' as multicentric in that all of its geographic features, as centres of activity, not only interact with and mutually affect one another but also function as autonomous spheres of operation, crisscrossed with tension, movement, internal organisms and an action agenda specific to each.

One of these major centres of activity revolves round Brand China, including both its recent surge in the world marketplace and its hidden problems, sporadically uncovered as contradictory to the country's awe-inspiring advancement. Another centre pivots on the momentum of globalization which has accelerated China's economic reforms and has thrust the country's contemporary art world into a concatenation of international relations, transnational capital flow and cross-cultural cooperation and competition. Yet another centre involves the global medium of time-based art: its conceptual presumptions, formalistic conventions and channels of transmission; its three-dimensional ephemeral genres, such as performance art and performative installation; and its permutation into diverse regional configurations, such as xingwei yishu and xingwei-zhuangzhi in China. Within this centre of time-based art lies the potential for an endless accretion of other centres—those made up of its practitioners, receivers and receiver-practitioners. *Fairytale* and *A Rock* exemplify two remarkable trajectories crisscrossing these multiple centres.

If the allure of Brand China has its material basis in the country's current position as a leader among Asia's emerging international powers, then globalization theoretically functions to distribute the brand's latest high cultural product lines among potential buyers worldwide. It's therefore not surprising that, as Liu Kang points out, among East Asian countries, 'China is perhaps the most enthusiastic of all about globalization, from its leadership to the general public.' Nevertheless, Liu warns, the country's unanimous enthusiasm for globalization cannot eradicate the ideological incommensurability between Deng's economic developmentalism (predicated exclusively on economic growth) and Mao's revolutionary hegemony which has continued to supply the rhetoric of legitimation (for example, socialism, perpetual revolution, mass democracy, egalitarianism) for the post-Deng regime. Yet, despite its legitimation crisis, the CCP has managed so far to retain its monopolistic reign on the nation-state which, awash with new stimuli since its cessation from isolationism, has seen the emergence of 'a new cultural formation' that 'cannot be simply defined as socialist, capitalist, modern, or postmodern' but as 'a hybrid postrevolutionary culture that embodies the fundamental tensions and contradictions of globalization' (2004: 4–5).

Globalization serves to adulterate the indigenous political economy by ushering in a transnational flow of capital, commerce, labour, information and population. Thus, not only have the local forces that control and enable cultural productions within China changed but also the impetus of globalization permits many Chinese artists, including those who practise time-based art—as shown in the cases of Ai and He—to acquire overseas support networks for their work. Opportunities for sustaining as well as suppressing controversial art may therefore come from multiple sources—domestic, foreign, transnational and diasporic. To build a sustainable career, a contemporary artist in today's China must negotiate, interact with and

take advantage of variously converging, conflicting and distracting influences. Christopher Berry and Mary Farquhar have analysed such skill in maintaining one's professional viability in the context of Chinese-language cinema. According to them, the filmmakers who have succeeded in crossing over to the international art and commercial markets, such as Zhang Yimou and Chen Kaige, have learned to selectively appropriate hegemonic global cinematic models (read Hollywood) and repackage local/national visual symbolism and narrative schema to attain creative 'agency' through 'a kind of transaction within the transnational' (Berry and Farquhar 2006: 196). The former polarizing postcolonial model of resistance to foreign dominance—often adopted by artists and intellectuals from developing countries in opposition to the American-style economic, military, ideological and discursive imperialism—no longer suffices to deal with a complex and variedly interconnected globalized world. The movers and shakers behind Brand China are predominantly those fit to adapt, no matter how ephemeral the brand itself, like changing fashions, may turn out to be.

Unlike the film medium—which straddles cultural values and industry expectations, popular entertainment and high-stakes, big-budget commerce—time-based art is neither popular nor fiscally profitable. Like a cinematic artwork, however, a time-based artwork includes both material and informational components in its output. Although a time-based artwork's information-content, represented by multifarious visual and discursive documents, may be circulated among those who seek access to it, its material substance—whether an artist's performing body or a performative installation—can exist in actuality only once, in contrast to the massive reproducibility of the film's celluloid body. Whereas a film, even with compulsory cuts to controversial content, can be widely distributed and seen by many in a form relatively true to what its creative team envisioned, the most high-exposure public outlets for a live time-based artwork are the international art festivals, galleries and museum shows located at sundry cosmopolitan cities. The variance in their means of reaching their audience/receivers dictates the divergent routes that the filmmakers and time-based art practitioners travel.

Should they have the privilege of being integrated into the international exhibition circuits, time-based art practitioners, who often complete their projects *in situ*, must deal with the pressures of global transportation to arrive at diverse national sites. Due to the peculiar fragility of their medium's embodied substance, the artists, who are themselves artworks in performance art and indispensable design-directors in performative installations, are required to be present onsite, even if their temporary artworks may be appreciated by spectatorial others offsite at other times. While it might be beneficial for a filmmaker to be present at a screening, there simply will not be a time-based art event without the artist-creator showing up. Roland Robertson's oft-cited definition of globalization as 'the compression of the world and the intensification of consciousness of the world as a whole' does not pronounce the human cost and family sacrifice involved in defying spatial distance on a planetary scale (1992: 8). At this globalized moment, making time-based art in Beijing, in Chengdu or in Shanghai demands that the artist be prepared to travel, always at the ready to join a temporary republic elsewhere. Underneath the perceptual fluidity of globalization is the ironic solidity of geography which determines the time- and patronage-designated site for an itinerant community of cross-national performance and installation artists, gathering to create an exhibition live. 'How many jet lags are there in a

performance art festival?' we might ask in jest. 'As many as there are participants, minus one or two representing the festival's given locale' might just be the answer.

As artworks involving transnational negotiation and international travel, both *Fairytale* and *A Rock* offer at once typical and atypical case studies for Chinese time-based art under globalization. On the one hand, the two pieces illustrate the typical paths towards artistic and financial 'self-sustainability' for those who choose to work in a non-commercially lucrative medium such as time-based art.[27] Both Ai and He had self-subsidized their art to build up a portfolio of projects—with impressive information contents—before

27 I am indebted to Rolf Hoefer for the idea of artistic and economic 'self-sustainability', which he developed under my guidance for his study of the Blue Man Group.

they won funding for such large-scale transnational projects as *Fairytale* and *A Rock*. Although prior to *Fairytale* Ai did not engage with time-based art in his professional practice, he had established his reputation as a noteworthy conceptual and installation artist while strengthening an international relationship network to earn the trust—moral, cultural and financial—of his European patrons and museum sponsors. As an artist utterly devoted to his xingwei yishu, He had likewise capitalized on the symbolic currency—the fame of extraordinary professional prowess—that added value to his name. To put it crudely, Ai and He attracted (cultural) investment because their artworks promised higher (civic) returns for those who financed their time-based art projects. The same scenario might happen to other time-based artists.

On the other hand, *Fairytale* and *A Rock* are atypical projects not just for the annals of (Chinese) time-based art but also for the artists. What made these two projects uncommon—like a fluke or a fairytale—is their scale. Both were supported by astronomical budgets as far as ephemeral art is concerned; both were enormous in their scale of execution. The fact that contemporary Chinese live artworks of such scale could be produced at European sites conjures up the survival lore surrounding Chinese cinema in the immediate post-Tiananmen period, when filmmakers had to smuggle films on sensitive topics piecemeal through China's customs to do postproduction work overseas with transnational funding and personnel.[28] Although,

28 See Chapter 3 for the case of Wang Xiaoshuai's *Frozen*.

like such films, both *Fairytale* and *A Rock* were 'assembled' transnationally, neither deals with politically or ethically sensitive subject matter; in fact, their 'positive' information content and fortuitous timing have contributed to their successful execution. As atypical projects realized with integrity and impact, *Fairytale* and *A Rock* serve to contour the edge of possibilities for time-based artworks watermarked with Brand China. Moreover, the transcultural production of *Fairytale* and *A Rock*, both being Chinese-made projects for primarily Western consumption at European sites, demonstrate a kind of international feedback loop for time-based art in a globalized world.

GLOCAL CLUSTERS OF TIME-BASED ART

However atypically serendipitous, the cases of *Fairytale* and *A Rock* suggest two paradigmatic recent developments in (Chinese) time-based art: One, the glocalization of time-based art; Two, the transition of Chinese artists from consumers (imitators, learners, recyclers, appropriators or synthesizers) of a foreign time-based art medium to producers of time-based artworks.

'Glocalization', a portmanteau word fusing 'globalization' and 'localization', signifies the selective local absorption, decoding, interpretation, appropriation and adaptation of the prevalent ideas, items, relations and processes that spread and diffused worldwide through globalization. A concept borrowed by Robertson from Japanese business strategies, glocalization linguistically highlights, in Victor Roudometof's explication, 'the extent to which the local is in many respects part of the globalization process itself—and not an opposite trend' (2003: 45). In lieu of polarizing the global and the local, glocalization emphasizes the intertwining of homogeneity (supposedly a result of globalization) and heterogeneity (localization), foregrounding the simultaneous movements in the universalizing and particularizing trends. 'Globalization' is 'about what is *happening to us all*,' writes Zygmunt Bauman (1998: 39), in a mixed tone of caution, exasperation and resignation, summing up the ineluctable condition of our contemporary cosmopolitan existence (see also Roudometof 2005 and Robertson 2001). If so, then glocalization is the microcosmic translation of such a pervasive twenty-first-century transregional environment into the concrete, applicable and locale-specific practices of everyday life.

Unlike Bauman, I will not presume that globalization, and its conceptually refined counterpart, glocalization, affect the consciousness and lived verbal and behavioural patterns of all inhabitants on our planet. Instead, I argue that the awareness of these trends actually indicates the privilege of those of us subject-actors who are *free* enough to experience the variegated persuasions, coercions and constraints of an interconnected global existence. As Roudometof puts it, paraphrasing Bauman's critique, 'the consequences of increased mobility are markedly different between the "first world" of the middle and upper classes in the advanced industrialized countries and the "second world" of the working or middle classes in the mostly peripheral societies that make up the majority of the world's population' (2005: 114). Although I doubt whether we may still apply the cognitive dichotomy of centre and periphery without troubling it as we do the global/local pairing, Roudometof's remark is pertinent in portraying a post–Cold War international landscape when 'class' rather than 'nation' increasingly becomes the factor segregating people into the affluent, resourceful and well-connected 'first world' residents and those enduring the opposite experiences in the 'second world'. Thus, it is within the precondition of privileged freedom—particular to a class of transcultural intellectual elite—that we may consider how time-based art, as a 'peripheral' practice within the interconnected, multicentric 'first world', has undergone an analogous process of globalization and glocalization.

> Instead of looking for world-wrapping evolutionary stages, logics, and epistemes, I would begin by finding what I call 'projects,' that is, relatively coherent bundles of ideas and practices as realized in particular times and places. The choice of what counts as a project depends on what one is trying to learn about, but, in each case, to identify projects is to maintain a commitment to localization, even of the biggest world-making dreams and schemes (Tsing 2000).

This elegant call from Anna Tsing empowers me to trace the global trajectories of time-based art by sharing a particular glocalized project—how I came to know the term 'time-based art' at a fortuitous temporal-spatial juncture and then renamed it as the analytical instrument with which I perform my riffs on Chinese time-based art. My project *Beijing Xingwei*—with the

multiple interrelated projects contained within it—is in this sense the assemblage of my 'chronophiliac' travelogues, endlessly rewritten with the interventions of my dialogue partners, actual and virtual, enfleshed as well as imagined.

Riffs on Time-Based Art | Without a doubt, the term 'time-based art' was not my invention. Before 2006, I would have connected this term to the theatre of Robert Wilson, to the plays of Samuel Beckett, Gertrude Stein and William Shakespeare, to my one-time entranced, half-hypnotic encounter with a Noh drama in Kyoto. Suddenly, one spring day in 2006, I found a mysterious brochure in my school mailbox. On the brochure's (3 in. x 6 in.) rectangular cover was what looked like a human figure covered with chicken feathers. A microphone cut in on a sharp angle on the upper left corner, and fragments of a sofa, a metal chair and a radio-like machine with antennae lay behind the chicken figure. The image reminded me instantly of Linda Montano performing *Chicken Woman* (1972) on the streets of San Francisco (see Roth 1983: 20). But there was more data within the rectangular frame—slender lines of Arabic numerals, like the hour, minute and second on a digital clock, formed two-and-a-half rectangular diagrams of recorded elapsed time, counting second by second from 00:00 to 00:00:29. Horizontally across the chest of the chicken figure was a blown up logo, T:BA:06, closely shadowed by a smaller-sized caption in all upper-case letters: TIME-BASED ART FESTIVAL, PORTLAND, OREGON, 09:07:06-09:17:06.

The brochure opened to a blurb from the Portland Institute for Contemporary Art (PICA), introducing TBA as 'a contemporary art festival of regional, national, and international artists presenting theatre, dance, music, film and—new this year—visual exhibition and installation'.[29]

29 See PICA's website for the 2006 festival archive, http://-www.pica.org/tba/tba06/default.aspx (9 June 2009). The chicken figure I described was a publicity shot from Vivarium Studio/Philippe Quesne for *The Itching of the Wings* (2003), 'a multi-tiered whimsical revue about flying and falling'. See also Vivarium Studio's website: www.vivarium-studio.net

The festival programme included a multimedia live performance by Laurie Anderson; a live electric-guitar concert featuring composer John King's 50-member Extreme Guitar Orchestra; a multi-channel video installation of Marina Abramovic's *Balkan Erotic Epic*; two live artworks by the performance group Forced Entertainment led by Tim Etchell; and an ensemble reading of *Leftover Stories to Tell*, drawing material from the late solo performer Spalding Gray's published and unpublished journals, poems and monologues. TBA: to be announced—as I knew the acronym before this PICA brochure—became cleverly merged with T:BA, for time-based art.

In a blink, the linguistic doubling between TBA and T:BA seared itself onto my mnemonic neurons. PICA's conceptual design revealed in the graphic layout appealed to me for its ingenuity, combining the unpredictability of a probable event (TBA)—one that will abruptly burst out in the nick of time . . . or never—with the numerical precision we habitually entrust to a non-analogue time-telling format, to yield a digital montage of temporality in performance. The term triggered my perennial fascination with neologism and conceptual coinage. For all its syllabic novelty, T:BA actually signified a phenomenon already familiar to me—intermedial performances, located in the amorphous in-between, a grey zone cast just outside the known boundaries of established traditional media (for example, classical theatre, dance, opera and music). Based on my experience of having written *In Other Los Angeleses*, in which I severely

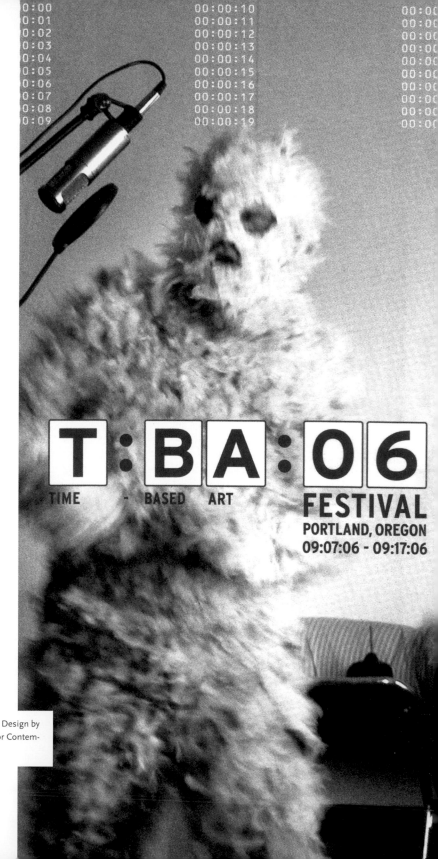

critique certain visual arts–trained performance artists' anti-theatrical prejudice, I took this new taxonomic term, 'time-based art', as a peace offering from a witty providence, for it avoided the contentious history associated with older terms by holding out a diplomatic translucent umbrella which, paradoxically, shed new light on all those under its inclusive canopy.

To me, the term 'time-based art' teases out an element common to all performative media, traditional or avant-garde—theatre, dance, music, performance art, live art, body art, land art, site-specific installation, singing human sculpture, acrobatic earthworms, expanded cinema, new media, etc.—no matter how they are embodied. This element is in and of itself colourless, formless, scentless and weightless but it may transform, seemingly merge with and ultimately destroy many, if not all, bodies. This element is changing you and me as I speak, even when I wish it would stop already. Would that it were a substance, an elixir that I might ingest for my immortality!

Maurice Merleau-Ponty, as if in response to my fantasy, eloquently cautions:

> If we are in fact destined to make contact with a sort of eternity, it will be at the core of our experience of time, and not in some non-temporal subject whose

IMAGE **1.9** The 2006 Time-Based Art Festival Brochure. Design by Shonna Spadt. Image courtesy of Portland Institute for Contemporary Art and Vivarium Studio.

T:BA:06
TIME – BASED ART
FESTIVAL
PORTLAND, OREGON
09:07:06 - 09:17:06

function it is to conceive and posit it. The problem is how to make time explicit as it comes into being and makes itself evident, having the *notion* of time at all times underlying it, and being, not an object of our knowledge, but a dimension of our being (1976: 415).

I feel that Merleau-Ponty is talking to me, caught—red-handed and green with envy—in my yearning for an eternally youthful, fully enfleshed and impassible sentience. He reasons, to those of us mortals who wish to know time, that temporality cannot be objectified as an epistemic partner, an article of knowledge that will gradually yield to our patient probing, for it exists as 'a dimension of our being'. We are, to mutate a famous coinage from Martin Heidegger, beings-in-time-walking-on-through-and-in-time-at-all-times (1962). How I wish my lot were otherwise!

Merleau-Ponty's phenomenological insight foregrounds the constant intertwining of my being with time; it agrees with my perception of temporality as simultaneously an aspect of my consciousness not fully in my control and an integral part of my daily being, a part so close and ever-present that I tend to forget it unless I am suddenly pressed by its urgency. While my consciousness of time does not create time, it does create the meaning of time for me. Merleau-Ponty confirms my intuition that temporality is a dimension of my subjectivity—being-here-and-now as who I am, I cannot walk apart from time nor time from me. The French philosopher's description inspires me to see the connection between my temporal consciousness and temporality as that which exists both within and beyond me. This perceptual understanding strikes me as resembling the concept of temporality implied by the common Chinese two-word phrase for time—*shi jian* (時間).

The first word *shi* (時), a traditional character for time, includes three multicentric components: *ri* (日) is the sun; *tu* (土) is the earth; *cun* (寸) means exact time, or a kind of measurement for a tiny distance, like that of an inch. Putting the three together to form *shi* (時, time) leads us to a natural scene in which time means the accumulation of tiny distances on the earth by the sun's movement. Insofar as I know that time will not stop after the sunset, *shi* implies the perspective of a diurnal animal, such as a human observer, whose sense of time becomes perceptually opaque when the sun, as the only source of light before other artificial light sources proliferated, disappears.

The second word in the phrase *jian* (間) means the space between two things—an interval, a gap or a span; it is also used as a unit in counting the number of houses. The word is composed of two parts: *ri* (日, the sun), which is a bright spot one can see outside the window, and *men* (門), which means a pair of doors; *jian* (間, an interval) is then the space between two doors through which the sun may pass and through which one may see the sun. Joining the two words to create the phrase for time, *shi jian* (時間) paints a liminal scene where culture meets nature—the observer, as the one who lives inside a house, stands at the door, looking into the sun's relation to the earth to measure time. One consistent element in this ideographic sequence is the sun, which is, from an observer's standpoint, both a source of light that permits perceptibility and a font of energy that initiates change. According to how I decipher its concept phrase, then, the Chinese sense of *time* coincides with an observer's ability to perceive *change*.

Merleau-Ponty's analysis, complemented by what I appreciate as the Chinese sense of time, modifies the accommodating syncretism underpinning PICA's characterization of time-based art which includes both ephemeral (theatre, dance, performance art, site-specific installation) and relatively permanent (video, film, photography) media. In PICA's classification, time-based art includes numerous expressive means that involve temporality in their making. Following a more restrictive definition, I consider 'time-based art' a creative medium that reveals the effects of temporal change as an existential dimension shared by the artist, the artwork, their viewers and the viewing environments. The 'matter' of time-based art is the irreproducible presence of temporality which can be perceived through tangible changes affecting the bodies it brings together at multicentric junctures; conceptually, time-based art blurs the distinction between these bodies—those of its practitioners, its artefacts, its receivers and its multiply construed viewing sites—and places them all on display as if on a stage made of time, for whomever it may concern—an audience of chance, plan and curiosity. This more rigorous criterion specifies time-based art as a quintessential ephemeral medium wherein a timed event, a perishable installation, an artist's body voluntarily under duress or a suddenly self-reflexive spectator appears, takes (its/her/his) place and disappears.

Following this restrictive parameter, I exclude video, film, photography and virtual technology-based new media from my book's purview insofar as their resulting artworks have become relatively stabilized and detached from further temporal intervention. I treat the temporal basis in time-based art, then, as an actuality that has physical consequences for the one who creates it, for the artwork being created and for the many who come to the artwork at various moments/sites. In my conception, time in time-based art is not solely an effect of artistic representation but also a constantly shifting material condition shared by all mortal beings and being laid bare for all interested perceivers to experience.

This notion of time-based art, nevertheless, depends on the paradox that the 'actuality' of time—a phenomenon that may be sensed by the changes happening to the perceiver and the surrounding objects—can be conceptually recalled and experienced after the fact. As a dimension of our mortal being, time is at once nebulous and concrete, fleeting and ever-present, perceivable via external aids and conceivable through our intuition and experience. This paradox of time as a known-unknowable facet of our existence refines my definition of time-based art by bringing into focus the (presumed inadequate) centrality of the perceiver-interpreter of an artwork. Thus, like the relation of the perceiver to the sun in the Chinese phrase for time, *shi jian*, the hermeneutic circle—or the Taijitu, if you will—of a time-based artwork is composed of two coexisting opposing/complementary components: the objective grounding provided by a time-based artwork; and the subjective agent of a hermeneutic act. On the one hand, a time-based artwork reveals the dimension of temporality by foregrounding the irreversible changes affecting the artwork itself. On the other, a perceiver who encounters a time-based artwork via various display or documentary means self-reflexively identifies the artwork as 'time-based' by tracking multiple temporal trajectories: the past of the original artwork becoming present by the perceiver's attention; and the perceiver's temporal engagement—past, present, future, phantasmal or dreamlike—with the artwork.

A time-based artwork can only happen *once*, an *actual transiency* that paradoxically releases its temporality to be remembered/imagined recurrently thereafter. In this light, the critical assessment of a time-based artwork simultaneously results from and results in the dialogic conjunction of several parallel temporalities—the 'real time' of the original artwork reimagined by the critic-perceiver intersecting with the 'real time' of the critic-perceiver in the process of assessing the artwork.

Glocalizing Chinese Time-Based Art

My take on time-based art centres on a twofold act which is volitionally generated by a critical subject, the perceiver-interpreter who recalls the artwork so as to experience it (again and again). This act first concerns retracing the medium-specific materiality of the artwork, a materiality that becomes dematerialized throughout the process of enactment. The act is then driven by a naming behaviour—the critic-perceiver of a given artwork reads into the work's mutability and declares 'time' as the source and basis of its impermanence.

This twofold act underscores my project to investigate how performance art and the performative installation, two global modes of ephemeral art, have become glocalized as xingwei yishu and xingwei-zhuangzhi yishu in China, using Beijing as the locale of my ethnographic encounters. In this aspect, my project itself may be traced to a glocalized impulse—my localized desire, or interpretive agency, to highlight the temporal basis as the common denominator—the global currency, as it were—linking the two transient art modes practised by numerous Beijing artists. My embodied locus, an emotive-cognitive-epistemic centre, serves as the urgeotemporal basis of my transregional quest, which aims to elucidate the reconfiguration of time-based art in Beijing and the subsequent dispersal of Chinese time-based art round the globe. Naming 'time-based art', I mark all the *times*—time and time again, persistent, protracted and swaying currents of remembering and forgetting—with which I came to know 'Chinese' time-based art. By adding a pan-regional qualifier—Chinese—to the medium, moreover, I acknowledge my 'Chineseness' as the most intimate source of all cultural-ethnic representational ingredients that spice up my quarry, *Beijing Xingwei*.

Infused with an experiential nexus of personal times, my embodied locus, as the intimate site that has initiated and continued to sustain my seeking, adds a self-reflexive layer of meaning to 'contemporary Chinese time-based art' as my authorial project. But how does this general label under which I subsume xingwei yishu and xingwei-zhuangzhi speak about their objective grounding?

First, the adjective 'Chinese' in this objective context is no longer diasporic but synonymous with its implied nation-state, because 98 per cent of the artists I study here reside in its capital Beijing, which has served as both the primary site of my fieldwork and a synecdoche of 'China'.

Now, why do the two distinct, if interrelated, expressive modes—xingwei yishu and xingwei-zhuangzhi—belong together as 'time-based art'? If 'time-based art' offers a phenomenological approach to art-making as a perceiving subject's creative response to the changing environment, then calling xingwei yishu and xingwei-zhuangzhi jointly by this family name brings into relief their practitioners' negotiations with the epochal changes that have been affecting reformist China, the most immediate 'contemporary' environment for their art.

'Contemporary China consists of multiple temporalities superimposed on one another; the premodern, the modern, and the postmodern coexist in the same space and at the same moment,' writes Sheldon H. Lu. 'Hybridity, unevenness, nonsynchronicity, and pastiche are the main features of Chinese postmodern culture' (2001: 13). Lu's analysis recalls what I've noted about He's conceptual syncretism in his proposal to amino and Ai's representation of China's nonsynchronous heterogeneity in *Fairytale*. Lu and I appear to perceive similar phenomena, although we favour different terminologies—his 'postmodernity' versus my 'multicentricity'. Lu follows up his specific analysis of the country's postmodern temporalities and 'transnational visuality' by detailing reformist China's exceptionalism: 'a major socialist/ postsocialist state' and 'the largest developing country'; a somewhat 'postcolonial' nation yet not in the same paradigmatic way as India and most African countries; an emulator of 'East Asian modernity (also known as "Confucian capitalism," via Hong Kong, Taiwan, South Korea, Singapore, Japan)' and of 'global capitalist practice (through the operation of such transnational corporations as Volkswagen, Motorola, General Motors, Kodak, and Nike)' but still a loyal heir to its 'indigenous socialist legacy (Mao Zedong's thought plus Deng's reforms)' (ibid.: 14). In short, much as China is traditionally known for its tendency to sinicize foreign influences, what Lu portrays here is a nation-state that carries on the same process of sinicization in its current trend towards glocalization.

I argue that xingwei yishu and xingwei-zhuangzhi, as time-based art, reflexively and symptomatically bear witness to the dynamism, neurosis, ambition, disillusion and heartbreaks resulting from their country's speedy makeover. One of the human-scaled consequences of this macrocosmic makeover is the diminishing significance of the Chinese intelligentsia, a class that includes time-based artists. With this latest makeover of the nation-state, however, they lose out not so much to despotic politics as to faceless capital. 'The urgent task for [the Chinese intellectuals] is their *repositioning*, the remapping of new kinds of spatio-temporal coordinates in the social landscape,' concludes Lu (ibid.: 15). If so, then practising time-based art may be deemed as the choice some Beijing contemporary artists have made in repositioning themselves.

In a large measure, this repositioning of Chinese time-based artists is both a defensive and proactive response to an ongoing globalization, which offers opportunities such as those that allowed He and Ai to realize *A Rock* and *Fairytale* but which also exposes the chronic deficiency of indigenous support for experimental art. As long as most of their audiences—actual and virtual—remain overseas, it behooves the marginalized Chinese experimental artists to assert a regional edge in adopting an already established international ephemeral art medium. What has made the glocalization of time-based art in China urgent is its practitioners' quest for professional distinctions on the international stage—so far the only stage most viable for their professional survival. Whereas time-based art, as a xenogenic art medium, like all other foreign ideas and things, went through the customary process of sinocentric domestication, I believe it is highly probable that the emergent cachet of Brand China has functioned to defamiliarize this routine process, making sinification a prime methodology for glocalizing contemporary Chinese time-based art.

SINIFICATION OF TIME-BASED ART | Sinification, a linguistic variant of 'sinicization', refers in general to the process of 'becoming Chinese' or 'becoming Han'. In the social sciences, sinicization indicates the assimilation of non–Han Chinese people (such as Manchurians) into the Chinese identity.[30] Sinicization is thus a notion related to what I have earlier hypothesized as 'the centrality of being Chinese', a self-identity compulsion instilled into a (normative/ethnic majority) Chinese cultural subject. In the case of an ethnic minority subject (a Tibetan, a Uyghur, etc.), this process of sinocentric acculturation and subliminal identity formation is further laden with the realpolitik of coercion and domination. I prefer to use 'sinification' over 'sinicization' here, however, for its near visual punning on 'signification' as a meaning-making process.

30 See 'Sinicization' at www.absoluteastronomy.com

According to Jing Wang, sinification is a set of strategies that China espouses, by drawing evidence from its splendid premodern history, to self-position as 'the cultural and spiritual centre of the world' (1996: 238). Citing Deng's 1982 policy for 'socialism with Chinese characteristics' as a case in point, Wang shrewdly observes that 'the underlying political agenda of sinification lies not in the allegedly Chinese impulse to harmonize, but in a nationalistic defense mechanism that seeks to neutralize and eventually to dissolve the alien' (ibid.: 239). In Wang's theorization, sinification verges on what Rey Chow calls 'sinochauvinism', which the latter critiques as a 'historically conditioned paranoid reaction to the West' flipped over and turned into 'a narcissistic, megalomaniac affirmation of China', claiming everything Chinese to be 'somehow better—longer in existence, more intelligent, more scientific, more valuable, and ultimately beyond comparison' (1998: 6).

As someone of Taiwanese ancestry and politically marginalized in this context, I certainly agree with Wang's and Chow's scrutiny of China's hegemonic belligerence. Nevertheless, I wonder if sinification, like multicentricity, may also be studied at an individual level as a pedagogical core of Chinese enculturation. Construed as a method of self-cultivation—without denying its potential aggression towards others—sinification may connote an epistemic proclivity towards reconfiguring otherness in a vernacular already inculcated and internalized by the self. In this light, sinification may transform from an ambitious regime's territorial 'strategy' into a minoritarian subject's 'tactic' for reterritorialization—to adopt Michel de Certeau's distinctions of the two practices (1984: xix). Thus I approach 'sinification' as a culturally inherited propensity to turn anything foreign into comparable Chinese idioms, to trace everything innovative to an ancient Chinese origin, to seamlessly integrate newly acquired objects of interest into the expanding Chinese cultural register, and to locate the purpose and relevance of one's work within the ongoing formation of Chinese history. If Chineseness is an array of representational features that a subject-actor may select to mark his/her cultural identity, then sinification is the cognitive procedure through which the subject-actor transforms an extrinsic entity into Chinese.

Consider the following excerpt from an essay about violence in Chinese experimental art by xingwei artist and theorist Yang Zhichao:

> The translation of 'performance art' into Chinese as 'xingwei' [behaviour] rather than
> '*biaoyan*' [performing/showing/acting] more pertinently conveys China's social reality

and existential environment. Theretofore [xingwei yishu] distances itself from what was originally categorized as performance art and broadens its realm of application.

In a different sense, it ends up enriching and extending its 'English' original, even though the term 'performance art' also means more than performing.[31]

31 Yang sent me his theoretical essay on performance art in 2006. The essay was later included in the bilingual exhibition catalogue for his solo show, *Yang Zhichao zuopin 1999–2008 / Yang Zhichao Works* (2008). I translated the citation based on Yang's Chinese version.

I cite Yang's passage not to prove performance art's utter transmutation in China to become xingwei yishu but to illustrate how a xingwei artist considers his chosen medium's divergence from its foreign source. In fact, Yang's viewpoint is typical among most xingwei artists I interviewed in Beijing. Although 'xingwei yishu' is not the only available Chinese translation for performance art, they favour the term for its 'down-to-earth' connection with everyday life and for its difference from the 'showy artifice' of a theatrical performance (*biaoyan*).[32] Most of them also insisted that xingwei yishu cannot be separated from what

32 I cite these two remarks respectively from my interviews with Ai Weiwei, 5 July 2005, Beijing; and Wang Chuyu, 3 July 2005, Tongzhou, Beijing.

Yang phrases here as China's 'social reality and existential environment'. While Yang does admit that the English term, 'performance art', also implies 'more than performing', he is more invested in proclaiming xingwei yishu's contribution to its original Western model than in theorizing about the model itself. Yang's subjective investment in glocalizing xingwei yishu exemplifies my approach to sinification as a Chinese learner's epistemic pattern in domesticating xenogenic phenomena.

By calling attention to Yang's sinification of xingwei yishu, I seek to explicate the glocalization process through which Chinese artists came to absorb performance art, regionalizing this internationally practised time-based art mode, with its historical linkage to the Euro-American avant-garde, into a type of experimental Chinese art. If performance art—and by extension time-based art in general—comes with a pre-existing international live art language, then xingwei yishu is the Chinese dialect collectively invented by its multicentric speakers. We may also understand this glocalization process in the paradigmatic way that Roudemetof suggests regarding the advent of 'modernity' throughout the world:

> In terms of form, modernity is globalized—and this globalization of modernity is evident in the construction of a world culture consisting of formal rules and regulations. In terms of content, however, modernity is localized, thereby producing glocal modernities—each of which is shaped by the particular historical specificity of a cultural context and the ways in which particular regions and civilizations have interacted with each other over the course of the last several centuries (2003: 45).

While a marginal experimental art medium, with its minute scale, cannot compare with a national modernization project, Yang's theorization of his art practice is tantamount to taking performance art's formal traits as a global vessel and filling it with the content of 'China's social reality and existential environment'. Roudemetof's analysis is also noteworthy for its emphasis on the ongoing dialectical interactions among global players which are influenced by their historical relationships as well as their current shifts of power. In the post–Cold War era, glocalization has made transparent the constant flux of international dynamics which have ushered

in Brand China at the onset of our present century. Within the context of contemporary Chinese art, sinification—as glocalization with 'Chinese characteristics'—initiated a spatio-temporal restructuring which has not only translated imported global stimuli into local circumstances and aspirations but also begun mutating that very translation in order to develop an indigenous contemporary art heritage, now ripe for export.

Although glocalization is a legitimate impetus through which an indigenous subject maintains a degree of intellectual independence while integrating a foreign/global cultural asset, this process is by no means natural, disinterested or free of competitive political and economic calculations. Given its long history in homogenizing or dismissing alien cultures, sinification is largely motivated by a self-centring politics whereby one identifies what one does as autonomous, self-referential and introspectively selected rather than always-already second-hand. Thus, despite my sympathy towards glocalization, I am wary of any xingwei artist's declaration about the radical difference between xingwei yishu and performance art, bearing in mind sinification's inherent mandate to construct a self-fulfilling prophecy.

A similar sense of ambivalence colours my nomination of xingwei yishu and xingwei-zhuangzhi as time-based art. However appropriately they fit into my summative term, I cannot help but catch a whiff of dramatic irony in subsuming these two sinified time-based art variations under what I initially recognized from the PICA brochure as a goodwill label, designed to evade any presumed hierarchy among various ephemeral art media. Indeed, except for Qiu Zhijie, whose practice of 'total art' includes theatre arts, all the other xingwei artists I met in Beijing disclosed their distaste for *biaoyan* (acting/performing/showing), betraying—without any self-consciousness—their antitheatrical bias. They preferred to align their corporeal artworks with visual rather than theatre arts. As for those who practice xingwei-zhuangzhi—most affiliated their works with installation rather than with performance.

Such a resistance to the 'theatrical'—narrowly interpreted as pretence, ostentation and pointless entertainment—reminded me of the suspicions expressed by many Western performance artists in the 1970s (see Meiling Cheng 2002: 1–65). In the ensuing decades, however, numerous 'antitheatrical' performance artists dropped out altogether from live art; others recanted their previous rejection of theatricality; yet others came to embrace multimedia performance to the histrionic extreme so as to tackle the emergent concepts of performativity, mediation and simulation. A renowned performance artist like Marina Abramovic, for example, even adopted the theatre as a therapeutic vehicle to help her revitalize her performance art career when it was stalled by her split from her long-term partner Ulay (see Kaplan 1999; Abramovich 2004). This Western trajectory of performance art's evolving entanglement with theatricality suggests that what Jonas Barish terms 'the antitheatrical prejudice' is not unique to the Chinese time-based artists (1981). Although part of the Chinese artists' antitheatrical prejudice may be attributed to their social status as *shi* (gentlemen/scholars, or intellectuals), who traditionally harbour disdain towards *xizi* (actors, or children of theatre), I hesitate to imply that they sought to make the antitheatrical a sinified phenomenon in xingwei yishu and xingwei-zhuangzhi. What's unusual in my discovery is the fact that this prevalent bias against the theatrical remains unquestioned by a group of people who are otherwise highly in tune with other Western art trends. To them, the antitheatrical is not specifically Chinese—it's simply

assumed without contest. Are these artists, especially xingwei artists, justified in so vehemently distinguishing their work from theatrical performance?

In an attempt to confront the ideological denunciation of the theatrical, I've previously maintained that performance art actually relies on theatrical elements—structurally construed as the time-space-action-performer-audience matrix of theatricality—for its presentation (see Meiling Cheng 2002: 273–349). The major distinction between theatre and performance art therefore derives not from their opposing claims to 'the real' but from their divergent genealogical assumptions—the former is a communal art medium which depends on a live audience to fulfil its ritualistic and civic functions; the latter is a conceptual art medium which may retain its imaginary viability through an other's interest. Whereas most performance artists in Euro-American countries have now recognized the possibility of a fruitful confluence between the communal (publicly realized for a live audience) and the conceptual (studiously documented for subsequent cultural dissemination), the majority of Chinese xingwei artists have continued to prioritize the conceptual. In the following chapters, I speculate on some of their reasons, including the political precariousness regarding public exposure of controversial acts (nudity, sexuality, cannibalism, etc.) and the relative lack of infrastructural support and interdisciplinary fertilization, thereby preventing the mounting of technology-oriented multimedia productions. Consequently, even with my complaint about xingwei artists' knee-jerk antitheatrical prejudice, I must admit that several ubiquitous features in xingwei yishu undercut its 'theatricality'— which I interpret functionally as a conglomerate of interactive affects emanating from the immediate encounter between the actors and their audience, congregating for a shared event.

First, xingwei artists tend to minimize their direct interaction with a live audience but sustain their actions' conceptual valence by keeping sufficient documentation to allow access to/for future viewers. Second, it's often impossible for a live audience to witness certain xingwei artworks in their entirety, variously because of their extended duration, multitrack processes, large-scale involvement or obscure location. Third, when some pieces do happen before a crowd, the artists typically maintain an internal focus, interacting only with their pre-scored tasks rather than with spectators. Further, the majority of xingwei actions take place without a verbal text or any significant sonic element. Whereas theatre thrives on the collaborative synergy of dramatic, scenic, sartorial, choreographic, performative and communal components, xingwei yishu often pares sensorial appeal down to the bare bones of visuality.

Xingwei-zhuangzhi follows, conversely, a mixture of conceptual and architectural considerations. As a time-based art mode involving a three-dimensional spatial environment, xingwei-zhuangzhi frequently activates rather than sedates the full palette of a viewer's bodily senses. A xingwei-zhuangzhi artwork resembles to a certain extent a theatrical set; but while the latter is made to serve other collaborating artists-performers, the former turns its viewers into inadvertent performers. Although site-specificity and interactivity are built-in criteria for xingwei-zhuangzhi, the artists, like architects, often exit from the scene once their artworks are on public display.

Therefore, most xingwei and xingwei-zhuangzhi artists prefer not to act as intermediaries between their artworks and viewers—even when the artist doubles as the artwork in the case

of xingwei. These two time-based art modes encourage their viewers to interact directly with the pieces rather than with their creators, letting their receivers savour a relationship with the artworks in the same way that artists themselves relate to their art-making processes.

In theatre, there is a primal scene, a collective ceremony that takes place between performers and spectators occupying the same site. In xingwei yishu, this primal scene may be the artist's original process-product, which is more often than not beyond the physical reach of its viewers/receivers. Having lost their privilege to be there when 'magic' first happened, future viewers of xingwei yishu may compensate for their losses by recreating another primal scene— a substitute, prosthetic origin—based on documentary remnants that are first-hand, second-hand, third-hand . . . ad infinitum. Drawing from an isolated strip of an artist's existence as an individual human subject, xingwei yishu empowers its receivers to tap into their 'human resources' and to break through the fabled theatrical fourth wall by becoming split personas, as viewers-cum-performers who witness the imaginary primal scene through self-enactment. The temporal imagination of xingwei yishu is, in this sense, recyclable, if subject to adaptation by its conceptual adopters.

Arguably, xingwei-zhuangzhi, as a spatial expansion of xingwei into a larger-than-human-scale structure, resists such temporal recyclability because it is much harder for a viewer to appreciate a site-specific installation off-site, through documentation. Therefore, in contrast to xingwei, xingwei-zhuangzhi is a time-based art that spells out the absolute finitude, the utter expenditure, of *onceness*.

Sinified with specific local content, xingwei yishu and xingwei-zhuangzhi in Beijing open creative windows into the surrounding sociocultural environment, providing durational and vigorous snapshots about a metropolis undergoing breathtaking changes. Unlike sinification, which is driven by an artist's intention, glocalization may at times produce results beyond individual design or expectation. What I noted as the habitual antitheatrical bias among Chinese time-based artists offers precisely such a case when glocal forces more complex than individual volitions bring about a regional specialization, which, ironically, may end up distinguishing Beijing's xingwei yishu and xingwei-zhuangzhi from time-based artworks produced in other regions.

THE GLOBAL DISPERSAL OR EXTERNAL GLOCALIZATION OF CHINESE TIME-BASED ART

As a concept, glocalization illuminates the intertwining of trends towards homogeneity and heterogeneity but it does not replace the transnational motion of globalization. Glossing on their distinction, Roudometof describes glocalization as 'internal globalization'—large numbers of people round the globe are exposed to other cultures on a daily basis without crossing borders on a regular basis, simply through the variety of communication media' or through physical encounters with 'immigrants, refugees, or tourists in their own locality' (2005: 121). Transnational trading, which makes available merchandise fabricated in far-off lands ready for purchase in our neighbourhood stores, is another effect of internal globalization.

To extend Roudometof's reasoning, we may understand globalization as the presence of cross-terrain, intercultural and transnational activities meant to facilitate interpersonal exchanges at divergent levels (political, economic, cultural, etc.). To reverse Roudometof's phraseology, we may also regard globalization as 'external glocalization', when a glocalized product—such as a sinified time-based artwork—is made available to international consumers/viewers domestically, or is transported to a foreign environment for overseas consumption. *A Rock* and *Fairytale* both belong to this category of high-prestige Chinese time-based artworks funded by transnational money and exported from Beijing to the UK and to Germany respectively. In this scenario of *external glocalization*, which is, moreover, mobilized by the transnational joint venture of monetary and creative capital, sinification becomes a visual and discursive system detachable from the Chinese artists themselves. In short, sinification is a procedure through which Chineseness as an array of representational effects is achieved. Any subject-actor who has a stake in sinifying a product to raise its value as a cultural commodity can exploit the procedure, which, like advertising, needs in turn to be *internally globalized*—this time, to adapt to the host locale. The producers of amino, for example, were subject-actors who were more invested than the artist himself in sinifying *A Rock* by drawing on Brand China, which in turn raised the artwork's perceived commodity value as an imported product. The amino team then promoted the Chinese artist's piece to the British audience as a live artwork in order to address the local interest in interactive public performances.

A typical (solo) xingwei artwork like *A Rock* and a collective xingwei piece with a strong xingwei-zhuangzhi component like *Fairytale* exemplify the necessity to consider sinification as a representational procedure when internally globalized (or glocalized) Chinese cultural products are placed in externally glocalized (or globalized) situations. The production processes I analyse with both cases demonstrate the general methods in sinifying time-based artworks in order to accentuate their Chineseness. The case studies also hint at how sinification as a representational procedure may be flexibly used to highlight, reinforce, hybridize or downplay an artwork's Chineseness. Moreover, as a visual and discursive schema, sinification may have different implications for xingwei yishu and xingwei-zhuangzhi as two distinct time-based art modes.

What is the most solid evidence for verifying an artwork's sinified status? Perhaps the most straightforward answer to this question would be the use of the Chinese language, with its identifiable linguistic codes. As an authentication procedure, this linguistic use is not readily available to xingwei yishu which typically features a single artist's often-naked body as its non-text-based language of embodiment. That xingwei artworks also depend much upon photographic documentation to reach a wider off-site audience further complicates this dilemma. How does a xingwei artist sinify an image of a human behaviour set in a typically glocalized cosmopolitan city? Or, inversely, how does a xingwei artist jettison sinification and pursue region-less universality in order to claim global relevance? Neither question has a sure-fire answer. The first is troubled by the homogeneity of globalized modern life and the migration of international populations—one sees Asian faces everywhere. The second confronts an opposite problem—without sinification, the enacted behaviour might look merely facile, mediocre or gratuitous, universally bland.

IMAGES **1.10.1–2** *Template* (2007) by Ai Weiwei, in Documenta 12 in Kassel, Germany. The installation collapsed after a storm. Image courtesy of the artist.

The photographic documents of xingwei yishu, similar to those of performance art, provide what I call 'enriched images', those images simultaneously enhanced and made opaque by embedded information. Enriched images are tightly bundled visual signifiers whose significance cannot be fully assessed without the viewer's proactive investment in deciphering their hidden content. As visual documents, the images, at face value, are inadequate records of certain art-making processes doubled as ephemeral artworks. Enriched images, however, may function as perceptual gateways, leading an invested viewer to cultural sites filled with the image-maker's concepts, experiences, memories, performance scores, contextual stimuli and sociocultural agenda. It is through this cross-referential network of supplementary and mutually inflected photographic, discursive and other documents that an enriched image may become a legible narrative. Consequently, a useful way for a xingwei artist to externally glocalize his/her artwork is to anticipate a viewer's interpretive response by sinifying auxiliary references accompanying a given piece. Ai's interviews in which he emphasized the value of individual Chinese subjects in *Fairytale* and Yang Zhichao's theorization of the proximity between xingwei yishu and contemporary Chinese society, published alongside photographic documents of his xingwei pieces, are both telling examples of this tactic.

By virtue of its grander scale and multifaceted materiality, xingwei-zhuangzhi enjoys more options for self-representation, sinification being one possibility among many. Since a xingwei-zhuangzhi artwork occupies a physical space, its artist literally has more room to manoeuvre, including constructing an authorial interpretive frame. Aspiring to sinify their projects, xingwei-zhuangzhi artists may draw from their inherited cultural repertoires of sino-specific visual codes. Beijing artists Qiu Zhijie and Song Dong often incorporate calligraphy in their xingwei-zhuangzhi artworks; similar tactics are evident in the *oeuvres* of once New York–based expatriate artists like Xu Bing and Wenda Gu, with their by-now-renowned, self-invented fake Chinese ideograms. The primary colour red—associated with both traditional and revolutionary China—is a recognizable cultural symbol favoured by Gu Dexin. Another unmistakable element of sinocentric visual culture originates from traditional Chinese carpentry and architecture. In Documenta 12, for example, Ai presented, alongside *Fairytale*, a zhuangzhi piece entitled *Template* (known in China as *Tingzi* [Pavilion] or *Mokuai* [Template], 2007), which was an odd-shaped, pagoda-like pavilion composed of 1,001 wooden doors and windows reclaimed from destroyed Ming- and Qing-dynasty houses. This monument built by Chinese fine craftsmen—who insisted on matching the number of wooden components with that of Ai's *Fairytale* participants—collapsed under an abrupt storm in Kassel and became, by pure chance, a xingwei-zhuangzhi on the spot.[33]

Just as xingwei-zhuangzhi artists have more opportunities for sinification, so they may more easily do the opposite. An expedient way is to distance themselves from sino-specific visual codes by using globally accessible material, such as water in its various states, preferred by many Beijing artists, or fruits and animal flesh, which Gu Dexin also favours. For the latter, these common consumable items serve to neutralize the regionalism of his colour choice, revealing the artist's ambivalence towards sinification. Yet another option is to contaminate sinification by employing jumbled

33 For the story of Ai's collapsed installation, see Coggins (2007). According to Ai in our interview on 23 March 2009, the craftsmen he hired to build the pavilion thought it auspicious to match the two numbers—one for the Chinese visitors and the other for the Chinese sculpture. The craftsmen decided to do so without Ai's request.

visual codes, turning the procedure itself into merely an attempt at globalized cosmopolitanism. I find a provocative example of this hybridized sinification in a xingwei-zhuangzhi artwork entitled *UFO* (known in China as *Nongmin Du Wenda de feidie* [Peasant Du Wenda's Flying Saucer]; 2005), which the Beijing artist duo Sun Yuan and Peng Yu presented in the inaugural China Pavilion in the 2005 Venice Biennale. To a degree, Sun and Peng's project anticipated Ai's *Fairytale* by bringing a sliver of living China to a prestigious European exhibition of international contemporary art.

Long before they were invited to represent China at the Venice Biennale, Sun and Peng heard about a group of Chinese peasants, led by a farmer named Du Wenda, who had been experimenting for years on constructing functional flying saucers designed by Du in their Anhui province hometown. Rumours had it that one generation of saucers did fly a few inches off the ground.[34] For their first Venice Biennale project, Sun and Peng decided to bring Du's team of peasant-engineers to Italy to instal and test-fly their DIY space shuttles on an international site. While the 3 ft high, 6 ft wide saucers look 'global' in their cosmopolitan

34 My interview with Peng Yu, 6 July 2006, Beijing.

IMAGE **1.11** *UFO (Nongmin Du Wenda de feidie [Peasant Du Wenda's Flying Saucer]*; 2005) by Sun Yuan and Peng Yu. The image is a rendering by the artists, showing the UFO taking off from the ground. Image courtesy of the artists.

anonymity, their flashy presence inside the China Pavilion, joined by their diligent Chinese-identified peasant-engineers and cheered on by their Beijing artists-sponsors, jointly create a rendition of the wild imagination behind Brand China.

The test flight failed, as the artists had half anticipated: 'We knew it probably wouldn't fly,' but then again, 'For all of us, it's a first. For the first time, the Venice Biennale had a China Pavilion. For the first time, Sun Yuan and I represented China in the Venice Biennale. For the first time, Du and his team went abroad and tried testing their flying saucer in public,' said Peng. 'It did fly up in our mind!'[35] No matter the result, the project succeeded in garnering much international attention. Considering Chairman Mao's revolutionary dictate for intellectuals to learn from the peasants, sinification in *UFO* is turned inside out into a self-reflexive aspiration towards Chineseness, twenty-first-century style.

35 My interview with Peng Yu, 6 July 2006, Beijing.

As Appadurai puts it so well, one of the most worthwhile byproducts of globalization is the enriched imagination of ordinary people (1996: 1–23).

IMAGE **1.12** *UFO* (2005) by Sun Yuan and Peng Yu. The image shows Sun, Peng and Du Wenda, standing next to *UFO*, still under construction. Image courtesy of the artists.

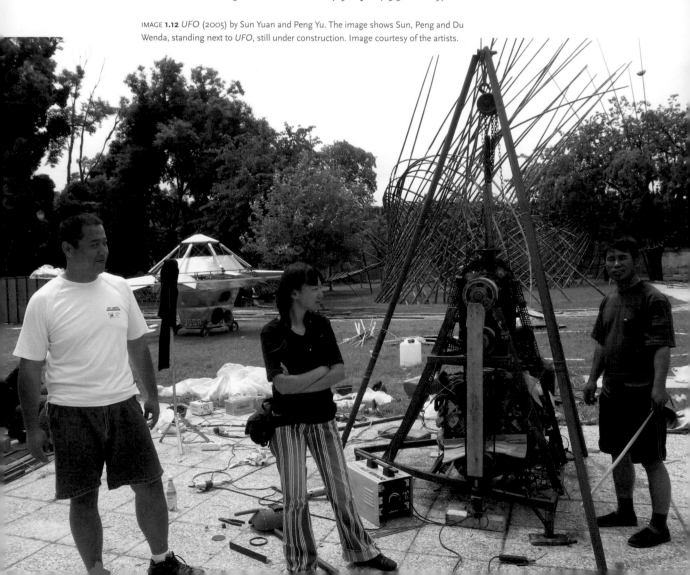

'Glocalization is first and foremost a redistribution of privileges and deprivations, of wealth and poverty, of resources and impotence, of power and powerlessness, of freedom and constraint,' writes Bauman, who moves on to critique the 'world-wide *restratification*' set in motion by glocalization (1998: 43). One of the most remarkable stories of this worldwide redistribution of power is the transformation of China from a nation-state that had endured in the twentieth century a succession of hardships (international humiliation, civil wars, cultural warfare, mismanaged isolationism) into 'the world's second-biggest economy after the United States' in 2010 (see Kollewe 2010). The recent ascendance of Brand China is a plot within this story, and the country's time-based artists attaining the opportunity to produce high-end intellectual properties for international consumption a subplot. Bauman has identified a dilemma that might emerge to thicken this plot and subplot—restratification. In the case of China, as the world's most populous nation in 2010, the restratification also lies within.

As a vivid illustration of such restratification, Bauman applies the new sociological paradigm to divide the world into two classes—those who 'live in *time*' and those 'who live in *space*'.

> If for the first world, the world of the rich and the affluent, the space has lost its constraining quality and is easily traversed in both its 'real' and 'virtual' renditions, for the second world, the world of the poor, the 'structurally redundant', real space is fast closing up—the deprivation made yet more painful by the obtrusive media display of space conquest and the '*virtual* accessibility' of distances unreachable in the non-virtual reality. Shrinking of space abolishes the flow of time; the inhabitants of the first world live in a perpetual present, going through a succession of episodes hygienically insulated from both their past and their future; those people are constantly busy and perpetually 'short of time', since each moment of time is non-extensive— an experience identical to that of the time 'full to the brim'. People marooned in the opposite world are crashed and crushed under the burden of abundant, redundant and useless time they have nothing to fill with. In their time, 'nothing ever happens'. They do not 'control' time, but neither are they controlled by it, unlike their clocking-in, clocking-out ancestors, subject to the faceless rhythm of factory time. They can only kill time, as they are slowly killed by it (1998: 45).

Bauman's dazzling narrative polarizes our experiences with time and space according to our abilities to profit from them or to evade their bondage. The former entails making time and space serve our purposes while the latter involves having the wherewithal to assert our freedom over their annihilating threats. If Bauman's analysis regarding the experiential braid of time and space and the techno-material restratification of global residents has indeed captured the pervasive phenomena within glocalization, then both *A Rock* and *Fairytale* present exemplary parables about our historical moment in the globalized twenty-first century.

As a xingwei piece luxurious in its budget, human labour and geographical scale, *A Rock* dramatizes the 'conquering' of *space* by an artist who had the will and resources to spend *time* on realizing a poetic gesture—to transport an otherwise immobile object (a rock, or by a metonymic leap, any *space*-bound being) for three months, sharing with it the shifting landscape made by *time* and then to return it safely home. In this epic of foreign exploration—a tale of

wandering in a relaxed pursuit of whatever wonders might show up on the hero's way—the man and the rock formed a tight pact, they were two in one. The reality of restratification is hidden in what's not shown on the project's enriched images—the photographic documents that place those 'structurally redundant' guides and helpers outside their frames.

Fairytale specifically annotates its fable of the temporal conquest of space with a Chinese footnote, as miraculous as its country's recent claim to fame in the global media. Confronting the restratification as a fact of Chinese reality, Ai extended his privilege of handsomely funded mobility towards his compatriots, many, if not all, of whom would have otherwise been 'marooned' in their ancestry-determined *space*, unable to trade their *time* for the leisure of wandering in a fancy foreign town. As living artworks, automatic art-makers and choosy tourists rolled into one, these 'second-world' participants in *Fairytale* were able to temporarily transcend their involuntary daily emplacement in the untimely-space of small Chinese towns. Although their transcendence remained transient, as brief as the duration of their roles in a time-based artwork, these individuals did indeed taste the flavour of time bubbling 'full to the brim', like German beers served in small pubs round Kassel, this *once* in their lifetimes.

From a split second to an eternity, with innumerable temporal ranges in between, time-based art has the versatility and flexibility to address diverse issues, ranging from the long-lasting and ever-present (space, time, speed, air, love, strife, fertility, mortality) to the topical and ephemeral (water pollution, population control, nuclear disarmament, trends in tourism, shifting diet fads, glocalization). Yet, to create time-based art is never to exert control over time, nor to extol its preciousness, but to become keenly aware of its fluid presence, its simultaneous enfolding of and interpenetration with my being. Paradoxically, time resembles at once a transparent envelope and an invisible pen. It surrounds me like a cherished but inevitably decaying letter; it dips in my blood for me to write on that letter while I can still inhale, exhale, stare into the air and sing.

On the morning of 12 August 2009, dozens of police officers broke into the Chengdu hotel room where Ai stayed, physically attacked Ai and his volunteers and prevented them from attending a trial to testify on behalf of Tan Zuoren, a civil rights advocate who pushed for the government investigation of the widespread school-building collapses during the 2008 Sichuan earthquake.[36] Beginning in the spring of 2009, Ai had been posting on his blog the names of students killed on campuses during the earthquake. When I visited him for an interview about *Fairytale* on 23 March in Beijing, he showed me how his blog entries were erased as soon as the names were posted. He said that he would keep posting the names, even though what his readers could see would only be his repeated notes: 'This blog entry is blocked.' I came back to Los Angeles and began working on *Fairytale*. At the time (March to June 2009), I was still able to access much of the online archive for *Fairytale* via Ai's blog; hence, my theory that the Internet and its virtual connectivity had kept *Fairytale* alive. As of now, Ai's entire sina.com blog is shut down, although information about his work is still accessible in a more diffused, decentralized way, via a variety of electronic communications media, such as 'Twitter and Fandou (a Chinese-market Twitter clone)' and selected blog entries excerpted in other overseas blogs (see Leung 2009). In 2011,

36 On the arrest of Ai Weiwei, see Jörg Heiser (2011).

Ai's blog entries (2006–09) also became available to an international readership through a volume published by the MIT Press in the US (see Ai Weiwei 2011).

On the evening of 2 December 2010, Ai was about to board a flight from Beijing to Seoul, South Korea, when a group of policemen politely handed him a piece of paper, stating that his departure from China 'would threaten national security' (Blanchard 2010). Ai's detainment was part of China's concerted effort to prevent anyone with the slightest connection to human rights advocacy or political dissent from attending the Nobel Peace Prize award ceremony in Oslo on behalf of its 2010 recipient, Liu Xiaobo, a leading Chinese literary critic, writer, professor and human rights activist currently serving an 11-year prison term. On the morning of 3 April 2011, Ai was about to board a flight to Hong Kong; he was detained again, this time walking away with three airport security guards to what would become internationally protested as Ai's controversial arrest, joining Liu and many others as another probable victim of political persecution in China.

Time in flight. It takes me soaring before dawn today; it leaves me grounded around sunset.

CHAPTER **2**

VIOLenT CapITAL

DOMAINS OF CONTROVERSY | A disturbing story began circulating via the Internet in early 2001.[1] Incredulous and indignant readers continued to pass it round until it reached the status of urban legend, attracting numerous myth-debunking websites to comment on the story's veracity. 'Do they eat babies in Asia?' was the main question the story raised. One spin on the story claimed that cannibalism had emerged as a perverse practice in Japan. Another condemned the horror of the latest fad dish in Taiwan—grilled human foetuses. The latter version became news when Qin Huizhu, a People First Party legislator, held a press conference on 21 March 2001 to call for an investigation into an alleged baby-eating phenomenon in Taiwanese restaurants that she read about in *Warta Perdana*, a weekly news magazine published in Malaysia (see Liao 2001; Rojas 2001 and 2002). *Warta Perdana* showed a photo culled from the same Internet image of an Asian male biting into what appeared to be a dissected human foetus. Taiwan's Government Information Office (GIO) responded to Qing's inquisition and obtained an official apology from *Warta Perdana*, which admitted that its news article entitled 'Taiwan's Hottest Food' was 'based on an anonymous, unverifiable e-mail message' (GIO 2001).

1 I draw parts of this chapter from my previous article, 'Violent Capital: Zhu Yu on File' (2005). I presented a draft of the article on 30 July 2004 at the Association of Theatre in Higher Education conference in Toronto, Canada. I thank especially Elin Diamond, Leon Katz and Richard Schechner for their invaluable comments in the discussions following the panel. I also thank Peggy Davis for her guidance with my legal research.

The controversial photo itself was not a hoax but, in most cases, it was circulated without a caption, hence inviting endless speculation. The image originally came from a set of photographic documents of a xingwei action entitled *Shi ren* (*Eating People*), carried out by Beijing artist Zhu Yu in his apartment on 17 October 2000. *Eating People* first became known through an exhibition identified with bilingual titles, *Bu hezuo fangshi/Fuck Off* (November 2000), hosted by Shanghai's Eastlink Gallery. Though extreme, *Eating People* did not seem out of line in a show that acquired notoreity for including many artworks that used bodies—the artist's or those of others, human or animal, complete or fragmented, dead or alive—as art material and medium. Although violence was not necessarily the exhibition's main theme, it certainly affected my body when I flipped through the catalogue for *Fuck Off* (Ai Weiwei et al. 2000). My visceral response as one approaching *Fuck Off* through its printed documents matches David Barrett's eyewitness account: 'Recombined horses, diseased and wounded humans, tests of physical endurance, raw flesh [. . .] the relentless quest for nausea' (2000).

MeiLING
CheNG

106

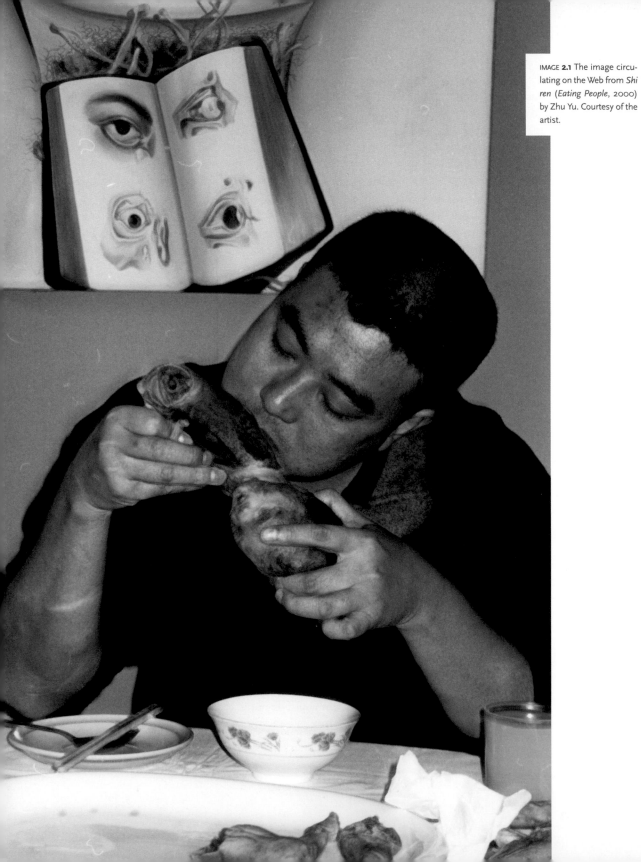

IMAGE **2.1** The image circulating on the Web from *Shi ren* (*Eating People*, 2000) by Zhu Yu. Courtesy of the artist.

I open this chapter with *Eating People* for several reasons.

First, the fear factor. The disgust and fear that motivated me to research Zhu's performance, I suspect, resemble the reactions that prompted countless Internet users to engage with this story and circulate rumours about cannibalism in Asia. Perhaps our curiosity, despite any accompanying repulsion, hints at why violence is a perennial subject in art. When I first studied Zhu's xingwei piece in 2004, I had to overcome intense loathing before I could look at the picture a second time. Now, my analytical familiarity with the piece does not lessen the neurosis it provokes in my eyes. This is a word I know—call it 'cannibalism' for short—but I still have difficulty tracing it.

Second, the photograph. Zhu's action, completed in the privacy of his home studio and witnessed by a few fellow artists, reached the majority of viewers through photographs. The artist's reclusive xingwei yishu effectively became public via documentation. While the photo may not prove that the artist did eat the foetus, it does provide a conceptual point of engagement between the artwork and its receivers.

Third, the photograph plus the Internet. For many reasons—including xingwei yishu's history of semi-clandestine actions and photography's relative cost-effectiveness—photographs have been the primary means of display and transmission for this time-based art mode, especially in its extreme vein.[2] These photographic documents—along with their often sketchy, even cryptic, captions—then become a catalyst, if not the sole basis, for further popular reactions and critical discourse. Since the mid-1990s, the Internet has emerged as the latest technological prosthesis to disseminate these documentary images. Thanks to its transregional connectivity and its capacity to integrate 'both different modalities of communication (reciprocal interaction, broadcasting, individual reference-searching, group discussion, person/machine interaction) and different kinds of content (text, video, visual images, audio) in a single medium' (DiMaggio et al. 2001), the Internet surpasses other communication mechanisms by extending a virtual public sphere—or, as Wu Hung calls it, borrowing from Song Dong, a 'public nonexhibition space' (see Wu Hung 2008: 22, 146)—for presenting photographic and textual documents for time-based art. With the availability of websites such as YouTube (since 2005), for example, the Internet has provided convenient and popular portals for artists to share videotaped performance documents and for galleries, museums and other news agencies to show interviews with artists. Thus far, however, photographs remain the dominant source of electronic dissemination for Chinese time-based art.

2 Numerous Chinese critics point out the importance of photography as a means of dissemination for xingwei yishu. I cite two examples here: Li Xianting (2003) and Daozi (2001).

Fourth, the Internet in a globalized world. For artists, critics and scholars alike, the accessibility of personal computers with modems or wireless Web connections refashions the Internet as our private links to international contemporary art worlds, permitting us to 'touch' and experience globalization's multifarious faces through our fingertips. Access and experience, however, do not our judgement make—the Internet-enabled heterogeneous information flows across the world may encourage our technologically enhanced cognitive mobility but it does not render obsolete our task to verify, discriminate and rank the information. The proliferation of Internet speculations about *Eating People* demonstrates the ease with which one can misread, fabricate and pass on narratives regarding a free-floating electronic image. This phenomenon

cautions me to heed the old-fashioned communication ethic of fact-checking, cross-examining and prioritizing editorial sophistication. Yet, even fact-finding can be a value-laden project, as revealed by the official GIO website, built specifically to refute 'e-mail allegations that human foetuses are eaten in Taiwan' (2001).

GIO classifies the baby-eating rumour as 'propaganda'—a code word for China's ideological warfare against Taiwan—and emphatically identifies the photographed cannibal as a 'Mainland Chinese artist'. Posting yet another unspecified image of Zhu's xingwei artwork, GIO cites as evidence some 'Simplified Chinese Characters, used in China' found in the picture to prove that no cannibalism had happened in Taiwan which uses 'the Traditional Chinese Characters'. The five unnamed images displayed on GIO's website actually came from two distinct pieces by Zhu, *Eating People* and *Quanbu zhishi de jichu* (*The Foundation of All Epistemology*, 1999). Unfortunately, GIO presents these images without differentiation, as if they formed a continuous anthropophagic sequence. This oversight suggests that GIO is more invested in political power struggles than in knowledge acquisition. Behind truth stands politics; globalization heightens the stakes and diversifies the viewership for such ideological contests.

IMAGE **2.2** An image from Zhu Yu's xingwei-zhuangzhi artwork *Quanbu zhishi de jichu* (*The Foundation of All Epistemology*, 1999), which is posted on Taiwan's GIO website without an identifying caption. Image courtesy of the artist.

Fifth, extremity and ephemerality. Seen from a distance, xingwei yishu seems immured in an aesthetic of the extreme. Zhu's *oeuvre*, with *Eating People* set at the midpoint of his decade-plus career, exemplifies a systematic plunge into perceptual extremity. Distinctive as they are in marking the internal progression of Zhu's career, his xingwei *oeuvre* typifies a brutal strain of Chinese time-based artworks produced within a five-year span (roughly from 1998 to 2002), when Beijing's experimental art scene appeared driven by a libidinal race—especially among younger artists—for audience outrage. Many Chinese critics condemned this development as a 'violent trend' and singled out xingwei yishu as the worst culprit (Lu Hong and Sun Zhenhua 2006: 80). That extreme phase has passed, like a completed triathlon, and the adrenaline rush and exhaustion of its instigators have paled in their memories. 'It was *then*,' they say, 'we have survived. Have you?' Yet, extremity, mediated by time, gives a somatic shape to ephemerality, which triggers my compulsion for historicization.

For all these reasons, *Eating People*, a xingwei piece created as the twenty-first century began, remains an exemplary case study of Chinese time-based art, if only of its sharpest edge. Unmatched in its infamy, Zhu's piece nevertheless reveals how a certain type of xingwei yishu is produced, received, accessed and assessed by its audiences, nationally and internationally. The paratheatrical intricacy of the piece's viral electronic circulation and feedback loops indicates the provocation of Zhu's behaviour art. That Zhu chose to enact such a defiant artwork at a particular glocal moment in Beijing invites us to ponder how individual creative expressions bear the strain of larger sociocultural tempers.

CONTENTIOUS ACTS OF YOUTH | Unlike other enterprising netvigators (that is, the ever-navigating netizens), I didn't see *Eating People*'s electronic image first. I read a brief report about the piece in an art magazine in 2003 but dismissed it outright as a prank.[3] A year later, during a guest lecture on controversial performance art, a college student brought Zhu's 'cannibalism piece' to my attention when I mentioned John Duncan's *Blind Date* (1980).

To a small audience of mostly his peers, the then Los Angeles–based artist Duncan began his performance of *Blind Date* by playing an audiotape of some unintelligible grunting sounds. Duncan then recounted his experience of purchasing a Mexican female corpse in Tijuana, engaging in sexual intercourse with the corpse and having a vasectomy afterwards back in the US.[4] To my academic audience, I admitted a personal distaste for Duncan's abusive act but I also disclosed my uncertainty regarding a particular response to his performance. Duncan's audience for *Blind Date* included Suzanne Lacy, Barbara T. Smith and Linda Frye Burnham. Deeply offended by the piece's degradation of 'the dead woman and her extended social circles',[5] these feminist artists and writers decided not to discuss Duncan's performance, nor, in Lacy's words, 'to call attention to it by protesting it'.[6] As Smith put it, Duncan was 'so desperate for attention' that

3 The article I read was by Didi Kirsten Tatlow (2001). I thank Robert Scales for bringing this journal to my attention.

4 I base my description of Duncan's live performance primarily on Barbara T. Smith's recollection through our phone interview on 16 December 2008, Los Angeles. I also consulted Kristine Stiles (1998).

5 I cite the remark by Barbara T. Smith from our phone interview on 16 December 2008. My following citations from Smith come from the same telephone interview. Smith also sent me an email dated 21 December 2008 to help clarify my description.

6 I cite the remark by Suzanne Lacy from our phone interview on 5 December 2008, Los Angeles. Following up on our phone interview, Lacy sent me several emails dated 18 December 2008 to explain the historical context.

their best response was 'to act as if it never happened', subjecting the artist to 'the ancient tribal law of ostracism' by silence. The 'ostracism' probably worked, for Duncan soon left Los Angeles for good. Decades later, however, Los Angeles curator Paul Shimmer selected *Blind Date* for the Museum of Contemporary Art's influential retrospective exhibition *Out of Actions: Between Performance and the Object, 1949–1979* (1998), offering Duncan's piece a prominent vehicle for historicization. In a catalogue essay, Kristine Stiles cites the refusal of Burnham, founding editor of the pioneering performance art quarterly *High Performance* (1978–97), to publish a record of *Blind Date*. Burnham found Duncan's piece 'highly morally objectionable', so she, as an editor, chose to be 'guilty of censorship' rather than to be held 'responsible for putting that material in front of any one, especially my kids'.[7] Though sympathetic with Burnham's position, I reasoned with my undergraduate listeners that 'since Duncan's piece has now become widely known, we need to subject *Blind Date* to a vigorous critique' (Meiling Cheng 2004b).

7 Stiles' citation of Burnham is based on Louis MacAdams (1981). I confirmed with Linda Frye Burnham regarding her statements in our email communications dated 18 December 2008. Burnham said that she doesn't remember the particular quotation but she might have said something to that effect at the time.

Perhaps my account of *Blind Date* reminded my student-informer of the analogous controversy surrounding *Eating People*. In retrospect, I can imagine how the undergraduate might have discerned certain parallels. Though two decades and continents apart, both *Blind Date* and *Eating People* involved a male artist exerting his living will on a dead other (one female, another foetal) who had no power to resist his invasion. Most people, including my students and myself, would consider these performance art pieces repulsive and unacceptable; we would rush to judgement, if only to dissociate ourselves from these horrific actions. Both artworks subsist on the tenuous membrane between aggressive art and legally liable criminal act. Both projects remind me of the Chinese ideogram for 'crime', *zui* (罪), with its upper semantic component meaning 'four' and the lower signifying 'violation, negativity, opposition, annihilation'. A crime, in my decoding of this ideogram, suggests an act that blatantly goes against the four basic units of (ancient Chinese) humanity: person; family; society; and country. The 'law' that forbids such an act is intuitive and enculturated, even if it's not legislative. Our task as students of contemporary experimental art, I believe, is to differentiate the kinds of agency and licence that an individual may claim in justifying a given behaviour within an artistic context.

Newer New Humanity

It is telling that I would have learnt of an Internet-generated scandal from a young American of Generation Y, the same generation for which an equivalent Chinese term *xin xin renlei* (newer new humanity, also translated as the '"new" new generation' [Annie Wang 2006: 9] or 'neo-neo-tribe' [Jing Wang 2005: 2]) was coined. Although my US students and their Chinese coevals might not share similar social values, cultural practices and political views, what's common to them is a level of proficiency with the Internet and other instant communication gadgets. They are the techno-savvy generations who have grown up forming virtual communities in online chat rooms and consuming a comparable popular 'C-culture— cartoons, computers, comic books, and nintendo games' (ibid.: 24); given certain glocal divergences in their ideological enculturations, they are spectators to a constant flow of transnational, and overwhelmingly commercial, audiovisual information.

Tracing the identity moniker's transfer from Hong Kong and Taiwan to the Mainland and its swift popularity among Chinese youths, Liu Kang quotes from an online author's 'self-styled manifesto' to define *xin xin renlei*: 'The Newer New Humanity is born at the age of globalization and technological innovation; [its members] consist of the middle class of the Internet and e-commerce specialists, cartoon-and-disco-loving generation, McDonald's, Coca-Cola, tele-marketing, independent workers, and avant-garde artists' (2004: 150).[8] Jing Wang extracts from numerous ad-speaks to characterize this emergent market segment: the neo-neo-tribe are 'superficial and restless' 'trend pursuers'; 'independent, willful, and self-centered'; 'irreverent' chasers of fun and of the 'safe cool'; rebels without icono-clasm, utterly disconnected from the Chinese tradition (see Jing Wang 2005). Thrill-seekers, entertainment-hunters and Web-surfers, these newer new humans might well regard globalization as an image screen, a search engine, a diet choice, a fashion statement or a cosmopolitanism defined—following a satirical news article—by 'the ability to speak English', 'the penchant for drinking black coffee at western style restaurants and taking vitamins', and a cultural fluency with activities 'linked to foreign (or western) practices' (Heung 2009: 7).

8 According to various findings from unstable electronic ori-gins, *xin xin renlei* was either an advertising lingo from Taiwan later spreading to East Asian popular cultures, or 'a translit-eration of the Japanese term *shin shin jinrei* introduced to the Mainland via Hong Kong and Taiwan'. See, for example, *xin xin ren lei* on Wikipedia and in Jing Wang (2005: 21).

The newer new humans, an electronically capable and commercially acclimatized generation of young urbanites—most, if not all, raised as single children in their families—reached adulthood in China's reformist era. They did not personally suffer from the Cultural Revolution nor were they old enough to participate in the pro-democratic movements of 1989. Depoliticized materialism is their state-sanctioned pragmatic ideal, unlike the political engage-ment of an earlier generation—those who had seen their dream of democracy crushed in the Tiananmen incident. 'China's yuppies,' observes Stanley Rosen, 'have become the new role models, not [the] "model worker" unselfishly serving the Party and the state. The newly affluent have enthusiastically embraced and become eager consumers in the global market place, and that has become a core aspiration of China's urban youth' (2004: 160). For those relatively well-off and under-30 urbanites—the Chinese 'Gen Xers and Gen Yers' (Annie Wang 2006)—consumerism is chic; speed might be the rhythm of their fingers' reflexive clicks and violence a legible commodity in online gaming. In contrast, politics is an overly sensitive topic, for which 'even minors can be arrested for expressing their opinions online' (He Qinglian 2006: 40).

Following Chinese economist and media scholar He Qinglian's critique, contemporary Chinese youths were fed 'after 1989 on a steady diet of official ideology, propaganda and indoc-trination' by a communist regime that had 'reverted to the Maoist era ideological strategy of defaming Western democratic values' (ibid.). This pervasive thought-control process is espe-cially evident in the Chinese government's 'double standard' concerning Internet use. On the one hand, it embraces the Internet for facilitating commercial ventures; on the other, it has spent tremendous funds (more than 'US$800 million' since 2000) on constructing the 'Golden Shield Project', a firewall system controlling 'the six gateways connecting China to the global Internet', in addition to employing '50,000 cyber police' to patrol Internet traffic (Erping Zhang 2005: 98). Most insidiously, as He alleges, such a double standard is exposed in the govern-ment's inconsistent filtering of banned information, forbidding political and religious debates

but allowing 'all sorts of degeneracy': 'Since any discussion of politics, democracy, freedom and human rights is prohibited', people are drawn to areas officially proscribed but practically permitted by the government, most notably pornographic and licentious sexualities: '"If you can sell your body, sell it; if you can sell your soul, sell it too" has become everybody's guiding principle, from government officials down to the common people'. He Qinglian, however, makes explicit the target of her censure by citing from Victor Hugo, 'If the soul is left in darkness, sins will be committed. The guilty one is not he who commits the sin, but the one who causes the darkness' (2006: 44–5).[9]

9 He's observation about inconsistent Internet-filtering practices concurs with other research reports. See Jonathan Zittrain and Benjamin Edelman (2003). For a different assessment of what He calls 'all sorts of degeneracy', see Sheldon H. Lu (2008).

How is the neo-neo tribe relevant to brutal time-based art? The same environment that has seen the sociopolitical imbalance between unbridled materialism and repressed intellectual pursuits has given rise to both. I argue that, unlike the official rear-guard art critics, educators and administrators who vociferously condemned the 'violent trend' in xingwei yishu and xingwei-zhuangzhi, the newer new humans, both craving for and immune to sensorial intensities, were potentially the audience group most receptive to the hard-edged experimental art. After all, some of the perceptually cruellest Chinese time-based artworks came from a cohort of slightly older artists who spent their early childhood in the last half of the Cultural Revolution. The major difference between these 'extreme' artists and their younger contemporaries is probably their respective communication technologies of choice—cellphones for the former and the Internet plus smart phones and social media for the latter. Their lack of a public outlet for civil disobedience and their desire for attention-grabbing alternative behaviours are the same. Yet, what's more disturbing than finding a group of art-makers and consumers so detached from the 'real' that they needed super doses of sensations to feel the impact is to recognize the causes of their apparent detachment.

Zhu Yu and Other New Humans

Born in Chengdu in 1970, Zhu Yu moved to Beijing in 1987 to attend the Central Academy of Fine Arts High School and began his independent art career in the mid-1990s.[10] When he enacted *Eating People* in 2000, the artist had just turned 30. Chronologically, Zhu is half a generation (about five years) older than newer new humans. Aesthetically, his extreme time-based art participated in what I describe as the 'brutal' strain of xingwei yishu. Outrageous aesthetics and the clearly delimited generation difference—these two themes appear prominently in Jonathan Napack's article, 'Young Beijing', published in a 2004 special issue on 'the new art of China' in the US magazine *Art in America*. Napack joins many cultural and film critics to suggest that '"Generation" is a powerful idea in modern Chinese culture.' Further, Napack points out, in the post-Mao China, there were at least two distinct 'new' generations:

10 My phone interview with Zhu, 16 February 2009, Los Angeles to Beijing.

> [T]he under-40s pressed hard by the under-30s, who were teenagers or younger at the time of Tiananmen Square and don't remember the days before China's economic reforms deepened and radicalized. Yet the two groups have more in common with each other than either has with the previous generation, raised in isolation from international trends and facing difficult choices about emigration (2004c: 143).

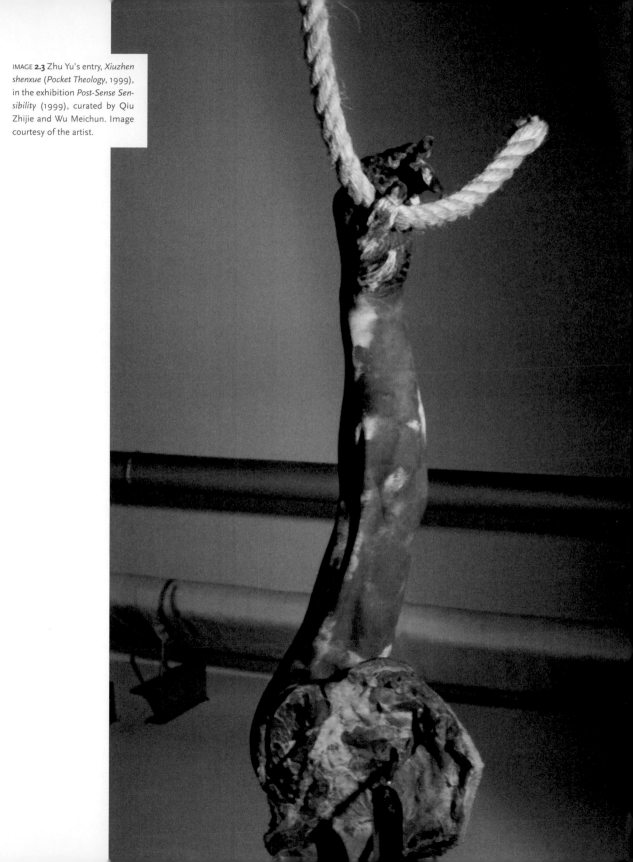

IMAGE **2.3** Zhu Yu's entry, *Xiuzhen shenxue* (*Pocket Theology*, 1999), in the exhibition *Post-Sense Sensibility* (1999), curated by Qiu Zhijie and Wu Meichun. Image courtesy of the artist.

Napack confirms the importance of Zhu's generation of artist-peers when he traces Beijing's 'most eye-catching movement' to a pivotal underground exhibition *Post-Sense Sensibility* (1999), organized by Qiu Zhijie and Wu Meichun. Calling it 'the watershed event', Napack's description of *Post-Sense Sensibility* resembles my characterization of *Fuck Off*. The show 'provoked international outrage for the use of live animals and human cadavers' but it 'included virtually all the artists who have emerged in the early years of the 21st century' (ibid.: 143–4). Zhu's entry for *Post-Sense Sensibility* was a xingwei-zhuangzhi entitled *Xiuzhen shenxue* (*Miniature Theology* or *Pocket Theology*, 1999), featuring an amputated human arm.

Most of Napack's *Art in America* readers, following his synopsis of *Post-Sense Sensibility*, would probably recall a previous contemporary art show, *Sensation* (1997), a likewise inflammatory exhibition that first opened in London's Royal Academy of Art. Culled from the advertising tycoon Charles Saatchi's 'Young British Artists' collection, *Sensation* became notorious for its participating artists' exploitation of shock tactics. Its most controversial exhibits included Damien Hirst's *The Physical Impossibility of Death in the Mind of Someone Living* (1991)—his by-then-famous aquatic installation of a tiger shark suspended in a formaldehyde-filled vitrine—and other dismembered or encased animals; Marcus Harvey's huge portrait, *Myra* (1995), using children's handprints to create the bust of Myra Hindley, a convicted child murderer; and Chris Ofili's painting, *The Holy Virgin Mary* (1996), incorporating a resin-coated lump of elephant dung (see Rosenthal et al. 1997). There are obvious similarities between *Sensation* and *Post-Sense Sensibility*. Besides their titles' near-alliteration, both exhibitions included transgressive intermedial artworks by creators in their late 20s and early 30s. The most infamous pieces in each show appropriated creatures, human and nonhuman specimens, everyday merchandise, detritus and techniques from natural, cultural, clinical, commercial and industrial worlds, pushing Marcel Duchamp's idea of the readymade to a liberal extreme.

Post-Sense Sensibility

The Chinese curators and artists were acutely aware of their British predecessors. In a memorandum written for art historian Wu Hung, Qiu Zhijie states that he began forming 'basic ideas for the *Post-Sense Sensibility* exhibition' in 1997 to counter Beijing's over-intellectualized and standardized trend of 'so-called conceptual art', replete with stereotypical 'minimalist formulas' and 'a penchant for petty cleverness'. Qiu envisioned using an experimental exhibition to foster a more sensuous and visceral art; he coined the Chinese phrase *Hou ganxing* (post-sensation or post-sensibility) to 'label the kind of art which [he] foresaw for the future'. Yet, as Qiu confesses, 'I was upset when I traveled to Europe in the autumn of 1997: I heard about the *Sensation* exhibition and cursed the Brit who had [beaten] us to the punch to use the concept first'. Subsequently, Qiu had a chance encounter with Hong Kong curator Chang Tsong-zung who suggested that Qiu use 'Post-Sense Sensibility' as the English translation for *Hou ganxing*. With this new promising English heading, co-curators Qiu and Wu decided, 'we shouldn't avoid an existing title, but should feel free to use any word that could best convey our true feeling'. The curatorial choice raised the stakes of their public display: 'This decision also put pressure on us to produce really good works, because people would definitely say that we got our idea from Damien Hirst. We had to prove that we didn't copy him and that we had actually gone beyond him' (Qiu Zhijie and Wu Meichun 1999: 167–71).

Qiu's memorandum is a revealing historical document. His anxiety over potential reactions to the *Post-Sense Sensibility* show reflects the extent of globalization in late-1990s Beijing; the organizer expected that even an unofficial exhibition, hosting a local group of 'beginning young artists' (ibid.: 168), would attract international media scrutiny of the supposed derivative status of contemporary Chinese art. In Qiu's anxiety over his coincidental belatedness, I discern three interwoven presumptions: he recognizes his predecessor's success; he believes his ability rivals that of the predecessor; he anticipates receiving similar recognition. These psychological reverberations reveal Qiu's belief that his coterie of young Chinese artists were no longer negligible figures in an isolated Asian alcove but equal players who would be judged—evaluated, criticized and potentially rewarded—by a global art (production, appreciation, circulation, collection and historicization) system. A detail in Qiu's memo—that he heard about the *Sensation* show in *Europe* (not in China) when he was invited to exhibit abroad—underscores another globalization-enabled possibility as it increases the mobility of artistic producers, patrons, mediators and consumers across vastly divergent geocultural regions, *provided* these individuals possess the prerequisite capital (money, fame, an invitation to a foreign exhibition, a visa, etc.). The central problem for these Chinese artists, then, was how to acquire any such capital—a topic impossible to even imagine prior to Deng's decree allowing the country to rejoin the global economic community.

This world of constant motion wherein material-less information (virtual products) and material-laden people (possible enactors) travel recalls Appadurai's acute analysis of the effects of mass media and mass migration under globalization:

> [E]lectronic mediation and mass migration mark the world of the present not as technically new forces but as ones that seem to impel (and sometimes compel) the work of the imagination. Together, they create specific irregularities because both viewers and images are in simultaneous circulation. Neither images nor viewers fit into circuits or audiences that are easily bound within local, national, or regional spaces (1996: 4).

Appaudurai has delineated what I hope to capture as the glocalized circumstance behind Qiu's anxiety. Appaudurai's most penetrating insight lies in the concept of 'collective imagination', which he defines not as the property of 'specially endowed (charismatic) individuals' but as a mental action available to all those who join in the mass-and-electronic-media-facilitated condition of 'collective reading, criticism, and pleasure': 'Ordinary people have begun to deploy their imaginations in the practice of their everyday lives' (ibid.: 5–6). I may fold Appaudurai's concept back to fit a smaller collective of Beijing individuals who have used 'imagination' as a discipline-refined cognitive asset to practise art-making at a historical moment filled with various obstacles: rampant government censorships; deficient exhibition infrastructure; and the scarcity of economic means. If ordinary people, nurtured by the glocal popular media, are now given to imagining existential alternatives, how much more so could artists imagine—not only for better working conditions but also for career advancement? Imagination is the most pliable capital, especially for those who lack other kinds.

I've extracted from Qiu's memorandum subtextual nuances that betray the curator's negotiations with the globalized art system at the end of the twentieth century. Owing to this globalized context, which enfolded both the British and Chinese art producers and exhibitors,

we may consider *Post-Sense Sensibility* a Beijing counterpart of the London *Sensation*—each a cutting-edge exhibition that framed itself as youthful, rude, sharp, chic and iconoclastic. Qiu's memorandum, however, documents crucial contrasts between the two shows, revealing point-by-point their differences: *Sensation* was well funded, widely publicized and housed in a historical museum; despite media controversies, it enjoyed a three-month lucrative run (18 September–28 December 1997), followed by an international tour to New York and Berlin. *Post-Sense Sensibility* was sparsely financed by participating artists; for fear of government censorship, its preparation was kept in secret until the opening day; without any prior public announcement, the organizers used word-of-mouth to inform interested viewers and cell-phones to text them the address to the exhibition site, a rented basement sprawl in a residential area; its entire run lasted two days (9–10 January 1999). Indeed *Post-Sense Sensibility* could not have taken place without the audacity, determination and ingenuity of some young artists' collective imagination.

The operational differences between *Sensation* and *Post-Sense Sensibility* reveal their host countries' contrasting sociocultural and political environments at the turn of the century, exposing uneven regional developments under globalization's deceptively levelling banner. While the global art production-consumption system might have become transnational in the late 1990s, citizens of different nations did not have equal access to that system. Perhaps those brutal artworks on display in *Post-Sense Sensibility* registered its participants' fury and frustration with the historical disjunction among international trading partners.

On 2 January 2003, the British Channel 4 television station broadcast a documentary entitled *Beijing Swings* as part of its series China Season. The documentary, directed by Martin Herring and written, hosted and produced by *Sunday Times* art critic Waldemar Januszczak, aims to investigate why 'the most extreme art currently being produced anywhere on the planet is, like so many other things, made in China' (2008). The film's advance publicity sounded explicit: 'Critic Waldemar Januszczak samples shock art in China, including baby-eating cannibalism, still lives composed of corpses, photographic portraits of the artist menstruating and wine made from human genitals' (cited in Mediawatch-UK 2003).

A SELF-PROLIFERATING MESSAGE

A predictable media furore broke out even before the screening. Enraged viewers flooded the Channel 4 website with complaints about the 'utter depravity' of showing cannibalism on TV (Cowen 2003). Hung Liu, third secretary at the Chinese embassy, condemned Channel 4's programme as 'detrimental' to China: 'This is a wrong image and very damaging' (cited in Brooks 2002). John Milton Whatmore, chairman of the private foundation Mediawatch-UK, objected to showing cannibalism as art: 'This artist is being controversial for controversy's sake, not for art. It is also typical of Channel 4 to try to be sensationalist' (cited in ibid.). Mediawatch also demanded that the Independent Television Commission (ITC) intervene and asked advertisers to withdraw funding from Channel 4. Jess Search, the executive in charge of China Season, justified the station's plan to proceed by placing *Beijing Swings* in a larger context: China is 'at a moment of change socially and culturally. We wanted the portrait of a young and modern China' (cited in ibid.).

An 'estimated 900,000' tuned in to watch *Beijing Swings*, broadcast once after 11 p.m. with an unambiguous prescreen warning about the film's unsettling content. Despite this precaution, controversies ensued. The Chinese government blacklisted the documentary's makers, denying their entry into China ever again (Januszczak 2008). The British independent television regulators investigated the incident, resulting in conflicting findings. The ITC reprimanded Channel 4 'for showing a "lack of respect and dignity" by broadcasting a picture of a Chinese performance artist eating a dead baby' (cited in Deans 2003). Channel 4's head of documentaries Peter Dale, however, refused to accept ITC's ruling, stating that these images, though shocking, 'have been previously exhibited at a major art show and are readily accessible on art websites', and that Channel 4 'will continue to defend to the hilt its right to open up debate about what goes on in the world rather than close it down' (cited in ibid.). Channel 4's tough stance gained support from the Broadcast Standard Commission's ruling which concluded that the 'highly disturbing' images shown in *Beijing Swings* were 'justified in an examination of extreme art in a totalitarian regime', endorsing the documentary filmmaker Januszczak's political angle in approaching the new Chinese art (cited in Mediawatch-UK 2003).

The discursive warfare centring on *Beijing Swings* recalls the internet hullabaloo over Zhu's *Eating People* in 2001. Once again Zhu's drastic xingwei raised rancour overseas. The official clarification by Taiwan's GIO—that the artist was from Mainland China, not Taiwan—and the media protest by China's embassy in the UK suggest the extent to which a radical art practice can affect the self-image projection of a body politic. These incidents imply that, in the era of cybernetic and mass media globalization, the front line of international competition resides substantially in the visual field—both Taiwan and China raged against the defamation caused by a cannibalistic *image* to their respective national *image*. I also find it intriguing that both governments rebuked the messenger for the unwanted image more than the image-maker— Taiwan demanded an apology from *Warta Perdana* for conveying a libellous message, attributing an unnamed picture to a fallacious source; China punished the producers of *Beijing Swings* for publicizing a 'wrong' message, using numerous 'damaging' pictures to represent present-day China. Zhu Yu, affixed to the oft-cited one-liner for his 'baby-eating' behaviour, was treated merely as an embarrassment, ironically deemed powerful enough to slander but not enough to merit serious consideration. 'This artist is controversial for controversy's sake,' voiced Mediawatch's Whatmore, 'not for art.'

The Role of Controversy in the Afterlife of Time-Based Art

These rhetorical dismissals of Zhu's xingwei piece drum up two issues concerning a time-based artwork's *afterlife*, when its post-event impacts ripple through wider cultural spheres: How is the artwork transmitted for broader cultural dissemination? How does the artwork—or the art world—construct its lure?

The fact that a tabloid and a documentary film each bears the brunt of political censure suggests how much a xingwei/performance artwork depends on a mediator/messenger to posthumously circulate its affective presence. This assumption is true even when an artist self-tapes a performance piece and simulcasts it over the Internet. The artist here plays the double

role of the enactor and messenger; the uploaded video document, if kept as a valid weblink after the original event ended, still relies on a messenger (the artist or a viewer) to transmit it for wider circulation. In any case, it is the messenger's motive, integrity and competency that determine how the message (the original piece, mediated by its mode of documentation) may be received. There is then a tacit, if often unacknowledged, connection (actual, virtual, inter-subjective or situational) between a xingwei enactor and the one who chooses to disseminate the piece, for they occupy two distinct positions in a relay of information—the latter actively relates to the former by assuming the responsibility of transmitting the *message* (the artwork). In this linkage, the *message-creator* (the artist who originates the information content) becomes 'vulnerable' to the *message-transmitter* (the one who digests, interprets and passes on the infor-mation, such as a reporter, a critic, a documentary filmmaker, an Internet blogger or the author here) because the quality of the information being relayed will change according to the intention, agency and ability of the message-transmitter. In this scenario, the creator may best minimize conceptual liability by making widely available (posting documentation online, publishing statements, accepting interviews, etc.) the original event's traces (photographic, textual or digital documents) to potential *message-receivers/second-order viewers* (you and I and many interested others) who may then gain direct access to the documents, however mediated they may be (by the artist's representation, the medium's particularity, etc.). A message-receiver's misreading, which may variously detract, alter or enhance the original message, is then its creator's assumed risk, taken in exchange for giving a prolific afterlife to the vanished xingwei artwork.

If misreading is an assumed risk, it would make quantitative sense—insofar as the anticipated reward outweighs the risk—for a xingwei artist to attract as many (mis)readers as possible. The main objective is not to rebut any given (mis)reading but to transmit information about a time-based artwork to actual and virtual arenas far beyond the original action. This objective brings up the next question: How does an artist construct a lure that may cast as wide a net as possible among interested *others*—the *messenger-fish* who have swum into the artist's net, ready to then flex their information muscles in diverse world markets? We might not all agree with Whatmore's self-righteous distinction between art and controversy but I believe the Mediawatch chairman has identified a vital engine in message transmission—controversy. Controversy—albeit not itself a lure intrinsic to the contested artwork—is a transoceanic wave strong enough to push schools of messenger-fish into the transmission-ready net. The two international commotions provoked by Zhu's *Eating People* confirm my assertion.

A public controversy is nevertheless time-bound, like mainstream fashion which often prevails through stylistic shock effects. Controversies can reflect the lure's initial attractiveness without necessarily securing its longevity. In the long run, a given controversy might survive short-term popular attention to be incorporated into written history; at best, it can propel an art-work into a post-mortem course of information transfers among voluntary receiver-messengers, those second-order viewers who learn about the work through hearsay or documents. Like a mob that builds from a fistfight in a crowd, a controversy encompasses and grows out of a contest of duelling opinions which respond to an event perceived as unexpected, outlandish, unsavoury, excessive or in breach of a taboo, such as Zhu's cannibalistic art. The adjudicating perceptions and discourses provoked by a controversial piece, however, may fade through time.

When the moment of topicality—however it's construed—passes, the controversy may function inversely to negate the work's inherent worth and to even replace the work's position in history. A work that seeks attention by creating controversy therefore risks near-immediate obsolescence. But antidotes to such public forgetfulness exist. One remedy is to insist that the controversy enlivening the work is current and relevant. This is the strategy the promoters of *Beijing Swings* adopted.

REGURGITATED SENSATION | After its one-time broadcast in 2003, *Beijing Swings* was taken out of mass circulation until 2008, when a 4 min. 30 sec. excerpt was posted on Saatchi Online TV, a website devoted to 'Films of Art Openings, Interviews, Artists' Studios, Art Performances and Videos' sponsored by the Saatchi Gallery."[11] The change in the status of *Beijing Swings*, from a late-night TV outrage to a cult documentary film suffering from censorship, probably resulted from a momentous art event in London—the Saatchi Gallery's opening after its relocation to the former Duke of York's 70,000 sq. ft headquarters in Chelsea. The new Saatchi Gallery's inaugural show, *The Revolution Continues: New Chinese Art* (9 October 2008–18 January 2009), attracted an average of 5,200 viewers a day. According to the *Observer*, *The Revolution Continues* had in two months broken the record 'for the number of visitors to a contemporary art exhibition, set in 1997 by the groundbreaking Sensation BritArt show [sic] at the Royal Academy' (Thorpe 2008). It appears that any contemporary art show, once touched by Saatchi's gold finger, becomes a success. He did it for the young British artists; he did it again for the Chinese.

11 *Beijing Swings* appeared under the 'Most Popular Videos' category for several weeks after its first posting by Saatchi Online Editorial on 10 November 2008. The homepage for Saatchi Online TV has since changed to be Saatchi Online TV and Magazine, http://www.saatchi-gallery.co.uk/blogon/

Then again, history never repeats itself without discrepancy. Although we have similar elements in place—namely Charles Saatchi, a blockbuster contemporary art show, a curious intertwining of the British and Chinese—*The Revolution Continues*, unlike the underground *Post-Sense Sensibility* in Beijing or the offensive *Beijing Swings*, comprised almost entirely mainstream works. Large-scale paintings with permutations of Mao's 'Political Pop' images, together with recent auction favourite Zhang Xiaogang's melancholy *Bloodline* faces and the equally popular Yue Minjun's big grinning heads occupied Saatchi's Chinese collection. The tycoon's past reputation for underwriting in-yer-face art was merely maintained by a few edgy sculptural installations, such as Zhang Huan's *Donkey* (2005), with a taxidermic donkey repeatedly penetrating a steel model of Shanghai's Jin Mao Tower; Zhang Dali's *Chinese Offspring* (2003–05), a selection of 15 suspended upside-down resin-and-fibreglass human figures cast from living migrant workers; and Sun Yuan and Peng Yu's *Old Persons' Home* (2007), with 13 life-size verisimilar sculptures of old men, garbed like world leaders, dozing or drooling in their mobile wheelchairs, endlessly circulating (Sharples 2008; see also Jiang Ming 2008).

Missing in the new Saatchi Gallery's opening show was the controversial rage of the new—most of the pieces had been under the international spotlight for some years. As Laura Cumming cynically puts it, 'What Saatchi is offering is a rapid glimpse of the kind of international art that

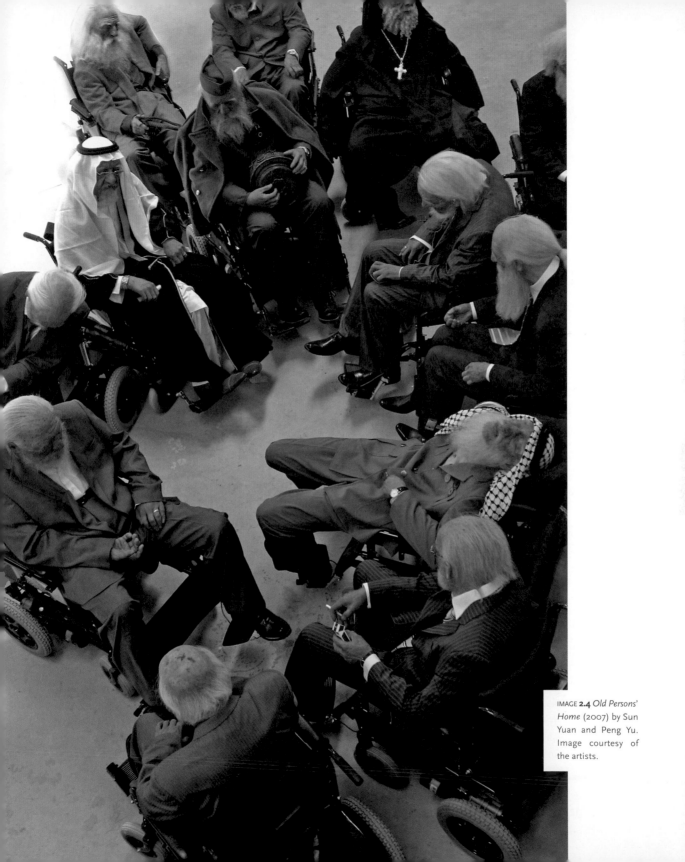

IMAGE **2.4** *Old Persons' Home* (2007) by Sun Yuan and Peng Yu. Image courtesy of the artists.

circulates around the world's biennales and auction houses, plus some finds of his own, before he sends it back out for sale again' (2008). Cumming's comment echoes what Ben Lewis analyses as the profitable Saatchi formula:

> Saatchi laid down a blueprint in the late 1990s that others have tried to copy—he bought the work of young artists, established a museum in which to display it or lent it to public museums, and used the media interest that such shows attracted (by virtue of the outlandish works involved and the association of celebrities) to sell on part of the collection at auction at greatly inflated prices. Some of the proceeds would then be reinvested in the work of other new discoveries. Saatchi's famous 1997 show, 'Sensation', demonstrated that this 'specullecting' was a great way to make a splash as an arbiter of taste (2008).

With his gallery's reopening, Saatchi has furthered his experiment of turning cash into taste and commerce into public service. As its website proudly advertises, the new Saatchi Gallery's partnership with the auction corporation Philips de Pury enables them to offer free entry to all exhibitions. This alliance between an art exhibitor and auctioneer reveals contemporary art's recent move into transnational big business, a trend fostered by 'the emergence of a global class of the new rich' in the twenty-first century (ibid.). These new billionaires, as Lewis observes, consider contemporary art an ideal vehicle for investment, because, unlike the publicly registered real-estate purchases, artworks are 'a uniquely portable and confidential form of wealth', almost entirely free from state regulation and surveillance (ibid.). *The Revolution Continues* stood as a conspicuous reminder of this art investment craze because new Chinese art has played a major role in promoting the latest global contemporary art boom.[12] In fact, I suggest, this newsworthy economic factor—à la Brand China—probably resulted in the popularity of Saatchi's Chinese show. The tycoon did not after all 'touch' new Chinese art and turn it into gold; he merely participated in showcasing the gold.

12 For how speculation has abetted the recent contemporary Chinese art boom, see Jonathan Napack and Charmaine Picard (2006). See also David Barboza (2007a).

Much has changed since the airing of *Beijing Swings*, when new Chinese art was linked in public perceptions with the violence of cannibalism and in Januszczak's interpretation with individual rebellions against political repression. In *The Revolution Continues*, violence merely simmers in the low-voltage parade of international dodgem and Sino-politics re-emerges as serial commodities. What gets staged at the Saatchi Gallery is not the corporeal evidence of human suffering that one would expect from the show's evocation of a calamitous Chinese history but the bloodless travesty of a once-omnipotent and still-omnipresent political icon. As Emmanual Lincot wrote: 'The real revolution in Chinese contemporary art was to be found in its integration into the logic of the market' (2008). This mercantile logic operates without disguise in *The Revolution Continues*, for all exhibits are collectible object-based items rather than perishable time-based artworks, as were most of those shown in *Beijing Swings*. While following the mercantile logic may bring artists financial success, it does not guarantee critical recognition or historical validation. It might adversely lock an artist into duplicating the same saleable line of work, as the repetitive Political Pop paintings demonstrate. The market trend towards self-objectification has motivated Western contemporary artists to resist by choosing

time-based art modes such as performance, body art and site-specific installations since the 1970s. The same resistance may also explain the choice by Chinese artists to practise xingwei and xingwei-zhuangzhi two decades later. In this light, the greatest difference between *Beijing Swings* and *The Revolution Continues* is not the former's blatant violence or the latter's flamboyant capitalism but the documentary film's focus on time-based art practitioners. Perhaps this difference was what instigated Saatchi Online TV to host an excerpted screening of *Beijing Swings*—it allowed the art collector to boast of a range of taste from the mainstream (on sale) to the marginal (on sale too as a documentary film).

'You will see things in this programme that will challenge your taste and turn your stomach,' warns Januszczak in *Beijing Swings*, 'and if this was a film about your tastes that would be a problem. But it isn't. It's about someone else's taste. And believe me it's different.' I transcribe the citation from the Saatchi Online TV website, which refers to the documentary's original TV broadcast to advertise its video excerpt. Underscoring Januszczak's preamble for the incendiary message he conveys is a rhetorical interplay between tantalization and condescension—he represents his film as a test of his viewers' aesthetic and cultural tolerance; he judges the 'taste' expressed by China's extreme art to be problematic; he distinguishes his presumably British viewers from those Chinese others who are decidedly 'different'. Nevertheless, Januszczak's professed attitude towards this difference was surprised fascination. As he announces earlier in the film, he wondered why 'China, of all places, had suddenly become the global leader of artistic progressiveness' (2008). Thus the subtext in Januszczak's preamble was not the habitual thinly veiled reference to Western superiority over the 'inscrutable East' but the controversy he expected to erupt with the airing of *Beijing Swings*.

Back to Controversy as Speculative Cash

As I've recounted, the controversy Januszczak expected did indeed erupt. Years later, when the film was finally available for purchase online, ZCZ Films, its producer and distributor, advertised this history of controversy to promote and lend credibility to *Beijing Swings*: 'The film they tried to ban! Waldemar Januszczak's controversial investigation of new art in China reveals a very different Beijing art world to the one that the Chinese authorities are trying to present to the world' (2008). The blurb further describes the documentary as secret footage shot 'in the build up to the Beijing Olympics', revealing 'a fractured society obsessed with death and decay, and fighting fiercely for the right to public self-expression'. Thus, the blurb implies, the 'real' controversy behind the film is state tyranny over individual human rights.

ZCZ Films' description of *Beijing Swings* echoes the Broadcast Standard Commission's 2003 finding which supported the TV programme for revealing the effect of 'a totalitarian regime' on art. Although it aptly sums up Januszczak's approach to China's extreme artworks produced around 2000, the description was no longer fitting by the time I began working on this chapter in 2008. In fact, there were clear signs that the Chinese government had reversed its attitude towards the country's potentially adversarial experimental art as early as 2003, when the first officially sponsored Beijing Biennale was allowed to take place with much fanfare. As Beijing's xingwei artist Zhang Wei noted: 'We saw the biennale as a signal of policy change that the new themes and forms of art, including the avant-garde, have indeed been accepted if

they were still regarded as being "underground" at the 2002 Shanghai Biennale' (cited in *China Daily* 2003). Zhang's view agrees with the observation of Philip Tinari who suggests that China's 'domestic legitimation of contemporary art was completed in June 2003 with official PRC sponsorship of the Centre Pompidou's Year of China bazaar *"Alors, la Chine?"'* (2007b).

I see other evidence of China's cultural policy change in the selection of Sun Yuan and Peng Yu to participate in the inaugural Chinese Pavilion at the 2005 Venice Biennale.[13] Sun and Peng's xingwei-zhuangzhi piece *Lian ti* (*Linked Bodies*, 2000),[14] in which the two artists offered a blood transfusion to dead Siamese twins, also appeared in *Beijing Swings*; most viewers who officially complained about Channel 4 cited *Linked Bodies* and *Eating People* as the two most offensive spectacles in the documentary. Similar complaints were voiced about *Linked Bodies* in China. Sun and Peng, together with Zhu and a few others, were once severely denigrated by Chinese critics who referred to them as 'shock artists', 'corpse players' and the 'cadaver school'.[15] Yet, in 2005, the duo represented China in the most prestigious international contemporary art show in Europe. ZCZ Film's advertisement for *Beijing Swings* fails to acknowledge these recent political and cultural changes in China and its blurb has effectively arrested China in a politically repressive standstill ever since the film's release on 2 January 2003. As its publicity suggests, the film bravely exposes the hypocrisy of an upstart despotic country 'in the build up to the Beijing Olympics'!

Controversy is the fuel that the maker of *Beijing Swings* counts on to fan potential buyers' enthusiasm for China's present-day heroic artist-rebels. In contrast, *The Revolution Continues* draws on the *nil*-controversy of Chinese new art's ascendance as a market sensation to enhance its 'specullecting' value. The difference between these two events has much to do with how their respective makers position their products in relation to their targeted consumers. For those who might favour the outrageous avant-garde, romanticizing artistic experimenters as political dissidents fulfils Westerners' fantasies about their country's superior freedom and human rights standards and assuages their anxiety over China's advancement in the post–Cold War era. For those who have watched on TV the conspicuous splendour of the 2008 Beijing Olympic Games' Opening Ceremony, *The Revolution Continues* conveniently brings the new global miracle home to a British-historical-heritage-hall-cum-renovated-contemporary-art-haven, cutting the alien marvel down to size as individual paintings, sculptures and mobile installations, visually manageable, attainable with cash and disposable as gradually fading memories of a live encounter.

No matter what strategies the producers chose to capitalize on their products, both the documentary and the exhibition have linked divergent cultural, economic and political spheres across geographic and ideological divides. The two events map out the expanded cartography within which contemporary Chinese art under globalization now operates. Inversely, the two events demonstrate how seemingly innocuous intercultural transactions, such as the study, display, purchase, patronage and evaluation of China's new art by British citizens, are microcosmic refractors of international power struggles.

13 See, for example, Carol Vogel (2005).

14 For an analysis of *Linked Bodies*, see Chapter 3.

15 I modified Thomas Berghuis's translation of the phrase '*wan shiti de*' (playing with corpses) as the 'cadaver group' to the 'cadaver school'. See Thomas J. Berghuis (2001 and 2006: 114).

Training my eyes on these macro-mechanisms affecting contemporary Chinese art, I cannot but notice that what is missing from these larger pictures is the artists' internal logic. How many of those who rebuked the Chinese artist's baby-eating depravity, for example, can discuss Zhu's art beyond reiterating the horror of cannibalism? Is time-based art a mere cipher for global politics and a pawn for transnational commerce? To better understand time-based artworks as context-sensitive but at least semi-autonomous creative expressions, we must allow ourselves the leisure to spend *time* with these pieces, made as they are so substantially of the ineffable stuff we name-for-lack-of-a-better-name *time*. 'This is art that makes viewers "work",' wrote Claire Huot about her experience with China's avant-garde performances (2000: 151). How do we do so? We could *work* by drawing concentric circles, like tracing ripples from their radiating edge closer and closer to where the stone falls. In 2008, London witnessed *The Revolution Continues*, which was preceded in 2003 by *Beijing Swings*, which looked back at the turn of the last millennium to explore Beijing's increasingly violent time-based art, which had seen numerous precursors since 1989 and throughout the post-Tiananmen 1990s, which precipitated the perceptual atrocity displayed in *Fuck Off* in 2000, the year when a Beijing artist named Zhu Yu committed a few more-than-startling acts.

A decade has passed since Zhu made *Eating People*; several springs have vanished since I last wrote about it in 2004. How would the shifted landscapes that have framed Zhu, a message creator, and me, a messenger—two distant lives—change our perceptions of an ephemeral message, sent for keepsake to our mnemonic inboxes, unreliable, chancy and subject to deletion, like cellular deposits dissolved by the acidic spleen of time?

Beyond Controversy

As recently as two decades ago, the habitat of Chinese time-based art was quite different from the seismic cartography I have thus traced, which maps the modes of communication reconfigured by the Internet, the coming of age of post-Tiananmen generations in China and the increasing international recognition of contemporary Chinese art in the time of globalization. In their efforts to create an indigenous field of time-based art, Chinese artists in the 1990s struggled with the suspicion and surveillance of an autocratic government, the utter lack of a domestic contemporary art exhibition and consumption infrastructure and their anxiety regarding the influence of not only their Western artistic predecessors but also their foreign curators, collectors and critics. We cannot account for what Januszczak called China's 'darkest art' without considering this indigenous time-based art heritage within which we may trace a genealogy of violent aesthetics culminating in Beijing's turn-of-the-millennium brutal temporal art trend.

Premonitions of Violence

My genealogical narrative begins with East Village and its young out-of-towners, newly relocated to participate in Beijing's experimental art world. According to Wu Hung, East Village differed from other concurrent artists' villages because its residents managed to form a close-knit learning community of 'performing artists and photographers, who inspired each other's work by serving as each other's audience' (Wu

East Village Precedents: 1992–94

Hung 2008: 38). Many pieces first presented in East Village by its most notable time-based artists—including Ma Liuming, Zhang Huan, Zhu Ming and Cang Xin—are now classic examples of xingwei yishu. Although Beijing had seen xingwei yishu in the 1980s, especially through the *China/Avant-Garde* exhibition, earlier pieces were mostly isolated events and collective guerrilla actions. In contrast, xingwei practitioners in East Village began consciously developing the medium into an individual artist-centred, technically universal but culturally specific art of embodiment. Joining other coeval xingwei artists in Beijing, the East Village pioneers worked towards establishing a formative lexicon for Chinese time-based art. To this lexicon, Ma Liuming and Zhang Huan have contributed major entries on violence.

In the sensitive post-Tiananmen climate, when politics became a dangerous topic for all, to work in an experimental art mode with a prior official stigma, such as xingwei yishu, was to tread a minefield. East Village xingwei artists minimized their risk by featuring an explicit personal agendum to downplay their work's political implications. The prescient 1970s Anglo-American feminist maxim—'The Personal is the Political'—seems to find a Chinese twist here. A different political situation compelled East Village male artists to pronounce the personal so as to obscure the political. Should these artists have failed to circumvent official attention, they could then resort to the *personal* or *aesthetic* defence against allegations of their *political* subversion—the latter being a more serious offence than creating avant-garde art. In this light, an artist's body, being a 'personal property' owned not by the state but by an individual, emerged as a convenient, low-cost, private and relatively neutral vehicle for making evanescent—and overtly depoliticized—bodyworks.

Most of the bodyworks presented in East Village during this time were palpably cruel but not all xingwei pieces from there tackled violence as their central experiential tenet. Zhu Ming's durational bubble-blowing projects, for example, while taxing the artist's endurance, dwelled more on the fluctuating relation between breaths and time, between an individual's will to live and an existential order that annuls any sense of permanence for mortal beings. Cang Xin's face-casting-and-trampling rituals tentatively explored his spiritual identity as an inchoate novice of Manchurian shamanism.[16] Ma's and Zhang's East Village projects, however, directly grappled with violence as a visual trope, a creative method and an external force with symbolic and material efficacy. Their bodyworks were pivotal to the millennial brutal art strain because Ma and Zhang began developing what we might call a semiotics of xingwei violence, from the epistemic to the physical to the durational, all in dialogue with xingwei yishu's central corporeal subject—the artist's body in thrall to the art-making impetus and process.

16 For an analysis of Zhu Ming's and Cang Xin's time-based artworks in East Village and beyond, see Chapter 5.

Ma Liuming | The first-ever xingwei yishu staged in East Village was Ma Liuming's bodywork, *Yu Gilbert he George duihua* (*Dialogue with Gilbert and George*, 1993). The phrase *duihua* (dialogue) in the piece's title subtly refers to a sculptural zhuangzhi artwork, *Duihua* (Dialogue), which became the 'set' for Xiao Lu and Tang Song's *Qiangji shijian* (*Pistol Shot Event*, 1989), the ostensibly belligerent 'happening' that caused the premature closing of the *China/Avant-Garde* exhibition. This reference to *Pistol Shot Event*, however, remains concealed in *Dialogue with Gilbert and George* while the British performance duo Gilbert and George, as the piece's

addressees, appear conspicuously as foreign markers—with their English names untranslated
—in Ma's Chinese title. In the autumn of 1993, the London-based Gilbert and George, already
internationally renowned for their performance as singing sculptures, came to Beijing during
their *Gilbert and George Visiting China* exhibition at the
China Art Gallery.[17] Ma attended the exhibition and spon-
taneously joined Gilbert and George to become a non-vocal
component of their singing sculptures. Shortly after, Ma staged *Dialogue with Gilbert and George*
when the British duo, joined by a handful of reporters, visited his East Village studio.

[17] Ma described this incident to me in our interview in Beijing on 8 July 2006 in . See also Berghuis (2006: 102–04).

With Pink Floyd's *The Wall* for ambience, *Dialogue with Gilbert and George* unfolds like a ritualistic sequence.
Ma, naked from the waist up, climbs onto a chair, pokes at a hole in the ceiling where he has hidden a bag of red
paint, and punctures the bag to let the red paint drip on his face and
torso.[18] Ma's performance reiterates elements seen in
Gilbert and George's live artworks which proceed through
varying combinations of sounds, motions, rhythms, colours and shapes by using the artists'
bodies. *Dialogue with Gilbert and George* is nonetheless significant in the chronicle of Chinese
time-based art because it epitomized the initial relationship between performance art and
xingwei yishu in the post-Tiananmen era. Through an intercultural encounter, Ma was inspired
by the pair of singing sculptures as exemplary performance art and initiated his practice of
xingwei yishu, which emerged as a glocal reconfiguration of a roughly 30-year-old international
time-based visual art medium.

[18] My interview with Ma, 8 July 2006, Beijing. See also Caroline Puel (2004: 13).

Strictly speaking, *Dialogue with Gilbert and George* is distinguished not so much by its
violence as by how it has violated the artist's previous practice to open up new possibilities.
Unlike *Pistol Shot Event*, in which violence underscored the transition of Xiao's *zhuangzhi* into
an interactive public *xingwei*, violence assumed an epistemic guise in Ma's bodywork, when a
young Chinese painter, shocked by the sensuous new, stumbled into an expanded visual
medium which re-coded his labouring body as central to art-making. Being a cognitive catalyst
rather than a brute force, violence in Ma's first bodywork is implicit and painterly. Although
the red paint trickling down the artist's upper torso looked like blood, it was after all just paint.
To me, the same painterly violence permeates Ma's signature stroke—the invention of his
performance alter ego, Fen•Ma Liuming.

The artist created the character Fen•Ma Liuming through a contradictory process of adorn-
ment and exposure—Ma wore make-up to exaggerate what he considered his 'feminine'
features; at the same time, he left his body bare to reveal his unadorned and typically male
genitals. This transformative procedure is aptly embodied by the character's name. The prefix,
fen (芬), attached to Ma's original name means 'fragrant like a flower' but the word is homo-
phonic with the verb, *fen* (分), denoting 'to divide'—hence, the addition to the artist's name
also subtracted certain aspects from his nominal identity. By applying 'fen'—a flower-like
painted visage—on his original face, Ma divided his visibly sexed body into two visual compo-
nents: joining artifice—his theatricalized face—with standard issue—his adult male body,
uncovered and undisguised.

Numerous commentators have held that Fen•Ma Liuming comprises a 'woman's head'
and a 'man's body' to represent a 'transgender' identity (see Puel 2004: 12; Hasegawa 2004:

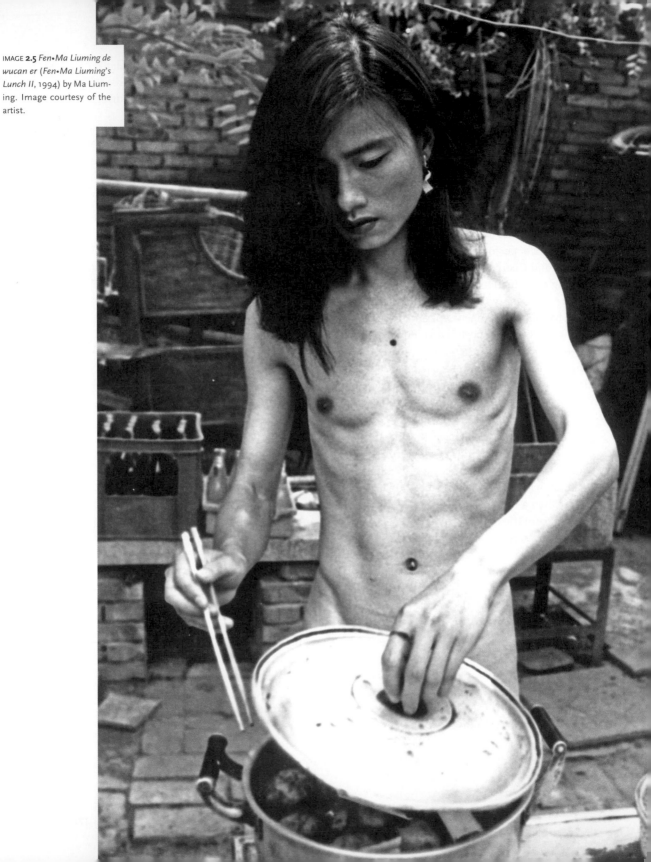

40; Berghuis 2006: 104). I disagree with such analyses because of its stereotypical associations of make-up and long hair with a 'woman' and a flat chest and a penis with a 'man', thereby conflating customary social practice and normatively classified sexual features with gender identity. To me, Ma's body-specific performance demonstrates precisely the opposite—the unintelligibility of external corporeal signs in relation to a person's sex, gender and sexuality. As Ma insisted during our interview—even to the point of admitting his homophobia—his construction of Fen•Ma Liuming has nothing to do with homosexuality, transsexuality and transvestitism.[19] While I do not

19 My interview with Ma Liuming, 8 July 2006, Beijing.

take an artist's words as the authoritative interpretation, I consider Ma's claim justified in that any intervention into restrictive gender coding and sexual identity requires an activist's conviction. An individual's express intent counts as the minimum prerequisite in political struggles for gender and sexual freedom. Ma's statement suggested that he had no intention to politicize the perceptual incongruity of Fen•Ma Liuming's bodily image as a transgendered slippage. Instead, he treated his performance alter ego rather like a canvas, a distinctive dermatological surface without psychological interiority. This explains why, during performances, in East Village or later abroad, Fen•Ma Liuming always stayed passive, mute, even occasionally unconscious, because this ambiguous persona was above all a wordless, if mobile and embodied, image: a time-based painting in flesh.

Fen•Ma Liuming's nude presence came in the wake of a more relaxed—market-and-mass media softened—public attitude towards 'nude art', which then primarily consisted of female nudity in oil paintings.[20] But a 'real' (not painted) gender-ambivalent naked person appearing in public was still too transgressive to be tolerated in the early 1990s. Once Ma left the protective anonymity of his home studio, his nude artistic xingwei/behaviour became vulnerable to the prevailing social code guarding public conduct, his claim to artistic autonomy the first casualty of such sociopolitical violence. On 10 July 1994, a Hong Kong TV crew, accompanied by local critics and artists from Beijing, came to film East Village performances (see Berghuis 2006: 109: Ma also mentioned this incident in our interview on 8 July 2006). Zhang Huan, Ma Liuming and Zhu Ming all planned to do xingwei pieces for this event. First, Zhang's 65KG—to be discussed later—took place indoors. Following Zhang's piece, Ma performed in a courtyard Fen•Ma Liuming de wucan er (Fen•Ma Liuming's Lunch II, 1994), in which his nude art character boiled earrings, bracelets, images of potatoes and real potatoes in a pot. The police arrived and arrested Ma for his lack of a valid Beijing residence ID and for his 'pornographic performance'.[21]

20 Richard Kraus has traced the development of 'nude art' from a forbidden zone in the beginning of reformist China to the unprecedented opening of the first all-nude art exhibition in Beijing's China Art Gallery in December 1988. The show included 135 nude paintings, among which 'almost all of the subjects were women; all but one of the painters were male' and 'attracted about a quarter of a million visitors in eighteen days' (2004: 80).

21 My interview with Ma Liuming, 8 July 2006, Beijing. See also He Yunchang and Tang Xin (2004: 88); Berghuis (2006: 110); Lu Hong and Sun Zhenhua (2006: 86). Zhu Ming was also arrested at the same time and served an even longer prison term.

This highly publicized arrest, covered by domestic and foreign media alike, had several consequences for Ma's career. The controversy, while intensifying public perceptions of xingwei yishu as unruly and even salacious, made Ma famous overnight and eventually gained him opportunities to perform abroad. Although Ma admitted that he benefited from his unexpected

'outlaw' credentials, his two-month prison term disturbed and intimidated him. So, in his future Beijing-sited xingwei events, he stopped inviting an audience and performed only to the camera (see He Yungchang and Tang Xin 2004: 89; Berghuis 2006: 109–11). To release his psychological agitation, Ma staged two hybrid xingwei pieces that melded bodywork with animalwork. Unlike the humorous absurdity emblematic of his xingwei persona's previous 'lunch' exploits, both of Ma's new pieces exercised a heightened degree of physical violence.

In *Fen Ma Liuming he yu* (*Fen•Ma Liuming and the Fish*, 1995), the character Fen•Ma Luming stands naked in an alleyway, cooking a live fish in a frying pan. Without any protection, his body trembles in the freezing cold while the fish is burning to ashes.[22] The artist employs two surrogates—his apparently androgynous alter ego and his sacrificial fish—to express his anguish over the violence of police censorship. In *Yu hai* (*Fish Child*, 1996), Fen•Ma Liuming suspends a number of live fish from his bathroom ceiling and takes a shower among the parched fish (see IMAGE **0.8**, p. 38). If violence is borne by both performers in Ma's 1995 fishwork, the dozen or so fish are the sole sacrificial victims in *Fish Child*, absorbing the human performer's dry rage upon their marine flesh with moist oxygen unavailable to their gills.

22 My interview with Ma Liuming, 8 July 2006, Beijing.

Zhang Huan

Zhang Huan's East Village xingwei yishu shares Ma's painterly quality in the statuesque composition of his enacted images. The violence underpinning Zhang's bodyworks, however, is much more explicit and physically harmful to the artist than the creative tension in Ma's xingwei pieces. More existential than methodological, Zhang's self-directed violence seems to thicken rather than flatten his body; his performing body does not merely project a reticent image but assails his viewers with sensations of tortured flesh, fractured skin, invaded orifices and overwhelmed entrails. Consider these two well-known East Village performances.[23]

23 I base my descriptions of Zhang's two pieces on a combination of sources, including Qian Zhijian (1999); Wu Hung (1999: 102–07); and Berghuis (2006: 109–11).

In *12M²/Shier pingfang mi* (1993), a hybrid of bodywork and animalwork, Zhang exposes his naked body, half coated with honey and half with fish oil, to the delectation of flies. In a public toilet 12 sq. m in size, Zhang sits still for an hour under the sweltering heat and putrid smell, playing both host and prey to his insect co-performers.

In his endurance bodywork *65KG/Liushiwu gongjin* (1993), Zhang's naked body is hung upside down, bound by 10 iron chains from a beam about 3 m above the ground. Two layers of plain quilts, a type often used in local hospitals, are laid out on the floor to form a rectangular performing and viewing space. A doctor performs an intravenous procedure on the suspended artist, allowing 250 cc of his blood to drip from one forearm through a catheter into a metal pan, heated by an electric stove placed on a stage made out of more quilts. Zhang stays in this painful position for about an hour as the acrid smell of the burnt blood infuses the room.

In contrast to Ma's dramatic creation of Fen•Ma Liuming, Zhang does not assume any role other than that of the artist in his bodyworks; nor does he particularize his performing body as an inimitable entity. Rather, in a manner resembling the mathematical titles he favours, Zhang adopts a matter-of-fact attitude towards his xingwei enactment. We see this attitude in his explanation of *65KG*: 'The title 65 kg refers to my weight or, more precisely, to the actions of a body with this weight conducted in specific environmental conditions' (Qian Zhijian 1999). The performer in Zhang's bodywork, then, resembles a taskmaster, who both assigns and carries out a sequence of planned duties, or a musician and instrument rolled into one, who

conducts and executes a certain score by both playing out and serving as the apparatus through which the music is played.

Given that his artist's body functions simultaneously as a ruthless flesh sculptor and a seemingly impassible corporal sculpture, Zhang's East Village performances recall the early 1970s violent bodyworks by Chris Burden, the Los Angeles daredevil performance artist. To a certain extent, Los Angeles in the early 1970s resembles Beijing in the 1990s—both places were nurturing grounds for an incipient performance art medium; the artists' community that inspired what Burden called his 'interactive sculptures'—those made of collisions between his body, concepts and enacted tasks—may not be so different in its experimental ethos from that of Beijing's East Village (see Meiling Cheng 2002: 1–65; Newport Harbor Art Museum 1988). Even so, we cannot belabour the two artists' similarity beyond their formalistic-choreographic parallels. Unlike Burden, who articulates his performance art pieces on an intermedial sociosculptural basis, Zhang connects his bodyworks with his native environment:

> Maybe it was because of the poor countryside in Henan where I grew up. There everything was colored by the yellow earth. I got hepatitis—because I had nothing to eat. There were many deaths and funerals [. . .] Maybe it was also because of my personal

IMAGE **2.6** *65KG/Liushiwu gongjin* (*65 Kilograms*, 1993) by Zhang Huan. Image courtesy of Zhang Huan Studio.

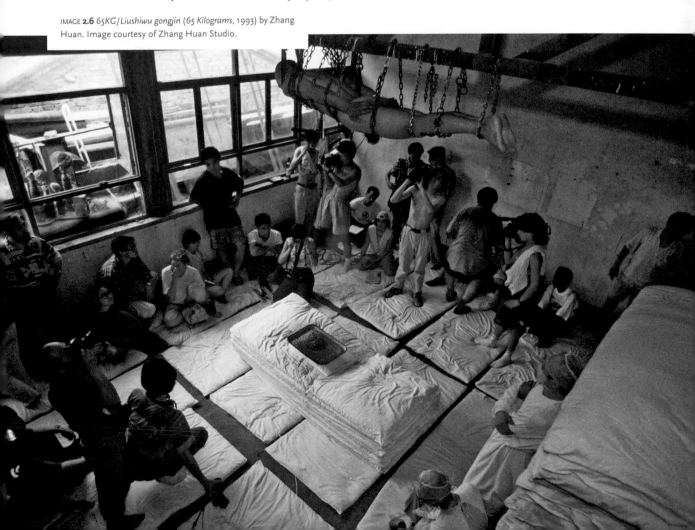

life in Beijing. You could not keep your child when your girlfriend was pregnant [. . .] Girls of my generation have to go through many abortions [. . .] Many unborn babies died. This is the situation of the nineties (cited in Wu Hung 1999: 105).

I cite the passage from Zhang's response to Wu Hung's question regarding the artist's sudden shift from oil painting to staging 'the series of violent and masochistic performances that have become his trademark' (ibid.: 104). Wu's observation of Zhang's performances as 'masochistic' reflects most critical assessments of the artist's intense bodyworks. Although I recognize that Zhang's bodyworks, especially those produced before he left China in 1998, involved self-torturing, I believe that qualifying his violent acts as masochistic is misleading. The term masochism, as coined by Richard Freiherr von Krafft-Ebing, derives from Leopold von Sacher-Masoch's narrative portrayal of a sexual behaviour that seeks one's erotic satisfaction from the physical subjugation of the self (see Krafft-Ebing 1925 and Deleuze 1991). To me, Zhang's performance of self-harming has little to do with the pursuit of sexual pleasure. Instead, as his statement reveals, the violence to which he subjects his performing body is empathic in nature, as if he wills his body to absorb and become one with his violent environment. Just as his childhood village was filled with the barren yellow earth, so too his skin turned sallow from hepatitis-induced jaundice; just as he and his peers lived in squalid conditions to pursue their peripheral art, so too his nostrils, ears, eyes, torso and limbs endured the nauseating colonization by flies; just as the deaths of countless unborn embittered poverty-ridden young couple's lives, so too his flesh grieved upon enduring his self-inflicted trauma. The extreme individuation of his 'body in pain' (see Scarry 1987)—to borrow from Elaine Scarry's concept—permits Zhang to mimic the word-defying, world-unmaking violence affecting his land, his people and his time, so as to imagine, through his sacrificial self-bondage, the possibility of an alternative release.

'My decision to do performance art is directly related to my personal experience. I have always had troubles in my life. And these troubles often ended up in physical conflicts. [. . .] When one is driven by such unnamable pressures to the edge of real madness [. . .] the best way to get rid of the horror and to return to a state of ease might be to torture the body itself to calm it,' said Zhang about using his body as an artistic language to express, resist and discharge himself from 'the existence and inescapability of external pressures' that had frequently violated his body and induced him to physical fights with strangers (Qian Zhijian 1999).[24] To empathize with violence is to be contaminated by it. Zhang's release consists of a purgation of external violence by voluntarily turning his body into a contaminated object, polluted by infectious violence.

24 As Mariellen R. Sandford suggested to me, Zhang's explanation about his motive for self-torture resembles the rationale of self-cutters, those who cut themselves to release their psychic pain, to externalize the pressure in order to exert a sense of control. For more, see Amando R. Favazza (1996).

Although Zhang conducts his xingwei yishu in a secular cultural context, his longing for catharsis through self-contagion and his search for spiritual release through bodily suffering recall René Girard's anthropological studies of primitive religions in *Violence and the Sacred* (1979). In brief, Girard's analysis revolves round three concepts: violence; the sacred; and sacrifice. 'Violence is the heart and secret soul of the sacred'; 'The sacred consists of all those forces whose dominance over man increases or seems to increase in proportion to man's effort to master them'; 'Sacrifice is primarily an act of violence without risk of vengeance'. I would

link these concepts in a syllogism to illustrate Girard's theory: the sacred compels violence; violence requires sacrifice to keep it in check; through sacrifice the sacred is momentarily appeased. Transpose this conceptual model to Zhang's case: through the ritualistic framework established by the structure of his bodywork, Zhang imposes violence upon his body, allowing it/himself to become a surrogate sacrificial victim, so as to stall—however temporarily—the escalating violence in an external world beyond his control.

The secret in this interpretation is of course the ambiguous nature of the sacred which, seen in a nonsectarian perspective, may very well be called politics, ethics, economics or any potentially overpowering force against the individual. It intrigues me to note that Zhang had identified poverty (his childhood starvation), the population crisis (repeated abortions) and social disorder (he got into frequent fights) as concrete examples of what he called 'unnamable pressures'—precisely those socioeconomic symptoms that the Dengist reformist policy sought to remedy. In this light, Zhang's self-harming East Village bodyworks are *depoliticized* only insofar as they are *timely*. As the artist represented them, his time-based pieces exactly conformed to the reigning postsocialist politics.

Elsewhere in Beijing: With Gu Dexin

Unlike Ma and Zhang, who launched their art careers with xingwei yishu in the early 1990s, Gu Dexin was already a veteran experimental artist when he began working with the time-based medium of xingwei-zhuangzhi in the mid-1990s. Whereas Ma and Zhang presented their earliest xingwei actions in the communal milieu of East Village, Gu's performative installations were mostly exhibited abroad until the late 1990s. In view of his later entry into the time-based medium, I address Gu's xingwei-zhuangzhi as the third moment in my partial genealogy of Beijing's turn-of-the-millennium brutal art, granting that my doing so might have the unwitting effect of postdating Gu's art practice by a decade.

Beginning as a zhuangzhi artist in the 1980s, Gu acquired fame among foreign curators for his inventive use of plastic as an art material. By burning, melting and moulding plastic in unusual ways, Gu created wide-ranging visceral structures from the monumental to the portable, from the texturally grotesque, morphologically obscure, to the plainly erotic. In 1989, together with Huang Yong Ping and Yang Jiechang, Gu appeared in the first overseas display of post-Mao Chinese new art: the *Magiciens de la terre* (*Magicians of the Earth*, 18 May–14 August) exhibition, curated by Jean Hubert Martin at the Centre Pompidou in Paris (see Teo 2007). The 4 June Tiananmen incident occurred while the exhibition was on. Huang and Yang sought political asylum in France but the Beijing native Gu decided to rush back home—a move that won him respect from younger artists.[25] By the mid-90s, Gu was one of the most internationally exhibited Chinese artists to remain in China while most other experimental artists of his stature had emigrated. Yet, because of the paucity of local exhibition resources, Gu's site-specific installations were rarely seen domestically until 1998.

25 | I learnt this fact from an interview with Wang Chuyu, 15 July 2008, Beijing.

Although Gu did not take on the time-based medium per se until the mid-90s, his preceding practice in (static) zhuangzhi yishu anticipated this transition. From the outset, Gu developed a working method with time-based characteristics. He routinely uses the invitation

to an exhibition to initiate his creative process, from investigating the exhibition site to constructing the project *in situ*. This production process is common in site-specific installation art but Gu appears to have a philosophical grounding besides a disciplinary one. As a zhuangzhi artist skilled at manipulating matter in space, Gu brings a temporal dimension into the fray by consistently identifying his artwork with its exhibition's opening date. Karen Smith indicates that Gu's use of dates to differentiate projects stems from the artist's aversion to stating his intent; by refraining from more suggestive titles, Gu avoids 'letting anything potentially Freudian slip' (2005: 200). To me, however, this tendency also reflects Gu's conception of art as a temporal engagement, like any transaction in life. His installation project then doubles as a process artwork, with its starting point triggered by a fortuitous occasion. Whatever factors this occasion dictates—the given site, its natural and artificial particularities, the curatorial narrative, the budget, etc.—determine Gu's subsequent plan, realized through the artist's onsite execution. To the artist, his process of art ends at the moment he 'transacts' the completed installation, passing it on to the viewers when the exhibition opens. Although Gu prefers audience interpretation to authorial dictation, he cares enough about the presence of time to mark his authorial departure with a string of numbers from the solar calendar—a documentary format supplied automatically by the camera.

No matter how serious a human transaction might seem, it is subject to life's one constant law—time. With the ceaseless flow of temporality, nothing mortal stays put; the apparently permanent belies the always-already ephemeral. Perhaps it was this realization that inspired Gu to shift his art from approximating the biomorphic to presenting the organic. If he was used to recording time's presence in abstract numbers printed on photographs of his installation pieces, now he laid bare time's materiality. Gu's transition happened in 1994, when he spent a year making a small flesh sculpture at his home studio for a 1995 exhibition in Germany.

In this extended xingwei process, Gu begins with a chunk of raw pork, has a picture taken of his right hand holding the fresh meat between his thumb and index finger, proceeds with the daily kneading of the flesh until it is hardened and finally encases the calcified meat in a small transparent plastic box.[26]

26 My phone interview with Gu Dexin, 6 February 2009, Los Angeles to Beijing.

Gu displayed both the picture and the sculpted meat in the exhibition. In between the genesis—contained in a photograph—and the apocalypse of a fossilized remains—shown onsite in a see-through box—emerged an archetypal xingwei-zhuangzhi as a performance-installation: an artist's protracted private performance led to an installation that was not so much site-specific as kinship-specific. In its mode of presentation, we see a photograph recalling a durational xingwei that cannot be fully witnessed by others onsite; we can also imagine touching—when the museum guard is not watching—the exterior of a zhuangzhi, a plastic case within which a 'processed meat' sculpture is placed, right next to an imagistic index of its making.

In 1998, when his large-scale installations had yet to be seen in Beijing, Gu presented another prototype of xingwei-zhuangzhi as a performative installation—using organic matter to create site-specific installations that would disintegrate throughout the exhibition process.[27] In the interest of tracing an indigenous time-based art lineage here, I shall discuss Gu's first two xingwei-zhuangzhi pieces created in Beijing.

27 For more analysis of Gu's consumableworks, see Chapter 5.

IMAGE **2.7** The year-long meat-kneading xingwei piece (1994–95) by Gu Dexin. Image courtesy of the artist.

In *98 1 2 (2 January 1998)*, Gu spreads out 100 kg of pig brains to form a blood-dripping rectangle on a trestle table covered with an outsized piece of red fabric. Two white curtains hang on either side and frame the table while a red cloth shaped like a large flag hangs on an adjacent wall.

This installation appeared in *Shengcun de henji: '98 Zhongguo dangdai yishu neibu guanmo zhan (Trace of Existence: A Private Showing of Contemporary Chinese Art '98)*, a group exhibition curated by Feng Boyi and Cai Qing and held in an abandoned private factory in the eastern outskirts of Beijing. Although *Trace of Existence* lasted for only one (wintry) day, the pool of raw brains assailed those who dared to approach it with olfactory aggression: 'This work evoked disgust, terror, and aversion in the spectator but it was also a deliberate bad joke, an assault on the senses, and a critique of conventional symbols of power,' remarked curator Feng (Ai Weiwei et al. 2000: 151).

In *98 11 8 (8 November 1998)*, Gu scatters six sets of almost identical flesh sculptures on the concrete floor across two windowless basement rooms. Each sculpture is a collage of five objects: a breast-size mound of pork with skin and fat intact; a partial pig brain lying on the mound's middle; a pig heart penetrated by a fresh rose resting next to the mound; and a lamp with a low-voltage pink bulb hanging low from the ceiling, casting a dim rosy glow round the sculpture.

98 11 8 appeared in the bilingually titled exhibition *Pianzhi/ Corruptionists (Persistent Deviation/Corruptionists*, 1998),

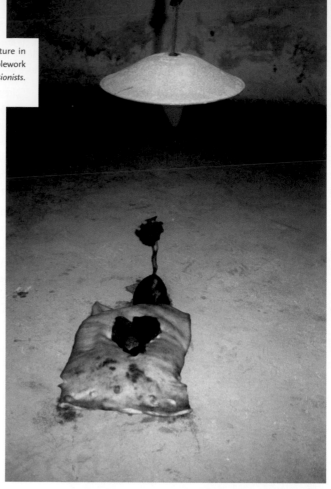

IMAGE **2.9** A set of xingwei-zhuangzhi sculpture in *98 11 8 (8 November 1998*, 1998), a consumablework by Gu Dexin, in the exhibition *Pianzhi/Corruptionists*. Image courtesy of the artist.

which, curated by Xu Ruotao and Xu Yihui, was the first experimental group show in Beijing to use a sprawling basement in an office/residential building as the exhibition site (see ibid.: 149–53). Under the soft pink light, Gu's six composite sculptures were indistinguishable from one another but they actually aged differently. Six days before the opening, Gu placed the first flesh sculpture in the room and then a new set each succeeding day, with the last—and freshest—set placed on the opening date. Discerning viewers could perhaps intuit the sculptures' different degrees of decay by their smell and by how much the rose in each had wilted but most, as the artist recalled, fled from the scene.[28]

28 My phone interview with Gu Dexin, 14 July 2008, Beijing to Beijing.

98 1 2 and *98 11 8* had many similarities. They both used animal flesh as the main art material, creating installations that were fluid, changing and perishable. Despite different quantities of material employed, both pieces featured repetition and duplication—the pig brains in *98 1 2* were aligned symmetrically like an army of clones, an artist's handmade simulation of mass production. Uniformly assembled and placed at regular intervals, the composite flesh sculptures in *98 11 8* presented, even as they disguised, a tension of opposites between their

taut biomorphic configurations and chaotic, entropic contents. Coincidentally, both pieces happened to result from Gu's compromised schemes. For *Trace of Existence*, Gu proposed to build—according to Karen Smith—'a vast bas-relief of female genitalia sculpted from minced pork, with a dousing of blood for added impropriety' (2005: 209). Feng Boyi rejected Gu's proposal for fear that such a blatantly sexual scheme would risk official cancellation of the whole show, even though the curators had explicitly identified the exhibition as a 'private showing' to avoid police inspection.[29] As a substitution, Gu presented an abstract formation of harvested pig brains. For *Persistent Deviation/Corruptionists*, Gu proposed to pave his two assigned basement rooms entirely with animal brains on the ground; he altered his design for lack of funding.

29 As Wu Hung notes, a private show could avoid the official inspections required for a public show (2000: 149).

Compromised or not, Gu's two resulting pieces addressed the curatorial themes while remaining actively multivalent. According to curator Feng in the exhibition catalogue, *Trace of Existence* emphasized 'personal experience' and 'the fluidity of daily life'. Feng further relates this individual-oriented quotidian theme to 'two current phenomena in China: the rapid development of a commercial economy; and people's growing lack of interest in political ideology. Art increasingly becomes a "collage" of life itself' (Ai Weiwei et al. 2000: 153). In interpreting Gu's piece, however, Feng deviates from his general analysis to point out its imagery's inseparability from 'politics', and Smith concurs with Feng by noting Gu's adulteration of 'the patriotic, emblematic nature of red in China, which traditionally encapsulates joy and celebration, latterly Communism and Maoist ideology' (2005: 209). She also adds that Gu's 'use of pigs' brains intelligibly echoed the metaphor used by George Orwell to signify the abuse of power in *Animal Farm*, where pigs rule the roost' (ibid.). While agreeing with these politicized readings, I believe it's equally plausible to read the pigs' brains biologically, as samples of the organ that produces, organizes and stores memories, hence keeping traces of existence for an animal subject—a human included. This thematic reading hints at a possible concept behind Gu's original scheme: the vagina may be deemed a nativity threshold where one begins accumulating and leaving life's traces.

Pianzhi/Corruptionists was an exhibition based on a non-theme, because the curators encouraged participants '"to persist" in their respective "deviations" and to develop their art towards their individual strengths' (Xu Yihui 2000: 157). Gu's original plan of utilizing copious amount of animal brains addressed both the nominal theme and his aesthetic preoccupation. Had this plan been realized, his xingwei-zhuangzhi would have transliterated 'persistent deviation' into organic terms, decoding psychic obsession through 'brainy' excess. His actualized scheme—which I consider a better one—expands the concept to implicate more parts of the animal body as sources for obsessive fixation. Such an obsession may be sexual in nature, as suggested by Smith, who describes Gu's organic sculpture as 'shaped like female genitalia' and the rose as a phallic symbol, 'proudly erect in each mound' (2005: 210). Reading it more broadly, I take Gu's flesh collage as a synecdoche for the whole body—the pig's doubled as the human's. By literally throwing spotlights on the brain and the heart, Gu highlights these two psychosomatic organs in which most of our 'deviant' humours amass; he dramatizes our turmoil at the exact moment that a fetish—the rose as any object of desire—punctures our seamless subjectivity.

I realized that it's less than strenuous for me to contemplate Gu's *objects-d'art* from a distance, when most of my bodily functions are stilled in a scholarly haze. Activating my sensory recall of similar encounters with over-ripe organic artworks—indeed, with decay of any sorts— I can imagine how vulnerable I would have felt in the presence of Gu's transmogrified animal anatomies. The visual terror compounded by pervasive sensory assaults as embodied by *98 1 2*, for example, would have thrust me into a fast-forward screening of my days beyond death, witnessing my putrefying innards melting into the earth. This piece's violence invokes my all-too-close kinship with the brains on the bleeding table, sheltered, as it were, by the pallid mourning of the white curtains, my winding-clothes in-waiting!

Notwithstanding this histrionic rendition, my self-reflexive reading of *98 1 2* cannot explain a coexisting conceptual motif, one that also appears in *98 11 8*—multiplication. One pig brain would have been a sufficient metonymy for all organic matters and its ceaseless disintegration their inevitable entropic ends. Why did Gu use so many? If repetition is an obsessive visual principle in *98 1 2*, then the replication of six flesh sculptures in *98 11 8* conveys a narrative about being-in-time—the same creature, at six different ages. Why, then, did Gu make the six look virtually identical?

An alternative picture emerges when we shift from an existential to a socioeconomic reading, taking into account China's epochal transformation from a Maoist communist economy which privileged production to a Dengist proto-capitalist market economy which, in contrast, encourages consumption, especially as the expenditure of goods and services helps to enhance the perceived quality of daily life. In the late 1990s, the idea of consumption as consumerism had become a behavioural pattern sanctioned by government policy and endorsed as a sign of social distinction. It was a sociocultural spectacle flirting with the bourgeoning mass culture, which consumed entertainment, and dovetailing with globalization's hegemonic ideology, which consumed Americanized ideals of leisure, glamour and individual freedom. Against this larger background, we may read Gu's aesthetic of excess and multiplication as an ambivalent reaction to consumption—the grotesque abundance of his perishable art critiques consumerism even as it reproduces its perverse glory and skin-deep opulence. The massive assembly of pigs' brains in *98 1 2* parodies the mass production of standardized commodities and exposes the carnage from hedonistic materialism. The replicated flesh sculptures in *98 11 8* satirize the discrepancy between appearance and deeper substance; their beguiling optical semblance may evoke cosmetic surgery's small wonder or economic globalization's *grande façade*— the former can erase external signs of ageing but cannot stop the body from growing old; the latter promotes transnational exchange of capital at the expense of exacerbated economic inequality among and within nations.

I raise all these interpretive possibilities for Gu's art not to privilege any one as the best reading but to demonstrate his xingwei-zhuangzhi's enriched openness. Gu's work is at once simple and complex, gross and sublime, poetic and violent. It is this dialectical dynamism that makes Gu's contribution quintessential to my genealogical tracking of Beijing's brutal time-based art. With Gu's projects, we see a sharp transition from zhuangzhi (static installation) to xingwei-zhuangzhi (performative/ever-shifting installation), when symbolic suggestion moves beyond metaphor and joins material presentation—ephemerality is now embodied by

ephemeras. We also see the emergence of consumablework, a new time-based art genre that I define here, according to Gu's paradigmatic practice, as a xingwei-zhuangzhi artwork made of consumable material, organic or otherwise. In Gu's *oeuvre*, animal flesh is used alongside plastic; other organic matter appears in juxtaposition with less perishable commodities. Some of Gu's projects are bodyworks joined with animalworks, such as his meat-kneading durational projects; others are animalworks bleeding into consumableworks, such as *98 1 2* and *98 11 8*. Almost all of them are consumableworks.

Consumableworks target the blind spot of consumerism as a psychological and behavioural fixation on acquiring more and more commercial goods and services for everyday life fulfilment. The euphoric charge that I derive from satisfying my craving for commodities depends much on my ability to push the violence associated with consumption to the unmarked sideline. With gleeful perversity, Gu reverses the figure-ground relationship in China's present proto-capitalist regime's hottest sociocultural habitus—his consumableworks bring violence centrestage while blocking out the erotics of consumption behind sensory shocks. Gu's unexpectedly appalling spectacles provoke strong emotional and physiological reactions from viewers, persuading them to perceptually register the violence, repulsion, taboo, destruction, exploitation and waste much more readily than the pleasure from compulsive and coercive consumerism. Consumableworks like *98 1 2* and *98 11 8* are then the objective equivalents of certain malcontent subjects who loudly protest against the proto-capitalist transubstantiation of the society round them by dragging out—unsightly, smelly detritus and all—the hidden costs of this ongoing process, even as they cannot help but simultaneously benefit from their country's postsocialist economic boom.

Thus far my compact genealogy of Beijing's brutal time-based art points to an evolving typology of performative violence. In the post-Tiananmen ## TYPOLOGY OF TEMPORAL VIOLENCE

era, when it was no longer safe to clash with the grand political ideology, Ma Liuming and Zhang Huan re-directed violence towards their acting bodies. Their East Village xingwei artworks sought to expand semiotic possibilities within the discipline and to empathically absorb the pressures of a fast-changing society. The violence radiating from Gu's xingwei-zhuangzhi, however, confronted a newly elevated level of perception and behaviour related to consumption. Unlike the cruelty in East Village works, violence in Gu's consumableworks became re-coded as an effect rather than a source of consumption. With the advent of consumableworks, I submit, consumption emerged as a raw creative concept in Beijing's time-based art.

Among concurrent consumableworks, what makes Gu's *oeuvre* particularly seminal in the lineage of aesthetic brutality I am tracing is his alignment of consumption with violence. To the extent that consumption as consumerism is a function of the accumulation, expenditure and circulation of capital, the violence of Gu's consumableworks becomes linked with the 'green' stare of banknotes (for cash) and the mathematical abstraction of shifting digits (for financial exchange). Gu's consumableworks both foregrounds the slimy heat of blood and gore—highlighting the colour *red*, wet and dripping, as decaying matter—and sardonically aims at the symbolic aridity of *green*, for greed. His xingwei-zhuangzhi therefore hits on two

experiential registers at once, showcasing violence as both the underside of excessive commercial consumption and a natural effect of time upon mortal flesh. By affiliating consumption with the obdurate force of time, Gu has effectively retrieved this capitalist concept's premodern signification as an act of destruction, waste and exhaustion, foregrounding those harmful dimensions evident in consumption's historical denotation as any wasting disease (see Williams 1983 for a semantic evolution of consumption in English). Gu's grossly sublime art relates a relatively recent phenomenon in China—capitalist consumerism—to an ever-present process inseparable from our organic and social existence. By conflating the topical issues with perpetual ones, Gu's temporal *oeuvre* has taught me to recognize consumption as a constant thematic layer in Beijing's brutal time-based art.

Indeed, acts of consumption suffuse my daily world. I do it when I spend, eat, drink and breathe. I do it when I walk, drive, travel in the air, when I read, watch a movie or surf the Internet. As one who consumes, my ability to act often necessitates rendering negligible the violence incurred by my actions. And I tend to forget I am also that which is being consumed— by my everyday routines; my efforts to earn a living; my interactions with others; my ambition, obligations, anxieties, obsessions and phobias; and the sheer physical functions that sustain my embodiment. I exert violence as I consume the world and the world reciprocates as it consumes me. Am I not myself a consumablework, driven as I am ceaselessly towards my expiration by the violence of being?

Perhaps a similar reasoning inspired a great number of Beijing artists to probe the violence of consumption as they plunged into their millennial gore fest. The theme was so ubiquitous that I devote nearly half of *Beijing Xingwei* to exploring its multifarious manifestations, with the present chapter mapping its genealogical 'nadirs'—its perceptual abyss—and the next two tracking variations in extreme bodyworks and animalworks. By unearthing consumption's hidden rage, these Beijing artists have cumulatively produced a conceptual repertoire of violence in art that can serve as a glocal reference point for creating and critiquing future time-based artworks.

Zhu Yu's corpus of consumableworks marks the 'event horizon' in my brutal genealogy. Because of his relatively later entry into Beijing's experimental art scene, Zhu encountered a different sociocultural ecology from those endured by his native predecessors. Although experimental artists continued to face a domestic environment with inadequate exhibition resources and rampant censorships, an indigenous Chinese time-based art heritage was gradually forming throughout the 1990s. By 1998, when Zhu began presenting his macabre opuses to the public, Gu's xingwei-zhuangzhi artworks were finally seen live in Beijing; Ma Liuming and Zhang Huan, like Gu before them, had become internationally known and were getting exhibition opportunities abroad. In fact, Zhang would soon depart for an overseas career in New York. Much of the violence underscoring Beijing's millennial brutal art reflected the tension of a paradoxical situation. On the one hand, Chinese experimental artists persisted in local struggles to be accepted for their alternative art; on the other, their options for participating in multiple global art circuits had increased exponentially. Both scenarios exerted pressure on Beijing's time-based artists to understand how to disseminate their perishable artworks among a wider audience, one that would validate their achievements and advance their careers.

Therefore, their success hinged on devising various ways of transmitting their creative outputs to the globalized contemporary art world. As the twenty-first century approached, Zhu and his cadaver-school peers were arguably better situated to take advantage of existing modes of transmission tested by their indigenous predecessors.

When I began my pre-fieldwork research in 2003, most information about Chinese xingwei yishu and xingwei-zhuangzhi existed on the Web in haphazard abundance. Traces of various pieces, especially controversial ones, appeared as piecemeal references in the press, as mere mentions in some vaguely identified exhibitions or as fragmented citations tenuously connecting critical reviews and Internet chats. A few still images from certain projects, usually with little explanation about the art-making and performance processes, were the most substantial anchors for prolonged exploration. This format for organizing and distributing information apparently favours visual stimuli over detailed discourse and indicates how an artist might conceivably construct an artwork to maximize the impact of photographic documents: the medium is the message and the message is the image! Or, virally put: the medium = the message = the image! Noticeably, our contemporary moment has pushed Marshall McLuhan's 1964 maxim further towards the visual spectrum (1994).

THE LOGIC OF VIRTUAL DISPLAY: A PRELUDE TO VIOLENT CAPITAL

Unlike actual publication and exhibition, however, the Internet is a rather unstable dissemination tool.[30] The case with Zhu's *Eating People*, which has generated more rumours than serious discussions in cyberspace, exemplifies the risk of authorless virtual display. At present, in the second decade of the twenty-first century, more and more Chinese time-based artists intervene in the Internet's 'viral culture' by supplying authorial information through their gallery or personal websites, their blogs, Twitter-equivalents and YouTube entries.[31] Only a few years ago, however, few Chinese artists had the financial/technological wherewithal to do so. This existing circumstance reinforces the increasing significance of the World Wide Web as a technological accessory to time-based art practice, which may well evolve into a hybrid new media art mode by integrating the Internet as a productive language and presentational channel. Alternatively, time-based art may use this multifarious and high-capacity, if volatile, platform as a means of locally documenting and globally transmitting ephemeral artworks.

My initial access to Zhu's controversial performance art demonstrates a prevalent means of retrieving information about Chinese time-based art by an overseas viewer/critic. It also suggests a decisive difference in Beijing's time-based art field between the early 1990s and subsequent years, when the Internet became a prominent globalization tool in China. Above all, the phenomenon indicates the power of virtual display as a prosthetic extension for actual exhibitions. All modes of transmission, other than live exhibitions, revolve round what I classify as *virtual display*—a two-dimensional exhibition on paper or on the screen—which can prolong

30 Websites that have been around for a while, hosted by certain organizations, may disappear overnight because of a lack of funds, or because of unmentioned hence mysterious reasons. A great loss was the disappearance of an online magazine Chinese-art.com, formerly named Chinese Type Contemporary Art, which kept an archive of images and articles for xingwei yishu from 1998 to 2003 but was shut down due to lack of funding (my email correspondence with Robert Bernel, the founding editor of Chinese-art.com, 2003). I no longer have the exact entry in my file.

31 'Viral culture' is a term used by Bill Wasik to analyse the hyper-connected Internet world (2009).

the public exposure of transient art actions and enable their post-mortem dissemination. This general condition for transmitting time-based art, however, had a different regional resonance in Beijing during the five-year period (1998–2003) in which Zhu was most active as a xingwei artist. In those years when the actual displays of experimental art in Beijing frequently suffered from censorships and cancellations, virtual display was considered not only a technological accessory to a live exhibition but also a proactive survival kit for artists to document their public presentations. Prior to and then concurrent with the Internet, an exhibition catalogue has served Chinese artists as both a discursive addendum to a live event and a platform for virtual display. In the event that an exhibition was banned before it opened, the virtual then substituted for the actual.

Concomitant to our discussion about display—virtual or not—is the question regarding implied viewership. We may arrive at the identity of the intended viewers of Chinese experimental art by considering two phenomena that have become routine practices since the late 1990s: One, many of the experimental exhibitions have two titles, one in Chinese and one in English; Two, many exhibition catalogues are published in Chinese and in English. Wu Hung has explained the former phenomenon as Chinese artists' characteristic 'dual positioning': 'The exhibition's two titles in two languages disclose two different positions from which the self is defined and imagined' (2000: 155). In conjunction with the second phenomenon, we may regard such dual positioning as a positive embrace of globalization by including its current lingua franca, English, in exhibitions and catalogues. Set against Beijing's then harsh domestic exhibition environment, however, this bilingual dual positioning admitted the need to facilitate information access by a non-Chinese-reading public.

Towards the end of the last millennium, with China's expanded economic reforms, the accessibility of transnational capital and international press coverage produced a globalized context for its experimental artists. As exemplified by Gu, Ma and Zhang, and by the success of many expatriate Chinese artists, the major outlet for art world recognition, critical appraisal and more rewarding career opportunities came from overseas, including the West and other wealthier Asian regions, such as Hong Kong, Taiwan, Singapore, South Korea and Japan. Such unilateral dependence on foreign (or non-Mainland) resources for affirmation and career sustenance illustrates what many Chinese art critics and curators have perceived as their indigenous art world's postcolonial condition. They responded to this cultural-economic imbalance variously with rage, bitterness, embarrassment, resignation or pragmatism. A sense of suppressed cultural subjectivity, for example, characterizes the following comment by curator Huang Zhuan:

> The international trend of postcolonialism in the 1990s has provided Chinese contemporary art with unprecedented opportunities to enter the global sphere. But because the position of Chinese art in this globalization process is determined by mainstream international art, it can only make a passive entrance onto the international stage. Not only is Chinese art stripped of an opportunity to demonstrate its real significance to a global audience, but it has been used as material to enrich a post–Cold War and postcolonial discourse (cited in ibid.: 136).

This analysis appeared in Huang's curatorial introduction to a large-scale exhibition which he planned for the express purpose of featuring contemporary Chinese artworks selected by a Chinese curator for the Chinese public. The authorities, based on some obscure bureaucratic procedure, cancelled the exhibition one day before its scheduled opening. Ironically, Huang's struggle to achieve indigenous autonomy was thwarted not by the *postcolonial* condition but by the *postsocialist* oppression. In its first post-Tiananmen decade, the Chinese government's continuous political surveillance of cultural spheres, aggravated by the country's paucity of cultural support structures, reinforced positively, if accidentally, its art workers' postcolonial condition. As someone of a Taiwanese descent, I grew up experiencing a similar postcolonial condition on an island across the Taiwan Strait. I sympathize with Huang's assertion of an underdog's dignity, yet I cannot bring myself to fault those artists who should seek top-dog status. Nationalistic pride is one thing, professional survival another.

If virtual display responds to the combined violence of postcolonialism and domestic political repression, its tacit selection criteria also generate implicit violence. The discursive environment resulting from such a confluence of violence at multiple levels possibly abetted Beijing's millennial brutal art trend. To say the least, extreme artworks make for striking, and often startling, pictures. These still images, captured furtive impressions from spent actions, bait the media and stimulate subsequent cultural circulation. As documents, the images quickly assume the compound status of products-cum-stylistic calling cards for their creators. So the logic goes: the more violent the actions and the more graphic the images, the more competitive and worthy of media attention their creators. The more the opportunities for the artworks to be virtually displayed. Thus, Beijing's atrocious time-based art trend may indicate the allure of what I term 'violent capital'—the capital (artistic reputation and attendant rewards) gained by violent actions framed within the symbolic realm of art.

Being primarily a symbolic distinction, 'violent capital' signifies a species of what Pierre Bourdieu calls 'symbolic capital'; it belongs specifically to the family of 'cultural capital' (see Bourdieu 1986). Although I strongly doubt that it singularly motivated Beijing's brutal art practitioners, violent capital does project the possibility of turning aesthetic violence into an instant artistic commodity. Financial reward, I admit, would not be a sufficient incentive for those who chose to work in the unprofitable time-based art medium. But what if these artists could simultaneously do all of the following: produce creatively satisfying artworks; gain a competitive edge over fellow artists, both native and foreign; and improve their career paths? In this light, violent capital represented an optimal condition of production for those artists already interested in probing the violence of consumption. The same argument explains why violence and brutality have ceased to be an obsessive motif in Beijing's time-based art. Insofar as shifting cultural fashions and periodic sociopolitical remodelling in China's bourgeoning consumer society have devalued violent capital, brutal consumableworks could hold only short-term currency within Beijing's experimental art subculture.

Now, can I apply the logic of violent capital to assess Zhu's *Eating People*?

Like Sun and Peng, Zhu figures prominently in an interview with Januszczak in *Beijing Swings*. As I mentioned, the duo's *Linked Bodies* and Zhu's *Eating People* shared the dubious honour of being the British viewers' most abhorred pieces in Januszczak's documentary. Yet,

Sun and Peng have prevailed—winning awards, representing China in Venice Biennale, getting invited often to international exhibitions, being published in major catalogues and being acquired by eminent collectors—in the past few years in ways that Zhu has not. In 2008, for example, Sun and Peng won critical acclaim for their mobile xingwei-zhuangzhi *Old Persons' Home* (2007) in *The Revolution Continues* show; Zhu's conceptual piece in the *Third Guangzhou Triennial: Farewell to Postcolonialism: Wei lianheguo chengyuan suo zuo de 192 ge fang an* (192 *Proposals for Members of the United Nations*, 2008), was partially blacked out and veiled by officials. This scenario did not appear preordained just a few years earlier. In fact, as Lu Hong and Sun Zhenhua phrase it in their first book-length study of xingwei yishu written and published in Chinese: 'In the xingwei yishu art world, some people say 2000 was the year of Zhu Yu' (2006: 91). What happened thereafter?

To tell the story here, I shall begin again with the *Fuck Off* exhibition.

VIOLENT CAPITAL | *Fuck Off* (1–7 November 2000) was one of the 'satellite exhibitions' surrounding the Shanghai Biennale 2000 (6 November 2000–6 January 2001), cashing in on the influx of international art critics, reporters, collectors and dealers attracted to the biennale. Shanghai Biennale 2000 was the first government-sponsored international contemporary art show, highly publicized and well funded, assembled by a team of overseas Chinese and other international curators and housed in the state-run Shanghai Art Museum. In contrast, *Fuck Off* was subsidized by private money, organized by two Beijing curators, featuring mostly confrontational artworks produced by Beijing artists and displayed in a warehouse belonging to Eastlink Gallery on the outskirts of Shanghai. If the cosmopolitan organization of Shanghai Biennale signalled China's official endorsement of globalization, then the belligerence emblematic of *Fuck Off* indicated its curators' cognizance of the rising popular nationalism and anti-American sentiments at the beginning of the new millennium.[32]

32 For the events leading to such popular nationalism and anti-Americanism, see Zhang Xudong (2008: 102–35); Ben Xu (2001: 120–40); and Li Cheng (2000: 112–29).

As an unofficial exhibition mainly affiliated with Beijing's experimental art world, *Fuck Off* represented itself in opposition to Shanghai's commercial spirit. The brief curatorial statement by its organizers, Ai Weiwei and Feng Boyi declared that their exhibition consciously resisted 'the threat of assimilation and vulgarization' by operating in 'an uncooperative and uncompromising way', assuming the position of 'alternative art' to revise and critique the 'power discourse and mainstream convention' (Ai Weiwei et al. 2000: 8–9).[33] This cultural position, they declared, had 'an overt exclusionary and alienating tendency', aiming at such themes as 'cultural power, art institution, art fashions and trends, the dialogue between the East and West, exoticism, postmodernism, postcolonialism, and so forth'. Moreover, all participating artists of *Fuck Off* defied edicts to turn their artworks into 'objects of choice, identification and judgement'. They sought no approval from 'any system of power discourse'; they even doubted 'the necessity of having an audience'.

33 I have consulted the translation provided in the *Fuck Off* catalogue but re-translated certain passages.

Despite their verbal defiance, Ai and Feng followed two conventions of Beijing's alternative art world. One, their exhibition had two titles, one English and one Chinese—*Fuck Off* and

Buhezuo fangshi (*Uncooperative Method*). The former expresses a neo-xenophobic rudeness while the latter reveals a principled—if much tamer—attitude towards their Chinese viewers, pre-empting, perhaps, interference from institutional censors. The pairing of these titles betrays, in Napack's diagnosis, 'calculated sensationalism for foreigners, self-censorship for local consumption' (2004b). Two, even though the curators verbally dismissed the need to have an audience, they still published their catalogue bilingually in Chinese and English, hence accommodating their English-reading viewers. Are these contradictions between the curators' attitudes and actions an insolent show of their sophistication or an awkward bow to their postcolonial dilemma?

Looking more closely at the catalogue, I feel inclined to see that both scenarios are true—Ai and Feng were honest about their aggressive independence but they were also pragmatic enough to give in to documentation which would potentially prove their exhibition's significance to the world-at-large. This catalogue's black cover bears two title lines in inverse print—不合作方式 (*Buhezuo fangshi*) 'white-shadowed' by *Fuck Off*. This cover design recalls an earlier publication coedited by Ai, the so-called *Heipi shu* (Black Cover Book, 1994), an untitled volume with black covers, containing interviews, translated articles and archival images submitted by participating xingwei artists who also funded its publication. Like its predecessor, the *Fuck Off* catalogue functions as virtual display, for it seems both more and less than a printed record for the exhibition at Eastlink. The catalogue reads like an anthology of selected artists and their recent works without identifying which work was meant specifically for *Fuck Off*. As a result, most images in the catalogue have been shown in other exhibitions, whereas all the time-based pieces that took place during the show—including, for example, Yang Zhichao's *Zhongcao* (*Planting Grass*, 2000), He Yunchang's *Shanghai shui ji* (*Shanghai Water Diary*, 2000) and Wang Chuyu's *Wo de meng* (*My Dream*, 2000)—leave no record in the catalogue.[34] In my phone interview with Ai, he attributed the way this catalogue was compiled to time constraints—'about nine days, from design to layout'—forcing them to exclude all artworks done onsite; they also had to make a last-minute change of printing companies because the first one threatened to call the police to report the book's controversial content.[35] In any

34 My interviews with Yang Zhichao, 10 July 2006, with He Yunchang, 10 July 2006, and with Wang Chuyu, 7 July 2006, all in Tongzhou, Beijing. See Chapter 3 for an extensive analysis of Yang's *Planting Grass*.

35 My phone interview with Ai Weiwei, 1 September 2004, Los Angeles to Beijing.

case, the catalogue serves selected artists as an ongoing public outlet for their work rather than as a document of one exhibition. It celebrates *Fuck Off* as an occasion to assemble all these artists in one place/book but it also effaces the live exhibition in favour of individual artistic corpora.

There are, then, two *Fuck Off* exhibitions: the one staged in Shanghai in 2000; and a parallel one that ever unfolds across the catalogue's pages. The first one surprised the public by its incessant and strident visual motifs of multifarious corporeality; its print counterpart, more comprehensive in scope and enduring through its contact with future viewers, shocked the world with its concentrated, if partial, portrayal of Chinese contemporary art's most abrasive fringe. When the real receded into history, its textual and visual surrogate, as an illustrated anthology, continues to recall the no-longer- or never-there.

The drama playing out between these two *Fuck Off* exhibitions projects a certain ironic poignancy in the case of Zhu's *Eating People*. Quite a few journalistic accounts, even scholarly

articles—including that of Carlos Rojas (2002)—have mentioned *Eating People* as a live performance enacted during *Fuck Off*. In fact, no one had seen *Eating People* during the actual exhibition! According to Zhu, Ai had accepted his proposal for using five photographs plus an artist's statement to display his cannibalistic xingwei piece. Ai also advised that Zhu changed his original title, the blunt and colloquial *Chi ren* (Devouring/Chewing on People) to the more literary *Shi ren* (Eating/Consuming People). When Zhu installed his photographs at Eastlink, a few participating artists were worried that the police would cancel the entire show. In deference to the concerned artists, Ai negotiated with Zhu to remove his photographs from the wall; when the artist agreed, Ai whisked them away from the exhibition site. In front of the empty wall, Ai displayed a black suitcase with a baby spoon locked inside.

As Ai explained to me, the curators used the black suitcase as 'a symbolic protest': 'We kept it locked up but we refused to remove it from the exhibition site.' Yet, I wonder, how effective would the protest have been, if no one had known the suitcase's purpose? To me, Ai's curatorial intervention created a different time-based piece all on its own—as a curator, he was forced to perform *ziwo shen cha* (self-inspection), an agreed-upon, pre-emptive form of internal censorship; as a conceptual artist, he also used the occasion to respond to Zhu's piece. Nonetheless, the trunk was locked and unmarked. When I first asked him what he had placed inside the suitcase, Ai resisted revealing the secret until I pressed him, persistently and with extreme politeness.[37] Did Ai mean for the sealed black suitcase to intimate a tomb? Shall I inscribe its epitaph: 'Once there lay a baby spoon, inside a locked trunk to which I have no key'? I cannot see inside the suitcase, nor can I find answers to the questions raised by Ai's clandestine protest: 'Who will use the baby spoon? Is the baby travelling? Where oh where has the baby gone?'

Zhu did not know what Ai placed inside the locked suitcase either. He agreed to the anonymous display devised by Ai for fear of becoming the official censors' excuse to close down the show. As Zhu told me, most reviewers and critics of *Eating People* had not seen the *Fuck Off* exhibition in Shanghai. The furore over Zhu's *Eating People* arose solely in response to the virtual/print display of its photo documents. The images that became widely circulated and contested in the media and on the Internet came straight from the catalogue.

37 My interview with Ai Weiwei, 5 July 2005, Beijing.

Eating People in the Printed *Fuck Off*

How, then, does *Eating People* fare in the paper gallery of the more-than-a-catalogue *Fuck Off*?

This document supports the archival interest by identifying, from the curatorial perspective and in (English) alphabetical order, top contenders in Chinese contemporary art. It also tantalizes researchers with its laconic approach, heavy on images and light on basic information—a déjà vu of the principal format I noticed in my Web research. It does, however, reserve a *visible* space for Zhu's xingwei artwork that remained hidden from sight during the actual—3D—exhibition. Since the pinyin for Zhu starts with a Z, *Eating People* happens to be the last entry closing the catalogue. Whether by design or by divine intervention, *Eating People* stands there literally as a boundary text. From its extreme margin, the piece symbolically 'bookmarks' the line where art borders on sacrifice in the religious sense, on taboo in the moral sense, on crime in the legal sense and on violence in the aesthetic sense.

No matter the curators' self-censoring precautions in the actual show, the print display in the *Fuck Off* catalogue was the proof and justification most critics used to condemn the patho-logical turn of Chinese contemporary art, blaming espe-cially the excess of xingwei yishu.[37] Chen Lvsheng, for example, pronounced that avant-garde art had gone over the edge to the point of demonification (*zou huo ru mo*, 'walking over fire into devilry') (2001). Chen augmented his censure by giving out an anonymous list of recent xing-wei violations which run the gamut from suicide, branding, blood-letting, flesh-cutting and self-mutilation to cannibal-ism, corpse-tampering and animal torture. Chen withheld the artists' names while describing their 'abominable' acts committed 'in the name of art', deliberately depriving perpetrators of the notoriety—and any resultant reward—he believed they were seeking. Without precisely using my term, Chen implicitly invoked the fiscal aspect of 'violent capital' as the sole motiva-tion behind these scandalous performances.

37 Both Zhu and Ai told me that, in the last weeks of the *Fuck Off* exhibition, the Public Safety Bureau took away some of the displayed artworks for closer study. The black trunk in place of Zhu's *Eating People*, however, remained throughout the exhibition period. *Eating People*, though, became the most cited case of artistic depravity in China's National People's Congress meeting in March 2002. See Jonathan Napack (2004a).

Even among concurrent transgressive performances, Zhu's *Eating People* retains its boundary-busting status as a xingwei artwork that questions the limit of xingwei. Although *Fuck Off* was the first and the last live exhibition that 'un-displayed' *Eating People*, Zhu is unde-terred, having professed to me that he would have carried out the action anyway, even without anticipating a public forum.[38] Like most xingwei practitioners, Zhu has devel-

38 My phone interview with Zhu Yu, 26 August 2004, Los Angeles to Beijing.

oped his artistic corpus following his self-determined initiatives rather than in accordance with exhibition opportunities. While the latter has been the model for most xingwei-zhuangzhi artists, such as Gu, I consider Zhu's art akin to Gu's because both artists are similarly fascinated with the violence of consumption. Zhu admitted that he had seen Gu's trestle table with pigs' brains in *Trace of Existence* but he deems Gu's art 'too hermetic and private to be connected with current sociocultural affairs'.[39] Without asserting Gu's direct influence on the younger artist, I contend that the series of time-based artworks that Zhu produced prior to

39 My phone interview with Zhu Yu, 16 February 2009, Los Angeles to Beijing.

Eating People and its spiritual sequel *Xian ji* (*Sacrificial Worship*, 2001–02) are consumableworks which extend Gu's experiments with perishable art materials to the anatomical space of dead human bodies. Gu has used non-human and non-animal (fruit) flesh as a metaphor for the corporeality of our *Homo sapiens* species; Zhu turns ultra-literally to dead humans as specimens to illustrate our imminent corporeal decay.

Zhu's earliest selection published in the *Fuck Off* catalogue is *The Foundation of All Epistemology*—the project posted on Taiwan's GIO site without proper identification. | **Inedible Brains**

Zhu began investigating the possibility of using human cadavers as art material in 1995. Having spent three years looking for a possible source for his cadavers, Zhu finally convinced a profes-sor in the Anatomy Department of Beijing Medical University of his sincerity, that his intention was to use the cadavers to engage in artistic experimentation. On Saturday, 31 October 1998, when the University was on weekend recess, Zhu purchased five human brain specimens from

the department and used its laboratory to manufacture his xingwei products. *The Foundation of All Epistemology* begins with the artist cutting, grinding and boiling the brain specimens to make a stew. He then soaks the brain stew in formaldehyde, stores it in 80 glass jars and labels each jar with the manufacturing information (date, place, method of storage). Across each cap, he places a warning sign: 'Human brain product—forbidden to be eaten'. A team of his artist-friends, including Qiu Zhijie, Sun Yuan and Xiao Yu, help Zhu photograph and videotape the whole process.

As Qiu recalls in his memorandum for *Post-Sense Sensibility*, *The Foundation of All Epistemology* was the fountainhead from which all subsequent human cadaver-related projects originated. If Qiu's remark does not prove Zhu's influence on his peers, Zhu at least succeeded in finding an academic—hence respectful—supplier for cadavers and establishing the precedent of linking artistic experimentation with scientific research. Moreover, Zhu's brainwork happens to touch on the violence of consumption, which would also interest those who later chose to work with cadavers.

Although Zhu did not use 'consumablework' to describe *The Foundation of All Epistemology*, I maintain that he did engage with consumption on two levels. Performatively, despite the unusual material, his making of the brain stew resembles a cooking process. This culinary act evokes consumption as eating, even though the cook marks his product as inedible. Thematically, the piece's title refers to the brain's physiological function. What is the foundation of all epistemology, a branch of human philosophy that investigates the nature of knowledge? Answer: Our ability to learn, to know, and to remember by using our brain, the human organ for cognition and memory. How can we enrich our brain? A Chinese folk belief proposes homeopathic nourishment—*chi nao bu nao*, to eat the brain (conventionally, a pig's) so as to supplement the brain (most favourably, a child's). An absurd syllogism thus arises—epistemology equals the brain; the (knowing) brain equals the (digesting) stomach; epistemology equals gastroenterology. To consume a brain entirely is to know all it contains. Zhu's first consumablework, whether or not intentional, taps into this superstitious folk medicine with gallows humour.

The Foundation of All Epistemology became yet another type of consumablework through a serendipitous occasion. Several months after he finished the work, Zhu received an invitation to participate in *Chao shi* (*Supermarket*, April 1999), an experimental exhibition that displayed and sold its art exhibits at Shanghai Square Shopping Centre, an actual commercial site. Zhu shipped off his jars of 'brain jams', hired a female clerk to tend his shop, showed a videotape document of his manufacturing process and managed to sell 15 bottles for the moderate price of 98 RMB (roughly US$13) each. In this context, Zhu's warning sign, barring his brain jams from being eaten, became a veritable brand which guaranteed the uselessness—the non-utilitarian characteristic—of those jars as artworks. A rarefied commodity for high art consumption, *The Foundation of All Epistemology* in practice resembles and inadvertently pays homage to its antecedent conceptual kin, *Merda d'artista* (*Artist's Shit*, 1961) by Piero Manzoni.

Amputated Epistle | Chronologically following *The Foundation of All Epistemology*, *Pocket Theology* (1999) was Zhu's first artwork to appear in public through the *Post-Sense Sensibility* show. Zhu's xingwei-zhuangzhi features a severed human arm, hung by metal hooks from the low ceiling of a basement room. The arm holds on to one end of a long rope that is coiled up on the floor, covering the entire room. Spectators

are forced to make a choice at the door; they either pass by the room without entering or they step on the rope connected to the amputated limb in order to get close enough to scrutinize the gruesome centrepiece, a specimen Zhu loaned from the same supplier for his brainwork.

At one level, *Pocket Theology* was a static zhuangzhi piece. As the severed arm was chemically treated and stabilized, it resembled more a relatively permanent anatomical readymade than a ceaselessly changing performative object. Yet, the piece transitioned from a sculptural zhuangzhi into a xingwei-zhuangzhi through its spectators' interactive complicity. By stepping onto the rope and into the structure of Zhu's artwork, these viewers-turned-participants consented—of their own free will—to forming a visible link with the dead arm which ostensibly controlled the rope. In this light, *Pocket Theology* emerges as a consumablework that highlights

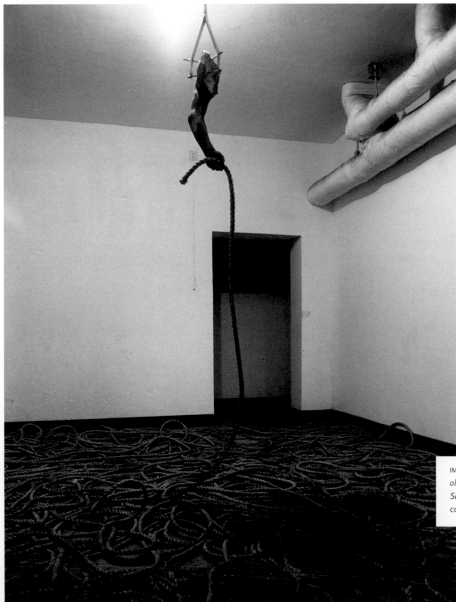

IMAGE **2.10** Zhu Yu's *Pocket Theology* in the exhibition *Post-Sense Sensibility* (1999). Image courtesy of the artist.

artistic consumption as a reciprocal violence—a *memento mori* brutally exposed to the gaze of the living who were temporarily annexed to an amputated reminder of their finite durations as sentient beings. Theology in a miniature: In my perceptual collision with a signifier of my mortality, am I obliged to contemplate the 'first cause' of my compulsory corporeality?

Nonsensical Switch | Like *The Foundation of All Epistemology*, *Zhi pi* (*Skin Graft*, 2000) was part performance, part process art and part installation.[40] Zhu began working on the piece months before its first public appearance on 22 April 2000 as part of *Dui shanghai de milian* (*Infatuation with Injury*, 2000, closed by authorities after three hours), an exhibition that shared the notoriety of *Post-Sense Sensibility* as a cadaver-school showcase.[41] *Skin Graft* revolved round the act of flesh transfer—from the artist to an other. Thus the piece is a consumablework even by its original concept, based as it is on an exchange behaviour that facilitates consumption. Zhu initially planned to operate on his thigh on the exhibition date and then use his

40 Urged by the art historian Wu Hung, Zhu Yu composed a detailed journal reflecting on the process of creating *Skin Graft*. Zhu began working on the project before December 1999 until the date of the performance on 22 April 2000. My assessment of the piece is based on this document, together with visual documents included in the *Fuck Off* catalogue. See Wu Hung and Zhu Yu (2001).

41 For a more detailed analysis of the *Infatuation with Injury* show, see Chapter 3.

IMAGE **2.11** An installation view of *Zhi pi* (*Skin Graft*, 2000) by Zhu Yu in the exhibition *Infatuation with Injury*. Zhu Yu standing with the curator Li Xianting, watching the videotaped document of Zhu's surgical skin removal procedure in the hospital.

excised skin patch to mend a human corpse with surface damage but a physician dissuaded Zhu from pursuing the dangerous self-operation. The artist eventually settled on gifting a dead *pig* to distinguish himself from other players of the *human* cadaver school.

As a multilayered installation on display, *Skin Graft* includes four components: a single hospital bed, on which rests the trunk of a quartered pig with skin from Zhu's abdomen (not his thigh) sewed onto a spot where the pig skin is damaged; a videotape document of the surgical process in which a surgeon removes the artist's epidermis; a blown-up picture of the artist lying on an operating table with his abdominal cut; and the artist himself showing his abdominal scar to spectators upon request. Like a Chinese box that contains multiple corresponding but smaller and smaller boxes, *Skin Graft* spreads its proverbial boxes in a series of framing processes. The artist's flesh supplied the first canvas, painting and frame which in turn, through the artist's act of transplantation, framed the trunk of pig as an art sculpture. The artist was simultaneously the framed and the framer, as he sewed his excised healthy skin onto the blemished abdominal skin of a carved pig. The site of the original xingwei-zhuangzhi also illustrated multiple frames: the clinical setting of the hospital bed and the picture of the surgery; the photographic apparatus that aided the sequencing of the frames during the art-making process; the interactive situation enabled by the frame of performance; and the post-performance circulation of discourse regarding *Skin Graft* which may multiply the interpretive framing of the piece ad infinitum.

My reading approaches *Skin Graft* as an embodied commentary on performance art, comparing its flesh transfer to the serial transfers of conceptual ownerships that keep a time-based piece alive. This reading, nevertheless, understates the actual violence endured by the artist's body. If we understand *Skin Graft* as a consumablework that allegorizes the nature of consuming/appreciating performance art, what role does violence play in this hermeneutic frame? Violence seems unavoidable in Zhu's performance score—but is it gratuitous?

The most direct consequence of that violence is pain, an inevitable response from Zhu's traumatized body during the healing period. Zhu, however, did not solicit pain as an active element of *Skin Graft*—he went through the epidermis-removal surgery under general anaesthesia. The violence to which he willingly subjected his body appears to be secondary to the goal of enacting the flesh transfer. He attempted to achieve his goal while making sure that his body would survive his artistic ambition (by engaging medical professionals to assist with his experiment). Risk, along with pain, is tolerated only as a possible side effect rather than a purpose or a desired result of *Skin Graft*.

In his pursuit of medical collaborators, Zhu received many rejections by doctors who believed that medicine is dedicated to healing rather than harming an individual. These doctors considered Zhu's plan to strip off a healthy stretch of skin from his body an exorbitant waste, not to mention its subsequent attachment to a surface that can neither increase nor recycle the skin graft—a squandering of dermatological wealth. Zhu eventually persuaded the doctor who operated on him through two official procedures: by submitting to the hospital where the doctor worked a formal recommendation letter that confirmed his status as an artist; and by setting up a specific contract that promised confidentiality for the hospital and absolved it of any legal and financial liabilities. In other words, Zhu had to purchase the hospital's 'technical assistance' with both cultural and financial capital, brandishing an artistic identity that reframed his bizarre

request as a cultural activity while personally paying 1,500 RMB (roughly US$188) as the surgery fee. These paratheatrical negotiations constitute the particular social and economic fabric of *Skin Graft*.

This expanded context supports my assessment of *Skin Graft* as a consumablework. Its act of grafting becomes a metaphor for trade—and not just the trade of organ transfer, transplantation or trafficking. It is a transactional act based on a consensual pact which allows Zhu to impose his artistic will upon a hospital and to carry on his performance by violating the institution's normative mandate. Zhu's compounded capital speaks in a complex way. The violence underscoring this whole process of persuasion echoes the macrocosmic forces that are radically altering a postsocialist society through the myriad implants of capitalistic agencies.

In Zhu's first three consumableworks, violence is not desired but implied by his action. In his next two consumableworks, however, violence can no longer be so | **CAPITAL VIOLENCE**

easily squared away as extraneous to his concept. Indeed the acts of consumption in the two pieces are so estranged from common sense as to present the cognitive bottleneck between the hitherto unthought and the outright unthinkable in art. With *Eating People* and *Sacrificial Worship*, which also involved a foetus, the artist attacked some sensitive cultural nerves. He reached the slippery boundary between fair use and exploitation. In the name of art, then, has Zhu committed capital offences against good taste? Have his capital offences so violated the *name* of art that they can no longer be called 'art'? Would labelling his actions with any other name exonerate or worsen them?

Zhu stopped doing any more xingwei project after he finished *Sacrificial Worship* in 2002. As he explained to me, he refrains from pursuing xingwei yishu for now because he is deeply traumatized by the tragedy of *Fuhuojie kuaile* (*Happy Easter*, 2001), a failed animalwork that caused the agonizing death of a pig.[42] He completed *Sacrificial Worship* afterwards only because he had already begun working on it in 2000. I believe Zhu reached an emotional

42 See Chapter 4 for an in-depth analysis of Zhu's *Happy Easter*.

impasse from the cumulative effects of all three xingwei projects he enacted in the twenty-first century, especially from *Sacrificial Worship*, the very topic he seemed least able to talk about during our interview. He even suggested to me that perhaps he had not 'actually' committed the two foetus-related projects, reversing his previous claims that he *realized* those xingwei pieces for art. Curiously, entertaining the possibility that *Eating People* and *Sacrificial Worship* might not be 'real' first gave me the psychological permission to study them more deeply but, later, my doubt plunged me into such an utter epistemological crisis that I had to phone Zhu to confirm if he had after all 'really' done them.

The extremity of what I will call Zhu's 'foetusphagic consumableworks' assails those who are the receivers, forcing especially their messenger—myself in this instance—to confront the ethical question of whether relating certain messages constitutes unpardonable complicity. I learned about *Sacrificial Worship* during the pre-publication revision process for my *TDR* article on *Eating People* in the winter of 2004, when Zhu sent me an archival package, including a text, a postcard pamphlet and a photograph showing a climactic scene in *Sacrificial Worship*.

This project so appalled and disturbed me that I decided not to write about it at all—a decision in concert with my feminist friends' unanimous choice to *not* write about John Duncan's *Blind Date* in 1980. With trepidation, I changed my mind for *Beijing Xingwei*, without having reached the emotional equilibrium or intellectual certainty that my present decision would not haunt me for the rest of my life. 'After Auschwitz, to write a poem is barbaric,' wrote Theodore W. Adorno (1982). But is it barbaric to write about Auschwitz itself? And the Rape of Nanjing, the atomic bombing of Hiroshima and Nagasaki, the genocide in Rwanda, in Bosnia, in Sudan and in Burma and the terrorist attacks in the US on 11 September 2001? What about portraying the spiritual conviction of a suicide bomber in Baghdad and the artistic devotion of a xingwei practitioner in Beijing?

Unlike *Eating People*, which was represented as a xingwei piece, *Sacrificial Worship* was shown twice—publicly but discreetly—as a video art project about an extended xingwei action. This piece, like *Eating People*, has attracted enormous negative response in China but it differs from the earlier piece in that it received nearly no critical attention. Might not some of those critics have faced a dilemma like mine?

Structurally speaking, *Eating People* and *Sacrificial Worship* have similar compositional elements—they both include a prolonged preparatory process (1999–2000 and 2000–02 respectively), and a live action documented on videotape and in photographs. They also share almost the same performance score, involving a human foetus in the act of being consumed by an other.

For *Eating People*, Zhu spent a year looking for a foetus from a miscarriage or an abortion, meanwhile misleading the medical staff into assuming that he would use the foetus as a model for realistic paintings and sculptures. On 16 October 2000, he acquired a dead six-month-old female foetus. The next day, he asked several fellow artists to videotape his process of cleaning, cooking and eating the foetus in his apartment. Having vomited a couple of times during the process, he consumed about one gram of the foetal flesh.

Zhu conceptualized the plan for *Sacrificial Worship* in 2000. During a subsequent process that lasted more than a year, he secretly documented his meetings and discussions with many women from various backgrounds in his attempt to find a collaborator. In the winter of 2001, he found a voluntary partner, who, persuaded by his money and reasoning, agreed to conceive a foetus with him through artificial insemination and to have the foetus aborted after four months. On 21 April 2002, Zhu stole the foetus from the hospital and placed it in his freezer. On 29 April 2002, he set up a table covered with white fabric in his veranda and fed the foetus to a dog he purchased from the market. The foetus was too big for the dog, so Zhu had to carve it into smaller chunks. The piece ended when, after 20 minutes, the dog stopped eating.

In my view, *Eating People* and *Sacrificial Worship* represent two sides of a coin; or, more exactly, the first piece entails the creation of the next. Although I consider *Sacrificial Worship* way beyond my tolerance for art, I can understand how this sequel to *Eating People* might have served as atonement for Zhu's original cannibalistic action. In his first foetusphagic consumablework, he acted the role of a cannibal who consumed someone else's young; in the sequel, he reversed the procedure, giving up his young to be devoured by an other—as it turned out, a dog from the market, meaning locally that the dog could have been on its way to becoming someone else's food.

Eating People has partially realized the tragic and savage concept captured in the Chinese phrase *yi zi er shi* (exchange one's child for another's child to eat), an ancient folk saying portraying a survival tactic during great famines. *Sacrificial Worship* appears to simultaneously comply with and violate another colloquial truism, *hu du bu shi zi* (a tiger, though poisonous/violent, will not eat its cub), an allegorical expression about Chinese parents' well-known affection for and protection of their children. Zhu did not eat his young; he fed it to an animal. In fact, Zhu mentioned both proverbs to me as part of his consideration in enacting these pieces.[43]

The titles he gave to the two projects, however, suggest a transition from a secular culinary context to a religious ritualistic one—from voluntary cannibalism to 'compulsory' human sacrifice. As far as I know, Zhu Yu, in 'real life', is not a practising cannibal. He also admitted—in a few documented exchanges with those women he contacted for *Sacrificial Worship*—that he felt 'accursed' and 'saddened' by what he must do for 'art' and for 'our human world', even though he would probably receive 'retribution' for doing it (Zhu Yu 2009). But why must he choose the difficult subject of cannibalism? And to top that: A premeditated foetal filicide? What is art, if art means death? Why couldn't Zhu leave death alone to do its inevitable job?

43 My interview with Zhu Yu, 13 July 2008, Tongzhou, Beijing.

Zhu articulates some of his reasons for performing these acts in two textual documents related to his foetusphagicworks. The first text is a brief public announcement published together with two photographs of *Eating People* in the *Fuck Off* catalogue. Zhu also presented this document—photographed, framed and hung on his apartment wall—to Januszczak in the documentary *Beijing Swings* while explaining that he located the basis for his action on an interstice between law and religion. Perhaps due to the a high-profile exposure of the catalogue and the film, most people in the English-speaking world affix this terse and somewhat naive text—which I will analyse in the next section—to Zhu's cannibalistic art. My initial critique of *Eating People* was also based on it. In retrospect, however, I find that this widely cited text is at best a preliminary statement, reflecting Zhu's tentative exploration of the condition of possibility for his drastic art. Instead of taking it as a manifesto, I believe it's most useful to regard Zhu's announcement as a conceptual diagram, mapping out the four interrelated spheres within which he contemplated his xingwei actions: art; religion; law; and morality.

The second text, little known and written soon after Zhu performed the final act of *Sacrificial Worship*, contains the most comprehensive account of his cadaver-manipulation series, including *The Foundation of All Epistemology*, *Pocket Theology*, *Eating People* and *Sacrificial Worship*. Intriguingly, this second text assumes the form of a fake document entitled *Zhu Yu wuru shiti an (jiexuan)* (*Zhu Yu Abusing-the-Corpse Case* [*Excerpt*], 2002), ostensibly a transcript from a criminal law court trial of the suspect Zhu Yu's corpse-related offence.[44] This document, written in Chinese without English translation, has two public versions. In 2002, Zhu posted on a Chinese art website a more extensive version which included a public prosecutor's accusation, the suspect's self-defence and an interrogation process. The website host deleted the posting before long. Later, for a mail art exhibition in 2003, Zhu created an abridged version

44 All quotations from *Zhu Yu Abusing-the-Corpse Case* (*Excerpt*) are from the unpaginated manuscript that Zhu sent to me. He said that the text was posted on a website for a brief time in 2002 but he cannot recall the website's address.

Textual Sacraments

as a four-page postcard book, including a sketch of the alleged court proceeding—with the judge, the suspect and an incriminating photograph of the suspect biting into a foetal torso—and the prosecutor's accusation. As I confirmed with Zhu, all the details (the dates, the processes and descriptions) of the cited xingwei actions in this fake document reflect—as far as his recollection goes—what had actually happened; the trial itself is fictitious. In fact, to this date, except for his experiences with censorship, Zhu has not suffered any legal consequences for his art actions in Beijing, even though some Internet rumours have alleged otherwise.

My work on Zhu's xingwei yishu reinforces my idea that a time-based artwork is endowed with a peculiar property: it is a transient action when it first occurs in the world, yet it has an afterlife as long as someone (an interested other, or the artist as an older self) remains invested in its conceptual valence. This afterlife is as much time-based as the work's first life because its conceptual substance—or shall we call it the old-fashioned 'meaning'—continues to change with *time*, which is a complex cognitive-emotive-experiential dimension ceaselessly reshaping the subjects involved in interpretations and reinterpretations that create meaning. My choice to write about *Sacrificial Worship* here exemplifies such a change. Zhu's creation of *Sacrificial Worship* may indicate a conceptual recycling or reversal of his *Eating People*; even the postcard mail art project he made in 2003 samples an infamous image from *Eating People*. Through such recycling, Zhu not only produces new projects but also to a certain degree changes the 'source' project. As xingwei yishu crucially exists in its concept, this kind of hermeneutic change to a past project represents a qualitative shift and the shift itself remains subject to further change.

The fictitious *Zhu Yu Abusing-the-Corpse Case*, composed two years after Zhu performed *Eating People*, gave the artist a legal frame within which he could narrate his controversial artworks and imagine a public prosecutor against whom he could more rigorously articulate his point of view. I see this fictitious trial document as both a critique of Zhu's cadaver-manipulation series and integral to it. The text indicates a moment of temporary cognitive/psychic closure, wherein the artist looked back at a passage of his art-life as if through a third eye—not one radiating spiritual peace and illumination but one penetrating his conscience and disturbing its emotional composure. Through the voice of his imagined prosecutor, Zhu absorbs into his textual body the disdain, suspicion, ridicule, misunderstanding and accusations that have been launched against him since *Fuck Off*. He has been on trial, even if the trial hasn't yet been staged in a public-entrusted legal theatre. With this text, he conjures up a discursive forum for himself, records factual details about his four cadaver-related projects and delves into their reasoning processes. As the text ends before the judge's sentencing, what Zhu seeks, I suggest, is neither justice (through acquittal), nor forgiveness (through conviction) but articulation through a convoluted yet compelling confession.

Reverse Sacrilege | In the laconic *Eating People* announcement dated 17 October 2000, Zhu bluntly raises the question: 'Why cannot people eat people?' He traces the interdiction against cannibalism to the arbitrary sense of morality which, he believes, changes over time simply to cater to our 'so-called needs of being human'. Zhu concludes, 'So long as it can be done in a way that does not commit a crime, eating people is not forbidden by any personal or societal laws or religions; I herewith announce my intention and my aim to eat people as a protest against mankind's moral idea that [one] cannot eat people' (Ai Weiwei et al. 2000: 192).

Zhu assumes an implicit hierarchy among the four civic spheres to which his statement refers: law (no crime can be committed); religion (there is no religious interdiction against cannibalism); art (his cannibalistic behaviour is therefore sanctioned and given a cultural context); and finally morality (which is arbitrary, fluctuating, inherently retrogressive). He reshuffles the hierarchical order of these four civic spheres in *Zhu Yu Abusing-the-Corpse Case*: art (for his art Zhu is on trial); law (the narrative context he has chosen to reassess his art); religion (as passing references); morality (deserving only one mention). In this fake trial transcript, Zhu adjusts his previous claim that he has committed no crime by engaging in anthropophagy. The prosecutor cites Zhu's violations of specific Chinese legal statues regarding anatomical studies of human corpses, transportation of cadavers and marriage laws to charge the accused with the crime of abusing human corpses. By bringing up the broader issue of human-corpse abuse, Zhu in effect reduces his past thematic emphasis on cannibalism, turning this act of consumption into a method of corpse-manipulation. Arguably, this shift in emphasis indicates Zhu's deflection away from what most people probably believe to be the 'real crime'—the cannibalism in *Eating People* and the reproduction and abortion of a foetus to serve as animal food in *Sacrificial Worship*—to the lesser offence of an artist's over-zealous pursuit of innovation.[45]

45 I thank Mariellen R. Sandford for this valuable insight about Zhu's underlying defensive move.

Zhu's fictitious trial document makes relevant a critical angle from which to scrutinize his extreme consumableworks—the artistic discovery and handling of dead human bodies as a novel art material. Speaking as the suspect, the artist Zhu insists that his xingwei yishu deals with issues much more complex than his chosen art material. Yet, the trial's focus on the crime of corpse-abuse allows the author Zhu to gear his protagonist's self-defence towards cadaver use. Zhu's narrative goes through three logical transitions to prepare for his eventual discussion of the ontology of art.

First, as the basis of his analysis, he differentiates his intention from the effects of his action: 'During my conceptual process for my xingwei yishu, I had no intention of violating any corpse, because I only focused on artistic structure itself. But in actuality, my artistic behaviour indeed caused injury to corpses'. Although the prosecutor never once addresses the accused as an artist, Zhu immediately re-establishes his position as a xingwei artist and frames whatever he did in relation to an artistic context. He does not deny that his art actions might have damaged the cadavers he used but he hastens to profess that he had no menace in performing these purposive actions.

Second, Zhu insists that his actions be judged within their original context. Based on the defence that he has committed all of these acts in the name of art, he contends that the law cannot effectively intervene in his case without considering the rules governing his art production.

Third, he broadens the context to cover the human society's use of dead human bodies for various purposes, especially to service the field of medicine. In a manner of self-apology recalling Gunther von Hagens' article published in the catalogue, *Body Worlds*: *The Anatomical Exhibition of Real Human Bodies*, for his world-touring exhibition, *Körperwelten/Body Worlds* (1995–present), Zhu brings up historical conflicts in the West between the Church and the medical profession over procuring human corpses for the purpose of anatomical research; he

also refers to the contemporary medical perception of human corpses as 'garbage, like an overcoat left by a dead person', as a 'pure object' for anatomical studies and as a source for organ transplants. Thus he situates his cadaver use within a global continuum and evokes the controversies confronting medical science to underscore the issue's complexity. Borrowing the intellectual cachet from prestigious others (Western religious and medical authorities), Zhu challenges, by implication, the crude epithets—'immoral', 'crazy', 'violent', 'bogus' or 'evil'— frequently thrown against his art.

Without citing Hagens by name, Zhu's narrative clearly recognizes *Body Worlds* as a contemporary reference. Zhu and Hagens, however, have opposite objectives. Hagens refers to the authority of medicine and science education to justify his anatomical displays: 'Plasti-nated specimens are not works of art, because they have been created for the sole purpose of sharing insights into human anatomy' (2003: 31). In contrast, Zhu uses medicine not as a validation but a stepping-stone for his art. Referencing the anatomical science, Zhu differenti-ates dead human bodies into two major types: (1) a '*shiti*' (a corpse) is—in his definition—'a dead person's natural bodily remains, which are corruptible and can be decomposed by other living creatures'; and (2) a '*shiti biao ben*' (a cadaver specimen) is—in my paraphrase—an artificially transformed corpse that can no longer be decomposed by other living creatures and cannot be restored into a corpse again. With this distinction, Zhu theorizes that a corpse is *yuan dian* (an original/essential point) and a cadaver specimen is *wai dian* (an external/derived point), created to facilitate medical studies. He believes that art should endeavour to explore the connections between an original point and *zhong dian* (an ultimate/ending point)—in other words, between birth and death.

Whereas both corpses and cadaver specimens are readymades and both symbolize death, Zhu argues that a corpse is a better art material and has more potential than a cadaver specimen to be used in art, because the latter, being previously treated, can no longer be changed by an artist's intervention, preventing the artist from directly interacting with it.

> Since we can move from 'a corpse' as 'an original point' to a 'cadaver specimen' as 'a derived point', we can similarly reverse the process to move from a 'cadaver specimen' as a 'derived point' back to 'a corpse' as 'an original point' [. . .] But this reversible rela-tionship can only exist in the concept of an art behaviour rather than in an actualized art behaviour. That is to say, once an art behaviour has used 'a corpse', there is no further need to use 'a cadaver specimen'. But, once it has used 'a cadaver specimen', [an art behaviour] can continue to use 'a corpse' (n.d.)

This passage, with its minute twists and turns between points in cognitive motion, reflects Zhu's conception of art as a behavioural arena that deals with the 'essence' of human existence. It also explains the rationale behind Zhu's progression from using cadaver specimens (that is, human brains, an amputated arm) in his first two consumableworks to manipulating corpses in his last two. Although Zhu seems to comment specifically on his art, his elevation of a particular art material—dead human bodies—to the level of artistic ontology implies a hidden cause behind his obsession. What is his subtext?

In an interview after the *Fuck Off* exhibition, Zhu revealed that his initial idea of enacting *Eating People* came from an impulse. He felt stymied by his designation as the source of the cadaver school, whose practitioners had turned to dead bodies as art material so rashly that their art became mutual imitations, plagiarizing one another in a competition for cruelty. Recognizing that art must produce sensory excitement so as to stimulate thought, Zhu joined the competition to 'out-cruel' others by doing something that no one else has dared. 'A human, isn't it simply carbohydrate compounds?' said Zhu, 'Now that something like [*Eating People*] has occurred in a civilized society, I will wait and see how the public criticizes this event' (2004). Artists of the cadaver school (including Zhu Yu, Sun Yuan, Peng Yu, Qin Ga and Xiao Yu) demonstrated—in a 'deadpan' manner—their sensorial vehemence mainly through three exhibitions, *Post-Sense Sensibility* (1999), *Infatuation with Injury* (2000) and *Fuck Off* (2000); except for Zhu, all others had used exclusively cadaver specimens. By differentiating artistic use of cadaver specimens from that of corpses, Zhu sets himself apart from—and above—what he might have perceived as his competitors, if not imitators.

I have moved one step closer to resolving my earlier question: Why did Zhu choose cannibalism as his action theme? Let me move even closer by hypothesizing Zhu's reasoning sequence.

First, according to Zhu's revisionary history narrated in his fake trial document, his choice was not to practise cannibalism per se but to work with a corpse. Cannibalism means a specific way of manipulating a corpse that fulfils his planned artistic objectives.

Second, how to acquire a corpse? This was a new challenge; the artist's past experiences up to the year 2000 had been limited to obtaining cadaver specimens—or shall we call them 'derived corpses'—from the same anatomy department. Based on his *Eating People* announcement, Zhu had given himself certain restrictions and objectives: he would not commit a crime; he would not defy religion; and he would make choices based on his avant-garde aesthetic in order to interrogate conventional morality. His way of obtaining a corpse had to follow these predetermined purpose and parameters.

Next, how to link a corpse with his planned attack against unquestioned morality? Zhu's solution was to zero in on the definition of humanity. As he maintains, moral codes have changed throughout human histories in response to our 'so-called needs of being human'. What would best visually externalize—or would embody—our conception of humanity? An object that is both material and symbol—a human foetus, with head, torso, limbs and all, complete in its promise to become a full human being. To manhandle a foetal corpse launches a deadly blow to long-held moral assumptions. What kind of interaction would elicit the most fervent responses from his moralistic fellow humans? To bite into and swallow the foetal corpse as a material symbol of humanity in miniature.

Now, would obtaining a dead human foetus be impossible? Abortion is legal in China. Since the one-child family policy instituted by Deng in 1979, there have even been incidents of government-enforced and work-unit-coerced abortions in rural areas: 'The ugliest aspects of the policy have received great attention: female infanticide, forced abortions, and selective abortion of female fetuses,' reads a scholarly report (Hesketh and Wei 1997). The corpse Zhu acquired for *Eating People* was a six-month-old *female* foetus, purchased from a clinic for his putative live sketch studies.

Is cannibalism against the law? Based on my survey of literature available on the Web—a research process, I believe, somewhat duplicating Zhu's—the artist's claim that cannibalism is not illegal is justified in that most countries today, including China, have no laws against cannibalism itself, defined in isolation as 'the nonconsensual consumption of another human's body matter'.[46] In fact, this legal oversight presented a dilemma for the German court in the notorious 2001 'cannibalism-by-consent' case in which a German man, Armin Meiwes, killed, dismembered and consumed the flesh of another German man, Bernd-Jürgen Brandes, the consenting victim whom Meiwes found by placing a personal advertisement on the Internet (Levitt 2011). At the time of Meiwes' prosecution, Germany had no law prohibiting cannibalism. 'Instead,' as Josh Clark notes, 'Meiwes and other cannibals like him, including serial murderers Albert Fish and Jeffrey Dahmer, were convicted of the killing, not the eating. Murder is illegal; cannibalism exists beyond the law. It is taboo' (2011). Thus, perpetrators of such a taken-for-granted proscribed act are charged with another crime preceding or accompanying cannibalism, such as murder, grave robbery, necrophilia or desecration of the corpse. Zhu believed he was not guilty of any of these crimes in acquiring his cannibalistic food stock.

46 See 'Cannibalism' in *Wex-Legal Information Institute's Community-built Law Dictionary and Encyclopedia* (2009).

Is cannibalism forbidden by religious doctrines? Acknowledging that he is a devout Christian, Zhu tells Januszczak in *Beijing Swings* that the Ten Commandments have no prohibition against cannibalism. Since Zhu overlooked certain dietary restrictions imposed by the laws of other religions—such as the laws of 'Kashrut' ('keeping kosher') specified in the Torah and religious vegetarianism in Buddhism—he might have even considered cannibalism compatible with his faith. There is, after all, a hint of cannibalism, albeit in a symbolic and spiritual vein, in the Catholic ritual of Holy Communion in which believers partake of the divine Body/Spirit by ingesting the consecrated bread and wine offered by a priest (see Strynkowski 1995).

Once Zhu had broken the moral taboo against cannibalism with *Eating People*, what more could be done to match or surpass its fury? Given the same restrictions and objectives, to push to the extreme the theme of foetusphagia is to change the identities of the eater and the eaten while keeping the artist's bodily investment central to the xingwei. Zhu resolved this next iconoclastic self-assignment by becoming the procreative source of the foetal corpse: the origin then merges with the end.

To artistically legitimize such a horrendous moral/ethical breach, Zhu designated a precondition for his sequel xingwei: he must find a voluntary collaborator who could complement the artist's procreative potential in engendering and terminating the 'art material'. After a year's painstaking search, Zhu found a woman who would join him not just for his money but also for his 'artistic purpose'. Theoretically, the project would not have been realized had Zhu not found this willing partner. The documented footage of Zhu's contacts with various women therefore forms the sociological basis of *Sacrificial Worship*. To deepen his aesthetic rationale beyond sociology, however, Zhu also needed an extraordinary narrative framework that would ritualize—make sacred if not intelligible—the cruel action. We may find a clue to the artist's conception by reviewing the following exchange between Zhu and an unidentified woman in his video document entitled *Wo yu nvren shangyi sheng haizi de shiyi C* (*I Negotiate with a Woman to Give Birth to a Child, Case C*):

WOMAN. . . . You said a child, completely innocent, and let you murder it. Then . . .

ZHU. Not to let me murder it. This child is to let . . . to let art murder it!

WOMAN. Retribution (2009).

Zhu's acceptance of a higher external power to which he must freely surrender himself in obeying its command appears to assign 'art' a metaphysical agency—art in effect is equated with God in a theological framework. Given his Christian background, the title and structure of *Sacrificial Worship* conjure up the parable of Abraham and Isaac in Genesis: 'And they came to the place which God had told him of; and Abraham built an altar there, and laid the wood in order, and bound Isaac his son, and laid him on the altar upon the wood' (Genesis 22:9). As a test of Abraham's faith, God commanded Abraham to sacrifice his beloved son, Isaac, as a divine offering. Abraham followed God's order without question and brought Isaac to the designated site of sacrificial worship. But, before he could slay Isaac, a miracle happened—an angel stopped him and showed him a ram caught in a thicket, sent by God to replace Isaac as the offering. Abraham proved his obedience to God by refusing to value his flesh and blood above his Lord. So the Angel conveyed God's message to Abraham the second time: 'And in thy seed shall all the nations of the earth be blessed; because thou hast obeyed my voice' (Genesis 22:18).

An altar in an outdoor space, a child turned into a sacrificial offering, an animal abruptly transported to the scene and a man who is less a father than a servant to a divine principle—these are shared narrative elements in *Sacrificial Worship* and its probable biblical archetype. While God intervened to salvage the biblical parable's chilling overtone, Zhu's mutated performance score only serves to eliminate any hope for redemption. Abraham did not give birth to Isaac so as to sacrifice the child; Zhu did. The ram appeared as a sacrificial surrogate for the child; the dog purchased by Zhu became a double for the Power that devours. For his absolute worship of God, Abraham received tremendous blessings not just for himself but for 'all the nations of the earth'; what Zhu received from pursuing his morality-defiant art is well summarized by a woman's intuitive evocation of a Buddhist concept—retribution.

WHAT VIOLENCE? WHOSE VIOLENCE AND ON WHOM?

For me, the most difficult challenge in writing about Zhu's last two xingwei projects is the fact that he used foetal bodies to expose the violence of consumption. It disturbs me deeply that even as Zhu depended on these foetal corpses to feed his art, their presences is under complete discursive erasure. In the public announcement for *Eating People*, Zhu failed to acknowledge that the human he ate was a six-month-old female foetus. Zhu did document in his fake trial text—through the voice of the prosecutor—how he obtained and utilized the two foetuses in *Eating People* and *Sacrificial Worship*. Nevertheless, in his analysis of the artistic use of corpses, Zhu never once mentioned that the corpse he manipulated in *Sacrificial Worship* was not just any readymade material but one intentionally made ready for his art: a foetus engendered, aborted and consumed solely to demonstrate the logical extreme of an impossible art concept. Zhu's foetusphagic consumable-works pit me against two personal questions: the limit of aesthetic violence; and the ethical boundary of art. These two pieces make me weep and force me to take a stand.

Being a woman and a mother, I cannot see past the pathetic sight of a brown and withered foetus on Zhu's plate in *Eating People*, nor can I condone Zhu's premeditated scheme to procreate a being so as to destroy and consume it in *Sacrificial Worship*. Most probably, my acute focus on the foetus reflects the ethos of my cultural surroundings in the US, in which the discursive environment is replete with debate about individual rights, including those of the unborn. Having said so, I am afraid of inadvertently joining forces with the anti-abortion/ pro-life contentions against women's right to choose—a specific debate that I must bracket here, for my present issue is not about the ethics of abortion per se but that of the ab/use of foetal corpses. Perhaps my sentiment towards the foetus is gender-based, as I am conditioned by my gender-specific enculturation and my embodied experiences of gestating, birthing, nursing and caring for my son from infanthood to toddlerhood to boyhood.

This confession, however, tends to essentialize my gender—a position I find untenable. Don't most fathers also love their children? Have there not been mothers who hurt their offspring? But, in Zhu's case, emotional bond is not an issue. In *Eating People*, the terminated foetus was reduced to the status of an organic commodity, treated by Zhu as no different from any other perishable, consumable meat. In *Sacrificial Worship*, a definite genetic/biological lineage existed between the artist and the foetus he killed to fulfil his artistic intention. Yet there was no temporally and experientially cultivated emotional attachment between the progenitor and his progeny. So, what Zhu violated in these pieces was not his ability to love either his neighbour's child or his biological issue but what we humans habitually perceive as a connection between a person, a living human body, and the corpse this person will eventually become. If we can recognize that a corpse is just an inanimate thing, as Zhu rationalizes, then why can't we consume it in any way we like?

But, can we, as humans, truly regard a human corpse as the same as any other perishable thing? Can we disregard the distinctions between the corpse of an old person and that of an infant; between an infant corpse and a foetal one; between a corpse that bears the wounds of extreme trauma, that dies of plane crash, earthquake or flood, and the one that seems to repose in a peaceful dream? Until I become a corpse myself, I will not know how or if a corpse feels, thinks and experiences as it decomposes but I know I will cling to and protect the corpses of those who once and for ever make my earthly being worthwhile, as if they were still alive, sentient. To hurt the corpse of the one I care about is first of all to hurt me, who am bereaved, left behind by a beloved departed. I cannot reason away my grief even though I know a corpse is different from a person, because my other senses and embodied capabilities, which are simultaneously distinctive from and entangled with my reason, take momentary control of my being; my separation anxiety and my irretrievable loss threaten my very survival. Having been trained to become the particular human I now am, I dread even the thought—not to mention the deed—of mistreating any human corpse, precisely because a species-based survival instinct and empathic imperative are drilled into the core of my personhood. To allow the desecration of a human corpse is to forfeit my protection as a future corpse; to recognize that my fellow humans and I are inextricably joined in a temporal-spatial stream moving towards whatever lies beyond forbids me to deliberately hurt not only other humans but also any living being; not only all those alive but also their/our living planet; not only those who are dying but also

the dead. Knowing that I am ultimately a consumablework doesn't mean that I want to be consumed. Even if I wish to become an organ-and-tissue donor when I die, I want to be able to state that decision in my will. Before I know what and whether a corpse desires, I'd rather err on the side of over-protection than unwitting exploitation.

I am keenly aware of my difference from Zhu as a 'trained' human. Thus we might have very different definitions for all the value-laden words I have mentioned—human, hurt, love, desecration, empathy, life, death, personhood. Since Zhu's extreme artworks are tests of existing values and boundaries, I cannot but lay bare the limits of my existential vocabulary. Even when I must critique Zhu's artistic extremism, I acknowledge that Zhu's corpse-related consumable-works boldly insist that the human collective face our saints and demons.

So far, I've followed Zhu's lead to place *Eating People* and *Sacrificial Worship* together under the category of corpse-manipulation. In fact, the two pieces have a crucial and qualitative difference in the way Zhu obtained his foetal bodies. They also have divergent aims—*Eating People* seeks to break the moral taboo of cannibalism; *Sacrificial Worship* interrogates the conflicting ethical bonds that one assumes, pitting one's moral/spiritual convictions against one's biological descendant. Both pieces exercise tremendous violence, although not in the simplistic ways often condemned by their critics.

Thematically speaking, *Eating People* does not break any new ground. Cannibalism is a long-standing subject matter in world literature. Take, for example, a satirical text that inspired my last assessment of *Eating People*: Jonathan Swift's 'A Modest Proposal' (1729), written at the height of the Irish famine, uses cannibalism as an anthropo-political trope to jostle with Britain as the empire that stood behind Ireland's misery. In Chinese literature, cannibalism is famously conjoined with morality—especially in its feudal Confucian articulation—in Lu Xun's canonical short story, 'Kuangren riji' (Diary of a Madman, 1918). Closer to Zhu's time, Mo Yan's meta-novel, *Jiu Guo* (*The Republic of Wine*, 1992), employs cannibalism to farcically eviscerate the hedonistic consumerism of postsocialist China. *Eating People* breaks from these literary works because, above all, it adopts a time-based art medium, an embodied genre that exists in the overlapped conceptual/perceptual zone between the symbolic and the real. Zhu's cannibalistic act in *Eating People* is, then, both emblematic and materialized; it introduces to our (human) world both a virtual construct, as does a literary work, and an actual event, a live/life incident. Cannibalism did actually happen at Zhu's rented apartment in Tongzhou, Beijing, and it happened precisely within the context of art—Zhu ingested a morsel of flesh from an anonymous female foetus not for survival (as in survival cannibalism), nor for erotic satisfaction (as in pathological sexual cannibalism) but to practise his xingwei yishu.

Like cannibalism, human sacrifice is a ritualistic practice far more ancient than the humanist disciplines of anthropology and comparative theology. Zhu stated to me that his *Sacrificial Worship* 'only borrowed from religious ceremonies to deal with social issues'. Considering that China has continued to suppress religious dissenters (like members of Falungong and rebellious Tibetans) and persists in its political claim to socialism, I can understand why Zhu would represent his artworks as worthy of cultural and ideological sanction. Nevertheless, Zhu also told me that 'the energy field' of his artwork is much greater than his 'authorial intention'—a magnanimous attitude that attests to his understanding of xingwei yishu as a hermeneutic

arena kept alive by discursive circulation. With this interpretive licence, I submit that metaphysics, more than a borrowed procedure, is the very genius loci of *Sacrificial Worship*. Our critique of this work cannot avoid examining its metaphysical dimension.

Zhu's violent ceremony evokes a spiritual principle even more primordial than the Abraham and Isaac parable. Girard's thesis of the tie between violence and sacrifice, which I've borrowed to analyse Zhang Huan's self-harming rituals, seems particularly illuminating for *Sacrificial Worship*. According to Girard, sacrificial rites serve a practical function in a prehistoric society by protecting 'the entire community from *its own violence*' and by providing a ritualistic outlet to check the cycle of vengeance provoked by an original offence. The sacrificial victim, entirely innocent, is chosen as 'a substitute for all the members of the community, offered up by the members themselves', in a pious endeavour to propitiate the aggressive impulses (murders, intra-tribal conflicts, a mysterious plague, natural disasters—all those believed to be emanations from the sacred) threatening to exterminate the whole community. In its pragmatic function, the institution of sacrifice resembles contemporary societies' judicial system, an 'infinitely more effective' system that serves to supersede its religious precursor (1979: 1–38).

I see a palpable parallel in *Sacrificial Worship*. Zhu, as a master of ceremony and member of a highly turbulent society, offers up his child as an absolutely innocent surrogate victim to a dog, an animal avatar of the sacred, so as to stall temporarily the escalating violence round him. Girard's comment about the efficacy of the judicial system, however, spells out the tragedy of Zhu's sacrificial rite: it's an utterly effete curative gesture, as futile and anachronistic as enacting cannibalism to protest 'arbitrary' morality. These two foetusphagicworks do not prevent violence from worsening; they worsen it. If Zhu follows his Christian faith to see his sacrificial act as analogous to that of God offering his Son to redeem the wicked world, then he has committed the sins of pride and deliberate martyrdom. Folly comes from the proud one who wills to martyr his engendered flesh; the blood of his lamb is his cross that promises no redemption to our mortal world.

Should Zhu reply that his works' uselessness as religious rituals validates their non-utilitarian status as art, then we are back to my questions regarding the limit of aesthetic violence and the ethical boundary of art. I cannot engage with these extremely complex questions in theoretical abstraction here. What I'll present is a time-based document of my thinking process to understand why *Eating People* and *Sacrificial Worship* feel at once so significant and so 'wrong' to me as xingwei artworks. 'Right' or 'wrong' are the simplest ways we express our moral values. Since visual constructs often remain opaque and multivalent in their values, we need to recall the two texts Zhu generated in relation to his xingwei pieces so as to confront the artist's conceptual and ethical blind spots in producing his foetusphagicworks.

Discursive Exorcism | To me, Zhu's aporia stems from the nexus of two tendencies expressed in his texts: (1) his exclusively reductive reasoning process, and; (2) his propensity for exercising cultural/artistic power against entities that are already endangered. In his announcement for *Eating People*, Zhu identifies law, religion and morality as the three civic spheres that regulate the ethical behaviour of humans. His reductive reasoning leads him to believe that these spheres are separate domains, stable in their ontological distinctions, rather than interrelated epistemic

and behavioural fields. Religion has established laws as much as law has its transcendental aspects; what began as a religious belief may become civic law, as Girard's analysis of primitive religions has taught us. Zhu knows that religion resembles law where cannibalism is concerned because of the potentially disciplinary powers the two social constructs possess but he falls short of noting that religious commandments and legal rules are, after all, institutionalized morality. He contradicts his defiant attitude by accepting institutionalized power while attacking the apparently more vulnerable moral taboo against cannibalism. He regards morality as of lesser import because the consequence of violating its taken-for-granted restrictions seems vague. Could it be that Zhu counts on such disciplinary vagueness to hold up morality as his art's ultimate target?

Theoretically, to shape one's art as a critical force against any potentially stagnant and oppressive social values, such as morality, sentimentality and familial obligation, can be a worthy cause. Lu Xun's 'Diary of a Madman' performs precisely such a function, using the metaphor of cannibalism to expose the individual subjects' gradual spiritual disembowelment under the devouring surveillance of orthodox Confucian morality. In Zhu's postsocialist era, however, traditional Chinese ethical values—often summarized as *li* (courtesy, propriety, civility, kindness), *yi* (justice, righteousness, loyalty, charity), *lian* (honesty, incorruptibility), *chi* (integrity, honour)—and Maoist communist values—'serve the people', material asceticism, daily practices of self-denial and self-improvement—have all collapsed with the advent of market opportunism and capitalist greed.[47] 'Morality' as defined traditionally or revolutionarily is already in short supply. To attack a much-weakened social value is not to challenge but to *join* the rising sociocultural status quo of materialistic nihilism. In this cynical and avaricious milieu, Zhu's pursuit of a morality-busting artistic objective is incongruous, oxymoronic, if not opportunistic.

[47] For critiques of postsocialist China's crumpling moral order, see Wang Xiaoying (2002); Stanley Rosen (2004); Zhang Zhen (2000); and Nancy Scheper-Hughes (1998).

What Zhu has done to 'morality' is mirrored by his treatment of the foetal bodies in both *Eating People* and *Sacrificial Worship*. This is where his artistic defiance against morality becomes indistinguishable from his unacknowledged exercise of violence against two dead foetuses. In *Eating People*, he might argue that his intention to eat a dead foetus bears no relation to any violence associated with what caused the foetus' termination. He simply assumes the role of a collector rather than predator in acquiring the cadaver. In *Sacrificial Worship*, this excuse is invalid because he did intentionally conceive and then abort a foetus for his art. He explained to the woman who questioned his motive that it was not his will to murder the foetus but 'art' that demanded such a sacrifice. He conceptualizes *Sacrificial Worship* as a conflict between his moral obligation towards his child and his sacred duty towards his art, which aims to eradicate, as it were, our superstitious reverence for commonsensical morality. As I've argued, Zhu's reduction of his art to a single purpose of defying morality is itself problematic. Turning his foetus into a pawn for his opportunistic proposal means double exploitations—doing violence to a principle and a being already under siege in his society. For me, art stops when exploitation of the weak begins; aesthetic violence crosses the line of ethical responsibility when the violated subject and object are already suffering from aggravation. I, as a witness to the violation of an entity that cannot self-defend, become the one accountable for voicing my suspicion, even if

my critique will expose my limitation as a vulnerable moral agent. My conscious voice makes me 'human', granting that what 'humanity' means is under constant revision.

Is Zhu's case, then, a paradigmatic example of the operation of violent capital? Zhu claims that Art has made him sacrifice his child. Should we retort that his child is actually sacrificed to/by his artistic ambition?

Zhu has admitted in various interviews that he threw up twice during the process of performing *Eating People*. He also stayed away from his home studio for fear of recalling the experience. Although he did not publicly relate how he felt after he enacted *Sacrificial Worship*, he stopped doing xingwei yishu and went back to painting. In the style of photo-realism, he then painted an obsessive series of white dinner plates empty but for a few tiny particles of food. Are these psychosomatic spillages from his contradictory moral beliefs? He willed his art against his morality but the sediment of his moral consciousness—debris, perhaps, from a system that he disdains but cannot dislodge—first makes him vomit against his art and then disables him, preventing him from engaging again in an art medium that elides the safe distinction between virtuality and actuality. Has Zhu underestimated the potential consequences of his violent xingwei yishu on his life?

I recently asked Zhu if he has benefitted from his artistic experiment. He replied that he did his extreme artwork out of a deep compulsion rather than any 'deliberate design'. 'Except for *Happy Easter*, have you regretted having done any of your violent art pieces?' I added. 'You raised this question to me too early . . . I am still in it,' answered the artist.[48] Where or what is 'it'? An empty white round plate discoloured by some remaining fluid? I saw it painted on his canvas last summer in Beijing and had to quickly avert my eyes from this heart-rending wretched sight.

48 My phone interview with Zhu Yu, 2 March 2009, Los Angeles to Beijing.

My exchanges with Zhu echo the artist's response to a reporter's question about whether his art sells well: *Eating People* was sold in Shanghai for US$1,000. He also won 7 RMB (US$0.87) for an art competition in elementary school. These are the total earnings from his experimental art. He knew that, for it to sell, a xingwei artwork's photographic documents must hold some aesthetic appeal but his works are so conceptual that they do not make for saleable pictures. As Qiu Zhijie (2001) argues—in an essay in defence of aggressive art—it is fallacious for Chinese critics to accuse xingwei artists of pandering to the Western taste for exotic violence. When Chinese artists push xingwei to its extreme, they actually repel Western buyers. Indeed since *Fuck Off*—or since *Beijing Swings*—Zhu seems to have become an anathema to the Western art world. For international exhibitors in the past few years, he has been an untouchable—an inverted Oedipus at Colonus! Did Zhu anticipate such a result in 2000 and then in 2002? Did he miscalculate? Or was he buried too deeply in his ultimately irrational artistic fervour to worry about how the world would respond?

These reflections suggest another aspect of my theme: when violent art exceeds the point of salability, it attests to the artist's existential condition, one that exceeds any calculated expressions.

If Zhu's foetusphagicworks are subliminal reflections of his contemporary environment, how should we approach the glaring power differential between an adult artist and the two dead foetuses on his sacrificial plates? Is it an exaggerated portrait of his country's putative postcolonial condition, pitting the industrialized late-capitalist West against the unevenly developing and ideologically disjointed socialist-capitalist China? Is it an index of the post-socialist nation's mounting tensions between the beneficiaries of its economic reforms (the urban nouveau riche; the self-perpetuating political elite; the multinational corporate managers; the overseas collectors of its contemporary art) and its casualties (dirt-poor rural residents; the floating population of migrant workers scraping by in coastal cities; female sweatshop, toy-shop, sex-shop assembly-line workers; fashionable, value-vacant neo-neo-tribe youngsters; over-zealous experimental artists)? Is it an epigrammatic epic theatre that bears witness to the larger wound splitting the nation between the eater and the eaten?

Amid the contradictory reverberations that have troubled and enriched Zhu Yu's soul-splitting consumableworks, I hear the pensive undertone of violent capital. In its minor key, violence is no longer the capital that grows its coffer by attracting its like but the violence of Capital, which thrusts its fierce demand on individual subjects who cannot refuse its vampire kiss.

LImiT ZOneS

On 23 February 2005, I attended a talk at Otis College of Art and Design by Zhang Huan, the then New York–based Chinese artist. Zhang's talk was one of the live events surrounding *Regeneration: Contemporary Chinese Art from China and the US* (2004–06), a concurrent exhibition which included a photographic document of Zhang's *My America (Hard to Acclimatize)* (1999), enacted soon after his immigration to the US in 1998.[1] The photograph features Zhang sitting naked at the centre of a stage littered with baguettes; a three-tier scaffold occupied by unclothed men and women frames the stage on three sides. During his talk, Zhang presented a video record of the original performance at the Seattle Art Museum.

NAMING 'LIMIT' THE CHINESE WAY: VIA ZHANG HUAN

My America begins with the artist leading nearly 60 local volunteers as his co-performers and live models through a ritualistic procession inspired by Tibetan Buddhism; it climaxes as he sits still, expressionless and passive while the participants assail him with bits of baguettes.

1 I draw parts of this chapter from two published articles: Meiling Cheng (2006a and 2006b). The exhibition *Regeneration: Contemporary Chinese Art from China and the US* (12 February–23 April 2005) was curated by Dan Mills and Xiaoze Xie and took place at the Ben Maltz Gallery of Otis College of Art and Design. Zhang's talk was part of the Otis Speaks lecture series in the spring of 2005.

IMAGE **3.1** *My America (Hard to Acclimatize,* 1999) by Zhang Huan, at the Seattle Art Museum. Image courtesy of Zhang Huan Studio.

Via a translator, Zhang explained the mob bread attack in *My America* to his Otis audience with the help of an anecdote, also retold most compellingly in 'A Piece of Nothing', written for *Zhang Huan: Altered States* (2007–08), his solo exhibition at the Asia Society in New York:

The idea came from one night at Madison Square Garden in New York City. I was looking for food for my pregnant wife. Two people walked towards me with bread in their hands. They asked, 'Are you hungry?' My feelings were complex. I could not speak. I felt emotional and wanted to cry. I accepted the bread and walked away. It made me think of my life in China. In China, no matter how hungry I was, I was an artist. Nobody would think of me as a beggar (2007: 79–80).

Reading through 'A Piece of Nothing' reminds me of Zhang's talk at Otis. But what struck me most in that talk was a moment of contradiction undocumented in the essay. Asked by an audience member about the origin of Chinese performance art, Zhang replied: 'Xingwei yishu was part of contemporary art that came to China entirely from the West in the 1980s.' 'Who has influenced your performance art?' asked another listener. 'Xingwei yishu already existed in ancient China, as conveyed by the old Chinese saying, "xuan liang ci gu" [hanging on the roof beam, poking at the thigh]. I was influenced by these ancient behaviours,' said the artist.[2] Having just acknowledged that performance art came from the West, Zhang in the next moment—quite unselfconsciously—claimed xing-wei yishu for China by ascribing his artistic inspiration to an ancient Chinese source. In earlier chapters, I've discussed such a contradictory sentiment as a compulsion for sinification: Zhang, being a Chinese-identified artist using a medium originated in the West, retrieves a native grounding and a personal justification by linking his body art to older indigenous practices.

2 I have translated this passage based on my memory of Zhang's remark. I have also translated all the Chinese proverbs included in this chapter.

A proverb familiar to me since childhood, 'xuan liang ci gu' is an ethical coinage combining moral lessons from two disparate historical incidents. In the Eastern Han dynasty (25–220 CE), a politician named Sun Jing, striving to advance his career and earn respect from his family, devoted himself to study so seriously that he refused to stop for food or rest. So that he could continue reading and not fall into an exhausted sleep, he tied his long hair with a rope to a roof beam. In the Warring States Period (476–221 BCE), a minor scholar-official named Su Qin also tried to improve his socio-familial standing by studying hard. Whenever he began to doze off, he would stab his thigh with an awl so as to wake up and resume reading. Xuan liang xi gu, the proverb commemorating the extreme study tactics of these two men, became my parents' proof of our hereditary Chinese wisdom: 'Should a mountain crash in front of you and a flood threaten to swallow you, you must remain steadfast and study hard—no matter what!' My parents' hyperbole emphasizing the insignificance of natural disasters compared to my obligation to study often culminated in a severe but somewhat promising prophecy: 'chi de ku zhong ku, fang wei ren shang ren'—(those who can) eat the bitterest among all bitterness, (will) therefore be the topmost among all people.

A manifest moral underlined my parents' words, complete with an unambiguous action plan (to study); a cognitive capacity supported by corporeal determination (to study hard, harder and hardest among all); and attendant rewards (parental affection, familial exaltation, social recognition, career success). My parents had distilled the mundane and distinctly

middle-class ethical essence from the endurance behaviours of Sun and Su—a specific action (academic dedication) is a means to an end (becoming a superior individual). The end justifies the means; the purpose validates the conduct: perseverance leads to knowledge leads to power. As long as the purpose is 'good' (orthodox, practical, socially acceptable, culturally advantageous), the process may be 'bitter' (hurting one's body, if bolstering one's will), and bitterness with a purpose, like medicine, must be 'swallowed' (eaten/endured) for the ultimate reward. Should I ever doubt the truth of their teachings, I need only look to the proverbs—the ancient poets do not lie! 'You shi wei zheng' (There is a poem to prove the truth)! In other words, well-crafted language, reinforced with 'good' content, carries eternal—ancestral—truth, which enjoins us to subject our bodies, themselves infinitely malleable, to volitional self-discipline. The sky is not the limit; our will is.

By evoking the proverb 'xuan liang ci gu' and conjuring up images that indeed call to mind actions typical of body art—a man's hair tied to the roof beam and another stabbing his thigs with an awl—Zhang has enunciated a subject position rather different from the one he produced with a piece like *My America*. In 1999, when Zhang enacted his first large-scale group performance piece in Seattle, he was a new immigrant, unknown by most of the international art world and barely able to speak English. Against an inchoate sense of estrangement, his encounter with two bread-givers at Madison Square Garden became tainted with extraordinary symbolic poignancy, for it suddenly plunged him into what Homi Bhabha calls 'the unhome-liness', signifying 'the condition of extra-territorial and cross-cultural initiations' (2006: 13). Zhang was initiated into his new 'unhomely' identity as an alien-other, a change from his role as a self-alienating outcast at home. Nevertheless, for the Chinese artist, his difficult acclimatization is only part of his American story. As Zhang recalls in 'A Piece of Nothing', his initial exposure to New York included being subsidized by non-profit foundations for his performance art practice, an experience that contrasted—like 'heaven and hell'—with his past in Beijing as an artistic pariah who 'worked almost exclusively underground' (Zhang 2007: 73–4). *My America*'s performance score dramatizes this split in Zhang's self-perception—as an artist, he was able to direct 60 complete strangers to strip and follow him into a museum; yet he also externalized his insecurity by subjecting his body to a scene of abjection, letting his volunteers-turned-mob transform an ordinary life-giving substance—bread—into degrading pellets against his person. The very cultural system that had afforded the artist a better professional existence also supplied, if inadvertently, the source of his humiliation.

In 2005, when he gave his talk at Otis, Zhang was already an internationally recognized and well-exhibited performance artist. Calm and reticent, he often paused in his exchange with audience members to let his translator speak—a pattern that intensified the artist's detachment. I sensed that, though Zhang had lived in New York for years, he still regarded himself as a Chinese rather than a diasporic, hybrid or stateless cosmopolitan subject, and certainly not as a Chinese-American immigrant artist on his way to being fully acclimatized. Did Zhang know at the time that he was on the cusp of a career shift?

In 2006, Zhang's series of nine performance photographs, *Family Tree* (2000), would establish an auction record at Sotheby's first New York sale of Chinese contemporary art; the sale followed the artist's resettlement in Shanghai at the end of 2005, along with a shift in his

3 For a discussion of Zhang's commercial success, see Barbara Pollack (2007) and Li Huang (2006). For Zhang's artistic developments, see Melissa Chiu (2007). Via an email query dated 22 July 2009, I confirmed with Zhang's studio regarding the date of his return to Shanghai. With respect to my query about the 2006 auction, Zhang's assistant replied that they seldom pay attention to auction sales.

4 I am indebted to Sonya Lee, an expert on Buddhist art, for clarifying the Chinese translation of *zhong sheng* as 'sentient beings'.

primary art practice from the time-based medium of performance art to making objects.[3] In *My America*, Zhang incorporated Buddhist imagery in both his choreography for the participants and in their collective presence as human incarnations, joined momentarily to form an enfleshed bas-relief of what might be called *zhong sheng* (sentient beings / all lives)—a Chinese translation for various Sanskrit terms such as *jantu, bahu jana, jagat, sattva* (see Getz 2003).[4] Now, in Zhang's vast Shanghai studio, he employs about 100 artisans to help him translate these fleeting Buddhist visions into massive sculptures made of incense ash or animal hides, like behemoth prehistoric relics. Perhaps in his talk at Otis, Zhang had begun the process of reclaiming his Chinese cultural subjectivity in anticipation of his voluntary repatriation. Projecting his xingwei yishu in the historical light of 'xuan liang ci gu' was then a rhetorical symptom of the artist's psychosomatic transition.

From another perspective, however, we may regard Zhang's artistic development as consistent throughout his career. Although Zhang had moved his artistic base from Beijing to New York and then to Shanghai, I discern his signature aesthetic as a synthesis of two interacting languages, one adopted and the other inherited—an individual language of time-based body-works and the cultural language of his mother tongue, Chinese. On the one hand, the artist's sentient body acts as the constant, basic vocabulary in his performance language, evoking such transcultural Buddhist notions as ephemerality, illusory existence and mortal suffering. On the other, the Chinese cultural language, to which Zhang often refers with sinified visual signs, became much more prominent in his performance and photographic works after his emigration to New York. These two languages merge dynamically in *My America*. The performative iconography of a single sentient body set against many others highlights the dialectic of multicentricity I have analysed in earlier chapters as a prevalent type of Chinese subjectivity. With flesh equally exposed, the artist appears no different from other naked bodies surrounding him; simultaneously, his isolated placement centrestage physicalizes his (fallible and vulnerable) centricity as a single perceiver in a multicentric universe.

If multicentricity is not specifically Chinese, then in *Family Tree*, which Zhang calls his 'serial self-portrait', sinification is unmistakably writ large (see Zhang Huan 2009). For *Family Tree*, Zhang commissions three calligraphers to inscribe on his face certain Chinese words and phrases. From dawn to dusk for a single day, the calligraphers continue to write, even after the artist's entire face is covered in black ink. At a glance, Zhang's *Family Tree* recalls an earlier xingwei piece by Qiu Zhijie, who repeatedly inscribed Wang Xizhi's calligraphic masterpiece, 'Lanting Xu' (Preface to the Orchid Pavillion) 1,000 times (between 1990 and 1997) on the same sheet of paper and long after the paper became utterly darkened with ink.[5] Although both time-based artworks involve the

5 See Chapter 6 for an analysis of Qiu's *Repeatedly Replicating A Thousand Times 'Lanting Xu'* (1990–97).

(FACING PAGE) IMAGE **3.2.1** Zhang Huan performing *Family Tree* (2000), recorded in a series of nine performance photographs. Image courtesy of Zhang Huan Studio.

meditative action of writing beyond legibility, their differing temporal frames indicate their conceptual divergence. Taking seven years to finish writing a 'casually chosen' number—1,000 times—Qiu's piece centres on the perennial and always present–tense relationship between the

(ABOVE AND FACING PAGE) IMAGES **3.2.2–5** Zhang Huan performing *Family Tree* (2000). Image courtesy of Zhang Huan Studio.

IMAGE **3.3** Qiu Zhijie performing *Repeatedly Replicating a Thousand Times 'Lanting Xu'* (1990–97). Image courtesy of the artist.

artist as calligrapher and the calligraphic text he studiously copies as mere traces of a writing action (Qiu Zhijie 2009). In contrast, the dawn-to-dusk duration that Zhang enacted for *Family Tree* is laden with the symbolism of a birth-to-death cycle, the artist's face being the chosen synecdoche for his sentient being. Another crucial difference lies in the projection of agency. Qiu takes the active stance as the one who writes, albeit within the restricted frame of a pre-existing canonical text. Zhang demonstrates a compromised agency: while his face is the surface being ceaselessly written on, he is also the one who chooses what is to be inscribed on this surface. Thus, Qiu's protracted brush-pen writing assignment comments on calligraphy as a performance art form whereas Zhang's opus of self-effacement draws from calligraphy's position in China as an orthodox cultural heritage.

Although Zhang entitled his piece *Family Tree*, the calligraphic scripts on his face did not record names of the artist's patrilineage, as does a traditional Chinese almanac of one's family tree. Instead, the words and phrases were culled from Chinese traditional folk and spiritual wisdom, including idiomatic expressions from fortune-telling/divination books and personality notations from Chinese physiognomy. I find it telling that among the ones he selected, Zhang picked a particular phrase to discuss in his note on *Family Tree*, a phrase conveying a similar

ethical lesson as the one captured by 'xuan liang ci gu': 'In the middle of my forehead, the text means "Move the Mountain by Fool (Yu Gong Yi Shan [愚公移山])". This traditional Chinese story is known by all common people. [It] is about determination and challenge. If you really want to do something, then it [can] really happen' (2009).

In the Warring States period, a 90-year-old man named 'Yu Gong' (Old Man Fool) lived underneath two mountains, which made his travel to the outside world extremely difficult. One day, Old Man Yu asked his family to join him in moving the mountains so that they might have a better passage going outwards to the sea. When his neighbour Zhi Gong (Old Man Clever) mocked him for his senility and feebleness, Yu replied that his determination would overcome all difficulties. If he died before the mountains were moved, his son and grandson and their sons and grandsons would continue his task. Their cumulative labour would keep chipping away rocks and mounds while the mountains themselves would not grow. Yu's resolve and persistence not only reduced Zhi to silence but also touched the heart of the celestial emperor, who then sent two deities to move the mountains to other locations.

Despite their equivalent stress on willpower, the two proverbs cited by Zhang—'xuan liang ci gu' and 'Yu Gong yi shan'—are divergent in their class implications and concomitant value systems.

Purportedly coined from historical incidents related to *shi* (learned gentlemen or scholar-officials), 'xuan liang ci gu' conjures up a pan-Confucian ideology in which learning, teaching and governing are mutually implicated and progressively linked. Pursuing knowledge is not a disinterested endeavour but an initial step in a process of self-cultivation that culminates in serving the world, as illustrated by these proverbial summonses from the classic text, *Da xue* (commonly translated as *The Great Learning*): *xiu shen* (cultivating the self); *qi jia* (ordering the family); *zhi guo* (governing the country); *ping tianxia* (bringing peace to the world). Through the highly influential commentary of Zhu Xi (1130–1202), a neo-Confucian philosopher and educator in the Southern Song dynasty, traditional Chinese intellectuals widely adopted these objectives as ethical cornerstones of Rujia (the Confucian School). That Zhang appeared to have extemporized this Rujia-derived motto 'xuan liang ci gu' in response to an Otis listener's question about his artistic source attests to the increasingly hegemonic revival of Confucianism as a state-endorsed ideology in post-Deng China.[6]

6 For the recent revival of Confucianism, see Liu Kang (1998).

In contrast to the scholastic outlook of 'xuan liang ci gu', 'Yu Gong yi shan' is a plebeian allegory, concluded with a wishful—*deus ex machina*—triumph for the idealistic patriarch. The allegory was inducted into the revolutionary pantheon of heroic texts when Chairman Mao alluded to it in a speech in 1945, naming 'imperialism' and 'feudalism' as the two mountains blocking China's freedom and equating the divine redemptive figure with the Chinese people (Mao Zedong 2006). Old Man Yu's steely resolve (and procreative prowess) in fighting against an overwhelming (enemy) force was transformed from an obscure anecdote about the blessing of being a wilful 'fool' into a nationalist mythology, extolling the relentless willpower of the Chinese people. Ancient ethics couched in Mao's idiom is communist ethos redeemed.

'Where there is a will, there is a way.' This English saying carries an advice similar to those given by Zhang Huan's two axioms. Although the axioms are both bequests from the sinocentric

cultural history—feudal or communist—they do not impart any unique Chinese wisdom. Nevertheless, I am interested in the fact that Zhang cited them in relation to his xingwei yishu for it confirms my hypothesis that Chinese time-based art's ultimate addressee is not the country's art history but its long-standing ethical tradition. Regardless of the politicized permutations in which it is rendered, this tradition signifies a dominant patriarchal legacy, wrought primarily by Confucian thought and inflected with the indigenous Daoist philosophy and sinified Buddhist outlook. To a large degree, this patriarchal legacy is transmitted to the populace through canonical literature distilled into folk proverbs. Specifying individual conduct as its sphere of inquiry, xingwei yishu wrestles with this Chinese ethical tradition which dictates how an individual ought to think, behave, interact, position oneself within one's patrilineage and confront various transitional stages of life (birth, childhood, education, adulthood, career, marriage, parenthood, grandparenthood, old age, death).

The two proverbs Zhang references (with many other classical verses, dictums, allusions and allegories turning up elsewhere in xingwei yishu and xingwei-zhuangzhi) point to a prevalent method in which Chinese time-based artists tackle their ethical heritage: by mimicking how this sinocentric heritage is expressed, absorbed, disseminated and practised orally, colloquially and pedagogically among the Chinese people. Thus, learning 'ethics' through 'proverbs' —both patently sinified—is a major plot in the story of Chinese time-based art. A competing plot in this story plays with the act of learning ethics without proverbs, that is, directly through wordless deeds. Another rival plot tells how learning ethics through proverbs, like painting by numbers, becomes a limitation in itself. To challenge this limit adds a dissenting voice to the story: how to unlearn 'ethics', as a given cultural inheritance, both through proverbs and without them. Zhang's verbal actions that I have analysed so far focus on just part of the story; his divergent performances tell the rest.

In naming 'xuan liang ci gu' as precedents, Zhang aligns his extreme bodyworks with those no-less-drastic corporeal self-disciplines, seemingly placing his art within their Confucian zeitgeist. Zhang's xingwei yishu also violates the ethical limit guarding these culturally sanctioned 'scholarly' behaviours because his non-utilitarian bodyworks are done for the artist's experiential *process* rather than for any orthodox *purpose*. Although Zhang had 'Yu Gong yi shan' written on his forehead, his face in *Family Tree* dramatizes a person's incessant enculturation as a gradual self-negating visual narrative—at the end of the day, no self nor any cultural traces can be read. The inky darkness erasing his facial features may then symbolize the self's demise, which promises no intelligibility to our mortal eyes. The thick ink borne by Zhang's face may also represent the burden of 'family' obligations or the ethical price that an individual must pay for belonging to the extended family tree of China. An effaced visage gives out no more information than of its erasure. In this sense, we may read Zhang's darkening face as a struggle with his Chinese cultural membership: he negates the inscribed messages by piling them up beyond the point of excess.

Being part of China's vastly effective ethical universe, xingwei yishu and its spatial kin, xingwei-zhuangzhi, cannot stand apart from their indigenous sociocultural make-up to launch a critique from without. During the 1990s, a number of Chinese time-based artworks—including Zhang Huan's earlier East Village bodyworks—engaged in frontal assaults against this

tradition. Chapter 2 has described some of these pieces which incorporate violence as a thematic trope and material force to grate against prevailing ethical expectations. This chapter shall treat some other confrontational pieces set in the sensitive zone where ethics and mortality meet. The physical intensity characteristic of behaviours like 'xuan liang ci gu' finds its match in these sharp-edged artworks that launched their attacks precisely at two temporal limits of an individual life: birth and death. I will also touch upon the other type of time-based projects—albeit rarer than its edgy other—that have chosen a circuitous route. They intervene in China's ethical foundation less by detonating its soundness than by tactically chiselling away its solidity. In these instances, 'Yu Gong yi shan' offers a suggestive allegory for xingwei yishu. Time-based artworks like these breach the ethical limit not by enacting overt transgression but by persisting in ineffectual protestation.

LIMIT: A POINT BETWEEN HERE AND THERE

What is a limit? Denotations for a 'limit' include: (1) a boundary and a frontier; (2) the utmost extent, a bound beyond which something ceases to be possible, permissible or safe; (3) a prescribed maximum or minimum amount, quantity or number; (4) something that's exasperating or intolerable.[7] The word's first sense places it spatially as a fringe marker for a territory accustomed by use, habitation or ownership. Its second sense aligns it with an action's highest imaginable, socially sanctionable or legally advisable degree.[8] The third sense pushes it spatially and temporally towards both ends (the maximal and minimal points) to bring a span, an interval, an in-between area or sequence into view. The fourth divulges its potential emotional effects on a perceiver. Common to all four senses is a relational dynamics—the limit as that which relates from a margin to a larger realm of habits, conventions and best practices. Occupying the limit, I, the actor, can choose to look in multiple directions—inwards towards preserving, modifying or destroying the *past* (which is still *here*), and outwards towards making available, revising or preventing a different *future* (somewhere out *there*).

[7] For these condensed denotations, I consulted *The New Shorter Oxford English Dictionary*.

[8] I am indebted to Rolf Hoefer for his judicious comment about what being 'permissible' and 'safe' entails.

How does a limit work lexically with ethics? In relation to the first usage, an ethical limit is the point of praxis beyond which lies a moral wilderness. According to the second, an action inhabiting the limit—let's call it 'a limit action'—declares its being like an ethical cliff beyond which lurks the maw of social death, a purgatory yawning incognito. In the third sense, a limit action transgresses received ethical assumptions by blowing them up like paper balloons, unable to float in the air without being forcefully thrown up, or by squeezing them tightly into crumbled balls of paper, ready to be flung into a wastebasket. Applying the fourth meaning, a limit action frequently ignites ethical controversies, dividing its perceivers into defenders and detractors of such an action.

What is a limit action? A limit action is a volitional behaviour that collides with multifarious limits by staging extreme situations, which tend to elicit strong responses from observers. Limit actions almost always take place in the field of ethics—as a behavioural arena that demands us to think, talk, sit, walk, eat and sleep in various culturally prescribed ways—for their effects are

perceived in relation to pre-existing moral conventions, those socially ordained to ritualize archetypal circumstances (such as birth, illness, learning, teaching, healing, survival, revival, union, separation, violation, interdiction and death). Ethical limits exist for each archetypal circumstance to interpret its given temporal-spatial framework and sociocultural habitus and to interact with its participatory community. I argue, however, that among all ethical limits, those provoked by birth and death as literal life events are exceptional for their factual and symbolic standings because they are the two existential episodes delimiting the earth-bound life spans of all sentient beings. As facts of life, they add the weight of finality to our biological limits; 'to be unborn' and 'to not die' are both options excluded from this finality. As symbolic entities reflecting our linear conception of mortality, birth connotes the beginning and creation while death the ending and destruction. Converging their semantics and poetics alerts us to recognize birth and death as the two liminal, endurance occasions that establish the definitive limits—the minimal and maximal points, as it were—for any archetypal circumstance. They mark the *here* and the *there* for all limit actions, made specifically to target ethical expectations at their most insistent moments.

In the field of time-based art, we can often encounter limit actions, especially those addressing the issues of vitality and mortality. Since xingwei yishu and xingwei-zhuangzhi target the mores of time-based behaviours, their practitioners are predisposed to probing the exceptional finality and utter ordinariness of birth and death, two globally relevant, limit life-events. As a durational and irretrievable engagement modelled after our transient existence, a time-based artwork presents a prototypical life, with birth/inception and death/cessation framing its limit moments. Treating birth and death as artistic matter allows time-based art to confront its ontological as well as ethical limits. There is the additional benefit of anticipating its viewers' visceral reactions, mobilized by a few close reminders of their inescapable biological limits which in turn expose their ethical habits.

Attempting to study how Chinese time-based artists challenge their own and their viewers' enculturated ethical assumptions, I devote the following inquiry to numerous limit actions that centre on the literal and metaphorical events of birth and death. In my extensive research, I have discovered a qualitative difference between the way in which Chinese artists treat birth and death: themes and figures of birth mostly appear as metaphors, symbolic allusions or circumstantial back-stories; conversely, acts, rituals and imagery of death often take centrestage as gruesome display. Why? I submit three speculations:

1. THE RISING 'PENCHANT FOR THE MACABRE' | This phrase from Li Xianting, curator of the exhibition *Dui shanghai de milian* (*Infatuation with Injury*, 2000), sums up a predominant tendency—one that Li himself nurtured—of Chinese time-based art as it hovered round the end of the twentieth century in Beijing. Perhaps the millennial transition, with its apocalyptic ambience, abetted Chinese artists' reveries about death as a theatre of anxiety. Birth took the quiet backseat accordingly.

2. A NEW ACCEPTANCE OF FLAUNTING FORBIDDEN IMAGERIES | According to Wu Hung, portraying images of ruins was taboo in premodern China for its implications of 'inauspiciousness and danger' (2008: 4). In the early twentieth century, under the influence of European photographs of the war-torn 'old China', images of architectural ruins were legitimated and popularized by

Chinese photographic works. Pushing this modern trend's limit at the end of the century, several xingwei-zhuangzhi artworks examined here displayed in public human cadavers as somatic ruins left by death.

3. A MOVE TOWARDS UNLEARNING ETHICS THROUGH PROVERBS | As Qiu Zhijie argues in 'Zhongyao de bushi ro' (What's Important is Not Meat, 2001), his apologia for the 'violent' xingwei yishu and xingwei-zhuangzhi, the uses of human corpses, severed limbs and tortured animals in Chinese experimental art have much to do with China's 'unique death culture and body concept', derived largely from a spiritual synthesis of such Daoist insight as Loazi's 'tiandi buren' (the sky and the earth are not humane / Nature has no mercy) and the Buddhist ideas of 'guan shen bu jing' (observing one's body to know that it is unclean / visualizing the lack of purity of one's body), 'zhongsheng pingdeng' (equivalence among all sentient beings) and 'lunhui' (transmigration) (Qiu Zhijie 2003: 89, my translation). Extending Qiu's analysis, I maintain that Chinese time-based art has indeed grappled with indigenous thoughts by evoking two well-known adages concerning not just death but also birth: the Confucian 'weizhi sheng yan zhi si?' (If [one] doesn't yet know birth, how does [one] know death?); and the Daoist 'si sheng, ming ye' (death, birth, [but] life).[9]

9 See 'Lunyu' in Confucius 2000 (2000); for the Daoist maxim, I have re-translated this passage from Zhuangzi based on its original Chinese text in Zhuangzi (1999: 92). I choose to follow the popular translation of 'Kongzi' as Confucius.

'Weizhi sheng yan zhi si?' (If [you] don't yet know birth, how do [you] know death?) was Confucius' response to his disciple Ji Lu, who bluntly raised the question, 'Gan wen si?' (Dare [I] ask [my master] about death?) The sage advised his student to learn, instead, how to place himself ethically within the daily living world rather than musing about something beyond mortal knowledge. Confucius' scrupulous attention to quotidian ethics recalls his other comment about superstitious metaphysics: 'jing guishen er yuan zhi' (respect ghosts and gods but stay away from them). Insofar as properties of death (dead bodies, burials, suicide notes, dying throes, etc.) resemble spiritual estate, Chinese time-based art has effectively violated both admonitions from the teacher-sage. By brazenly sighting references of death, a few daring time-based artists in Beijing seem to have reversed the syntactical and conceptual order of the Confucian adage to retort: 'Weizhi si, yan zhi sheng?' (If one doesn't yet know death, how does one know birth?).

My birth brings me *here* and my death might take me *there*. If I cannot know for now whether there is a *there* out there, I'd better conduct myself well *here*. This is the Confucian logic—for if there is no *here*, how do I reach *there*? The solid *here* is the basis of the ever-ethereal *there*, supposing that there is indeed a *there*. Even so, I would bow to the great teacher and rejoin: If there is only *here*, *here* is already *there*. Here only becomes a *here* because there is a *there*. I would also be curious to know—even if I cannot be sure—when *there* is finally *here*, is there still a *there* and a *here*? To me, these tongue twisters illustrate that *here* and *there* are complementary concepts. While not interchangeable, they positively construct each other: *Here* is in t/*here* and t/*here* here, even though in *here*, without the letter *t*—which may well stand for *time*—I don't quite know (how to be) *there* yet. To translate *here* into *birth* and *there* into *death* leads to the Daoist philosopher Zhuangzi's maxim in his contemplation about the natural law

of Dao (the Way): 'si sheng, ming ye' (death, birth, [but] life) (1999: 92). Bracketing the span of my life at both limits, birth and death are integral to my being-in-impermanence. Gauged radically, being born is to begin dying. Without consent, I was born; without the possibility of resistance, I will die—my lot in this life.

We may take Zhuangzi's saying ('si sheng, ming ye') as describing the process of making/showing an ephemeral artwork, with death and birth paradoxically rounding out its limit moments: the point of incipience ends past inaction while dissipation ushers in new stillness. Zhuangzi teaches us to accept the inevitability of our mortal lot with *wu wei* (nonactive/nonreactive way). Is it possible that Chinese time-based art, revolving as it is round *xing wei* (to move and to do / vigorous, intentional behaviour), tries to unlearn Zhuangzi's ethical vision by consciously embracing the birth–death dyad as not only a phenomenon innate to temporal beings but also a constant rationale for action? Flipping 'si sheng, ming ye', we will get 'ming, sheng si ye' (Life, [but] birth and death). To understand life is then to embrace its limit experiences as a constant flux, a relatively unlimited anthology of quasi-births, quasi-deaths, quasi-birthdeaths and quasi-deathbirths—intertwined, a-sequential and endlessly extreme, even as they are also not too extraordinary.

In the spirit of un/re-learning my proverbial ethical enculturation, I select a number of time-based artworks to study how they wrestle with a peculiar limit of our sentient existence— not that we exist before we learn of our essence but that our essence is itself un/re-learnable. If my essence evolves through time, flowing through un/changing cycles of birth–death dyads, I can then never fully grasp what it is. Nonetheless I can try to un/re-learn that which emerges out of my seeking as a hitherto subliminal limit to my self-understanding and realization. I go beyond the *here* of my cognitive limit by vicariously leaping into the *there* and *there* and *there* of my otherness. The artworks sampled in this chapter all stage certain limit actions; only a few of them pursue outright the themes of birth and death. Yet, if we reconceptualize 'birth' as 'a condition of possibility' and 'death' as 'a transition into otherness', then no limit action can avoid dealing with these two edges that frame its duration—even though variables exist to turn a beginning suddenly into an end and an end into a new beginning. All selected artworks, to varying degrees, pit their artists against the life cycles of birth-in-death-in-birth-in-death-in-time. Together they offer a repository of limit actions as inquiries into the cyclical liminality of birth and death.

BIRTH, OR A CONDITION OF POSSIBILITY, PLUS . . .

Risking Termination: He Yunchang

22 October 2005. In broad daylight, a naked man walks into the upper streams of Niagara Falls, slicing through the rapid currents to move towards the falls. He swims across a small creek and stands among the low bushes mid-stream. He pauses and pulls at a rope that stretches from a boulder on the bank, across the water, to circle his waist. Shivering in the chill that dips below 35°F, he throws the rope's loose end forward. He is surprised when the rope sinks under the water and dismayed when he fails to dislodge the rope after repeated tugging. He turns round and retraces the rope back to the bank, hoping to get a razor to cut loose the stuck end. Several policemen are waiting for him on the bank. They glance at the man's drenched body—blue from the cold

10 The descriptions of He's performances in the US are based on my interview with He, 31 January 2006, Beijing. See also He Yunchang (2005).

and raw from a multitude of flesh wounds—handcuff him, wrap him up in a blanket and rush him off to a hospital in Buffalo.[10]

The man was He Yunchang, enacting a self-sponsored xingwei project during his first US visit to participate in *The Wall: Reshaping Contemporary Chinese Art*, a large-scale exhibition curated by Gao Minglu at the Albright-Knox Art Gallery in Buffalo, New York. The evening before his plunge into Niagara Falls, He performed *Jiangjun Ling* (*The General's Command*, 21 October 2005) behind the Albright-Knox as part of the opening events for the exhibition (see Gaasch 2004).

With just a coating of grease on the skin, He climbs into a transparent Plexiglas cube (1.8 m in length and width, 1.5 m in height) to execute *The General's Command*. He sits on a chair inside the cube, ties his ankles to the chair and asks his assistants to activate a churning cement-mixer which begins pouring concrete from a tube into the cube. Within minutes, He's body is buried up to his shoulders in a solid damp mass. After about 30 minutes, when several attempts at intervention by the gallery staff are met with the artist's refusal, a woman in the audience yells, 'Make the decision for him!' But He, while showing distress by repeatedly banging his head backwards against the Plexiglas surface, endures his physical suffering to persist in self-internment. After an hour, the artist finally consents to being rescued from his concrete encasement, allowing the cement paste to fall off his body when his assistants remove the Plexiglas walls. Acidic traces of concrete, however, have seared into the artist's body, leaving around 2,000 blackened scars on his torso and limbs.

IMAGE **3.4** He Yunchang performing *Jiangjun Ling* (*The General's Command*, 21 October 2005). Image courtesy of the artist.

Less than 20 hours later, He walked into the dazzling waterscape of Niagara Falls, attempting to perform *Nijialagua Pubu de yanshi* (*A Rock in Niagara Falls*, 2005). Similar to his plan for *A Rock Tours Round Great Britain*, He's proposal for his piece on the aquatic border between the US and Canada was deceptively simple—he would find a rock in Niagara Falls and stay there for 24 hours. The water's low temperature forced him to revise the project's duration to an hour but his arrest after only about 20 minutes aborted the performance. A tourist who spotted He's action called the police with a suicide alert. The artist was eventually tried and convicted on counts of 'inappropriate behaviour in public' and 'indecent bodily exposure'.[11] He was fined, as were the two students who had helped him film the performance onsite. The gallery that sponsored He's visit suffered no legal liability, because it had explicitly rejected the artist's site-specific proposal for *A Rock in Niagara Falls* in favour of his alternative scheme, carried out as *The General's Command*. The lack of official support notwithstanding, the artist took what he considered an ideal natural site's propinquity as an invitation for action.

11 My phone interview with He Yunchang, 31 January 2006, Los Angeles to Beijing.

Both *The General's Command* and *A Rock in Niagara Falls* dramatize the head-on collision between mortal flesh and external force, be it natural or manufactured. The chance for the human individual to survive the inhuman onslaught seemed so slim that observers read them as scenes of senseless danger. The woman yelling 'Make the decision for him' during *The General's Command* and the tourist who helped stop *A Rock in Niagara Falls* probably did not mean to censor an art performance—they were responding to a dangerous slippage between art and life occasioned by He's limit actions. Although the woman in the gallery knew she was viewing a live art event, the artist's seemingly irrational doggedness in placing his body in harm's way invalidated his artistic licence, making her ethically responsible to intervene. The gallery staff members who sought to shorten the performance probably shared her view but their ultimate ethical obligation as guardians of art compelled them to support the artist's freedom of expression. The Niagara Falls tourist did not see art but a suicidal behaviour which amounted to a life-and-death emergency demanding an immediate call to 911. According to the types of misdemeanours with which He was charged, however, the US court adjudicates the artist's 'harm condition' not in the legal locus of individual rights (for example, to criminalize He for a suicide attempt, reckless body art, etc.) but in that of public interest (for offences like inappropriate behaviour and nakedness in public).[12]

12 For a discussion of the relationship between the 'harm condition' and legal prohibitions, see Anthony Ellis (1984).

These diverse responses to He's actions from a range of US citizenry suggest that ethical judgements are not only predetermined by local laws and customs but that they are also contingent upon certain enculturated, socially positioned yet somewhat autonomous agents. He Yunchang himself was one of those individual ethical agents in the paratheatrical scenarios triggered by his extreme performances, even though the source of his socio-cultural conditioning and contestation significantly differed from theirs. Indeed, the threat of actual danger is a premeditated aspect in the Chinese artist's xingwei yishu. He once told me in an interview that he always prepared a written will and settled various pending affairs before he enacted a xingwei project.[13] Whereas

13 My interview with He Yunchang, 4 July 2005, Beijing.

death is not necessarily an express theme in his potentially lethal performances, the artist realizes that self-termination may well be a consequence of his time-based art practice. Perhaps by figuring death into his calculation, He frees himself from any inhibition in pursuing his limit artworks to their logical conclusions.

While He has systematically initiated irreversible bodily harm throughout his xingwei career, death has never been his desired destination.[14] Instead of structuring his artwork according to a projected goal, the artist has typically circumscribed his performance journey by a chosen time frame —from 15 minutes to his preferred 24 hours. He gauges a project's efficacy by the extent to which his body is capable of withstanding the premeditated conditions and duration of each piece. He subjects himself to a contest of wills, pitting his fragile flesh steeled by personal resolve against an apparently indomitable force—weather, water, fire or concrete. 'My body is my own and I can do anything I like with it,' replied He to my query about his series of physically taxing bodyworks enacted in China since 1992.[15] The irony of his first cultural exchange with the US was an unexpected discovery: his ability to exercise in public what he believed to be his corporeal 'property right' was curtailed in a nation that, unlike his, assertively promotes freedom of expression, identity politics and human rights.

14 For example, *Dragon Fish* (2006) left some permanent scars as did *The General's Command. Shili ceyan (Eyesight Test*, 2003) weakened his eyesight. In *Yi gen le gu (A Rib*, 2008), He had his surgically removed front rib made into a necklace, which I saw but did not touch in He's Beijing studio. (My interview with He Yunchang, 17 July 2008, Caochangdi, Beijing.)

15 My interview with He Yunchang, 4 July 2005, Tongxian, Beijing.

Unbendable will, endurance, faith and perseverance for the sake of an almost 'foolish' objective—these behavioural tenors in He's bodyworks seem to have migrated right out of the allegory of 'Yu Gong yi shan'. In fact, Old Man 'Fool' ('Yu' as the allegorical 'fool') could have been the very patriarch He portrayed in *Yi shan (Moving the Mountain*, 26 February 1999), a xingwei piece that the artist staged in his home province Yunnan, near a river named Lianghe. Tying four ropes to a line of wooden stakes driven into a mountain, the artist carries the ropes across his shoulder, attempting to vigorously pull the mountain for 30 minutes. As He notes, 'The Earth rotates 1,670 km per hour. After 30 minutes, the mountain has moved from west to east by 835 km' (He Yunchang and Tang Xin 2004: 12, my translation). Keeping faith with his forerunner Yu's stubborn optimism, He's mathematical astrophysics wittily reinterprets the ancient allegory's divine quantum translocation of two mountains. A similar conceptual arithmetic appears in He's description for another bodywork, *Yu shui duihua (Dialogue with Water*, 14 February 1999), staged at Lianghe two weeks prior to his mountain piece.

For *Dialogue with Water*, He hires a local butcher to slash symmetrical 1 cm–deep cuts on his upper arms. As blood seeps from his wounds, the artist is tied upside down with metal chains onto an industrial crane which hoists him up to hover above the Liang River. When the crane stops moving, the artist stretches out both arms to thrust a knife into the flowing stream. As blood congeals along his arms, He sinks his knife 30 cm into the water and remains in that position for 30 minutes. 'The river flows at 150 m per minute. The performance lasts 30 minutes. The river is left with a 4,500 m–long and 30 cm–deep wound,' notes He in his solo exhibition catalogue (ibid.: 12, my translation).

Like *Moving the Mountain, Dialogue with Water* exhibits many traits typical of concurrent bodyworks in Beijing. These bodyworks tend to transplant the strange onto the mundane and

IMAGE **3.5** He Yunchang performing *Yu shui duihua* (*Dialogue with Water*, 14 February 1999), in Lianghe, Yunnan Province, China. Image courtesy of the artist.

conflate the literal with the symbolic. Employing the corporeal to distil existential concerns, He and his body art peers are liable to ignore the absolute limit in art-making. The common traits in their bodyworks often derive from displacement and intensification. He's mountain and water pieces, for example, are made of ordinary components: a male artist; found natural land-scapes; wooden stakes, ropes and a butcher's knife; human horsepower and the kind of indus-trial crane that has become ubiquitous in Chinese cities in their race for urbanization. By assembling these elements atypically in a rural setting for a scored behaviour, the artist has repossessed quotidian objects for art and turned them into xingwei readymades. He's *Dialogue with Water*, however, contrasts with the deadpan positivity of *Moving the Mountain* in its empha-sis on the theme of injury.

Unlike the German Expressionism's scream against the Industrial Revolution's mechaniza-tion of humanity, the theme of injury in *Dialogue with Water* has little to do with external pressures. In my view, the crane, the iron chains and the gushing stream function more like collaborators with the artist than his rivals or oppressors. Since a dialogic act entails the participation of equal

partners, He designed a way to place himself at par with the Lianghe. By attaching his body to a gigantic machine, He both elevates and enlarges his stature, like a *deus ex machina*, to gain visual parity with the magnificent currents. He further elaborates the dialogue by undertaking a mirroring act—the knife driven into his flesh later penetrates the water's liquid skin. The act that interrupts the blood circulation *within* the artist's body becomes the medium for his dialogic exchange, which in turn disrupts the river's otherwise unimpeded flow. The 'dialogue' as embodied by He's piece is, then, a bartering of injuries; the artist's conversations with the water leave both parties with keepsake wounds.

In *Dialogue with Water*, the theme of injury, made manifest through a self-harming ordeal, refers less to death than to the constancy of injury in daily exchange. The mutilation of the artist's body and the violation of the river's autonomy symbolize the sombre, even perilous, potential of contacts between subject and subject (the artist and the river as conversation partners), between subject and object (a conscious human individual and an insentient natural element) and between object and object (a flesh-and-blood entity and a source of hydraulic power). I cannot survive without contacts with others but I might hurt and hurt again through these contacts. The artist's status as a corporeal being, able to feel pain and sustain damage, together with the river's body as an overpowering presence expose the dilemma of my present incarnation: the assured prospect of mortality. If death is a mortal being's absolute limit, an artist like He nevertheless regards it only as his bodywork's potential side effect. Death occupies no territory a xingwei artist cannot explore; what we don't yet know is whether death erects a border beyond which a xingwei artist can/not return.[16]

16 I am indebted to Rolf Hoefer for this latter more challenging task—for a xingwei artist, like Hercules, to return from death.

In any case, He does not consider death a limit for his xingwei yishu. What is then the limit against which his art presses? 'Shenti fafu, shou zhi fumu, bugan huishang, xiao zhi shi ye' ('The body, hair and skin, all have been received from the parents, and so one doesn't dare damage them—that is the beginning of *xiao*'). This four-phrase aphorism appears in the 'Opening Explanation' of *Xiao Jing* (commonly translated as *Classic of Filial Piety*) to extol the virtue of *xiao* which, according to Feng Xin-ming, was first translated into 'filial piety' by the Jesuits in the sixteenth century. A more direct translation for this 'secular yet idealistic concept of *xiao*' may be 'be good to parents and ancestors' (Zengzi 2009). From the adoption of Confucianism by the Former Han dynasty (206 BCE–24 CE) as its official ideology to the abolition of the Imperial System in 1911, *Xiao Jing* 'has been one of the most basic, must-read classics texts' for Chinese intellectuals (ibid.). Many of its blank-verse excerpts are transmitted orally to form the nonsectarian ethical core of Chinese traditional culture which has proved tenacious enough to survive the Cultural Revolution. According to my alternative enculturation in Taiwan, which suffered no rupture from the Cultural Revolution, these catchphrases from *Xiao Jing* have seamlessly constituted the domestic ethics of a child's upbringing and structured social relationships with elders (not just with their parents but with any older person). More frequently than the two mottos cited by Zhang Huan, my parents taught me these classic filial dictums as nursery rhymes. Whenever I carelessly hurt myself, I would hear my parents' voices chanting the quoted aphorism to my ears, like a mantra or a spell against my further careless accidents. 'You do not own your body,' my parents seemed to say, 'we do.'

By arranging his time-based artworks to progressively damage his body, He's xingwei artworks challenge the semi-sacred bond between Chinese parents and children formed through the ancestral gift of embodiment. I suggest that this is the specific ethical background that distinguishes Chinese bodyworks from predominant models of body art, which generally agitate against the ideological apparatus of Judaeo-Christian religions, identitarian politics, sexual prohibitions or Enlightenment philosophies.[17]

He's limit bodyworks find a particular niche in Beijing's experimental art practice; his rhetoric sounds extreme only because he explicitly stakes his xingwei rationale on violating the enfleshed limit of filial piety. Insofar as *xiao* involves more than one's parents, such a conscious act of auto-mutilation implies not only a familial betrayal committed by an ungrateful, ill-behaved son but also a surreptitious tearing of the ethical fabric underpinning China's body politics.

[17] For an expert analysis of Western body art, see Amelia Jones (1998).

In view of the Chinese government's tight and often arbitrary control over public art exhibitions throughout the 1990s, what was the condition of possibility for He to stage his behavioural critique of ethics? Uli Sigg's insight provides a clue: 'In China personal freedom is today perhaps greater than in Western societies.' Whereas the public arena is still highly restrictive, Sigg observes that Chinese artists have much room for manoeuvring within the private sphere, including breaching taboos: 'Against a background of a society centered on material gain and in total upheaval, ethical, and religious norms are applied as one sees fit, or else even total indifference to one's fellow human beings prevails' (Sigg and Frehner 2005: 20).[18] Sigg portrays a country in the middle of a chaotic and opportunistic restructuring, a bourgeoning world focusing all its energy on economic development and leaving an unsupervised private sector for individuals' other-than-material pursuits. In this light, Chinese time-based art's revaluation of traditional or revolutionary ethics is both complicit with and critical of the mainstream ethos, simultaneously participating in its disregard for pre-existing moral boundaries and countering its shallow mercantile excess.

[18] Sigg resided in Beijing during most of the reformist decades.

He's strenuous bodyworks, routinely staged in China's remote and sparsely populated areas, came out of this kind of permissiveness tucked below public surveillance. Edward K. Y. Chen has humorously referred to this unspoken zone of personal freedom as the 'don't ask' policy: 'You do not have to observe all rules and regulations, especially for business, but you have to learn this trick of the "don't ask" policy. If you do not ask, you just go ahead and do it and you will not be bothered. If you ask, the answer is always "no." The strategy is that if you think up something reasonable and productive, then just go ahead and do it' (2005: 7). The 'Don't Ask' policy enabled He to stage *Dialogue with Water* without any official interference, if also without an intentional audience. To the artist's surprise and exasperation, the personal freedom he enjoyed at home by being furtive and inconspicuous was not available to him in a country as highly regulated, litigious and puritanical as the US.

Dialogue with Water and *A Rock in Niagara Falls* juxtapose a solitary artist's body with a natural setting featuring spectacular flowing water. The slight difference in their kinetic scores, however, seems to have ironically projected their disparate life spans. Although the Niagara Falls action ended prematurely, its title implies that the artist might have wished to stress his

steadfast tenacity in the midst of a tremendous onrush. Does stagnation bring about an untimely end? Conversely, *Dialogue with Water* emphasizes fluid movement as the artist carries on an energetic exchange with a river. So it would imply that dynamism in peril enhances vitality. But of course, beyond my superstitious associations, a larger global diversity of circumstances is at play.

Given the action's hazardous nature and the elaborate contraptions employed, one can imagine just how 'easy' it would have been to mount *Dialogue with Water* at any picturesque site in the US! The insurance cost, the time and legal procedures involved, even the advance scheduling for a particular site, would make such a live venture nearly impossible. In contrast, He needed no government permit to enact *Dialogue with Water* in rural Yunnan. The most money he spent was on the rental cost for the crane. Baffled by his action, those who happened to witness He risking his physical well-being to perform a mid-air acrobatic feat, while bleeding into a river, were too awestruck or intimidated to impede his work. No such combination of factors existed to facilitate *A Rock in Niagara Falls*, a time-based issue terminated, as if were, midway through an artist's labour pains.

| Requiring Adaptability: Sun Yuan and Peng Yu | 15 September 2006. Four old men, fully dressed in suits, float face down on a lake in an odd square formation. Three hours later, policemen order the removal of these simulation corpses. |

This scene of peripeteia happened during *Mingtian/Tomorrow* (2006), a xingwei-zhuangzhi piece that the Beijing-based duo Sun Yuan and Peng Yu produced, by invitation, for the 2006

IMAGE **3.6** *Mingtian/Tomorrow* (2006), a xingwei-zhuangzhi piece by Sun Yuan and Peng Yu, in the Liverpool Biennial, UK. Image courtesy of the artists.

Liverpool Biennial.[19] The artists proposed setting adrift in the water four prostrated mannequins created in the images of elderly European men, dressed in formal suits which implied different economic classes. The hyper-realistic dummies were also weighted to simulate the way actual human bodies float in water. Characteristic of their trademark shock aesthetics, Sun and Peng chose a highly sensitive site for their four 'European men' to drown: the port at Albert Dock, right in front of a building that houses, on the second floor, the Tate Liverpool Museum and, on the ground floor, the Beatles Story, a shrine/shop devoted to Beatles music and memorabilia. Despite this recipe for controversy, the biennial's organizers approved the proposal for its innovative use of an outdoor site, which addressed the Tate Museum's interest in engaging viewers throughout Liverpool and to sponsor an international festival that 'leads the field, is cutting edge and challenging' (Liverpool Biennial 2009). An aggressive public art piece like *Tomorrow* —which would direct the biennale viewers' attention to the famous Albert Dock on whose floating stage the Beatles once performed—fit its bill.

19 Documentation for this piece appears with a brief description in Sun Yuan and Peng Yu (2007a).

The museum's stamp of approval produced the initial condition of possibility for Sun and Peng's project. The duo, nevertheless, packed their piece with sufficient ammunition to turn this seemingly benign situation into a potential minefield. Certain aspects in *Tomorrow* petulantly flirt with the history of the Beatles, who, as the artists noted, are both native and 'sacred' to Liverpool.[20] The duo's *four* European-looking dummies and the specific site chosen for displaying the floating quartet both tip the project towards a mimic-the-Beatles concept. Even the piece's title, *Tomorrow*, as Peng admitted, obliquely references 'the famous Beatles' song, "Yesterday"' (Sun and Peng 2007b). At the same time, the artists also chose to disrupt these references. Their quartet of simulated humans act as corpses, whereas two former Beatles band members (Paul McCartney and Ringo Starr) are still alive. Nor do the four hyper-naturalistic, male and Caucasian-looking mannequins bear any facial resemblance to the Fab Four from Liverpool. 'The four dummies merely look like old people,' insisted Peng, 'We all look the same when we are old' (see Sun and Peng 2007a). Peng's remark foregrounds our common prospect of ageing, which appears to stretch ever longer between our birth and death, the two limits in all sentient beings' zero-sum game.

20 My phone interview with Peng Yu, 7 October 2007, Los Angeles to Beijing. See also Sun and Peng (2007a).

The artists' rationalization notwithstanding, the city of Liverpool decided not to release its jealous guardianship of the Beatles' memories, which haunted the entire mounting process of *Tomorrow*. The moment Sun and Peng's four dummies hit British soil at the Liverpool Airport, they were subject to a meticulous inspection by the custom officers, who took upon themselves the duties of ruling out any potential sacrilege to their city's music idols. After they were satisfactorily *un-identified* with the Beatles, the dummies were allowed to proceed to their destination, where a phalanx of sceptical police officers waited, pending an official banning order from the Liverpool Police Department, to pounce on the inert suspects. Without the banning order in hand, the officers were not able to stop the Port Authority workers from installing the artwork, for the latter belonged to a different government unit with the mandate to supervise and mount any waterborne structure surrounding the Albert Dock. Thus, *Tomorrow* managed to float for three hours it took for the delayed paperwork to arrive and the conflicting bureaucratic duties to resolve themselves.

With a subtext patently stalked by the Beatles' shadows and a history of ethical clashes with the Tate Museum, the Liverpool Police Department prohibited the aquatic display of *Tomorrow* on the pretext of public safety: 'Suppose some drunkards mistake the dummies for real people and endanger themselves by trying to save the dummies,' insisted a policeman.[21] In response, the artists devised an alternative display method involving no risk of anybody drowning. On 16 September 2006—shall we call it the 'post-censorship tomorrow'?— Sun and Peng tie up the four dummies on the back of a rented truck and then send their mobile museum circling Liverpool. The hired driver spontaneously volunteers herself as a docent, engaging in longer and longer conversations with the camera-snapping tourists in a language that the Chinese artists can barely follow. Meanwhile, the Liverpool police, poised to swoop down on any hint of a traffic violation, continue their surveillance nearby.

16 My interview with Peng Yu, 7 October 2007, Beijing.

Unforeseen by the artists, their site-specific zhuangzhi, *Tomorrow*, evolved into a xingwei comedy of mistaken identity. The Liverpool policemen mistook the artists' fake human foursome as too closely resembling the Beatles; they also

IMAGE 3.7 Sun and Peng's revised scheme for their xingwei-zhuangzhi piece *Tomorrow* (2006) , in which the four simulated corpses of European men were roped onto a truck for a one-day tour round Liverpool. Image courtesy of the artists.

justified their censorship by raising the threat of mistaken identity: some drunkards might remain clear-headed enough to mistake the fake for the real and try to save the fake at the risk of killing the real—the drunken saviours themselves! Hilarious in retrospect, this sequence of 'unfortunate' events for the artists attests to their ability to arouse strong emotions in their viewers, especially from those who decline to grant their art a sanctuary. *Tomorrow* pushed beyond the limit of tolerance for Liverpool's body politic owing to the ethical disturbance created by a perceptual slippage—the fake death slid into the real murder of a past glory that remained present. The sight of mortality embodied by four verisimilar corpses violated the city's living memories of the Beatles as its undying cultural heritage—its musical gods had been sullied by the profane humanity of a Chinese contemporary artwork. Thus, a piece about the inevitability of our shared *tomorrow* became terminated because of a precious memory from *yesterday*. Yet, after having been 'exhumed' from its watery tomb *today*, the piece gained a rebirth-on-wheels to show its quartet of death masks as *Tomorrow*.

Provocatively, this transvisual intercultural comedy of mistaken identity has also affected *Tomorrow*'s critical reception in China. Owing to Sun and Peng's choice to produce dummies in the image of Caucasian males and to fake their drowning in a European site, some critics read *Tomorrow* as a postcolonial critique. The artists jokingly deflected this interpretation by pleading their ignorance of 'postcolonial critique' (Sun and Peng 2007b). To me, such a politicized reading by Chinese critics errs on the side of mistaken identity for it essentializes the duo's Chinese lineage as the only criterion for judging their art. I counter that Sun and Peng try to pre-empt such a postcolonial assessment by opting to place British-looking dummies at a British site—their drifting corpses are then 'native' to the environment in which they are immersed and their foreign origin becomes, to some extent, camouflaged. Indeed, a postcolonial critic could make a better case had the duo displayed four Chinese-looking dummies drowning in Liverpool. The spectres of the Opium War might then have loomed accusatorily.

During the three hours when *Tomorrow* actually appeared floating in Liverpool, all four dummies had their faces buried in the water. Perhaps this impression proffers a poetic coda to our mortal end: on we go, solitary and serene, a temporal symphony of silence.

Sustaining Manifestations: Yang Zhichao, with Ai Weiwei

They met in Lanzhou, the capital of Gansu Province, on the bank of the Yellow River in 1995 (Ai Weiwei and Yang Zhichao 2008: 1–5).[22] Yang Zhichao, a young local painter thirsty for worldly knowledge, and Ai Weiwei, an artistic personality visiting from Beijing soon after his return from New York, became friends. Before their encounter, Yang had read *Heipi shu*, the untitled art journal with black covers coedited by Ai. The book opens with an extensive 1993 interview by Xu Bing and Ai, two Chinese expatriate artists then staying in New York, with the New York–based Taiwanese expatriate artist, Tehching Hsieh. A collection of photographic documents about xingwei yishu follows the interview. The shock and exhilaration that Yang experienced upon reading the volume redoubled as he listened to Ai talking about the latter's idol, Andy Warhol, and about Ai's struggle to study and survive abroad. A way of art-making utterly alien to Yang's academic visual

22 The descriptions of Yang's xingwei projects are also based on my extensive interviews with the artist on 3 July 2005 and 10 July 2006 in Tongxian, Beijing, and on 13 July 2008 and 25 March 2009 in Songzhuang, Beijing.

arts training in traditional Chinese painting suddenly became imaginable. For Yang, the next step was to seek out Ai as a mentor and a sounding board after the younger artist's migration to Beijing in 1998.

Yang's association with Ai established a condition of possibility for his xingwei practice in Beijing. Prior to his move to the capital, Yang had developed two tentative yet distinct lines of xingwei explorations: one focusing on what I'll call 'documentarywork', a xingwei project experienced by others solely through documentation; the other on bodyworks, or, in Yang's words, on the use of his body as 'a tool', like 'a canvas' (ibid.: 8). Both genres responded to his given life circumstances as an artist with little financial means. Documentation enabled him to translate his conceptual 'capital' into process artworks; engaging in bodyworks took advantage of his constant access to a free and readily available art material. Yang's relationship with Ai had proved to be so fruitful that four out of five of his earliest major xingwei projects conceived in Beijing involved Ai as a catalyst. *Si huan zhinei* (*Within the Fourth Ring Road*, 1999), Yang's first Beijing-based documentarywork, enlisted Ai as an authenticator and legal mediator.[23] Ai played increasingly more substantial roles in Yang's three subsequent bodyworks.

23 See chapter 6 for my extensive analysis of documentary-works, including *Within the Fourth Ring Road*.

Luo (*Branding*, 9 October 2000) includes three interacting elements: Yang as the flesh-subject exposed to branding; Ai as the warden-accomplice executing the branding; and a custom-made square-set, copper-wire-embedded iron stamp, engraved with 15 digits representing Yang's national identification card number. Yang lies bare-chested and face down on a slender Qing-dynasty wooden bench placed inside Ai's recently constructed residence at Caochangdi, on the eastern outskirts of Beijing. Ai heats up the iron stamp with electricity and applies it on the skin of Yang's right shoulder blade. The process lasts 15 minutes, searing Yang's back with an indelible square mark.

Zhongcao (*Planting Grass*, 5 November 2000) took place at Shanghai's Eastlink Gallery during the *Buhezuo fangshi / Fuck Off* exhibition, co-curated by Ai. Yang lies face down on a makeshift operating table. Without administering anaesthesia, a hired medical doctor makes two incisions (each 1 cm in width and depth) into the artist's left scapula and plants two fresh stems of grass in the cuts. The whole procedure lasts 45 minutes. Like *Branding*, this bodywork entails the performative joining of three disparate components: the artist as the corporeal ground open to ploughing and planting; the doctor as the grower carrying out a simple horticultural surgery; and two grass-stems picked from the bank of the nearby Suzhou River. As a public performance, however, *Planting Grass* added a live audience, including Yang's wife and fellow artists, reporters with their camera crews and gallery spectators. In this performance's video document, I heard a voice speaking gently to Yang at the end of the surgery, 'It's over. It's over.' The pain suffered by the artist might be severe, yet doesn't such compassion, pouring forth from an unseen face, make his self-harm bearable, even worthwhile? I experienced the emotional apex of *Planting Grass* precisely at this unplanned moment.

If Ai's presence is at once actual and symbolic in *Branding* and curatorial in *Planting Grass*, he is Yang's irreplaceable partner in *Cang* (*Hide*, 2002). On a chair placed inside Ai's Caochangdi residence, Yang stoically sits while a surgeon operates without anaesthesia on his right thigh, creating an incision deep enough to bury a small object, pre-selected by Ai, inside Yang's flesh. The two agree that, as long as the project stands, Ai will reveal nothing to Yang, or to anyone else, about the permanent implant.

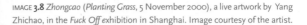

From *Branding* to *Planting Grass* to *Hide*, the friendship between Yang and Ai had been the consistent basis upon which Yang built his body-works. *Branding* dramatizes the hierarchy between Ai's and Yang's artistic and social statuses while acknowledging the former's support of the latter. Ai not only provided his newsworthy residence as a performance venue but also endorsed Yang's xingwei piece by participating as the one who branded the younger artist. Ai's gesture complicated the act of branding in Yang's bodywork, for his hand conferred both experience and distinction on what he touched. As a senior friend, Ai seared Yang's flesh with an anonymously homogenizing personal identification number, as if to initiate his fraternal friend into the pain of socialization. As a more established artist, Ai marked Yang's then unknown artist's body with the celebrated Ai Weiwei brand, calling attention to branding as a procedure that creates privileged and alluring commodities. This microcosmic branding ritual expanded in *Planting Grass* into an exhibition occasion which afforded Yang the coveted public exposure for his plant-sprouting bodywork, spectacular if agonizing. At the same time, Yang's

(ABOVE AND FACING PAGE) IMAGES **3.9.1–2** *Cang* (*Hide*, 2002), a xingwei piece by Yang Zhichao in collaboration with Ai Weiwei, in Ai's Caochangdi studio complex. The two X-ray front and side views show Yang's thigh into which the secret object selected by Ai is inserted. Image courtesy of Yang Zhichao.

limit action, perceptually sanctified by the physical pain he endured, reciprocated Ai's curatorial sponsorship. *Planting Grass* demonstrates the fuck-off attitude in Yang's gratuitous behaviour—having his flesh carved open to manifest the vitality of temporary greenery, as erect as it is fading.

Such public reciprocity in the interface between *Planting Grass* and *Fuck Off* becomes submerged in *Hide*, which dives into an interior zone of private exchange. *Hide* plays on a paradox in the relationship between Yang and Ai—the more the two friends understand each other the less the outside world is able to witness their

friendship's external signs. If Ai's secret object crystallizes the friends' mutual appreciation, Yang, being the bearer of this 'friendship crystal', demonstrates, as a leap of faith, his trust in Ai's judgement and goodwill. Yang suffered tangibly for this faith, including the pain he endured during the operation and the alien object lodged within his body; his suffering nonetheless yielded an emotional rather than an epistemic experience. The burial of the object in Yang's flesh gives birth to an anomalous physiological region, inaccessible to full knowing and unavailable to assimilation by his own organism. This death to Yang's full knowledge of a friendship insignia also binds Ai as a keeper of a friendship secret. The two artists' less-than-equal reciprocity simultaneously enables them to produce a collaborative time-based artwork. *Hide* uses Yang's skin, blood and flesh as the site and material of a bodywork with an unforeseeable duration. Since the collaborators have chosen to continually visualize Ai's insert through a pair of X-ray photographs (front and side views) taken annually until the day Yang dies, *Hide* also exists as a documentarywork—a paradoxical one, as it depends on the concurrent enclosure and exposure, withholding and sharing, of information regarding its central hidden document.

In his project description, Yang typically documents only a bodywork's beginning and not its end. The 45 minutes he noted for *Planting Grass*, for example, records the surgical procedure's duration without specifying the length of time those two grass stems stayed in his body or the manner in which they were removed. Manifestation of vitality, however transitory, appears to be the thematic vigour sustaining Yang's bodyworks, which envision the positivity of birth but leave its negative counterpart an implicated mystery.

Flaunting Deviancy: He Chengyao

On 17 May 2001, painter He Chengyao, with 'several busloads of art enthusiasts and journalists', hiked up to Jinshanling, a section of the Great Wall of China near Beijing, to see a site-specific installation called *Trash People*.[24] The installation, created by the German artist HA Schult, consisted of 1,000 human-shaped, adult-size statues made from consumer waste. Lining up parallel to the two walls, these imported trash troopers stood in a formation recalling the terracotta army of the Qin dynasty (221–206 BCE), produced by the decree of the First Emperor Qin Shihuangdi, who also ordered the Great Wall to be built. The spectacle so inspired He Chengyao that she removed her red tank top, exposed her upper body and trekked through the corridor between the junk sculptures until she reached the next beacon tower. In a photograph left of this accidental action, we can see HA Schult, beaming in amusement, trailing behind the half-naked He.

He's unplanned response to Schult's open-air exhibition provoked severe media censure of herself and her family. Most attacks focused on her stripped upper body. Some insinuated that her action was a female artist's last-ditch effort to win fame and fortune; others pointed out her miscalculation in revealing 'a less than youthful, postpartum maternal body'.[25] Enraged that her denunciation by the media betrayed explicit misogyny, He decided to incorporate xingwei yishu in her *oeuvre*, thus shifting her primary art medium from

24 The description of the project is based on my interview with He Chengyao, 1 July 2005, Beijing. The citation comes from Sasha Su-Ling Welland (2007: 59). For more on *Trash People*, see HA Schult (2009).

25 My interviews with He Chengyao, 1 July 2005 and 14 July 2008, Beijing.

painting to embodied action. She retrospectively entitled her public behaviour *Kaifang Changcheng* (*Opening the Great Wall*, 2001), identifying it as her first xingwei artwork. 'But is it valid to claim an inadvertent happening as a conscious artwork?' I asked He during our first interview. '*Opening the Great Wall* became a xingwei piece because of my follow-up actions,' she replied.[26] In other words, her successive xingwei artworks have established the condition of possibility to turn her first unwitting outburst into their antecedent.

26 My interview with He Chengyao, 1 July 2005, Beijing.

Prior to her impromptu action on the Great Wall, He had been searching for an artistic language that would speak to her with more urgency than that of her easel-based art. Although she had never tried xingwei yishu, she was aware of the time-based art mode's popularity among her peers. Her encounter with *Trash People*, a celebrated artwork on an international tour, became the catalyst for her unexpected live art. The painter deviated from her routine course as a result of the impact of some foreign bodies, a massive array of at once uniform and diverse anthropomorphic figures, creatively reassembled from trash. By publicly baring her middle-aged female body, He not only transgressed China's entrenched patriarchal gender coding but also trespassed into a hitherto unexplored methodological territory. The performer's risky xingwei experiment took an exorbitant personal and familial toll, leaving her in grave social disgrace. What, then, was the impetus that prompted He to re-chart her art career against all odds and to reconceive an accident as a self-midwifed rebirth?

It's impossible for us to tract He's initial perception of *Trash People*, since she cannot articulate her impressions other than describing herself being moved. We do know her immediate response: what she could not verbalize she enacted by undressing her upper body, effectively daring her surprised spectators to interfere. Her adoption of a subject position in denuding her female body is a performance technique frequently used by Euro-American feminist artists since the 1970s. He neither denies nor refers to the influence of feminist performance, however, when she discusses *Opening* in a bilingually published exhibition-catalogue essay. Instead, resorting to another familiar feminist narrative device, she gives her art an autobiographical genealogy: 'Everything must be traced back to the original story,' she confesses (2004: 26).

He's original story began with her maternal grandmother, widowed when her young husband, suffering from a mental illness, accidentally fell into a river and drowned. The grandmother maintained fidelity to her dead husband for four decades, as deemed obligatory by the traditional Chinese society. In the early 1960s, He's mother became pregnant with her out of wedlock and defiantly chose to keep her foetus rather than her job. Her father, fired from his work unit, suffered relentless social scorn. Her mother, unable to bear the public shaming of her 'moral degeneracy', eventually went insane and remained so for the rest of her life (ibid.: 28). By disclosing her dreaded family secret of psychosis across generations, He asserts a direct connection between her choice of partial nudity and her mother's illness-induced habit of baring her upper body in public:

> If my mother did not run about, day and night, stark naked with dishevelled hair, shouting, through the streets and alleys of my hometown, if she did not use this method to expose the confining morals of patriarchy, to protest its discipline and violence, and to regard its authority with contempt, using her extreme behaviour of

insanity to realize her freedom, then I wouldn't have used the identity of 'artist' for my behaviour on the Great Wall. I understand that I similarly violated the prohibition of male-dominated society against women freely controlling their bodies, especially in the 'name of art' (ibid.).

He Chengyao attributes the origin of her xingwei yishu to her mother's self-liberation through pathological release and interprets her impulsive behaviour in *Opening* as a mimetic echo of her mother's disease-sanctioned insubordination. This interpretation hints at the limit moment when He extemporized an action in response to a perceived catalyst. What compelled He to improvise? What was the condition of possibility for He to turn her body into an instant scandal? Gao Minglu calls attention to the exhibition site's symbolic import: 'The artist instigated the event when her memory of her life collided with the historical significance of the wall' (2004: 784). In He's 'gendered reading', the Great Wall came to signify 'abstract cruelty and a patriarchal system bent on regulating the female body' (ibid.: 785). Put otherwise, He's flaunting of her unglamorous female body defies that paternal governing system's 'brick-like' restrictions. *Opening the Great Wall* is, in this sense, He's feminist challenge to break *open* what the 'Great Wall' symbolizes—the masculocentric interdiction against 'inappropriate' female behaviour, including her public nudity.

Although I agree with Gao's feminist interpretation of He's action, I find his analysis giving short shrift to a prominent time-based element—Schult's epic-scale installation. I argue that *Trash People*, with its imposing presence, had reconfigured the historical monument into a public art site, thereby shifting the Great Wall from an eternal symbol of nationalistic defence and pride into an immediate asset for the nation's economic policy of profiting from globalization. In this context, He's choice of featuring 'opening' and the 'Great Wall' in her retrospective title for her improvised xingwei may refer to Deng's 'Open Door' policy which led to the national monument's post-Deng repositioning from the everlasting (symbolism) to the utilitarian (a rental exhibition site). Given He's action sequence, her *opening* of her naked body to public gazes analogously turns her embodied property, like the Great Wall for China, into a native resource from which she is entitled to benefit creatively. Nevertheless, at the initial less calculating moment when the artist suddenly bared her chest, is it possible that He, as an entranced 'spect-actor'—to borrow Augusto Boal's famous term—responded more to Schult's alien stimulus than to a familiar native site? When *Trash People*, as an experiential figure, moves to the forefront of He's perceptual stage, the Great Wall may well recede into its background.

If the primary impetus on He's behaviour should be attributed more to *Trash People* than to the Great Wall, how then was He's already active imagination stirred by these colourful junk sculptures? These 'trash people', with their festive facades, belie the laborious procedures that Schult and his crew followed, from acquiring garbage, to deodorizing and sanitizing the waste material, to reassembling junk into anthropomorphic figures. Aside from its ecological implications, Schult's piece addresses the redemptive power of art, turning debased objects (trash) into emblematic subjects (people). If art can transform trash into people, what can it do for trashed people, for those sentient beings rendered worthless by society's wrath? Perhaps Schult's negentropic process of recycling rubbish into art had touched He so deeply that she made the link between wasted humans and artistic redemption. Perhaps the link managed to

unlock her family memory, forcing her to confront her shame and to translate her epiphanic homecoming into openly defiant behaviour. Perhaps the artist's awakened desire to understand her mother better—to live, as it were, in her mother's skin—inspired her spontaneous dalliance with perceived social deviance?

By reproducing her role model's bare-breasted rebellion in *Opening the Great Wall*, He became her mother's surrogate even as she, if instinctively, made her debut as a xingwei artist. With hindsight, we know that the artist unleashed similar patriarchal censures of her transgression. Her risk-taking, however, enabled several personal breakthroughs. As a compensatory act, she provoked the kind of traumatic humiliation that her mother endured while revisiting a childhood troubled by a daughter's shameful shunning of an insane parent. As a proactive interrogation, she probed the censorial patriarchy's limit, exposing its masculocentric hypocrisy. As an artistic experiment, she exploited a readymade exhibition environment, undertaking her bricolage-xingwei in the midst of Schult's high-profile artwork and on top of the Great Wall.

'My work focuses on two key concerns—self-reflection, and creating a direct connection with the audience' (2005b: 124). The citation comes from He's biographical notes as a participating artist in *China Live* (2005), a UK–China collaboration for bilateral cultural exchanges. Her contributed to *China Live* was an interactive performance piece called *Wen* (*Kiss*, 2004–). In *Kiss*, the artist offers a plate of differently flavoured homemade popsicles to audience members, whom she invites to come on stage, one by one, and to randomly pick a popsicle to share with her. Eating the same popsicle from opposite ends, the artist and her participant thus form an icy bridge between two mouths, a path towards a kiss. As He recalled, each segment of this xingwei piece varied greatly in its duration, lasting from a few seconds to several minutes, depending on the popsicles' flavours (some extremely spicy or sour) and the participants' intentions (some aggressive; others shy, awkward or torpid).

IMAGE **3.11** He Chengyao performs *Wen* (*Kiss*, 2004–), an ongoing xingwei yishu series enacted in various live art festival sites. Image courtesy of the artist.

If *Kiss* exemplifies He's creation of a live structure to connect with her audience, then *Opening the Great Wall* demonstrates her introspection. At its deeper emotional level, however, *Opening* also allows the artist to connect with another individual, her mother, even though their phantasmic reunion crossed divergent times and consciousnesses. As I mentioned earlier, He has drawn from her subsequent xingwei *oeuvres* to justify her inaugural *ji xing xingwei* (improvised behaviour) as an artwork. But hasn't her explicit action in *Opening* also released sufficient creative energies to engender its xingwei successors? As He concludes in her 2004 catalogue essay: 'Traditional rule has oppressed and cultivated me. It has also made me choose art as my medium to create and to rebel. I understand that I am using a different way than my mother did to save myself, to dissolve the curse of my destiny. Thank art' (2004: 26). Although the 'art' extolled by the artist here remains anonymous in its nationality, He has given it a special weight, the thickness of a middle-aged Chinese woman rooting her liberatory practice.

Absorbing Vicissitudes: Wang Chuyu

'In the beginning of our interview,' said Wang Chuyu while he arranged his clay-on-wood tea set to treat me as a guest from afar on 3 July 2005, 'I need to tell you an incident that had changed my outlook of life and determined the patterns of my art career.'[27]

27 I translated the passage from my first interview with Wang Chuyu, 3 July 2005, Tongxian, Beijing.

The incident occurred during Wang's xingwei series entitled *Cashi riji* (*Wiping Diary*, 1996), his second project in Beijing. Having read about Tehching Hsieh's performance art and seen the archival images of East Village xingwei yishu in the Black Cover Book, Wang decided to emigrate to the capital in 1994 from his home province, Shaanxi, in order to practise what he considered 'the most direct type of art in revealing social attitudes'.[28] The *Wiping Diary* series includes three experiments. The first happens in the artist's apartment: Wang picks up a square of toilet

28 My interview with Wang Chuyu, 3 July 2005, Tongxian, Beijing.

paper (in pink, as customarily manufactured at the time) to wipe clean his TV screen. The second takes place on public buses: Wang randomly distributes a stack of toilet-paper squares pre-inscribed with his favourite poems among the passengers.

The third instalment involves a conceptual adjustment and a heightening of stakes. Now regarding the poetic inscriptions as unnecessary adornments, Wang reverted to his earlier scheme of using blank pieces of toilet paper, effectively simplifying his props from what Duchamp calls 'readymade aided' to plain 'readymades' (1989: 141–2). Wang also chose a highly sensitive occasion for his action. In *Wiping Diary 3*, Wang visits the opening reception for the first Chinese Art Fair in Beijing and moves among exhibition stands to place squares of toilet paper unobtrusively on each table's corner. Before long, four policemen interrupted Wang's silent behaviour and took him to a separate room for inquisition. Coincidentally, the four policemen also came from Shaanxi. Wang chatted with them amicably, exchanging cigarettes and tales about their hometown. But his detention took a precipitous turn with the arrival of the police chief who ordered the four policemen out of the room. When the four re-entered, they avoided eye contact with Wang and then took turns to beat him.

What was the panoptical lens that perceived a few flimsy sheets of blank toilet paper as subversive fliers? What was the mechanism that instantly turned four individuals violent?

What was the most pernicious dimension of the artist's daily life, one so unsuspectingly ingrained as to make both the oppressor and the oppressed take oppression for granted? These were questions that did not immediately occur to Wang after the humiliating incident. 'The beating had shattered my self-image and made me feel ashamed of doing xingwei yishu,' said Wang.[29] For the next three years, Wang turned to painting and writing but stayed away from public action, trying to be as inconspicuous as anonymity allowed.

29 My interview with Wang Chuyu, 3 July 2005, Tongxian, Beijing. The following two quotes are from my interview with Wang Chuyu, 25 March 2009, in Songzhuang, Beijing. My translation.

I realized that as an individual I could not choose what to think, but society has produced [enough] problems forcing me to think. I should not have been beaten up. Yet how many others are beaten up every day for no reason whatsoever? The beating served as *bang he* (awakening by a stick, a Chan/Zen Buddhist initiation method), obliging me to contemplate human rights issues.

Wang's awakening shaped the condition of possibility for him to return to embodied time-based art. The contact of his flesh with fists transformed politics from an inchoate, abstract and distant subtext into a dialectical intertext, a manifest reference and target of scrutiny, for his subsequent art actions. The artist insisted, however, that his ensuing career path had little to do with creative autonomy: 'All the series of artworks that I produced afterwards are not my choice.' In other words, he did not seek to make political art but politics had crossed his path, compelling him to bear witness to its injustice. Still, the pain he suffered from the government agents had instilled caution into his psyche. In lieu of overt political activism, Wang began again by enacting his politicized art within more protective settings. The rebirth of his xingwei career, at least initially, took up the reclusive genres of performative photographs and private time-based actions; the former were composed live solely for the camera, the latter mainly done for his benefit. Both avoided the public exposure risked by his *Wiping Diary* series.

In *Feng* (*Sealed*, 1999), Wang's mouth is crisscrossed with two strips of sealing tape on which are inscribed haphazardly plus and minus signs. Thus the artist's outer organ for oral expression, even for simple enunciation, is barred. Like a forbidden door in a condemned house—a familiar sight in developing Beijing—his sealed lips keep his tongue and its potential voice of dissent hostage: There is no way in, nor out. Although the press often identifies the image as Wang's xingwei yishu, the artist actually executed *Sealed* as *guannian sheying* (conceptual photograph), which I consider a concept-in-still-life, a photograph that inaugurates a virtual performance. *Zhongguo gongfu 2* (*Chinese Kongfu 2*, in a series of three disparate pieces, 1999) features four naked men in profile, forming a flesh ladder; from the bottom up, each person jams his head below the crotch of the man above, leading to the top man, who stands raising a Chinese flag that obliterates his face. A hierarchical social map presents itself as a chain of trampled individuals, defaced by the triumphant body politic. Putatively a document for an incendiary xingwei, *Chinese Kongfu 2* is, like *Sealed*, also a performative photograph.

Both *Sealed* and *Chinese Kongfu 2* bear the sign of sarcasm and its sly indictment. This rhetorical feature, characterized by a detached witticism, affirms the artist's rage but allows its

IMAGE **3.12** *Zhongguo gongfu 2* (*Chinese Kongfu 2*, 1999), a performative photograph by Wang Chuyu. Image courtesy of the artist.

IMAGES **3.13.1–3** *Xianfa yuedu* (*Reading the Constitution*, 4 June 2002),
a xingwei artwork by Wang Chuyu. Image courtesy of the artist.

target to be vague. The identity of the accused is less ambiguous in *Xianfa yuedu* (*Reading the Constitution*, 4 June 2002), a solitary xingwei piece staged in the artist's apartment without an invited audience: Wang slides a razor against his right index finger and begins reading a popular edition of *Zhongguo renmin gongheguo xianfa* (*People's Republic of China Constitution*). His blood oozes out, staining the booklet. On the thirteenth anniversary of the 4 June Tiananmen massacre, Wang commemorated the untimely deaths by miming the clash between flesh and steel. His blood, a sacrificial libation, pays homage to those unexpectedly martyred in the crossfire between youthful naivety and wrangling political wills. The front cover of the *PRC Constitution* booklet displays a logo, a red round stamp comprising the outline of *Gu Gong* (the Imperial Palace, now the Palace Museum, located to the north of the Tiananmen Square) and the five-star symbol from the Chinese National Flag. As a visual prop, the booklet's cover soaked in Wang's fresh blood restages the trauma of a national tragedy. In Chapter 2 of the *PRC Constitution*, Article 35 reads, 'Citizens of the People's Republic of China enjoy freedom of speech, of the press, of assembly, of association, of procession and of demonstration' (People's Daily Online 2009). Cited as a legal text, the booklet, with its blood-lined pages, spells out its contradiction: Does this document record a nation's legitimizing principles, deserving patriotic bloodshed to protect its integrity, or does it inventory mere bureaucratic verbiage, mocking its reader's earnest folly?

Reflecting on China's post-Tiananmen intellectual milieu, Zhang Xudong observes, 'In so-called totalitarian societies, state repression is transparent while possibilities are opaque. And nobody can even pretend to ignore that condition for knowledge production' (2008: 3). If the blood dripping from Wang's index finger visualizes political repression's transparency, then his cautiously 'privatized' xingwei yishu tests possibilities within opacity. Just as Wang's flowing blood remembers the vital gift of birth, so his bruises from an unexpected beating tally the savage promise of death.

'This is a true story,' begins the narrative voiceover in the film *Jidu hanleng* (*Extremely Cold*, known in English as *Frozen*, 1996–97).[30] Claiming the veracity of a story retold in dramatization is not an unusual narrative device in a film. What complicates the claim in *Frozen* are two circumstantial clues: One, the signature of its writer-director as Wu Ming (吴明, homonymic with 无名, 'no name'); Two, the extremity of the story told. Both clues suggest the possibility of *life* as a birth of discursive memory, which is paradoxically enabled by *death* as the erasure of cognitive certainty.

DEATH, OR A TRANSITION INTO OTHERNESS, AND THEN PERHAPS . . .

Celluloid Burials:
Wang Xiaoshuai via Qi Li / Qi Lei

30 The translated citations from the film are based on my transcriptions.

'I made *Frozen* as an underground film and it still can't be released in China,' said Wang Xiaoshuai in an interview during the public screening of *Qing hong* (known in English as *Shanghai Dreams*, 2005), Wang's first officially released film in China (see Clarke and Wang 2006). The change of Wang's status from being blacklisted by his government to becoming an internationally award-winning Chinese filmmaker allows the director to avow his authorship of *Frozen*. Shot on location in Beijing, *Frozen*'s film was smuggled piecemeal out of the country to have its post-production work done in Amsterdam. Wang's tactic 'to acknowledge the presence of the film but not its director' by using a common Chinese alias for anonymity helped him avoid government reprisal at the same time as it enhanced *Frozen*'s mystique as a censored product in international art film circuits (Shih 2006). By assuming the non-identity of namelessness—hence, accepting a nominal authorial death—Wang facilitated his film's overseas circulation as both a *banned* art film and a historical document of China's censorship regime. 'This is a true story' may well refer to the writer-director's process of having the film produced.

'One of the first internationally distributed films by a Sixth Generation filmmaker, *Frozen* is unique in providing a rare look at the avant-garde art world of Beijing,' writes the reviewer

for International Film Circuit, echoing many others in touting the film's documentary value (see International Film Circuit 2009). Indeed, Wang's furtive choreography to have *Frozen* produced recalls many xingwei artists' underground manoeuvres during the first post-Tiananmen decade. Wang's film is shot in a mock documentary style, which sets off a viewer's expectation to see *Frozen* as a candid record of xingwei yishu's early history in Beijing. Wang himself encourages such a reading by disclosing that his screenplay was based on a real case he heard about Qi Li, a theatre student who committed suicide in 1992 to end his death-themed xingwei artworks.[31] As Wang remarked in our interview, after Qi's relatives and friends repeatedly rejected his requests to talk, he had to re/construct a narrative about Qi's last year by elaborating on the few details he found on his own, such as the series of burials preceding Qi's suicide and the art critic-mentor figure who had inspired and betrayed Qi.[32] Wang also mentioned that he was disappointed in an early xingwei piece he saw in East Village because the work wasn't daring enough. Perhaps Wang's longing to solve a largely unverifiable life mystery and his idealized conception of xingwei yishu have led him to compose a fictitious documentary, wrapping the bone of his imaginary truth in layers of fabricated flesh. The film memorializes a suicide that had actually happened beyond the celluloid frames, yet it also hypothesizes for the dead a probable course towards his self-termination. Another artist's death—and its attendant silence—both invites and justifies the writer-director's subjective investment. In this light, the 'true story' buried in *Frozen* is less about a young xingwei artist's terminal art than about a young filmmaker's path towards xingwei yishu. Wang writes the time-based score for Qi.

Set in Beijing in 1994, *Frozen*'s unnamed narrator begins introducing his protagonist Qi Lei (a name homonymic with 'strange thunder'), who committed suicide as the last action of his brief xingwei career. Implying disapproval, the narrator questions whether death is too dear a price to pay for art. His inability to decipher the 'truth' behind another person's suicidal act exasperates him, 'To the living, death is a black hole that can never be illuminated.' Yet try he will. Despite a black hole's all-consuming voracity, the film charts how Qi seeks to apprehend the black hole by skirting its fringe and how this seeking precipitates his final plunge into its impenetrable otherness. Through flashbacks, we see how Qi Lei is introduced to xingwei yishu's conceptual basis by his art-critic mentor;

31 My interview with Wang Xiaoshuai and Pi Li, 1 July 2005, Beijing.

32 On 11 July 2006, in Beijing, I spoke with one of Qi Li's close friends, artist Zhang Hui, who said that he had rejected Wang Xiaoshuai's interview request because he sensed that Wang had a preconceived notion about Qi's suicide and that he did not wish to participate in the fabrication. I also had a phone interview with Xu Bing, who was admired by Qi as a senior artist-mentor and who had corresponded with Qi until Xu left China in the early 1990s. Wang Xiaoshuai suggested that Qi felt somehow 'abandoned' by his mentor. He addressed Qi's sense of betrayal in *Frozen* in a different way.

IMAGES **3.14.1–8** The protagonist Qi Lei staging a series of seasonal burials in the film, *Jidu hanleng* (lit., 'extremely cold'; known in English as *Frozen*, 1996–97), directed by Wang Xiaoshuai.

He begins in autumn, with an Earth Burial.

He goes to the limits of what his body can endure.

On the day winter begins, he holds a Water Burial.

how Qi's fellow art students interpret xingwei as arduous, if also preposterous, behaviour, trying to best each other in swallowing bars of soap; and how Qi arrives at his conclusion that xingwei yishu, to be noteworthy, should tackle the ultimate existential conundrum—death. Qi proceeds to carry out four seasonal death rituals: an earth burial on the autumnal equinox; a water burial on the winter solstice; a fire burial on the spring equinox; and an ice burial on the summer solstice. Although Qi announces that he will die from hypothermia in his last public performance, his eventual cause of death is suicide—three months later on the autumnal equinox, in a tree-shaded outdoor site (which departs from the rumoured version that Qi Li slit his wrists in his home bathroom a week after the ice burial).

Although *Frozen*'s production history reflects China's combustible political reality and stagnant civil life in the early 1990s, the film itself delves more into the ontology of art than its suppression. This ostensible apolitical facade provoked Daryl Chin to voice his frustration that 'there doesn't seem to be any overt political or social dimension to the art being shown' (1998). I maintain, however, that the ostentatious lack of political reference and the solipsistic dedication to art are the negatives left unexposed for their sociopolitical content, repressed as they were by the ideological vacuum and utilitarian mixed economy of China's postsocialist era. That Beijing's xingwei yishu shown in *Frozen* appears out of context is its very historical context. When politics is taboo, when youthful sexual love is often traumatized by a reigning ethos of enforced abortion and monetarism, an absolute devotion to art, even to its meaninglessness, might be the purest existentialist gesture an individual with limited agency can muster. Wang has resorted to his agency as a filmmaker by constructing an allegorical figure out of the ruins of redemptive urges.

I argue that Wang's revision of Qi's suicidal event shifts his film's focus from an inquiry into what caused an artist's death to a meditation on the role of death in art. By dating his protagonist's final act to the autumnal equinox of 1994, Wang links Qi Lei's suicide with the preceding art burials. Qi's self-termination therefore assumes a ceremonious quality, simultaneously evoking its artistic antecedents and embracing the sanctity of a verdant site. Wang's authorial choice intensifies the ambiguity attending Qi's irreversible transition to otherness— what counts now as the most important driver for that transition is not Qi's reason for initiating the drive but his choice to model this drive on art. Qi Lei's xingwei of self-extinction structurally mirrors his four seasonal burials. Except for the acute degree of its execution, the suicide appears as part of his serial death rituals. Qi's morbid performances challenge the given assumption of death as a biological event that can hardly be scheduled or comprehended by the self. He encodes death, instead, as a time-based action motif, with several reproducible, if

variable, ingredients: a voluntary subject; the subject's endurance of an extreme experiential state; the subject's ritualistic burial by a natural element; a calendar date symbolically marking the seasonal transition; and a group of witnesses to establish the artistic framework. All these elements are present in Qi's suicide, if we treat the subject who dies as also a witness to his dying. In this sense, the witnessing is so intertwined with the dying that, I assume, it ends when the subject's consciousness stops. The artistic context becomes obsolete at the point when the artist's will and the witness' ability to maintain a distance dissolve. Art has been frozen in death, even as death has been frozen in art—a static mutual entanglement replaces their erstwhile fluid exchange.

Admittedly, none of Qi Lei's public burials goes beyond the approximation of death. When his death is realized in the film's last shot, it remains unclear whether the artist intends for his suicide to be art. As a concept in abstraction, however, Qi's performance burials not only contradict the narrator's implicit value that life is dearer than art but also reinforce the status of xingwei as an embodied aesthetic vehicle that transports, draws from and is propelled by the totality of life which certainly includes death. For what is death but body minus behaviour for the dead and body plus behaviour for the bereaved? Death is a physiological destination awaiting all mortal bodies. In human society, death also signifies diverse culturally specific behavioural patterns occasioned by survivors' ceremonious mourning of the deceased. To treat death in xingwei, as Qi Lei does, utilizes both the innate capacity of the artist's body as a sentient being and the specialized human conduct surrounding a voluntary death—albeit the act is forbidden to some and regrettable to others. Following this reasoning, death is not a 'price' paid for art but one of the value-infused possibilities intrinsic to the realm of art. Even though I don't condone the character's suicide, I feel humbled by the director's temerity to proclaim an artist's absolute logic for xingwei yishu.

In repeating his seasonal rituals, Qi Li / Qi Lei allowed his body to experience—but also to flee from—death's rugged edges so as to bear witness to his auto-memorials. Wang's filmic treatment acknowledges the need for Qi Lei's death art not to be realized fully in order to maintain its option of recurrence; it also entertains xingwei yishu's possibility beyond its commonsensical limit point, where a human individual becomes something else. Wang's interest ensures that traces from Qi's serial burials—even merely as fictitious documents—are *frozen*, deposited in film history like icy archives, waiting to be thawed—rebirthed?—by curious eyes.

Cemetery Intervention: Qiu Zhijie

On 4 April 1994, a day before *Qingmingjie* (Ancestral Memorial Day, annually on 5 April), Qiu Zhijie visits a cemetery located in Manjuelong Village, Hangzhou, to engage in a clandestine xingwei entitled *Qingmíngjie de jiyili ceyan* (*Memory Tests on Ancestral Memorial Day*, 1994).[33] Using black masking tape, he covers up the inscriptions on tombstones, literally de-facing the epitaphs by shrouding the names of the deceased and of those who erected the monuments. He marks about 60 tombstones in this way within a circumference of 300 sq. m. Qiu returns on Ancestral Memorial Day to observe by stealth the cemetery visitors' reactions. The artist notices how the visitors become utterly confounded by his simple obscuring action. Even more than anger and confusion, fear seems to be their predominant responses.

33 A document for this project appears in Li Yumin (2004: 137). My description of the project is based mainly on my interview with Qiu Zhijie, 5 July 2005, Beijing.

On a holiday designated to remember the ancestral dead, paying reverence to one's deceased kin by cleaning and caring for their graves is, according to the Chinese cultural belief

IMAGE **3.15** *Qingmíngjie de jiyili ceyan (Memory Tests on the Ancestral Memorial Day*, 1994) by Qiu Zhijie. Image courtesy of the artist.

in 'ancestor worship', the single most sacred family activity (see Spier 1987; Religion Facts 2010; and 'Qingmingjie' in *Baidu Baike* 2010). The cemetery visitors who showed up at the graveyard redesigned by Qiu, however, found an unexpected scene: the individual names carved on the tombstones, essential 'geographic' guides to the visitors, had disappeared behind a systematic network of solid black panes. Qiu's sabotage made the visitors' task of recognizing their destinations extremely difficult, considering that most graves in the area were built in a similar style. The artist put the grave seekers to an impromptu examination, testing their courage, their superstition, their persistence, their adaptability, their sense of filial obligation and their capacity for non-verbal memory.

Calling his xingwei piece 'a memory test', Qiu grounded his mischief on an epistemic plane. He questioned whether our memories are constituted in our brains primarily through verbalization. By erasing the differential verbal signs from look-alike tombstones, Qiu exposed the grave seekers to a world without distinction, to one whose very visual uniformity creates the chaos of anonymity. He redirected the seekers' eyes—perhaps those shifting between some vague mental images of the dead and their no-longer-specific resting places—to a larger barren landscape, periodically interrupted by an earthy mound topped by a set of greyish stone blocks.

Qiu's hand, by repeatedly taping over vital information, made present a scene of otherness hitherto unregistered in cognition, a scene where somatic extinction is made visible in blackness, the heavy blanks congealed in the colour of mourning. The names of the cemetery residents, recalling life's plenitude, were individualistic and vociferous. Death's singular reticence now superseded them. In the ensuing silence, the already dead were lost again to the bereaved.

The specific venue and occasion that Qiu chose for his covert xingwei superimposed a certain ethical and metaphysical significance on his mnemonic exercise. By defiling a cemetery right before a commemorating anniversary for the ancestral dead, Qiu brought under scrutiny the Chinese conception of death as it intersects with the practice of ancestor veneration. In a country where no single religion is dominant, ancestor worship exists as a quasi-religious spiritual foundation which turns death into a secular familial event. The family/clan continues to regard the 'bodies' of the dead relatives, represented by their metonymic mementoes (the graves, the tombstones or conventional wooden tablets on which the names of the dead are engraved) as physical and spiritual extensions of the departed, symbolizing their incessant, if transformed, existence within the family/clan (see Yingzhong Lu 2010). Such veneration for dead kin requires one to care for the family graves with deep respect. Desecrating the tomb breaches this longstanding filial/spiritual ethics and will most likely horrify the living—perhaps also the dead. The living visitors are forced into a compulsory scenario of betrayal, forgetting where the dead repose. The dead, estranged from the familiar/familial grave estate by such forgetfulness, is turned *other*, instantly rendered non-kin and unkind—a homeless ghost.

Within the context of ancestor worship, Qiu's prankish interrogation into the metaphysical core of Chinese kinship became a sacrilegious act. The cemetery visitors' fear reflected the acute degree of such ethical and spiritual violation. In fact, Qiu revealed his awareness of this deep violation by remaining inconspicuous when he returned to survey his 'crime' scene. Involuntarily subjected to a 'memory test', those trapped faced a double bind: They could not pass the artist's test unless they dared to touch the very evidence of sacrilege and remove the black tape. When they dared, they still risked simultaneously failing the test *and* trespassing on other families' graves. Without the prompt of verbal identity, the instability of their memories, as fallible as their bodies, was brought into relief. Their ancestors, mute as deformed tombstones, faded like disfigured faces, their tongues bound, their eyes and mouths sealed.

Death, ominous in its presence, paves a treacherous route to memory disintegration, mocking people's desire to turn nominal engravings on tombstones into permanent homesteads for the ancestral dead. Qiu's xingwei-turned-zhuangzhi deconstructs the pretence of earthly monuments as mnemonic reservoirs for the departed at the same time as it uncovers attitudes towards death among the living.

Cadaver Display and Unsighted Corpse: From *Infatuation with Injury*	In Beijing's time-based art history, the year 2000 was pivotal largely due to three contentious experimental exhibitions: *Infatuation with Injury* in spring; *Ren•Dongwu (Human•Animal)* throughout summer and autumn; and *Buhezuo fangshi / Fuck Off* in winter.[34] Although each showcased radical sensory disturbances, *Infatuation with Injury*,

34 For an extensive analysis of *Human•Animal*, see Chapter 4.

being the first domestic exhibition to display whole-body human cadavers as xingwei-zhuangzhi, actively shaped the anti-aesthetic tenet of China's Y2K.

Infatuation with Injury (22 April 2000, 3.30–5.30 p.m.), curated by Li Xianting, took place for two hours as an 'internal academic exchange' sponsored by the Open Studio programme at the Research Institute of Sculpture, Central Academy of Fine Arts. Officially a 'closed' show, *Infatuation with Injury* did not issue any advertisement or printed invitation; nevertheless it drew a crowd of 200 people, including some children and quite a few foreigners (see Wu Hung 2000a: 205).[35] Although the event's brief time span served to avoid police intervention, the ensuing controversy alarmed the Central Academy of Fine Arts and it ordered the Research Institute to conduct an investigation and file a report. The hullabaloo was caused by the use of human cadavers as art material in three of the six xingwei-zhuangzhi artworks on display; all three pieces—which I see as consumableworks—translated the general theme of injury into sites/sights of death.

35 My descriptions of the xingwei-zhuangzhi pieces in this show are based mainly on my interviews: with Sun Yuan and Peng Yu, 28 June 2005 and 6 July 2006; with Qin Ga, 17 July 2008, Beijing.

The centrepiece in Qin Ga's *Bingdong* (*Freeze*, 2000) is the cadaver specimen of an adolescent girl, propped up by two crutches on a floor overlaid with ice bricks. Qin puts a pair of sunglasses on the girl and sculpts on her naked body legions of sores—symptomatic of the inflammation often seen in terminal AIDS patients. Scattered inside the ice bricks, crimson rose petals are frozen in sterility. As complementary optical tropes, both the female cadaver and the rose petals envisage premature suspension—her life cut short by an untimely death, like the rose petals fallen in their prime. Her young body, abject and grotesque, juxtaposed with the traditional symbol of love in the colour of blood, appears as a chilling imago for the Chinese homophonic translation of AIDS as *aizibing*,

IMAGE **3.16** Qin Ga's *Bingdong* (*Freeze*, 2000), starring an adolescent female cadaver. The xingwei-zhuangzhi piece appeared in the *Infatuation with Injury* exhibition, curated by Li Xianting. Image courtesy of the artist.

which may be transliterated back into English as 'love', 'to grow or to multiply', 'disease'. Qin has built a limit zone for sighting the contemporary plague.

Qin Ga's installation raises many touchy issues. As a male artist, he exploited a younger, female cadaver in his artwork. The power differential between the male artist and his female model remained untroubled as Qin assumed the masculocentric art historical convention to objectify a female nude. The status of the model as a dead specimen and the pointed reference to AIDS, however, complicate the relevance of a feminist critique. In the first instance, the gender of the corpse becomes a non-issue. Death, which neutralizes all distinctions, makes obsolete any socially constructed identity. The problem here shifts from one of gender to that of volition and vitality: Has the live artist exploited the dead body by using it in an art project made for the living? In the second instance, the body's gender seems a specific and important choice. The adolescent female cadaver, bearing symptoms of a highly perilous disease, confronted the local government's reticence to acknowledge an epidemic while it exposed the increasing toll of HIV/AIDS on women and children, who many had mistakenly believed to be immune from the epidemic.[36]

36 For a chronology of the history and the government responses to HIV/AIDS, see Avert (2006). On 6 March 2000, a symposium, cosponsored by the All China Women's Federation, the Beijing Office of United Nations Department of Fund for Women and the United Nations Theme Group on HIV/AIDS, was held in Beijing to discuss 'the dramatic increase of HIV/AIDS in women and children' (Casy 2006).

The controversy concerning cadaver display in Qin's xingwei-zhuangzhi foregrounds the incorporation of death in time-based (live) art. His ice bricks are melting, marking their durations and exposing the passage of time. The adolescent cadaver, demonstrating the lethal moment, is nevertheless not a live body sacrificed to an art project but an anatomical specimen borrowed from a medical institution. Conceptually a Duchampian readymade aided, the cadaver in *Freeze* stands as a palpable site of collaboration between death, embalming science and art. Death first remade the given body into a material site of mortality; embalming technology chemically sterilized, stabilized and turned the corpse into a permanent specimen for scientific study; Qin, through his artistic choice and skill, transported the medical readymade from the laboratory to the stage and adorned it with thematic and sculptural accessories. He propped it up on the crutches, added surface wounds to its skin and gave it a pair of fashionable sunglasses. If we accept death solely as an image-moulding process, then the science of cadaver preservation manages to fix the image while Qin's project functions as a public outlet for the painterly aptitude of a biological agent, aided by science and art. The problem, of course, lies in the conditional clause: the sheer referential density of death—a discursive product of human society—inhibits us from considering death merely nature's metabolic process. Yet, this very problem makes *Freeze* so much more ponderable than the sampling of an unremarkable organic course.

The same compounded quandary applies to the two other xingwei-zhuangzhi pieces: *Ren you* (*Human Oil*, 2000) by Peng Yu, who enacted this solo piece right after she finished performing *Lian ti* (*Linked Bodies*, 2000), a collaborative project with Sun Yuan.

In *Human Oil*, Peng feeds the oil extracted from a human body through a tube into the mouth of a skinless dead infant which she cradles in her lap. The image of a woman feeding a child evokes the iconography of motherhood. Peng's attempt at nurturing is further underscored by the corresponding details of this transaction. Transferring matter to

where it is lacking, the artist tries to infuse the human oil, arguably a substance of life, into an infant body stripped of the epidermis that preserves the fatty tissues. All the elements for a mother-and-child communion are present: the mother, calm in her expression and patient in accomplishing her feeding task; the infant, inclining on the mother's lap, compliant in its posture; and the food, organic and liquefied, nearly wholesome. There is much tenderness there—only the timetable is off. The maternal tableau in *Human Oil* is destined to be a masquerade, as determined by a prior process—the death of the child. Death renders impossible any reciprocal exchange in this secular tableau of Madonna and Child. The infant's stiff mouth, discoloured muscles and bilaterally scarred torso cannot absorb the substance proffered, leaving it squandered on the floor.

A profound sense of futility deepens the pathos of *Human Oil*. The recognition that a living person is utterly impotent to counteract the effects of death recalls the discursive context of the exhibition theme—the morbid fascination with harm typical of certain human populations. In a country where some women in remote rural areas have suffered from enforced late-term abortions, Peng's mimicry in feeding/reviving a dead infant points to the innumerable casualties of China's one-child policy. Death, in both the artistic and sociopolitical contexts, erects an insurmountable barrier between the bereaved mother/s and the exterminated foetus/es. Aside from this indigenous reference, however, have the artists further violated the dead infant by displacing the specimen from its anonymous utility in a pathology clinic to its pathetic exposure as part of an artwork? Doesn't objectification happen in either case, whether it's under the scalpel or under the spotlight? The act of injury, then, results more from the futility of the living to seek communion with the dead than from the cadaver's misplacement.

On a deeper level, *Human Oil* inverts normative values associated with life and death by implying that the effort to revitalize the dead infant causes the damage—the peace of death/the dead is contravened by the burden of life/the living. A tiny body, flayed and transfixed by formaldehyde in its rigor mortis, is forced to be reborn under the living gaze like a wireless monster marionette, an inflexible receptacle of extracted human fat, its post-mortem death mask on show. Such a blatant deployment of counter-intuitive values in *Human Oil* served to elicit radically opposing responses from onsite viewers: those who objected to using cadavers in art found it to be 'inauspicious' and disrespectful of the dead; those who believed 'a dead person is only a material substance and no longer a human being' complimented the artists' innovative choice of art material to confront superstition. A supportive response further related the artwork to the country's distinctive secularism: 'There are taboos connected with the corpse in Christianity in the West; we should not forget that China is not a religious country.'[37]

37 See the samples of audience responses included in Wu Hung (2008: 208).

Death functions as more than a visual and procedural agent in *Linked Bodies*, which connects two artists' living bodies with the corpse/s of conjoined twin infants. Seated facing the audience, on two symmetrically placed chairs, Sun and Peng calmly engage themselves in intravenous blood transfusion. Their fresh blood drips through a pair of catheters inserted into the mouths of the twin corpses, attached at their abdomens—a less-than-a-pair of blood-gift recipients placed on the floor in front of the artists. Finding no viable outlets, the blood seeps through the orifice and overflows onto the side of the conjoined twins' torsos. The clash between the immobile flesh, with its telltale signs of death, and the excess, spilled blood (cumulatively, 100 cc from each artist) as evidence of life, betrays the piece's aberration. Nevertheless, *Linked Bodies* supplies a rather straightforward solution to what its title promises: all 'bodies' present in this xingwei-zhuangzhi—whether alive or dead, male or female, adult or juvenile, regular or anomalous, organic or synthetic, born or artificially arranged—are joined.

(FACING PAGE) IMAGE **3.18** *Lian ti* (*Linked Bodies*, 2000) by Sun Yuan and Peng Yu, in *Infatuation with Injury*. Image courtesy of the artists.

Like the mother-nursing-baby duet evoked by *Human Oil*, the human bodies in *Linked Bodies* depict the facade of 'a happy family'—a photograph with Mummy, Daddy and the Babies. Both pictures, however, are off-kilter, out of tune with the melody of daily life for they integrate the harsh resonance from what lies beyond sentience. Death inserts its dire presence in the midst of a harmonious union and drenches the domestic heaven and earth in a deep shade of livid grey. The contrast between the live adult artists and the dead conjoined infants manifests the oft-arbitrary logic of death—the young may go just as quickly as the old; a wayward arrow may last longer in the air than a bonny and fast one. Mimicking the image of a domestic tableau, *Linked Bodies* wryly invokes the Chinese belief in ancestor worship, family solidarity and clan longevity. Here the ostensible parents are linked through visible bloodlines with their onsite children. Although not even death can part these determined, make-believe kinfolk, their cross-generational tie has suffered a dusty change. As death transmutes the semantics of familial routines into that of predictable contingencies, it also acts as a macabre architect to stall the spatial flow. Structurally, the individual components in *Linked Bodies* look like a circulatory system, recalling the function of blood vessels in a vital mammalian body. Yet, the circulation is cut off—the life-saving blood is wasted on an inanimate twin receptacle.

But Sun and Peng's wasted blood is also the emblem of an allegory, featuring death as less the grim reaper than a magnanimous host; never too squeamish for promiscuity, death rejects none who travels to its door. *Linked Bodies* connects an array of diverse bodies in one continuous, if faulty, system, one in which all corporeal and manufactured materials are imbricated as perishable matter. By interweaving its disparate parties, *Linked Bodies* avows the equivalent status of all entities in existence, subverting, as it were, the Great Chain of Being which hierarchically organized the mediaeval European cosmology. Sun and Peng's consumablework recasts death as a liminal state connecting all mortal beings. The beyond is here.

> We have always wanted to explore fundamental problems concerning the existence and death of human beings [. . .] A dead person can be cremated, used in a medical demonstration, or shown in a museum of natural sciences. So why can't it be used in an artistic experiment? [. . .] In our works we hope to imbue energy and new significance into a material substance that has lost its spiritual attribute [. . .] We hope to transcend the cultural conventions of East and West, to challenge intuitive ethical rules, to stimulate people to think, and to make people see things more objectively and independently. To break superstitions and to liberate ideas should always be the ultimate goal of the human race (Wu Hung 2008: 207).

I cite the statement from an interview with the participating artists—the 'Beijing shockers', as dubbed by the Press—that Wu Hung collected in his translated archive for *Infatuation with Injury*. The opening remark, which asserts the artists' motivation in committing their 'shock art', evokes Zhuangzi's poetic summation of mortal being as 'death, birth, but life'. To understand life is therefore to accept one's birth and death as a given process. In another passage, Zhuangzi contemplates, 'fu dakuai zai wo yi xing, lao wo yi sheng, yi wo yi lao, xi wo yi si' (the earth firms up to carry me with forms, births me to give me labour, ages me to allow me idleness, lets me die to have rest) (Zhuangzi 1999: 94, my translation). Zhuangzi portrays a universe where an individual sentient life exists as part of a continuum with nature. Thus, the

form I carry as a human being comes from the solidity of the earth which gives me birth so I may labour for it, allows me to age so I may have leisure and permits me to die so I can rest. My existence is, in this philosophical vista, an emanation from the universe, ever interacting with the environment; every phase in my life has its natural tendencies; being born does not warrant inordinate jubilation nor should dying bring infinite sorrow.

By inserting a dead human body into an artistic quest for the mystery of 'the existence and death of human beings', artists like Qin, Sun and Peng, however, question the impassivity of Zhuangzi's wisdom. They cut into our often taken-for-granted fact of being alive to serve up a slice of our denial—that our living is concurrent with our dying, a phenomenon shrouded by 'cultural conventions of East and West' through segregation of the dead from the living. Yet, apart from invigorating critical discourse that time-based art engenders—as it does mine here— I wonder if these xingwei-zhuangzhi artworks in and of themselves can penetrate the enigma of birth and death. The artists seem to assume that just seeing 'death' in plain sight communicates thoughts like an intelligent telegram and the presence of breathing bodies energizes those without breath. Could the blood-soaked conjoined twins placed just two feet away from me teach me about death? Even if I could behold, smell and touch their deformed torsos, would I learn much about my anticipated transition into a being *other than* and *other to* the one who speaks to you now?

If strong visual images are vocal like sensorial noises, then absent pictures might underscore the silence that speaks volumes. While critics were divided as to the merit of cadaver display, none of them raised any objection to the curator Li's inclusion of a set of photos as documents of the final action by artist Zhang Shengquan (known among fellow artists as Da Tong Da Zhang, Big Zhang from Da Tong, Shanxi Province). Da Zhang was, perhaps in more than one sense, a phantom participant in the *Infatuation with Injury* show, since his name did not appear on the official roster of selected artists. Zhang committed suicide by hanging on 1 January 2000, leaving behind various notes in sprawling calligraphy on the walls of the bedroom where he died (see Li Xianting 2000a).[38] In a move incidentally echoing what Wang Xiaoshuai did for Qi Li with *Frozen*, Li Xianting pieced together compelling—yet indefinite—clues left by Zhang since 1992 and decided to memorialize Zhang's suicide as an extreme xingwei artwork. Thus, through a curator's intervention, Zhang's fatal act became a linchpin that sadly embodied the exhibition theme as incremental self-erasure.

[38] Based on my phone interviews with Li Xianting, 27 August 2004, Los Angeles to Beijing; 11 July 2006, in Beijing; with Wu Yanguang, 11 July 2006, Beijing. See also Meishu Tongmeng (2000).

I suspect that self-negation, rather than self-commemoration, was what motivated Zhang's suicide/xingwei. Li's empathic reading of Zhang's death as a conscious artwork is, after all, based on circumstantial evidence. In fact, the curator revealed his ambivalence towards the artist's intention in the way he displayed Zhang's final behaviour, representing it with photographs taken four months after Zhang's death, when Li and a few other artists visited Zhang's apartment on Ancestral Memorial Day. Upon Zhang's request, his younger brother had preserved most of the contents of the artist's room from the suicide scene. Li's photographs, then, offer glimpses into Zhang's last days, months, or even years, when he locked himself inside a squalid bedroom-studio, cluttered with sundry household items, dusty stationery,

piles of magazines, crumpled newspapers and soiled plastic bags. These mundane possessions, long entropic, look forlorn and menacing without their owner. Next to his pinned-up oil paintings, Zhang inscribed in charcoal directly on the walls his poems and statements about art, calling forth on one corner 'Dada', on another his belief that 'there is no right and wrong in the universe; all depend on one's particular coordinate system.'[39] Another series of photographs records the posthumous scene of mourning, when Li and others offered flowers to Zhang's room and burnt paper spirit-money in front of the wooden box containing Zhang's ashes in an open sand dune. Are these photographs documents of a drastic artwork or of an extreme life—or of both?

39 I've studied the photographs of Zhang's room provided by Li Xianting to describe the scene. I translated the citations from Zhang's writings on the wall captured by photographs.

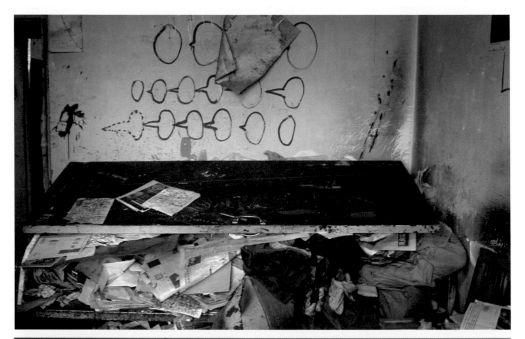

IMAGES **3.19.1–2** Zhang Shengquan's room and his writings on the wall. Image courtesy of Li Xianting.

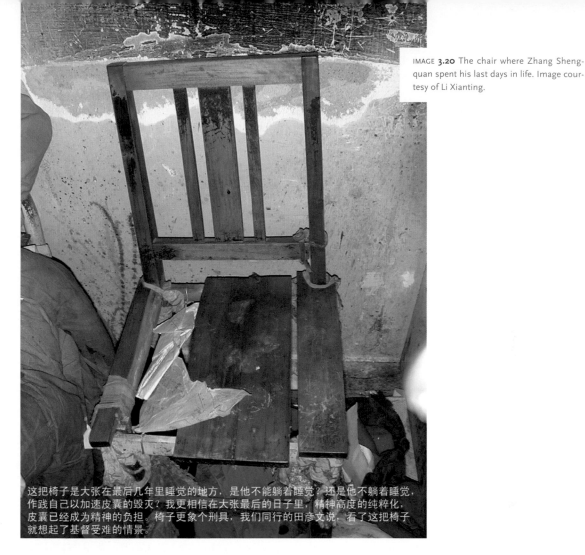

IMAGE **3.20** The chair where Zhang Sheng-quan spent his last days in life. Image courtesy of Li Xianting.

这把椅子是大张在最后几年里睡觉的地方，是他不能躺着睡觉？还是他不躺着睡觉，作践自己以加速皮囊的毁灭。我更相信在大张最后的日子里，精神高度的纯粹化，皮囊已经成为精神的负担。椅子更象个刑具，我们同行的田彦文说，看了这把椅子就想起了基督受难的情景。

These pictures on display make visible what we cannot see, for what's common in them is the insistent void where the artist's body is missing. This absent body makes its presence felt especially in the image of a decrepit chair, captioned with a curatorial message:

> This chair was the place where Zhang slept for his last few years. Was it because he couldn't lie down to sleep? Was he unwilling to lie down to sleep, damaging himself to hasten the destruction of his bag of skin? I'd rather believe that in his last days Da Zhang's spirit was highly purified; his bag of skin had become a burden to his spirit, his chair an instrument of torture [. . .]. [40]

40 My translated transcription from the photographic image provided by Li.

According to Wu Yanguang, Zhang's close friend and professional associate until around 1996, the dead artist, a former soldier who remained single, suffered from an unknown disease that incapacitated his knees and made it impossible for Zhang to straighten his legs. In the

last few years of his life, Zhang isolated himself from others for fear of sharing a meal with anyone, even with members of his family.[41] Li's editorial caption reflects these basic facts;

41 My interview with Wu Yanguang, 11 July 2006, Beijing.

nevertheless, it concludes with a somewhat hyperbolic remark made by a fellow artist named Tian Yanwen who compares Da Zhang's chair to the crucifix of Jesus: the apotheosis of suffering. This closure, which projects a redemptive promise for Zhang's physiological and mental agony, reveals the curator's desire to make Zhang's suicide more meaningful—as a service to humanity, like art-making—rather than a resignation through self-obliteration.

But does the curator's interpretation agree with the artist's writings on the walls? 'The last question in art------- [sic] is whether or not to preserve a good life. For any discovery by an artist, once it is exploited by others, even if it's exploited by the artist himself, becomes utterly mean-

42 I translated the citations from Zhang's suicide notes from the statements posted in Meishu Tongmeng (2000).

ingless.'[42] If I may take this transcription from Zhang's wall as his quasi-epitaph, then the artist's remarks imply that he seeks in death an entry to an all-encompassing erasure where nothing remains to be used or abused by any living being. Did he understand death as coinciding with pure visual negativity, for what cannot be owned by another's sight can scarcely be looted by hand? Zhang's succinctly stated suicide note, addressed to 'Those Who Are Related to Me', only deepens the mystery. The first line begins: 'The step I took was completely determined by fate. In 1992 I had already said, "My forty-fifth year in life will be the anniversary of my death." I merely kept my promise.' After bequeathing all his money to his father and requesting that his younger brother take care of the old man, Zhang describes his preferred funereal arrangement: 'Do not change my clothes, nor put my ashes in a vase. Just throw me outside the crematorium. Walk along a mud path there and you will see a big hovel of sand . . .'

A hint of nihilism, mitigated by an eerie sense of peace, characterizes Zhang's will and instructions for his end-of-life affairs. Would someone who had reached a level of emotional equilibrium by/before ending his life deliberately commit suicide as art? 'My behaviour (xing-wei) is absolutely an individual behaviour and it has nothing to do with anyone else,' reads another passage in Zhang's suicide note. Did Zhang use the term 'xingwei' in its quotidian usage as a prosaic deed or in the specialized lingo of art as shorthand for xingwei yishu? Did Zhang attempt to create an artwork that can be imitated by none who wishes to survive the deed? If so, should I consider his suicidal event a successful xingwei piece, having attained the recognition of an art exhibition? If not, am I not infringing on his right to privacy by conflating his existential act with an art product, one that may become circulated posthumously as a discursive commodity? Or, to say at once both aye and nay, might Zhang have hoped to double the efficacy of his final xingwei as *simultaneously* an *art* and a *life* choice? Doesn't his symbolic death day, 1 January 2000, indicate a wish to provoke speculations from strangers?

Seen from my vantage point, a perspective as yet uninitiated into the otherness of death, one thing appears certain: by proposing Zhang's terminal xingwei as an extreme art action, Li Xianting demonstrates the power of the living to frame death. Although the curator's interpretation does not fully convince me, I become aware of Zhang's fatal behaviour from Li's testimony. Nevertheless, Zhang's last living act remains enigmatic. Death obstructs any access to the artist's original intent; it also obliges an empathic other to disrupt its agency of annihilation.

If the beyond is here, how can we tell hither from thither? This question might have inspired He Yunchang's conception for *Zhu* (*Casting*, 23–24 April 2004), a xingwei-zhuangzhi piece enacted at the opening of *A Chang de jianchi* (*The Persistence of Ar Chang* [He's nickname], 2004), his solo exhibition. Or, to put the question differently: If death, either as a self's future possibility or as an other's past experience, is no longer a limit for xingwei yishu, how will a practitioner take the next audacious step, short of suicide, homicide and zoonicide? Whatever the question, the artist confessed a simpler motivation: He conceived of *Casting* to overcome his 'dread of darkness' and to pursue his fascination with 'the proximity of concrete as a material to his body' (Tang Xin 2004: 6).

Recasting Death:
He Yunchang, Redux

IMAGES **3.21.1–3** He Yunchang entered the constructed concrete cube to perform *Zhu* (*Casting*, 23–24 April 2004), a xingwei-zhuangzhi piece staged at the Beijing Tokyo Art Projects. The concrete cube constructed for *Casting* resembled a monument built inside a gallery. Image courtesy of the artist.

A crew of workers constructs an cube (120 x 80 x 280 cm) out of steel plates and cement blocks inside the exhibition hall of Beijing Tokyo Art Projects, where *Casting* is taking place. He Yunchang, naked and carrying only a cell phone, enters the cube through a small square opening left in the cement wall. Once his body disappears from sight, the workers seal the opening, cover the five external walls with wooden moulds and begin to pour cement into the gaps to create a 30 cm–thick layer round the entire cube. After 10-plus hours, the workers finish casting to yield a minimalist monument (180 x 140 x 320 cm), austere in its basic geometry. The solid mass is sealed tight except for two air-circulation holes (each 12 cm in diameter), providing the artist's minimal need for survival. After 24 hours, He emerges from his self-imposed immurement through a gap cracked open by his curator Tang Xin and assistants.

Casting is a rich artwork, dense with interpretive possibilities. Characteristically, the artist relates the project to the exultation of his personal will, a stubborn 'persistence' that has carried him through a xingwei career verging on the practice of extreme sports. By the sheer strength of his will, he would face his phobia of darkness for 24 hours, the symbolic duration he preset for *Casting*. In case his self-imposed test grew unbearable, he made sure he took along an emergency measure— a cell phone. In this light, *Casting*

IMAGES **3.22** He Yunchang performing *Casting* (2004). The artist emerges after spending 24 hours in the dark cube. Image courtesy of the artist.

dramatizes an artist's self-arrest in pursuit of his aesthetic investment and the collective will of a society to grant him such a licence. Since He performed his naked action in a gallery without any official interference, *Casting* confirmed the Chinese government's about-face regarding contemporary art in post-biennale Beijing (the first biennale was held in 2003). To me, the fact that the authorities permitted this kind of work invalidates a reading of *Casting* as a political allegory, one that might compare the artist to a human rights activist being confined for his dissension. But is it plausible to consider the piece an individual's evocation of our shared mortal bondage?

Swayed by my present agenda, I submit that death constitutes an ineluctable thematic dimension in *Casting*. The performance comprises a process resembling a burial rite, in which a group of survivors erect a monument—a tombstone not unlike a cement block—to simultaneously enclose and memorialize a dearly departed individual. Likewise, the process shielding He from plain sight marked him as *different* from those who had ritualistically placed him in the exclusive enclosure. Thus, *Casting* recast death analogously as a behavioural mode involving two intertwined steps: a negation of others' visual access to the departed subject; and a temporary social/kinship congregation to witness the subject's entry into absence. *Casting* created a spectacle for the artist's transition from a corporeal presence into a mere memory; meanwhile, it entailed the death of the artist as a spectacle. He's 'spectacular' body was replaced by an abstract memento, a structure that gradually solidified into an evolving narrative in space. Given time, the memento could shift from a conspicuous monument, a vertical landscape, a visual white noise, an architectural nuisance, to a ruin.

If He's merging with his concrete cell resembled a descent into a catacomb, then how do I plot my narrative for his re-entrance into the world of sight, motion and relation? To reiterate: *Casting* conceptualized death as a communal process culminating in a collective optical deficiency. He's viewers, through their joint complicity, erected the very barrier to what they most desired to see—the artist who had to ration his metabolic pace in order to endure his arduous xingwei. He's bursting out of his confinement to end *Casting* was therefore a resurrection; he had survived his status as a memory to become revived as a spectacle again or, more exactly, as a voice that had crossed to the beyond and back, ready to speak of his near-death experience as a sensorium of acute affects: 'First, [I felt] nervous. Second, cold. Third, hot. Then, [I was] out' (Tang Xin 2004: 8). Is He's recap of his experience in *Casting* a story about his birth into death, or his rebirth from death? Did he inadvertently fall asleep and experience a brief dream as a rehearsal for death or a semi-death as a forgotten dream?

Casting transmutes death from an episode of biological finality that a person must suffer alone into an elastic experiential drama composed of, for and by all finite beings. Through its refusal to visualize death as a somatic manifestation, *Casting* offered a coda to xingwei-zhuangzhi's infatuation with death as a flamboyant visual trope in Chinese time-based art. Much light—minus some clouds of concrete powder—came from an artist's dread of darkness.

In 2004, even Sun Yuan and Peng Yu—*les deux enfants terribles* among the Beijing shockers—relented. Around the turn of the millennium, the duo was notorious for their literal citations of death by presenting spectacles ranging from callous sacrifice to humorous horror, such as *Linked Bodies*, *Human Oil* and numerous other controversial animalworks.[43] Less than half a decade

[43] See Chapter 4 for an assessment of Sun and Peng's animalworks.

later, Sun and Peng had moved from their strident juxtaposition of gory tableaux and seditious smirks to a more subterranean aesthetic in which death lurks beneath a tranquil surface. Instead of overtly confronting the viewer, death functions more like an embedded double to shadow Sun and Peng's *One or All* (original English title, 2004), which made its first public appearance in the exhibition *All Under Heaven: China Now!* held in the Museum van Hedendaagse Kunst (MuHKA) in Antwerp, Belgium.

One or All features a pillar-size column of chalk slanting towards a white wall. Nearly 2.5 m in height and 25 cm in diameter, the cylindrical chalk looks massive against an average-size human body. The chalk's monumental scale is enhanced by the multiple shadows surrounding it. Because of the angles of the overhead lighting, dark triangular shapes radiate from the top of the chalk and trail its bottom, casting spectral spikes on the adjacent walls and floors, haunting their blankness.

One or All's minimalist sculpture looks like a visual pun on ephemerality. As a drawing and writing instrument, chalk is typically used to inscribe signs, patterns and diagrams that facilitate communication in transit. Chalk marks tend to be erased, either deliberately eliminated to make room for new marks or forgotten after use, left to be disposed of by random natural elements. A piece of chalk that leaves only shadows on a surface, as does the one in *One or All*, would seem doubly transient. The chalk's instrumentality as a temporary medium is here disturbed by its materiality as a solid, heavy mass which can hardly be handled by human fingers and will leave nothing behind without the elusory property of light. In this context, I read the piece's title, *One or All*, as a dynamic pull between the chalk's singular objecthood and its potential to deliver all sorts of inscriptions.

The ephemerality that the giant chalk represents in *One or All* gains a special existential resonance when we consider the base material from which it is made. Chalk is conventionally manufactured from fine-grained sedimentary rock consisting almost wholly of calcite. Sun and Peng, however, constructed their chalk in *One or All* from a different source of calcium carbonate—the compressed ashes of cremated human flesh and bones. This crucial choice transforms the chalk into something more than what it appears to be: it is now not only a thing (for casting shadows), a functional tool (for sketching) and a metaphor (for ephemerality) but also a metonymy for what's left of a human body. With this added shading, the title *One or All* crystallizes as a meditation on the isolated and collective nature of death, a process to which all of us are bound as we each transition to a different order of existence.

Sun and Peng's choice of human ashes is consistent with their ongoing exploration of archetypal themes (birth, death, union, separation, love, harm) in their artwork by employing basic corporeal materials (live, dying, dead animal and human bodies). Their art's appeal lies largely in their ingenious melding of concept with expression, navigating familiar themes by employing hitherto untested materials. In *One or All*, the artists complement this conflation

of idea and form with an aesthetic economy which renders their sculptural installation into visual poetry, akin to a neologistic ideogram.

(FACING PAGE) IMAGE **3.23** *One or All* (2004), a xingwei-zhuangzhi artwork by Sun Yuan and Peng Yu, displayed at Museum van Hedendaagse Kunst, Antwerpen, Belgium. Image courtesy of the artists.

What does the ideogram in *One or All* signify?

In a subtextual whisper, the ideogram speaks self-reflexively of its making. Due to the sensitive nature of their art material, the artists spent over a year collecting human ashes from various crematoriums and, whenever necessary, acquiring legal approval from surviving relatives. As Peng Yu commented in our interview, they could have created another piece simply based on the sheer number of legal documents they collected on behalf of their sculptural zhuangzhi.[44] This strenuous process not only constitutes the implicit xingwei dimension in *One or All* but also adds a certain historical weight to the chalk's bulk. The legal issues involved in the artists' production process also hints at the socialization of death in human societies.

44 My interviews with Sun Yuan and Peng Yu, 28 June 2005, 6 July 2006, and 15 July 2008, Beijing.

Touching on its para-textual significance, the ideogram intimates a particular sociopolitical circumstance to which the xingwei-zhuangzhi artwork tacitly alludes. In July 1997, the Chinese government issued a 'Burial Management Policy' to promote cremation and discourage ground burials because there was insufficient land for human habitation (see Zeng Renquan 2004).[45] The pro-cremation policy became law in July 2002, causing trauma—and tragic farce—especially among rural residents who resist forgoing burials which they believes are the only way to ensure peace for the dead. The Chinese proverb 'rutu wei an' ([to be buried] into the earth is [to gain] peace) conveys the traditional attitude towards burials in a cultural economy based on agricultural development. By inventing a tightly packed column of cremated human remains, Sun and Peng demonstrate, with *One or All*, a novel—and communal—way of storing human ashes. This seemingly pragmatic, but in execution extravagant, solution might serve as a satirical jibe at the compulsory cremation policy, which has added yet another opportunity for corruption among rural officials. The compulsory cremation law has since fostered a two-tier burial system in rural areas: for those who cannot pay, their dead relatives will be burnt; for those who can, pseudo-cremation ceremonies are scheduled, followed by clandestine burials in order to afford the dead all the pomp and rituals that bribes can buy.

45 The author's name, Zeng Renquan, is homonymic with the Chinese phrase 'to fight for human rights'. I believe it is a pseudonym.

The ideogram in *One or All* includes two major components: a text and an intertext. The 'One' in *One or All* is a word that ruminates over a solitary process unique to each individual, a process that follows the course of dying and death. Both overlaying and embedded within the 'One' is the 'All' which is not merely a text but an intertext: it thrives on the rapture of unanimity that no single text can resist, constantly swinging between a force over which none can perpetually prevail and a common thrust into the unknown. 'All' is an intertext that is also an always-viable hypertext, transporting us towards a most radical dematerialization or transubstantiation that all of us—humans, mortals, breathing, perspiring and metabolizing organisms—have to go through: from hither to whither we know not (yet)!

A pole of totemic chalk made of human ashes sloping towards a blank wall haunted by ghosts: the tenuous balance that the chalk strikes suggests a mere pause midstream by a

prolific executioner, death, whose act affects each individual in a singular way yet produces an invariable effect on all. Even so, the chalk's status as an instrument for creative inscriptions reverses the gruesome fatality of the macabre act to underscore its regenerative potential. From death we may yet trace birth—past, present and to come—even when those traces are fleeting, like random chalk marks on the sidewalk.

ECHOES: LIMIT AND ITS OTHER | In temporal terms, a limit zone is a perceptual instant when my attention is caught by the intransigence of immoderate emotions. Perturbed by the onslaught of an intense sensorial stimulus, I grip my eyes as my lips come slightly apart, left ajar; without knowing, I knit my brows, tighten my neck and raise my shoulders. To move—I cannot; to breathe—I forget. But then—another minute, another hour, or another day spent unaware—I suddenly pass my experiential limen with my physiological, psychological and spiritual equilibrium somewhat restored and reordered. I float in time again. Although I might still experience a degree of untimeliness with the object/event that caused my perturbation, I have begun the process of incorporating its stimulating aura into my daily durational repertoire. I am free to *live* once more. Given a chance, or the serendipitous cleavage of time, I might reenact the impact left of that already dormant stimulus and naively believe my reenactment, or, to borrow Schechner's felicitous phrase again, my 'twice-behaved behaviour', to be an improvisation—spontaneous, autonomous, even if not quite original.

By presenting limit actions, the time-based artists covered in this chapter have experimented with the extremity of arrested time. Yet, similar to a concept, extreme performances have an almost immediate expiration date. However drastic, unsettling, disgusting, scandalous or transcendent, an extreme time-based artwork, once it is imagined, done and shared, inevitably becomes absorbed into a viewer's epistemic horizon and eventually homogenized into live art history. A suspense born of surprise cannot outlast the burst of energy expended in quieting my palpitating heart. My eyes will search for new stimuli; my nose will turn towards other scents. Before I encounter another spectacle, however, I shall willy-nilly settle into the routine of waiting-for-the-next-new-shock-to-happen, while I experience this imperceptible yearning process as duration. What is duration? Henri Bergson once associated duration with memory (2010). In my tracking of its relation with my temporal sensations here, I see duration as the other that compliments, distinguishes, surrounds and extends from a limit. If a limit is my perception of a moment spatialized into a zone of my fascination, then duration is the continuous presence of time as a measurement of my patience in space. A limit zone is the vehement property of time-based art; duration is its substance and norm, the prolonged temporal span on which ethical conventions may yet impose their contesting power games on recalcitrant individuals.

I've maintained earlier that Chinese time-based artists, especially those favouring limit actions, intervene in their culture's entrenched ethical tradition to alternatively imagine fundamental issues of human existence. In their examplary ethical frictions, they have veritably reversed the two ingrained Confucian and Daoist maxims, 'weizhi sheng, yan zhi si'; 'si, sheng, ming ye', by exaggerating their limit points—birth and death as the freedom, justification and

urgency to create. Despite their divergent philosophical attitudes, the two classical dictums share one target of contemplation: life. For Confucius, life is a conscious human subject's birth into and ceaseless immersion in socio-ethical interactions with other more or less conscious beings. Regarding death, the teacher-sage recommends agnosticism. For Zhuangzi, life is a manifestation of nature; death and birth are merely its more momentous moments. In the light under which I read them, then, both classical dictums call forth *life* as a temporal-spatial *duration* in which human subjects participate. Thus, no matter the conceptual contortions attempted by Beijing's time-based artists in order to unlearn their ethical conditioning, they cannot 'somersault'—like the trickster Monkey King Sun Wukong in the classical novel *Xiyouji* (known as *Journey to the West*)—beyond the *duration* of their framed art behaviours.[46] In a bet with Rulai Buddha, the arrogant Monkey King thought that he had reached the edge of the world but, to his chagrin, he discovered a moment later that he had not even passed the Buddha's giant palm. Might these Beijing artists not suddenly realize the same thing—that limits are intertwined with and defined against duration?

[46] For an abridged English translation of *Journey to the West*, see Wu Ch'eng-en (1943).

A motto to end a chapter about mottoes: The basic premise of human time is life. Limit zones are but the architecture of excessive desires built to house my curiosity restlessly triggered by life.

CHAPTER **4**

AnIMALwoRKS

SCENES OF SAVAGE GODS | A young boar, with tattoos, mounting a fat sow, also tattooed.

Two men debating fervently next to a bound ram on a stony riverbank.

A pig, undergoing open-heart surgery, suddenly squealing.

A skinned dog, standing upright, with smoke coming out of its forehead.

A bound piglet cradled by an unbound man simmering in a huge earthenware pot on a slow fire.

A naked male scratching his back inside a metal cage labelled 'Human'.

A shower of insects pouring over a man reclining in a dry bathtub.

An adult human male bursting out of a cow's belly, scattering rose petals.

A creature with a lizard's body and a human head testing gravity from the edge of a fabricated leaf.

A group of people inside a cage watching a full-grown tiger on the other side of the bars.

Crouching atop a 40 m–tall chimney, a vulture scanning the ground for prey.[1]

1 Parts of this chapter appeared in Meiling Cheng (2007a). I thank the guest editor Una Chaudhuri for her perceptive comments.

I base my descriptions of the pieces cited here on:

Wenhua dongwu (*Cultural Animals*, 1993–94) by Xu Bing: Xu Bing (1994); the artist's website, www.xubing.com (19 March 2010); phone interview with Xu Bing, 3 August 2005, Los Angeles to New York.

Du (*Passage* or *Deliverance*, 1996) by Zhang Shengquan: Ai Weiwei et al. (2000: 176–9); My interview with Song Dong, 5 July 2006, Beijing; my interview with Wu Yanguang, 11 July 2006, Beijing.

Fuhuojie kuaile (*Happy Easter*, 2001) by Zhu Yu: Dai Yanni (2001); my interview with Zhu Yu, 13 July 2008, Beijing.

Linghun zhuisha (*Soul Killing*, 2000) by Sun Yuan and Peng Yu: the artists' website, www.sunyuanpengyu.com; Wu Hung (2000); my interview with Sun Yuan and Peng Yu, 6 July 2006 and 7 October 2007, Beijing.

Da Jianggang (*A Big Vat of Soy Sauce*, 2000) by Liu Jin: my interview with Liu Jin, 3 July 2005 and 9 July 2006, Beijing.

Biaozhun dongwu (*Standard Animal*, 2000) by Feng Weidong: Val Wang (2000).

Xizao (*Bath*, 2000) by Cang Xin: my interviews with Cang Xin, 29 June 2005, 6 July 2006 and 16 July 2008, Beijing.

Wuyue ershiba dansheng (*Born on 28 May*, 2000) by Wu Gaozhong: my phone interviews with Gu Zhengqing, 25 August 2004 and 28 July 2005, Los Angeles to Beijing; interview with Gu Zhengqing, 16 July 2008, Beijing; phone interview with Wu Gaozhong, 13 November 2004, Los Angeles to Beijing; interview with Wu Gaozhong, 30 June 2005, Beijing. See also Meiling Cheng (2004a).

Sama xilie (*Shamanism Series*, 2005 on) by Cang Xin: my interviews with Cang Xin, 29 June 2005, 6 July 2006 and 16 July 2008, Beijing.

Anquandao (*Safety Island*, 2003) by Sun Yuan and Peng Yu: the artists' website, www.sunyuanpengyu.com.

Deng ni (*Waiting for You*, 2006) by Sun Yuan and Peng Yu: the artists' website, www.sunyuanpengyu.com.

(FACING PAGE) IMAGE **4.1** *Linghun zhuisha* (*Soul Killing*, 2000) by Sun Yuan and Peng Yu, in the *Food as Art exhibition*, curated by Zhang Zhaohui, at Beijing's Club Vogue Bar. Image courtesy of the artists.

Having seen the Press-night performance of Alfred Jarry's *Ubu Roi*, W. B. Yeats, with a tinge of wistfulness, wrote, 'After Stéphane Mallarmé, after Paul Verlaine, after Gustave Moreau, after Puvis de Chavannes, after our own verse, after all our subtle colour and nervous rhythm, after the faint mixed tints of Conder, what more is possible? After us the Savage God' (cited in Benedikt 1966: xiii). Although I doubt that any genealogical tracing of animal performances would land on the subtle symbolist moodiness Yeats struck here, the Irish poet's stunning epithet well captures my initial response to Chinese animalworks.

(FACING PAGE) IMAGE **4.2** *Da jianggang (A Big Vat of Soy Sauce*, 28 May 2000) by Liu Jin in the *Human•Animal* exhibition, Nanjing. Image courtesy of the artist.

I use the term 'animalwork' to identify a time-based art genre that incorporates animals as in/voluntary performers and/or manipulated art objects. The opening samples of my perceptual snapshots hint at the sensorial disturbance unleashed perhaps by the selfsame entity that Yeats named. But exactly *where-when* did I sense the Savage God? Was it in the subjugated animals, in their human handlers or in the deliberate juxtaposition of human and nonhuman animals in dire conditions? How do I characterize the awesome presence that held me spellbound? Strident affectability, visceral intensity, perverse humour, ruthless literalism and detachment from cross-species identification: these are stylistic features I frequently discern in Chinese animalworks—even though the Savage God, so glaring in Its epiphany, eludes the grasp of my human language.

The tableaux of animalworks with which I begin this chapter indicate the temporal scope and variegated approaches found in this genre. The earliest piece, *Wenhua dongwu* (*Cultural Animals*, subsequently renamed *A Case Study of Transference*, 1993–94), was a live hog performance staged by the then New York–based expatriate artist Xu Bing at the Han Mo Art Centre in Beijing. This project received substantial coverage in the Black Cover Book, through which Xu's pig-breeding-and-breeding-pigs xingwei became well known in China's experimental art circles. The latest piece, *Deng ni* (*Waiting for You*, 2006, subsequently renamed *Waiting*), was a site-specific zhuangzhi planted by Sun Yuan and Peng Yu at a found outdoor chimneystack as part of the exhibition, *Er-ti-jiao: Zhongguo dangdai yishu zhan* (*Double-Kick-Cracker: Chinese Contemporary Art Exhibition*, 2006), sponsored by Tang Gallery in Beijing's 798 art district. The vulture in *Waiting* is an oversized sculpture made of fibreglass-reinforced plastic, silica gel and real feathers. *A Case Study of Transference* and *Waiting* differ from each other in their use of animal bodies: from the farmed to the fabricated; from the quick to the still. Their divergences mirror the conceptual and methodological shifts within Chinese time-based art, which has moved from a focus on 'the real' to a more recent engagement with 'the fake'. The 12-year distance between these two animalworks chronicles Chinese time-based art's transition from a furtive countercultural margin to a lauded contemporary art niche, with 798 art district shortly thereafter designated as 'an official destination for visiting 2008 Olympic athletes and press' (see Wood 2008).

The genre of animalworks, as pervasive and diverse as they are, indexes the evolving trends in Chinese time-based art. The endemic scenes I have listed point to the escalating use of violence in those pieces produced around 2000. This violent tendency recalls what I've analysed as a brutal millennial strain in Beijing's time-based art, when its disparate sub-fields seemingly conspired to set the art world alight with their visceral fervour. The extremities underlying these

experimental artworks were probably symptomatic of their indigenous urban environment, which was contaminated, as it were, by the country's turbulent economic shift. More specifically, my opening snapshots of animalworks offer paradigmatic examples from a single genre which demonstrates the changing attitudes of Chinese artists towards the nonhuman animals—partial or whole, dead or alive, figurative or somatic entities—they used in the name of art.

From breeding to killing animals, from treating animals as food to venerating them as talismanic agents, from exploiting animals as raw art material to placing them on the higher rung of a reversed anthropocentric value hierarchy, the animalworks that this chapter studies reveal how human beings position themselves vis-à-vis their animal others. Likewise, they imply how people perceive and interact in a sociocultural economy as mutable as that of postsocialist China. These transient artworks, being creative distillations from a given sociocultural habitat, betray the encompassing native forces within which they are embedded. I argue, however, that insofar as those native forces cannot help but participate in contemporary global information and communication networks, we must also regard Chinese animalworks as active players in the emergent transregional field of animal studies. Whether or not intended by the artists, the pieces examined here, as symbolic emanations from a variously self-affirming, self-reflexive, self-modifying and self-critical anthropocentrism, add to the global repertoire of what Una Chaudhuri, with optimistic aspiration, calls, 'a reawakened animalculture' (2007: 11).

CRITICAL ZOOËSIS; ZOONTOLOGIES; HUMANISM; HOMIXENOLOGY

In an attempt to evoke both the centuries-old notion of mimesis and Cary Wolfe's more recent coinage of 'zoontologies', Chaudhuri proposes the neologism 'zooësis' to signify 'the myriad performance and semiotic elements involved in and around the vast field of *cultural animal practices*' (Chaudhuri 2003: 647). Zooësis refers comprehensively to those embodied, discursive and social engagements that have shaped our understanding and interpretations of animality in human life. So widespread and multifarious are these 'human animal practices' that the effects of zooësis, as Chaudhuri observes, saturate 'our social, psychological, and material existence' (ibid.). What zooësis maps out then are the epistemic, experiential, imaginative and behavioural domains that have inspired many contemporary artists to create animalworks.

The creation of animalworks per se does not necessarily contribute to an animalculture more empathic towards our ecological neighbours than our present one, which bases its smooth operation on shielding urbanized, cosmopolitan humans from sighting the large-scale slaughter and exploitation of other animals. In fact, there are plenty of animalworks that maintain, reinforce, even exacerbate, the existing human subjugation of nonhuman beings. To advance a more *humane* animalculture, therefore, requires a fundamental questioning of our reified assumptions about humans' supremacy over other life forms. As Wolfe indicates, recent researches in cognitive ethology, field ecology, cybernetic and systems theory and other anti- or posthumanist critical discourses have exposed the anthropocentric prejudices underlying the presumed superiority (for example, language, tool use, inherited cultural behaviours, knowledge transmission, etc.) of *Homo sapiens*, making it possible to displace our centrality as the master species of our planet (2003: xi). Joining Wolfe, Chaudhuri urges that we form a less speciesist

animalculture by consciously pursuing a 'critical zooësis' which deconstructs the supposed 'ontological distinction' and 'ethical divide' between human and nonhuman animals (2003).

I appreciate the compassionate ethics and ecological common sense advocated by zoontological scholars and activists such as Wolfe and Chaudhuri. Nevertheless, I cannot but confess my dilemma in transplanting their analytical modes onto my inquiry into Chinese animalworks. As Mary E. Gallagher comments, China has maintained 'a rapid pace of economic growth for over twenty years without succumbing to political liberalization—indeed with only the slightest movement toward democratic government' (2002: 338). Defying political theorists' predictions about the close tie between capitalism and democracy and withstanding precedents set by other formerly communist countries, China's 'economic development and increasing openness' has, instead, reinforced 'the stability of [its] authoritarian rule' (ibid.). Gallagher's analysis of the 'Chinese exceptionalism' addresses my concern about the more-than-sporadic incompatibility between a radically posthumanist thought central to deterritorialized animal studies and various animalworks produced in a country still plagued by poverty, human rights abuses, interethnic and interregional inequality, and uneven economic, cultural-political (base, infra- and superstructural systems included) and technological developments.

According to a 2009 poverty assessment report by the World Bank, China, for the last quarter century, has lifted 'more than half a billion people' out of poverty (Li Li 2009). Despite such an enviable record, Chinese Vice Premier Hui Liangyu admitted in the same year that China 'remains a country of low per capita income and unbalanced regional, urban and rural development' (BBC 2009). The poverty statistics, which the Chinese government acknowledged, stand alongside the country's other equally devastating but more anxiously silenced records. On 8 August 2008, when China globally telecast the arrival of the veritable Brand China through its Olympics Opening Ceremony, the screen images of its (partially simulated) fireworks-studded glory could hardly erase the world's memory of its most recent double calamities: the Tibetan unrest (in March 2008), known in China as '3-14 Riots', when the communist government sent armed troops to suppress Tibetan uprisings that escalated from 'peaceful protests of 400 monks in the Tibetan capital Lhasa' 'into riots involving thousands of disaffected Tibetans' who 'gutted hundreds of Han Chinese businesses' (Alan Taylor 2008); and the 7.9-magnitude earthquake (on 12 May 2008) in Sichuan Province, leaving more than '10,000 students' crushed by the collapse of '7,000' shoddily constructed classrooms and dormitories (ibid.). Barely a year later, in the run up to the sixtieth anniversary of the PRC's founding on 1 October 2009, another ethnic clash (in July 2009), involving the Muslim Turkic Uyghurs and Han Chinese, erupted in the Xinjiang autonomous region (Ying 2009).

These disheartening records expose the deep contradictions that threaten to split post-socialist China's body politic. Heeding these contradictions, in turn, prevents me from adopting a wholesale zoontological perspective in analyzing the country's animalworks, considering that, in present-day China, a broadly construed humanism seems just as wanting as a conceptually tailored posthumanism. In a place where human rights are still a vulnerable civic entitlement, posthumanism might sound stratospheric—if not far-fetched, then at least extravagant.

Ironically, and precisely because of these contradictions, my critical conundrum also fails to invalidate the relevance of critical zooësis to my project. Rather, it points me towards an

earlier moment in animal studies, one exemplified by John Berger's iconic essay, 'Why Look at Animals?' (1980: 3–30). 'Animals are born, are sentient and are mortal,' he writes in an analysis anticipating the zoontological premise (ibid.: 4). Zoontology pushes to deconstruct the onto-logical-cum- ethical distinction between human and nonhuman animals by virtue of their—or, rather, our—shared mortality as locomotive organic beings. Berger's arguably more humanist stance for a species-based differentiation, however, still manages to leave a theoretical grey space: animals differ from humans in 'their superficial anatomy—less in their deep anatomy—in their habits, in their time, in their physical capacities'. Thus, humans and animals are 'both like and unlike' (ibid.). As Berger traces the trajectory, we see that humans and animals have endured a similar historical process, rendering obsolete their original proximity in natural surroundings while transforming them into distant and isolated parallel units in the civilized world. Since we humans regard ourselves as active agents of the civilized world, this analogous historical process has not diminished but heightened our sense of distinctiveness from animals. Correspondingly, in our perceptions, animals have changed from their primordial status as those dualistic beings that were 'subjected *and* worshipped, bred *and* sacrificed', to machine-like utilitarian entities used for food, labour and transport in the eras surrounding the Industrial Revolution and, even-tually, in the postindustrial societies, to 'raw material', serving various alimentary, commercial, scientific, domestic and recreational functions (ibid.: 5–6). A dire consequence to humans' self-differentiation from animals is, therefore, the latter's utter marginalization.

After three decades, Berger's analysis remains incisive and timely and it retains its applicability especially for China, whose uneven industrialization has caused an inter-regional de-synchronicity, as if its diverse populations are historically, temporal-spatially and practically segregated by the rural/urban, inland/coastal, ethnic/Han, migratory/settlement divides. Because of this de-synchronicity, I suggest that all the diachronic phases Berger traces in human-animal relations coexist in China as concurrent, if irregularly dispersed, phenomena. In a remote Chinese village where animal husbandry still operates in traditional ways, livestock lives in the backyard of a household; pigs and chickens are raised *and* eaten, valued *and* sold. In a nearby provincial city, animals may be purchased for their various postagrarian functions. Nevertheless, in most major southern and eastern Chinese metropolises, such as Beijing, Shanghai and Shenzhen, a postindustrial paradigm is current.

Berger's genealogy of how we humans relate to other animals stops at the historical juncture when nonhuman animals were reduced from myth to tool to pure mass—'raw material'. The recent advent of our globalized information age enables us to add a contemporary coda to Berger's critique: *humans and other animals are now more like than unlike.* Although information resources in our contemporary world remain unequally distributed, for those of us who reside in well-networked cosmopolitan locales, there appears a new global order, insis-tent in its emergence and pervasive in its coverage. This ascending global order has not only altered the nature, rhythm and pattern of our quotidian lives but also reshaped our human identities as coextensive with those of our intelligent machines. Our daily dependence on telecommunication technologies (the Internet, cell phones, email, electronic social networks and various software and hardware) has enmeshed us in a wired cosmology in which no stable boundary exists between sentient and non-sentient, enfleshed and virtual, beings.

Many theorists—ranging from Donna Haraway, N. Katherine Hayles and Jean Baudrillard to Cary Wolfe and Una Chaudhuri—have recognized this advancing information age as 'the posthuman condition' (Peperell 2003). The process of mathematization associated with our posthumanism 'produce[s] a new way of looking at humans: as a set of data' (see Nayar 2004: 19–88). How long before we regard all other animals, alongside all non-animals, as sets of data? Seen from the posthuman perspective, the moment has long since arrived. The material bases of all life forms are becoming equitable research subjects; barring concerns over bioethics, they exist as biological data able to be tracked, scrutinized, manipulated and modified. The mapping of the human genome, completed in 2003, and the ongoing genomic research into the DNA sequences of other animals represent only two relatively recent and overt pieces of evidence that we are acquiring a certain digital epistemology, if we are not already fully bound by a digital phenomenology (see US Department of Energy and the National Institutes of Health 2008). Beyond the virtual frontier, recombining cross-species genetic sequences to create transgenic animal super-producers, as in the 2010 breakthrough invention of 'artificial spider silk', for an allegedly more self-sustainable and ecologically viable industry, is already an existing commercial venture (see Kraig Biocraft Laboratories 2011 and EntoGenetics 2010).[2]

2 I thank Rolf Hoefer for pointing me to these references.

Against this highly technologized and rapidly commercialized backdrop, we humans, as reproduced, sentient and mortal beings, are closer to other animals than ever before—even in our common potential as raw material. A pig's heart might one day pump in a human's chest, offering a second chance at life through the gift of xenotransplantation (see Goodenough 2004). And the pig compelled to gift to the human is just as unwilling as a child kidnapped for her kidney by an illegal transnational organ-trafficking chain. In these parallel situations, both the pig and the child are sacrificed, commoditized as animal bodies with functional organs, extractable for the purpose of prolonging another being's life. Moving deeper into the molecular level, we see animal bodies serving as raw material for genetic manipulation in the neo-alchemical enterprises of biomedicine and genetic engineering: from cloning to stem cell research to organ farming and harvesting, from the controversial genetically modified organisms (GMOs) to transgenic microbes (see Avise 2004 and Bio-Medicine 2008). Biotechnology crisscrossed with transnational capitalism writ large: these utopic/dystopic scenarios, no longer science fiction, signal neo-naturalistic turns of events that have complicated our emergent global order. These contemporary scenarios provide sociocultural fodder for posthuman animalworks.

In a country like China, where a preindustrial agricultural and nomadic culture coexists with globalized, industrialized and extensively wired cosmopolitanism, both humanist and posthumanist paradigms of animal studies are necessary and relevant to the critique of animalworks. Among my selections, a more prominent theoretical context is the humanist paradigm, in both its conservative sense as anthropocentrism and its constructive sense as the sociocultural system facilitating a individual's economic and political well-being. Albeit less pronounced, the late-capitalist nexus of biotechnology and commercialism also extends a global backdrop for numerous animalworks, especially those exploring what I call 'homixenology', the performative merging of human and other morphologies.[3]

3 I first presented this concept in Meiling Cheng (2001).

Chinese exceptionalism, or the given indigenous circumstance that distinguishes the country from its global peers, also functions to further modify both analytical contexts. Most Chinese animalworks, even those conceptually posthumanist ones, employ predigital technologies, mobilizing metaphors rather than motorized genetic chimeras; they tamper with actual flesh and bones rather than artificial 'metacreations' (Whitelaw 2004). Often, a blunt hyperliteralism reigns. These edgy time-based artists stake their claim on the realm of the actual and plebeian (vs those of the virtual and scientifically patrician) by dealing with tangible found materials in unexpected, low-tech and imaginative ways. They pursue an ingenuity born of a resolve to impress others deeply and quickly—even with brutality. The Chinese artists' aspirations for generating international headlines perhaps reflects their country's quite recent ascension into the rank of international superpowers, if also their own limitations due to China's inequitable economic and technological distribution. Despite these tendencies, several of the animalworks annotated here share the zoontological logic of reconceptualizing human and nonhuman animals as terrestrial peers who differ not in their intrinsic corporeal-cognitive attributes but in their respective stages of evolutionary and sociohistorical development. Admittedly, many of these so-called posthumanist animalworks might have based their pan-species egalitarianism on native sources, such as prehistoric animism and shamanism, the Daoist concept of the universe as one constantly transmuting body or the Buddhist notion of transmigration. Nevertheless, I find it compelling not to abjure analytical lenses such as zoontology, critical zooësis and homixenology in interpreting Chinese animalworks.

To test these idiosyncratic hypotheses, my lab work begins.

CULTURAL PIGS | Hogs, a species of animal producers long intertwined with the history of Chinese livestock husbandry, initiated Xu Bing's line of animalworks.

In a pigpen set up inside the Han Mo art centre, a boar mates with a sow under the watch of human spectators. Aside from its unorthodox setting, what makes this mating-pigs xingwei piece, appropriately called *Cultural Animals* rather than *Zoo Attractions*, is the porcine couple's skin decorations—the boar carries printed English letters in random combinations and the sow nonsensical Chinese characters.

Before *Cultural Animals*, Xu was known for his integration of conceptual printmaking artworks with monumental installations. For his signature piece, *Tian shu* (*Book from the Sky*, or *Sky/Heavenly Book*, 1987–91), Xu spent more than four years of intensive creative and physical labour designing and carving into printing woodblocks 4,000 individual, arbitrarily altered ideographs which look like written Chinese but which cannot be semantically deciphered—just like the proverbial 'heavenly scripts', incomprehensible to mundane eyes (Xu Bing 2009).[4] Xu then followed the traditional methods of transmitting classical Chinese texts by printing these nonsensical ideograms on hand-bound books and on large scrolls, with vertical lines spreading across horizontal strips of paper. *Book from the Sky*, shown for the first time in Xu's 1988 solo exhibition at Beijing's China Art Gallery, appeared as an installation comprising open books displayed on low platforms and long scrolls mounted on walls and pillars and draped from the ceiling. The project aroused enormous controversy among

4 See also Britta Erickson (2001: 32–45). I follow Xu's website for the number (4,000) of heavenly script he invented.

IMAGE **4.3** *Wenhua dongwu* (*Cultural Animals*, subsequently renamed *A Case Study of Transference*, 1993–94), a live hog performance staged by Xu Bing at the Han Mo Art Centre, Beijing. Image courtesy of the artist.

Chinese critics, who further attacked the inclusion of *Book from the Sky* as a centrepiece in the 1989 *China/Avant-Garde* exhibition. Xu emigrated to the United States soon afterwards and did not return to China until 1994 to create *Cultural Animals*, an animalwork that happened to be the first publicly staged xingwei event to resurface in Beijing after the easing of political repression in the post-Tiananmen era.[5]

Cultural Animals introduced at least two novel elements into Xu's *oeuvre*: One, an extensive pre-performance process documented in both written notes and on videotape as part of the artist's xingwei experiment; Two, an emergent xingwei-zhuangzhi genre dealing with interaction between human and non-human animals. If the first element recorded the artist's re-entry into a cultural milieu once familiar to him, then the second reflected his desire to further challenge the convention-ridden human civilization—as he had done before by nullifying the semantics of apparent linguistic signifiers.

'In order to recognize the limit of mankind including myself, I started the work with other living beings so that we can fill up our deficiency and degeneration by means of their assistance,' said Xu. Animals are, he added, 'the most wonderful collaborators. Working with animals

[5] My phone interview with Xu Bing, 3 August 2005, Los Angeles to New York. There are different records regarding the dates of the performance. I follow the year (1994) listed in Xu's website which agrees with the year listed in the Black Cover Book.

IMAGES **4.4.1–2** Hogs being prepared for *Cultural Animals*, subsequently renamed *A Case Study of Transference* (1994), by Xu Bing at the Han Mo Art Centre, Beijing. Image courtesy of the artist.

is my artistic process. I learned from them' (quoted in Weintraub 1998: 43–9). These statements, which reveal Xu's motivation in conducting animalworks, combine a posthumanist quest to surpass anthropocentric boundary with a residual humanist habit of using his animal others as redemptive aids. But why did Xu pick pigs in particular to begin his zoontological experiment?

According to Britta Erickson, Xu perceives pigs as 'both intelligent and primitive, harking back in spirit to some primal era' (2001: 59). While Xu might not be able to justify beyond personal belief this mystical characterization of pigs, his remark does evoke China's antediluvian domestication of swine, dating back to the Shang Period (3000–2000 BCE), and the country's continuous preference for swine—the most populous livestock and the most common meat source. China is unique among the world's large hog-raising countries because the 'majority of [its] pork still comes from household backyard feeding' in a way once described by Earl B. Shaw as 'the scavenger method': 'Pigs are fed on refuse from the table and refuse from cultivated fields, on food that would go to waste were it not utilized by the most efficient producer of any domesticated animal' (1938: 381; see also Tuan and Dyck 1999). Is it possible that such historical co-dependence between Chinese farmers and their pigs and the virtuosic contributions of Chinese pigs to the household farming industry persuaded Xu to adopt this animal as his living trope for a creature both like and unlike humans, like and unlike Chinese?

In addition to the animal's indigenous cultural significance, pigs also occupied a position in Xu's biographical trajectory. As an expatriate returning to Beijing to produce a live event,

Xu's path of temporary repatriation inversely replicates his past as a 'sent-down youth' who moved to the countryside in order to be rusticated, or re-educated, by the peasants during the Cultural Revolution.[6] Since Xu had the experience of rais-ing a pig then, to work with an already familiar animal species for *Cultural Animals* facilitated his time-based art at a precarious moment in China's capital, allowing him to re-encounter the present rural community while evoking a poignant national memory shared by his generation. The animalwork enabled its human creator to cultivate a multifaceted relationship with his nonhuman collaborators through an actual and mental passage culminating in the public xingwei of two copulating pigs. Did the artwork's experiential proximity to Xu's personal journey inspire the artist to reconceptualize his pre-performance preparations as integral to his animalwork?

6 For 'sent-down youths', see Thomas P. Bernstein (1977).

Similar to his previous work, *Cultural Animals* reflects Xu's strategic contextualization of site-and-medium-specificity in relation to his biographical identity. Indicative of this scrupulous attention to ever-changing circumstances is the artist's choice to re-title his project, revealing his incessant conceptual investment in re-positioning a piece for various versions and in doc-umenting and disseminating the ongoing process. *Wenhua dongwu* (*Cultural Animals*), for example, was the title published in the Black Cover Book for the live hog performance on 22 January 1994 at Han Mo. Xu later reserved this title for a private experiment that took place a day later, at Han Mo, for which the boar mounted a male mannequin sprinkled with the scent of the sow. He renamed the event with the two live pigs, *Yige zhuanhuan gean de yanjiu* (A Turn-and-Exchange Case Study, known in English as *A Case Study of Transference*).[7] The phrase *zhuanhuan* may be translated into 'transposition', 'transformation', 'transfer' or 'transference'—all denotations reflecting a sense of fluidity linked with change from one state to another.[8] Perhaps this stress on mutability appealed to Xu's time-based sensibility that he adopted this title for the project during its subsequent Western tours as a video document in the 1990s.

7 My phone interview with Xu Bing, 3 August 2005.

8 In my phone interview on 3 August 2005, Xu recalled that his choice of 'transference' for the Chinese 'zhuanhuan' came from a suggestion by Lydia Yee, a curator at the Bronx Museum of the Arts in New York.

Transposition between 'nature' and 'culture' is a key concept in Xu's hogwork. The former category—nature—is accessed through what Xu called his 'sociological animal experiment', which included selecting two domesticated pigs not averse to coupling with each other, raising them for a period in their original farm, training the inexperienced boar to mount the sow and calculating the live performance date against the sow's oestrus cycle (Xu Bing 1994: 87). The latter category—culture—covers a human artist's intentional action to transform an urban art centre into a temporary habitat for two pigs and to reframe the animals' procreative behaviour as a live artwork. Xu first rusticated the space by constructing breeding pens for the pigs inside Han Mo. He then retrieved the space's connection with human cultural history by littering the pigpen with open books written in numerous languages. This human heritage, however, appeared to be a non-issue for the two porcine avatars from 'nature', as they happily pursued their courtship and coitus on top of the open books, treating them like common straw in traditional pigpens.

An analogous but reversed procedure of transposition applies to the pigs who/which were trained to transition from their naturalized state of farm domestication to their acculturated

state as spectacle-makers, ready to enact their coached instinctive behaviour without much ado. To make the animals 'cultural' performers, Xu ornamented both pigs with printed 'costumes' showcasing his invented sky-scripts, an assemblage of carefully designed nonsensical words. Turning the sow's pinkish dermatological surface into a scroll, Xu printed in orderly vertical lines a random selection from his counterfeit Chinese ideograms. The boar's skin displays another sky language, featuring horizontal lines of alphabetical letters resembling meaningless English. The porcine mates, however, remained indifferent to their cultural inscriptions, for they exhibited no inhibitions in performing sexual consummation before a group of variously stunned, embarrassed, nauseated, amused and excited human spectators. The singe of culture burns deepest on the anthropocentric flesh.

Within the anthropomorphic hide ticks a civilized heart. Xu's original title for the hog performance begs the question: Who really are the cultural animals in this animalwork? The answer implicates both the artist and the viewers. As the pigs have endured an involuntary transfer to an artificial habitat, so too the artist has undergone a transformation. While the pigs incrementally transition to becoming cultural—if only in a skin-deep way—Xu does not inversely move to 'becoming animal', as Gilles Deleuze and Félix Guattari's famous conceit proposes (1988: 232). Instead, Xu's roles evolved from being the pigs' breeder, trainer and taskmaster, to director, set designer and participant observer. The process required him to gradually relinquish his autonomous authorship to his animal collaborators. They would take over the performing site during the live show while the artist stood among other human voyeurs, sharing the novel sensation of being upstaged by the amorous pigs. At that moment, the *Homo sapiens*' so-called superiority became a sideshow, with the spotlight focused on a bookish pigpen.

Xu staged *A Case Study of Transference* when Beijing's experimental art world was still reeling from the post-Tiananmen traumas and the rest of China rallied round Deng's renewed economic reform policy of 1992 with its double emphasis on mixed market economy and socialist nationalism. For fear of censorship and other legal troubles, Xu sent out only 20 invitations for the event to his artist friends. The performance nevertheless drew nearly 200 spectators to Han Mo. During the post-mortem discussions, certain comments, symptomatic of the prevalent nationalism, criticized the artist for his supposed allegorical positioning between the boar, tattooed with pseudo-English signifiers, and the sow, bearing fake Chinese ideographs. The gist of the comments: What does it mean for an imperialist boar to screw a postcolonial sow? Although Xu's expatriate status complicated the political salience of such an allegorical critique, his presence alongside the performing pigs bespoke two other dramas: the return of repressed edgy art; the homecoming of a prodigal son.

The scope, complexity and promise of *A Case Study of Transference* helped initiate multiple possibilities for Chinese time-based art: it established a paradigm for xingwei-based animalwork; it also demonstrated an ingenious sample of xingwei-zhuangzhi—a malleable architecture temporarily arranged for a site-and-activity-specific display of the artist's conceptual printmaking outputs. Sporting Xu's sky-scripts, the pigs are spontaneous performers; they are a pair of evanescent mobile galleries; they are also living installations, two cavorting 'sky books' erratically interacting with other open books inside a repurposed zooëtic library. To the extent

that we may read the pigs' fluid exchange as a juxtaposition of two cultural surfaces, the performers serve as the artist's surrogates, intimating his negotiation with multiple cultures: his country of origin; his chosen residence; and the microcosm of his aesthetic invention.

The drive behind his work, as Xu Bing once wrote, has been his 'search for the living word' (2001: 13). With two decorated pigs animated by their mating instincts, *A Case Study of Transference* offers him a neologistic living word composed of human–hog interactions. What is a living word but a time-based word, one that never stays put, changing ceaselessly? Transformation is the ether sustaining the living word. Thus the living word could manifest as an actor, one who moves and makes sounds; a xingwei artist, one who typically behaves to disturb the ethical status quo; a xingwei-zhuangzhi, an impermanent locus within which something shifts constantly; or a prodigious insect, like a white-grey moth and its offspring silkworms, with metamorphosis written on their charts. It's not surprising, then, that Xu would be drawn to an animal collaborator who embodies the living word.

In the Black Cover Book, an anthology in which Xu published his process notes on *Cultural Animals*, there is a two-page spread on Liang Shaoji, an artist based in Zhejiang Province, China. On the left-hand page are three black-and-white photographic images, all shot outdoors: the top is a montage of a central sculptural figure against a mountainous background; the middle is a cluster of four detailed segments of a triangular sculpture; the bottom, a slightly distant view of several pyramids placed on a mossy pavement.

IMAGE **4.5** Several pyramidal silkworm sculptures placed on a mossy pavement from *Ziran xilie* (*Nature Series No-2*, 1990–94), by Liang Shaoji, published in Black Cover Book. Image courtesy of the artist.

Identified as Liang's *Ziran xilie* (*Nature Series*) *No. 2, 1990–94*, all these sculptures are made of spiky metal wires wrapped in thick layers of white silky secretions from live silkworms, still crawling about and spinning threads. Mixing in among the silk-thread colonies are collections of cocoons, like random assemblages, fraying cotton balls entangled by their natural affinity or their circumstance of being thrown together. These xingwei-zhuangzhi pieces exude a strange beauty in their tension of opposites—the fragile cocoons find skeletal support in the metal springs, and the luxuriant silkworms soften the cutting edges of the steel castoffs with their shimmering filaments.

Liang follows on the right page with a two-paragraph meditation regarding *Nature Series*: 'The weft woven across a warp forms the basic, if not the only, structure of fabric' (1994). When he pushed beyond the rich decorative seduction of woven textures to sink into the ontology of fabric, however, the artist discovered 'what exists between science and nature, weaving and sculpting [:] xingwei yishu's limit point [*linjiedian*]' (ibid.). Liang then reflects on his five-year experiment (since 1989) of raising silkworms in artificial habitats, such as rusty metal rods contaminated with industrial oil, to observe how the silkworms survive, adapt, proliferate and moult. He also uses these transforming processes to create 'contemporary fabric sculptures' and to explore 'the power of fiber language' (ibid.).

Though a newcomer to xingwei yishu, Liang already had an established career in arts-and-crafts design, which evolved from fabric art and soft sculpture to his extended xingwei project devoted to the *Nature Series*. After this first printed exposure of silkwormworks in the Black Cover Book—which explicitly focuses on xingwei yishu—Liang continued into the twenty-first century his silkworm-breeding and cocoon-watching in order to glean existential lessons from his invertebrate masters. *Nature Series,* mostly presented in overseas exhibitions as Liang's enumerated silkworm sculptures, stars these metamorphosis-happy, natural-born weavers spinning out their bio-architectures to encase hybrid, even polluted, environments. Collaborators on *Nature Series*, the larvae act as ecological architects to enrich the human artist's environmental design.

Since 1994, Xu Bing has embarked on a parallel exploration in his New York studio, with a serial project identified by the general title *Zai Meiguo yangcan xilie* (lit., 'In the US Raising Silkworms Series', known as *American Silkworms Series*, 1994–98). 'I am interested in the silkworms' pronounced cultural connotation and their natural transformation. They are also great collaborators,' stated Xu (2010).[9] Xu's remark echoes Liang's claim in his expanded set of notes about *Nature Series*, published when the latter received the 2002 Chinese Contemporary Art Award: 'The silkworm (Bombyx [mori]) originated in China, where the breeding, reeling and weaving of silk has for over 5,000 years of history moulded China's character, aesthetic and history' (2002: 40).[10] Although I hesitate to endorse Liang's coronation of *Bombyx mori* as the 'master-builder' of Chinese national artistry, Liang's declaration delineates the historical lineage between contemporary sericulture and an ancient sinotechnology, which Xu has appropriated for his silkwormworks as a means of identifying aspects of his Chineseness. As if citing from Liang's *Nature Series*, Xu's insectworks exploit the same ethological subjectivity of silkworms and the collaborative fusion between ecological architecture and environmental design. But Xu also sufficiently adapts these elements in *American*

9 All my information regarding Xu's *American Silkworm Series* comes from his website. I've retranslated some of his remarks based on the Chinese version provided on the website.

10 I have retranslated Liang's remarks based on the Chinese versions provided in this book.

IMAGES **4.6.1–2** *Can hua* (*Silkworm Flowers*, 1998) as *American Silkworm Series Part III* by Xu Bing at the beginning and closing of the exhibition, *Where Heaven and Earth Meet: Xu Bing and Cai Guo Qiang*, Bard College Center for Curatorial Studies, New York. Image courtesy of the artist.

Silkworm Series to meet his perennial search for the living *word*, embodied by the dynamic pull between the word's multifarious textuality and its modes of expression. Moreover, Xu demonstrates a virtuosity that turns the entire metamorphosis of moths-to-eggs-to-larvae-to-cocoons-to-moths cycle into his xingwei-zhuangzhi.

There have been four instalments in the *American Silkworm Series*:

Part I: *Can shu* (*Silkworm Book*, 1994). Xu turns the blank pages of an open book into a transitory habitat for egg-laying moths and times the breeding cycle in such a way that the eggs hatch during the exhibition. The result is an effervescent insect book whose entomological contents crawl about, periodically change their sizes, colours, shapes, positions and appetites.

Part II: *Bao guo* (*Packages*, 1995). Hundreds of silkworms spin their threads over books, computers, papers, photographs and other everyday objects, converting Xu's East Village studio into a phantom post office, filled with address-less packages.

Part III: *Can hua* (*Silkworm Flowers*, 1998). A huge bouquet of leafy mulberry branches arranged in an oversized vase gradually lose their foliage to the insatiable appetites of leaf-munching silkworms, vigorous in their ecdysis. A horticultural gift exchange takes place. During the course of the exhibition, the yellow and white cocoons become guest blossoms nestling in the bare mulberry branches.

Part IV: *Can de VCR* (*Silkworms' VCR*, 1998). Silkworms spin their life cycles inside an un-encased VCR machine. A videotape plays continuously. A monitor shows what appears to be the exposed silkworms in the VCR, prompting viewers to speculate on whether the image is a recording or a live feed.

IMAGE **4.7** *Can shu* (*Silkworm Book*, 1994), an insectwork as *American Silkworm Series Part I*, by Xu Bing, in the Massachusetts College of Art, Boston. Image courtesy of the artist.

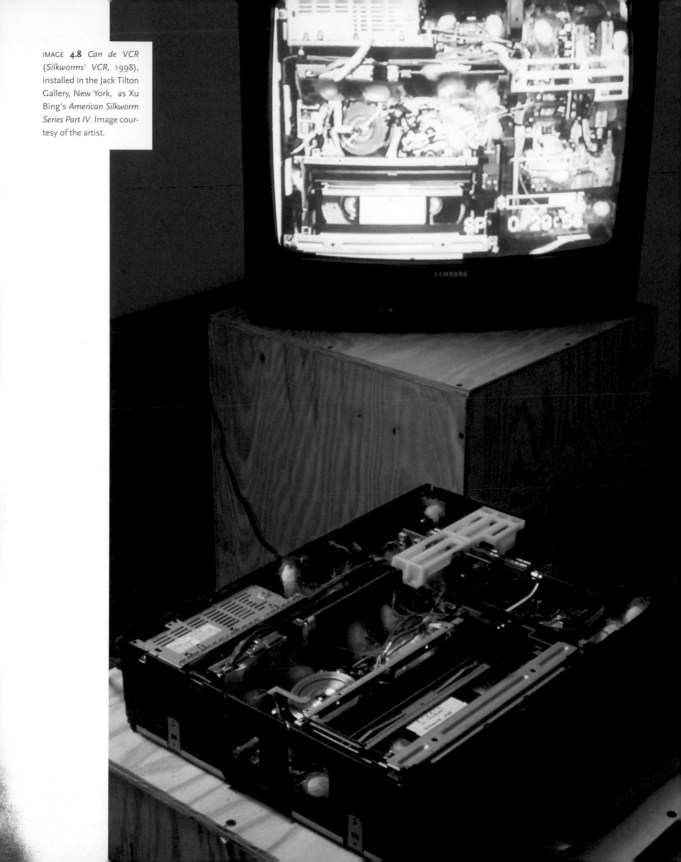

IMAGE **4.8** *Can de VCR* (*Silkworms' VCR*, 1998), installed in the Jack Tilton Gallery, New York, as Xu Bing's *American Silkworm Series Part IV*. Image courtesy of the artist.

All of Xu's silkwormworks dramatize the interchange and transformation of contrasting material forms: insects, decaying pages, silk-bound quotidian items, adaptable flora and exposed machinery. As manifestations of his living word, these *nature + culture* 'books' dispense lessons about time-based art not unlike the ideas Liang offered in his updated analysis of *linjiedian* in silkworm art: a limit point between 'biology and socio-biology, weaving and sculpting, zhuangzhi and xingwei yishu' (ibid.: 41). As Liang's text implies, the silkworms are the weavers, sculptors and performers of their own garments, dwellings and communities. Liang's and Xu's insectworks acknowledge and reiterate this understanding, staging front, back and centre the unsuspecting silkworms as constitutive subjects and hosts of certain randomly altered entomological microcosms while turning their absentee human collaborators into awestruck disciples.

Although Xu has not overtly related his animalworks to posthuman zoontologies, his stance—to learn from the animals by effacing his authorial ownership—is in harmony with Chaudhuri's advocacy for critical zooësis. Liang, in contrast, consciously aligns his discoveries of 'silkworm philosophy' and 'cocoon philosophy' with contemporary inquiries into bioengineering, situating his silkwormworks at the conjunction of 'experiment, adventure, reverie, science, fairytale, and creativity' (ibid.). Both Liang and Xu, however, also articulate their animalworks within a traditionally humanist realm of phenomenological observations and cognitive enlightenment. Liang poetically describes his silkwormworks as creations 'to document the fourth dimension': that of the 'weaving sculpture, time sculpture, life sculpture, nature sculpture' (ibid.: 44). Xu compares his art to constructing conceptual obstacles, like a Chan Buddhist *gong an* (public case), or a Zen koan, conceived to open up 'a wider, untapped cognitive space' for his viewers to reach enlightened 'cognition and understanding' (Harper 2010).

In the spirit of Liang and Xu, then, let me raise a public question, one planted in the soil of perpetual meditation on the fourth dimension: What are their two pairs of guest ears watching?

The silkwormworks by Liang and Xu evoke a philosophical source even more ancient than Chan Buddhism.[11] Once the Daoist master Zhuangzi had a dream. He became a butterfly, fluttering joyously about, forgetting that he was Zhuangzi. Suddenly he woke up and saw his human body lying in bed. 'Did [Zhuangzi] dream of the butterfly or did the butterfly dream of [Zhuangzi]?' he wondered (Zhuangzi 1999: 38). Did Liang and Xu dream of their silkworms or did those silkworms dream of Liang and Xu? Might we not wonder? 'Since [Zhuangzi] and the butterfly are different,' as Zhuangzi meditated further, 'this merging and transformation may be called "turning-into-things" [*wu hua*]' (ibid.: 41). Thus neither subject—butterfly or philosopher—exists permanently; both will be 'things', eventually, as dust or faceless molecules in the mud. I don't know how the butterfly would think about this *gong an*. But isn't turning-into-things a humanist conundrum softened of late by the cool silk of our post-humanist epiphany? An intuitive knowing crystallized in time-based animalworks: Could even our contemporary fantasy of digital immortality bear us away from our prospect of turning-into-things?

11 For the influence of Daoism on Chan Buddhism, see Julia Hardy (2011).

GEESE ON THE LOOSE | A farmer carries a huge shallow bamboo basket on top of his hat while numerous silkworms crawl out of the basket onto his ear, neck and shoulders. The farmer seems nonplussed by his creepy-crawly passengers.

A motorcyclist collapses on his way to the day market, pulled down by the weight of his geese cargo and falling halfway to the ground.

These two images were among 600 by 250 photographers displayed in the show *Zhongguo renben / Humanism in China* (2003–04), which its organizer, the Guangdong Museum of Art, claimed to be the most comprehensive exhibition of documentary photography in China (Guangdong Museum of Art 2003). Dating from 1951 to 2003, the photographs collected in the exhibition catalogue reflect the country's broad range of social contexts from diverse, unadorned and ostensibly uneditorialized perspectives. Sharing the faces of Chinese daily life, the photographs provide rich intertextual references to my chosen animalworks' sinocentric humanism.

The picture of the silkworm farmer came from Lushan, Henan Province, an inland agricultural region that has changed relatively little since 1987, the year when the picture was taken (Zhao Zhenhai 2003). The photo shows the farmer and his animals in cohabitation, if not symbiosis. It suggests how familiar this animal is to the rural Chinese and the perceptibly

IMAGE **4.9** A farmer who raises silkworms in Lushan, Henan Province (1987). Photo credit: Zhao Zhenhai. Image courtesy of the Guangdong Museum of Art.

harmonious human–animal relationship ensured by such familiarity. This regional/historical factor situates Liang's *Nature Series* within an indigenous existential continuum: at one end lies the silkworm farmer's cottage industry where the insects are utilitarian producers; at the other lies Liang's animalworks which reframe the silkworms as artistic creators. Xu's *American Silkworms Series* evokes this continuum abroad and activates the insect's efficacy as both a cultural symbol and a performance vehicle.

Shot in 2002, the motorcycle accident in Sichuan Province conveys a different human–animal relationship. Instead of harmony, we see tension and struggles between the cyclist and the geese. Since the picture was taken from behind, the gaggle of geese claims our immediate visual sympathy while the cyclist, without his face shown, looks more like a part of the mechanism binding the animals than he does a hapless livestock farmer. But the man is *both* a perpetrator and a victim. Despite his impersonal visual status, he has to first rescue himself and the geese from the ground before he can move on to make his profit. This image exposes the co-dependency between a livestock breeder and his livestock. It indicates the small-scale, preindustrial system of household animal domestication as a structure that mutually constructs the livestock and their human owners.

IMAGE **4.10** An overloaded-motorcycle accident in Nanbu, Sichuan Province (2002). Photo credit: Yang Hui. Image courtesy of the Guangdong Museum of Art.

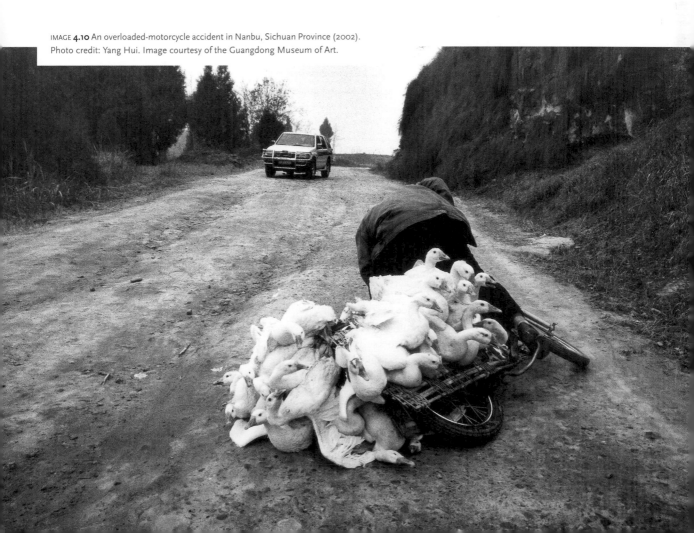

The image of the cyclist and the geese recalls the temporary bond between Xu and the two pigs in *A Case Study of Transference* and references Xu's dilemma about how to deal with the pig performers after the art project. Xu planned to release the pigs into the wild but then he realized that the animals, domesticated for generations, could no longer survive outside a human-constructed breeding environment. Ironically, the traditional system of domestication has become the pigs' survival mechanism. So he sold them back to the farm from where he purchased them; they might be sold again later but at least they would not starve nor be instantly slaughtered by wild dogs.

The two pictures assessed here—the silkworm farmer and the goose peddler—exemplify the many images included in the Guangdong Museum show that documents a prevalent type of human–animal relationship: the raising of domestic animals for food, labour or profit. Indeed, the raising of animals is an aspect shared by Xu's and Liang's aforementioned animal-works. This indigenous factor illustrates what I've described as China's interregional de-synchronicity, alerting us to the radical difference in socioeconomic conditions between China as an unevenly developed country and a highly urbanized and industrialized nation such as the US. Because of this difference, we have to be cautious in importing presumed 'universal' values such as animal rights, eco-consciousness, or posthumanism to China without modifying these Western notions to address the regional complexities.

The system of small-scale animal husbandry is a case in point. Since 1978, animal husbandry has developed rapidly in China (China in Brief 2005). In the past decade, the country's livestock sector has grown to be 'an engine of growth in the broader agricultural sector, and the economic "pillar" of many underdeveloped' regions' (Waldron et al. 2007: 1). But, as Scott Waldron and others in a 2007 study observed, 'hundreds of millions of households in China raise livestock on a very low scale of production, often in the range of a few heads per household. Supply chains are dominated by hundreds of thousands of small traders and processors, rather than centralized slaughter and auction systems' (ibid.: 5). This factor of decentralized and fragmented livestock industries, resulting in the vast majority of 'low quality and low value' livestock products in rural areas, reinforces the distressing circumstance of 'interregional and interprovincial' economic and developmental inequalities among coastal and interior regions (ibid.: 8).

Much of this rapidly growing yet irregularly resourced and distributed homegrown livestock industry takes place in China's poor rural areas. In these regions, raising domestic animals is a labour-intensive practice and vital to survival to a degree that binds the animals and their human hosts to each other in ways unimaginable to those in different economic circumstances. Suppose rice is scarce, should a poor farmer feed the chicken first or the child? How would a desperate mother choose between an infant girl and a litter of piglets? These apparently simple questions become heartbreakingly complicated as we appreciate their harsh implications: the chicken and piglets promise food and income while the child—deemed even less worthy if a girl—means an extra mouth to feed. Extreme as these choices are, the logic of poverty and its power to reduce human survival to the bare minimum challenges what those in an affluent economy may condemn. Just as it is self-serving to regard the human invention of animal husbandry as an outcome of natural selection, so too is it reductive to conclude that

domesticating animals for consumption necessarily means total human domination over the animals. In a country of rural penury, worsened by over-population, we must ponder what drives people to abandon girl infants and to feed the chicken ahead of the children. After all, these are people who too often must sell their blood, sometimes even their kidneys. When human rights are endangered values, anthropocentrism may not sound as pernicious as it does to Western ears while issues regarding animal rights might further marginalize downtrodden humans.

However persuasive, my analysis here pays little attention to China's simultaneous status as a rapidly developing country, an economic powerhouse whose capital, Beijing, hosted the 2008 Olympic Games. The deep chasm between China's rural poor and urban nouveau riche hints at the drastic contradictions affecting the nation as it strives to become a strong global player in the twenty-first century. Symptomatic of these contradictions is the paradox that a given analysis (such as mine) may succeed and fail at the same time.

My aporia has also apparently affected the curators of *Humanism in China* who have given ample representation to animals as domesticated resources but only sparse coverage of probably the most frequent way in which ordinary Chinese relate to animals: through eating. The few photographs on eating behaviours in this 'humanistic' album emphasize the collective nature of eating in China, documenting lives from the communes, from asylums and prisons and from a live animal market corner where a herd of bound water buffaloes stands ready to be sold. Did the curators fail to regard eating as a hedonistic release a worthy specimen of Chinese humanism?

Raising domestic animals and consuming animals as food entail different behaviour patterns and experiences. Whereas the former activity allows for a range of human-animal relationships, the latter inevitably reduces animals to their nutritional, medicinal and/or gastronomic values. Through the predatory behaviour of recreational eating, animals are treated as simultaneously equal and unequal—equally edible but unequally prized. The pre-eminence of eating as a social ritual in China perpetuates a lopsided value system that gauges an animal's worth by its taste. No wonder we cannot find a single image of voracious diners swallowing live shrimp in *Humanism in China*! Yet, such excess in humanism is the behavioural magnet drawing many artists to create animalworks, so as to mimic, satirize, mirror, intensify or critique the explicit human interest served by turning animals into food. The ethos of posthumanism emerges from the interstices pried open by these zoontological performances.

TO MARRY A MULE, TO FALL FOR A GOAT OR TO BEAR A RAM?

If animal husbandry produces an existential structure that binds at least two creatures in their complimentary/conflicting roles for an extended period, are there analogous structures in other realms of human behaviour? This question might not have been what motivated Wang Jin to stage his xingwei piece *Qu to luozi* (*To Marry a Mule*, 28 July 1995) but I find it persuasive enough for a provocative reading.

Originally a live performance that took place in Laiguanying Village, Beijing, *To Marry a Mule*, captioned *Qu* (*To Wed*, 1995), first reached a wider audience through a black-and-white photographic document included in *Baipi shu* (*White Cover Book*, 1995), an untitled volume

with a white cover published a year after the Black Cover Book. The same photograph, in full colour and restored to what the artist claimed to be his original title, *To Marry a Mule*, appeared in the exhibition *Inside Out: New Chinese Art* (1998–99) which toured several US cities.

The photographic document included in the *Inside Out* catalogue presents an odd couple: the artist as the groom, dressed in a black tuxedo and holding a bouquet, poses next to the bride, an albino mule in clownish make-up, its face powdered and cheeks heavily rouged, sporting a gaudy floral hat, pink bridal veil and sheer black stockings. Against the garish red-and-pink backdrop, the groom looks a bit sullen while the kitschy bride appears modestly indifferent. Although we see a cross-species coupling here, the wedding portrait otherwise mimics that of a human couple, dazed by the conventions of a wedding ceremony and slightly petrified by their rowdy wedding guests. The picture's hilarity exposes the ostentatious theatricality of a matrimonial ritual in human society.

Typical of most critical accounts, Chinese curator and art critic Zhang Zhaohui approaches *To Marry a Mule* as a conceptual performance piece that 'symbolized the bizarre combination of tradition and modernity' by having the artist-groom dressed in 'a Western suit' and the mule-bride in 'a Chinese-style trousseau' (2001). Although I share Zhang's amusement at the absurd set-up, I don't see how the couple's dress codes contrast. To my eyes, the man and the mule are attired similarly in generic 'modern' or 'Western' formal wear. The incongruous fusion of modernity and tradition appears elsewhere: first in the artist's nontraditional wedding partner, and again in the juxtaposition of this modern-style nuptials and the old brick house in the background, all but hidden behind a festive Chinese-red drapery. But the most humorous tension between modernity and tradition, I submit, comes from an English-based etymological wordplay unintended by the artist.[12] The word 'husbandry' has its root in the Middle English 'housebondrie' which derives from 'housebond'—'husband' in its modern form. Thus, let me liberally re-parse the phrase: *animal husbandry*, as the practice of cultivating crops and raising livestock, becomes *the act and rite of being an animal's husband* in *To Marry a Mule*. Why not?

12 In Meiling Cheng (2007a), I surmised that the wordplay was a prankish gesture from Wang Jin. Later in my interview with the artist on 5 July 2006, Wang responded that he didn't even know the word 'husbandry'.

To Marry a Mule pays a wry tribute to the contribution of animals to human life, transforming the (sterile) mule from a load-bearing draft animal into a participant in a life ritual that ushers in the obligation of bearing another kind of load, as wife—if not also as mother. The mule's burden, even on its wedding date, is jarringly made visible in the headgear it wears along with the bridal veil: the equine bridal, complete with a rough browband, noseband and a throat-lash, perhaps also a mouth bit, though unseen, linked to the rein. This unexceptional harness carried by the mule bride for its groom's control doubles as a reminder of male and human oppression, with the animal under the bridal veil a stand-in for a wedded woman in a patriarchal economy. Whereas I read the marriage ceremony as central to this animalwork, the artist emphasizes instead the specific animal he chose for marriage. According to Wang, he felt upset that the editors of the White Cover Book left out the most important part from his title: the mule, whose sterility further heightens his piece's 'absurdity and futility', for there is no procreative future in this union.[13] If I may inverse Wang's logic—his remark implies that he would expect certain procreative potentials had he married a fertile mare!

13 My interview with Wang Jin, 5 July 2006, Beijing.

IMAGE **4.11** *Qu to luozi* (*To Marry a Mule*, 28 July 1995), a xingwei piece by Wang Jin. Image courtesy of the artist.

To different degrees, a marriage 'yokes' the wife as well as the husband. By exploring the equivalence of matrimonial partners, *To Marry a Mule* conceptualizes the prospect of human-animal parity. In this aspect, Wang's animalwork anticipated a significant moment in North American theatre when dramaturgy was united with critical zooësis: Edward Albee's *The Goat, or Who Is Sylvia* (2002), a play that Chaudhuri analysed as a prime example of animal studies (2003). Albee's play tells the story of Martin Gray, a successful architect who slips into an extramarital affair with Sylvia, an alluring goat. The play posits that a middle-age man and a female of another species might enjoy a reciprocal erotic bond which promises the two lovers an idyllic paradise even as it attracts scandal and sparks a revenge tragedy. Despite Martin's idealization of his romance with Sylvia, making his marriage with Stevie—and its violation as adultery—appear peripheral to this new relationship, the dramatic action unfolds largely through the other characters' incremental discoveries of Martin's transgression. Their self-righteous reactions to his 'outlandish' secret eventually reduce Sylvia, the play's hircine subject-object of desire and controversy, to a slaughtered goat.[14]

14 In my reading, I assess Edward Albee's play in the style of 'outlandish naturalism', punning on the word 'outlandish' as something 'strange' and 'marginal'—as in the peripheral 'outerland'.

Martin's impulse to give a pretty sylvan name to his country mistress expresses his longing to humanize the goat from an *it* to a *she*. Such a nominal species swapping, however, does not save Sylvia from being butchered as a legally expendable victim by her rival, Martin's anguished wife, Stevie. Enraged by Martin's insistence that Sylvia reciprocates his love the way Stevie does, the wife kills the goat to avenge her husband's 'lessening' of her by comparing her with an animal (Albee 2000: 59). Wang's magnetic mule, identified only by its human-given species name, is spared from the WASP upper-middle-class histrionics of anthropocentric rage and the love triangle that entrap Albee's Sylvia. To those who cannot overlook Sylvia's 'illegitimate' status as a bestial other, the goat's erotic availability to the human society preordains her violent death. In contrast, the albino mule in *To Marry a Mule* appears both aberrant and conventional as the male artist's chosen wedding partner: the marital ceremony that exposes the mule's otherness also renders it ritualistically legitimate as 'bride', a sanctioned societal role. Nevertheless, beyond the symbolic frameworks in which they temporarily fit, the goat and the mule, whether or not perceived as humanized, remain chattel in our current global socioecology of living beings. Neither comedy nor romance is for ever for these nonhuman performers—a fact made palpably tragic by Sylvia's bloody corpse that Stevie drags on stage. Married or not, Chinese or not, the mule too, like Martin's goat-mistress, can still be killed with impunity.

That humans can kill nonhuman animals without suffering legal consequences has much to do with the latter's perceived status as 'food', broadly construed as material for consumption. In fact, the transnational anthropocentric hegemony, which Albee's goat-drama exposes and Wang's mulework evokes, has long been the sociocultural status quo underpinning a strain of Chinese animalworks that address the use of animals as food. These harsh animalworks lay bare a major utilitarian end of animal husbandry and fully articulate what remains subtextual in *Humanism in China*.

Humanistic or not, Chinese culture is synonymous with Chinese food in many parts of the world. What's less known is the degree to which most Chinese are obsessed with freshness and variety of taste. This obsession finds an extravagant expression in the 'wet market' which sells

IMAGE **4.12** *Du* (*Passage* or *Deliverance*, 1996) by Zhang Shengquan, in the *Water Protectors* performance festival in Lhasa, Tibet. Image courtesy of Li Xianting. (The picture shown here is different from the one included in the *Fuck Off* catalogue.)

wild or farm-raised 'exotic' animals, from poultry, fish, insects and reptiles to mammals (Webster 2004). Popular in southern China and other tropical or subtropical Asian countries, wet markets cater to a populace that will pay a high price for fresh—alive when purchased and never tasted—animal flesh. As a specialty shop, the wet market only exaggerates the general preference for fresh produce in China. This preference renders the act of killing small animals in a market, in a restaurant or at home an ordinary part of Chinese cooking.

Consider the experiential sequence where killing animals is intertwined with devouring their meat as food: the sensations of taste, ingestion and digestion occupy centrestage while the necessity of killing is quickly forgotten if not shielded from sight. The fluctuating sensations from killing to cooking to eating constitute the concave/evident and convex/obscured sides of the experience of consuming animal flesh. I find this contrast epitomized by *Du* (translated either as *Passage* or *Deliverance*, 1996), an animalwork enacted by xingwei artist Zhang Shengquan, who later committed suicide on 1 January 2000. An enigmatic photograph of Zhang's live performance, captioned by a nickname-title known to fellow artists, *Bei yang* (*Bearing a Ram*), appeared posthumously in the exhibition *Fuck Off* in November 2000.[15]

15 My interview with Song Dong, 5 July 2006, Beijing. Song told me the original title, *Du*, for Zhang Shengquan's ramwork. I first learnt about the story of Zhang's Tibet performance and his debate with Song from Zhu Yu, who had great respect for Zhang's work.

So, what are the concave and convex actions embedded in this cryptic visual document?

The photograph features Zhang moving within the tranquil landscape of Lhasa, Tibet, crossing a river whose water reaches his knees. He carries on his back an adult ram with bound feet. In the background are placid, bluish mountains. The 'concave' side of this action appears ambiguous, for the artist seems to be playing the role of a beast of burden by bearing the ram on his shoulders, yet the ram looks less like a

pampered passenger than bound cargo. This impression of mutual thraldom between a man and a ram, however, captures only a transitional moment in the original performance. *Passage/ Deliverance* was part of *Hu shui* (*Water Protectors*, 18 August—3 September 1996), Lhasa's performance festival featuring a large group of artists (Wu Hung 2000a: 213). Zhang's plan was to carry the ram across the river—hence, 'passage'—and then to slaughter the animal on the other bank—perhaps as an act of charity, invoking the Buddhist precept of 'deliverance' from suffering. Or, another possibility: sacrifice the ram to the 'water protectors' hidden among the ripples and pebbles of the Lhasa River. As he prepared to kill the ram, however, a fellow xingwei artist Song Dong intervened. Witnessed by many artists participating in the festival, the long debate between Zhang and Song ended with Song's citation of a Tibetan custom which designates certain animals with talismans to live out their natural life spans. Somewhat pressured rather than convinced, Zhang released the ram.

16 As Qiu Zhijie mentioned to me, Song Dong became laden with guilt after Zhang committed suicide, for Qiu once half-seriously teased Song that, had Song not stopped Zhang's action in killing the ram, Zhang would not have had to die in place of the ram four years later. Qiu's remark might be deemed superstitious, yet its spiritual logic is akin to the mystical concept of 'water protectors', the deities that guard the well-being of the water (my interview with Qiu, 5 July 2005, Beijing). In my subsequent interview with Song (5 July 2006, Beijing), he admitted his guilt in interfering with Zhang's art. These incidents indicate how Chinese experimental artists frequently interact during joint performance opportunities and form a niche community to support and critique one another.

Thus, undocumented by the photograph of *Bei yang / Bearing a Ram*—as most Beijing artists remember Zhang's animalwork—was a convex story about how the ram survived the artist's original xingwei score to have it slain on the other shore. Neither can we learn for sure another convex story: How did Zhang himself become the sacrifice to his xingwei yishu four years down the line? And yet another: Where can Song address his undeliverable guilt in interfering with Zhang's art? [16]

MENAGERIES, LIVE, DYING, DEAD AND DEAD AGAIN | The cruelty latent in Zhang's ramwork prefigured the sensorial vehemence in a string of brutal xingwei-zhuangzhi pieces that emerged in the late 1990s through numerous experimental exhibitions. We now enter the terrain of controversy where there is no safe hermeneutic ground—exactly the cognitive location where animalworks slide into consumableworks which interrogate the ideas and acts of consumption. These consumption-inspired animalworks, often ruthless and startlingly mimetic, literalize their behavioural affinity with eating to such an extent that the violence underscoring animal flesh ingestion becomes their method of presentation. Their exercise of a literalist zooësis replicates what Gang Yue analyses as the ravenous 'carnivorism' of the reformist China (1999: 262–87). In its government-sanctioned campaign to 'catch up with the level of consumption of late capitalist societies' (ibid.: 378), post-Deng China has emerged as a restless environ insatiable for ever-more sensational commodities, especially for those consumed orally. Although they neither originate nor advocate such carnivorism, ultra-naturalistic animalworks play into their country's unselfconscious social gluttony.

One of the earliest of these brutal animalworks is Sun Yuan and Xiao Yu's collaborative xingwei-zhuangzhi, *Muzhe* (*Herdsman*, 1998), included in the exhibition *Fan shi—zishen yu huanjing yishu zhan* (*Anti-Perspective—Self and Environment Art*, 1998) in Beijing.[17] In a snowfield on the outskirts of Beijing, a herd of strange red creatures with arched backs assemble like a

17 My interview with Sun Yuan, 28 June 2005, Beijing; my interview with Xiao Yu, 7 July 2006, Beijing. See also Xiao Yu (2002: 93).

IMAGE **4.13** *Muzhe* (*Herdsman*, 1998) by Sun Yuan and Xiao Yu, in the *Anti-Perspective—Self and Environment Art* exhibition. Image courtesy of the artists.

determined army, marching towards a common destination. In the midst of these snakelike creatures stands a herdsman, swaddled in layers of blankets but shirtless, his bare back intermittently shown. Looking closer, we notice something amiss—these creatures are oozing blood onto the new snow. The herd is actually an orderly arrangement of fresh sheep spines, just purchased from a nearby food market (see cover).

In an interview with Li Xianting (2004), Sun mentioned that his inspiration for *Herdsman* came from Matthew 24:26: 'Wherefore if they shall say unto you, Behold, he is in the desert; go not forth: behold, he is in the secret chambers; believe it not'. Sun took this Biblical passage as a warning against the lies, phoney prophets and pseudo phenomena that abound when a catastrophe looms nigh. In Sun's understanding, this warning is tricky because even a faked phenomenon—one of dubious, rather than divine, origin—can be a true omen. In a later 2005 interview, I urged Sun to elaborate on how *Herdsman* enacts a falsehood.[18] He replied that he had constructed *Herdsman* as

18 My interview with Sun and Peng, 28 June 2005, Beijing.

a spectacle, an optical illusion of sorts, where none of the elements in it—not the 200 sheep spines nor the herder played by Xiao—changed from their original states. Put otherwise, the falsehood derives from the discrepancy between facade and actuality. The dead sheep spines appeared to be marching yet they could not move on their own. The herdsman appeared to be guarding the animals yet he was only there posing, silently. Sun links falsity with stagnancy, implying an equivalent link between their opposites, truth and mutability. Accordingly, that which is not false changes in its state of being. The artist reverses the conventional tie between truth and constancy to stress instead a connection between immobility and artifice. His assumption reveals a preference for vitality, for the forward thrust of temporality, since what is still living changes constantly. The sheep spines cannot move because they are the remains of dead animals. The herdsman moves but he cannot change his function as a live model within a performance about the spectacular intransigence of death.

Sun's logic is persuasive up to a point. But his argument becomes vulnerable when we push his reasoning further. As biological matter, neither the extracted sheep spines nor the herder's breathing body remain unchanged. Quietly on that serene snowfield, both the performer and the performing skeletons move a couple of hours closer to decay and disintegration. While their corporeality contradicts the artist's claim, a lone man amid the bloody spinal columns of beasts might still be read as an omen—echoing Sun's warning that even a phoney phenomenon can be a powerful omen. What does this omen portend? The inevitable mutability of organic beings. In retrospect, we may also take *Herdsman* as a sign of what was to come: a quick succession of xingwei-zhuangzhi pieces that use animals as both material and symbol to divulge the dialectic of life and death.

'Immediately after the tribulation of those days shall the sun be darkened, and the moon shall not give her light, and the stars shall fall from heaven, and the powers of the heavens shall be shaken' (Matthew 24:29). Did Sun know that a few verses after the biblical citation that inspired *Herdsman* is this graphic description of a catastrophe, one foreshadowed by the wandering charlatan in the desert and promising the eventual redemption of the faithful by 'the Son of Man'? (Matthew 24:30) Even without addressing the remote prospect of redemption signalled by a divinely ordained calamity, I would be guilty of gross exaggeration to suggest a correlation between violent animalworks and natural disasters. Nevertheless, I feel that some of these drastic artworks do rouse a horror and confusion akin to a cataclysm of perceptions. In the almanac of Chinese animalworks, two pieces in particular stir in me epistemic earthquakes, causing paralysis in an assessment that precludes cognitive salvation. Humanism in its most stupendous excess spells out the letters for an ethological apocalypse.

In *Er wo buxuyao sheme* (*But I Don't Need Anything*, 1998), the Shanghai-based artist Xu Zhen grabs a dead cat by its leg and continuously smashes it against the floor for 45 minutes.[19] Xu had planned to find road kill on the street to use in the piece. When nothing turned up, he purchased a live cat from the food market and strangled it in order to perform the ferocious act. Although the cat did not die from being flung repeatedly, Xu did kill it for his art and pulverized its corpse during the course of his xingwei, which he intended to present not as a live performance but as a video documentary. When the video was shown in the 2001 Venice Biennale, however, the excessive violence involved in Xu's cat-bashing behaviour, even in its mediated presentational mode, still proved too difficult to tolerate for many experienced art viewers. The biennale's organizers responded to public outcry by removing Xu's video, citing vague sociolegal conventions in Italy to justify the censorship. Given no opportunity to defend his case, Xu later stated in an interview with a Chinese reporter: 'While I was really upset at first, it also occurred to me that the situation was not so different from that of China' (Chen Xiaoyun 2001).

Xu enacted *But I Don't Need Anything* at an early stage of his career which, since 2001, has become increasingly visible and internationally lauded for its prolific virtuosity and prankish humour—a shining example from the Chinese contemporary art world. Asked why he did a

19 Xu Zhen's entire cat-throwing action was videotaped and, when I checked it in 2005, the tape was available for purchase online at http://china.shangartgallery.com/galleryarchive/-artists/name/xuzhen. The piece is still listed on Xu's website but no longer available for purchase. I found divergent information about this performance: some dated it 1998, others 1999. I chose to follow the year listed on Xu's online archives. See BizArt (2004); Chen Xiaoyun (2001); Michel Nuridsang (2004).

notorious piece like *Throwing a Cat*—as the piece came to be known—Xu responded that 'A cat is sexy' and that he used the cat 'as a substitute' to release his own pent-up sexual energies without 'violence towards the public': 'The cat was already dead but to me it was still sexy.' 'If a woman was sexy, would you do the same thing to her?' pursued the interviewer. 'No, I won't do that to a human being. A cat is an animal—totally different. I personally dislike cats. The reason for choosing the cat was that it gave me the very sense I wanted [. . .] Other animals weren't suitable [. . .] The cat is hot. I actually had the idea in 1997 but no chance to actually do it. Finally I did it but only once and I'm now past that stage' (Schiefke and Liu 2010).

As Xu admitted, *But I Don't Need Anything* was a channel to vent his voracious youthful energy. The title boasts of the artist's ability to create art out of nothing or, rather, to make decimating-something-into-nothing an artwork. The problem with Xu's declaration lies in how to construe the status of his 'art material'. Xu's rhetoric in explaining why he chose a cat disturbs me because it echoes the sadistic prurience behind the production of 'crush videos', those involving the torture and tramping to death of small animals by women in stiletto heels to satisfy some viewers' alleged sexual fetishes (see Brady 2010). The US Congress sought to curb such acts of animal cruelty by passing a law in 1999 to criminalize 'any visual or auditory depiction [. . .] of conduct in which a living animal is intentionally maimed, mutilated, tortured, wounded, or killed', exempting only those depictions with 'serious religious, political, scientific, educational, journalistic, historical, or artistic value' (see Will 2009: 154, 16 and 22).[20] Certainly, US law cannot intervene in China's domestic sphere but most Chinese appear to share a similar moral sentiment, demonstrated, for example, by the public outrage against the infamous 2006 Internet videocasting of a Hangzhou woman victimizing a kitten (see *Shanghai Daily* 2006). Xu's animalwork, however, differed from crush videos in using an *already dead* cat; this aligned his moral offence not with live animal torture but with corpse abuse. The local factor that Xu purchased the cat from a food market, moreover, rendered his felinicide a culinary rather than a criminal act. Comprehending Xu's personal logic within its indigenous context does not make his action any less chilling for me, though.

20 In 2010, however, the US Supreme Court ruled that a statute banning the sale of animal cruelty 'crush videos' would violate free speech. See David G. Savage (2010). I thank Rolf Hoefer for bringing this news to my attention.

If socially condoned anthropocentrism allowed Xu to discriminate between a cat and a woman for purging his sexual rage, then Zhu Yu's animalwork sought to annotate anthropocentrism's glorious potential as an arbitrator of life. In *Fuhuojie kuaile* (*Happy Easter*, 2001), a pig is put under anaesthesia for an open-heart surgery, conducted by a medical doctor on a makeshift surgical table with the watchful assistance of the artist (Dai 2001; Zhang Xinyu 2001). Zhu presented *Happy Easter* in the second international *Dakai xingwei yishu jie / Open Performance Art Festival* in Chengdu, Sichuan Province—a highly publicized and well-attended international art event including many foreign artist-participants. Zhu's plan was to have a medical doctor surgically open a boar's chest, expose the heart pumping inside the chest cavity and then close the wound to keep the boar alive. Zhu had done a prior experiment in an agricultural science academy in Beijing, where the pig, his involuntary patient, survived the surgery. In Zhu's judgement, the pig was therefore 'resurrected'—a term referencing the Christian mystery of resurrection while punning

on the Chinese phrase *fu huo* (again alive) (Zhang Xinyu 2001).[21] The boar in Chengdu, however, had no such luck. Because of the doctor's miscalculation in applying the anaesthesia, the pig woke up during the operation, squealed and thrashed about desperately until it died. The open-heart surgery therefore deteriorated into a vivisection. The pig's fierce struggle during the performance enraged UK performance artist Miriam King, who attempted to stop the operation by force but an alarmed crowd barred her entry. When the commotion subsided, Zhu, saddened by the pig's agony, hung a white cloth —a Chinese sign for mourning and an international sign for defeat—on the door to the operating room, declaring the performance a failure.

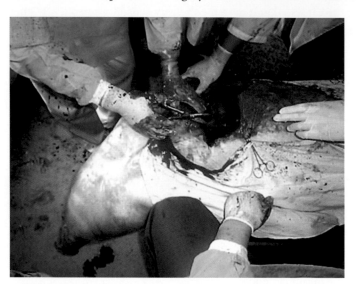

IMAGE **4.14** *Fuhuojie kuaile* (*Happy Easter*, 2001) by Zhu Yu in the second *Open Performance Art Festival* in Chengdu, Sichuan Province. Image courtesy of the artist.

'Is It Art or Is It Murder?' asked the headline in *Sichuan zaixian*, reiterating the criticism from several major Chengdu newspapers (Dai 2001). Internet chats speculated whether Zhu Yu was now certifiably insane, citing his previous xingwei piece *Eating People* (2000) as a prelude to his psychic descent. The legitimacy of Zhu's animalwork was openly questioned by Li Xianting, the very curator who boosted the artist's early career by including him in the exhibition, *Infatuation with Injury* (2000), which featured what Li identified as a violent tendency in xingwei yishu. Refusing to see *Happy Easter*, Li expressed his belief that an inhumane act such as the one to which Zhu would subject the boar exceeded the boundary of xingwei yishu. In art-making, Li reasoned, it is acceptable for the artist to self-injure but not to hurt others (ibid.; Zhang Xinyu 2001).

Like Li, I am appalled by the gratuitous violence visited on the pig, the compulsory performer in *Happy Easter*. I understand that Zhu wished to celebrate the marvel of life under competent medical guidance by showing the surgically revealed pumping heart. The pig is, in this conceptual scheme, a surrogate for a human being. Similar to Xu Bing, Zhu's choice of a pig also has a personal resonance. In *Skin Graft* (2000)—which happened to be his contribution to *Infatuation with Injury*—Zhu underwent surgery to remove a patch of skin, which was then sewn onto a slab of pork. In *Happy Easter*, Zhu employed not himself but an animal body double to endure a high-risk surgery, theoretically maintaining the previous trinity of an artist + a doctor + a pig but switching the artist's role with that of the pig, turning the former (dead)

'beneficiary' of a surgical gift into the (living) one forced to gift under the scalpel. In this light, *Happy Easter* is a slightly mutated inversion of *Skin Graft*—just like Zhu's second infantiphagia xingwei piece, *Sacrificial Worship* (2002), is a logical next step after *Eating People*. These inter-related xingwei projects indicate Zhu's ongoing cognitive immersion in his art practice. Sympathetic as I am with his devotion, I cannot help but be bothered by the casualties of his live/life art. His belaboured concept in *Happy Easter*, for example, pursued such a literal corporeal manifestation that it cost another living being unbearable suffering and death. Nevertheless, I wonder: Has the pain of the squealing pig in Chengdu caused me to respond viscerally? How would I have felt had *Happy Easter* in the second *Open Performance Art Festival* repeated the success that Zhu claimed to have had in Beijing? What would have been my reaction had the pig 'slept' through the operation, been sutured and emerged hardly the worse for wear?

Caught in this conundrum, I found some intellectual relief in an astute critique by Liu Yuan. *Happy Easter*, as Liu maintains, obliges us to raise several questions regarding the complex relationships between animal and human: '1. Is an animal "human"? Not human? 2. Is there a difference between an artist and a butcher? Who is crueler? 3. Is a doctor also a butcher? 4. Does the artist have the freedom and right to express everything?' (2001). Liu's comment betrays an anthropocentric premise in that he uses the 'human' to measure the worth—by implication, both ethical and existential—of a nonhuman animal. His humanist premise, however, may be a necessary analytical tactic to address his habitually anthropocentric readers, waking them up to the moral and biological equivalence of a human's other and kin. Further, the analogous links Liu makes among an artist, a doctor and a butcher bring into relief the potential cruelty associated with divergent human acts, underscoring especially the corporeal violence often interlacing animalworks—an aspect similarly affecting bodyworks, the genre's self-targeted counterpart.

But I Don't Need Anything and *Happy Easter* both provoked a desire for censorship from experienced art viewers and practitioners. The controversies associated with these harsh animalworks recall the conceptual basis of their Western precedent, performance art, whose challenge to the division between art and life often translates into an insistence on the 'realness' of a given action. Chris Burden's judgement that performance art is 'real' in comparison to 'mushy' theatre fakery comes to mind (see Carlson 1996: 103; Meiling Cheng 2002: 51–6). Xu had to use excessive force and Zhu unwarranted violence to *prove* that they had the guts to *really* smash a dead cat and incise a live pig! But Xu and Zhu were not suddenly inventing their sadistic rituals to aestheticize—even glamorize—the whiff of criminality in art. Instead, they participated in a global history of violent time-based art (harming the self and/or damaging others), which may be traced to Austria in the early 1960s (the Vienna Actionists), to the US in the early 1970s (Chris Burden, John Duncan, Vito Acconci, etc.), to various European feminist body artists (Gina Pane, Valie Export, Marina Abramovic, Orlan, Kira O'Reilly, among others) from the past few decades and now to China at the turn of the twenty-first century.[22]

Both Xu's and Zhu's animalworks exploit nonhuman mammals as material symbols to render visible the fragility and tenacity of mortal flesh. By using animals as multivalent surrogates for human beings, they effectively trouble the gastronomic status quo of perceiving all animals solely as dinner.

22 It is beyond the scope of the present inquiry to examine the macrocosmic conditions that contributed to this trend in each of these locations at these particular moments. See, for example, Amelia Jones (1998); Kathy O'Dell (1998); Lea Vergine (2000).

IMAGE **4.15** *Shuizuqiang* (*Aquatic Walls*, 1998) by Sun Yuan, in the Inlaid exhibition, Beijing. Image courtesy of the artist.

In their unnerving literalism, these pieces evoke two other animalworks that sacrifice marine, reptilian and amphibian creatures to art.

As part of an exhibition entitled *Xiangqian* (*Inlaid*, 1998), Sun Yuan constructs a U-shaped corridor of double-layered walls in which he has carved carefully measured openings. He places a live marine animal in each niche, tailored to snugly hold the given animal, creating 'aquatic walls'— the English translation of the artwork's Chinese title: *Shuizuqiang* (see Ai Weiwei et al. 2000: 118–19; Ai Weiwei 2002: 12–27).[23]

23 Also my interview with Sun and Peng, 28 June 2005, Beijing.

In *Man* (*Curtain*, 1999), a xingwei-zhuangzhi shown as part of the exhibition, *Wenhua•Shenghuo* (*Culture•Life*), Peng Yu designs a curtain made out of '400 kg of lobsters, 30 kg of eels, 30 kg of snakes and 20 kg of bullfrogs', all alive when they are pierced by metal wires to fabricate the 4 x 6 ft drapery (Zhang Liujiang 2001).

There are many similarities in these two animalworks by an artist couple who often collaborate but also produce works independently. Both *Aquatic Walls* and *Curtain* simultaneously quote and reproach the reigning culture of eating in China and point, in particular, to the treatment of live animals in livestock and fish markets. Both pieces proposed an ingenious if pitiless response to the respective exhibition themes, constructing an artificial environment to put on view the natural process of dying. A sense of displacement, if not deception, characterizes both pieces. *Aquatic Walls* cites the convention of displaying animal trophies as wall decorations; nonetheless, these trophies are not sanitized taxidermic specimens but smelly, decaying animal flesh. *Curtain* takes the name from an inert, utilitarian and often overlooked household object; yet Peng's live drapery can hardly be ignored. Both animalworks traverse the ambivalent border between xingwei and zhuangzhi. As life-endowed acting bodies, the animals' dying behaviours become their enforced xingwei, with their staring eyes, odour, movement, velocity and tactility comprising its multisensory contents. As biological matter, the fish, lobsters, crabs, eels, grass snakes and bullfrogs constitute the substance and texture of two constantly shifting and sonorously despairing zhuangzhi.

Peng admitted in my interview with her that Sun's *Aquatic Walls* had influenced her conception of *Curtain*.[24] Her production process serves to elucidate both animalworks' connections with the Chinese eating culture. Around 3 a.m. on the first day of the *Culture•Life* exhibition, Peng went to a wholesale fresh animal market to purchase her materials which, according to her, were only a minuscule portion of the abundant stock. Having poured ice on her purchases—to maintain their freshness—she quickly drove to the exhibition site and directed 10 hired hands to construct her live curtain. It took two hours to make. During the exhibition, the animals writhed and wrenched themselves so fiercely that the whole curtain moved with overwhelming sound and fury and smell. After three days, when the exhibition ended, some animals were still alive. Peng dumped the dead ones and gave the living ones to fellow artists for food.

24 My interview with Sun and Peng, 28 June 2005, Beijing.

Similar to many other spectators who had vociferously rebuked the two animalworks, I pale before the ruthlessness with which Sun and Peng tortured their animal victims en masse. Nevertheless, I am also intrigued by the artists' abilities to deflect criticism. Their justification coalesces on two defensive fronts: the anti-anthropomorphic; and the homoeopathic. Asked whether she had considered the pain endured by the animals during the making and showing

of *Curtain*, Peng dismissed my question as irrelevant to art. 'Pain is a human-defined emotion,' interjected Sun. His remark aimed to expose my enculturated anthropomorphic fallacy: How do we know how the animals—say, in *Aquatic Walls* and *Curtain*—experience the world? Despite his scepticism, Sun agreed with my proposition that there is the possibility of empathy. I know I suffer when my tongue is parched and sharp metal pierces my abdomen; therefore, I imagine the animals, being sentient, are also hurt. In response, Peng circled back to the animals' status as food and pointed out the hypocrisy within the Confucian admonition that a gentleman should stay away from the kitchen to avoid witnessing the cruelty of animal killing— junzi yuan pao chu—which serves one's stomach and not one's conscience. Peng's self-defence implies that one can fight hypocrisy with shock treatment. Yet, at what cost? Sun and Peng further argued that their animalworks, while unbearably intense, only hint at the sweeping aggression committed by their fellow meat-eating, live-shrimp-swallowing Chinese: 'An iris for an eye,' so to speak. Yet, I doubt: Can we separate pain from the instinct for life and the process of dying? Can we exploit others' pain for our creative compulsion? Can we protest against blindness by being blind?

Aquatic Walls and *Curtain* push to the extreme the practice of cultural citation so as to expose the rampant carnivorism in their larger national context. If we are shocked by the savagery of both pieces, Sun and Peng seem to aver, how do we respond to the even greater and more insidious violence committed to a multitude of human subjects, those circumstantial victims of China's socialist market economy, unrelenting in its pace and callous towards its unfit castaways? In this sense, both animalworks apply homoeopathic tactics, proffering their 'smaller' dose of cruelty to resist the grand-scale incursion of a non-discriminating appetite. The homoeopathic solution, however, has the methodological limit of having to reproduce the very ill it seeks to cure. Sun's and Peng's homeopathic animalworks have incurred such a stupendous waste that I am forced to question their ethical merit and aesthetic economy. At the same time, I must concede that the power of both pieces derives largely from the horror of their animal sacrifices. Were their fish, lobsters, eels, grass snakes and bullfrogs fake, *Aquatic Walls* and *Curtain* would have become merely decorative rather than unforgettable animalworks.

There remain many unresolved questions. Are *Aquatic Walls* and *Curtain* any less cruel or crude than *But I Don't Need Anything* and *Happy Easter*? I don't believe it's possible to measure the degrees of cruelty in these menageries of live animalworks. That Zhu's pig could loudly vocalize its agony and splatter its voluminous blood on hapless spectators does not prove that dying from open-heart surgery is more tragic or painful than dying from thirst, suffocation and impalement. Besides, a pig is a pig, a frog is a frog and a lobster is a lobster, no matter their sizes or how much they resemble humans.

'Whenever I went to a live-animal market, I would see cages of fully packed rabbits set next to many dead rabbits' skins, with their flesh removed. I felt a deep inexpressible sadness at the sight,' comments Zhu on his attempt to produce *Happy Easter* as a re-evaluation of human-animal relations (Zhang Xinyu 2001). Does compassion ever assume the mask of violence? If so, how can we tell the face from the mask? Do citations of violence disturb or perpetuate the exercise of violence? Does the extreme practice of art wake people up or shut them off? Another unanswerable question is the perceived value of a death or the act of dying. Can we ever stand inside the

IMAGES **4.16.1–16** Various views of *Man* (*Curtain*, 1999) by Peng Yu in the *Culture•Life* exhibition, Beijing. Image courtesy of the artist.

RUAN

---- 杂食、有翅、哺乳动物。由于它特有的生理结构，在生物学上至今无法准确分类。它的生长发育经历了单脊椎水生、两栖爬行类、哺乳类的生长过程。早在侏罗纪恐龙时期已进化成熟，白垩纪恐龙绝后依然繁衍至今。可能在未来相当长的时期内继续繁衍卜去。　　萧昱　**1999.**

24 'Which animal would consent to be eaten?' asked my editors Mariellen R. Sandford and T. Nikki Cesare in October 2006, when we prepared my *TDR* article, 'Animalworks in China' (Meiling Cheng 2007a), for publication. My supposition is based on anthropological imagination, ancient metaphysical rationalization and folktales. I also recall a mythic episode in Maxine Hong Kingston's *The Woman Warrior* (1976) about the training of a girl who runs away from home to learn kung fu with an ancient couple in the mountain—a recurrent motif in Chinese folktales. In one of her solitary training sessions, the girl is on the verge of starvation, sitting next to a fire she has built but with nothing to eat. A white rabbit hops beside her, studies her and jumps into the fire to offer its flesh as a meal to the girl: 'Perhaps this one was sick because normally the animals did not like fire. The rabbit seemed alert enough, however, looking at me so acutely, bounding up to the fire. But it did not stop when it got to the edge. It turned its face once toward me, then jumped into the fire. The fire went down for a moment, as if crouching in surprise, then the flames shot up taller than before. When the fire became calm again, I saw the rabbit had turned into meat, browned just right. I ate it, knowing the rabbit had sacrificed itself for me. It had made me a gift of meat' (1976: 26).

25 I retranslated the passage cited here. See also more recently posted files on Xiao Yu (Other Shore Arts Institute 2010).

animals' skins, carapaces, paws and claws to proclaim, 'Ah, dying for art is much nobler than dying as food'? Might not animals think, dream or feel the opposite—that which consents to be eaten to sustain life is divine, hence, not merely human?[24]

ALIEN MOULTING | In a liquid-filled glass container floats an alien creature. The creature has a head resembling that of a human foetus, protruding rabbit eyes, a pair of white-feathered wings sprouting from the shoulders, a furless torso with a vertebral column, a tail and two legs.

Ruan, the name given to the hybrid animal by Xiao Yu, made its first public appearance as part of the exhibition, *Post-Sense Sensibility: Alien Bodies and Delusion* (1999). Besides naming the creature with a neologistic Chinese name in Pinyin, *Ruan*, Xiao also created its zoography: 'A carnivorous animal with wings and mammary glands. Because of its peculiar physiology, it cannot be classified by today's science of biology. It evolved through the periods from the single vertebrae marine creatures, to amphibians, to mammals and matured during the Paleolithic Age. It survived the extinction of the dinosaurs to the present date. Most likely, it will continue to propagate for years to come' (2000: 140).[25]

A formaldehyde-filled jar with a specimen in it: *Ruan*, a still-life zhuangzhi, cites the convention of animal exhibits in natural science museums. The sculptural animalwork came from artificially grafting a human foetal head specimen onto a body assembled from parts of a rabbit, a pigeon, a cat and a mouse (see Xiao Yu 2002).[26] *Ruan* responds pertinently to the two themes featured in *Post-Sense Sensibility*. The material presence of this hybrid bio-form imagines a particular 'alien body'. By fabricating an identity and a species history for this floating alien body, Xiao promotes the *delusional* perception that such a creature exists on earth.

26 Also my interview with Xiao Yu, 7 July 2006, Beijing.

The image of *Ruan* simulated a sense of liveness suspended in preservatives. In his next animalwork, *Jiu* (2000), Xiao moved to the genre of xingwei-zhuangzhi by making liveness or, rather, vitality his central concern. Since *Jiu* was produced first for the *Infatuation with Injury* show, Xiao grafted the theme of injury onto his pre-existing line of experiments with fabricating new/mythic bio-forms. In *Jiu*, the victims of Xiao's injurious intent are more than a dozen living lab mice, sewn together in twos and threes and placed in separate glass bowls on an elegant metal rack. A feeder basket, with actual fodder for the mice, and a video monitor for close observation, stand next to the rack. A concise zoography for *Jiu* identifies the animals as 'small in body size; robust capability in procreation; strong adaptability; inheritors of the future' (Li Xianting 2000b).[27] The zoography, however, fails to state the typical life span of each *jiu*.

27 I based my original citation on information posted on a Chinese website that no longer exists but I have translated it into English for my article (Meiling Cheng 2007a). Li's article cited the same description of *Jiu*.

In *The Postmodern Animal*, Steve Baker uses 'botched taxidermy' to characterize a typical artistic approach in creating 'the *look* of the postmodern animal' which is 'more likely to be that of a fractured, awkward, "wrong" or wronged thing' (2000: 54). 'Botched taxidermy' provides another angle from which to view an animalwork such as Sun's *Aquatic Walls*, which subverts the taxidermic codes by presenting animal samples that are both 'wrong' (for being

IMAGES **4.18.1–2** *Jiu* (1999), an animalwork by Xiao Yu in the *Infatuation with Injury* exhibition. The neologistic name of the animals, along with their zoography, appears as the Chinese caption at the bottom of the image on the left. Image courtesy of the artist.

alive and dying) and 'wronged' (for being subjected to what amounts to live burial). The same concept is applicable to Xiao's zoontological series of fabricated bio-forms. *Ruan* offers a taxidermic specimen that appears wrong for disturbing the established zoological taxonomy; *Jiu* presents living/dying evidence of those very animals being wronged, rapaciously turning the tenacity of the mutilated lab mice into an ethological xingwei artwork.

By flirting with scientific protocol, Xiao locates his animalworks in a cultural sphere that holds 'the future' as its best investment. Both *Ruan* and *Jiu* evoke the practice of bio-engineering, recalling Liang Shaoji's declaration that life sciences open up an immense space for contemporary art. What differentiates Liang's and Xiao's animalworks, however, lies in the divergent functions assigned to the animals in their art. *Nature Series* foregrounds the silkworms' capacity to spin softness round chaos, thereby homogenizing dissonance with harmony. Chaos and dissonance, however, are the very effects cultivated by Xiao's animalworks. *Ruan*, the name that Xiao invented for his first alien bio-form, is composed of various ideographic units indicating animals but its sound is nearly homonymic with the Chinese character *luan* (亂)—chaos. The lab mice in *Jiu* demonstrate point-blank the cruelty involved in sacrificing selected animals to scientific experiments.

As a living animalwork, *Jiu* is suffused with an ethical ambiguity similar to that of homoeopathic critique and anthropocentric pragmatism affecting *Aquatic Walls* and *Curtain*. Although *Ruan*, a biomorphic haiku thriving in stillness, avoids the pitfall of live animal torture, its hybridization of trans-species body parts might still offend some viewers. Bracketing their ethical implications for the moment, however, I find Xiao's corpus of alien animalworks conceptually provocative in three respects:

1. IDEOGRAPHIC EPISTEMOLOGY | Xiao created a new ideogram to pair with each bio-form he invented. The underlying assumption is a syllogism familiar to a culture that accesses the phenomenal world through an ideographic language: new form = new word; new word = new reality; new form = new reality.

2. DEFAMILIARIZING THE ANIMALS | Xiao's bio-zhuangzhi pieces depart from what I've isolated as the two predominant contexts for animalworks: animal husbandry; and a carnivorous/voracious food culture. His art reveals the desire to find alternative possibilities for the place of animals in Chinese society.

3. HOMIXENOLOGY | My neologism derives from merging an inflected Latin prefix 'homi' with the Greek 'xeno' and suffix 'logy'; it names an aesthetic methodology that I've proposed elsewhere to analyse a tendency in live art (see Meiling Cheng 2001 and 2002). Homixenology, in brief, refers to the transitory fusion of two mutually alien forms, identifying one end in this performative interface as human and the other as non-, supra- or posthuman. As a sculpture, *Ruan* effects a homixenological fusion more permanent than anything that is sustainable by an ephemeral live performance. Yet, Xiao's animalwork shares the impulse for homixenology in projecting the utopian vision that human beings might be able to transform, renew or invigorate themselves through symbolic/psychic/physical unions with alien others. The presence of this vision, in turn, suggests a Chinese artist's attempt to revitalize his national culture by inversing the conventional value hierarchy that places humans above and apart from other animals.

I consider each of these concepts a synthesis between sinification and posthumanism, revealing a sinocentric pursuit of a zoontological ethos while funnelling a liminal dynamism to contemporary time-based art. Underscoring all three dimensions is a quest to generate an alternative reality, whether through word-coinage, form-invention or fantasy fusion. To create an alternative reality is to invest in the future possibility of transformation. This logic supports Xiao's remark about *Ruan* in another censorship case involving Chinese animalworks. 'It's precisely because I respect all life that I did this,' stated Xiao in defence of his controversial use of the foetal head joined with animal parts. The foetal specimen dated from the 1960s, before China's one-child policy was instituted in 1979. The foetus, as Xiao speculated, most probably came from a miscarriage rather than an enforced late-term abortion. Xiao melded this damaged being with others 'as a way for them to have another life'. [28]

28 I found a report about the censorship controversy surrounding *Ruan* at the Bern Art Museum in Switzerland, in Alexa Olesen (2005). See also Associated Press (2005) and Other Shore Arts Institute (2010).

The three conceptual dimensions discernible in Xiao's animalworks—ideographic critique, defamiliarizing the animal, homixenology—exceed his individual investigation and signify

MARGINS OF ANTHROPOCENTRISM, INSCRIBING HOMIXENOLOGY

the intellectual ferment latent in subsequent animalworks. A roving exhibition series entitled *Ren•Dongwu* (*Human•Animal*), organized by independent curator Gu Zhenqing in diverse regions throughout most of 2000, inspired new animalworks that continued to develop Xiao's ideas.

Gu had two goals for his ambitious project: to expand the audience base for xingwei yishu; and to challenge the mainstream's as well as the art world's mistreatment of animals. [29] He accomplished the first goal by widely publicizing his exhibitions and presenting them in six cities from different provinces, including Beijing (23 April), Chengdu (30 April), Guilin (21–23 May), Nanjing (28 May), Changchun (2–3 July) and Guiyang (2 September). *Human•Animal* generated tremendous media

29 My phone interviews with Gu Zhenqing, 25 August 2004 and 28 July 2005, Los Angeles to Beijing; and my interview with Gu Zhenqing, 16 July 2008, Beijing. See also Meiling Cheng (2004a).

response both before and after the shows, with coverage by 120 newspapers in China alone. The media exposure, however, also impeded Gu as he attempted to produce these events, many of which happened in a chaotic rush due to bureaucratic interference and threats of arrest. For the second goal, Gu's series sought to re-examine 'the specific relationship between [humans] and animals' in order to redress the brutal art trend that had been gaining momentum since 1998 (Chinese-art.com 2000). The various rationales that Gu offered in justifying his exhibition to the regional government officials included the morality of 'animal protection', the 'everyday violence' that often occurs between humans and animals and the general insensitivity towards animals in a culture obsessed with food. 'The whole society is terrorizing animals to satisfy its own spiritual needs,' said Gu. 'People are in the centre. They rule by force. They can kill [animals], let them live, put them in zoos' (ibid.).

By placing human and animal as the two factors in his thematic equation, Gu's umbrella title for the series seems to locate itself within conventional humanism, wherein the human subject defines his/her worldly position against that of the animal other. But the dot between

his two terms is more ambiguous than a polarizing 'vs'. It may just as well link human and animal together in a homixenological union, either as a 'humanimal connection' of sorts or as a hybridization of both—that is, 'animalizing humans' and 'humanizing animals', to borrow Chaudhuri's phrases (2007: 15)—thereby erasing the absolute distinction between them. Since Gu's curatorial rationale focuses on exposing and deconstructing anthropocentrism, he shares the ethical purpose of critical zoöésis even when the multivalent openness of his general exhibition title also allows for strictly humanist interpretations.

Human•Animal managed to produce and display an array of performances (32 in all) that mirror, exaggerate or critique what its curator identifies as habitual anthropocentrism in China. Since this exhibition series favoured xingwei yishu, homixenology—broadly construed as varying degrees of corporeal interface between a human artist and other chosen animals—appeared to be a predominant approach among Gu's selections. Artists applying homixenology to *Human•Animal* tended to take the thematic pair as a spatial directive of two embodied positions; they shifted to either side of the dot to prioritize a given entity or to stress the contiguous placement of both units. Their animalworks served to showcase neologistic figural ideograms like multicentric emanations from six geographically dispersed Chinese cities.

Biaozhun dongwu (*Standard Animal*, 3 July 2000), for example, features artist Feng Weidong standing naked inside a cage as a living illustration of '人' (*ren*, human), the animal species to which the exhibit belongs. An informational placard, hung on his cage, identifies the creature inside as a 'standard animal', followed by an exposition delineating the species as 'the cruellest, greediest and most possessive' of all living beings, 'the worst enemy for all creatures (including human beings themselves)'.[30]

30 I translated the zoography label from the caption of a documentary image that the artist emailed to me on 16 July 2006.

Feng's performative strategy accentuated the latter term—animal—without altering the former. Conceptually, however, Feng employed an alienation technique to overlay his human body with his species label. The piece therefore simultanesouly exposes the human's presumption to serve as a standard of all animals and the human's own status as an animal. To further puncture the facade of generalization, the zoography zeroes in on the individual humanimal on display: 'yellow, male, married, ancestry China Shanxi, now 31 years old, personal hobby naked body photography, original name Feng Weidong, presently cage-kept. Time: 20 minutes. Year 2000 Month July. Changchun.'

Wang Chuyu's *Xunzhang gou* (*Medalled Dog*, 2 July 2000) emphasizes the human side of the equation by transposing the conventional status of the human and the animal—hence animalizing the former and humanizing the latter.

Wearing only a pair of khaki trousers and sneakers, Wang enters bare-chested, with a red ribbon tied from his neck to the neck of a dog named Dou Dou, whose front legs have been crippled since birth. Wang decorates the dog with medals, places the 'champion' dog on a podium and begins to applaud. After clapping for 20 minutes, hurting his own palms, Wang snaps a picture of Dou Dou to end the performance (Val Wang 2000).[31]

31 Also my interview with Wang Chuyu, 3 July 2005, Beijing.

Depending on how a viewer feels about a disabled dog, Wang's animalwork is either a cynical comment on false hero worship or a witty, if physically costly, tribute to a dedicated public servant. While the ritual of formalized adulation through ovation satirizes a routine behaviour in political arenas, the red ribbon binding a dog and a man shifts the behavioural

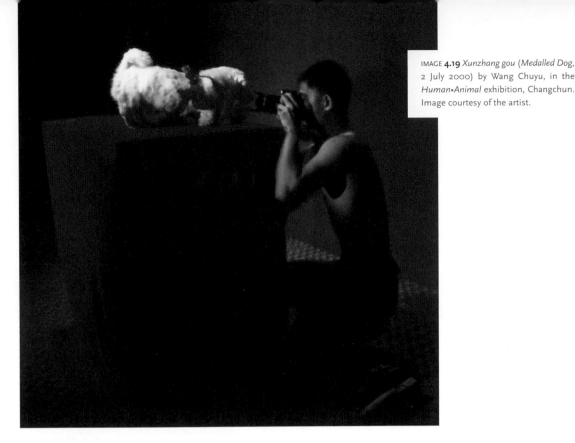

IMAGE **4.19** *Xunzhang gou* (*Medalled Dog*, 2 July 2000) by Wang Chuyu, in the *Human•Animal* exhibition, Changchun. Image courtesy of the artist.

register to human–animal affairs such as pet-keeping, which mutually reconstructs the keeper and the kept.

Another pair of examples underlines the inherent similarity, or the lack of practical distinction, between the co-performers—voluntary and otherwise—through their equivalent treatment in each xingwei.

In *Da jianggang* (*A Big Vat of Soy Sauce*, 28 May 2000), Liu Jin, unclothed, holds a bound piglet in his arms and soaks inside a chest-high earthenware pot of soy sauce. A slow fire burning underneath the pot heats up the soy sauce until it simmers. Liu, with the piglet nestling close to him for companionship and protection, stays in the pot until he can no longer bear the heat (about 15 minutes). Climbing out with the piglet, which has fainted, in his arms, Liu resuscitates the young boar and releases it.[32] (See IMAGE **4.3**, p. 238.)

32 My interview with Liu Jin, 3 July 2005, Beijing.

In *Jinjichuko* (*Emergency Exit*, 3 July 2000), He Yunchang covers himself in concrete and brings a pigeon with him into a kerosene-coated cage set up in a field close to a river. When he fails to ignite a red yarn that is wrapped round the cage, the artist finds a white cloth onsite, immerses it in kerosene, sets it on fire and throws it burning on the top of the cage. This impromptu solution unexpectedly exacerbates the intensity of the fire. As the temperature rises with the increasing smoke and flames, He lies down, hovering over the pigeon to protect it from harm. When the fire burns out, the artist lets the pigeon go and pushes the cage into the nearby river until it is submerged.[33] The pigeon is unharmed and the artist walks away with a few burns.

33 My interview with He Yunchang, 4 July 2005, Beijing. See also Val Wang (2000).

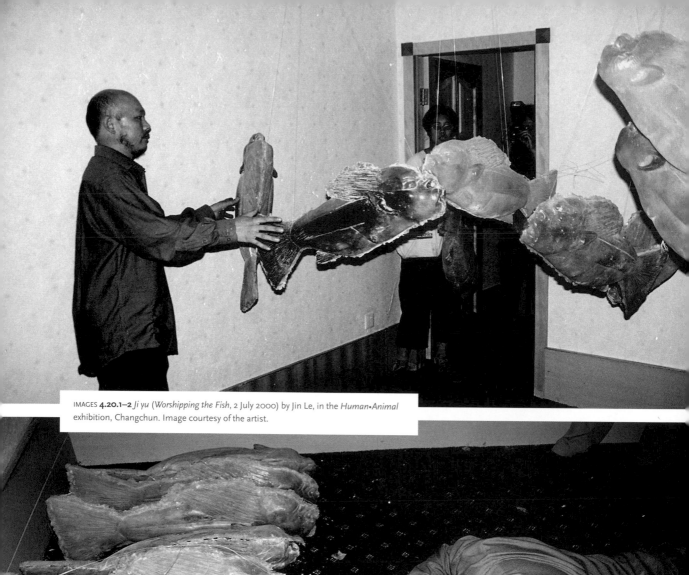

IMAGES **4.20.1–2** *Ji yu* (*Worshipping the Fish*, 2 July 2000) by Jin Le, in the *Human•Animal* exhibition, Changchun. Image courtesy of the artist.

Both Liu's and He's animalworks turn the human–animal co-performers into partners in disaster, permitting a similar level of protection, or lack thereof, to each. Both performers in *A Big Vat* are naked. Their skin offers the only barriers against an increasingly dangerous external agent—heat. Due to their relative body sizes, there were different outcomes for Liu, an adult male, and for a piglet half his body weight. Luckily, the piglet survived the ordeal while the artist experienced what it was like to be cooked in a soy sauce stew. *Emergency Exit* pushes this show of empathy further. While the artist had only a concrete coating to shield him from the fire, the pigeon was twice removed from harm—being protected by the artist's body plus its layer of concrete.

Homixenology explores the kinship between human and nonhuman animals as exemplified by *A Big Vat* and *Emergency Exit*. It can also reinforce the persistent difference between two mutually foreign bodies placed in proximity. When an artist performatively raises the status of nonhuman animals above those of humans, homixenology may emerge as a means of transcending humans' enculturated boundaries. Without subverting the existing anthropocentric value hierarchy, however, a similar procedure of incorporating others for the self's benefit may risk reiterating the habitual subjugation of animal bodies in human society.

Jin Le's *Ji yu* (*Worshipping the Fish*, 2 July 2000) tackles the role of human's animal other as a totem and a surrogate.

Jin constructs a structure from which hangs a row of resin fish—their heads sculpted in his likeness. Burning incense, the artist prostrates himself before the hanging fish. He then hammers the structure until it collapses, bringing the fish crashing down among the debris. Jin finishes the devotional ritual by fully prostrating himself again before the fallen fish, which he has lined up on the ground (see Val Wang 2000).

By doubling the ritual of veneration—in mid-air and on the ground—Jin positioned the fish between a divine surrogate and the artist's totemic alter ego. If symbolic homixenology— bonding the self's verisimilar face with the other's fish torso, fins and tail—constitutes the artist's image of *deus* (a divine other) or of *telos* (within the self), then the artist's behavioural sequence ends up inserting a degree of uncertainty into his sculptural fishwork. Is shattering the structure of worship an iconoclastic act or an attempt to bring the hybrid godhead closer by toppling a calcified religious institution? The artist's closing prostration seems to reinstate a sense of reverence; nevertheless, is he paying homage to the bestial other or saluting the animality within himself? The tone of *Worshipping the Fish* appears ambivalent, poised between the satirical and the earnest.

Yu Ji's *Youwu zhi wen* (*Beauty's Kiss*, 30 April 2000)—which curator Gu claimed to be the only piece in his series to have caused the accidental death of some animals—placed the artist together with a chattering of chicks to show the damage done by a human's self-centred affection for the cute and feathery animals.

Holding the beak of a chick tightly with his lips, Yu walks out naked to climb into a pre-installed 1 cu. m empty glass box, with a hole carved out on one side.[34] Once Yu sits down, assistants pour 1,000 chicks into the box; they pile up as high as the artist's waist. The assistants then seal the top, leaving the artist and the chicks to share the cube. Yu spits the

34 My phone interview with Yu Ji, 28 July 2005, Los Angeles to Beijing; my interview with Yu Ji, 9 July 2006, Beijing; my phone interview with Gu Zhenqing, 28 July 2005, Los Angeles to Beijing; my interview with Yang Li, 1 July 2005, Beijing.

chick out from the hole whenever the chick he 'kissed' faints from lack of air. The artist repeats this ritual of kissing and spitting out the chicks for as many rounds as he can manage within 20 minutes.

35 According to Yu's original plan, he had hoped to fill up the glass cube with chicks, revealing only his own face within a fuzzy yellow cube. But he didn't calculate the dimensions well enough and the 1,000 chicks, as many as he could afford to purchase, only filled up half the cube. He also didn't expect that so many chicks would be crushed to death by the combined weight of those above them. My phone interview with Yu, 28 July 2005, Los Angeles to Beijing.

Many chicks, having suffered Yu's kiss, revived after the performance; yet, unforeseen by the artist, those chicks stuck near the bottom of the pile in the glass box were crushed or suffocated to death.[35] How many animals, I wonder, die from human (mis)calculation per hour? As *Beauty's Kiss* keenly invites a gendered reading, I wonder too: How many girls (chicks) become casualties of human trafficking per day?

Not all animalworks in Gu's series follow homixenology's proclivity for joining interspecies bodies. Some present human–animal interactions by placing their contiguous performers in parallel situations. The following two examples adopt analogous procedures yet contrast in their manipulation of animals.

In *2000-7-2* (2 July 2000), Zhu Ming covers his naked body with blacklight paint—a paste that, after some exposure to light, will glow in the dark.[36] As the spectators wander into the dark karaoke room where the action

36 Typically, Zhu Ming marks each of his live performances with the date of its presentation. In 'Animal Games', Val Wang identifies Zhu's performance as *Subtle Brightness* or *Exposure* but Zhu told me that he didn't use the title. My interviews with Zhu Ming, 4 July 2005 and 10 July 2006, Beijing.

takes place, Zhu begins tracing patterns on his body; these emit an eerie glow when he turns off a flashlight. He then traces with the flashlight the body of a live fish which also shows patterns the artist has made with blacklight paint. Zhu then places the glowing fish into a water-filled tank where they begin to splash and swim.

With elegance and economy, Zhu turned the surface of his body and that of a fish into canvases while permitting the two performers—who doubled as somatic xingwei-zhuangzhi—to survive the art-making process, yielding sporadic glows amid acts of endurance.

Contemplation of the fragility of being finds a cruder version in *Meili you duojiu?* (*Beautiful, But for How Long?* 28 May), the first-ever xingwei piece by the young artist Liu Ding. Liu ties seven goldfish to little plastic dolls with red thread, returning the fish to their tank and allowing the encumbered fish to swim a while. Then he smashes the fish tank. As the goldfish gasp for air, a woman from the audience comes forward to save them, further involving the artist and other spectators in her rescue (Gu Zhenqing 2001).[37]

37 Also my interview with Liu Ding, 9 July 2006, Beijing.

Judged by its original plan, *Beautiful, But for How Long?* ponders mortality's terrifying power by showing animals dying. Liu's goldfishwork recalls, on a smaller scale, Sun's *Aquatic Walls* and Peng's *Curtain*. All three projects follow a homoeopathic principle, taking a small dose of poison (other beings' moribund agony) to guard against the same poison's fatal potency (our fear of death). The interactive dimension of a public xingwei artwork, nonetheless, leaves room for salvaging *Beautiful* from a literal manifestation of mortality to demonstrating the medium's rewarding openness to unpredictability.

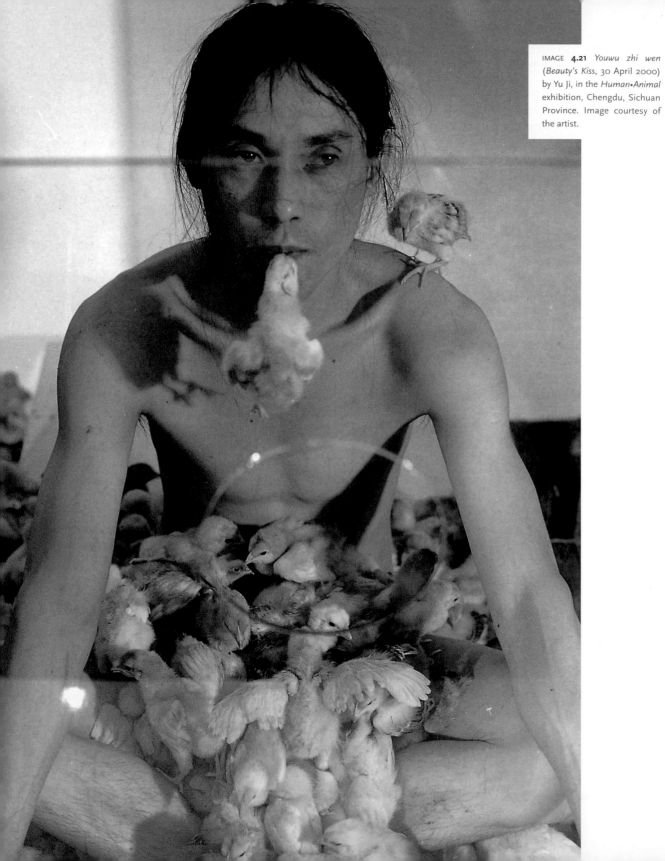

IMAGE **4.21** *Youwu zhi wen* (*Beauty's Kiss*, 30 April 2000) by Yu Ji, in the *Human•Animal* exhibition, Chengdu, Sichuan Province. Image courtesy of the artist.

| In most works from the *Human•Animal* exhibition, homixenology appears as a loose assemblage of differential bodies, human and nonhuman. Its effect of alien fusion stops at the skin's surface, without the deeper corporeal interpenetration that metaphorically indicates, within the performance's duration, radical transformation. Indeed, taken as a spatial directive, the thematic pair of *Human•Animal* encourages strategies that privilege exteriority, articulating relations between interacting surfaces—the artist's skin moving next to that of the animal's. Is it possible for us humans to thoroughly regenerate the self by engaging homixenology more deeply, as a catalyst for moulting via alien fusion? Can we shed our earthbound cocoons, stretch our shoulder blades into wings and become Zhuangzi's butterflies? Might we not also fly if we try and try, dreaming differently?

I shall approach this question by recalling my earlier proposition about the ideographic epistemology which, I believe, characterizes how a people who first invented and have since been inculcated by a linguistic/writing system centring on ideograms tend to conceptualize the world. Ideographic epistemology supports ideographic critique as a method of rereading the multiple implications of certain ideograms, such as *ren* (人) and *dongwu* (動物). Through an ideographic rereading of Gu's exhibition theme, then, I suppose we could access, or simply recognize, the fleeting vision of a human self's radical transformation. Admittedly, my theory is tentative and favours literacy; and my analysis is a speculative gesture towards sinification. I pursue it in the hope of imagining alternative realities through the process of uttering incongruous thoughts: strange ideas = new words; new words = other realities; strange ideas = other realities.

As the shapes of the Chinese ideograms have evolved throughout history, not to mention the system of simplified Chinese instituted by Mao Zedong in Mainland China after 1949, I opt to base my analysis on the particular traditional ideograms deciphered here, following the Taiwanese system I learnt.

The title *Human•Animal* covers three Chinese words: *ren* (人) and *dongwu* (動物). The ideogram for 人 (human) is simple, with a stroke slanting to the left, joined in the middle by another stroke slanting to the right. The word is shaped like an erect figure, with two arms stretching, reaching out, or two legs wide apart, ready to move. *Dongwu*, the phrase for animals, is composed of an ideogram for movement and another for object: *dong* (動) combines *zhong* (重, heavy), with *li* (力, weight), implying the strength necessary to counter gravity in motion; *wu* (物) includes a component for *niu* (牛, cow) and another for *wu* (勿, interdiction), hence, a forbidden cow, a thing not yet available for possession. To me, the most radical usage of homixenology comes from collapsing the two phrases in *Ren•Dongwu* into one ideographic entity: *shou* (獸), a classical/literary term for animals that may be translated as 'beast' for its mythic or monstrous qualities.

The ideogram for *shou* (beast)—獸—is much more complex than that for *ren* (human)—人—perhaps implying the otherness and inscrutability radiating from an alien subject. The ideogram is composed of two distinctive parts: on the left is as many as seven squares, each square an ideogram for *kou* (口, mouth), intimating the voraciousness of a creature with many mouths, eating away *tian* (田, the rice field); on the right is an ideogram, *quan* (犬, dog), that incorporates the ideogram for *ren* (人) but adds two more legs and a tail. Thus, the idea and shape of a human person (*ren*, 人) is contained within the ideogram for beast (*shou*, 獸)—although, with so many extra mouths to eat with and legs to run on, a 'beastly' animal would

probably hold some extraordinary—superhuman—power. Serendipitously, the Chinese classical word for 'animal' embodies my concept of homixenology—they even look equally awkward!

Philosophical significance aside, the ideogram for animal provides a greater range of formalistic possibilities than the one for human. The most dominant feature in *shou* (獸) is the mouth—*kou* (口) is a gate for change, an orifice able to absorb or filter alien substances and a malleable interface with otherness. The word's assorted mouthful openings foreground the potential for frequent transactions and they indicate the benefits, even as they expose the risks, of a symbolic/physical/psychic merging with foreign beings. The presence of *quan* (犬) in *shou* (獸) implies mobility, the speed of change which refers back to the movement and objecthood underscoring the phrase *dongwu* (動物, animal). So, where else is better for *ren* (人) to search for metamorphosis but in *shou* (獸), an ideogram that pulsates with the alchemy of transmutation?

The animalworks that fascinate me most from *Human•Animal* embrace the idea and process of self-transformation through alien-induced moulting. These artists employ homixenology to delve into the promising monstrosity of *shou*, perhaps for the re-genesis of *ren*, if not for the resulting hybrid that sheds the burden of being *ren* like a moult.

Consider these xingwei actions:

In *Luan tan* (*Chaotic Playing*, 28 May 2000), Gu Xiaoping places a *qin*, a traditional string instrument, across a cow carcase sprinkled with red rose petals. He plays furiously on the *qin* for several minutes, until his fingers bleed.[38]

38 My phone interview with Gu Zhenqing, 25 August 2004, Los Angeles to Beijing.

IMAGES **4.22.1–2** *Luan tan* (*Chaotic Playing*, 28 May 2000) by Gu Xiaoping. Image courtesy of the artist.

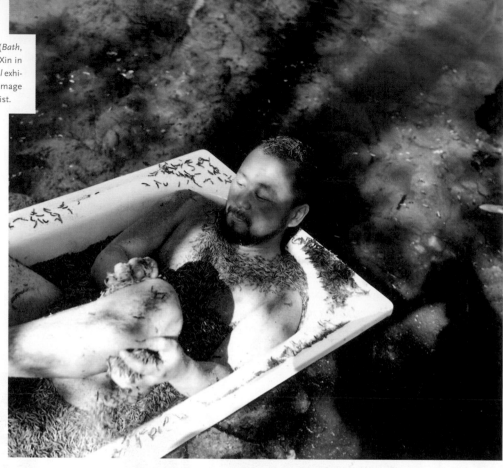

IMAGE **4.23** *Xizao* (*Bath*, 23 April) by Cang Xin in the *Human•Animal* exhibition, Beijing. Image courtesy of the artist.

In *Xizao* (*Bath*, 23 April 2000), Cang Xin stretches out inside a dry bathtub, letting insects swarm all over his uncovered body.[39] This single action done for *Human•Animal* extends from Cang's xingwei series *Bathing* (2000–02), in which the artist takes baths with, among other animals, lobsters, lizards, frogs and koi fish.

In *Wuyue ershiba dansheng* (*Born on 28 May*, 28 May 2000), Wu Gaozhong borrows the outer carcase of a cow from a slaughterhouse and allows his nude body to be sewed up inside the cow's belly. After a few minutes of wriggling, he cuts himself out and emerges, brand new and streaked with blood, throwing rose petals up in the air.[40]

These three animalworks are spatially and conceptually distinct from others in *Human•Animal*. The two components for the theme—*ren*/human and *dongwu*/animal—are no longer laterally aligned in space; they are merged, however briefly, into *shou*/beast. We cannot seek *ren* anywhere but within *shou*.

Gu's *Chaotic Playing* seems closest to other previously noted *Human•Animal* selections because he played the *qin* above, rather than below or inside, a cow carcase. Yet, instead of overwhelming the alien presence, Gu served both the music and the cow carcase by playing the

39 My interviews with Cang Xin, 29 June 2005 and 6 July 2006, Beijing.

40 My phone interview with Gu Zhenqing, 25 August 2004; my phone interview with Wu Gaozhong, 13 November 2004, Los Angeles to Beijing; and my interview with Qu Gaozhong, 30 June 2005, Beijing.

IMAGES **4.24.1–7** *Wuyue ershiba dansheng* (*Born on 28 May*, 28 May 2000) by Wu Gaozhong in the *Human•Animal* exhibition, Nanjing. Image courtesy of the artist.

qin, as an offering for the sacrificial beast, until he injured his fingers. The artist then removed himself from the scene, leaving his blood and the rose petals behind like libations, extending his gift for the spectacular monster he midwifed—a cow with a limb of *qin*.

'Grotesque', 'tickly' and 'molten' appear to be more appropriate qualifiers for the beast created by Cang's *Bath*. As Cang told me, *mianbao chong* (bread worm), the insects covering his body in this tactile insectwork, is a delicacy in northern China.[41]

41 My interview with Cang Xin, 29 June 2005, Beijing.

The swarm conceals and distorts Cang's torso or, rather, the migrating insects gift their human host with an extra epidermal layer, free-flowing and picturesque. The artist permits those that others relish as a crunchy dessert to colonize his body, graphically turning himself into a flesh motel to house the itsy-bitsy patrons. The sly grin from Cang's temporarily mutated face, however, checks my analogy of altruistic sacrifice. Cang's bath heralds a self-aware amalgam.

The theatricality of *Born on 28 May* emulates the rite of birth. Marking his performance date as a procreative moment, Wu practically literalizes what I theorize as alien fusion through homixenology. Strikingly, the birth of Wu's strange beast takes a double-turn: he is first born into the cow before he emerges from the cow. For a moment, we cannot find Wu but inside the hairy skin of the beast: as a *ren,* he has submerged into the *shou* to be reborn as a *renshou* (humanimal).

To different degrees, these three animalworks all grapple with the concept of transmutation. The human artists submit to an extrinsic force which is both a symbol and a task, a material challenge to be overcome and endured. The tactile negotiations between the artist and the task enact the spectacles of estrangement that these eccentric xingwei pieces project.

The estrangement, I argue, results largely from overturning the normative assumptions of anthropocentrism in an act of self-critique. No longer standing at the centre of the world, *ren* immerses his/her subjectivity into the affective environment of *shou*. At this cognitively remodelled moment, the presence of animal, or animal remnants, becomes a multivalent material sign. We may call it 'metaphysical cruelty' after Antonin Artaud (1958), or 'sublime terror' after Edmund Burke (1998), or 'terrible beauty' after W. B. Yeats (1996) or homixenology as I have proposed. Provoking the senses available to our human bodies, this sign of otherness is conceptually emplaced within the ideographic universe of *shou* (獸). This foreign sign resides at the margins of humanity and the borders of posthumanity, hinting at a subject's transcendence through the immanence of alien incorporation. Giving itself to be swallowed by an other, the ideographic flesh of *ren* (人) waits alertly for the next moulting season.

LET ANIMALS MULTIPLY! | *Human•Animal* served as a strong curatorial occasion to solicit animalworks from all over China. The pieces I analysed from this series, especially those that search for an ethos, if not an elixir, of self-transformation, reflect the effervescent mood of China at the cusp of a new millennium. My reading of these time-based artworks reinforces their tenor of transmutation, as if they were divination hexagrams from *I Ching*. But what exactly do these visions prophesy? A future in which human beings, though humbled by their

(FACING PAGE) IMAGE **4.25** Cang Xin's transanimalwork in his *Shamanism Series* (2005-), conceived by Cang Xin and drawn by Zhang Jun. Image courtesy of Cang Xin.

IMAGE **4.26** A transanimal drawing in Cang Xin's *Shamanism Series* (2005–), conceived by Cang Xin and executed by Zhang Jun. Image courtesy of Cang Xin.

limitations, continue to seek in their animal others a path towards personal salvation? If so, then homixenology, as the major alchemical 'medicine' or posthuman 'magic' I discern in these animalworks, is teleologically aligned with humanism's exclusive purpose to profit human societies. Although I am not against preserving and enhancing the future of human beings, this rationale per se functions to restrict conceptual possibilities for animalworks. In the past few years, however, numerous pieces coming out of Beijing have begun to envision a more expanded typological sphere for animalworks. Decisively, some of these animalworks moved out of time-based art's general fixation with 'the real' to embrace the symbolic eloquence of 'the fake'.

Cang Xin, for example, created a series of mythological transanimalworks through black-and-white pencil drawings. As his way of daydreaming impossible xingwei scores, the drawings from Cang's *Sama xilie* (*Shamanism Series*, 2005–) employ a homixenological principle at several levels.[42] In the production process, these drawings are collaborations between Cang, who designs all conceptual schemes, and his assistant Zhang Jun, who fully sketches out and realizes the corresponding picture on paper. In their execution, these drawings feature hyperrealistic renderings of surrealistic scenes in a syncretic style that defies the conventional criteria of either hyperrealism or surrealism. In their narrative content, the drawings depict Cang, as the protagonist, engaging in various supernatural actions. Many of these imaginary scenes play with homixenology by merging the image of Cang with those of fauna and flora.

[42] My interview with Cang Xin, 29 June 2005, Beijing; see also Cang Xin and Su Chen Hsieh (2008: 29).

As a giant, Cang sits devouring his midget clones; he stands in a business suit with his head floating apart from his neck, surrounded by pairs of zebras, ibexes, goats and buffaloes.[43] Cang is now lying on the ground busy writing on a thick notebook while his lower body disappears into the mouth of a chimera which looks like a crossbreed among a crocodile, a hippopotamus, a goat and a dinosaur. On top of this conjoined writerly beast, swirls of white circles zigzag like a twisted tornado: Is this 'tornado' a vacuum tube for the soul of the writing beast? Is it a spinning manifestation of the beast's vitality, radiating heavenwards?

[43] I've seen all these drawings in Cang's studio when I visited him in 2005. Reproductions of these drawings are collected in Cang Xin (2006).

I see these drawings in Cang's *Shamanism Series* as complementary extensions from his live xingwei projects, such as his series of tactile insectworks, *Bath*. What makes his virtual animalworks, or transanimalworks, in the *Shamanism Series* worthy of my double mention is Cang's acknowledgement, through his title, of the spiritual lineage that sustains these imagistic expressions: the Manchurian shamanism that is part of his ethnic heritage. This positions his transanimalworks not only within a contemporary art context but also within the larger spiritual awakenings and minority cultural self-definitions of postsocialist China. Cang's aspiration to serve as a 'cultural shaman' is perhaps best embodied in the drawing I prefigured among the opening *tableaux vivants*:

A lizard with the artist's head perches at the lower corner of a leaf, its veins supporting rows and rows of skyscrapers. His head is raised, yet looking downwards; his lizard body alert, with all but three toes hanging unto the edge and a long tail balancing against gravity. This is a shaman pausing in the midst of a metamorphosis, ready to leap from a microcosm, a metropolis nestled inside a self-sustainable verdant cosmos. The shaman is envisioning a future with precision and passion so that the version he dreams will become realized as the legacy of his ardent will.

I will close my lab session, however, with another return—back to the time-based animalworks that Sun Yuan and Peng Yu have been developing since 1998. *Aquatic Walls* and *Curtain* established Sun and Peng's notoriety for making heart-rending animalworks. If notoriety signals the acute degree of (negative) popular fascination, then it also proves the duo's ability to provoke audience response with their sheer ferocious aesthetic—which the critic Wei Xing once dubbed *sheng meng* (lively and fierce), facetiously evoking the pet phrase used by Chinese restaurants to advertise fresh seafood (Sun and Peng 2007b). I suggest, though, that the 'shock value' of the duo's animalworks simultaneously derives from their atrocious spectacles and conceptual inventiveness. This combination of visceral and cerebral intensity has propelled the duo's joint artistic inquiry, which excels in its temerity—Sun and Peng dare to go where most shy to even dream. But temerity may assume different guises: to stun with an in-yer-face audacity, to enrage with a blunt coolness or to surprise by eschewing time-honoured precedents. While it is facile to trace a lineal progression in Sun and Peng's output from youthful cruelty to mature sophistication, I recognize their consistent drive to transgress and to transcend their personal limits. Beyond the desire to shock and the need to outwit changing fashions, it is probably this drive for constant self-renewal—if only to keep their own nerves on edge—that has pushed Sun and Peng to diversify their subsequent animalworks.

We may begin again with an apparent counter-example to critical zooësis.

Linghun zhuisha (*Soul Killing*, 2000), which starred a canine corpse, made its unappetizing one-evening public appearance in a show called *Yishu Dacan* (*Food as Art*, 2000) at Beijing's Club Vogue Bar (Wu Hung 2000a: 190–5).[44] Characteristically, Sun and Peng pursued the exhibition theme to it literal edge:

44 Unless otherwise noted, all my descriptions about the Sun and Peng's animalworks are based on information provided on their website.

45 My interview with Sun and Peng, 28 June 2005, Beijing

> First, the artists purchase their primary art material—a complete and skinned frozen greyhound—from a food market and move the dog in its original frozen pose unto their table at Club Vogue.[45] Next, they set up several spotlights and a large magnifying glass as their cooking implements, incorporating a scientific experiment into the culinary event. They direct the heat from the high-voltage light sources through the magnifier onto the skull of their canine food stock/art object, barbequing the dog's forehead, burning its brain and gradually thawing its frozen torso, inducing a steam to rise from the dog's head and blood to drip down onto the white table cloth. (See IMAGE **4.1**, p. 235.)

This extreme and highly impractical 'food' preparation process is further troubled by the duo's disconcerting title for the piece: *Soul Killing*. Where is the 'soul' that the artists are 'killing' with concentrated electric light? Does it reside in an animal's brain? By the implication of their title, the steam coming out of the dog's brain is doubled as a natural and mystical phenomenon. It gives a visible physical shape to what some of us believe to be a spiritual entity, the soul, and exposes what some others believe to be an incontrovertible fact: 'An animal doesn't have a soul.' Here we see the light murdering the soul. Can we bear eating this soul-bearing flesh in the form of a dog in broad daylight?

Soul Killing turns Sun and Peng's usual practice of cultural citation on its head but retains their theme of literally treating animals as meat. The duo moved to a new theme of intra-species aggression in two subsequent, analogously structured, pieces. Both animalworks revolve round the performers' negotiations—voluntary or compulsory—with pre-established game

rules. The more lively and inventive the performer's responses to the game the better the show. Thus, the subjectivity of the performers is encouraged, although their actions are bound by regulations.

A bell rings. Eight pit bull terriers, groomed to perfection and barking periodically, mount eight modified treadmills to perform *Quan wu jin* (*Dogs That Cannot Touch Each Other*, September 2003). The treadmills are evenly divided into four parallel sets of two, with each set blocked in the middle by a cardboard barrier. Once the pit bulls are securely harnessed, their human attendants pull out the cardboard, leaving the dogs to face each other. Barking menacingly, the dogs attempt to attack the ones they face but manage only to activate the treadmills on which they run nonstop.

A bell rings. Three human boxers—each in a different weight category—step into a boxing ring to perform *Zheng ba* (*Contend for Hegemony*, December 2003). The boxers greet the cheering crowd ceremoniously and proceed to fight with one another. A fluid alliance-and/or-opposition configuration is quickly formed—at times two boxers fight the third; at others, all three are entangled in a storm of fists and kicks. When one boxer falls, he is left alone; the other two continue the fierce combat.

For the canine piece, the artists rented the eight pit bulls from a provincial breeding and training institute for fighting dogs. The pit bulls were so territorial and violent towards each other that they had to be transported individually in eight limousines, with their human coach and attendants in tow. Like the limousines, the custom-made treadmills separated the dogs but the machines were lined up to keep the dogs in plain sight of their rivals. As their bloodlust urged the dogs forward, the human-made restraints succeeded in turning a would-be deathly fight into a fierce sonic, olfactory and muscular sporting event. In fact, the dogs' regular coach found the treadmills so effective for canine training that he purchased four units from the artists right after the show.

Dogs That Cannot Touch Each Other references the brutal sport of live animal combat which involves crickets, cocks, dogs and bulls in various parts of the world. Instead of overtly challenging the ethics and legitimacy of staging live animal fights, however, Sun and Peng intervened in this pre-existing zoöetic context by modifying the competitive structure with numerous performance procedures. They appropriated a common human exercise machine to shape the canine game, demonstrating how humans can sublimate the dogs' aggressive behaviour into a physical training/gaming regimen. They also divided the event into three precisely timed seven-minute segments, beginning with a round of matches, followed by an equally long intermission and closing with another round of matches. During the intermission, the human trainers diligently cared for the dogs, gave them water and rubbed down their sweaty furry bodies to relax their muscles, treating them like star athletes.[46] As the artists' temporal structure suggests, these restorative rituals that the humans lavished on the dogs were as much part of this xingwei-zhuangzhi as were the dogs' running and barking matches. Although Sun and Peng's art event was as coercive for their involuntary dog performers as the brutal sporting events they referenced, their altered game rules protected the dogs from excessive physical harm—a routine consequence suffered by canine performers in conventional dog fights.

While the artists' zhuangzhi set-up physically enforced the simple rules on their pit bulls, *Contend for Hegemony* adopted a complex set of rules to challenge their more calculating

46 My interview with Peng Yu, 6 July 2006, in Beijing.

IMAGES **4.27.1–4** *Quan wu jin* (*Dogs That Cannot Touch Each Other*, September 2003) by Sun Yuan and Peng Yu, in the *Second Hand Reality* exhibition, in Today Art Museum, Beijing. Image courtesy of the artists.

IMAGES **4.28.1–5** *Zheng ba* (*Contend for Hegemony*, December 2003) by Sun Yuan and Peng Yu, in the *Left Wing* exhibition, Left Bank Gallery, Beijing. Image courtesy of the artists.

human/animal players. This dynamic xingwei-zhuangzhi piece proceeded as a sparring contest among three professional athletes, recruited by the artists from actual national sparring teams; each boxer belonged to a different weight category (80 kg, 75 kg, 70 kg respectively). The goal of the contest was to accumulate the most points. A contestant could score points by hitting on the opponents' targets, printed on the front side of the three different-coloured vests worn by the participants. Each contestant could team up with any other at any time to attack the third. No one was allowed to attack a fighter who fell but had to turn against the other one who remained standing. Except for hits to certain restricted body parts, all other techniques—punching, kicking and wrestling—were permitted. In the actual performance, which lasted 17 minutes, the first player to lose out belonged to the lightest weight category; the final winner was the medium-weight player. I suspect this result was accidental, contingent upon the impromptu tactics adopted by the mixed-level players. The humour of this humanimalwork stems from its blending of distortion and allusion: it distorted certain existing rules in gaming, boxing and wrestling matches but it alluded to some parallel procedures elsewhere in human society, such as global business competitions and political rivalry in international relations.

Anquandao (*Safety Island*, October 2003), a tigerwork presented between the duo's treadmill-running pit bulls and hegemonic boxers, refers to another humanimal institution: the zoo.

Safety Island comprises a cage within a cage: one for the tiger, the other for people. The tiger is on loan from the Nanjing Zoo; the people are viewers attracted to a group art show, *Muma Ji* (*Trojan Horse*), in which *Safety Island* participates.[47] Observing that tigers would pace back and forth in an unfamiliar environment, Sun and Peng designed a transient zoo within the

47 My interview with Peng Yu, 6 July 2006, Beijing.

IMAGES **4.29.1–2** *Anquandao* (*Safety Island*, October 2003), an animalwork by Sun Yuan and Peng Yu in *Trojan Horse*, Nanjing. Image courtesy of the artists.

exhibition hall, surrounding its four walls with a large and unimpeded corridor, divided by steel bars from the rest of the hall—a caged walkway round the cage. They place the tiger inside the caged corridor, letting it pace about or rest, depending on its mood. They also equip the caged corridor with two possible entrances/exits that can be converted by folding two steel cage doors inward to make openings for people to pass through while closing off the tiger. The artists further pose attendants in traffic-police uniforms at the two convertible gates, asking them to heed the tiger's motion as the indicator of when to let people in and out. Their one traffic rule is to enable the tiger freedom of movement. This in turn restricts human traffic, for no viewer can enter or leave the exhibition hall without passing through the two convertible gates.

Based on the artists' conceptual design, the title for this tigerwork—*Safety Island*—acquires a double meaning: as a substantial partition between opposite traffic and a protective zone for its sole inhabitant and visitors. Inside this 'safety island', the tiger's instinct to evade capture was given relatively free expression while its carnivorous appetite was kept at bay. Although the tiger remained caged, it enjoyed a degree of mobility; that in turn deprived its human spectators of their autonomy. The captive was symbolically granted the agency and power to determine its captors' potential passage. In their inversion of conventional expectations, Sun and Peng's cage installation functioned like a Trojan horse, a furtive stratagem that could endanger its unsuspecting capturers. Their tiger corridor was simultaneously part of and an obstruction to the *Trojan Horse* show, framing all other exhibits within its cage by barring viewers from accessing them without first passing through their own xingwei-zhuangzhi. The strong presence of an Asian tiger in a cage inflects the entire exhibition, turning this Foucaultian 'heterotopic' site into a mixed-use zoo, displaying animals and their artefacts to an interspecies viewership: people watching a tiger watching them watching human-made objects of art (see Foucault 2008).

A zoo, as Berger puts it succinctly, is a place to which 'people go to meet animals, to observe them, to see them, is, in fact, a monument to the impossibility of such encounters' (1980: 19). By quoting from the cultural practice of zoos, *Safety Island* remains complicit with its anthropocentric logic: a tiger kept is a tiger changed. But this animalwork also subverts such logic by turning viewers into a kept herd, shepherded by their tiger patrol. While the artists risked frustrating their viewers' desire to remain in control, they counted on their capacity for curiosity and hunger for novelty to tolerate, even relish, temporary confinement. Nevertheless, *Safety Island* was after all an event for humans. The tiger, now appearing performatively at an advantage, would return to its confinement in the Nanjing Zoo, whereas the viewers, who had experienced captivity, would retrieve their self-determination after the show. This time-based artwork's interactive structure made explicit the viewers' different *and* shared experiences with the tiger while evoking the multifarious restrictions in human society. If nonhuman animals are domesticated, placed in zoos or driven to the fringe of survival by humans, are we humans really free to do all we desire in a world ruled by our own species?

In *Shiwan nian* (*Ten Thousand Years*, 2005), Sun and Peng departed from their citation of cultural zooësis to question the conventional distinction between humans and other mammals based on their dissimilar phenotypes. This animalwork adopted the eponymous title of a group show curated by Sun and Peng, who required all participants to use art materials available 10,000 years ago, such as water, mud, plants and stones.[48] The show began at 3 p.m. and ended at the onset of darkness; no electricity was used to extend the exhibition hours.

[48] My interview with Peng Yu, 6 July 2006, Beijing.

A lone figure moves on top of a glass roof. Dressed in a dark suit, the figure resembles a man, yet an abundant layer of thick black hair covers his face and body. From time to time, the figure looks through a zigzag hole in the ceiling at the activities inside the building.

For their contribution to *Ten Thousand Years*, Sun and Peng juxtaposed a found and a fabricated element: the lone figure on the rooftop was a man named Yu Zhenhuan, nicknamed Mao Hai (literally, Fur Child), who was born with an abundant layer of black hair all over his body, including his face. The artists found Yu, who agreed to partner with them to devise the performance score. Staying on top of the exhibition's loft space during the entire show, Yu paced round and periodically peered through a custom-made broken pane of glass.

Strictly speaking, both found and fabricated elements in *Ten Thousand Years* violated the material restriction imposed by their curatorial scheme. The man they found exists in the present world—although, according to the artists, their hairy protagonist expresses certain genetic traits recalling those of our prehistoric ancestors. The broken glass window that the duo fabricated is made of a material probably first invented in Egypt around 2500 BCE—although the artists might argue that they only simulated removing a fragment from the existing glass ceiling rather than using glass as their material. In any case, these actual, if somewhat defensible, violations heighten the

IMAGE **4.30** The performer Yu Zhenhuan watching his audience from the rooftop in *Shiwan nian* (*Ten Thousand Years*, 2005) by Sun Yuan and Peng Yu, in the *Ten Thousand Years* exhibition, Beijing. Image courtesy of the artists.

ambiguity of the piece's title, which could point backward to the past or forward to the future. A narrative of temporal flux and convergence results: the figure walking on top of the glass roof appeared like an avatar from 10,000 years *ago* or *ahead*. Perhaps the impact of his descent, like a precipitating comet, broke the window. Yu's ostensibly interspecies presence portended an alternative evolutionary path. He gazed at his others, those hustling and bustling art patrons down below, from his vantage point, literally as a 'higher' being. This Fur Child exemplified the power of a voyeur as a perceiving subject.

My identification of *Ten Thousand Years* as an animalwork follows the internal logic of my critical project, which has elected 'animals' as the totalizing taxonomic term to subsume both humans and other animals. While my analysis has problematized the ontological distinction between human and nonhuman animals, I have not addressed the functional difference specific to each species. In other words, I call all of us animals without asserting that all animals are therefore humans. The presence of Yu in *Ten Thousand Years*, nevertheless, brings up a question: If not all animals are human, how do we identify a human being? This general question poses different challenges to the artists and to me, their critic/interlocutor, in constructing and assessing *Ten Thousand Years*.

A professional singer who aspires to move into acting, Yu Zhenhuan wanted to present himself as an extraordinary human being, not an interspecies freak. Although Sun and Peng's concept for *Ten Thousand Years* hinged on Yu's hairy appearance, the artists remained sensitive to their performer's particular identity and avoided creating a scenario that would exploit Yu's external features to his detriment. As the action score suggests, their solution was to let Yu occupy a dominant position—being the one on top and in the know—while making their spectators his spectacles. Within this performative reframing, Yu reversed the power dynamic he probably often experiences in daily life by gazing at those who might otherwise feel licenced—by virtue of their majority status—to gawk at his otherness. This piece therefore subverted the convention of a freak show by placing Yu outside the exhibition frame, endowing the one who might be labelled a 'human oddity' the privilege of spontaneously moving about, seeing, being seen or turning his back to remain partially hidden from sight.

My challenge in critiquing *Ten Thousand Years* lies in nomenclature which results not from Sun and Peng's aesthetic scheme but from my analytical agenda. Since the artists do not claim *Ten Thousand Years* to be an animalwork, they evade the taxonomic pitfall that I risk. By definition, a performer's human identity in a time-based xingwei-zhuangzhi does not necessarily contradict my conception of animalworks. Yet, due to Yu's unique appearance, my naming *Ten Thousand Years* as an animalwork might inadvertently obscure his human identity, thereby conflating my strategic deconstruction of human and animal dichotomy with the knee-jerk denial of the performer's species status: 'How can that hairy ape be a man?' My semantic dilemma may be resolved, I submit, by honouring Yu's preferred identity. Giving Yu the final say in *Ten Thousand Years* would then answer my earlier question about how to identify a human being. Yu's self-identification as a human male indicates that genetics, parentage, upbringing, education, individual characterization, community affiliation and societal agreement are some of the criteria with which we recognize a human being. In this sense, *Ten Thousand Years* is an animalwork that exhibits the visible disparity and diversity within the human species.

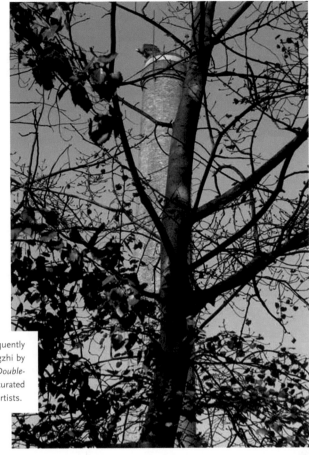

IMAGE **4.31** *Deng ni* (*Waiting for You*, 2006, subsequently renamed *Waiting*), a site-specific xingwei-zhuangzhi by Sun Yuan and Peng Yu as part of the exhibition, *Double-Kick-Cracker: Chinese Contemporary Art Exhibition*, curated by Gu Zhenqing, Beijing. Image courtesy of the artists.

In their subsequent animalwork, Sun and Peng returned to their perennial preoccupation with mortality.

The artists plant a gigantic verisimilar vulture on a factory chimneystack and slant the statue towards the ground. They provocatively entitle the piece, *Deng* (*Waiting*, 2006).

What is a vulture waiting for? Dead meat. Today, we live; tomorrow, we die. And the vulture knows when its prey is ready; it hovers above, waiting for us at the next instant to initiate our own uncooked process of *becoming-food*—if I may give an altruistic slant on the Deleuze-Guattarian conceit of 'becoming-animal' (1988: 233–309). While the theme of fatality is not new, Sun and Peng have remodelled their aesthetics by crossing the border between the live and the static, the real and the verisimilar. In terms of its material usage alone, the vulture in *Waiting* differs from the duo's previous animalworks for being a straightforward sculpture—made of relatively stable substances (fibreglass, steel, plastic, bird feathers, etc.)—which does not expire when its public exposure ends. By integrating synthetic materials into their artistic comment on death, the duo has eschewed their literalist approach to move further towards the symbolic property of art. This move might indicate their attempt to test new grounds, exploring

the provocation of the figurative rhetoric. By implication, it also redefines animality to include not only that which is innate but also that which is incited by the entity's phenomenological presence. The time-based element in this piece no longer resides in its animal performer's essence as a procreated, sentient, motile and mortal being; rather, it is interactively engendered by a perceiver's impression: 'Look, there is a vulture up there!'

Responding to my query about this change, Peng stated that she and Sun never insisted on using any particular substance but always tried to find what best fit a given project.[49] Thus, the creation of their art depends on the interactive context for each project. Since they have often produced an artwork in relation to a commissioning exhibitor, they have used the logistical circumstances (budget, location, theme, etc.) to orient their artistic response. *Waiting* is paradigmatic of such a flexible process. During a scouting trip to their group exhibition site in the 798 art district, the duo spotted a tall chimney. This inspired them to place a vulture on top of it, angled predatorily towards its future human prey. Because of the chimney's height (40 m), they decided not to use a live vulture, which would be too small and too difficult to bind to the structure, but hand-made a enormous one to give the scavenger more weight. The vulture's extraordinary stature overcame the optical limit imposed by the physical distance, casting an ominous presence over its earth-bound viewers.

I know the vulture is also waiting for me, but who/what is waiting for the vulture?

49 My phone interview with Peng Yu, 7 October 2007, Los Angeles to Beijing.

ANIMAL REVERIES | 'Zoocentrism', in microbiologist Lynn Margulis' definition, signifies,

> Preoccupation with animals, including humans, as if animals were the main organisms in existence, and/or the only ones worthy of study. Great disregard for members of the other four kingdoms of life, dismissal of them as 'lower' forms, ignores the major impact that these four kingdoms have upon members of the animal kingdom and Earth's ecosystems (Margulis and Sagan 2002: 217).

My inquiry into Chinese animalworks is guilty of zoocentrism which—theoretically encompassing both humanism and posthumanism to reach the entire 'Animalia' kingdom—excludes the dense and complex richness of other vital centres of terrestrial lives: the other four kingdoms of Monera, Protista, Fungi and Plantae, according to the Linnaean System that Margulis references (see O'Neil 2009). This exclusion, however, reflects Chinese time-based art's current optical premise, which privileges what's visible to the naked eye as the boundary of its praxis largely because the scientific data and discoveries regarding, say, symbiotic microbes, obtainable through the aid of an advanced technological infrastructure, is beyond the reach of its practitioners. In this chapter, I walk the pathways built by numerous artists—all but four now living in Beijing—with lots of help from other animals—all plainly accessible to the five basic human senses. Zoocentrism is the best recourse for these 'poor' artists to utilize the raw bio-power of their animal performers without the high-grade prosthetic augmentation of biotechnology. In this light, zoocentrism is the very limitation that enables the artists and me to pursue our intertwined creations and interpretations.

Why do people produce animalworks? An animalwork differs the most from other types of time-based art when it involves the subjectivity, materiality, volition and motility of a nonhuman performer with whom the artist-creator must interact. This scenario heightens an artwork's danger, surprise and wonder because the artist's animal other is never entirely predictable or under control. Unpredictability, however, is not the sole attraction of engaging an animal other. I hold that the appeal of an animal other in art consists of two paradoxical qualities: its proximity to and distance from humans. Compared to single-celled bacteria and multicellular filamentous beings like fungi, a pig or a silkworm, a ram, a frog or a dog is as near, dear and comprehensible to me as is my distant human relative. Yet, however closely I observe a pig, my nostrils cannot grunt and dilate the same way its snout does, nor can I translate into exact human language what the pig says to me when it twitches its ears, moves its buttocks and wags its curly tail. I am all the more fascinated with this pig before me because, like me, it walks, runs and lies down to rest; but, unlike me, it does all those things with four legs. Our biological proximity reinforces my empathic connection with my model pig; our inability to confirm mutual understanding keeps me ever curious about its next move, an inexhaustible mystery of porcine cognition and locomotion. An animalwork compels my attention because it turns my incompetence at fully grasping the psychology of an involuntary performer into my incentive to keep watching—an enabling limitation, ever tantalizing for its partial mystique.

An animalwork is thus made to benefit people like me, who wish to learn from a boar and a sow, a brood of silkworms, a ram that survives a manmade ordeal, a pigeon that flies away, a swarm of insects . . . swarming, eight running pit bulls, a tiger on guard and a verisimilar vulture. They teach me to dream differently, humming like a cicada in interglacial times and leaping like a reindeer on shamanic plains.

INDIgeSTIBLE COmmDITIES

THE DURATION OF ICE | *Object #1* (1996) | A new shopping mall in Zhengzhou, the capital of Henan Province, unveils a monumental wall of ice.¹ The wall, built on the public square facing the mall, stretches to 30 m in length and consists of approximately 600 individual ice blocks, standing firm against the wintry sky and the boisterous cityscape. Encased within these ice blocks are photographs about the old mall, burnt by an accidental fire a year ago, and more than 1,000 luxury commodities, ranging from cell phones, cameras and TVs to watches, gold rings, leather bags and bottles of perfume.

1 An earlier version of this essay appeared as Meiling Cheng (2007b). Special thanks to Winnie Wong, my fellow researcher on Chinese contemporary art, for reading the first draft of this chapter and offering many insightful suggestions. The descriptions of all time-based objects in this chapter are based on my analysis of archival documents, including extensive photographic images, a few videotapes, artist statements, websites and exhibition catalogues, supplemented by my interviews with artists and other critical/curatorial accounts cited with individual pieces.

IMAGE **5.1** *Object #1—Bing. 96 Zhongyuan (Ice. 96 Central China, 1996)*, by Wang Jin, in Zhengzhou, Sichuan Province. Image courtesy of the artist.

The management team in the Zhengzhou shopping mall, together with the Samsung Group, a multinational corporation from South Korea that wished to enter the Zhengzhou market, commissioned Beijing artist Wang Jin to create a sensational event for its opening ceremony. Wang proposed to build *Bing. 96 Zhongyuan (Ice. 96 Central China*, 1996), an enormous ice

IMAGE **5.2** Spectators dismantling Wang Jin's *Ice. 96 Central China* (1996). Image courtesy of the artist.

sculpture embedded with pictures of the mall's predecessor, plus an abundance of commercial goods. Although Zhengzhou was then a conservative provincial city, the sponsors welcomed Wang's innovative proposal which they hoped would culturally augment the commercial occasion and attract more customers to the new mall's inauguration. In order to satisfy his clients' need and desire for advertising, the artist shielded his installation process from public view with a safety fence which doubled as a billboard for friendly messages from South Korea: 'Greetings! Samsung salutes residents of Zheng-zhou!'[2] Wang also spent part of his production fee on purchasing historical photos of the burnt mall from local photographers and a huge quantity of merchandise from the new mall. Wang's resulting xingwei-zhuangzhi scheme was ambivalent enough to meet his clients' wishes for conspicuous display and to fulfil his purpose of criticizing China's amped-up commercial turn.

2 My phone interview with Wang Jin, 6 February 2011, Los Angeles to Beijing.

The opening ceremony surrounding *Ice. 96 Central China* began in a traditional fashion: a city official was invited to cut the ribbon, followed by teams of folk artists performing the auspicious dragon dance, undulating amid the festive sounds of drums, gongs and firecrackers. More and more spectators stepped closer and closer to the sumptuous ice sculpture until their numbers soon overwhelmed that of the dozen or so guards stationed round it. Glowing in its translucent monumentality, Wang's great wall of ice was alluring window dressing for the mall's retail splendours but it also kept the merchandise inside the 'window' and frozen beyond reach. By the artist's initial calculation, the thick ice layer would last about a week in the roughly 0°C temperature of Zhengzhou in January 1996. To Wang, the frosty presence of the ice symbolized rationality which served to purify the tantalizing commodities through the 'baptism' of detached

contemplation (Wang Jin 2002). Although Wang expected some spectators, in 'three or four days', to succumb to his transparent temptation and break down the icy barrier, both he and his sponsors, watching the event from a distance, were surprised by the zealous crowd. The nearly 10,000 spectators gathered by the mall's publicity campaign soon downgraded the ice wall from a visual curiosity to an obstacle, tearing it apart like a bulky package to obtain the enclosed treasures. Beginning with a few fingers poking here and there, the audience participation escalated into a 'spontaneous frenzy of desire' (Aric Chen 2007). The swarm, now including neighbours, intrigued passers-by, destination shoppers and folk performers for the opening ceremony, wielded hammers, crowbars, rocks, dragon-dance poles and other impromptu tools to compete for the instant rewards. Within hours, the mob demolished the imposing sculpture—which took much longer to erect—transforming a sober zhuang-zhi, installed partly to critique its complicity with commercialism, into a carnivalesque xing-wei 'parade' of the socialist market economy, à la central China.

Object #2 (1995) | A 10 cu. ft mass of ice blocks appears on the public pavement next to the Funan River, which flows 47 km through Chengdu, a populous city in the inland province of Sichuan (Yin Xiuzhen 2002: 17).[3] The assemblage of ice slabs looks sordid and dull, besides emitting a fetid smell under the August sun. Yin Xiuzhen, the artist for this xingwei-zhuangzhi, has constructed the ice assemblage through a recycling process. She drew water from the polluted river, transported the tainted supply to a factory to be frozen into building blocks, stacked the blocks to form an ice mound and then

3 Also my interview with Yin Xiuzhen, 5 July 2006, Beijing.

IMAGES **5.3.1–4** A sequence of performance shots from *Object #2—Xi he* (*Washing the River*, 1995) by Yin Xiuzhen. Image courtesy of the artist.

transferred the mound back to the river's edge. Standing next to her sweating assemblage, Yin uses a brush and buckets of fresh water to scrub the ice's contaminated surface; she also invites passers-by to join her xingwei in *Xi he* (*Washing the River*, 1995). It takes the artist and her participating viewers-turned-co-performers two days to finish their cleansing act by which time the putrid ice mound disappears.

According to a local old timer, the Funan River used to be clear and vibrant with fish and frolicking swimmers (Ma Guihua 2002). By 1985, the river had become so dirty and foul-smelling that it prompted a class of primary-school children, after their one-day field study, to write a letter to the mayor, beseeching all residents to stop dumping domestic and industrial waste into the river. Chengdu's city government finally acted in 1992 to institute a comprehensive five-year Funan River Revitalization Project which closed down hundreds of polluting factories, demanded better waste-disposal technology from others and relocated more than 100,000 shanty-town residents to restore grasslands along the banks. As part of the local government's concerted efforts to raise residents' ecological consciousness, the city sponsored time-based art projects like *Washing the River*. Through an ephemeral artistic gesture of symbolic redress, Yin's negentropic xingwei anticipates the Funan River's incremental regeneration to again become a 'green necklace round the neck of Chengdu' (ibid.).

Both *Ice. 96 Central China* and *Washing the River* revolve round an art object whose material attributes render it palpably transient and mutable, hence time-based. Wang's ice wall and Yin's ice mound are then performative objects, because both ceaselessly change their material state during their open display, as if they were 'performing' an ongoing dialogue with their environments, taking in whatever natural and contingent effects were offered by time. These two temporary sculptures also function as catalysts for interactive performances with their spectators, although, once placed in an unrestricted public context, neither can control what they might inspire. *Washing the River* unfolded more or less as the artist had planned. Yin did not endure solitary labour for long before random passers-by joined her ritualistic 'river-washing' which relied on her participants' voluntary communal collaboration to bring to light its social efficacy. The time it took for Yin's polluted ice stack to be washed away also marks the duration of her artistic-civic service. Although the water from Yin's melted ice sculpture could not be recycled, the communal effort in cleansing the dirty river's frozen double affirmed her artwork's proactive ecological implication.

Conversely, the glacial monument in *Ice. 96 Central China* was a catalyst that 'dematerialized' its social critique through the interactive performance it provoked. The covetable commodities suspended in Wang's semi-transparent treasure chest enticed spectators to enact, en masse, the capitalist machinery of greed. These spontaneous players were united in their respective quests to convert, as Wu Hung observes, what they saw as 'images' into 'material things' that could be owned and carted away (1999: 159). Ironically, this irruption of over-ardent audience participation shaped the sociohistorical significance of *Ice. 96 Central China*. That which failed to transpire in Wang's time-based artwork was precisely the natural temporal progression. Given enough time, the icy layer of Wang's wall would have dissolved, yielding its implanted prizes to possessive hands. Nevertheless, the spectators decided to take the matter into their own hands; their competitive efficiency drastically shortened the duration of Wang's xingwei-zhuangzhi. Through their concurrent individual xingwei/behaviours, these 'spect-actors'

4 The term 'spect-actor' was coined by Augusto Boal in *Theatre of the Oppressed* (1985).

collectively revised an authorial allegory against mercantile seduction, restaging it as a combustible show of China's accelerated consumer revolution.[4]

Although Wang's ice wall and Yin's ice mound are both perishable performative catalysts, they belong to different time-based art modes which allow varying possibilities for authorial intervention. As a stand-alone xingwei-zhuangzhi artefact, the ice wall cannot be pinned down to any meaning. The occasion of a shopping mall's opening circumstantially endowed the installation with a festive promise which then became realized as a commercial drama through its audience's participatory agency. The crowd's improvised competitive 'game show' overrode the artist's critical intent, if not his premonition to inspire an audience response similar to that which he had just witnessed. After the event, Wang chose to supply an art historical addendum by publicizing his motivation through the press, although his very act of doing so inversely exposed his authorial impotence. As a behind-the-scenes presence, Wang might have vaguely foreseen but could not fully control how his spectators-turned-participants would react to the sensorial stimuli exuding from his catalytic object.

If Wang was unable to direct how his live audience would interact with his xingwei-zhuangzhi, he did have some influence over how his ephemeral artwork was read going forwards. Through post-mortem interviews, Wang first represented his subject position as dubious about the commercial excess. From this perspective, *Ice. 96 Central China* positively identifies the artist's critical attitude with his transient art object—the iconographic ice barrier to thousands of mercantile inserts embodies his antagonism towards commoditization. Wang erected the frozen blockade, then, as the material equivalent of an individual's wish to stop the march of capitalism, if only temporarily. More recently, however, Wang professed that he tried to provide a possible 'contact point' for his viewers to 'enter' his artwork by making the icy wall 'highly transparent'.[5] In other words, unlike his sponsors, who were somewhat disappointed that the ice sculpture was destroyed in less than a day, Wang himself now interprets the crowd's frenzied 'entry' into his artwork as indicative of his icework's power.

5 My phone interview with Wang Jin, 6 February 2011, Los Angeles to Beijing.

The dilemma of leaving an ephemeral artwork at the mercy of those who happen to show up plays itself out differently in a xingwei piece. Yin's ice mound in *Washing the River* is simultaneously a xingwei-zhuangzhi sculpture and a prop she used during her performance. Her active presence as the xingwei artist within the artwork taught her viewers how to behave. By taking the lead and motivating others, Yin enjoyed relatively more control over the way her self-enlisted participants would carry out her score. Their joint cleansing action serves to articulate Yin's subject position in *Washing the River*, which posits a negative or dialectic identification between the artist and her catalytic object. Yin's status as an individual living in a postindustrial world is threatened by the ecological depredation that her tainted ice mound indexes. The largely symbolic remedy taken by her and her co-performers—in its infinitesimal scale—works towards restoring the river as a living environmental asset for the city. The more they diminish the polluted mound, the less onerous their task remains and the less odious their target object becomes. *Washing the River* shifts the process of *consumption* from a wasteful act (as an utter *expenditure* of matter) to the communal *elimination* of an urban crisis.

Ice. 96 Central China and *Washing the River* were both located in a public space, open to a haphazard audience of ordinary citizens who became, by provocation or by design, the artists' collaborators. Since Wang did not appear in the artwork, his authorial presence remained implicit though he did later avow an interventionist stance similar to Yin's in *Washing the River*. Both artists position themselves as emblematic human subjects and public intellectuals, fulfilling their responsibilities towards the body politic through their democratic art which addresses urgent social issues. Such non-region-specific traits (that is, social relevance, public interest, accessible civic sites, the artist's engaged ethical self-positioning and collaborative outlook) affiliate Wang's and Yin's pieces with what Suzanne Lacy has theorized as 'new genre public art' (1995). They remind us that xingwei yishu and xingwei-zhuangzhi exist in the dynamic tension between globalization and regionalization. Methodologically, Chinese time-based art has assimilated many lessons from equivalent international art media; thematically, it treats numerous problems affecting our current global existence—consumerism and ecological degeneration being two typical cases. To locate Chinese time-based art as a medium of international creative expression modified by glocal particularities, then, requires a nuanced contextual reading.

While employing a common material for transient art, the ice-made sculptures in *Ice. 96 Central China* and *Washing the River* pointedly reference China's postreformist push for modernization, industrialization and economic advancement. Wang's translucent ice wall tantalizingly display the fruits of Zhengzhou's commercial boom. Yin's foul-smelling ice mound exposes the negative yields of Chengdu's hitherto unregulated or poorly planned urban development. Wang's choice of ice in winter and his artwork's massive scale reveal his desire to extend the duration of his frosty installation as a physical and figurative blockade to the embedded commodities. Yin transforms the imperilled, disease-ridden river water into solid ice to facilitate her viewers' interaction with the otherwise untouchable stream. She constructs her ice mound on a slightly larger-than-life scale to highlight the river's ecological crisis as a collective problem. Yet, mindful of her xingwei artwork as a symbolic redress, Yin refrains from raising a structure so colossal that it would require inordinate human labour to wash it clean. The duration of each icework therefore derives from its projected goal, even though the goal might not be achieved during the actual presentation. In *Ice. 96 Central China*, the planned duration for an enormous ice structure to melt indicates the artist's cautionary stance against consumerism; in *Washing the River*, the ice's modest volume and anticipated short life span reflect the artist's consideration of practical feasibility while thematically suggesting that such a cleansing ritual is not a singular, monumental act but an ordinary restorative routine repeatable by individuals.[6]

6 I thank Winnie Wong for pointing out the possible connection between Yin's choice of a less-than-monumental structure in *Washing the River* and the repeatable action facilitated by such a scale. Personal email correspondence, 31 August 2010.

My assessment of *Ice. 96 Central China* and *Washing the River* offers an analytical point of departure for an inquiry into the status of performative objects in selected Chinese time-based artworks. In my most straightforward usage, 'objects' are material entities that can be seen, touched, smelled, tasted, assembled, erased and studied; they may be inflated, diminished,

TYPOLOGY OF TRANSIENT OBJECTHOOD: CATALYSTS, PRAXIS, HABITAT, SIMILITUDE

broken, inhabited, copied or purchased. How do these objects—which are by and large things without agency—perform? Since I consider only impermanent artworks, these objects may appear to be performing their changing material states by revealing the effects of time on them. Their automatic performances draw on a viewer's perception of the ceaseless interplay between matter and time. In my second usage, I investigate the selected 'objects' for their roles within the time-based artworks that revolve round them. The functions they serve define their performances. In my third usage, 'objects' are taken as itemized targets in my research inventory. Their variegated standings as transient artworks are the performances that elicit my query into their time-based objecthood. The 15 objects treated in this chapter all comprise shifting elements; at times, they are themselves performance artworks which exhibit an expanded sense of materiality by incorporating both three-dimensional beings and a certain process in time, traceable only through a narrative recall. These temporal artworks-as-mnemonic objects are performative when they first happened and again when they inspire a future other's imaginative reenactment.

To assess the list of intellectual commodities as objects of my cognitive purchase reflects my desire to understand how an ephemeral medium like time-based art deals with art objects and how these art objects become entangled with and yet remain distinguishable from ordinary commodities. Instead of cross-referencing these pieces in an art historical network of preceding trends, such as minimalism, pop art and conceptual art, as Martha Buskirk has done expertly in *The Contingent Object of Contemporary Art* (2003), I've chosen to draw a performative 'map' for my selected pieces by tracking both their 'geographical' features and their mapmaker's methodology.[7] A basic 'mapping' tool I use is typology, which enables me to differentiate similarly purposed performative objects from one another by the way in which each object relates to the time-based piece it activates. Specifically, my typology delves into the various role types— or, plainly put, functions—served by an array of objects in relation to the 15 transient artworks featured in this chapter. However partial, this typology highlights the multicentricity of my enumerated objects, because, like other commodities, the uniqueness/centricity of each item is paradoxically established by the coexistence of other more or less similar items.

7 I am indebted to Winnie Wong for pointing me to Buskirk's book.

My partial typology of transient art objecthood covers four prototypes, each corresponding to the object's perceived function: catalyst, praxis, habitat and similitude.

Catalytic objects are transformative mediators that exchange their dormant materiality for dynamic actions. Fundamentally, all performative objects are 'catalysts' of sorts; they act as stimulants for ephemeral events which progressively expend the catalytic objects themselves and dissipate the resulting performances. I borrow this oft-cited term in chemistry from its historical precedent, alchemy, which I consider a converse analogy for time-based art. Catalytic objects are at once the *prima materia*, the formless base material subject to purification, and the 'philosopher's stone', the mythic substance enabling the amelioration process.[8] In alchemy, the goal of transformation is the attainment of *gold* or *elixir*—the former a perfect body and the latter the medicine to achieve a perfect body— both believed to embody and ensure immortality. Contrary to alchemy, the telos driving time-based art is neither absolute nor quite utilitarian but multivalent.

8 I am indebted to Antonin Artaud for the source of my fascination with alchemy. For the history and theory of alchemy, see, for example, Stanton J. Linden (2003).

As Wang's ice wall and Yin's ice mound exemplify, both catalytic iceworks aspire to the civic ethics of new genre public art. But a time-based artwork might just as well take place in a private setting; it might be displayed within a museum or cordoned inside an exclusive night-club. *Where* a performance happens often implies *why* it happens but *how* the where and why are linked is still open to interpretation on a case-by-case basis. By multiplying its purposes, time-based art enacts a perverse alchemy; it also exacerbates the perversion by failing to distin-guish the *prima materia* (a xingwei artist and/or a xingwei-zhuangzhi object) from the philoso-pher's stone (a catalyst), confusing the base matter under transformation with its facilitating agent. By unflinchingly embracing the natural effects of time on perishable bodies, time-based art de-alchemizes its performative subject and object. Thus, catalytic objects, as illustrated by Wang's and Yin's ice sculptures, generally cannot outlast one-time art events. Even when the artist serves as a catalytic object, as in the cases of He Chengyao and Wang Chuyu discussed later, the artist's body may survive the event but cannot remain unchanged.

Some robust catalytic objects, however, may exceed their roles as stimulants for isolated events to become instrumental to an artist's creative evolution. These objects function like com-pounded catalysts, for they are either partially recycled or replaced with similar objects so that the artist may routinely deploy them. Compounded catalysts are, then, habituated or ritualistic objects vigorously moulding an artistic praxis. Moreover, out of their long-term serial usage, such praxis-objects often come to define an artist's stylistic signature. Gu Dexin's organic art material, Cang Xin's tongue, Zhu Ming's bubbles and Song Dong's edible delicacies—all cov-ered in this chapter—are exemplary praxis-objects.

While a praxis-object extends through time, some other objects reach into space to provide ceremonial, epistemic or figural coordinates for a transitory habitat, a fabricated environment that accommodates, sustains, encloses or even conceals a performance. Habitat-objects reside in the dialectic interchange between ecology and habitation, between the spatial expanse that both enables and challenges biological existence and the architectural dwelling that maximizes human survival. Certain praxis-objects double as habitat-objects which often catalyse time-based artworks enamoured with the poetics of space. Zhu Ming's tent-sized and house-sized balloons, for example, are paradigmatic habitat-objects that have also shaped his xingwei praxis.

The exterior surface of architecture is a facade, a formalistic element that may be used to cover up a nonexistent interior. Inflected with this make-believe modality, habitation slides from its promise of relative permanency into evanescence, for it presents the appearance of a shelter that cannot bear time's scrutiny—one enters the front door into the shadow of a mere wall. Under this flickering light, habitat-objects dovetail with those of similitude. Wang Wei's series of 'hypocritical room', composed of a moveable cube, with blown-up photographs of architectural interiors as its four walls, demonstrates this perceptual slippage when a habitat-object offers solely the illusion of habitability (see Karen Smith 2007: 122–31).

I adopt the qualifier 'similitude', which refers to a scaled model in engineering, to classify those objects that reductively sample the real. Similitude-objects may be entities of 'simula-tion'—in the sense explicated by Jean Baudrillard as 'a real without origin or reality: a hyperreal' (1983: 2). They may exhibit forged properties, or be objects of piracy—as is a genus of China's underground exports. They may also be openly acknowledged 'appropriation' artworks (see

Irvin 2005 and Buskirk 2003: 59–106). Similitude-objects are, then, performative catalysts that interrogate contemporary assumptions regarding authorship, authenticity, fakery, mimicry, intellectual property rights, provenance verification and aesthetic validation. Liu Ding evoked these contentious issues when he hired a group of painters from Dafen Village—China's unspoken capital of forged and assembly-line-produced paintings—to turn out his art commodities for exhibition and for sale.

My concise typology of manipulated art objecthood by no means exhausts the use of performative objects in time-based art, nor does it mark distinct conceptual spheres. Rather, this schematic typology suggests how performative objects often serve multiple functions: as expiring catalysts in interactive events, habituated constituents of artistic practices, fabricated structures for temporary habitation and/or appropriated articles for cultural consumption. The overlapping of these functions indicates the frequent blurring of disparate experiential categories in our lives, which provide models for time-based art. As a diagram charting the internal working of time-based art, this typology also brings into relief the mutual imbrications and conglomerations between material objects and pre-scored actions.

While this typology equips me with a provisional tool to begin my performative mapping, it is itself an object of inquiry which cannot even be formulated without supplementary archival aids. This factor reiterates a thesis that I've stressed throughout *Beijing Xingwei*: the indispensable support of documentation for evanescent art. Should artists desire for their ephemeral work to be woven into the cultural and historical fabric, they must rely on a common transmutation procedure: the technical transfer from the 4D [3D + time] actuality to the 2D media, from live enactment to visual documentation. Consider this sequence: during a performance, an object's laden matterness becomes practically fluid, dispersed in an intensive and context-specific temporal process. At the instant the documentary transfer happens, the object looks as if stiffened, suddenly flattened into a photographic or video image. A 3D time-based object, whose materiality is intertwined with ephemerality, draws from this extended and fluctuating sense of objecthood.

CARTOGRAPHY OF 'CHINESE' TIME-BASED ART—VIA APS

Perhaps the main objection to my hypothetical typology of transitory objecthood would target its global applicability, because, being a structural model, it holds little regional (Chinese) specificity and therefore cannot adequately elucidate the (Chinese-produced) artworks examined here. Indeed, we can theoretically take my schematic typology to analyse most performative objects and their imaginative possibilities within the international language of time-based art, which is, to be sure, not exclusively Chinese. Though reasonable, such an objection reveals an underlying presumption that Chinese artists must necessarily be unique, indigenous and distinctive rather than stylistically anonymous, generically modern or simply cosmopolitan. This presumption is problematic—if only because hardly any contemporary artist can claim immunity from foreign influences. The ongoing trend of globalization has hastened the rate of exchanges for commerce, information and population, rendering the notion of a well-preserved national cultural enclave increasingly obsolete, if not utopian. That most Chinese time-based artists use an indeterminate visual language rather than a code-specific and convention-laden linguistic language further

facilitates the transcultural mobility of their art. In fact, many of them—Gu Dexin and Song Dong, for example—when creating catalytic objects for time-based installations overseas, produced them in situ. Other artists—such as Cang Xin and Zhu Ming—have employed praxis-objects as recurrent components in their already syncretic artistic lexicons; they often recycled these objects, recombined them with novel objects or transmuted them in diverse media throug numerous projects for different occasions. Still others—Wang Wei, for one—had designed habitat objects in order to to tantalize and mock the orientalist craving for 'Chineseness'.

'Chinese are international,' asserted curator Hou Hanru in the early 1980s, when contemporary art from China had just emerged on the global horizon (see Yu Hsiao-hwei 2002: 15). Hou insists that contemporary Chinese art belongs not only to the Chinese but also to the rest of the world and is therefore responsible for contributing to 'part of Western cultural reality' (ibid.: 14). Hou's argument takes into account the impact of globalization, in addition to contemporary art's inherent tendency to evade geohistorical boundaries. From this perspective, a viewer's search for specific 'Chinese' content in artworks produced by China-based practitioners smacks of the hegemonic pressure to otherize/exoticize—for lack of a better term—'Chinese' contemporary art. From another perspective, however, the national/ethnic/regional qualifier 'Chinese', which marks at least the cultural affiliation of my selected artists, does signify something, even though that 'something' is obscure, mutable and constantly evolving. Although certain Chinese artists might repudiate their critics' attempts to ghettoize their work, they might still catch themselves pondering—along a pantheistic ancestral shore—their exceptional Chinese heritage!

I have argued that we may best regard Chineseness as a representational politics adopted by self-identified Chinese artists. Yet, it remains a critical viewer's task to discern the artist's adoption of this representational politics and to assess the thematic, formalistic and/or ornamental effects of 'Chineseness' on the artworks so produced. My critical inquiry must therefore negotiate the tension between finding and failing to find 'something Chinese' in the performative objects under scrutiny, even as I appraise how these objects enhance the transregional time-based art medium.

The issues regarding a performative object's medium-specific structural function and its cross-cultural and/or regionally inflected creative possibilities present two consistent intersecting dimensions that coordinate my critique. This crisscrossing between the global and the local attests to the complexity of contemporary performative artworks produced by creators based in a certain geocultural region—who might choose at different moments to affiliate or not with the given region—for the consumption of a global, or non-region-specific, audience. My performative mapping project aspires to tackle such glocal complexity typical of a contemporary (Chinese) artwork in our globalized era. To elucidate how my exemplary list of time-based pieces confront and present solutions for these constantly interacting factors effectively pushes me to complicate my 2D performative map-making to be a 3D charting of cartography. This critical cartography takes the international time-based art medium as its global topography and draws from the sampled Chinese artworks, with their sinified permutations, to delineate its regional terrains. I argue that only such a complex and systematic analysis can illuminate how the listed performative objects—all made by artists from Beijing—contribute to contemporary art and cultural productions worldwide.

In the Global Positioning System (GPS), a radionavigation receiver is able to locate a site through three-dimensional coordinates (latitude, longitude, altitude) plus the precise local time. I propose to map my selected artworks through an Analytical Positioning System (APS), modelled after the GPS. Analogously, I may compare my typology of transient objecthood to *latitude* and the given object's region-specific sociocultural particularities, or the lack thereof, to *longitude*. But what might be the APS equivalent of the GPS's *altitude*? Moreover, given that all the artworks featured in my book have already happened, what might be the fourth dimension in my APS to replace that of the differentiated global synchronization of local *times*?

Jon Erickson, in *The Fate of the Object*, observes a twofold significance for the position of the art object in contemporary culture: it reflects the condition of the human subject, and it continually responds to the state of easily understood and expendable objecthood embodied by a commodity (1995: x). Erickson's book addresses only those art objects produced in Euro-American cultures; my book focuses on artists from a different geocultural region. Nevertheless, Erickson's structural analysis parallels my functional typology for transient art objecthood. Since we both deal with the impact of capitalism on artistic production, Erickson's thesis about the art object's dual referential aspects also corresponds to the two major themes I tracked in analysing *Ice. 96 Central China* and *Washing the River*—namely, the artist's subjectivity vis-à-vis his/her art object and the transient art objects vis-à-vis the encroaching commercialism. Both Wang's and Yin's projects involved audience participation and, with varying degrees of complicity, critiqued the sociocultural costs of unchecked commercialism. In both pieces, the artist's subject position and his/her transient artwork's perceived distinction from an ordinary commodity are two consistent analytical problems.

My double themes echo the two emergent cultural forces in China during the past three decades—one superstructural and the other socioeconomic: One, the debates among Chinese intellectuals in the 1980s regarding humanism and the individual subject alongside their country's quest for (multidimensional) modernity; Two, the rise of the market economy in the post-Tiananmen era, through a state-sanctioned policy that threatens to erase all traces of China's revolutionary legacy (see Jing Wang 1996; Liu Kang 1998; Zhang Xudong 1998). These two forces, I submit, have contributed to the psychic, cognitive, experiential and material circumstances of everyday life for contemporary Chinese artists, affecting in turn the condition of production for their art objects. Thus, to evoke my APS paradigm, how an artist frames, represents and reveals his/her creative agency and subjectivity through the artwork—as a measurement for the 'height' of his/her self-aspiration—provides the coordinate of *altitude* in my cartography.

In addition to the three analytical dimensions, the fourth component in my APS to supersede the GPS' local temporal coordinate is the *climate*. As a natural element that exists largely beyond human control, climate can energetically shape the lived environment, yet its influence on human behaviour is sometimes vague and inexplicable, sometimes pleasant and enabling, sometimes capricious, oppressive, even annihilating, unlike the precise effect of the GPS atomic clocks on demarcating global time zones. The imprecise, far-reaching and every so often overwhelming power of the climate on a geographical region, however, supplies a fitting metaphor for a politicized economic regime's influence on a given sociocultural environment

while establishing the overall condition of production and consumption for its residents. Reversing the exact, technical and ever-ticking GPS local time, I identify the fourth coordinate in my APS as an unpredictable, ideological and relatively protracted element: a region's politicized economic climate.

Emulating GPS, my APS too has four analogous coordinates. One, as latitude is measured by its distance from the Equator, so we may use my typology of transient objecthood to test how each listed object absorbs and adds to the international medium of time-based art. Two, as longitude is set against a provisional meridian, so we may probe whether or not each performative object exhibits region-specific or glocalized eccentricities. Three, as altitude is defined based on a given context, so we may examine an artist's subject position based on his/her representations and other supplementary documents. Four, inverting the globally differentiated and synchronized local time, we may trace a geocultural region's all-encompassing and politically determined economic system as the climate that has allowed, if also constrained, the creation and public display of certain long vanished performative artworks.

Through the first three APS coordinates, we may recall the historical moment—made distinct by a specific context—when a time-based artwork appeared for a while and then disappeared from sight. In contrast, we may describe the last APS coordinate by painting in broad strokes the macrocosmic ambience in which the *positioned* artworks were produced.

Deng's 1978 reform and opening-up policy aimed to rectify the harrowing consequences of the Cultural Revolution and in its wake ushered in an exhilarating decade. The Chinese intelligentsia, now politically redeemed

SPECTRAL CLIMATE: TEMPERATURE, WHITE HEAT

and socially restored to their prerevolutionary elite enclaves, absorbed a century's worth of aesthetic, philosophical and technocultural innovations from the West. An epistemic environment was formed, characterized by a peculiar compression of chronological time into the instant and simultaneous access to information. With the resultant fortuitous juxtapositions, one might read translations of Sartre next to those of Derrida and Nietzsche and Benjamin; register postmodernism before modernism; or encounter images of Dada, pop art, cubism, feminism, body art, minimalism, conceptual art, impressionism, social sculpture and those of collages with found articles and painted animal skulls—all in one 72-hour sitting! Given my exaggeration for rhetorical effects, suffice it to say that this environment has little use for the grammatical tense—which, after all, is a feature absent from the Chinese language.

To better describe this invigorating epistemic ecology enabled by the radical shift in the country's economic climate, I borrow from Tang Xiaobing the notion of 'spectrality', which Tang borrowed from Derrida in an attempt to endorse a nuanced, cross-referential reading of twentieth-century Chinese literature as a dynamic totality (2000: 342). Spectrality, in Tang's elaboration, allows us to see 'the present as continually haunted and disturbed by ghosts of the past', thereby enabling us to conceptualize historical movement 'not so much as a temporal flow as an ever-expanding space of spectrality' (ibid.). Spectrality may elucidate the syncretic mix of ideas and styles regardless of the historical origins or connective logic that a viewer might detect in a contemporary Chinese artwork. Spectrality also provides a psychological explanation for the

speed with which the Chinese intelligentsia, a class to which many contemporary artists belong, managed to assimilate such a great quantity of Western knowledge in the 1980s (they were driven by the ghosts of their country's much-bemoaned harrowing modern history to excel at all costs, so as to quickly rejoin the international rank of formidable cultural producers).[9] In this light, we may regard spectrality also as a creative mechanism whereby a learner digests spectres from the past as present nourishment and reprocesses painful memories as impetus for productive transformation. While not all learners would respond the same to the accelerated importation of cognitive stimuli, we may reasonably compare spectrality to an energetic high-pressure centre, affecting the intellectual weather condition for all.

9 See a similar argument about the formation of Chinese identity in the post-Tiananmen era, when Deng reformed Beijing's propaganda system to combine a celebration of the country's glorious ancient history with the commemoration of its humiliating modern history to cultivate the patriotism of Chinese youths, in William A. Callahan (2009).

The epistemic exuberance of the 1980s halted abruptly with the Deng-endorsed 4 June 1989 Tiananmen Square massacre. 'In 1989 China entered the 90s,' understated the Hong Kong curator Chang Tsong-zung while casting the shadow of an ominous ellipse over the Mainland intelligentsia's quest for humanistic enlightenment and democratic liberation in the previous decade (2001: 1). Although China's second reformist decade began with memories of civilian bloodshed in Beijing, it closed in anticipation of the country's 'hard-earned, controversial entry into the World Trade Organization as the WTO's 143rd member' on 11 December 2001 (Zhang Xudong 2008: 1). Emblematic of the decade's fluctuating moods, this radical discrepancy between a traumatized body politic and its triumphant integration into the global trade community betrays a citizenry fraught with cynicism, cautious self-preservation and political apathy, all pessimistic traits that were soon to be supplanted by a general fervour for commercialism. Liu Kang traces this pragmatic depoliticization of the Chinese citizens to a decisive political mandate from Deng, who instituted in 1992 a three-year ban 'on any theoretical discussion of the ideological nature of reform' (1998: 171). Deng's renewed reformist policy, with its double emphasis on a free market economy and socialist nationalism, proved to be a sophisticated strategy to quell potential political unrest for it effectively dissolved the intellectuals' power of critique against any 'nationalistic' causes at the same time as it encouraged the populace to pursue commercial interests in its patriotic path towards accumulated wealth.

A couple of epochal changes occurred towards the end of the 1990s. Deng passed away in February 1997. A few months later, the nation regained sovereignty over Hong Kong, ending the region's colonial history. As President Jiang Zemin consolidated his regime in 1998, China was bracing against the impact of the 1997 Asian financial crisis which worsened setbacks related to Deng's reform: huge increase in laid-off workers and the unemployment rate; more frequent social protests against financial hardships; heightened concerns over corruption, smuggling and higher crime rates; and the growing inequality between rural and urban regions, causing large-scale migration of *liu min* (a floating population) from the countryside to the coastal cities (see Goldstein 1998; Fewsmith 1999; and Dutton 2000). Since 1999, irked by a silent sit-in protest by over 10,000 members of the Falungong sect, the Chinese government launched a nation-wide brutal suppression of this semi-religious *qigong* movement (Li Cheng 2000 and Shue 2004). On 8 May 1999, three American bombs struck the PRC embassy

in Belgrade, inciting Chinese students' to an anti-American mass protest in Beijing. Popular nationalism bolstered the political monopoly of the CCP which based the legitimacy of its reign on delivering economic growth (see Zhang Xudong 2008 and Li Cheng 2001). According to the government's rationale, then, political stability, or the authoritarian one-party rule, ensures an uninterrupted economic boom. And every international mishap affecting China serves to affirm this logic.

We now enter the twenty-first century, the period that I've traced sporadically in previous chapters. To reiterate a few of the country's latest woes: the 2003 SARS epidemic; the 2008 Sichuan earthquake; the intensified ethnic and urban agitation; the unsafe exported food products; the aggravated ecological crisis; and the unresolved political tension with Tibet and Taiwan. These negative reports, however, cannot suppress the fact that, internationally, China has risen as a formidable world power and it has, domestically, achieved, ahead of schedule, the primary objective professed by Deng's regime: to allow most Chinese to lead a life of *xiaokang* (small prosperity, or relative comfort), with 'a per capita annual income of [US]$800 by the year 2000' (see Davis 2000: 1–22 and Hanlong Lu 2000). In the past decade, China has witnessed what many sociologists call 'the consumer revolution', which both resulted from and has encouraged fundamental social changes, including the transfer of responsibility for personal welfare from the state to the individual; the newly pronounced horizontal interpersonal networks that have diminished the significance of vertical 'official' relationships; the 'commercialization of consumption' that has increased consumer choice, raised the standard of living and reduced the central control over the flow of commodities; and the coming-of-age of the first 'S-generation', the egocentric, fickle, well-educated and brand-conscious 'single-child' consumers who take peace, relative material comfort and materialistic consumption for granted (see Conghua Li 1998 and Davis 2000).

This ongoing consumer revolution has intensified the postsocialist transformation of the art production and consumption modes. As Richard Kraus points out, China's arts—from literature, opera and dance, to calligraphy and painting—have enjoyed state patronage during the country's long imperial history as well as through Mao's revolutionary years. After the economic reform, however, 'a new politics of culture has taken shape, with greater openness, vastly diminished state supervision, and increased professionalism by artists' (2004: viii). Nowadays many artists have moved from being state employees, with assigned housing and steady salaries, to working independently, trying to earn a living from a combination of commercial and institutional patronage. The change in their employment structure means that these artists no longer need to reproduce standardized propaganda for the state's mass campaigns; instead, joining their international peers in countries with meagre state subsidy for the arts, such as the US, they have the freedom and headache of negotiating personal aspirations, cultural callings and market pressures.

Corresponding to the evolving socioeconomic climate for professionalized art-making is the shift in aesthetic concerns from a monolithic preoccupation with the state interest to a variety of calculations surrounding market preferences. As Hou Hanrou maintains, Chinese 'avant-garde artists' in the 1980s shared a general interest in the 'problem of ideology', for they aimed to 'break down the constraints of the authority of official discourse and reclaim freedom of

expression' (2002: 24). After 1989, with the emergent 'fusion of a new-born commercial consciousness, behaviour and art itself in a formative period of the art market', the past idealistic debates among 'unofficial' artists regarding ideology took on a different resonance (ibid.: 31). In this post-Tiananmen decade, 'China's "Avant-garde art" began to be [. . .] "accepted" into the international art market/institution/media system, mostly through the promotion of "Post-89 Political Pop" and "Cynical Realism".' Consequently, many international viewers have taken 'the problem of ideology', expressed as an opposition between the official and unofficial stances, as 'the "fundamental" concern of Chinese contemporary art' (ibid.: 24). Indeed this international myth about contentious Chinese art, characterized by a sardonic protest against totalitarian oppression and human rights abuses, has remained an overseas market favourite *even*—if not *especially*—after the 2008 Olympic Games, as witnessed by Saatchi Gallery's blockbuster exhibition, *The Revolution Continues* (2008). In this mercenary climate, there is—to borrow Hou's term—a 'complot', or an ironic concurrence, between 'the official ideological discourses' and the so-called avant-garde artists' 'ideologic-centricism', both 'consciously identifying with the values of the market system' (ibid.: 25).

Hou's acute analysis of the market's power to cohere ostensible opposites does not preclude minority models. Since the 1990s, a number of experimental artists—dubbed 'un-unofficial artists' by Hou—have turned away from their previous fixation on ideology to explore a more 'open, multi-orientational' space for artistic innovation (ibid.: 27). These artists reject what they perceive as a compromise between the official promotion of the market economy and the 'unofficial' status exploited by certain artists who have profited from selling their cynical portrayals of the stereotypical 'Chinese realities' to the West. In principle, the un-unofficial artists consider obsolete the erstwhile antagonism between official and unofficial art; they welcome the respite from an overpoliticized bygone era and acknowledge commercialism as part of the social reality within which they must operate. In daily practice, some of them have transferred their energies to creating art objects that counter-balance the prevailing ethos of get-rich-quick banality. Within this environment of government-sanctioned mercantile aggression, I argue, to employ a time-based medium is to extend a poignant, if somewhat subdued, artistic gesture of resistance or detachment against the multifarious forces of commodification.

| PRODUCING CONSUMABLEWORKS: REBOOTING APS | Under an emphatically apolitical and profit-scouting socioeconomic climate, any defiant gesture might appear as furtive and futile as a spectre in a graceless land. How do artists search for alternative modes of operation? |

The answers to this question are, I suspect, as numerous as the practitioners who have chosen to work, at least periodically, with a transient medium, which leaves behind little more than some archival images and documents with limited commercial profitability. Whereas in a developed and late-capitalist nation like the US, museums and private collectors have devised means of acquiring and preserving transient artworks (see Buskirk 2003: 1–16), in a country like China, still developing its domestic exhibition infrastructure and collecting institutions,

for an artist to adopt a time-based medium is to spend time away from making other more profitable art products. I apply my APS paradigm to navigate the *how, what, when* and *where* of creative alternatives that Beijing's time-based artists have chosen to deviate from a straight-forward monetary agenda. While opposing the art market is not necessarily their professed goals, the practitioners I highlight here have all generated xingwei and/or xingwei-zhuangzhi projects involving hard-to-sell art objects. Because of the current global fascination with Chinese contemporary art, some of these artists have attained international fame and have had many opportunities, both domestically and internationally, to exhibit their ephemeral artworks. Yet, immediate monetary gain is not what motivates their time-based creations, considering that some of their artist-peers, especially the painters, have become overnight multi-millionaires after a few international auction sales of their more permanent artworks.

However variable their alternative modes of operation are, the time-based artists typically refuse to collude with the prevalent commercial enterprise. Yet, none of them rejects wholesale the opportunities that their country's newly globalized market economy and international trade and diplomatic relationships will bring. Their common *ambivalence*—not outright resistance—towards pure and simple greed is the premise behind my inquiry via a consistent APS paradigm. The 10 artists assessed in this chapter have all produced time-based artworks pivoting on transient artefacts, those objects I've analysed in earlier chapters as consumableworks. In brief, I define consumableworks as those art objects made of perishable materials. As an inquiry into materiality, a consumablework may exist in/as a xingwei-zhuangzhi to claim the viewers' full sensory atten-tion (for example. Wang Jin's ice wall). A consumablework may exist too in/as a xingwei piece, to the extent that the piece engages thematically with various acts and implications of consump-tion (for example, Yin's ice mound as the artist's redress of unchecked ecological consumption).

The title for this chapter, 'Indigestible Commodities', announces my interest in probing an odd type of commodity, those—metaphorically put—difficult to digest and consume by an eater; hence, those commodities unwilling or failing to please their buyers. My conceptual thrust presupposes a relational syllogism: (A) transient art objects = (B) consumableworks = (C) disagreeable commodities. But there are many hidden questions disturbing the smooth transition of A=B; B=C; A=C. I mentioned earlier that this chapter contemplates the status of performative objects in time-based art. My typology of transient art objecthood, as the APS equivalent of latitude, guides my further investigation. Given that the phrase 'transient art objects' is quite sufficient to designate artefacts made of perishable materials, why, other than my fixation on neologisms, am I compelled to call them consumableworks? Consumableworks are, by my definition, ephemeral art objects. Are they, therefore, commodities with attitudes—too insolent, obtuse, mediocre or earnest to be saleable? Are transient art objects fractious cul-tural commodities by virtue of their perishability, their incremental rottenness or their one-time-only rarity? What exactly are indigestible commodities—so named as to declare their inedible toxicity to the common taste?

As in other chapters, I ultimately pursue a broadly Daoist syllogism (1=2; 2=3; 3=the multitude): (1) my *method* of analysis activates (2) a *process* of argument which elucidates (3) the *matter* of my inquiry, which aspires to reach and explicate the phenomenal world relevant

to and implicated by my inquiry: the *multitude*, which we might call (D) for Dao. In this chapter, my method is to use a systematic assessment mode, the APS paradigm, to examine several constant, recurrent and interwoven thematic dimensions existing in the multitude symbolically represented here by my list of 15 time-based artworks. My process of argument includes applying the APS to establish the theoretical equivalence among three central concepts: (A) transient art objects; (B) consumableworks; and (C) disagreeable commodities. The three analytical concepts will help me illuminate the cultural functions of my selected time-based artworks and, through them, evoke (D), the multitude of other contemporary time-based artworks that deal with our experiences of transience, obsolescence, consumption, expenditure and commodification in a globalized world.

By disappearing into the mnemonic ether, a transient artwork both entices and empowers future performance-explorers to seek its traces via their narrative flights. I contribute to these narrative flights by claiming my imaginary licence to operate the APS, which guides my discursive space shuttle to deliver its inventory of time-based art products to the global marketplace of public contemplations. Since the APS is itself a novel conceptual device, it may present a cognitive obstacle before a user can handle it smoothly. I argue that this initial obstacle course is well worth taking because the APS is designed to address common (universal) but also complicated (glocal and particular) experiences resulting from our thoroughly commercialized everyday existence under global capitalism. Like a spatial coordinate, the consistent analytical dimensions in the APS illuminate the ever-present, if variable, themes informing transient artworks; the less-than-transparent applicability of this analytical model serves to defamiliarize these ordinarily taken-for-granted themes, hence restoring a sense of wonder in our encounters with the selected time-based artworks. Thus I chart a path towards the multicentric multitude in the 'multiverse' out there.[10]

10 I am borrowing the concept of the 'multiverse'—coined as a plural for 'universe'—from theoretical physicist Brian Greene (2011). See also Janet Maslin (2011).

3=the multitude! But, first, we shall attend to the '3'.

Test Fly (A) (B) (C) with the APS | The *latitude* for (A) transient art objects extends across the field of time-based art to supply imaginative possibilities for this global live art medium. The *longitude* for these objects, as material embodiments of ephemerality, revolves round the sense of rapid flux that China has witnessed in the throes of its millennial economic reform, modernization and globalization. The *altitude* for these transient objects cannot but be ever shifting, following their makers' ingenious leaps, tenacious scrambling and the angles from which their creative footsteps fall. Inspired by the *climate* of their country's post-economic reform's consumer revolution, I name these objects, along with some artists' voluntarily objectified body-subjects, (B) consumableworks. This act of double naming underscores the selected transient artworks' conceptual investment in the ideas, acts and effects of consumption.

The *latitude* for (B) consumableworks consists of the eternal but also private dimension of consumption as corporeal phenomena: I am born; I consume and metabolize; I age, sadly but true; I remain healthy and, if lucky, age some more; I die. The *longitude* for consumableworks passes through the multiple quotidian transactions in China's bourgeoning consumer society.

Their *altitude*, again quite mobile, reflects the varying degrees of distance their makers assume from the surrounding commercial milieu. Their shared *climate* is such that most consumable-works function as catalysts for cultural consumption, or as temporary civic habitats to generate a public sphere for diversified cultural activities—an experience in direct contrast with the state-authorized uniform patterns of cultural consumption in the nation's revolutionary past.

This quick APS survey has brought us to (C) indigestible commodity, the third and newest entity in my syllogism. Before we prove its equivalence with the other two, however, we need to ask: What is a commodity?

Considering China's communist heritage, we may well begin by reviewing Karl Marx's main theses for this key concept in his critique of capitalism. Having established that 'a single commodity' is a 'unit' of wealth accumulation in the capitalist mode of production, Marx moves on to characterize a commodity as an object, distinct from a human subject, and as a thing that complies with human desires: 'A commodity is, in the first place, an object outside us, a thing that by its properties satisfies human wants of some sort or another' (Marx 1993b). He further asserts that a commodity is a peculiar object because it is 'a complex of two things—use value and exchange value'; commodities are 'something twofold, both objects of utility, and, at the same time, depositories of value' (ibid.). In other words, a commodity is an object that reveals its use value primarily in the act of exchange, as its exchange value, a criterion not inherent to the object itself but reciprocally determined by the people engaged in the exchange.

> A commodity is therefore a mysterious thing, simply because in it the social character of men's labour appears to them as an objective character stamped upon the product of that labour; because the relation of the producers to the sum total of their own labour is presented to them as a social relation, existing not between themselves, but between the products of their labour (Marx 1993c).

The citation leads to 'fetishism of commodities', Marx's influential conceptual coinage, exposing a consumer's quasi-religious worship of commodities while disregarding the commoditized, hence objectified and alienated, human labours producing these objects of twofold value.

In a strictly Marxian sense, then, a consumablework is a commodity only to the extent that it is an object whose use value is manifested in the act of exchange, when the artwork reaches a viewing public through an exhibition, either onsite or published via other media of documentation. Unlike a Marxian commodity, however, the exchange generating the value of a consumablework is primarily cultural rather than economic; moreover, its cultural efficacy cannot be instantly quantified in monetary terms. While a commodity is a saleable object that becomes detached from its human producer's labour, a consumablework is a unique object that has a profound connection with its artist-producer. In the case of xingwei-zhuangzhi, a consumablework may be taken as a prosthetic extension of its producer's creative ego—the work is never seen apart from its artist's signature, not even when the artist is absent. In the case of xingwei, especially in the bodywork genre, a consumablework, being the artist per se, simply does not exist apart from its human creator. In both scenarios, the Marxian commodity fetishism is not only present but often paired with an exaltation of the artist, the human producer of a

non-retail-friendly artefact. In contrast to a Marxian commodity—as a thing manufactured to satisfy human wants—a consumablework, being a transient art object, cannot be owned nor exchanged for profit without transubstantiation (for example, being turned into an image). Further, consumableworks typically meet no existing market demand but seek to kindle new public interest in such intangible phenomena as generating cultural consumption, refining leisure life or learning about a globalized curiosity called 'contemporary art'—all emergent social events made possible by China's consumer revolution.

Despite their differences from Marx's somewhat moralistic definition, I contend that consumableworks are not categorical non-commodities but a special breed of commodity which fits into China's zeitgeist of economic reform. As transient art objects that cannot be resold, consumableworks are what Igor Kopytoff terms 'singularized' objects, those things deemed culturally significant enough that they are 'pulled out of their commodity sphere' to be marked as opposite to 'common commodities', saleable and widely exchangeable for something else (1986: 73–7). In fact, given their quick expiration dates, consumableworks are not merely singularized cultural products but those placed in a process Kopytoff calls 'terminal commoditization, in which further exchange is precluded by fiat' (ibid.: 75). Time-based art is then a creative medium whose practitioners specialize in producing terminal artworks for singularized cultural occasions. Nevertheless, there is no law in reformist China against seeking—to cite Appadurai's felicitous phrase—'the commodity potential of all things' under heaven, including a strange, seemingly self-destructing art (1986: 13).

Neither collectively designated cultural singularity nor materially predetermined terminality would prevent a consumablework from becoming a commodity. As Kopytoff further observes, singularized objects may rejoin the commoditization process later on while most consumer goods are 'destined to be terminal' (Kopytoff 1986: 75). Singularized as a contemporary artwork, a consumablework exacerbates the oft-heard conspiratorial 'planned obsolescence' of consumer products. To be exact, I hold that consumableworks are uncommon commodities with a protracted materialistic potential for their producers. Although a consumablework expires with a time-based performance and cannot be instantly exchanged for money (especially since most exhibitions in China are free of entry fees), it does have the potential to bring its artist-creator critical acclaim, media recognition, further exhibition opportunities and future monetary rewards. Insofar as this protracted commoditization process may be compared to a body's uneasy and prolonged metabolic cycle, (B) a consumablework is (C) an indigestible commodity. Therefore, (A) a transient art object is (B) a consumablework is (C) an indigestible commodity.

Chinese time-based art has entered the global art scene at a moment when traditional art institutions in the West, such as museums, galleries and well-endowed private collectors, have developed numerous mechanisms to absorb transient artworks into their cultural—as well as economic—exchange circuits. In a recent article on transient materiality, Linda Sandino surveys the move of contemporary art to utilize materials 'from marble to chocolate' and 'from excrement to gold' as well as various art institutions' capacity to assimilate the trash-turned-durables-turned-endurables which may be displayed and preserved by museums (2004: 286). To restart my APS again: this global recognition of transient art as a legitimate branch of contemporary

art is the *latitude* for (C) indigestible commodities. Their *longitude* is what I've analysed in Chapter I as the rise of Brand China in the global consciousness, with contemporary Chinese art as one of its beneficiaries. Their *altitude* relies on their particular makers' tactical or subliminal upward-and-downward-and-sideward mobility. Their *climate* is the speculative economic spectrality of aspiring artists, joining the rank of independent professionals and needing to provide themselves a relatively comfortable (that is, *xiaokang*) environment, a self-sustainable private ecosystem for life, play and work.

In examining my selected multitude of indigestible commodities, I shall track their typology with interrelated section titles, contextualize each listed performative object within its glocal circumstances according to

Towards a Taxonomic Table of Terminal Commodities

the site and purpose of its production and explore its artist's subject position in relation to the item under analysis. From time to time, I will demonstrate the explicit working of my APS as a critical compass, designed to orient a mind-traveller towards the complexity of contemporary (Chinese) transient artworks. A customized reference kit, the APS is effective because all the artworks collected for scrutiny here have been generated under the persistent force of glocalization which has served the Chinese artists variously as support, constraint and perceived criteria of creative production. A technological contraption like the GPS remains the metaphorical North Star that orients my analytical positioning system; by analogy, then, the navigator need not call out each geographical site's coordinates on her compass unless she is especially excited or lost.

Gearing up towards the ensuing taxonomy of indigestible commodities, I must follow my self-critical multicentric principle—my ever-nomadic *altitude*—to disclose a built-in flaw in my structural model. Since an object of inquiry is always pitted against the limit of the inquiring subject, my systematic critique risks some glitches. Above all, what is 'artistic subjectivity'— my APS altitude—but a dynamic entity performatively and cumulatively constructed by the choices an artist has made for each project? Considering that none of the artists I cover is a one-show or one-genre wonder, we cannot even begin to define what each artistic subject position is without having sampled at least the major trends in that practitioner's extensive multimedia career. This is a task that I carry out to an extent with the entire cross-referential body of *Beijing Xingwei* but it exceeds my present parameter. Except for the few praxis-objects that require diachronic studies, this chapter offers mostly a partial picture of each subjectivity-in-evolution by delving into its list of objects-by-numbers. I knowingly commit acts of objectification because I cannot possibly re/view each artistic subject without keeping him/her in an objectifying discursive distance. Worse, I share the hubris of most art historians and performance scholars by approaching each consumablework from an inverse chronology, unravelling the object to find the artist, treating the creator practically as the issue of his/her creation. Thus I acknowledge my commodity fetishism as the point of departure for my APS.

IMAGE **5.4** *Object #3—To fa de Kenengxing* (*The Possibility of Hair*, 2006) by He Chengyao, in the VITAL 06 exhibition at the Chinese Arts Centre, Manchester, UK. Image courtesy of the artist.

CATALYTIC COMMODITIES | *Object #3* (2006) | A Chinese woman, in an embroidered, loose-fitting blue silk *qipao* jacket, kneels next to a rectangular table covered in white cloth. [11] Her head tilts backwards to rest on the table's edge while her long black hair, plaited and tied up with a red thread, stretches out neatly behind her across half the table's length. Other items on the table include a pair of scissors on a hair-styling bag; a tiny, inch-long candle set on an overturned mug; and four plaques of texts lined up like product descriptions for an item on sale. Next to the table is a screen for a live video feed projection which captures the tensions between the braid and the scissors, between the woman's still gaze, her tilted chin and stiffly angled neck. A British woman enters, introducing herself as Sarah Champion, the auctioneer, and the lot being bid on is the hair of Beijing-based artist He Chengyao. Champion then refers to the plaques which contain blown-up photocopies of the artist's original residential certificate in Chongqing, Sichuan Province; her personal identification card as a Chinese citizen; her basic personal data listed in English (birthplace, weight, height, blood type, interests, religion [80 per cent Buddhist], etc.), and the product for sale (its title, source, history and length). The auction begins when the auctioneer lights the candle.

11 My interview with He Chengyao, 14 July 2008, Beijing; phone interviews with He Chengyao, 28 and 29 June 2010, Los Angeles to Beijing. See also Judith Palmer (2007) and Chinese Arts Centre (2006). I thank Keith Gallasch, managing editor of *RealTime* and Judith Palmer for responding to my email queries.

Even before she enacted her first impromptu xingwei, *Opening the Great Wall* (2000), He Chengyao did a zhuangzhi piece about hair in response to the fad of hair dyeing in China and Japan. *Fa biaoben* (*Hair Specimens*, 2000) comprised several sets of purchased Chinese hair-strands dyed in various fashionable colours—blond, brunette, purple, red: 'On the streets of Beijing, you saw all hair colours. Even women in the countryside dyed their hair, feeling urbanized and attractive simply by their Westernized hair.'[12] At the time, the artist had kept her hair uncut for several years. So, she decided to use her hair for a future artwork.

12 My phone interview with He Chengyao, 28 June 2010, Los Angeles to Beijing (my translation).

When He received the UK-based Chinese Arts Centre's invitation to perform in VITAL 06 (2–5 November 2006), a citywide performance art festival in Manchester, the hair-dyeing fashion was long passé. In contrast, an auction was a behavioural arena that had been gaining attention among Chinese artists, especially with the rapid rise in numerous painters' personal fortunes through international art auctions. Inserting her hair motif into the trendier discursive milieu, He adopted the commercial setting of an auction to structure her Manchester presentation. The new piece's title, *To fa de Kenengxing* (*The Possibility of Hair*, 2006), extends and modifies her previous installation theme, shifting the target of her cultural commentary from the fetishization of exotic ex-colonial powers (for example, to dye one's hair platinum blond) to the all-consuming worship of cash (to turn her hair into the commodity/artwork on sale). If He is a buyer and re-processor in *Hair Specimens*, then she is a consumablework in *The Possibility of Hair*.

Billed in English by VITAL 06 as *Auction of Very Personal Possessions, Object #3* resides at the dialectic pull between its apparently genteel commercial frame and barely suppressed political undertones. The artist's gendered and racialized identity as a Chinese woman is accentuated by her distinct costume and hairstyle, reminiscent of the infamous pigtail in the Manchurian-reigned Qing dynasty. She further localizes this event by adopting an auction format indigenous to the UK and popular from the fifteenth to the nineteenth centuries: the candle auction, in which the auctioneer would light an inch-long tallow candle and accept bids in an ascending order until the candle was extinguished (about 15 to 20 minutes) (see McAfee and McMillan 1987). Although He assured me that she picked her brightly coloured costume only to make her figure more visually striking onstage, her sinified silhouette arrested in a vulnerable position inside a European setting, with her hair ready to be sheared, evokes a range of traumatic historical memories from the Opium War to the Holocaust, from the colonial profiteering at the expense of subjugated (often deliberately feminized and infantilized) human bodies to the contemporary bioethics conundrum in judging the voluntary commoditization of one's somewhat expendable/replenishable body parts, such as the hair, sperm and ovum.

Despite these historically pointed references, we may also read He's performance according to its less loaded (or, rather, differently inflected) time-based art language. Her action unfolds inside an art space converted into an auction platform; the performance duration is determined by the candlelight; the performers include the curator-turned-auctioneer, the artist-turned-merchandise and the audience-turned-competitive bidders. In the immediate thematic context, her performance auction revolves round the commodity potential of her hair, whose mystique as a collectible is heightened by its intimate one-decade history with the artist and its luxuriant

length of 112 cm. Ironically, as the very commodity being pursued by rivalling consumers, the artist's hair seems more valuable than the artist who serves to authenticate and package the commodity—the hair is the desirable body part, the artist its severable appendage.

The artist's hair as a catalytic object in He's consumablework recalls other contemporary artworks that use human hair as a central biomaterial, including Chinese expatriate artist Wenda Gu's *United Nations* series (1993–), in which the artist collected hair from barber shops across the world and wove them into monumental tapestries (see Bessire 2003). The transcultural and diasporic mobility of contemporary 'Chinese' artworks resonates with the fact that He's auction took place at the Chinese Arts Centre, an Asian establishment in Manchester. This paratheatrical circumstance of reshuffled international economic and cultural power brings He's consumablework back to a current global moment when Brand China has become a coveted symbolic commodity, adding an aura to He's filamentous corporeal product. Most intriguingly, the auction itself mirrors the international power dynamics: the first bidder was a Hong Kong artist, Leung Po-shan, a fellow VITAL 06 participant, who, having told He beforehand of her interest in collecting the hair, began by setting a high bar for the bidding game. According to Judith Palmer's eyewitness account, soon 'participation in the sale had been swept imperiously out of most people's reach' and, finally, two Chinese-born UK-based performance artists, Cai Yuan and JJ Xi, who also participated in VITAL 06 as the duo Mad for Real, won the bid of £325.[13]

[13] Palmer (2007) mentions in her article that Cai Yuan and JJ Xi were known for their prankster sabotages of other artists' works, such as jumping on Tracy Emin's bed and pissing in Duchamp's urinal, and wondered if they meant to intervene in He's piece. He Chengyao told me in our phone interview on 28 June 2010, however, that this occasion was different because JJ Xi bid on and paid for the hair as a present for Cai's 50th birthday. Cai later repaid the money to Xi but kept the prized product.

He's arrangement for the winner to claim the prize reflects her subjectivity as a feminist artist, asserting her creative autonomy by placing her gendered body as art material in an ostensibly compromised position. She insisted that the actual buyer do the haircutting rather than the professional barber hired by her curator to do a 'better' job. She also requested a microphone to magnify the sounds of the scissors cutting her hair and the video camera to continue live-feeding the proceedings. Under such video surveillance, Cai Yuan, the victorious purchaser, revealed a certain trepidation in extricating his commodity and eventually cut He's hair off near her scalp, leaving the artist partially bald. When I asked if she felt mutilated by the clumsy cut, the artist surprised and impressed me with her response, 'I felt exhilarated because I've completed a project and I also felt light because my long hair was very heavy and troublesome to wash.'[14]

[14] My phone interview with He Chengyao, 28 June 2010, Los Angeles to Beijing (my translation).

More than her feminist agency, however, He considers that her project's central significance resides in three post-performance details: First, the buyer (Cai) has in his possession the hair and the four plaques of information, verifying the hair as an artwork; Second, she gave all the money she earned from selling her hair to her father (since her mother, being mentally ill, could not understand her action); Third, her father completed *The Possibility of Hair* by writing a receipt for her to keep. On the receipt, her father used a brush pen and ink to inscribe in calligraphy four aphorisms from *Xiao Jing* (*The Classic of Filial Piety*): 'Shenti fa fu, shou zhi fumu, bugan huishang, xiao zhi shi ye' (The body, hair and skin, all received from the parents, one dares not damage them, that is the beginning of *xiao*)—

IMAGE **5.5** The buyer claiming his purchase in *The Possibility of Hair* (2006) by He Chengyao. Image courtesy of the artist.

the same proverb that I cited in Chapter 3 as a source of contention for Chinese bodyworks! The Big Brother of sinocentric moral inculcation lives within many of us Chinese cultural descendants.

Reformist China, with its proto-capitalist climate, has enabled a feminist artist like He to turn her hair, together with and then severed from her body, into a consumablework. Yet, she seeks to legitimize her self-commoditization by paying tribute to what she perceives as the ultimate source of her embodied self—her parent, a long-standing guardian of China's ethical tradition, a heritage that has managed to survive, at least in this instance, the *altitudinal* erosion of communism and capitalism.

COMMODITIZED CATALYST | *Object #4* (2007) | On a raised stage, a spotlight illuminates a naked man, blindfolded and bound to a wooden pole.[15] His face turns towards stage left, his mouth wide open, as if emitting a scream. The rope pulls his left arm across his front ribs and presses it tightly into his abdomen while his right arm is constricted against his body. With both knees bent at acute angles, his right leg folds up in front of his pubis and his left leg is tied doubled up towards his back. The man looks like a victim, a criminal or a prisoner of war, arrested in the middle of extreme torture. But he hasn't given up his will to resist; his struggle to vocalize is echoed in his taut hand gestures, the curled-up fingers ready to make a fist or to grab the knife lying tantalizingly close to his right hand. The only sign distorting this iconography of torment is the instrument of bondage—the man's blindfold is made of two flat, glued-together 100-RMB banknotes and the same paper currency wraps round the thick rope winding across his neck, torso and limbs.

15 My interviews with Wang Chuyu, 15 July 2008 and 25 March 2009, Beijing, and my phone interview with Wang Chuyu, 2 July 2010, Los Angeles to Beijing.

As the audience enters, two masked figures—sporting black T-shirts with the English word MASK inscribed in large letters—adjust and correct the bound man's posture by consulting a leaflet. Each audience member receives the same leaflet which includes a reproduction of *Nuho ba, Zhongguo!* (*Roar, China!*, 1935), the classic woodcut print by Li Hua featuring a man similarly bound to a pole. The leaflet identifies Li's woodcut figure as the source of the 'living sculpture' on stage; it also lists a set of rules for audience participation:

IMAGES **5.6.1–2** The classic woodcut print, *Nuho ba, Zhongguo!* (*Roar, China!*, 1935), by Li Hua. *Object #4—Nuho ba! Zhongguo* (*Roar! China*, 2007) by Wang Chuyu in South Gate Space, Beijing. Image courtesy of the artist.

IMAGE **5.7** Two masked inspectors correcting the pose of the living sculpture in Wang Chuyu's *Roar! China* (2007). Image courtesy of the artist.

You may use any poses or forms to be photographed together with the living sculpture (a Polaroid snapshot).

You must spend 100 RMB to collect this Polaroid photograph.

You may place the 100 RMB in any part of the living sculpture, to express your ideas and attitudes towards 'money'. Or you may use the money to improvise a live art xingwei piece.

Once the performance is finished, the artist will sign on the photograph you collect to authenticate the value of your collection.

These photographs are printed in a limited edition of 30. If you want to purchase one, do it fast.[16]

This xingwei piece entitled *Nuho ba! Zhongguo* (*Roar! China*, 2007) appeared in a small theatre called Nanmen Kongjian (South Gate Space), located inside Beijing's 798 art district. The *tableau vivant* was enacted by Wang Chuyu as the opening performance of his solo exhibition, presented in *Diyijie yishujia pingtai: Wang Chuyu* (The First Artist's Platform), organized by Gao Xiaolan from Hong Kong and Li Jing

16 I've translated these rules from Chinese into English based on the programme leaflet distributed to the audience. Wang gave me a digital image of this programme.

from France. That an international curatorial team had produced this 'Artist's Platform' series indicates the extent to which globalization is normalized in Beijing.

The rules outlined in Wang's leaflet for the spectators presented his staged action as a commercial exchange. The two masked players' verification process became the manufacturer's quality-control procedure while the subsequent audience participation performed various customers' improvisations of the buying routine. Although a consumer's choice is passively restricted by the merchant's available stock, the buyer still has power over the bought commodity. *Roar! China* dramatizes this imbalance of power. Despite being an experiential and volitional subject, the artist could not see, nor talk, nor move—a condition of self-objectification actualized by his blindfolded eyes, his parted lips and his unnaturally contracted muscles. As a photographic commodity, the living sculpture is valued for its silent stillness; it moves and the picture is blurred. As a consumablework, the artist's body is desired for being accessible to further alterations by other subjects, those cash-licenced collectors who are buying simultaneously the privilege of placing 100 RMB anywhere on the living sculpture and a chance to steal the spotlight, becoming temporarily the agent of change, control and visual significance.

Roar! China involves audience participation but interactivity is not part of its game. The artist's objective is to remain as fixed as possible in his sculptural position, using his physical limits to determine his xingwei's duration (about 20 minutes, when his limbs became unbearably numb). Wang sought no interaction with his buyer-participants; as he remembered, none of them sought to verbally interact with him either. Unable to see and preoccupied with his physical discomfort, Wang was largely oblivious to what others did. His sensory recall came afterwards, when he viewed the extensive documentary photographs, taken in addition to the Polaroid shots collected by 11 buyers. Except for a couple of strangers, Wang recognized most participants, who were themselves artists, effectively purchasing their performance slots to make a statement about money. A woman, for example, stuffed the 100 RMB into Wang's mouth and played with the knife next to his right foot; a man folded the paper money and then jammed the stiffened bill like a machete into Wang's blindfold. One individual, however, put the 100 RMB underneath Wang's left knee to cushion its acute contact with the floor. Cash exchanges do not good deeds expunge.

By placing his vulnerable body at the mercy of his viewer-participants, Wang's *Roar! China* recalls similar tactics applied in several well-known performance artworks, such as Yoko Ono's *Cut Piece* (1965), Chris Burden's *Prelude to 220, or 110* (1971), Barbara T. Smith's *Feed Me* (1973) and Marina Abramovic's *Rhythm 0* (1974) (for details, see Ferguson 1998). All these pieces pivot on the artist's body as a modifiable art object that catalyses the spectators' reactions. Like his Euro-American predecessors, Wang uses his passive stance to proactively consign ethical responsibility to his viewers who are given full agency to decide how to relate to the artist before a spectatorial public within an artistic setting. Wang's subject position as defined by his performance score therefore derives from the dialectic interplay between calculation and risk: he relies on an art audience's conventional behaviours to absorb the potential risk to his body. Unlike Ono, Burden, Smith and Abramovic, Wang does not merely play himself but also an emblematic Chinese figure, the defiant victim in Li Hua's *Roar, China!*—a woodblock print canonized in anthologies and taught in high-school fine art

courses.[17] The politics of Wang's consumablework, I suggest, hinges on his source of iconographic mimicry.

17 My phone interview with Wang Chuyu, 2 July 2010, Los Angeles to Beijing.

In the early twentieth century, as Tang Xiaobing notes, the famous writer Lu Xun promoted the woodcut 'as a portable and expedient art form befitting the modern age' (2006: 474). Lu's endorsement paved the way for the woodcut to be accepted in China as a populist medium, ripe for socialist politicization and, later, for resisting Japanese military aggression. Li Hua's *Roar, China*! adopted the woodcut medium and drew from a title that had become internationally known since 1926 as an anti-imperialist dramatic production by Russian poet Sergei Tretyakov and director Vsevolod Meyerhold. In Tang's analysis, the historical significance of Li's woodcut must be situated within such 'internationalist political solidarity' and 'collective struggles against colonialism, imperialism, and capitalism' (ibid.: 484). Moreover, as the image of the blindfolded screaming victim urges, Li's *Roar, China*! instigates us, its viewers, to transform from silent spectators into active voicing subjects so as to recognize the depicted victim's pain and to 'affirm our own humanity and agency' (ibid.: 473).

I argue that Wang's mimicry of Li's woodcut expresses his satirical attitude towards the rampant consumerism in postsocialist China—the rope now strapping him is cash. While the artist has denied himself the vocal agency of roaring with pain and fury against the domineering materialism, he counts on most of his viewers' familiarity with Li's woodcut and its leftist politics to achieve a post-rationalized effect of what I might call (half-borrowing from Gertrude Stein) 'syncopated interactivity', when they responded to two disparate memories—Li's *Roar, China*! and Wang's *Roar*! *China*.[18] Inadvertently, Wang had quoted Li's original title with a slight difference in punctuation.[19] In my reading, the placing of the exclamation mark shifts the title's emphasis: Li's woodcut demands 'China'—then a subjugated body politics—to roar; Wang's consumablework stresses the viewers' obligation to 'roar'—for, against, or towards a China that seems to have lost its way. The fact that Wang's xingwei piece presented numerous cash transactions without any interventionist vocal exchange only reinforces the artist's agitation for an alternative, if not dissenting, position.

18 Gertrude Stein first proposed the concept of 'syncopation' as her audience's response to a theatrical spectacle in 'Plays' (1935), collected in Gertrude Stein (1977).

19 Wang admitted to me in his email message dated 7 July 2010 that he made a mistake in citing Li Hua's title. Later he noticed the wrong punctuation but thought 'this accidental mistake was pretty good' and didn't want to change it.

Roar! *China* earned Wang Chuyu 1,100 RMB from participating collectors. Ironically, as the artist confessed to me, this sardonic jibe into China's consumerism earned him the most money he had ever made from doing xingwei yishu. I wonder how Chairman Mao, gazing from the printed face of 100 RMB and smiling benevolently, belying his censure of decadent materialism, would appreciate such an irony.

Object #5 (1995) | Three custom-made glass coffins line up horizontally from across an ornate fireplace inside a chamber decorated with grand curtained windows, chandeliers and dark-panelled walls.[20] A rectangular, monochromatic swath of red fabric hangs in front of the fireplace, simplifying its classical frame while veiling the fire pit. Inside each coffin

PALPABLY SELF-CONSUMING PRAXIS CATALYSTS

20 For *Objects #5*, *#6* and *#7*: my interviews with Gu Dexin, 9 July 2006 and 14 July 2008, Beijing; see also Karen Smith (2005: 205).

lie one hundred kilos of raw beef. Simmering in the summer heat within the supposedly airtight coffins, the beef rots quickly, emitting misty patterns of vapour on the internal glass walls. As blood and other noxious liquid seep out of the glass seams to stain the red plastic floor-coverings, the festering meat fills the chamber with a repugnant smell. After three days, the exhibition organizers remove the decomposed flesh, leaving their empty, misty, but deodorized, coffins behind.

Object #6 (1997) | A hollow quadrangle filled with newly picked strawberries (100 kg), framed by greyish flat roughly hewn rocks, creates an aromatic red central square in a courtyard. Adjacent to the strawberry quad are two symmetrically plotted lawns, divided by a stone pavement leading to a brick barrack: one lawn is now strewn lavishly with gold and red apples (1,000 kg); the other with bananas (1,000 kg), radiant in bright yellow. A springtime vegan banquet is spread under a blue sky. The fresh fruit offerings temporarily soften the sparsely shaded 150 sq. m patio surrounded by two-storey, dark-brick buildings. Enter visitors, who are encouraged to eat the fruit, provided they place the waste back on the grass.

Object #7 (1999) | A couple of raw fleshy mounds piled up symmetrically on a narrow bed covered with a red sheet. The symmetrical order persists in the more detailed configurations for each heap, glistening with blood, sinew and fat: one mass consists of a round of rump being penetrated by a plastic penile vibrator, and the other a synthetic vaginal simulator wrapping round a stretch of foreshank. Battery-charged, with electric cords extending out to implements for speed control, the sex toys animate the meaty mounds, sending them wobbling in electrified ecstasy. Matter and machine, the entwined objects offer a humorous graphic rendering of the garden of cyborg delights. One might have found this quivering spectacle hilarious, even mesmerizing, had it not been for the putrid smell emanating from the raw meat, betraying its decay and making the interior exhibition space barely tolerable.

IMAGE **5.8** *Object #5—95 6 9 (9 June 1995)* by Gu Dexin, in *Asiana*, one of the satellite exhibitions surrounding the forty-sixth Venice Biennale (1995). Image courtesy of the artist.

IMAGE **5.9** *Object #6—97 5 31 (31 May 1997)*, by Gu Dexin, in *Another Long March: Chinese Conceptual and Installation Art in the Nineties* (1997), Breda, the Netherlands. Image courtesy of the artist.

The three xingwei-zhuangzhi artworks, created by Gu Dexin, all involve seemingly self-expending catalytic objects. *Object #5*, identified as *95 6 9 (9 June 1995)*, appeared in an opulent Venetian casino rented for *Asiana*, a satellite exhibition surrounding the forty-sixth Venice Biennale and curated by Chinese-born Paris-based Fei Dawei. *Object #6*, identified as *97 5 31 (31 May 1997)*, took place in *Another Long March*: *Chinese Conceptual and Installation Art in the Nineties*, co-curated by Marianne Brouwer and Chris Driessen and presented in the Fundament Foundation at Breda, the Netherlands. *Object #7*, identified as *99 5 7 (7 May 1999)*, was part of the bilingually titled *Fenbenyixi/Polyphenylene*, curated by Li Xianting in Beijing. Two traits remain consistent in these geoculturally dispersed projects: the artist's use of organic matter as art material, and his routine of identifying all his artworks with dates.

In Chapter 2, I have discussed how Gu began his daily xingwei of kneading meat in 1994 and made the transition from using the plastic to the organic as the primary material for his xingwei-zhuangzhi. This chapter brings us to Gu's piece—*95 6 9*—that used an abundant amount of meat and his piece—*97 5 31*—that introduced fresh fruit to the artist's repertoire of organic art materials. *99 5 7*, presented soon after Gu began exhibiting in Beijing, marks his explicit visual association of corporeality with sexuality by joining his signature praxis materials—the plastic and the organic. I have also related in Chapter 2 Gu's practice of identifying a project with its exhibition's opening date. Gu recently commented on why he has developed this professional habit: 'On the one hand, the audience's response to a given piece or exhibition should not be confined by the use of language, or guided by a title. On the other, I think writing

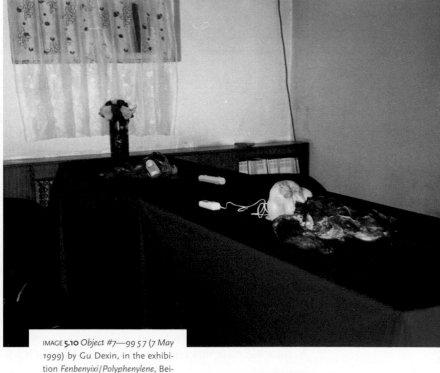

IMAGE **5.10** *Object #7—99 5 7 (7 May 1999)* by Gu Dexin, in the exhibition *Fenbenyixi/Polyphenylene*, Beijing. Image courtesy of the artist.

down a date represents either the beginning or the ending of an event. To me, the date of an exhibition is the end. To you [a viewer], it's the beginning' (Zhang Li 2005: 64). Gu's remark suggests his understanding of the time-based medium as the enabler of two moments in transaction: the closure for the artist's creative agency, and the incipience for the viewer's interpretive licence. The artist's intention doesn't necessarily matter to the latter.

For an installation artist, taking an artwork's public showing as the end of a project is nothing new. Nor is it extraordinary at our current post-postmodernist moment for artists to resign their creations to audience interpretation. In these aspects Gu by no means stands alone. Nevertheless, as one of the earliest Chinese artists to explore the corporeal and behavioural dimensions of consumption, I credit Gu as a seminal contributor to, if not the originator of, consumableworks. Gu's career is also relatively unique because he was among the first Chinese contemporary artists to begin exhibiting abroad since 1989. Whereas the first factor positions Gu's consumableworks on the *latitude* of embodiment as a human phenomenon, the second factor might pit him against the *longitude* of region-specific expectations from foreign others. Although the artist might resist fixing his subject position at a definitive *altitude*, a viewer's question of what 'being Chinese' means would most likely come to the fore as an object of fascination and contention in a non-Chinese setting, itself an alien *climate*. The two factors combined make Gu's time-based art ideal for testing my argument that 'Chineseness' is not an intrinsic formalistic or thematic trait but a deliberate politics of representation available to a subject of Chinese cultural heritage. In short, I hold 'Chineseness'—however it is expressed— to be an authorial prerogative rather than a readerly imposition, even if an author's expressive choices cannot be deciphered unless read.

Does Gu choose to articulate his 'Chineseness'? Among the three selections, *Object #6* is the least relevant to this discussion, for the only Chinese element in this xingwei-zhuangzhi was the artist himself; all the apples, bananas and strawberries were purchased locally in Breda. What about the heavy-meated *Objects #5* and *#7*? Arguably, their only possible cultural-specific ingredient is the artist's choice of the colour red, given the traditional Chinese preference for and the Maoist politicization of this colour. Yet, the colour red, which frequently connotes blood, fire, passion and fury, also complements the corporeality of Gu's sculptural material and the archetypal existential themes (such as birth, death, sex, love, compulsion) that the presence of raw flesh might evoke. Seen as the abstract ground for Gu's broadly evocative figures, the colour red's potential cultural specificity is neutralized. But what about the common organic substance used to shape the performative sculptures in *Objects #5* and *#7*? Is the beef procured in Venice less Chinese than the pork purchased in Beijing? Or, are the muscles and tendons enclosed in glass coffins (of *Object #5*) in *Asiana* no more Chinese than the foreshank entangled with plastic (of *Object #7*) in *Polyphenylene*?

Gu's transient artworks lend themselves more readily to speculations about how the artist displays his performative objects than about what those objects represent. I find it less stimulating to worry about how the rotten meat encased in glass might allegorize human suffering under a totalitarian regime than to raise questions about Gu's design for the particular performance. Why did Gu, for example, place barriers at both entrances to the exhibition chamber for *95 6 9*, barring the international spectators—who perhaps visited *Asiana* as part of their Venice Biennale itinerary—from getting closer to his fleshy/glassy objects? Why did Gu, in

Another Long March, allow viewers to walk up to his gifts of fruit in the venue's open courtyard, exposing his *97 5 31* to picky fingers, local fauna and microbes and the natural elements? Or why did Gu, in *99 5 7*, leave the sex toys' control panels in plain sight, allowing viewers easy access to the prosthetic pleasure-organs, tempting them to change the speed of the game?

Metamorphosed by the mediating movement of time, Gu's cultural commodities do not treat their patrons equally. We can imagine how each of the viewers who encountered *95 6 9* during the first three days of *Asiana*—before the organizers disposed of the decayed meat— would have had drastically different experiences. Progressively for these 'early-bird' viewers, the sense of smell would take precedence over the sense of sight to dominate the perceptual drama elicited by Gu's flesh-bound objects. Right before the three-day endurance test ended for the on-site management team, the smell would have become an insurmountable barrier, blocking out the viewers' other senses, blinding them, in effect, to the sight they would most desire to see: the source of the smell. Perhaps even more so than the olfactory overload and the concurrent public health concerns, this *blinding* effect would justify the organizers' censorial action because it negated their institutional mandate to display artworks for attentive *viewing*.

If a confusion between optical and olfactory senses in *95 6 9* necessitated the evisceration of the glass caskets, then sensorial confluences in *97 5 31* allowed a gentler drama to unfold. Spectators attending the opening of *Another Long March* could easily translate the sight, touch and smell of Gu's fruitwork into taste. Through an interactive exchange, they could transfer their roles from viewers to eaters, eradicating the distance between artworks and vitamin boosts. As they replaced the stems, cores, pits and peels on the lawns, they would have simultaneously blurred the boundary between being art-recipients and producers, breaking into Gu's edible earthwork to add their organic autographs to the devolving installation and eventual compost. And this compost, stewed to varying degrees of imperfection, would have been what greeted successive spectators to *Another Long March*, until, at the end of its two-month-plus run (31 May– 3 Aug 1997), fertilized grass would reclaim the courtyard and assimilate all traces of *97 5 31*.

IMAGE **5.11** The former exhibition site for *Object #6—97 5 31 (31 May 1997)* by Gu Dexin—restored to be a regular grassy courtyard in the Fundament Foundation at Breda, the Netherlands. Image courtesy of the artist.

Being sultry and fleshy like *95 6 9*, *99 5 7* might have been equally suffused with the theatricality of smell. Nevertheless, since *Polyphenylene* lasted for only one day and used less raw meat, the nasty odour might have had a comparatively minor impact on the viewers' sensorial engagement with this xingwei-zhuangzhi. Their deepest discomfort was probably provoked by their sense of sight or by their sense of being caught as they watched illicit sights. The shameless copulation of the real and prosthetic flesh, happening right in front of their eyes—without so much as a curtain or a peephole for shelter—rendered these viewers instant voyeurs despite any efforts to appear indifferent. If they were not amused by the naked, motorized passion shaking away on the red bed, then these witnesses, complicit in their witnessing, might have felt affronted, appalled, embarrassed, even entrapped by the orgy. In any case, Gu's cavorting objects could not fail to arouse keen sensations, be they sensorial, emotional or moral. As Karen Smith recalled, 'It was the most talked-about piece of the entire show' (2005: 211).

Ultimately, what *Objects #5*, *#6* and *#7* share is their incorporation of time as a presence-and-absence-making agent in producing consumableworks. As catalytic objects palpably, if not actually, self-expiring, Gu's three consumableworks give tangible forms to the temporal movement; they perceptually affect the performative sites Gu constructed to initiate and accommodate a moment of exchange between subjects and subjects (I see you peel a banana while I bite into my strawberry), between subjects and objects (what's inside that horrific coffin filled with translucent vapours and emitting such a stench?), and between objects and objects (my pupils dilate, my cheeks burn, my heart palpitates and my thighs tingle, standing adjacent to this scandalous *mechanica erotica*). I am a sensorial consumer before Gu's transgressive commodities. A previous moment led me here, to this instant when my gaze alone seems to have triggered the entropic dance of this unstable art object, its unpreserved organic matter decaying even as I retch—discreetly for the sake of etiquette. The more time I spend with Gu's conspicuously consumptive object, the more untenable my continuous presence becomes. For the duration of my tolerance appears to transmute the hermetic entity I encounter into an increasingly chaotic body, reducing its vibrant colours and elastic tissue to a rotting odour, to a public health hazard, to biodegradable trash. Do I let myself remain in this phenomenological abyss of abominable sensations? Or do I allow the next moment to take me elsewhere, rendering absent— save for the indelible mnemonic deposit in my psyche—what I've just perceived as a peril?

Gu's liberal use of raw material for his de-sublimating art objects encourages a materialist interpretation of how the artist understands the human subject within the cosmic scheme of creatures and things. Through this lens, rare chunks of beef sealed inside coffins become a synecdoche for our mortality; the putrefaction of radiant, fragrant fruits parallels our ageing process; the naked flesh hooked up with prosthetic sexual equipment epitomizes our technologically enhanced eroticism. *Cho pinang* (a stinky skin pouch): this old Chinese saying that sardonically describes our physical selves annotates Gu's unsentimental acknowledgement of human existence as organic matter—enfleshed, passing through natural life cycles, and transitory. The artist, as a human individual, is implicated in this fleeting matterness of our being. This materialist interpretation, albeit persuasive to an extent, will leave certain contradictory details eclipsed, such as the fine glass encasing the meat or the enforced distance between the displays and the viewers in *Asiana*; the partaking of sensuous refreshments in

Another Long March; the polymorphous flesh pleasured by sexualized commodities and the proximity of the artworks and the spectators in *Polyphenylene*. Aren't these details as essential as Gu's use of perishable matter? Are they not integral to expressing his artistic subjectivity, as is his penchant for time-based, site-specific xingwei-zhuangzhi?

A more dynamic APS reading of *Objects #5*, *#6* and *#7* as catalytic consumableworks, however, gives us the portrait of a 'Beijing artist Gu Dexin' as a joker, fond of designing high-impact, viscerally charged, industrial-grade concept-objects that tease out his curators' and viewers' lowest possible comfort zones. For the sophisticated international art patrons visiting *Asiana*, Gu literalized the modernist value of aesthetic distance first at the micro-level, by placing his raw-flesh readymades inside custom-built glass display cases, and then again at the macro-level, by keeping the spectators physically a few feet away from the exhibits. Simultaneously, Gu challenged the viewers' ability to maintain their blasé disinterest by exploiting their olfactory senses, letting the stench touch and test their composure. For *Another Long March*, a show featuring 'Chinese conceptual and installation art', Gu entertained the predominantly local visitors from Breda with Chinese hospitality—through eating—while eroding conceptual art's intellectual armature with his apparently auto-dissipating installation. For *Polyphenylene*, Gu dared his relatively green and demure Beijing spectators to join the spasmodic meat and machines by touching their speed control panels, thereby taking part in a public orgy.

Gu's time-based artworks are perverse products, or anomalous commodities, supplied by the artist to at once repel and seduce their unsuspecting consumers with their unorthodox, extravagant and disobliging art-objecthood—they rot too fast, taste too ripe and frolic too hard.

DELECTABLE PRAXIS CATALYSTS

Object #8 (2000) | Four small shelves are attached at knee height to a white wall; on each shelf sits a flat rectangular tray; on each tray extends a miniature landscape.[21] All mountains and trees: three ridges built of salmon heads, with broccoli-stalk forests and soy-sauce creeks, comprise one landscape; two slopes of raw salmon flesh, dotted with tiny mossy wasabi-rocks, compose another; a curving line of chicken thighs and wings, interspersed with scallions, ginger, garlic and broccoli crowns for greenery, yield a third panorama; ground beef with black pepper, salt and some sugar, corn starch, diced carrots and more broccoli florets roll out the summits, hills and valleys of the fourth vista. Accompanying the savoury trays are four vernacular poems inscribed on the wall in black-inked Chinese calligraphy, recording the ingredients and culinary procedures for creating each landscape. Then, a fork here and a finger there, the mountains crumble and the trees disappear—only their doggerel genealogies on the wall remain intact.

21 My interviews with Song Dong, 5 July 2006, 17 July 2008 and 24 March 2009, Beijing. See also Alessio Antoniolli (2002: 44–5).

These four gastronomic terrains were xingwei-zhuangzhi offerings that Beijing artist Song Dong cooked up for his British visitors to his Open Studio at Gasworks in London. The title of Song's consumablework, *Chi Penjing*, brings together two usually discrete experiences: the word *chi*, meaning 'to eat' or 'edible', evokes the quotidian activity of having a meal or making something into a meal; the phrase *penjing*, literally translated as 'tray scenery', refers to China's ancient art of cultivating diminutive trees and rockery in earthenware trays to create artificial landscapes for decoration and meditation. Known by its English title as *Edible Penjing* (16 June

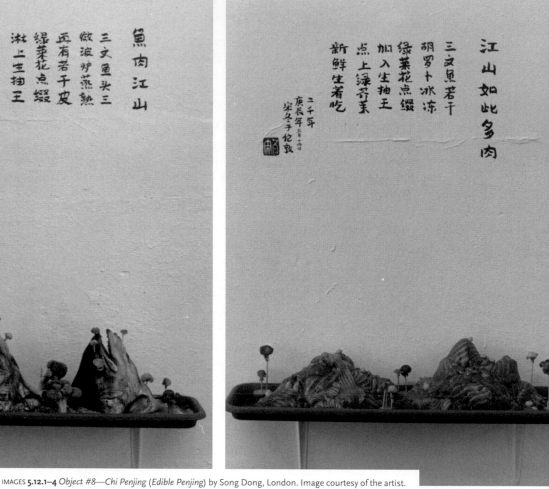

IMAGES **5.12.1–4** *Object #8—Chi Penjing (Edible Penjing)* by Song Dong, London. Image courtesy of the artist.

2000), Song's Gasworks event manages to mix up even more behavioural systems: (1) *viewing* an artwork—*Edible Penjing*—in an artistic context; (2) *eating* a delicious spread of food—fine cuisine with venison and vegetables—in a communal context; (3) *contemplating* an artifice—*penjing*—in a private leisurely context; (4) *pondering* Chinese calligraphy and poetry—wall inscriptions, with an author's red-inked signature seal—in a literary connoisseurship context; (5) *collecting* an art object—*Edible Penjing*—in a cultural commerce context. Food as art and art as food: to appreciate art and become edified by its nutritious value is to consume it with my body, from my cognitive and digestive systems, to my spiritual complex!

This intermingling of disparate contexts in *Edible Penjing* reflects what Song mentioned in our interview as his predominant creative method—*jie jing* (to borrow a scene, or borrowed scenery), an aesthetic principle from Chinese classical garden design.[22] To borrow a scene is to place one's garden in a way that can optimally incorporate the pre-existing natural landscape as parts of one's design. Since this principle relies on the designer's selection and contextual juxtaposition, it anticipates

22 My interview with Song Dong, 24 March 2009, Beijing.

Duchamp's idea of the readymade which effectively reverses the figure-ground relationship in *jie jing* by turning the ground of 'a borrowed scene' into the figure of a readymade object. Although Song himself made no reference to Duchamp, I see *Edible Penjing* applying both *jie jing* and the readymade as mutually reinforcing conceits: the food Song prepares (as a deliberately made artefact) becomes art by borrowing from a readymade art context (Gasworks); his unconventional artworks (four dishes borrowed from an Asian fusion cuisine, annotated by Chinese calligraphy), like Duchampian 'readymades aided', function to interrogate the pre-existing institution of art (How can one devour an artwork on display?) (see Duchamp 1973: 141–2). In both analytical contexts, Song's edible art objects—recalling too the Fluxus sandwiches and salads prepared by Allison Knowles—are catalysts for a delightful communal gathering in the name of art (see Stiles 1993).

Song's time-based art follows the twentieth-century Euro-American antiart lineage from Duchamp to Fluxus to conceptual art in expanding the province of art. Seen in relation to the Chinese *jie jing*, antiart's challenge to the conventional split between art and life becomes a

matter-of-fact acknowledgement of the always-already circumstantial borrowings that are in play—art borrows from life, as life borrows from art; art and life serve as each other's spotlights and backdrops or garden pavilions and natural surroundings. Thus, consumableworks merely borrow from the equivalent ephemerality of art and life. Without denying antiart's influence, Song articulates his use of *jie jing* as a cultural integration of 'Daoism, Confucianism and Buddhism': 'We *borrow* things throughout our lives. You cannot truly own anything forever, for all things are external to the individual.'[23] Moreover, 'the world has no beginning, nor ending. No origin, nor destination. No bigness, nor smallness.' Extending from this syncretic philosophical outlook, Song's art centres on—in his words—*'you/wu'* (fullness/emptiness, being/nothingness or having/lacking), a classical Chinese notion that had probably inspired *jie jing* and its recognition of the ever-fluid interchange between coexisting complementary/contrasting entities.

23 My interview with Song Dong, on 17 July 2008, Beijing. I translated and paraphrased Song's remarks. Unless otherwise noted, all cited remarks from Song are from this interview.

What is *you/wu* but a lingual-conceptual representation of the liminal instant when zero becomes one becomes zero in Dao (the cosmic vastness/emptiness)? We may, then, take *Edible Penjing* as a Chan Buddhist *gong an* (public conundrum) to ask: 'When does this piece emerge and vanish as art, from zero to one and back to zero?' From the moment the artist purchased the three salmon in London or from when the same salmon were hatched in their upstream nest? From the day Song received Gasworks' invitation for an international art residency or the hour he inscribed four poems on a 'borrowed' wall in his Gasworks Studio? From the minute Song began arranging seasoned food into tray-top minuscule scenery, till the second the last guest at Gasworks finished swallowing a bite of ground-beef *penjing* with soy-sauce scallions? As Song said, 'Some people use their eyes to collect art; others use their memory. All visitors to my *Edible Penjing* were collectors. They used their mouths to collect art. They would then go out to different places and excrete art all over the world!' Does *Edible Penjing*, then, finally end with a sewage management system in Nottingham, or with you reading through my paragraphs on Song's appetizing consumableworks?

Edible Penjing was Song's first live art piece in which he featured food consumption as an interactive event for the audience. The act of eating, however, had appeared with four other quotidian activities in an earlier photographic series entitled *Chi, he, la, sa, shui* (*Eating, Drinking, Shitting, Pissing, Sleeping*, 1999)—five photographs capturing the artist performing these acts in a domestic setting. Though candid and commonplace in its representation, the piece reveals three significant features in Song's artistic practice. First, Song adopts a colloquial style particular to Beijing natives to title this photographic series. In fact, he uses the same linguistic style in composing his four poems for *Object #8*, even though few among his Gasworks visitors could read the writing on the wall. Second, Song asserts that eating, drinking, shitting, pissing and sleeping are the five acts indispensable for human survival. As the essential acts of life, they anchor his artistic exploration. Third, the photographic series implies the artist's matter-of-fact acceptance, even relaxed appreciation, of the most prosaic routines of daily life, simultaneously experiencing them as art. 'Is there something in life that's not art?' I asked. And Song replied, 'No. If to eat, to drink, to shit, to piss and to sleep can all be art, what else in life cannot be art?' 'What about killing other lives?' I added, remembering how Song once prevented

IMAGE **5.13** *Eating*, a performative photograph from the series *Chi, he, la, sa, shui (Eating, Drinking, Shitting, Pissing, Sleeping*, 1999) by Song Dong. Image courtesy of the artist.

a fellow artist, Zhang Shengquan, from killing a ram for art. 'I don't do violence and don't directly end other lives in my art—I still accept the killing of other lives, since I am not a vegetarian. But violence can also be art,' he affirmed. Has time made more lenient Song's tolerance for those opinions that oppose his moral conviction?

The three features I trace in Song's artistic practice delineate the landscape of his psychic geography or, in the APS terms, the *altitudinal* parameter of his creative subjectivity. All three features are discernible in *Object #8*. First, I will borrow Wu Hung's judicious term, 'vernacular postmodern', to explicate Song's colloquial artistic language which is witty, everyday, effortless and improvisational but—as the Beijing-born Wu points out—fully comprehensible only to 'insiders', the ordinary Beijingers (see Wu Hung 2002a). Though an outsider whose tongue cannot reproduce the artist's playful intonations, I can tell that Song's vernacular voice has spiced up his four poems for *Edible Penjing* with colloquial humour. Wu's insight, however, inspires me to leave the verses untranslated, so as to preserve their insider-readers' most mundane mystery. Second, *Edible Penjing* falls into the eating category on the artist's list of five essential acts of human survival. In fact, Song has since developed an ongoing series of time-based public art pieces, using food made into visually and orally scrumptious objects to catalyse audience interaction. A well-known example is *Chi chengshi* (*Eating the City*; 2006–), in which Song, with some local architects, constructs a standard but imaginary metropolis with a variety of cookies, which is then eaten by appreciative spectators.

Finally, the most elusive feature is Song's attitude of carefree engagement. This philosophical sensibility, straddling at once commitment and detachment, sincerity and insouciance, prevents me from claiming Song's Chineseness as an intentional representational strategy of identity politics. While *Edible Penjing* includes plenty of visual and linguistic signs that are identifiably Chinese, it is doubtful whether Song employs them as strategic channels for his unique sinocentric identity. In *Object #8*, his predominant nationalistic assertion appears to be his choice to keep the Chinese Pinyin, *penjing*, in his English title, in lieu of the more popular Japanese equivalent, *bonsai*. Yet, how is using *penjing* different from writing flippant unrhymed verses in Chinese detailing simple recipes that most of his dining spectators would solely appreciate as wall decorations? Song once remarked that he chanced upon eating as an artistic theme because he didn't speak much English when he began exhibiting abroad in 1997. He found eating to be the easiest way of tearing down linguistic and cultural barriers, in addition to the convenient fact that he 'loved to eat and had pretty good cooking skills' (Zhong Yiyin 2007). Does Song treat his Chineseness no more and no less seriously than his well-seasoned food? Are not both his food and identity catalytic objects affably consumable by the collecting mouths and nibbling minds?

Edible Penjing has generated a reproducible pattern in Song's time-based art practice, employing food consumption as a catalyst for public art gatherings. In retrospect, this consumablework, being a catalytic object, becomes also a praxis-object. As a praxis-object with an extended symbolic duration, it assumes the status of a frequently circulated cultural commodity for its maker. However gracious as a host, Song has tendered his food art in venues that would enhance his value as an artist; the more events he hosts, the dearer his signature becomes. Still, insofar as his food art is not for monetary exchange with its consumers, what Song produces

is a commodity self-critical of its commodity status—both inquisitive and disagreeable. Is *Edible Penjing*, then, an indigestible commodity? Doesn't this proposition contradict the piece's principle choreography: digestion per se scored as a temporal process? Fullness/emptiness. When Song's plate becomes empty and my stomach becomes full, perhaps I might recollect the stretch of time I spent consuming from his borrowed kitchen a salmon slice—a delectable exchange that oddly resists the corrosive force of forgetfulness. What an aromatic mouthful of indelible fish!

Object #9 (2001) | An artist and his hired photographer approach the manager of Haiko | **PRAXIS COMMODITIES** supermarket in Beijing with an unusual request—the artist wishes to inventory the shop's wares by licking them. Suspicious, the manager asks, 'Why does he want to lick things?' The photographer responds, 'Because he is famous, he's been licking things for years [. . .] If you let him lick things, it might make you famous. It's like an advertisement for you' (Val Wang 2003). The photographer then spends three hours taking 60 snapshots of the artist licking 60 different commodities, including a shampoo bottle, a woman's sandal, a nail clipper and many more dusty plastic packages of cheap everyday goods. Each photograph uniformly features a frontal portrait shot of the artist with his tongue sticking out to lick a grocery item.

IMAGE **5.14** *Object #9—Jiaoliu / Communication Series* (1996–) by Cang Xin, in Haiko supermarket, Beijing. Image courtesy of the artist.

Object #10 (2000) | An artist and his photographer visit the chef of a high-end Beijing restaurant at work, in the kitchen that the chef commandeers.[24] Expecting the artist's arrival, the chef has cleared out a spot in the kitchen, making sure all the seasoning bottles are spick-and-span and placing on a nearby counter two wholesome chef-prepared culinary samples, set neatly in front of a doll-sized model of a chubby foreign chef. Upon the artist's arrival, the chef takes off his uniform and hat, leaving on only his underwear, socks and shoes. The artist proceeds to dress himself in the chef's clothing. The chef and the artist then stand side by side to take a picture together while the chef's staff, trying hard not to smirk, continues uninterrupted with their meal preparations.

24 My interviews with Cang Xin, 29 June 2005, 6 July 2006 and 16 July 2008, Beijing, and also my phone interview with Xiang Xiaoli, Cang's wife, 16 May 2007, Los Angeles to Beijing.

The artist in both *Objects #9* and *#10* is Cang Xin, a Manchurian (nonethnic majority Han) Chinese who began his career in 1993 among the fervent underground xingwei yishu community in Beijing's East Village. While Cang shares his peers' interest in bodyworks, his artistic corpus has distinctly progressed through several concurrent, interrelated and ongoing series. *Object #9* was the third in a series called *Jiaoliu / Communication Series* (1996–). *Object #10* initiated another series: *Shenfen huhuan / Identity Exchange Series* (2000–). Characteristically, both the *Communication* and the *Identity Exchange* series combine xingwei with photography in a repeated documentary format, as exemplified by *Object #9*'s 60 different photographs, recording the artist's oral encounters with commodities. The routinized seriality of these photographs suggests that they exceed the purpose of

documenting a xingwei action and function as independent photographic works—especially in the display format of the repetitive grid made famous by Andy Warhol's silkscreen pop art images (see Buskirk 2003: 59–105). Although *Object #10* produced only one photograph, its compositional method and style would be duplicated throughout the *Identity Exchange* series. Since neither has an individual title and both participate in ensembles of serial reiterations, I consider *Objects #9* and *#10* praxis-objects: they each claims more semiotic significance when juxtaposed in aggregation with their likes.

Both *Objects #9* and *#10* operate on the principle of a calculated exchange between things deemed equivalent in value—a principle that propels the circulation of commodities. Although both pieces involve interpersonal encounters, their human exchanges appear largely anonymous and expedient, serving solely to further the artist's objectives. As the primary investigator of these interactive events, Cang assumes a social position somewhat equivalent to those of his target participants, including the supermarket manager and the chef. He relates to them more in his professional role as an artist than as an individual. In *Object #9*, his artist's identity legitimizes and rationalizes his apparently bizarre, even unsavoury, request to lick the store merchandise. But what finally persuaded the manager to accept the potential risk of product contamination is self-interest: instead of actually explaining 'why' the artist wanted to lick things, Cang's photographer-assistant seduced the manager with the prospect of fame and a celebrity-endorsed advertisement. *Object #10* included an additional factor: since a mutual friend referred Cang to the chef, his cultural capital as an artist convinced his target other to accept a temporary partnership with him while conferring sociocultural legibility—an ethical meaningfulness—upon their joint action. There we see in the photograph: pride emanates from the partially denuded chef!

If Cang has accomplished *Objects #9* and *#10* through negotiations resembling commercial transactions, he did not start these time-based series to investigate systems of consumption. Cang began developing a prototype for *Communication Series* in 1996, during a post–East Village period when he suffered from a profound despair over his art practice—a condition exacerbated by extreme poverty, alienation from the art community and a self-imposed social exile. Locked in what he would later self-diagnose as a withdrawal from speech induced by *zibizheng* (a Chinese translation of autism), Cang searched for an emotional release by intuitively sticking out his tongue to lick household objects: a mirror, a brick, a dead goose, his muddy shoe and a one-hundred-RMB-bill.[25] He initiated tactile contact with the surrounding objects to treat his isolation, as if talking to these others by sampling their tastes. The experience inspired him to launch a xingwei series foregrounding the very cure for his continuous healing: *Communication*, whose original Chinese title includes two words: *jiao*, denoting 'to intersect', and *liu*, 'to circulate'.

Intersection and circulation are the two acts circumscribing Cang's repetitive score for each enactment in *Communication*. The series singles out the artist's tongue as his primary experiential medium through which his body *intersects* with an external object, puncturing, as it were, the hermetic seal round his mute selfhood while touching an other via an organ 'indispensable' for 'talking, eating and having sex', to borrow Cang's phrase. Cang further objectifies

25 My interview with Cang Xin, 29 June 2005, Beijing. The next reference is from the same source. See also *Cang Xin* (2006: 27–31).

IMAGES **5.16.1–4** The first serial actions of *Communication Series* (1996) by Cang Xin, in East Village, Beijing. Image courtesy of the artist.

this intimate contact by having himself photographed at the moment his tongue licks the object, producing an imagistic memento that concomitantly facilitates the *circulation* of his repetitively enacted behavioural 'ephemeras' in cultural memory and potential commodity markets. Scanning through Cang's successive photographs in the *Communication Series*, however, I discover a qualitative leap in his documentary format. While the images in his first instalment (1996) look random and variable, those made for his second instalment (1999) assume a formalistic design rigorously replicated throughout the sequence. Since subsequent instalments all follow this repetitive documentary format—one maintained till this date—I suggest that Cang experienced a turning point in how to represent his artistic subject position, the APS *altitude*.

To understand this turning point, we may turn to Cang's *Communication Series 2* (1999), the first xingwei-plus-photography series publicizing the artist's newly branded subject position. *Communication 2* repeatedly dramatizes two intersecting objects: the artist's tongue, stretching out from his lower face, touching a product coded with popular Chineseness, culled from the country's vast symbolic repertoire of traditional and revolutionary material cultures. With Cang's distinctive upper face cropped out of the photographic frame, the pink tongue becomes isolated as a visual figure, hustling promiscuously from partner to partner, kissing now an abacus, now a gilded dragon, now Mao Zedong's postcard forehead, now a printed calligraphic text, now an ancient fortune-telling turtle shell. Displayed serially and en masse—as Cang has typically exhibited them—these pictures yield a mural of rhythmic sensorial impressions, mobilizing the static portraits and interjecting, in my perception, a temporal movement, as my eyes

IMAGES **5.17.1–16** A composite shot of the second instalment in *Communication Series* (1999) by Cang Xin. Image courtesy of the artist.

trace the epic tongue salivating on multitudinous emblems of a cultural legacy disseminated through souvenirs.

But can I taste those souvenirs, as can the cruising tongue? Licking happens to be a common human behaviour whose sensations are private and unshareable. For the artist as the active taster, the resulting photograph serves as tangible proof, a mnemonic prosthesis that extends his empirical learning and corporeal memory. Yet, for a vicarious visual taster like myself, how does seeing the image of a tongue licking a smiling French woman on a soap package differ from my learning to French-kiss by reading a sex education manual? There has to be an additional experiential hook to catch my interest in these pictures. To me—as well as to many other commentators—the hook hinges on the spiritual heritage associated with Cang's ethnic identity: Manchurian Shamanism (see Zhu Qi 2006 and Cheng Ziwen 2006).

'I am a cultural shaman,' Cang told me when we first met on 29 June 2005. An autodidact with no formal training either in art or in shamanism, Cang does not presume to practise shamanism as a charismatic gift for healing, divination, mediumistic transmission, spirit summoning or any other supernatural prowess. But he proclaims that art-making is analogous to shamanistic practice which he considers 'not a religion but a type of cultural witchery'.[26] Moreover, as he believes, he has gradually recovered ancestral memories inherited from his Manchurian mother's suppressed shamanistic proclivities. I argue that Cang's evolving spiritual awareness—an *altitudinal* shift in the artist's perceived subjectivity—has allowed him to review, conceptualize and represent his work differently. In this new light of a simultaneously found and constructed self-identity, Cang's instinctive licking behaviour becomes a purposeful mimicry of shamanistic quests and his tongue a mediumistic bridge to taste and transmit the other's spirit. 'A Siberian shaman would lick a coal-heated stone before s/he gets into a trance state for healing,' as the artist informed me. Cang is also able to translate his innate tendency to treat as equals people and objects, animate creatures and inanimate things into the shamanistic beliefs in animism and transmigration of the soul. Since Cang has done substantial research to cultivate his brand of cultural witchery, it is possible to corroborate his theories with anthropological literature on prehistoric religions. My point here is not to verify Cang's mystical claims but to take his metaphysical beliefs as an enabling mechanism, with which he moulds his creative praxis and shapes potential audience response to his art. In other words, Manchurian Shamanism has emerged as a conceptual and expressive system—itself a praxis-object—for Cang, who then draws from the same system in discursively representing his pursuit of cultural shamanism.

26 My interview with Cang Xin, 6 July 2006, Beijing.

Citing shamanism as a source for one's art practice is not unique. Joseph Beuys, for example, famously cultivated his artistic identity as a shaman. What's provocative in Cang's claim to shamanism is his concurrent assertion of a minority ethnic identity as his ancestral licence to approximate this spiritual discipline in art. Thus, Cang incorporates the transcultural spirituality of shamanism and the ethnic-specific Manchurianism to *colour*, hence to complicate, his Chineseness. These identificational details—reinforced even by Cang's deliberate self-image, with a shaved forehead and long hair, reminiscent of the Qing-dynasty male hairdo, without the actual braid—add a new interpretive lens for a critical viewer to assess his *Communication Series 2* and any subsequent instalments. Following the artist's cues, I would now over-

lay a ritualistic significance to Cang's serial display of his licking behaviour, reading his tongue not only as a philandering organ illustrating commodity fetishism but also as a shamanistic instrument enduring a trying discipline to benefit the world. The reproducibility of his documentary photographs, which help commodify his time-based art, is then not just meant for sale. It also aims to demonstrate the innate spiritual kinship of all beings, healing our divisive phenomenal world via corporeal exchange.

The same lens would enrich our reading of Cang's *Identity Exchange Series*, even though this later series does not focus on one mystical organ but features the artist's entire body as a field investigator, devising an interactive structure to perform transactional behaviour with consenting human subjects. Cang framed the *Identity Exchange Series* as his sociocultural-cum-spiritual inquiries but it also enacted a chain of economic transactions, since he had to pay in cash to engage most partners. In the same restaurant where the artist and the chef staged *Object #10*, for example, Cang chanced upon another target other from its karaoke bar: a so-called *sanpei xiaojie* (triple-companion waitress-escort), who would accept money for singing, dancing, talking, even sleeping, with the clients. In this semi-impromptu instalment to the *Identity Exchange Series*, the artist pays his model to strip half-naked while he dons her red dressy *qipao* uniform so that he can try out—or put on—her professional identity. Then they stand together facing the camera to take a picture, posing in her daily work environment, where two guests leisurely incline on a couch and watch the karaoke prompters on a TV screen. A monetary exchange had taken place. The

IMAGE **5.18** *Identity Exchange Series* (2000–) by Cang Xin, in Beijing. Image courtesy of the artist.

artist purchased the opportunity to execute his artwork, which in turn exposes to public scrutiny a corner of society rarely seen in an aesthetic context.

This proffering of cultural visibility to the underrepresented adds an ethnographic element to the *Identity Exchange Series*. Moving from place to place, Cang surveys a wide range of sociocultural sites, from a garbage dump to a surgical room, an insane asylum to a university, a police station to an agricultural field, a Beijing Opera stage to a judo studio. Being a minority subject himself, Cang conducts his reverse ethnography to sample an array of Han identities, as if *tasting* their differences. As a self-aware cultural shaman, Cang models his fieldwork after a shamanic journey, his ethnographic tasting an apprenticeship in spirit-collecting while he immerses his body in diverse energy-microcosms. Cang travels to institutional sites and wears the others' 'professional' garbs as a shaman visits realities other than his/her own: the artist as the ethnographer as the shaman.

Whether ethnographic or shamanic, Cang's performance score in *Identity Exchange Series* assists his quest to temporarily suspend his identity while absorbing the other's public attributes. Yet, does this score enable a two-way exchange of identities between the photographic partners, as the piece's title implies? I suspect that most of the time there is only unilateral conversion. A case in point is the transaction between Cang and the waitress-escort. Their photo reveals that a certain behind-the-scenes procedure has occurred, resulting in the distortion captured in the scene: a cross-dressed bearded man standing next to a woman in mismatched underwear. But does the preceding transaction, hidden from the photo's glossy surface, amount to an exchange of identities between the two subjects objectified by the camera's lens? For the artist, it is a performance for his *Identity Exchange Series*; for the lady escort, it is business as usual—if slightly offbeat. Both of them are, in effect, doing exactly what they were doing before they joined in this collaborative portrait.

If there is an identity exchange, I suggest that it happens not between the artist and his co-performer but between two media: the time-based xingwei yishu, and the object-based photography. Through the photographic apparatus, the lived encounter between Cang and the woman transforms into a 2D image on a slick photographic print. In its ensuing cultural circulation, this photographic image may have the potential to be converted back into its viewers' lived experiences. Such a reciprocal concatenation between a durational event and its mediated photographic record has been a major mode of disseminating time-based art while activating its implanted mechanism for commoditization. What singularizes Cang's time-based practice is his equal emphasis on the experiential xingwei process and the resulting stylized, reproducible photographic stills. Whereas we might consider conventional photographic documents for time-based art subsidiary products with commodity potentials, Cang's xingwei-enriched photographs are his customary end products, self-evident in their commodity status. Indeed, Cang's mature praxis consistently pairs the process-oriented xingwei with the more permanent product-yielding photography. If Cang's serial xingwei presents transient praxis-objects, then his concomitant serial photographs are his praxis-commodities.

As an artist, Cang's subject position is constructed through his high mobility, his insatiable appetite for contact with new objects of inquiry and his incorporation of a technological tool—the camera—to formalize and memorialize his transient xingwei rituals. Central to the allure

of the 'Cang Xin brand' is his Manchurian cultural shamanism which underwrites both elements of his praxis. The value for each segment of the work increases through their exchange, when each step of Cang's introspective shamanic journey becomes crystallized as a fixed image and each repeated, if also varied, photographic portrait becomes an extrospective testimonial of his ongoing shamanic narrative. This self-sustaining circulation of cultural and economic values in Cang's praxis explains why his photographs do not capture the artist in successive action shots, as do most photographs documenting xingwei artworks, but repeatedly transfix the artist's body, including his affective tongue, next to multiple contact partners in formulaic poses. 'The photography is still a time-based medium,' insisted the artist to me, 'The instant the camera clicks, do you know how many *shana* [a Chinese translation of the Sanskrit *kshana*, denoting the briefest time span] have passed?'[27]

27 My interview with Cang Xin, 16 July 2008, Beijing.

As the singular recurring sight in all his xingwei photographs, Cang's highly replicated *imagistic body*—be it his tongue, or his costumed full-body pose—radiating a shamanic aura, becomes the central object that brands his praxis commodities, those emerging out of his persistent ritualistic actions. More than merely conceptual photographs that sell an innovative idea, Cang's praxis commodities bear the distinction of his imagistic body which authenticates his photographic products with what we might call a spiritual 'patina' effect.[28] The value of this authorial/authenticating body image is credentialled by its having had a prolonged formation period, when the cultural shaman invested in his self-transformation and spiritual elevation via the close encounters with others—

28 For the 'spiritual patina' effect, I was inspired by Linda Sandino's recounting of the 'symbolic capital of patina in the eighteenth century, as outlined by Grant McCracken' (2004: 284).

the brief intersections captured in the commodity photographs. Insofar as these praxis commodities base their value on a prior consumable/ephemeral process, they keep their buyers from possessing—so to speak—the entirety of their beings. 'Transience value is scarcity value in time,' as Sigmund Freud elegantly put it almost a century ago (see Freud 1985: 159). Perhaps it is in this schizophrenic sense that Cang's praxis commodities remain disagreeable, for what they sell is a desirable, if somewhat vexing, distance between the collector and the collected: each set of the artist's serial xingwei photographs promises its owners that they might approximate, but never fully attain, the spiritual patina of the artist-shaman.

Object #11 (1997) | On 10 August 1997, Zhu Ming enters a huge transparent orb. With two pipes inserted into the orb, one for his intake of air and the other for water, he seals off his spherical environment.[29] An assistant then begins filling the orb with water while Zhu remains inside. After about an hour, no longer able to bear the water pressure, Zhu cuts open the orb with a knife to end his xingwei.

PRAXIS HABITAT

29 *Objects #11* and *#12* are based on my interviews with Zhu Ming, 4 July 2005 and 10 July 2006, Beijing.

Object #12 (2002) | On 26 July 2002, Zhu transports 30 deflated plastic orbs from Beijing to the beach in Laoshan, Shandong Province. He hires some local fishermen to inflate the orbs, take them—with the artist in one—to the ocean and plunge them all on to the waves. Zhu doesn't specify a time to pick him up but the fishermen, when they can barely see Zhu's body among the floating orbs, sail back after 40 minutes to save him just as he desperately tries to plug a little hole and prevent salt water from flooding his orb.

IMAGE **5.19** *Object #11—10 August 1997* by Zhu Ming, in Beijing. Image courtesy of the artist.

Object #13 (2008) | On 27 July 2008, Zhu and 18 peasants hike up towards the peak of Xiaoxiangling, a mountain that rises up to 4,000 m above sea level, in Sichuan Province. They inflate a huge plastic balloon (8 m in diameter) into a dome-like abode and set it on a plateau covered in wild flowers. Following the artist, his hired male models undress themselves, file inside the transparent balloon and seal it. They move about within the sphere, standing, sitting down and resting; some chat occasionally, observing the drifting cloud formations and complaining about the unbearable heat inside the balloon. After 50 minutes, the artist unseals the sphere and all 19 men disperse, scattering in the chilly, oxygen-thin mountain air.[30]

30 My interviews with Zhu Ming, 13 July 2008 and 25 March 2009, Beijing, and phone interview with Zhu Ming, 24 July 2010, Los Angeles to Beijing.

Though spread out in both geography and time, the three scenes share several components: Zhu Ming and his naked body; his self-designed and custom-manufactured plastic orbs;

IMAGES **5.20.1–8** *Object #12—26 July 2002* by Zhu Ming, in Laoshan. Image courtesy of the artist.

and an engineered circumstance that tests the artist's endurance and the habitability of his temporary abode. These xingwei artworks belong to Zhu's ongoing series of investigations that began in 1997, with *Object #11* being his first interaction with a tent-size balloon. A laboratory scientist and a test pilot rolled into one, Zhu devises his extensive 'balloon' experiments by keeping consistent certain elements but varying the condition of their combination in order to experience how his body will survive 'highly difficult' situations.[31]

31 My interview with Zhu Ming, 4 July 2005, Beijing.

The prototype for these tests with orbs emerged on 30 April 1994, when Zhu, then a self-taught visual artist living in Beijing's East Village, began a durational bodywork with soap bubbles (see Berghuis 2006: 105). Connecting a tube to a glass bowl filled with water and detergent, the artist blows bubbles ceaselessly for two hours until he collapses from exhaustion. The way Zhu positions his props marks his transition from painting to performance. He forms a triangular space by leaning together two canvas-less wooden frameworks; he then hangs the glass bowl from where the frameworks meet and places a rectangular mirror beneath the bowl on the floor. If the wooden structure delineates the habitat of Zhu's incipient time-based art, then the artist, an inhabitant 'painting' with air and moving about inside this habitat, becomes its primary subject matter and material. As the artist continues to blow through the tube, the bubbles populate his studio, cover his body and blanket the mirror. Zhu's action announces that his artist's body, through strenuous aesthetic labour, will now be the main source of his mimesis.

We may compare Zhu's first bubble-blowing xingwei to an inaugural experiment that prioritizes his laboratory's objects of inquiry. Top on his list is time. To mark the passage—or, rather, the isolation—of a moment in time, Zhu entitles his bubble-performance *1994 nian 4 yue 30 ri* (*30 April 1994*), adopting a method of identifying his xingwei artwork with the date of its enactment. As Zhu states in a 2006 catalogue essay for his solo exhibition at the international art gallery Chinese Contemporary (Beijing, New York, London),

> I use time to entitle my artworks. Time is an artificial human tool. My artwork's title indicates a point in time. This point is its own beginning and ending, like a line with two points 'A. B'. How to eliminate the temporal differential between A and B? Only when A and B as two points become utterly overlapped, when 'AB' makes an 'O'—then there is no temporal distance. A and B are respectively their own beginning and ending. This is the point I choose. In fact, every point on this 'O' has an equal meaning in time (2007: 24–5; my translation).

I find it intriguing that Zhu would choose the figure of a circle as the timeless point in time to represent his time-based artworks. Among its other symbolic connotations, a circle

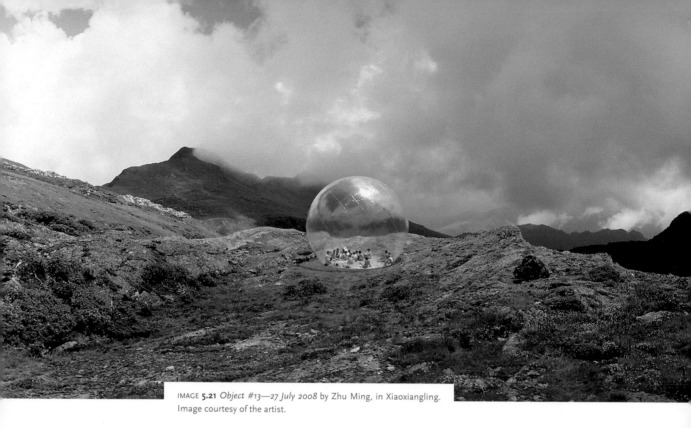

IMAGE **5.21** *Object #13—27 July 2008* by Zhu Ming, in Xiaoxiangling. Image courtesy of the artist.

happens to be the shape of the Chinese punctuation for a period (。). It notes the closure of one thought at the interstice wherein another is about to emerge—a pregnant suspension when all possibilities are equally unrealized, equally present. A circle also approximates the Arabic numeral sign for a zero, an oval outline signifying nothingness or, in temporal terms, a lingering stillness perceptually detached from the artificially registered divisions of seconds, minutes and hours. Further, a circle shapes like the two art objects that have defined Zhu's career: it resembles a *bubble* (a tiny foamy balloon filled with invisible air) and a *balloon* (an enlarged bubble, able to accommodate something else besides air). Perhaps all these musings and presentiments passed through Zhu's consciousness in the flash of a *kshana* to spark his ecstatic discovery of a congenial art material.

The second item on Zhu's laboratory list is the external object with which his body interacts to create transient actions. Zhu favours the bubble for its quality of being 'both real and empty', like 'the futility of life', and for its tendency to 'circulate endlessly', reflecting 'the traditional Chinese philosophical understanding of *qi* [energy flow]' (Zhu Ming and Li Xianting 2007: 4– 11; my translation). This material entity expresses Zhu's interest in the 'ceaseless energy transfers' between 'vital bodies', between 'life and death', between 'living beings' and 'the lifeless external world'—'xu shi zai' (an empty reality) (Zhu Ming 2007: 24). The fragile soapsuds answered Zhu's search for a concept-substance that might become part of his creative signature. Through recurrent usage, the bubbles became habituated as Zhu's praxis-objects; they would not be replaced until the artist shifted to the architectonic balloons with *Object #11*.

The third item queried by Zhu's laboratory is the site, a space animated by a timed action. Although Zhu disavows the linear passage of time, the expenditure of his durational labour visibly changes his environment and shows the differential effects of temporal movements. His prolonged bubble-blowing action in *30 April 1994*, for example, produced an effervescent site. The more he breathed into the tube, the more bubbles he generated; the bubbles' fluctuating volume ever reconfigured his xingwei space. By the time he stopped blowing, most of the bubbles would have transformed back into soapy water outside the glass bowl. The dissipating bubbles indicated the momentary depletion of Zhu's energy, which ended his bodywork and converted his action site back into his studio. A direct correlation, then, existed between Zhu's bodywork and the temporary site of habitation it constructed. Beyond this individualized site, however, was the impersonal surrounding, the habitat that both sustained and remained indifferent to that which had consumed the artist's energy. The bubbles, as Zhu's praxis-objects, anticipated his subsequent inquiry into habitat-objects.

Zhu's rumination over 'O' as a geometric emblem of the coexisting duality between absence and presence recalls Song Dong's fascination with fullness/emptiness. Likely Zhu's philosophical interpretation of what's 'the real' in finite existence emanates from the same cultural caldron of 'Daoism, Confucianism and Buddhism'—the Chinese branch of spiritual syncretism that Song identifies. Nevertheless, I recognize that Zhu's artistic praxis resembles even more closely that of Gu Dexin. Both artists entitle their time-based artworks with calendar dates. If Gu, a typical xingwei-zhuangzhi artist, dates his opus by the separation between his creative subjectivity and the created object, then Zhu, a typical xingwei artist, privileges the moment his creative subjectivity becomes inseparable from his intentional behaviour. Insofar as the date is itself impersonal data, Zhu shares Gu's rational approach to art. Both artists are inclined to research methodically into a given material's expressive possibilities. Thus, for both, catalytic objects tend to double as praxis-objects.

How is a field of apples rotting in Belgium different from those decaying in Beijing? This ironic question that I might raise on Gu's behalf inspires similar questions to those wishing to verify the Chinese pedigree of Zhu's xingwei: Would the artist's Chinese blood help him last longer—per the country's long-lasting history—inside a water-filled globe? How would his orb-boat float differently on the river in Shanghai or on the sea in Sidney? Zhu's *oeuvre* reveals an ambiguous void of cultural/ethnic locality, a void paradoxically made more opaque by his straightforward use of readily symbolic materials to create consumableworks. Zhu incorporates the evanescent bubbles and the membranous orbs to allude to the fragility and elasticity of our being and the life-and-death cycles in which all of us whirl. But these themes, being archetypal, are commonplace. I find it more energizing—even if such a sentiment betrays my sedimented modernist proclivity—to ponder how Zhu probes his medium's possibilities than to pinpoint allegorical references in his artworks.

In view of his propensity to repeat similar elements in varying combinations, I would compare Zhu's exploration of the ephemeral art medium to the composition of a performance text. This text's most insistent grammatical feature is its present tense. In addition, three syntactical parts recur: the artist's body; his transient objects; and the circumstance binding them together. Zhu's body is the experiential subject; his body-subject's negotiation with a malleable object

moulds the active verb; and their sentence structure arises from the external challenge that tests the limits of both the artist-subject and his transient object.

For their direct links with the artist's breath, the bubbles, as the incipient praxis-objects in Zhu's performance language, become a metonym for his vitality, a rhetorical figure augmenting the artist-subject. A semantic shift occurs when the artist-subject moves from manipulating an object with his exhalations to occupying an object that encompasses and partially controls him. The inflatable translucent orb in *Object #11* envelops the artist-subject in an increasingly dangerous clause, a seemingly self-destructing site requiring its occupant to inhale outside air to survive. It introduces Zhu's subsequent praxis-object as a flooded dwelling, an endangered habitat-consumablework that coincides with the artist's bodywork. Exchanging the peril within for the hazard without, Zhu's orb-boat in *Object #12* has an ameliorated residential condition but it is also left adrift on a treacherous sea. A habitat-object acting as a risky survival vessel, Zhu's spherical gallery is further lost among its subject-less clones in an ocean-bound paragraph that evades deciphering. In *Object #13*, the artist-subject has purchased an assemblage of extra corporeal displays—are they replicated male-gendered pronouns?—for his expanded spherical gallery on a mountaintop. Since there is no ventilation nor shade, the plastic globe's long exposure to the solar radiation turns it into a greenhouse for its sun-baked human plants. The plastic oven effect: perhaps Zhu's praxis-habitat in *Object #13* has its allegorical efficacy after all, for the piece presents a layman's essay on global warming.

Although Zhu has performed his balloon series in many international biennials and art festivals, most of his xingwei experiments, like the three discussed here, were not seen live by the public, nor were they financed by an institutional sponsor or a private patron. So far, Zhu could only realize his xingwei project when he had the available personal funds. He delayed producing *Object #13* for a decade due to the lack of money. Since he prefers to do a piece only once, the expensive, custom-made balloons—many destroyed during performances—become his consumption, his personal consumableworks. The 29 uninhabited balloons in *Object #12*, for example, simply went with the waves; the anxious fishermen cared only about saving the 'Beijing boss' who hired them. 'Are you doing these xingwei pieces in beautiful landscapes to make photographs?' I asked Zhu. 'No, I do xingwei for my personal experiences. But I told the models that we were taking pictures, so they would understand. They didn't really care. They just wanted to make money.'[32] In contrast to the models and perhaps also to many other contemporary artists, *spending* rather than making money is routinely Zhu's immediate prospect when executing his ephemeral art.

32 My phone interview with Zhu Ming, 24 July 2010, Los Angeles to Beijing. My translation.

Fleeting as they were, Zhu's consumable balloons came into sight like illuminated manuscripts, inscribing human behaviours vis-à-vis objective environments. In both *Objects #11* and *#12*, the artist's primary task was to coexist with his transitory, crisis-ridden habitat. Throughout his xingwei process, the ecological condition within his globular site became incrementally worsened to utter uninhabitability, forcing the artist to exit. In these situations, Zhu's artistic subjectivity was affirmed by his tenacity to overcome both the crisis within his habitat and the habitat's confining materiality the instant he needed to escape from it. *Object #13* departed from this pattern of solitary existential struggle to reveal the artist's alienation from

and entanglement with the surrounding consumer society. The same rising temperature suffered by the occupants inside Zhu's greenhouse commune could not melt away their divided purposes, when an artist's cultural production sat adjacent to his models' economic exchange, each with his own calculation. While Zhu does sell photographic documents of his consumableworks to subsidize his time-based art practice, these objects appear to be products longing for a hiatus from their commodity status.

Object #14 (2003) | Several donkey-pulled carts, neatly stacked with bricks, stop in front of a brick building. A sign hanging on the building's wooden door identifies the place as 'Erwan wuqian li wenhua chuanbo zhongxin' (25,000 Cultural Transmission Centre) in Beijing.[33] Ten migrant workers begin unloading the bricks, bringing them inside to the centre's empty gallery space. They spend the next several days constructing a 100 sq. m enclosure entirely made of bricks and mortar. The workers build the four brick walls evenly, so that the evolving structure looks like a rising brick cube which mimics the main gallery's shape and occupies much of its interior space, leaving only a 60 cm–wide corridor surrounding the cube for viewers to pass through one at a time. The artist, Wang Wei, who has hired these workers, photographs the construction process daily and opens the gallery to the public every afternoon. When the workers bring the brick walls up to 4 m in height, leaving a 60 cm distance from the ceiling, Wang and his

SIMILITUDE HABITAT

[33] My interviews with Wang Wei, 11 July 2006 and 17 July 2008, Beijing; see also a video document and other archival materials on Wang Wei's website (2010).

IMAGES **5.22.1–2** *Object #14—Linshi kongjian / Temporary Space* (30 June–19 July 2003) by Wang Wei, in 25,000 Cultural Transmission Centre / Long March Space, in Beijing. Image courtesy of the artist.

IMAGES **5.22.3–4** *Temporary Space* (30 June–19 July 2003) by Wang Wei, in 25,000 Cultural Transmission Centre / Long March Space, in Beijing. Image courtesy of the artist.

curator Phil Tinari host a formal opening reception (on 12 July) for their exhibition entitled *Linshi kongjian /Temporary Space* (30 June–19 July 2003). After two days, the workers begin demolishing the brick structure, clean up the gallery, buy back the unbroken bricks at a much-reduced price from the artist and load them back on their donkey carts, ending Wang's time-based artwork in 17 days.

Although the most conspicuous physical presence in Wang Wei's *Temporary Space* is the roofless, doorless and windowless brick room-within-a-room, the object's solidity feels almost like a mirage. Not only does the piece's title announce this object's predetermined life span as 'temporary' but the noun it modifies, 'space', also reminds us of the void within its brick walls. That Wang's impermanent object no longer exists reinforces its illusory quality but, even during its active life span, the object's changing presence seems already haunted by its imminent absence. To be exact, its presence and absence are always bound up together, for the object is an architectural facade in motion, heading towards its planned obsolescence. Transience radiates through its mortar-fastened brick-skin—the solid walls are ever on their way to becoming a void.

The interrelated components that Wang planned for *Temporary Space* affirm this paradoxical bonding of presence and absence, zhuangzhi and xingwei. The workers engaged in repetitive manual labour to construct a brick building constituted one fast-changing live component. But Wang pre-empted the complete loss of this process by supplementing it with a photographic component, designed as a self-reflexive documentary process shadowing the construction. The

artist hung 12 picture frames in the gallery's back room and filled one frame per day with a black-and-white photograph of a transitional moment. Beginning with a picture of an empty room, the next three pictures showed the workers, staring directly at the camera, inside the incomplete structure they were building. By Day Five, no workers could be seen behind the tall brick wall with a jagged upper ridge which was gradually smoothed out to reach its complete height on Day Seven. Thus, on the opening date, seven pictures were fit into the frames, with five remaining empty. Presence/absence—these photographs made visible the passage of time and bore witness for the participants in the construction process. Were these people bricklayers doubled as xingwei artists? Weren't the brick walls and the successive spatial profiles they assumed also locked in a silent xingwei dialogue with time? Wasn't the person behind the camera, Wang Wei—who had a day job as a newspaper photojournalist—enacting a parallel xingwei, undocumented by the documentary photographs he was taking? Most xingwei-zhuangzhi pieces use xingwei to modify zhuangzhi. *Temporary Space* permits its consumable zhuangzhi to pull together various xingwei, visually present or otherwise.

> In subtle subversion of the exhibition system, we have ensured that at no single point can all three works be perceived in their entirety; when the building is at its highest and most complete, the series of photographs will remain unfinished. Once all twelve photographs are present, the building will be gone (Tinari 2003: *n.p.*).

The citation comes from Tinari's curatorial essay in the exhibition catalogue published months after *Object #14* was gone. The specific presentational concept Tinari notes for *Temporary Space*—the title with which he identifies the entire exhibition—confirms what I observe as the coexisting dialectic of presence and absence. The 'three works' he mentions refer to the exhibition's three original components, including the structure being built, identified as *25,000 kuai zhuanto* (*25,000 Bricks*); an 8-minute digital video entitled *Dong Ba*, the job site where Wang found the migrant workers; and the cycle of 12 black-and-white photographs called *Bu li bu po* (*What Does Not Stand Cannot Fall*). As I write about the project in 2010, however, many of these details recorded in the printed catalogue have changed in subsequent international exhibitions and their related discursive circulation. Most notably, the gallery housing the original project was renamed Changzheng kongjian (Long March Space) and *25,000 Bricks* was retitled *Temporary Space*. The catalogue well captures this sense of volatility permeating Wang's time-based artwork by including a series of fascinating email exchanges among Tinari, Wang, and the gallery founder Lu Jie, offering a glimpse into the minute twists and turns of the creative process. In short, everything that appears solid in *Temporary Space*—the bricks, the printed pages, even the market for recycled bricks to feed Beijing's reconstruction frenzy—is subject to change, fluctuation, construction, deconstruction, decay, obsolescence, oblivion, remembrance, on and on and on.[34]

If the catalogue provides a customized space to shelter the information regarding Wang's project, then *Temporary Space* explores time's intervention into space through an architectural design that divides the available property into a part for enclosure and another for free movement. Like an Artaudian poem in space, *Temporary Space* contemplates

34 As Karen Smith notes in her curatorial essay, for 'a brief period around the turn of the millennium, these workers collected bricks from the huge number of derelict or demolished buildings, which made for a ready supply [. . .] However, the rapid changes in construction techniques and materials used, has greatly reduced the demand for bricks and at the same time as the bricks themselves are becoming scarce as the majority of the older buildings have now been demolished' (2007: 129).

all these concepts in abstraction; simultaneously, it invites a contextual reading to imbue each with glocal specificity. As such, its 'time' takes on historical significance at a pre–2008 Olympic Games moment when China was radically modernizing Beijing's global image; its 'space' becomes a symbolic evocation of the metropolis-in-process; its 'architectural structure' presents—to use my typological vocabulary—a similitude model of the urban built environment negotiating with its surrounding public space. The way Wang designs this similitude model implies his attitude: the 'enclosure', a supposed 'shelter' for residents, is a brick building increasingly difficult to access and on its way to being torn down; the 'public space' for pedestrian movement is a leftover alleyway both constraining and ominous. Indeed, I felt giddy with elation when I saw the workers pulling down the brick walls in the video documentary for *Temporary Space*. Wang's transient brick building as a habitat-object centres on a 'dysfunctional' design to make its *dehabitation*—when the bricks crumble and the space expands—a moment of gleeful liberation.

'This project's whole process is filled with absurdity, satirizing the real world. To demolish and then to build. To build and then to demolish. A purposeless blind construction course' (Wang Wei 2007; my translation). Wang's 'Artist's Statement' in the original catalogue suggests a stance of detached reconciliation with the absurdly speedy interchange of habitation with dehabitation. The artist's purposeless construction offers a rather *purposeful* creative interpolation into the seeming inevitability of urban redevelopment, which has erased old Beijing's traditional built environments. In this sense, *Temporary Space* follows its numerous well-known predecessors, such as Zhan Wang's *Ruin Cleaning Project, 94* (1994), Yin Xiuzhen's *Ruined City* (1996) and *Transformation* (1997) and Zhang Dali's baldheaded profile, signed AK-47 (1995–98), which was spray-painted as graffiti on half-hammered-down walls throughout Beijing.[35] All these pieces incorporate found remnants of building materials

35 For these earlier projects, see Wu Hung (1999: 109–26; 2004: 30–4; and 2000c).

or demolition sites into their art proper, both to foreground the city's rapid, large-scale transubstantiation and to mirror its residents' sentiments of nostalgia, panic, mourning and outrage. *Temporary Space* shares the region-specific practice of reclaiming old bricks from bulldozed courtyard houses as salvaged readymades. Wang's project is singular, however, in actually constructing a habitat-object so as to destroy it. If its indigenous antecedents disturb the general amnesia regarding a diminished native habitat, then *Temporary Space* takes the homoeopathic route to reproduce in similitude the city's architectural experiments on urban re/habitation.

As an all-encompassing, if visually undocumented, agent, Wang's artistic subjectivity in *Temporary Space* is constructed through his perceptive conjunction of time as an impetus for change and space as the material being changed. His Daoist dialectic joins the impermanent solidity of actual bricks and cement with the slightly longer-lasting virtual solidity of visual and discursive information, housed in various documentary habitats. *Temporary Space* brings into relief a major commodity item—contemporary architecture—in the cosmopolitan capital of a globalized twenty-first-century China, so as to subvert the architectural commodity's projected ideal of modern living in a comfortable urban enclave with an expansive communal green space. Many such gated apartment complexes exist in present-day Beijing. Wang's process-centred

xingwei-zhuangzhi supplies, instead, a similitude de/habitation object which, in its smaller scale, evokes a dystopic urban habitat, distorted as it has been by excessive commercial competition for re/habitation.

Object #15 (2005) | Thirteen easels are placed on a three-tiered wooden platform inside a factory-converted auxiliary exhibition hall for the second Guangzhou Triennial (18 November 2005–15 January 2006).[36] Thirteen painters enter, set up their blank canvases, painting paraphernalia and numerous chairs. Palettes in hand, they begin working, periodically moving to a different canvas—left and right, up and down, or diagonally across to the other side of the platform. A few painters, equipped with a range of blue and white paint, daub onto all canvases the sky, the clouds, a distant waterfall on the left and a picturesque lake in the middle. The others—those with pink, orange and red paint—saturate sky after sky with soft dawn radiance. Moving on to the verdant varieties, a painter sketches out a generic tree trunk on a canvas' right foreground, others add leaves rustling in the breeze, yet others cover its bottom with an abundant fringe of plants. Ditto the sequence again and again. One adventurous painter—mixing some bright yellow with leftover soft dawn colours—sprinkles the grassy fringe with wild spring flowers,

SIMILITUDE COMMODITY

36 My interview with Liu Ding, 23 March 2009, Beijing; phone interviews with the Liu Ding, 4 and 5 August 2010. See also Winnie Wong (2010), whom I thank for sharing her unpublished dissertation chapter, 'The Great Painting Factory: Assembled Labor from the Canton Trade to Dafen Village', which informs me about the assembly-painting methods developed at Dafen.

IMAGE **5.23** *Object #15—Chanpin/Products* (18 November 2005) by Liu Ding, in the Guangzhou Triennial, Guangdong Province. Image courtesy of the artist.

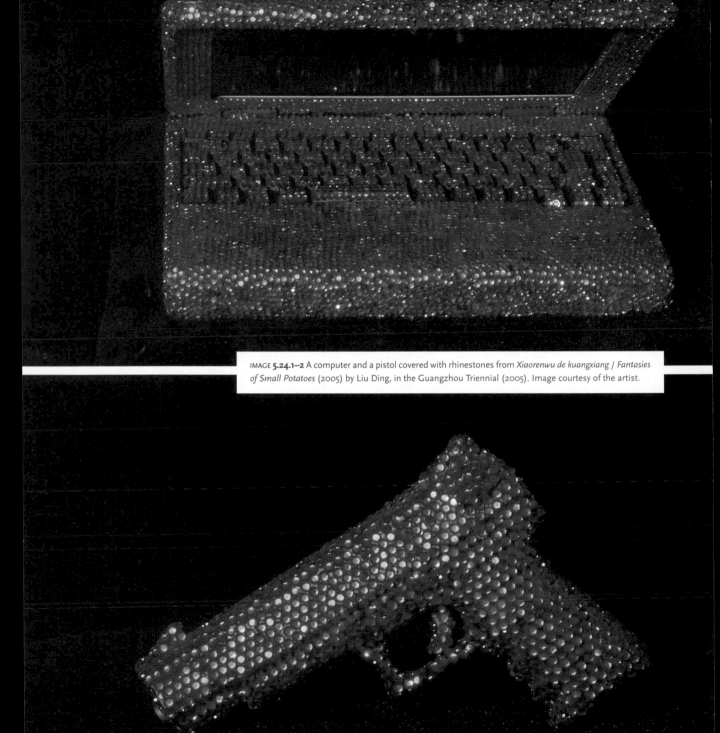

IMAGE **5.24.1–2** A computer and a pistol covered with rhinestones from *Xiaorenwu de kuangxiang / Fantasies of Small Potatoes* (2005) by Liu Ding, in the Guangzhou Triennial (2005). Image courtesy of the artist.

thereupon switching the tinted landscape to a different season. Finally, two cranes fly in, adding a touch of vivacity to the calm idyllic scene. Whenever a canvas is completed, a new blank one is placed on the easel, as the assembly-line production process resumes. After four hours (3 to 7 p.m.), the painters produce 43 oil paintings (60 x 90 cm), with slight detailed variations on their overall landscape motif. From among these 43, about 8 paintings exist in varying degrees of completion.

This performance of a collective art production process appeared as the third instalment of Liu Ding's series, *Zhuanxingqi de biaoben / Samples from the Transition* (2005–07). Liu presented two *Samples* in the Guangzhou Triennial: One was an installation with an individual subtitle, *Xiaorenwu de kuangxiang / Fantasies of Small Potatoes* (2005), consisting of numerous readymade-aided pieces, such as a pistol, a hammer, a laptop computer and a RMB banknote, all covered in tiny red rhinestones; the other was *Object #15*, the ensemble xingwei piece that the artist subtitled as *Chanpin/Products* (18 November 2005), shown during the triennial's opening (see Guangdong Museum of Modern Art 2010). *Fantasies* wittily questions the nature of commodities—an inquiry followed up by *Products*.[37] 'How does one appraise a commodity?' ask Liu's refashioned consumer products. Does adding a surface of glitzy jewellery heighten the value of a laptop computer? Do the fake gems turn a perfectly operable and expensive intelligent machine into a toy, a fetishistic ploy for a daydreaming individual, an ordinary 'small potato'? These questions about how commodities function lead reflexively to those about their display context. Does an international exhibition such as the Guangzhou Triennial elevate the tawdry, brittle sheath of a now-useless hammer to the level of a legitimizing aesthetic credential? Do cultural distinction and economic worth mutually define each other in the circulations and trades of art commodities? How do Liu's artworks, tailor-made to his specification by hired artisans, relate to 'high-concept designer products', as a furniture advertiser might dub them?

37 See a parallel analysis regarding the nature of art objects with relation to its context of display in Buskirk (2003: 161–208).

Fantasies speculates on the fluctuating exchange values when common commodities, those generally associated with power, wealth and aggression, become contemporary art collectibles through the anointment of an artist's concept and signature. *Products* similarly tackles the slippery line between an artwork and a commodity by further exposing the links between shifting channels of manufacture and exchange which socially determine an object's value. Whereas *Fantasies* focuses on singularized sculptural items, Liu conceives of *Products* as a two-part site-specific series, with an incipient xingwei portion—*Object #15*—showing the making of a given product and a subsequent open-ended zhuangzhi serving as a template for exhibiting what is made in various contexts. Because of this compounded structure, *Products* represents for the artist the fullest articulation of his *Samples from a Transition* series.

As Liu explained in our interview, the entire *Samples from a Transition* series pursues his ongoing analysis of the commodity culture by organizing 'a parallel system' through which to present, circulate, distribute and commodify his artworks.[38] To illustrate this parallel system for me, Liu referred to his latest project, *Liu Ding's Store* (2009), a conceptual art-store-within-a-museum which, at the time of our interview (23 March 2009), he was about to launch in the China Pavillion for the fifty-third Venice Biennale (June–November 2009). 'In *Liu Ding's Store*, I will sell my artworks cheaper than the

38 My interview with Liu Ding, 23 March 2009, Beijing. All following citations from the artist are based on this interview. I paraphrased and translated the artist's remarks.

gallery but more expensive than the supermarket.' Since Liu is primarily interested in discovering how his parallel system as 'a value in transition' may relate to other mainstream systems, specifically the dominant art world system and the commercial system, he regards all his artworks as parts of an extended serial project. In this light, his isolated pieces, like modular components, must be situated in diverse 'temporal and discursive environments' in order to complete his inquiry.

Liu's remarks reveal two crucial premises of his conceptual system. One, to a large extent, his parallel system functions as an economic mechanism through which he may become a direct supplier of his artwork to potential patrons and customers. Two, as a parallel track that exists within an interstitial habitat between the art world and the commercial world, Liu's transitional system depends on those two pre-existing structures to define its boundary, validate its *raison d'être* and provide the game rules it plays. Liu's parallel system therefore functions almost like a parasite, which strikes a symbiotic relationship with its two hosts for its sustenance—with potential disturbing effects on both. Or, as David Spalding puts it, using another sensational metaphor inspired by a microbial species,

> The critique waged by Liu Ding's artwork can only be characterized as viral. By continually mutating, it endures in nearly any context, threatening to infect all it touches. In the process, it jeopardizes the status of the artist, his artwork, the workers who fabricate it, the galleries and museums that show his work, the collectors who buy it, and the critics who privilege or deny certain meanings produced by the work (2008: 31–2).

Whether parasitical or viral, these qualifiers appear well suited for the selected commodity Liu targets for *Products*. Commissioned by the Guangzhou Triennial, *Object #15* addresses the exhibition's main theme of the modernizing Pearl River Delta—the prosperous southern Chinese coastal regions—by throwing a spotlight on one of the area's most successful export products: the bourgeois lifestyle decor paintings made to order and mass produced in an assembly-line fashion at Dafencun (Dafen Village), located in Shenzhen, the first Deng-designated Special Economic Zone (see Tinari 2007a and Zhang Jing 2010). To investigate the entire production mode of the business of art manufacturing, Liu assumed a customer's role to visit Dafen. This is where he began the research and production process of his art commodity. Liu found an intermediary, Luo Zhijiang, a painter who, based on the client's request to have 'a lake, a mountain, some birds', supplied Liu the sample image and subcontracted the other 12 painters for *Object #15*.[39] According to Luo, the group of painters he assembled for Liu's order had never worked together.[40] Therefore, they produced only 43 paintings, short of Luo's estimated 46 for a 4-hour duration.

39 My phone interview with Liu Ding, 4 August 2010, Los Angeles to Beijing.

40 Personal correspondence with Winnie Wong, 31 August 2010. Wong had an interview with Luo in Dafen.

As a transient artwork, *Object #15* enacts the actual production process of multiple oil paintings with more or less identical contents. The performers are hired hands who circulate among 13 easels, not to demonstrate a choreographic routine but to accomplish a collective task as speedily and efficiently as possible. The three-tier stage seems to suggest a hierarchy but the canvases and painters are evenly distributed, not to enforce a culminating order but to facilitate the assembly-line collaboration. The artist—who had

hovered like a witness round the stage he set up in the Guangzhou Triennial—mentioned in our phone interview that he observed the assembly-line production process as 'organic' rather than 'mechanical'.[41] The subcontractor—who participated in the assembly-line painting—confessed to art historian Winnie Wong that while he remembered the triennial event 'as a pleasurable group outing', he found the particular job 'very difficult' because of the amount of work required within the time limit (2010: 189–90). A critic, Philip Tinari, comments that Liu Ding is 'brushing a bit too close to exploitation' by displaying the Dafen painters 'for an international audience like so many side show performers' (Tinari 2007a: 345). In short, *Object #15* presents a consumablework of mixed conventions, eliciting mixed audience responses.

41 Personal correspondence, 5 August 2010, in response to my query.

Object #15 included a transitory human spectacle but it also yielded 43 non-ephemeral products, which would later be lined up round the stage as a zhuangzhi artwork. Although the artist appropriates an existing social phenomenon—assembly-line painting—as the parodic subject matter of his xingwei piece, he also theatricalizes what Wong observes as a typical 'grid'-structured 'assembly-line-ification' order in Dafen with a more monumental layout (Winnie Wong 2010: 177). Dafen's painting factories invented assembly-line painting as a pragmatic quality-control measure for mass producing standardized products; Liu features it as a unique native mode of production for some collectively made yet far from rigidly uniform handiworks. Liu's consumablework brings attention to a prosperous yet much-maligned export commodity industry in globalized China. At the same time, the artist verges on courting scandals for his xingwei-zhuangzhi by flirting with what might be perceived as the same 'mechanization of unskilled labourers' à la Dafen, a place internationally notorious for churning out fake Western painting-by-numbers in sweatshop conditions. With *Object #15*, Liu appears to reference his compatriots' violations of intellectual property rights via piracy, forgery and repackaging; nevertheless, he has taken the precaution for his *Products* to replicate an original (not pirated) design, guilty only of imitative mediocrity.

To those critics accusing him of exploitation, Liu rejoined that he paid the Dafen painters a 'standard wage' (ibid.: 188). In other words, the painters were routinely compensated to do their professional work, only in a different setting. Besides, they knowingly consented to this project's condition of employment. It is after all a job. But, I wonder, were these Dafen painters really doing their standard work? Being relocated to a museum to be part of a mobile tableau of assembly-line production already changed their status and the nature of their work and artistic output. Even without the intention of performing, their bodies doubled as labourers and artworks, their actions as a living ethnographic diorama and contemporary Chinese time-based art. In the Guangzhou Triennial, their landscape paintings were no longer negligible hotel decorations sold at Walmart (a big client for Dafen) but valuable modules of Liu's parallel system. To complete Liu's *Products* (2006), the 43 paintings manufactured in *Object #15* were shipped overseas to Frankfurt, Germany, to be displayed at Lothar Albrecht Gallery. Following Liu's installation template, these paintings were hung, salon style, in a room—designed by the artist—with red walls, a Persian carpet and classical European furniture. The paintings, which have constituted Liu's convertible picturesque habitat-object, would be displayed again in Turin,

IMAGE **5.25** *Products* by Liu Ding, exhibited in Lothar Albrecht Galerie, Frankfurt, Germany (2006). Image courtesy of the artist.

Italy (2006) and in Bristol, UK (2008). They were eventually bought as a complete set by a European collector; and they surely paved Liu's path to his store-within-the-biennale in Venice (2009).

But then again, despite the criticism levelled at Liu for participating in the same exploitative enterprise allegedly typical of Dafen and despite the uncalculated 'residuals' for the participating painters in Liu's Guangzhou Triennial performance, the only indispensable artist/author at the centre of the consumablework that I renamed *Object #15* is Liu Ding.[42]

42 For this insight, I am indebted to Nonchi Wang, who challenges my habitual Left-leaning interpretations. For an analysis of contemporary art's general explorations of 'authorship and authority', see Buskirk (2003: 19–56).

As the proprietor of his parallel entrepreneurial system, Liu's artistic subjectivity is camouflaged by his parasitic commodities, which compromise the established game rules of both art commerce and commercial art, if merely with their subtly subversive pricing politics. In response to my query about whether he practises Chineseness, Liu said that he would conduct the same parallel

inquiry into commodity culture, had he lived in the UK. Still, for all its unresolved ambiguity, controversy and complicity with glocal capitalism, I categorize *Object #15* as a similitude commodity which, in its microcosmic density, mimics postsocialist China's indigestible complexity.

Among the 15 transient objects analytically positioned in this chapter, most were xingwei-zhuangzhi pieces made for a public. As consumableworks

addressing *a*—if not *the*—dominant international phenomenon of consumerism, they contribute to the contemplative diversification of a global public culture by producers from a country only recently open to capitalist consumption's loaded allure. As self-reflexive commodities, they refuse to hide their complicity with the commercial logic while agitating for individual critical agency among their spectators, especially those fellow Chinese consumers dazzled by their country's accelerated economic warming. When the artists enacted these pieces as introspective xingwei events more for themselves than for the public, such performative objects act as private sanctuaries, shielding their makers, if only temporarily, from the pervasive priorities of a mercantile global society.

The consumableworks I inventory here propose ingenious solutions to the problem of reconceptualizing the status of material objects in time-based artworks. Designed in part to leave traces only in a viewer's memory, these mnemonic grits, hardly easily digestible, tenaciously refuse to disappear. If commercial culture has left us unsuspectingly with a taste for monotony through its process of standardization and quick consumption, then these eccentric commodities serve up frictional supplements, making us pause momentarily for popping thumb-sized cognitive vitamins, which trouble our oesophagus but energize our quotidian lives. These consumableworks cultivate alternative tastes by proffering contrary objects—chunks and lumps impossible for us to swallow without painstaking chewing.

IMAGES **6.1.1–3** *Chongfu shuxie yiqian ci 'Lantingxu' (Repeatedly Replicating a Thousand Times 'Lantingxu', 1990–97) by* Qiu Zhijie. Courtesy of the artist.

| CHAPTER **6** |

KeePSAKE MORseLS

A SHEET OF RICE PAPER

At first it shows a face of immense whiteness disturbed only by a tiny inconsistency in its texture: white on white. Then the whiteness is interrupted—repeatedly, if intermittently—by black ink seeping into the paper in the form of classical Chinese characters. The white paper, transfigured from a surface into a background, now bears the commemorative text known as *Lantingxu* (*Orchid Pavillion Preface*), originally authored by master calligrapher Wang Xizhi on 3 March 353 CE.[1] The paper's unmarked spatiality gradually loses ground, as Wang's text—composed of 324 words in the *xingshu* (literally 'walking-writing') style—is inscribed again and again, one after the other, in vertical after vertical line, onto the remaining whiteness. After being duplicated 10 times in this layering fashion, Wang's text disappears, like whispers in cacophony, into an intricate ink painting made of overlapping columns of lines, curves, tilts and dots. After 50 times, the painting evolves into a rectangular inky mass, its individual patterns no longer discernible. After a thousand times, Qiu Zhijie, the calligrapher who has laboured for seven years to reproduce Wang's xingshu on the same sheet of paper, concludes his durational exercise. He has fulfilled a performance plan, promised by its straightforward title, *Chongfu shuxie yiqian ci 'Lantingxu'* (*Repeatedly Replicating a Thousand Times 'Lantingxu'*, 1990–97).

A BLACK-AND-WHITE PHOTOGRAPH

A Chinese man stares at me—the one who reads—from the verso page of an opened Chinese book bilingually titled *Document/Xianchang* (*Live Action Site*) (see Yang Zhichao 2005).[2] His gaze is steady, his expression calm and his crew cut overgrown. The man wears a longsleeved shirt and carries a canteen, its canvas strap diagonally cutting across his front. His partially shaded shirt looks like an extension of the weatherworn brick wall in the background. The picture's caption reads, "'Sihuan zhi nei"

EMPATHIC HYPERLINKS

1 Parts of this chapter first appeared in Meiling Cheng (2012b). See 'Wang Xizhi' in *Baidu Baike* (2010). I base my account of Qiu's performance on documentation from his website, QIUZHIJIE.com (2010). My translation of the piece's title follows its Chinese title closely and differs from the translated title—*A One-Thousand-Time Copy of Lantingxu*—listed by the artist. Also, Qiu categorizes the piece under 'calligraphy' whereas I consider it a durational xingwei piece with calligraphic actions. I also discussed this piece in my interviews with Qiu, 5 July 2005 and 8 July 2006, Beijing.

2 Although Document/Xianchang, in which Yang's essay appears, has a bilingual title, its text is published only in Chinese. I translated the list of rules from its Chinese version. Yang devised these rules before he undertook the action, but he noted 'four days' as the duration of his action when the list of rules was published as part of his performance documents. For the police interference, see Yang's journal entry dated 30 July 1999.

BeiJING
XIngWEI

369

IMAGE **6.2** The artist's snapshot for *Sihuan zhi nei* (*Within the Fourth Ring Road*, 26–30 July 1999). Photograph by Ai Weiwei. Courtesy of the artist.

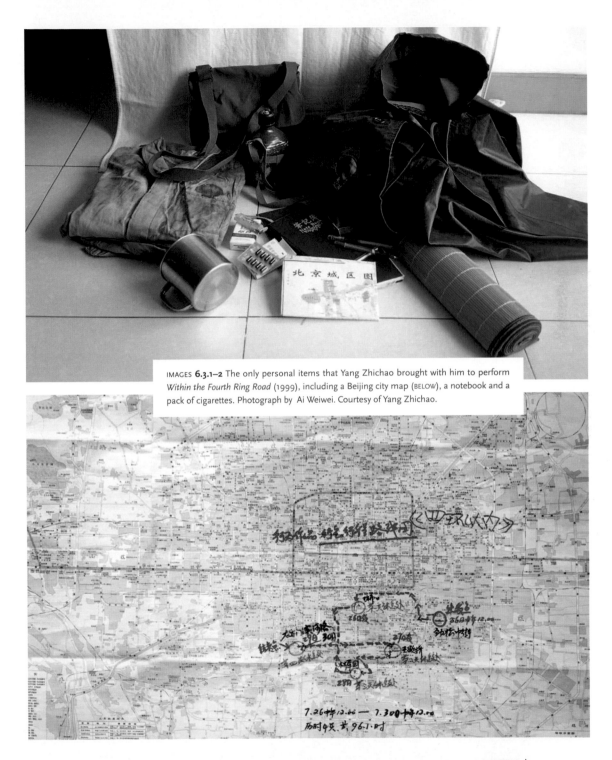

IMAGES **6.3.1–2** The only personal items that Yang Zhichao brought with him to perform *Within the Fourth Ring Road* (1999), including a Beijing city map (BELOW), a notebook and a pack of cigarettes. Photograph by Ai Weiwei. Courtesy of Yang Zhichao.

《"王冕粮油商店"档案》 作品计划

作者：王楚禹 王洪

"王冕粮油商店"开业于2005年8月20日 注册法人：田海珍

店址：北京市通州区宋庄镇市场

经营管理人员：王洪 田海珍

主要进货渠道：北京市通州区八里桥批发市场

经营范围：零售粮油、定型包装食品、干果。

经营家庭成员：王洪（丈夫） 田海珍（妻子） 王冕（儿子）

家庭经济来源："王冕粮油商店"收入

作品的实施计划和过程：

1 作品将从2006年元月1号开始实施，至该粮油店在不可抗拒的外力情况下终止经营时宣告结束。

2
在此期间，每天将经营与生活的所有帐目进行登记整理，按月发布经营的财务报表，每年进行全面报帐盘点，总结经营情况，全面公布收入及支出的帐目。

3作品完成后将产生"王冕粮油商店"的所有档案文献。

4
作品完成后将产生粮油商店在整个经营期间的经营档案、家庭生活档案及文献，粮油商店经营和生活的财务帐目。

作品呈现方式：

1 按月在网上公布"王冕粮油商店"的经营财务报表及经营者生活财务报表。

2按月公布一副"王冕粮油商店"的经营现场照片。

3制作记录片《王冕粮油商店》

4 作品结束后，将举办"王冕粮油商店档案"作品展
展出粮油店全貌、照片、所有文献档案、经营者生活资料及粮油店记录片。

作品浏览网站：tom美术同盟　画家村 西维艺术网

2005年12月24日王楚禹 王洪发布于通州

IMAGE **6.4** The original project plan by Wang Chuyu and Wang Hong for '*Wang Mian Liangyou Shangdian*' *dang an* ('*Wang Mian Rice Oil Shop*' *Document Files*, 2005–) and posted on tomarts.cn on 24 December 2005. Image courtesy of the artists.

chufaqian liuying. Sheying: Ai Weiwei' (*Within the Fourth Ring Road*, snapshot before departure. Photograph by Ai Weiwei). A brief resume listing the man's accomplishments appears on the recto page, identifying the man as Yang Zhichao, the artist about to leave for his endurance xingwei project *Within the Fourth Ring Road* (26–30 July 1999). I flip the page and find another image-list pairing. On the left is a grayish reproduction of a Beijing map, superimposed with a diagram made of thick white arrows and dotted lines, marking Yang's itinerary within Beijing's downtown area circumscribed by the Fourth Ring Road. Five circles, accompanied by handwritten notations of dates and places, record the departing, resting and closing spots for Yang's action. The list on the right shows the rules Yang established prior to enacting *Within the Fourth Ring Road*. Although one of the regulations leaves the duration of this xingwei piece contingent upon outside interference, Yang filled in the piece's actual duration of 'four days' when he published this document, which I translate and reproduce from its published format as the following:

Xingwei Rules

Process: To beg within Beijing's Fourth Ring Road

Regulations: 1. The beggar has no money whatsoever.

2. Does not accept any help from acquaintances or friends.

3. Does not contact friends or family during the begging process.

4. Does not stop the begging activity without reason.

Time: 26 July 1999, 12 p.m.– 30 July 1999, 12 p.m. (lasting four days)

Range: Beijing, east to East Fourth Ring, west to West Fourth Ring, south to South Fourth Ring, north to North Fourth Ring.

Records: 1. Handwritten journals, 2. Photographs.

(Note: Ai Weiwei serves as the witness for this activity. Ai is entitled to supervise the one who executes this action and to interpret the action's rules.)

AN INTERNET ANNOUNCEMENT ON A CHINESE-LANGUAGE WEBSITE

First posted on Meishu tongmeng (tomarts.cn) on 24 December 2005 and now popping up on various websites and blogspheres, the notice consists of a list of facts and regulations outlining the plan for an artwork entitled '*Wang Mian Liangyou Shangdian*' *dang an* ('*Wang Mian Rice Oil Shop*' *Document Files*). The disclosures include the authors' names (Wang Chuyu and Wang Hong), the date when '*Wang Mian Rice Oil Shop*' began operation (20 August 2005), the location of the shop (in Tongzhou, a suburb of Beijing), the family who manages the shop (Wang Hong, husband; Tian Haizhen, wife; Wang Mian, son), and the family's financial source (income from the Wang Mian Rice Oil Shop). Following such basic information is a list of artist-developed rules:

The Artwork's Execution Plan and Process

1. The artwork will be executed beginning 1 January 2006, until this Rice Oil Shop is forced to close by external factors beyond its control.

2. During this period, a daily financial record for business, living expenses and income will be kept. Every month, all these financial records will be presented. Every year, an overall balance sheet will be tabulated to evaluate the shop's operation. All income and expenses will be publicized.

3. Once the artwork is finished, the resulting product will be the compilation of all document files for the 'Wang Mian Rice Oil Shop'.

4. The artwork will produce documents of operation for the Rice Oil Shop, literature and documents for [Wang's] family life and financial records for the business and life in the Rice Oil Shop.

The Artwork's Methods of Display

1. Monthly web-posting of financial records of 'Wang Mian Rice Oil Shop' and the operators' itemized records for living expenses.

2. Monthly web-posting of a photograph of the live operation site in 'Wang Mian Rice Oil Shop'.

3. Producing a documentary video, *Wang Mian Rice Oil Shop*.

4. When the artwork is finished, an exhibition will be held to display all pictures, document files, literature about the operators' lives and the documentary video (Wang Chuyu and Wang Hong 2005).[3]

3 The original posting on tomarts.cn is no longer extant. My interviews with Wang Chuyu, 7 July 2006 and 15 July 2008, in Songzhuang, Beijing.

A SMALL BOOKLET WITH BURGUNDY COVERS

Its front cover features an official PRC signet and bilingual titles (in Chinese followed by English), indicating it to be *Jumin huko bu, Household Register* [sic.], issued 'Under Supervision of the Ministry of Public Security of PRC'. Its back cover, the fine print aligned at its lower left corner, certifies this booklet to be a different type of residential registry whose most crucial information I amplify in a larger typeface:

物尽其用 赵湘源和宋冬 [*Wu jin qi yong*, Zhao Xiangyuan and Song Dong]
Waste Not Zhao Xiangyuan and Song Dong

This registry is then also an exhibition catalogue which partially appropriates the form and idea of PRC's 'Household Registry' (an official record of basic information about all residents in a household). Like a passport-sized notepad, the catalogue's spine appears on its cover's upper edge, so that the bilingual text inside is read from left to right, top to bottom. Flipping the front cover upwards to reveal the booklet's first page, I see a black-and-white photograph of a smiling young woman with a little boy. The caption identifies them as Zhao Xiangyuan and Song Dong, in 1970 in Beijing. The next two pages display in Chinese, 'Wu jin qi yong—Foreword', an introductory note written by its curator, Wu Hung, in September 2005. The foreword bears the red stamp of 'approval', framed by a circle with one star in its middle and a title suggesting its 'official' source—the City of Beijing's Bureau of Household Registry. Next is a colour photograph of an installation view of *Waste Not* as it was exhibited at BTAP—Beijing Tokyo Art Projects (2005). I enter deeper into the 'household' of *Waste Not*, following the pages of Chinese texts by the two artists, their English translations and the pervasive red seals of approval. A detailed shot of bricklike brown soaps, neatly stacked on a concrete table, leads to an accordion-folded centrefold featuring five colour photographs. I turn the booklet sideways to view across a horizontal span a 180-degree panoramic view of the xingwei-zhuangzhi, *Waste Not*—the wooden frame of a traditional Chinese house, together with assorted and carefully arranged quotidian items—at BTAP's converted-warehouse gallery. Each photograph shows Zhao in the midst of organizing her household possessions which constitute *Waste Not*. More pictures follow, including a candid shot of Zhao's living room, cluttered with the stuff that now fills the gallery, and another of the BTAP gallery's clerestories from an interior vantage point, revealing a line of blue neon-tube-illuminated Chinese characters displayed in reverse. I realize that the Chinese sentence is hung outside the row of clerestory windows. Facing skywards, as if dispatching a telegraph

居民户口簿
Household Register

中华人民共和国公安部制
Under Supervision of The Ministry of Public Security of P.R.C

IMAGES **6.5.1–2** The cover of the passport-like catalogue (ABOVE) and the photograph of Zhao Xiangyuan and Song Dong (BELOW) in the catalogue for *Wu jing qi yong* (*Waste Not*, 2005). Image courtesy of Song Dong.

4 I adopt the catalogue's English translation for the sentence written for Song's father. I also base my information of *Waste Not* on my interview with Song Dong, 24 March 2009, Beijing.

to heaven, the sentence reads, following the catalogue's English version: 'Dad, don't worry, mum and we are fine!' (Zhao Xiangyuan and Song Dong 2005).[4]

PERCEPTUAL GATEWAYS | These four pieces comprise varying combinations of selected mediums, experiential interfaces, performance durations and microcosms of cultural sentiments.

Qiu's *Repeatedly Replicating a Thousand Times 'Lantingxu'* is a hybrid between calligraphy and performance. His action score consists of recurrent inscriptions of the same text on the same piece of paper over an extended period. The primary interface exists in the inscriber's deliberate hand moving across a progressively indecipherable writing surface that becomes, as it were, a darkened mirror. 'A thousand times', chosen 'arbitrarily'[5] by the artist, functions as the temporal outer frame—one necessarily prolonged due to its copious requirement—for the artwork's flexible duration. The piece's cultural sentiments revolve round the artist's commitment to a preset task as an impersonal, non-negotiable objective, however casually its goal was selected. Sol LeWitt's dictum for conceptual art—'The idea becomes a machine that makes the art' (1999: 12)—also comes to mind. Qiu's corporeal engagement with the task as a protracted xingwei project, however, overlays a contemporary bodywork dimension onto a traditional literary discipline while at the same thickening the cerebral centre of his mutated conceptual art.

5 See QIUZHIJIE.com. Also my interviews with Qiu Zhijie, 5 July 2005; 8 July 2006.

Yang's *Within the Fourth Ring Road* is a loose assemblage of endurance bodywork via psychosomatic self-studies, ethnographic fieldwork, interactive urban ritual and sociological investigation, deploying a performance mode characterized by Augusto Boal as 'invisible theatre' (2002: 112). Having chosen 'begging' as his project's main action and his sole source of survival during its enactment, Yang binds himself to a compulsory scenario of initiating contact with another person, soliciting the person's help, bearing the humiliation of being rejected or expressing gratitude. Interactivity mobilizes the artist through his immersion in an unevenly developed postsocialist metropolis. Yet, interactivity also triggers the artist's process of 'dis-identification',[6] shifting his role from someone who consciously undertakes a productive act to an indolent, parasitical or downtrodden nobody. Befitting his liminal mask as one who withholds the right to self-determination, Yang also rescinds his personal control over the project's duration—his artwork ended after four days when the law intervened. *Within the Fourth Ring Road* puts to the test the traditional Chinese sentiments of *renqing wei* (lit., 'the taste of human emotions')—to show warmth and affection towards strangers—even when the artist registers, with every cold shoulder received, the erosion of such communal hospitality in an increasingly mercenary society.

6 My use of the term 'dis-identification' here focuses on the etymological sense of 'dis' as in 'opposite' or 'denoting the absence of', as used, for example, in 'diseased', meaning 'ill at ease', which is opposite to the inventive 'disidentification' developed by José Esteban Muñoz (1999).

'*Wang Mian Rice Oil Shop*' *Document Files* includes several parallel components, indicating the divergent professional credentials and experiential differences between its collaborators: Wang Chuyu, an established independent artist uninvolved in the rice oil shop's daily operation;

and Wang Hong, an aspiring artist whose main livelihood depends on the shop's smooth operation. We may consider the project, for Wang Chuyu's part, as a classic example of what Gregory Battcock calls 'Conceptual or Idea Art', delineated as a contemporary art genre that produces not a commodifiable object but 'some kind of documentation referring to the concept' (1973: 1). Conversely, for Wang Hong, a clear-cut distinction between his art, his work and his life is elusive; instead, the project approximates what Allan Kaprow has noted as 'making nonart into art': 'work in unrecognizable, i.e., nonart, modes but present the work in recognizable art contexts' (1993: 174–5). Wang Chuyu has taken Wang Hong's nonart business—running a grocery store—and reconceptualized it as art by presenting its financial documents every month on tomarts.cn, an established Chinese art website.[7] The project's doubled status also affects its possible duration. While its process-oriented

7 My interview with Wang Chuyu, 7 July 2006, Beijing. Since 2010, the information about the work has been transferred to Wang Chuyu's blog (2007).

emphasis renders its durational aspect artistically less significant, its actual duration is contingent upon the quotidian sustainability of Wang Mian Rice Oil Shop. The shop's potential nonart longevity would ironically render the artwork indefinitely incomplete, making its culminating, post-mortem art exhibition ever premature. Similar to Yang's *Within the Fourth Ring Road*, '*Wang Mian Rice Oil Shop' Document Files* teases out the culturally sanctioned sentiments of *renqing wei*, here defined more narrowly as an emotional affiliation with one's *lao xiang* (old village friend), because Wang Chuyu's motivation was to help his boyhood friend, Wang Hong, who hailed from the same town in Shaanxi Province. Conversely, the piece's conceptual underpinnings permit Wang Hong to make the cognitive transition from having no means of practising art to reimagining his pursuit of economic survival as art.

Waste Not has more than a doubled body, even though it also involves two collaborating artists with very different professional credentials: Song Dong, a multimedia artist with an established international reputation; and Zhao Xiangyuan, Song's mother, who never considered herself an artist. Song initiated this project after the sudden death of his father, Song Shiping, in 2002, and used the artwork to help his mother cope with her grief. As an artwork emerging from an irreversible loss, *Waste Not* moves through acts of substitution, transfer and recollection. Following her unexpected bereavement, Zhao's lifelong habit of collecting used, unused and disused household items developed into a pathology; through her hoarding, she entombed herself with excessive objects. To lift his mother out of depression, Song asked her to help him with his art, subtly persuading her to substitute her mourning for the dead with her care for the living. Song himself reimagined what he saw as his mother's burden—the salvaged junk burying her—as readymade art materials and, with her consent and collaboration, transferred most of her lifetime possessions to a public space for reinstallation. The 'body' of *Waste Not* is then a cumulative composition with unfolding motifs: the longing for an absent body gives way to the upkeep of those left behind; the reassembling of remnants laden with memories of the departed opens a door to new bodies, those of visitors who add their private, family and cultural memories to an expanding mnemonic constellation. The project became a composite and interactive oral history of a nation and of the generation of Zhao (1938–2009), epitomized by her thrifty ethos of saving everything that might be of use later—an enculturated habit characteristic of the same generation, that of my parents, in Taiwan. As a communal composition set in motion by its public exposure, *Waste Not* is a time-based artwork of an uncertain

duration, for it links one person's life narrative with those audience narratives triggered by the narrator's tonal gestures, corporeal bearing, affective osmosis and her period-and-region-evocative everyday experiences and commodities. While the strongest sentiment in *Waste Not* is *qinqing* (family love), its transfer into the public realm allows this familywork to stir up *renqing wei*—a taste of communal affection—in postsocialist Beijing.

INFORMATION ARCHITECTURE: DOCUMENTARYWORKS | Enacted between 1990 and, at least for the *Wang Mian Rice Oil Shop* and *Waste Not*, today, each of these projects rely on documentation as its primary mode of display, transmission and dissemination—so much so that I'd like to call them 'documentaryworks'. Like bodyworks, animalworks and consumableworks, documentaryworks are named after their primary art materials. None of these labels, however, specifies why the artworks are made, in what forms they will be presented or for how long their formal output will last. My naming and defining the parameters of these genres offers only provisional containers to bring into relief the diversity among them and within each category. While other time-based art genres often employ documentation as a supplement, to propagate their traces among a wider audience, a documentarywork utilizes documentation to partially constitute rather than merely augment its time-based component. If the typical multi-media fragments (performance scores, site diagrams, action sketches, photographs, videotapes, interviews and statements of purpose) that an artist uses to conceptualize, record and verify an ephemeral artwork are seedlings and offshoots, then the documents generated by a documentarywork during the span of its enactment shape the main trunk. Other time-based genres may resort to documentation to multiply their potential for public exposure; a documentarywork contains within its action proper what Chantal Pontbriand has called 'deferred performance' (1979: 11). Perhaps illustrating a postmodernist aversion to definitions, Pontbriand does not elaborate on her concept. I am inspired, however, by her provocative phrase to characterize 'deferred performance' as a time-based event that can only be experienced subsequently—that is, to be reenacted, imaginarily or otherwise, by its receivers. A documentarywork manifests, then, a conceptual kinship with deferred performance.

Documentaryworks tend to reach their receivers after the fact, via visual and discursive documents produced conterminously with their time-based actions. At times, this tendency responds to the sheer impossibility of the artist sharing an ongoing performance with an onsite audience. In *Repeatedly Replicating*, for example, Qiu had designated a number—a thousand times—for his calligraphic action, yet he adopted an ad-hoc structure for its execution. He performed the inscription once a day, several times a day, but also sometimes spent days without touching the brush pen; he did the work indoors or out. Because of its extended duration and semi-improvisational event structure, Qiu's calligraphic xingwei cannot be witnessed live in its entirety by anyone other than the calligrapher himself.

At times, the documentary aspect is integral to the execution of the live artwork. Yang's 'begging' xingwei in *Within the Fourth Ring Road* depends on the artist's willing suspension of his professional identity so as to experience 'a means of survival based on an individual's freely chosen act to lose all human dignity' (2005: 29; my translation). Yang's unwitting co-performers

were precisely those who could not recognize his begging as art. Indeed Yang's interactive art could succeed only when those from whom he sought alms failed to discern his disguise. His performance is, then, an openly engaged clandestine action. Even Ai Weiwei, Yang's long-term mentor and the only 'witness' to *Within the Fourth Ring Road*, guaranteed the project's veracity without seeing Yang's xingwei live.

At times, perhaps counter-intuitively, documentaryworks exist to facilitate their accompanying live artworks. Whereas Qiu's and Yang's pieces depend on documentation to reach subsequent offsite viewers, documentation and its attendant public display constitute '*Wang Mian Rice Oil Shop*'. In this light, the shop and its documented existence in art mutually reinforce each other. The shop's 'real-world' operation allows the documentation to continue; the continuous documentation redistributes the shop's financial protocols as idea art and art ideas on the Web's citational engines and virtual galleries. Ironically, while the act of documenting provides the indispensable cognitive frame for Wang and Wang's collaborative documentary-work, that process is meaningful mainly as an enabling machine for its xingwei components, executed by Wang Chuyu as the one who sustains a friend's art practice with the convention of conceptual art and the non-cash subsidy of collegiality, and by Wang Hong as the one who enacts his grocer's livelihood as art-making.

At times, a documentarywork can suddenly become itself when life/the live, with its unpredictable vicissitudes, intervenes. *Waste Not* resembles the two Wangs' project in its incorporation of both live and documentary dimensions as reciprocal supplements, only to privilege the artists' lived experiences. 'The exhibited objects are just the visible parts of the project, the most important thing is that it gave my mother a space for her to put her memories, her history, in order,' wrote Song in the BTAP catalogue.[8] Song used the occasion of exhibiting *Waste Not* and sharing with the public the life source that the exhibit documented as an impetus for bringing his mother Zhao—her body, psyche and consciousness—back to the living. Live interaction between the artist Zhao and her viewers/participants/conversation partners—including her three family assistants (usually Song Dong and his sister Song Hui, and occasionally Song's wife, artist Yin Xiuzhen) as well as her curious and commiserating gallery visitors—injected vitality into *Waste Not*. Nevertheless, I consider the piece a documentarywork for much of its materiality derives from object-based 'documents', transported directly from Zhao's storage to the gallery, with only one exception: the skeletal traditional Chinese house reconstructed from Zhao's stockpile of used timber.

8 Song's statement, in English translation, is reprinted in Wu Hung (2009: 17).

The xingwei-zhuangzhi score for *Waste Not* consists of the packing, moving, unpacking, categorizing and rearranging of household possessions that Zhao accumulated over roughly five decades—'from the 1950s to 2005' (Wu Hung 2009: 6). Detached from her domestic sphere, Zhao's assortments became period relics—old things, outmoded fashions, dusty remains—documenting a bygone era and its residual overlaps with the present. Zhao served as an onsite oral historian for her keepsakes; she also began writing a memoir in the form of numerous biographies of her 'waste not' objects. Since *Waste Not* was invited for overseas exhibitions, its documentary dimension, with the accretion of international viewers' accounts, is both expanded and diversified. Sadly, Zhao passed away in January 2009 (she fell from a tree

in an attempt to save a bird trapped in the branches) and thus was not around for the more recent exhibitions. With its primary artist, collector and archivist gone, *Waste Not* became a portentous documentarywork, paradoxically glossing on the logic behind the maxim, 'waste not, want not': what's saved affords access to resources not so much for the self as for the others who are here, there and yet to come.

SCANNING HETEROGENEOUS DOCUMENTARYWORKS

I've observed throughout *Beijing Xingwei* that deploying documentation to reach a wider remote audience is not a novel strategy in time-based art. Documentation, in various formats, has almost always existed alongside an enacted artwork as a method of recollecting, recording, authenticating and disseminating the transient opus. In some cases, such as London artist Hayley Newman's *Connotations: Performance Images* (1994–98), the photographic documentation *is* the actual work whereas the 'live performances' to which the photos refer are just Newman's appropriated poses, struck in dialogue with selected performance precedents canonized in numerous historical photo documents. Newman's *Crying Glasses* (*An Aid to Melancholia*) (1995), for example,

IMAGE **6.7** *Crying Glasses (An Aid to Melancholia)* by Hayley Newman from her *Connotations—Performance Images* (1994–98) series. Photograph by Casey Orr. Image courtesy of the artist and Matt's Gallery, London.

9 In a personal email dated 18 July 2011, Newman, via Matt's Gallery, sent me the following 'fictional text' to accompany her *Crying Glasses (An Aid to Melancholy)* (1995): 'On public transport in Hamburg, Berlin, Rostock, London and Guildford. Photograph by Christina Lamb. Over a year I wore the crying glasses while travelling on public transport in all the cities I visited. The glasses functioned using a pump system which, hidden inside my jacket, allowed me to pump water up out of the glasses and produce a trickle of tears down my cheeks. The glasses were conceived as a tool to enable the representation of feelings in public spaces. Over the months of wearing the glasses they became an external mechanism which enabled the manifestation of internal and unidentifiable emotions.'

10 I first learnt about Adrian Piper's *Catalysis* series from Josephine Withers (1994: 160).

consists of a black-and-white photograph of the artist in profile, wearing a pair of 'tear-dripping' sunglasses. The caption states that Newman performed this work on 'public transport in Hamburg, Berlin, Rostock, London and Guildford' over 'a year' to experiment with 'the representation of feelings in public spaces' (see Newman 2004).[9] The image immediately reminded me of the black-and-white photographic document of Adrian Piper, her mouth stuffed with a white handkerchief, sitting in a New York City public bus and performing her *Catalysis No. 4* (1970).[10] Indeed, in Newman's essay about *Connotations*, the artist reveals that '*Crying Glasses* was made as a fictional counterpart to Piper's piece' (ibid.: 173). To me, Newman's *Connotations*

series typifies what we might describe as a 'self-referential documentarywork'—it has no live origin other than the artist's iconographic action that the camera then captures. By deliberately presenting her quasi-'still life' portrait as a live action shot and then revealing its dissemblance, Newman problematizes the conventional use of a photographic performance document as either a proof or a subsidiary product of the live action. Newman's self-referential *Connotations* series,made in 1998, anticipated the recent resurgence of global contemporary art's interest in documentation, treating it not only as a communicative vehicle for art but also as itself a unique body of art.

I shall cite, if self-reflexively, another example of this latest archival turn in international live art practices and theories by disclosing the prehistory of 'Keepsake Morsels', a preliminary version of which appeared in the anthology, *Perform, Repeat, Record* (2011). The volume's title renders on equal footing three disparate acts associated with the process of making-and-sharing ephemeral art; their syntax challenges our encultured habit to prioritize the original (to *perform*) over the subsequent (to *repeat*) and the supplementary (to *record*). Nevertheless, not to utterly surrender the vigour of the live (the once alive) to its documented afterlife, co-editors Heathfield and Jones arrange these three acts in a tacit chronology. To *perform* comes first; to *repeat*—either through reenactment of the original performance score, or by recalling what's been enacted in one's imagination—comes next, perhaps simultaneously or just a moment ahead of the third task: to *record* the performance, thereby mobilizing the possibility for the given piece to enter the cultural memesphere and the chronicle of art history.

This tacit chronology, dating a performance before its repetition and recording, does not fit my Chinese samples—even though none of these documentaryworks shares the simulated, or self-referential, vein of Newman's *Connotations* (1998), which renders 'to repeat' and 'to record' as a rationale for 'to perform'. While the Chinese pieces all comprise a durational process of enactment, their original creative acts are so intertwined with their documentary records that it is hard to distinguish when the artists' performances end and their documentation begins.

In *Repeatedly Replicating*, Qiu's performance is, literally, a repetition which simultaneously keeps a record; the keeping of that record is itself recorded. This xingwei artwork cites from a traditional calligraphic technique called *linmo* (tracing/copying/duplicating)—a two-word phrase indicating a sequence of close encounters. *Lin* suggests proximity at two junctures: where the calligrapher's fingers grasp the brush pen, and where the calligrapher's master model (say, Wang Xizhi's breathtaking *xingshu* in 'Lantingxu') is placed close by the calligrapher's hand for reverential imitation. An apt translation for *mo* happens to be 'imitation'. Insofar as imitation is repetition, Qiu's piece involves no original act: his creativity lies in his re-creativity. Further complication: his re-creativity involves a self-defacing mechanism. The more he re-creates, the less legible his product becomes, yielding meanwhile a by-product that eventually erases even references to what's been re-created. Qiu's excessive record-keeping services his performance by overcrowding and obliterating its traces.

In *Within the Fourth Ring Road*, documentation both constructs and adds to Yang's performance. The artist kept numerous journal entries on each begging day, relating his encounters, observations and philosophical meditations. From his futile efforts at shooing away

mosquitoes to his bone-eating loneliness and depression, from his anger at receiving coarse insults to his fear of being physically hurt, Yang's journal narrates, if in a piecemeal and haphazard fashion, the rough struggles and small consolations endured by his body. His words recall what we, his remote reader-spectators, did not and cannot see and hear in the flesh; they therefore serve as accessible surrogates for the missing originary act. Although the artist's body is absent, his verbal remnants are here, within reach. Through their associative flights, they further enlarge the body of his performance, leading us into a temporary republic of diachronically conjoined reveries—a conceptual double take not easily achievable at first sight, even if we had been immersed in the live that Yang initiated.

In 'Wang Mian Rice Oil Shop', the artwork is the process and aggregate of its documentation. Documentation here exceeds its usual function of verification through record-keeping by positively underwriting the performance. When infused with an artistic intention, Wang Hong's daily act of jotting down petty cash exchanges is suddenly endowed with a different purpose— if not higher, at least less pragmatic and compulsory. Staying clear of the shop's day-to-day management, Wang Chuyu's performance consists of alchemizing the shop's commercial records into noncommercial art. Although his invented documentary structure does not automatically enhance Wang Hong's pleasure as a shopkeeper, it does abet a conceptual rhythm for the grocer to transmute drudgery into art, the tedious repetition of labour into a monthly authentication of this merchant's alternative vocation. Wang Hong's record-keeping, cognitively reframed, performs his desired identity as an artist. As long as Wang and Wang keep replicating this documentary structure, additional instalments of their project will appear. In this collaboration, to perform equals to repeat and to record; the three acts happen in synchronicity.

Different from the three documentaryworks, which require no live interface between the artists and their audiences to communicate the art, Waste Not initially included, as its most pivotal element, direct contact between the artist, Zhao Xiangyuan, and her audience. Nevertheless, for Zhao, to perform in Waste Not was always to reminisce, to repeat in speech and record in words what she remembered; her *new* gallery visitors, no less than her cumulatively saved *old* objects, functioned as memory triggers for her narrative projectiles. Although Zhao's indiscriminate acquisitions came from her desire to not waste anything rather than to document her family life, the things she kept became reticent documents that, through Waste Not, invited her to discursively excavate their buried historical information. In this context, Waste Not is a documentarywork bolstered by having an onsite archivist who could reveal what those documents record.

Once the archivist was gone, the context changed. In its 2009 MoMA exhibition in New York, I experienced Waste Not as a massive xingwei-zhuangzhi *and* a non-self-sufficient documentarywork which, as I learnt from other audience accounts, elicited varying degrees of historical, cultural and familial legibility (see Cotter 2009 and Wang Yang 2009). Most of the viewers needed the buttress of other documents—catalogues (especially with Song's and Zhao's texts), reviews, blogs, the artist's interviews on YouTube, etc.—to make sense of the exhibit. Without Zhao explaining what her possessions reticently perform, the records embodied in these objects are inarticulate, vestigial. Since I had spoken to Zhao over the phone about Waste Not in 2008, I mourned her absence acutely, pining for her speaking presence and the fullness

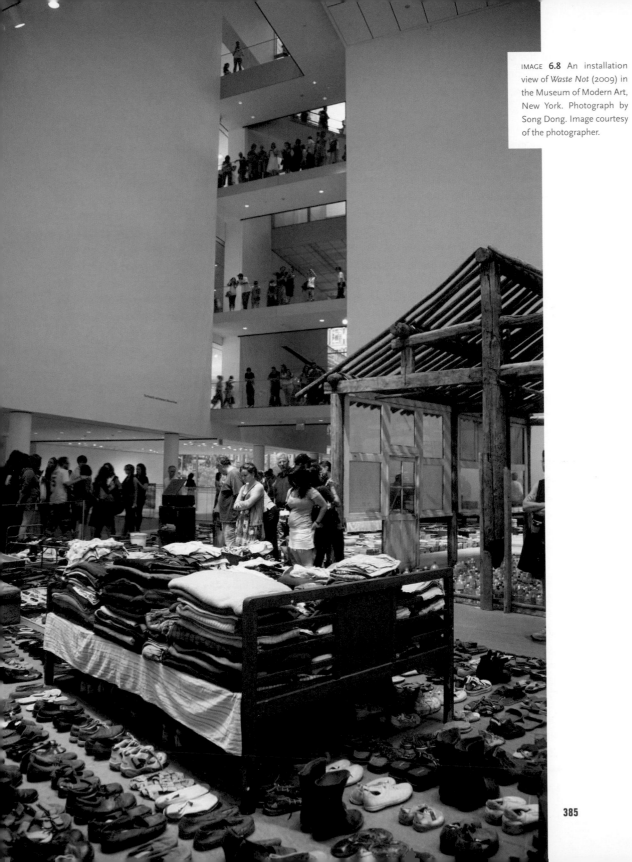

IMAGE **6.8** An installation view of *Waste Not* (2009) in the Museum of Modern Art, New York. Photograph by Song Dong. Image courtesy of the photographer.

of her three-dimensional body that I had seen only in flat images. Zhao and Song's exhibited documentarywork bore out—overwhelmingly for me—the irreversibility of lost times, even as it conjured up my memory of a warm, if mediated, older Chinese woman's voice.

NAVIGATING LIVE SITES

My four Chinese case studies have arguably displaced the live into the *once-lived*. If we may regard the 'live' in live art as a collective sensory ecology surrounding the present-tense interchange between an artist's doing and some viewers' witnessing, then such collectivity becomes drastically dissipated in the once-lived, which occupies a private universe, a hermetic time-space, shared by an artist and his/her intentionally framed art actions. As art, however, the once-lived aspires to avoid becoming the *already-dead*. Documentation is the *deus ex machina* that intervenes to transform the once-lived into the *again-alive*. How does documentation accomplish this mythic feat? By breaking the solitude of the once-lived. Documentation's magic lies in its explosive power; it shatters the reclusive planet inhabited by the once-lived into a radiating galaxy of asteroids. Each asteroid carries some memories of the once-lived; each in turn extends, renews or replaces the vitality of the once-lived; each has the potential to grow into a different planet. Thus, the once-lived lives again and lives on, not as itself per se but as itself altered—dismembered, redone, augmented, partially replicated, diminished, burnt into ashes, consumed as legend.

What strikes me as the most generative force in my improvised live art mythology is documentation's function as a transmitter, a boundary-blasting messenger who carries some information from the past to other ears. Yet, to identify documentation as a Hermes-like agent is to distinguish its ontology from that of performance. Just as a messenger is not synonymous with its message, so documentation (as a representational system for a certain once-lived condition) is not identical to what it represents: a given performance (as a once-alive nexus of information). This kind of ontological distinction between performance and documentation is nevertheless untenable for those time-based artworks that have collapsed the temporal sequences and conceptual differences between their embodied actions and discursive reenactments: namely, documentaryworks. In *Repeatedly Replicating*, Qiu's very first embodied action—as he sat quietly, breathing all his energies into a moving brush pen—was already a discursive reenactment of a writerly behaviour enacted centuries ago by a reputedly inebriated, hence deeply inspired, Wang Xizhi. *Within the Fourth Ring Road* provides another prototype in which Yang's action and documentation are interwoven as complementary parts of performance. 'Wang Mian Rice Oil Shop' pushes this prototype towards the discursive extreme, practically construing Wang Hong's shopkeeping lived experiences as a pretext for his art documentation. Reversing such an art/life dynamic, Song in *Waste Not* stresses art's service to life by utilizing documentation as a consciousness-revitalizing act for the newly widowed Zhao while paradoxically re-casting his mother as an artist.

My sampled Chinese documentaryworks are, then, hybrid time-based artworks for they blend, combine, adjoin and fuse transient durational actions with relatively more permanent documentary objects, those intrinsic to the enacted performances. In their niches of duo-dimensional (evanescent and static) admixtures, these documentaryworks both participate in and divert from

the contemporary art world's global focus on performance documents, those sanctified relics made to preserve, transmit and distribute the memory of certain past actions. I will first address documentation as a remedial act, yielding subsidiary residual products from 'pure' time-based artworks and then delve into their hybrid manifestations in documentaryworks.

The latest trend in performance research, with its special attention to residual performance documents, has implicitly 'upgraded' documentation from its traditional status as that which enables a critic/writer/distant viewer to retrospectively access a vanished artwork to the more exalted position of a legitimate, if not fully independent, object of inquiry. Such an upgrade endows—discursively if not literally—a given performance's documentary traces with the aura of the originary live event. Documentation, in this view, produces not only an inert archive, nor just a reenactable score, but also a virtual performance event: it is (virtually) live.

The proposition of a discursive near-equivalence between a performance artwork and its documentary traces adjusts an existing presumption regarding the stable distinction between a live art event and its subsequent multisourced (visual, audiovisual, literary, painterly, schematic, digital, multimedia) performance documents, for it implies that there is no dichotomy but a spectrum of possibilities existing between an originary performance (the live as well as the once-lived) and its documentation. At one end of this spectrum lies my Chinese documentaryworks, in which the embodied art actions and their documentary partners function as coincidental, interdependent, even bilaterally engendering, counterparts. At the other end appear those—most of them from the early history of Euro-American performance art— wherein the artists want to share some transient actions with an onsite audience without leaving behind any (significant) documentation. In between are the majority of instances where certain live events do happen first and their documentations next—or simultaneously, as in an audio-visual recording. It is this middle majority that tends to be most suspicious of documentation's capacity to usurp live performance.

The middle majority's impulse for conservation does have a rational grounding. There are two direct consequences to loosening the barrier between a time-based art event and its documentation: One, it permits the (relatively) permanent to impinge upon the (supposedly) ephemeral; Two, it challenges the priority of the live. The combination of these two tendencies brings forth an obvious threat to live art, sending it back to the embrace of commodification— live art documentation is now available for sale, for exhibition, for collection and for canonization. 'Live', which thrives formlessly between some sentient beings who self-select to share a stretch of site-specific temporality, becomes materialized, solidified, (yet another) art object, detachable from its communal *raison d'être*. Is there no escape from the protean clutches of capitalism?

The invisible hand of capitalism, under its current guise of transnational globalization, may have created the most encompassing climate affecting the production of all artworks— time-based or not—in our late post-postmodernist era. Yet, even 'bad' weather cannot stop those wanting fresh air from going outdoors! Time-based art practitioners may choose to consider the cash-laden forces of commodification a threat, a temptation, a numbing white noise, an opponent, an oppressor, a patron saint, a big break or an open challenge. Thus, we can still wonder: Beyond its pragmatic and profitable use values, how does the blurring of boundaries

between performance and its documentation modify our conceptual mores in studying time-based art?

Most immediately, such a blurring compels us to re-evaluate a prized methodology in performance critique, one based on an intensive onsite engagement with a live artwork. While immensely worthy, this methodology is problematic if we assume it to be the most authoritative credential, even a minimal requirement, for a critic/historian to analyse a performance piece. I find that this assumption implies an epistemic collapse between experience and knowledge, corporeal presence and purposeful introspection. Seeing/hearing something live, alas, doesn't guarantee knowing it fully. As Amelia Jones cautions in her influential *Art Journal* article, '"Presence" in Absentia', there is no 'unmediated relationship' between a perceiver and 'any kind of cultural product'; moreover, it requires distance for the perceiver to make sense of a live experience through retrospective deliberation. Jones argues convincingly for experiencing performance as documentation by indicating the analogous exchange process between a viewer watching an artist performing and a viewer/reader examining the performance documents: 'While the live situation may enable the phenomenological relations of flesh-to-flesh engagement, the documentary exchange (viewer/reader ↔ document) is equally intersubjective.' Consequently, Jones contends, the specific knowledge a spectator gains from participating in a live event, though useful, should not take precedence over the equally specific knowledge that a critic/historian develops 'in relation to the documentary traces of such an event' (1997: 12).

Philip Auslander extends Jones' argument but from the opposite direction, championing the 'performativity of performance documentation' to authenticate a future spectator's encounter of 'the document itself *as a performance*' (2006: 9). Auslander's theoretical proposition evokes the irreducible centrality of the documentation which is characteristic of my Chinese documentaryworks; indeed, he privileges documentation to the extent of putting its source live event in parentheses. Such a position shifts the status of a performance document from its normative role as the trace that verifies and helps recoup a live event to that of a performance in its own right. Auslander further reverses the temporal sequence of a live event and its recording to assert that 'the act of documenting an event as a performance is what constitutes it as such' (ibid.: 5). This statement effectively repositions a performance document from its place as an indexical link to the originary event to a self-sufficient position as a performative entity in dialogue with its present beholder.

Jones' and Auslander's arguments share in their defence of the perceptual immediacy, analytical rigour, ethical feasibility and epistemic validity of a performance critique offered by a viewer/reader who may not have seen the live event but who has studied the performance artwork through its various documentary remnants. Both arguments support my conceptual basis in assessing almost all of the Chinese time-based artworks assembled in *Beijing Xingwei*. Our similar theoretical standpoints amount to a declaration of critical subjectivity, which responds to but assumes neither a subservient nor a solely reactive stance towards the artistic subjectivity expressed through the artwork—via its documentation—under scrutiny. As critics, what we seek seems less the 'truth' of the originary scene than the few cognitive potentialities that become substantiated through our discursive in(ter)ventions. Hardly innocent, our interpolations might seem subversive, imperialist, parasitical and altogether ill-mannered in relation

to those creators who call up the 'light' to stage the originary acts. What exactly is at stake in these power struggles between the paradigmatic pair, the creative and re-creative agents who are joined diachronically by their interest in the same artwork?

The move to highlight the 'intersubjective as well as interobjective' (Jones 1997: 12) exchange between a critic/reader and selected performance documents has **FRICTIONAL DOMAINS**
the potential to divest the artist, the original creator, from her/his conceptual monopoly over the given artwork. The artwork itself, as reflected in its documentary fragments and reconstructed by the critic/writer, is the real object of inquiry whereas the artist becomes simply a source, as the one who had produced—with varying degrees of control—the artwork of interest. In a critique of Jones' *Art Journal* article, for example, Catherine Elwes protests against precisely what she regards as a reduction of the artist's creative agency by a critic who has chosen, without having seen the live event, to interpret the piece via its documents. Elwes takes exception especially to Jones' reservation about getting to know an artist personally in order to ascertain his/her perceived intentions about the work. 'What we were left with,' as Elwes objects, 'was the primacy of the written word over the visual, the postrational over the immediate non-verbal response and the critic over the person and creative output of the artist' (2004: 194). In other words, the (relatively) permanent takes precedence over the fleeting, the unsaid and the inexpressible: human inventions (a removed critic's verbal texts) over the human given (a present viewer's preverbalized sensations).

As a performance critic myself, whose primary medium is the written word, I accept Elwes' charge that favouring the performance documentation over its irretrievable referent tends to displace the artist-performer from centrestage to the wings. Moreover, the spot from which the artist/creator is inadvertently evacuated is now occupied by the critic/writer, whose actions alternate between thumbing through an assortment of performance documents, staring at digital images on a computer screen and gazing—in semi-hallucination—into thin air. This scenario, centring on a writerly reader's response, sanctions an excursion, even an intrusion, of critical subjectivity into a time-based artwork's creative domain, effectively 'demoting' artistic subjectivity—at least, the parts embodied by the artist/performer's intentionality and mnemonic agency—to mere traces among many consulted by the critic/writer in evaluating the performance as a public cultural bequest. While a critic/scholar might be justified and, indeed, compelled to do so while composing a historiographic account about a century-old performance, the situation becomes complicated and contentious with respect to a contemporary performance piece whose original author is still alive and open to queries. After all, 'intentional fallacy' (see Wimsatt and Beardsley 1946)—the stance held by literary critics to guard against asking an author for a given text's intended meaning—is hardly applicable to a performance medium that is often explicitly chosen to enunciate an artist's subjectivity.

Based on the knowledge gained from my cumulative experiences, I vouch for the benefit of learning from an accessible creator. In fact, I could not have launched my journey into xingwei yishu and xingwei-zhuangzhi without the generous sharing of those who had sweated to build the stations through which I transited during my brief sojourns. Nevertheless, given

my indebtedness to these creators, I argue that the emergence of critical subjectivity, as a composite, contingent and provisional textual embodiment of spectatorial commitment, re-creative agency and interpretive critique, is fostered by performance art's conceptual lineage. As I've theorized in *In Other Los Angeleses*, performance art—an embodied, hence time-based, visual art form—thrives on a radical incompleteness for it anticipates a spectatorial other's active perceptual, cognitive and hermeneutic investments in order to extend its affective-and-efficacious cultural vitality (2002). My thesis departs from the historical linkage of performance art with the early-twentieth-century European avant-garde movements, which appropriated from theatre art the decisive element of an immediate audience. This intermedial borrowing helped constitute performance art's consistent structural ecology: the time-space-action-performer-audience matrix of theatricality. This adoption of theatricality, which implies its negative claim of anti-theatricality, concomitantly positioned performance art within a century-plus genealogy shared by experimental theatre, a methodological kin against which performance art sought to define its own unique identity.

According to Bruce Barber, the term 'performance art' did not appear in print until 1973 (1979: 187). Artistic activities resembling performance art, however, long preceded its naming and perturbed the aesthetic status quo of both visual and performing arts throughout the twentieth century. A by-now conventional charting of performance art's genealogy would include its numerous avant-garde precursors, such as futurism, Dada, surrealism, expressionism, the Bauhaus, destruction art, goddess rituals, body art, action painting, Fluxus and happenings (see, for example, Goldberg 1996 and Stiles 1996b). A similarly established genealogy of experimental theatre would typically go by its directorial innovators to include, naming but a few, Vsevolod Meyerhold, Antonin Artaud, Bertolt Brecht, Tadeusz Kantor, Peter Brook, Jerzy Grotowski, Merce Cunningham, Joseph Chaikin, Lee Breuer, Richard Foreman, Richard Schechner, Meredith Monk, Ariane Mnouchkine, Robert Wilson, Pina Bausch, Elizabeth LeCompte, Tadashi Suzuki, Anne Bogart and Romeo Castellucci (see, for example, Mitter and Shevtsova 2005 and Schneider and Cody 2002). Extending my previous proposition, I maintain that these two parallel genealogies may be linked by their practitioners' perennial and variable explorations of my hypothesized theatrical matrix. For every performative action cannot but consider how to deal with the five irreducible structural elements in its presentation: the *time* and *space* that cover the site, set and duration of an action; types of *action* that range from the mystical, dramatic, and solitary to the collective and activist, from the controversial, abstract, populist and lifelike to the highly technological; kinds of *performer* that vary from a single in/animate entity, to a human ensemble to numerous involuntarily enlisted nonhuman animals; and, finally, the nature of the intended *audience*. To me, it is this last element that most crucially distinguishes performance art from experimental theatre.

Many artists and theorists engaged with performance art in its formative period attempted to differentiate it from theatre art by privileging 'the real', by asserting that the *time* in performance art is real-time, its *space* a non-artificial found site, its *action* taken with actual corporeal consequence for the *performer* who is none other than the artist-creator. These assertions proved less and less sustainable as newer generations of performance artists, cultivated by a techno-science environ suffused with simulacra, came to recognize that the 'fake' was just as 'real' and

vice versa. Thus released from the mythic grip of 'the real', performance artists could elastically remodel their take on the theatrical matrix, often producing work with a greater surface resemblance to experimental theatre.

Contrary to performance art's general suspicion of pretence, the collaborative art of theatre, through its oft-cited 'willing suspension of disbelief', operates from the plausibility of the probable and the probability of the fabulated. Theatre art's communal roots, however, compels it to favour 'the real' with regard to its intended audience. Intriguingly, this aspect is reversed with performance art whose historical affinity with conceptual art affords it a greater freedom in construing what counts as an 'audience'. Whereas theatre—experimental or otherwise—cannot sustain itself without the communal presence of a live audience, performance art manages to reconceptualize the dialogic relationship between the performer and the audience as a *promise* rather than an essence. This redefinition enables performance art to seek the polyphonic dynamics of the (theatrical) here-and-now even in the (conceptual) thereafter. 'The theater is the only place in the world where a gesture, once made, can never be made the same way twice' (Artaud 1958: 75). While this observation memorializes the intransigent singularity of every time-bound act exposed under the spotlight, it also captures the fragile fullness of a communal encounter that can only take place *once* among a specific and arbitrary grouping of individuals. Theatre art values and exists in this *once*. Clinging to the portable abstraction of an idea as a self-renewable body of art, performance art simultaneously reifies and phantomizes the same 'once' as a solitary thinking moment made flesh through a perceiver's personal sensory recall which, even when absolutely faithful, is ineluctably adulterated.

Has performance art then benefited or suffered from its conceptual heredity?

In a controversial missive entitled, 'Declaration of Intent' (1968), conceptual artist Lawrence Weiner lists several possibilities for his artwork to be made and appreciated:

1. The artist may construct the piece

2. The piece may be fabricated

3. The piece need not be built

Each being equal and consistent with the intent of the artist, the decision as to condition rests with the receiver upon the occasion of receivership (in Meyer 1972: 218).[11]

As Weiner further summarized his intent in an interview, 'The art is as validly communicated orally, verbally, or physically. It's all the same' (cited in Alberro 1999: xxxii–xxxiii). The same idea, no matter its multifarious expressions. By equating an artist's idea for an artwork with the resulting output, Weiner's verbal declaration illustrates one of conceptual art's incipient questions: Does the form of visual art need to remain visual?[12]

[11] This statement of intent was first published in the catalogue for the exhibition, January 5–31, 1969 (1969: *n.p.*).

[12] I am paraphrasing the question raised by Terry Atkinson: 'Initially what conceptual art seems to be doing is questioning the condition that seems to rigidly govern the form of visual art—that visual art remains visual' (1972: 9–10).

The question regarding the nature of visual art hearkens back to Duchamp's 1917 pronouncement that an artist is 'someone able to rethink the world and remake meaning through language, rather than someone who produces handcrafted visual objects for "retinal" pleasure' (Stiles 1996a: 804). Wiener's epigrammatic manifesto, in effect, echoes Duchamp's anti-retinal

interdiction to ask: Can an artwork consist solely of suggestions about how the piece may be executed? He responds to the self-query by displacing his potential visual object into the non-material realm of ideas. In exchange for the lack of retinal pleasure, Weiner offers his art receiver conceptual co-ownership of his piece—a transaction of shareholdership endorsed by his ending sentence which gives the art-receiver autonomy in realizing his idea-centred artwork. Weiner's 'Declaration' implicates at least two parties—from the artist who delivers to the other who receives—and serves to diagram the volitional circuit comprising what Duchamp calls 'the two poles of the creation of art: the artist on one hand, and on the other the spectator who later becomes the posterity' (1996: 818). The conceptual co-ownership of a nonstatic artwork by the artist and his/her *spectator*—as, shall we say, a *speculating human factor*—makes cognitive, strategic and reciprocally invigorating fellowship sense because of what Duchamp articulates as the 'art co-efficient', manifest in the gap between 'the unexpressed but intended and the unintentionally expressed': 'All in all, the creative act is not performed by the artist alone; the spectator brings the work in contact with the external world by deciphering and interpreting its inner qualifications and thus adds his[/her] contribution to the creative act' (ibid.: 819).

'All art (after Duchamp) is conceptual (in nature) because art only exists conceptually,' thus spake Joseph Kosuth (1999: 162). His statement elucidates performance art's 'family' resemblance to conceptual art, a likeness gained by inheriting its antecedent's revolt against the morphological requirements of object-based art. Solipsistic as it sounds, Kosuth's claim is vulnerable to charges of totalization; the post-Duchampian artist-theorist fails to consider that a post-conceptual art form may assimilate certain aspects of its artistic forebear, reject others and add something alien to the gene pool, thereby hybridizing its 'conceptual' nature. In fact, performance art has done just that, having redressed its Neoplatonic precursor's over-cerebral, meta-artistic, self-murmuring opacity with expressionist fervour, messy corporeal eroticism, relational ethics and 'other'-accommodating multicentricity. The *brain beautiful*, after all, is only one organ among many!

If I may make my totalizing claim here: I find that performance art's key revision of conceptual art derives from its incorporation of the theatrical matrix, which offers a mimetic structure to absorb, contemplate, invent, reflect and display human existence in its myriad minutiae. Or, as John Cage puts it more delightfully:

Where do we go from here? Towards theatre. That art more than music resembles nature. We have eyes as well as ears, and it is our business while we are alive to use them. [. . .] Or the answer must take the form of paradox: a purposeful purposelessness or a purposeless play. This play, however, is an affirmation of life—not an attempt to bring order out of chaos nor to suggest improvements in creation, but simply a way of waking up to the very life we're living, which is so excellent once one gets one's mind and one's desire out of its way and lets it act of its own accord (2009: 5).

Cage's brand of ecstatic Zen detachment places theatre in an exulted and relaxed position as an art form that most resembles 'nature' in its mode of operation. In contrast, performance art, spurred by its passionate doublethink, refuses to impassively let nature 'act of its own accord'. Instead, this time-based art medium sets its 'mind' and 'desire' to defy the perishing time by entrusting its survival to the care of others. Thus, after some initial resistance to

documentation, performance art has quickly evolved tactics for posthumous revivals by adopting a technological arsenal for self-memorialization, as if to pre-empt its own mortality.

From performance art's open invitation for spectatorial others to witness, experience and share the work's present-tensed unfolding comes infinite possibilities for onsite viewers to proliferate what the work signifies or how the live action touches those present. From performance art's desire to document itself for wider and future cultural dissemination comes the prospect of diversifying its audience base to include all those subsequent others provoked by the artwork, however distanced in time and space they are from the originary action, which might have been witnessed only by a camera's lens, the eye of a technological audience. By willingly distributing conceptual ownership among its actual and/or virtual receivers, performance art has (inadvertently) nourished the rise of performative writing as a discursive mode that enacts—by writing into being—critical subjectivity. Although an artist might feel threatened by a critic's professed adoption of a subject position in critiquing the artwork, I hold that the expression of critical subjectivity remains bound to the analysed artwork and, as such, communicates nothing but the response to an affective force.

Whereas conceptual art seeks to assimilate criticality into its artistic corpus, performance art turns the circle counterclockwise to spread creativity among all it inspires: 'Everyone an artist,' as Joseph Beuys famously proclaimed (2004: 9). To foreground critical subjectivity, I submit, merely discloses an inevitable but rarely exposed process within any analytical project. Critical subjectivity complements, contests, challenges and supplements artistic subjectivity to collaboratively locate the time-based artwork in its larger sociocultural contexts. The critic and artist, therefore, join in their purpose to articulate and propagate the artwork's significance in discursive memories. This joint purpose validates performance research's latest focus on documentation as both a retrospective site, giving one accesses to appraise the originary live artwork, and a generative site, permitting a subsequent critic/writer to discern, imagine and amplify a given piece's cultural resonance.

I've earlier compared documentation to a *deus ex machina*, swooping down from its multimedia crane to salvage the hermetic body of the once-lived and then catapult it explosively into space, tearing the once-lived apart into countless star-seeds, waiting to sprout again. The critic as an experiential, probing, empathetic and epistemic subject supplies one of those potentially sustainable eco-space-pods, wherein the once-lived, even with only smithereens, may come alive again—albeit in an alternative incarnation—in the cultural ether. Can we clearly differentiate who owes whom in this exchange? The eco-pod is inert until it's triggered into animation by a wandering star-seed and the fragile star-seed is lonely until it finds an eco-pod to germinate, evolve and, through sympathetic echoes, make polyphonic interstellar music.

In my allegory for the information transfer process that enables live art to circulate posthumously in the culture-at-large, I chanced upon the imagery of outer space, conjuring up a boundless vista without national borders, geohistorical heterogeneities, economic, demographic, political, religious and other regional differences. This is a picture that exists only in the abstraction of a heuristic model. The model has zeroed in on elucidating performance

CLICKING ON THE PROSTHESES

documentation's contribution as a facilitator in disseminating time-based art but fails to address, for example, why artists in different countries may have both different and similar reasons for documenting their artworks. This heuristic model's analytical inadequacy brings me face to face with the source of its high-flying, sci-fi imagery: Where did my star-seed and eco-pod come from if not round the wormhole blown open by *2001: A Space Odyssey* (1968), the *Star Wars* series (1977–2005), the *Alien* quadrilogy (1979–1997), *Blade Runner* (1982), the *Terminator* series (1984–2009), *Total Recall* (1990) and, most recently, *Avatar* (2009)? Can I ever wake up from my popular-culture indoctrination via Hollywood's dream machine? Not incidentally, the boundless space with freedom for movement, play, spontaneity and self-determination—drawn by my half-colonized, late-capitalist allegory—harmoniously parallels the projection of a globalized world market filled with infinite opportunities provided by a multi-national corporate CEO.

Without a doubt, my hermeneutic horizon has been affected—both cultivated and contaminated—by my particularized residency within the US, harried but still complacent at its current historical moment as a relatively affluent, expansionist, self-defensive, post-industrialized nation. Despite conscious vigilance, my position as a critical subject remains complicit with this basic fact of my life, making every encounter with my Chinese artistic subjects an intercultural negotiation and my performance research on their artworks a sub-field of sinology. Complicating this factor is my personal immigration background as someone of Taiwanese ancestry—someone who, moreover, had spent her formative years on an island that continues to have an ambivalent and tense political relationship with Mainland China. There is more than one way for the Chinese artists to mark me even before or just when we begin to speak; my accent, here and there, speaks louder than my syntax, English or Chinese. While there is hardly any neutral critical subject to begin with, my diasporic acculturation heightens the stakes of my transcontinental investigation. To document (for) anyone other than me is to advance into a territory semi-known; to present my archival quest to others is to become vulnerable to unknown inquests, turning 'me' into an other to myself.

These reflections bring back memories of another concept that I began exploring in my first book: 'prosthetic performance', addressing the complex afterlife of a time-based artwork through a process largely set in motion by performance documentation. A prosthetic device is above all an entity that stands in substitution for the irretrievable origin; it extends the origin's functionality by metaphorically giving it a second life—one that may survive indefinitely in the hereafter of an expired body of action. A constant reminder of the origin that has disappeared, a prosthesis yearns for the absent body even as it recuperates the body's *raison d'être* and re-engages with its existential potentials. In a minor usage emerging more recently in the body modification subculture, a prosthetic unit (say, a breast implant) may be added to an existing body to alter the body's images, thereby augmenting, calling attention to or otherwise transforming its functions (see Nayar 2004: 211–62). Departing from the instrumentality of prosthetics as a medical or cosmetic technology, I use prosthetic performance to account for the various ways in which a live performance extends its vitality beyond its originary sited and time-based lifespan.

Prosthetic performances belong to the order of documentation and signify the relatively more accessible and distributable information sources for a live action that has transpired

elsewhere. An embodied vehicle for cultural memories, a prosthetic performance enables a virtual spectator to imaginarily encounter a past time-based artwork. An eyewitness account, an oral recollection, a journalistic review and a scholarly critique about a particular live event are prosthetic performances; so are a documentary photograph, a written statement, a diagram or a performance score prepared by the artists. These documents, remnants, evidences and responses, appearing in a sporadic chronology and encompassing a variety of genres and media, are prosthetic performances. Since a prosthetic performance deals explicitly with the privilege of access, it exists less for itself than for highlighting and enriching the particular live performance to which it refers. The very emergence of a prosthetic performance responds to a vanished antecedent. While not a replica, a prosthetic performance imitates its origin by emulating its intended cultural efficacy/affectability. In prosthetic performance, time-based art finds an evolutionary answer to its existential dilemma—that it lives as it dies and vice versa. Resurrecting the memory of an already spent life, a prosthetic performance supplies a conciliatory solution to the problem of preserving an art/life form that fulfils itself by its own expenditure.

I initially coined 'prosthetic performance' to differentiate the contribution of an artist/performer's creative agency from that of a critic/writer's re-creative labour. If what an artist makes is a perishable body of performance, then what a critic makes, having sifted through the performance's documentary substitutes to piece together, evoke, reconfigure and extend the original body, is a prosthetic performance. Claiming a critic's analytical as well as inventive response as a *prosthetic performance* rather than an *authentic representation*, I try to articulate my two perennial obsessions: First, the bond between an artist and a critic in producing a live art critique; Second, the unavoidable emanation of critical subjectivity into the historiographic process. Both obsessions deal with the consequence of mortality and a mortal's attempt not to bypass death but to transfigure its finality. The first brings up the issue of acquired, in lieu of biological, inheritance—through affinity, an other gifts the self with an act, if not of love then at least of concentrated energy. This observation applies to the artist/maker as the self, who gifts the world of others with an ephemeral artwork but who then depends on those others to remember, historicize and make public the artwork. It also applies to the critic/writer as the self who is stirred by the live presence and/or documentary traces of an other's artwork to operate the re-creative licence, producing in turn a piece that resurrects, however partially, its source of stimulation and gratitude. My second obsession concedes to the entropic tendency within human memories—what we call history is at its most honest an approximation of what has happened. Historical verity is produced rather than retrieved by the historian's scrupulous research, both in the field and at the desk. The prosthesis of this once-lived 'verity' is imagination.

My conceptual coinage suffered an epistemic crisis when I encountered the Chinese documentaryworks in which no clear distinction exists between enactment and documentation.What these artists make as the original performances already include prosthetic performances. Qiu Zhijie's calligraphy was at first a prosthetic performance of Wang Xizhi's masterpiece; subsequently, he duplicated 999 palimpsests on it. *Repeatedly Replicating a Thousand Times 'Lantingxu'* is therefore nothing but a durational prosthetic performance.

Yang Zhichao's begging xingwei in *Within the Fourth Ring Road* contains a table of regulations, a documentary photographic portrait of the artist, the interactive live events on which he

depended for survival and his diary entries. Is not Yang's table of regulations the original performance, for which his actual begging serves as its prosthetic extension? Or, are not his diary entries, produced alongside his begging, the originary performances which manage to turn their action referents—the begging that cannot be perceived as art—into prosthetic performances?

'*Wang Mian Rice Oil Shop*' *Document Files* concerns the continuous accumulation of art documents through the nonart action of running a grocery shop. This piece's originary action is split into two, both revolving round the documenting act: Wang Hong produces the original documents (his shop's actual financial records) and Wang Chuyu documents Wang Hong's documentation by framing it as art and distributing the artwork on the Internet. The two artists create prosthetic performances for which their respective lives are the origins.

Waste Not's originary action consists of sorting through innumerable objects, relics or de facto material documents, saved throughout Zhao Xiangyuan's life journey. Are those mementoes made public in *Waste Not* prosthetic performances of Zhao's life? Is Zhao's life the origin for which *Waste Not* serves as the prosthetic performance? Or is *Waste Not* the originary performance that retroactively turns Zhao's life into its prophetic prosthesis? As the artist who conceptualized the performance score for *Waste Not*, Song Dong nevertheless cast himself as Zhao's assistant, facilitator, listener and participant observer who had partially shared and witnessed Zhao's life. Is Song's originary performance in *Waste Not* the prosthetic frame that isolated parts of Zhao's life into a portrait, dramatizing her prosthetic performances, while she annotated from memory the original stories of her reticent life documents?

Naming these Chinese pieces 'documentaryworks' is my way of coping with the cognitive maelstrom in reassessing 'prosthetic performances'. In essence chrono-hybrids, documentaryworks recognize that temporal homogeneity is not a self-sustainable condition within time-based art. The information imbued within an expiring artwork requires its transfer to a different kind of body for it to last in historical memories. The interweaving of (time-based) human behaviours and (object-based) archival actions in these Chinese documentaryworks analogously recall what I mentioned as the 'cosmetic' application of prosthetics—to add something extra to an existing body part, not exactly to replace it but to modify, ornament and enhance it. Wang's '*Lantingxu*' is the existing 'body part' of the prosthetic performances contributed by Qiu. The various parts of Yang's performances in *Within the Fourth Ring Road* serve as one another's compliments or prostheses. The collaborating artists in '*Wang Mian Rice Oil Shop*' intend to produce prosthetic performances whose original live/life source is artistically irrelevant. *Waste Not* employs prosthetic performances as the artistic channel for its mother-son duo to re-encounter the wonders of a life whose ongoing body has been reconfigured by time.

If 'cosmetic prosthetics' connotes inessential adornment to an existing body, then these artists' choices to integrate documentation into their time-based art reflect reasons weightier and more long-standing in the Chinese tradition than my superficial analogy can convey. What's a possible 'weightier' reason? One wrought from a foreign country in a different season. Before we contemplate the reason, however, more demonstrations of the likes—documentaryworks—from those alike—the group of artists discussed here—would be of use: four cases reveal a community; more, even from the same group of artists, project a society.

I see them inside the polished catalogue that Qiu Zhijie gave me from *The Shape of Time | Shijian de xingzhuang*, his 2006 solo exhibition at Chambers Fine Art in New York City (see Christopher Mao 2007). The exhibition's subtitle features 'light calli-photography', a neologistic phrase coined by Qiu to name the methodology he invented for the photographs on display.[13] The procedure for light calli-photography, or *guang shuxie* (light writing), includes the artist inserting his body into a chosen site, in front of his tripod-mounted camera, and using a flashlight to inscribe in reverse calligraphy a linguistic phrase, illuminating his momentary poetic act. Under prolonged exposure, the camera's lens is able to capture the calligraphic light-script, impossible to read with the naked eye, and to transfer onto the photographic print the glowing words superimposed on a barely visible contour of the writer's body moving within the landscape. The particular series I look at in the catalogue revolves round the 24 *jieqi* (seasonal air), the seasonal markers that divide a year in China's traditional solar calendar. To enact his xingwei cycle, *24 Jieqi | 24 Seasons*, Qiu, for 12 months, beginning in the summer of 2005, staged his light calli-photographic xingwei on the date of every *jieqi*, inscribing its Chinese name—each a two-word phrase—vigorously in mid-air.

13 My interviews with Qiu Zhijie, 12 July 2008, Shanghai, and 15 July 2008, Beijing.

AN ORAL HISTORY ABOUT A FURTIVE MEMORIAL

Sitting across a table from me in his newly rented studio in Songzhuang, Beijing, Yang Zhichao recounts his recent experience of enacting *Bairi wu yi er* (*A Hundred Days from 12 May*) in Sichuan Province a hundred days after the 7.9-magnitude earthquake hit the region on 12 May 2008, with countless aftershocks.[14] Yang and his wife Zhang Lan, posing as professional reporters from Beijing, first travelled to Chengdu where they heard about a disaster site, the small town of Muyu in the southwestern Qingshuan district, that had not received much attention from the media. Local rumours alleged that the officials in Muyu had grossly underreported the town's death toll—the regional government claimed 90 out of the probable 300 dead, most of them being schoolchildren. So the artists hired a veteran taxi driver to take them from Chengdu to the town's only high school, Muyu Zhongxue (Muyu High School), and, with the driver's enthusiastic support, took pictures of the earthquake wreckage along the mountainous way. The calamity they witnessed on campus brought the artists to tears: 'A three-storey-high student dormitory was completely flattened to the ground, burying all residents underneath it [. . .] What saddened me the most was the sight of scattered compasses and broken pencils among the debris [. . .] Since it's hard to seal a compass in my belly, I go for the pencil lead, considering that pencils are used so much in our learning processes.' Having secured their camera on a tripod and asked their driver to click it, Zhang—who had worked in a hospital before—placed a bit of pencil lead into a prepared silicone capsule and surgically implanted the capsule into Yang's abdomen. They finished the action in 20 minutes behind the half-crumpled classrooms without encountering any interference. Before they left the schoolyard, however, several undercover policemen stopped them and, on the excuse that they had no approval letter from the Qingshuan county's Propaganda Department, ordered their taxi to follow the police car to the police station. The police interrogated Yang and Zhang in separate rooms for an hour, accused them of illegal reporting, searched all their bags and confiscated the film from their camera. Fortunately, the artists were not body-searched—they had hidden a roll of film and a digital camera's memory card in their underwear during their ride to the police station.

14 My interview with Yang Zhichao, 24 March 2009, Songzhuang, Beijing. I paraphrased and translated the subsequent citations based on this interview. I also consulted the unpublished text Yang wrote about this event (Yang Zhichao 2008), in which he mentions that the official report gave out '200' as the number of the dead. For a report on the 2008 Sichuan earthquake, see *New York Times* (2009).

IMAGES **6.9.1–24** The 24 photographs composed of the xingwei cycle *24 Jie qi / 24 Seasons* (2005–06) by Qiu Zhijie. Images courtesy of the artist.

(ABOVE AND BELOW) IMAGES **6.10.1–2** Aftermath of the Sichuan earthquake. *A Hundred Days from 12 May* (2008) by Yang Zhichao. Images courtesy of the artist.

IMAGE **6.11** *A Hundred Days from 12 May* (2008) by Yang Zhichao, with Zhang Lan, in Muyu, Sichuan Province. Image courtesy of the artist.

A SUCCESSION OF DOCUMENTARY PHOTOGRAPHS

I scan through the sequence of digital snapshots documenting the xingwei action entitled *Lunhui* (lit., 'wheel-returning', a Chinese translation of the Sanskrit *samsara*). Wang Chuyu performed the xingwei in 2006 on a plaza across the street from the Yasakuni shrine in Tokyo. From the earliest shot Wang selects for me, I can tell that the artist crouched for a long time in order to inscribe his message on the stone pavement directly across the street from the shrine's front entrance. Using his right index finger, Wang repeatedly writes on the ground the Chinese names of three cities: Changqi (Nagasaki); Nanjing; and Guangdao (Hiroshima), followed by the date of his action—2006 • 4 • 28—and its place—Dongjing (Tokyo). These words gradually become visible as his blood, seeping from his forefinger, dyes his inscriptions red. I put more images in a narrative chronology to trace a circumstantial drama unfolding round Wang's painstaking labour. A few passers-by—in business suits—stop now and then to observe the artist's action; some even shoot pictures of it. Ironically, Wang's most persistent spectators are two Yasakuni shrine security guards. As soon as the artist walks away, they swoop down on the bloody imprints with a broom and a bucket of water and wash the pavement clean. Without invitation, the guards volunteer to perform the erasure of historical memories—a notorious act that China and Korea had periodically accused Japan of committing by enshrining in Yasakuni '14 convicted class-A war criminals', among its 2.5 million souls sacrificed to the nation's imperial causes (BBC News 2006).[15]

15 I also base my account on my interview with Wang Chuyu, 25 March 2009, when he gave me all the digital images reordered here.

A STORY WITH SLIDES

'You may say that I use paying special attention to time to dismiss time,' remarks Song Dong with paradoxical insouciance while flipping through a set of slides to show me his *Shui xie shijian / Writing Time with Water*,

IMAGES **6.12.1–5** Wang Chuyu performing *Lunhui* (*Samsara*, 2006) across the street from the Yasakuni shrine, Tokyo. Images courtesy of the artist.

a recurring xingwei cycle, in his darkened studio located in the northern outskirts of Beijing. 'It appears that I value time so much that I document every minute passing, yet the documentation itself is meaningless and it will soon disappear.'[16] The typical equipment for this xingwei series includes brush pens (of varying sizes), a container with water (the source of the ink) and a wristwatch to tell time. The location varies with the artist's travelling circumstances: from 1995 to 2007 (the period shown to me), the alleyway of Beijing's hutong (the city's traditional residential neighbourhood where Song used to live); the streets of Tokyo, Hong Kong, London, Kwangju, Munich and New York; galleries in Chengdu and Sydney; the bank of Lhasa River; and next to the sea on a dock in Venice. His xingwei score has become a routine: bend over on a chosen site; use a brush pen dipped in water and write in Arabic numerals directly on the ground the time indicated on his watch: the 'hour : minute : second'. Once the writing is done, check the watch again and inscribe the next set of digits, and so on, continuously, until the predetermined duration is reached. 'Why do you do it?' 'To pass the time' is the Beckettian answer Song offers me. 'How do you document it?' The documentation often comprises a few successive shots snapped on the artist's request by a passer-by. Thus, the one who records time is recorded by another brought by time.

16 My interview with Song Dong, 24 March 2009, Beijing. All the citations from Song in this paragraph are my paraphrased transcriptions and translations based on the interview tape. See also Shen Qibin (2008: 43–7).

IMAGE **6.13** Song Dong performing *Shui xie shijian / Writing Time with Water* (1995) in a public park near his home in Beijing's hutong. Photograph by Yin Xiuzhen. Image courtesy of the artist and the Pace Beijing Gallery.

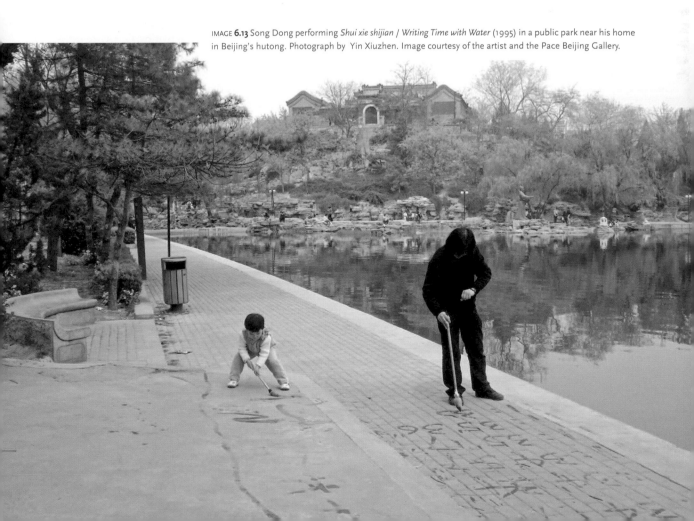

Classifying this last sampling of multicentric time-based art pieces as 'documentary-works' allows me to recognize the artists' similar impulses in transmuting the passage of time into mnemonic devices. The four artists share a preference for serial xingwei as their experiential mode. While the medium is ephemeral, a particular xingwei score's repetition in time creates a rhythm akin to periodic ceremonial routines whose cyclical nature approximates a documentary act's effect on human memory: by its repetition, albeit with variations, a serial xingwei makes a stronger impression on the enactor's cognitive muscles. To document these cyclical behaviours merely intensifies a mnemonic motion—an intention to remember by paying attention—that's already in progress. Provocatively, what sets these documentaryworks apart is the ways in which the artists choose to integrate documentation into their time-based art. How they document, in turn, varies according to their artistic languages and highlights their attitudes towards temporality, memory, history and individual interventions.

The xingwei event in Qiu's *24 Seasons* cannot be separated from his documentary act, which he produced by bringing together several technologies—from an ancient agrarian calendar and sophisticated calligraphic training to temporally manipulated photography. Except for the *space* as his event location, selected by the artist through chance encounters in the geographical region where he happens to reside or visit, the other four elements in the theatrical matrix underpinning his xingwei are predetermined. The *time* of his xingwei falls on each seasonal transition date following the Chinese solar calendar, which was initiated in the Xia dynasty (c.2070–1600 BCE) to coordinate the year-round planting, reaping and other farming activities. Qiu's live *action* assumes a reproducible pattern: photographing his semi-improvised movement with an electric torch; composing a spatial poetry in reverse calligraphic choreography; and gifting the landscape with a literary dance that can become legible as meaningful verbal signs only in the future. Qiu as the sole *performer* is also the documenter who cannot see what he documents unless he collaborates with his consistent *audience* of one: his camera's lens, as a protracted prosthetic eye, provides the indispensable technological mediation to convey the drama of Qiu's seasonal naming rituals. This drama is literally a prosthetic performance, one that cannot be enjoyed by a viewer without photography as the technological prosthetic that replaces the absent corporeal seeing.

As the inventor and manipulator of his calli-photography, Qiu is nevertheless the least visible of all objects documented by his camera. Consider, for example, this piece from his *24 Seasons*. In *Jingzhe | The Awakening of Insects* (2006)—late winter, in early March, when thunder awakens underground insects—Qiu performs his action among numerous public telephone booths under Sihui Bridge, Beijing (see IMAGE 6.9.3, p. 398).

> The willow trees are just budding; millions of migrant workers again flooded into Beijing and dispersed to various construction sites. The simple yellow building in the distant background is where they reside. Usually more than ten people share one room. The skyscraper farther away is what they constructed. In the following year, their chief means of contact with their wives, children and parents is through these public phone booths. The night I came here to shoot my light-writing, a labourer spent more than one hour talking on the phone. As I wrote I wondered, did he get good or bad news on the phone? (Qiu 2007: 40; my translation.)

The narrative Qiu wrote to accompany his photograph in the catalogue for *The Shape of Time* paints the scene, the moment and the sentiment in which the artist enacted *The Awakening of Insects*. The image I see features the calligrapher's ghostly contour, like a partially disembodied whisper, hovering behind the phrase 惊蛰 inscribed in a rapid vertical column of curvy and jostling lines; somewhere beside him stands the solid profile of a man, his head concealed behind a yellow umbrella-like plastic phone-booth canopy, talking away his nocturnal loneliness. I feel the chill descending from the slight wind passing through the cloudless indigo sky. Is this calli-photographic artwork not a postcard—with landscape, people and their mundane existential pursuits crystallized in picture and prose—sent to me? Am I not an equally phantasmic narrative voice, nestled within a cerebral canopy and projecting into my solitude, while I measure the verve and melancholy of this poetic-pictorial time capsule? Tomorrow I might remember this instant—either vaguely or vividly, I don't yet know—when I contemplate a prehistoric message regarding time. It makes me wonder, awestruck, about my ancestors' affinity with the earth, a changing abode that houses insects and nurtures those that feed me.

A Hundred Days from 12 May is the fourth instalment in Yang Zhichao's xingwei series *Qishi lu* (the Chinese translation for the biblical Book of Revelation). In *Revelation I: Tu* (*Earth*, 14 July 2004), Yang places 1.6 gm of fine yellow earth dug up from the bank of the Yellow River in his hometown, Lanzhou, Gansu Province, into a silicone capsule and has a physician surgically implant the filled capsule into the right side of his belly.[17] In *Revelation II: Jin* (*Ashes*), another capsule, filled with ashes from a site incinerated by forest fire, is surgically inserted into the artist's abdomen on the left side. Yang collected the ashes soon after the fire on Beijing's Huairou Mountain

17 My retelling of the Revelation series is based on my interview with Yang, 25 March 2009, Beijing. See also Yang Zhichao Zuopin (2008: 68–81).

on 24 March 2006 and visited the site three months later (on 27 July)—when the ground was again covered with weeds—to enact *Ashes*. In *Revelation III: Ye* (*Night*, 11 November 2006), Yang has a sliver of 'night-time' sealed into his stomach. Enclosed inside an unlit windowless room in the Tang Contemporary Gallery in Beijing's 798 art district, a surgeon, wearing a pair of infra-red glasses, makes a 2 cm incision below Yang's navel to let the darkness sink into the slit before he sutures up the wound.

Assessed in isolation, each piece from Yang's *Revelation* series resembles a bodywork. *Earth*, for example, recycles motifs from two of Yang's earlier bodyworks—*Planting Grass* (2000) and *Hide* (2002)—by involving a doctor, an external object and the artist's body used as a corporal ground, a locus both actual and emblematic, to inter the object. While Yang retains the bodywork as a consistent xingwei component, he signifies his artist's body differently in the *Revelation* series through a new detail: the use of local anaesthesia for his surgical procedures. If the physical pain Yang endured for his earlier bodyworks demonstrates his sacrificial devotion to artmaking and his unflinching acceptance of suffering as a mortal bondage, minimizing the surgical pain in his later series reframes his body as something beyond an individual existential host. What role, then, does Yang's body play in the *Revelation* series so as to distinguish it as a set of documentaryworks?

Yang seems to answer this question most clearly with his comprehensive scheme for the latest addition to *Revelation*. *A Hundred Days from 12 May*, like Yang's *Within the Fourth Ring Road*, includes an experiential process that doubles as documentation; a major behaviour pattern, be it begging or undergoing surgery, executed by the artist's body; many documentary

photographs; and the artist's journal reflecting on the xingwei process. In this inventory, the artist's body appears functionally similar to his other documentary vehicles. Such a practical equivalence among all the recording devices in *A Hundred Days* not only turns Yang's body per se into a documentarywork but also retrospectively renders the three earlier instalments in *Revelation* as interrelated documentaryworks.

A key recurrent element in *Revelation*, Yang's body serves as an embedded corporeal archive—a sort of flesh cabinet, with filled capsules as files—and a prosthetic extension, a surrogate for those stored but not readily accessible keepsakes from various primal scenes: the fine yellow mud from his hometown river bank; the

IMAGES **6.14.1–2** Yang Zhichao performing *Jin* (*Ashes*, 2006) on 27 July 2006 on top of Huairou Mountain, which suffered from a forest fire in March 2006. The capsule (LEFT) shows the ash contained and buried in the artist's abdomen. Images courtesy of the artist.

ashes from a burnt hill; the darkness from a fabricated art environment; and the bit end of a child's lead pencil-core picked up from an earthquake disaster site. In the sense that Yang's implanted capsules carry material 'documents' whose significance is opaque without supplementary information, his body resembles what Diana Taylor calls the 'repertoire'—an embodied treasury open to the discovery and transmission of unstable, pre-linguistic and non-discursive knowledge (2003: 20). The artist, however, does offer a conspicuous clue. Despite his specific regional sources, Yang urges his documentary series towards global resonance by grouping its pieces under a meaning-laden biblical title. Yang's body, therefore, is analogous to the prophetic or apocalyptic Book of Revelation, replete with cryptic messages and redemptive symbolisms locked inside the pages, waiting to be opened by future initiates. Yang's documentary body, recoded by his transcultural ambitions, becomes a prosthetic miniature of our terrestrial corpus which bears the imprints of all mortal struggles—spiritual, physiological, political, economic or ecological—and buries within its depths the aftermath.

IMAGE **6.15** *Ye* (*Night*, 2006) by Yang Zhichao. Image courtesy of the artist.

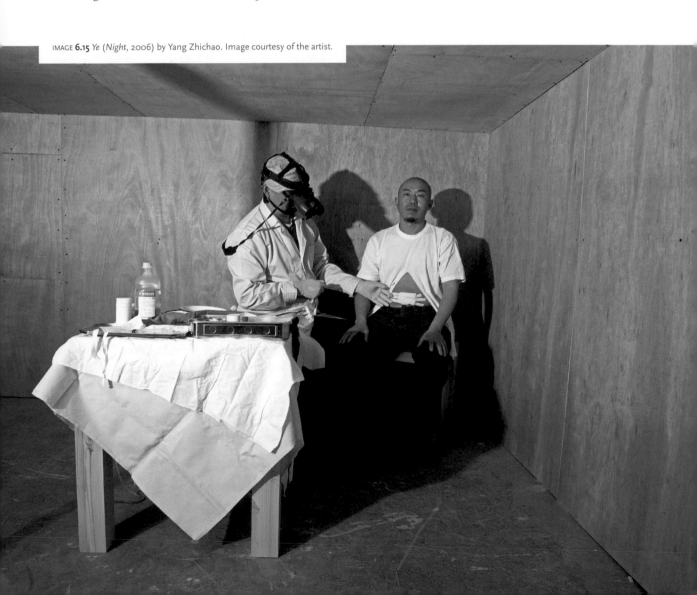

Visiting an earthquake site to stage a private memorial for the victims is not necessarily a political act. The troubles that Yang and Zhang encountered during the process of enacting *A Hundred Days*, however, circumstantially establishes the political relevance of this documentarywork. The calamity to which Yang's flesh archive bears witness exposes the regional government's corruption which resulted in the shoddy construction of public school buildings; it also goes against the version of history that the central government promotes, touting its triumphant mobilization of political resources in remedying natural disasters while eliding its simultaneous coercion of the victims' grieving parents into silence. In this context, the metaphysical framework within which Yang situates his *Revelation* series might be seen as a smokescreen to camouflage its political exigency. No such smokescreen is placed before Wang Chuyu's documentaryworks. Or, more exactly, Wang adopts a different kind of camouflage. Whereas politics sits front and centre in all his xingwei pieces, the political incidents Wang has chosen to highlight happened to coincide with the Chinese government's ideological agenda.

An index finger, a rough surface, ink made of flowing blood, an inscribed message: these are the consistent elements in Wang Chuyu's *Tuya xilie* (*Graffiti* series, 2004–), an ongoing xingwei series to which his *Samsara* belongs. Under Wang's hand, each of these morphological elements is also drawn with a thematic undertone: the index finger is an activist's pen; the rough surface might be the powers that be; the bloody ink commemorates the casualties of war or of political dissent; the inscribed message reflects the writer's politicized attitude. As discussed in Chapter 3, Wang began using his bleeding index finger to leave a trace for his time-based action in *Reading the Constitution* (2002), staged in the privacy of his apartment on 4 June, the thirteenth anniversary of the Tiananmen Square massacre (see IMAGES **3.13.1–3**, pp. 208–09). The blood dripping from his razor-sliced finger contaminates the pages of the PRC's constitution, making the pamphlet a wounded document. If his cut finger doubles as a prosthetic for the victims of a state contradicting its own national constitution, Wang turns the same index finger from a reactive reader into a proactive writer in his subsequent *Graffiti* series. The artist's blood as an automatic bio-spill from a traumatized body now becomes an intentional implement, the ink that makes visible a bloody text.

Wang's first instalment for the *Graffiti* series happened in front of a small international audience during *Dierjie Beijing guoji xianchang yishu jie* (Second Beijing International Live Art Festival, 2004) in Beijing SOHO—a festival curated by Wang himself. Wang's contribution to the festival was *Shijie zhi wei: Jin Shanri* (*The Flavour of the World: Kim Sun-il*, 15 July 2004), a xingwei memorial for South Korean translator Kim Sun-il, the hostage beheaded on 22 June 2004 by Iraqi insurgents with links to al-Qaeda. The day before Kim's execution, Al-Jazeera broadcast a videotape showing armed and masked militants standing behind a kneeling Kim. A hooded speaker, suspected to be the Jordanian Abu Musab al-Zarqawi, threatened to kill Kim if South Korea proceeded to send additional troops to Iraq. Wearing an orange jumpsuit—the kind worn by detainees at Guantanamo Bay and in Abu Ghraib—Kim cried out in English, 'Please get out of here. I don't want to die . . . Your life is important, but my life is important' (CNN 2004a and 2004b).

Wang adapted Kim's last desperate plea heard on the air for *The Flavour of the World: Kim Sun-il*. The artist begins by scissoring off tips of his hair and placing them in an urn. He then asks the spectators

to contribute some of their hair to the urn before he burns it all, along with many incense sticks. Having activated his Chinese mourning ritual for the dead, Wang kneels and writes with his index finger on the floor until his blood forms a five-word sentence, 'Wo buxiang likai' (I don't want to leave).

Before Wang enacted *Samsara* in Tokyo as part of NIPAF (the Nippon International Performance Art Festival, April 2006), he added two more pieces to the *Graffiti* series through international contemporary art exhibitions in the UK. In *Shuo yingyu | Speak English* (November 2004), Wang inscribes with blood on a gallery wall the phrase 'Speak English', first in English, then in Arabic and finally in Chinese; in London (November 2005), Wang traces the word 'London' on a street pavement until the blood-saturated letters blurs into the figure of a train.[18] *Speak English* might be a critique of the capitalism-and-technology-enforced lingua franca in the trend of globalization, which becomes a dictate also in China; the artist's choice to spell out the command in Ara-bic—the most commonly spoken language in the Middle East—however, narrows down the reference to the concurrent military invasions of Iraq, a war initiated by the US and aided by the UK. In the more pensive *London*, Wang changes his attitude from implicating his temporary host country as an international military aggressor to mourning the suffering of its civilians from Islamic terrorism. The word 'London' turned into a blood-drenched locomotive commem-orates the victims from the four coordinated explosions by suicide bombers in the city's Under-ground and a double-decker bus on 7 July 2005.

18 Wang presented the piece in the 2004 Liverpool Biennale. Email correspondence, 8 November 2010. Wang presented *London* (2005) in the *China Live* performance series, spon-sored by Chinese Art Centre, Live Art UK, Live Art Develop-ment Agency, UK, and Shu Yang, DaDao Live Art Festival, Beijing.

IMAGE **6.16** *Shuo yingyu | Speak English* (November 2004) by Wang Chuyu, in the 2004 Liverpool Biennale. Image courtesy of the artist.

IMAGE **6.17** *London* (2005) by Wang Chuyu, in the *China Live* performance series, UK. Image courtesy of the artist.

Read in conjunction, the two pieces Wang staged in the UK elucidate the political stance and Buddhist compassion he expresses with *Samsara*. Nagasaki, Nanjing, Hiroshima—the three cities that were decimated by opposing forces during the Second World War—form the circle of sufferings in *Samsara*. Between December 1937 and March 1938, the Japanese imperial soldiers committed deplorable atrocities in Nanjing, killing between 250,000 and 300,000 Chinese, many of them women and children. During the war's final stage, the US dropped an atomic bomb on Hiroshima on 6 August 1945 and another on Nagasaki three days later, killing tens of thousands of Japanese. Given their divergent scales, 'Nanjing', like the command 'Speak English', confronts the unsettling history of Wang's host country, whether it's UK's involvement in the Iraq War or Japan's rape of Nanjing. Evoking the ravished city in front of Yasakuni shrine, where the spirits of honoured Japanese imperial soldiers rest, appears to protest Japan's revisionist denial of the Nanjing holocaust. Having 'Nanjing' sandwiched between 'Nagasaki' and 'Hiroshima' might likewise suggest the retributions endured by the aggressor's body politic. To me, nevertheless, Wang's equivocal political stance in *Samsara* is more complex than a cause-and-effect accusation indicates. I sense the same pathos and civilian solidarity that the artist reveals with *London* in his bleeding imprints for 'Nagasaki' and 'Hiroshima'. Before nirvana, all but *Samsara*!

Although the texts Wang chose for his blood-writings are succinct, their connections with well-known current affairs and historical incidents make them comprehensible to most viewers—at least in the first decade of the

IMAGE **6.18** *London* (2005) by Wang Chuyu, in the *China Live* performance series, UK. The name of the city inscribed by Wang's blood blurred into the shape of a locomotive. Image courtesy of the artist.

twenty-first century—as critical documents. By committing his flesh to sighting his political voice, Wang produces a time-based documentarywork, doubling up his live bodywork with its documentary output. His bloodstained graffiti is then both original and prosthetic, requiring other documentary prostheses—those longer-lasting ones like photographs and printed explanatory texts—to record their temporal passage. The Japanese security guards' over-zealous protection of Yasakuni shrine's sanctified neighbouring ground, however, exposes the fact that all human-made documents are ephemera. Producing documentaryworks might seem to invest in permanency and its attendant promise of reaching like-minded future others but the act perhaps functions, at best, as mental insurance and historical companionship for the enactor, succouring the one who places his/her body on the line with the belief that each individual action, no matter how slight and transient, scratches a neurological pathway along glocal memories. This self-referential philosophical angle, I suggest, may also elucidate an unspoken political dimension in Wang's *Graffiti* series.

'Did it hurt you to write with an injured finger?' I asked Wang. 'Not really. I felt released. My pent-up rage and tension found an outlet.'[19] *The Flavour of the World*, a protest against the cost of innocent lives as a consequence of the Iraq War; *Speak English*, a painstaking examination of the imperialist logic in Western military aggression based on tacit economic self-interest; *London*, a humane condolence for the casualties of religious terrorism; *Samsara*: a sinocentric testimonial for a tragic history threatened to be erased by Japan's political amnesia. Slanted interpretively as such, these are the public faces of Wang's *Graffiti* series, which patriotically agrees with China's dominant political will. Yet, the prototype for Wang's *Graffiti* series was his *Reading Constitution* series originating from his traumatic encounter with the Chinese government. Is it possible that Wang has produced, with his *Graffiti* series, a sequence of prosthetic performances for an origin shy about speaking its name?

19 My interview with Wang Chuyu, 25 March 2009, Beijing.

Using water to write on a temporary surface became part of Song's art practice soon after *You yitangke, ni yuanyi gen wo wan ma?* / *Another Lesson: Do You Want to Play with Me?* (10 April 1994), his first public xingwei-zhuangzhi piece, was shut down by authorities on its opening day. As a government-employed high-school art teacher, Song enlisted several of his students to read wordless books in a classroom wallpapered and carpeted with all kinds of actual tests and worksheets that Song collected from various schools across Beijing (see Wu Hung 2000a: 99–101).[20] Roughly a year later, on a family excursion, Song picked up a stone block from a mountain site in Beijing. As a private xingwei experience, he began using a brush pen dipped in water to write a diary entry on the rock every day. *Shui xie riji* / *Water Diary* (1995–) was a conscientious personal project for Song until it became habituated as a relaxed daily routine of life. In fact, the artist felt so in tune with this routine that he would carry the rock and brush pen with him whenever he travelled, in order to continue his water diary. After a while, however, he realized that the stone's material being was redundant (and 'too heavy' to carry round); he needed only a brush pen. By repeatedly jotting down spontaneous reflections on the same stone surface, Song turned the block into a ritualistic implement, a transitional spiritual other that could be further internalized. Like a novice who meditates with a chanting tape until the chanting is integrated into the breathing, Song has learnt to regard any surface on which he keeps his liquid journal effectively as a prosthesis for his diary stone, hence activating its listening presence solely as a thought.

20 Also, my interview with Song Dong, 24 March 2009. Except for an outline, Song did not wish to describe this performance in detail to me; he said that the whole process was 'too complex to retrace'.

IMAGES **6.19.1–4** The only four photos that Song made for his *Shui xie riji* / *Water Diary* (1995–), 'a private and personal event'. *Water Diary* (1995–), Beijing. Images courtesy of the artist.

Because of their shared behavioural pattern—of writing calligraphic texts with water on a randomly selected surface—we may trace Song's *Writing Time with Water* to *Water Diary*, his original documentarywork. Song himself traced the source of *Water Diary* to a childhood lesson learnt from his father—practising calligraphy with a water-soaked brush pen on a rock (since the family could barely afford ink and paper). This biographical note about an expedient method of furthering his education might explain Song's techniques but it cannot account for another logic that the artist offers: 'You might not think about this generally but, during the diary writing process, consider that someone else might be reading this some day' (cited in Walsh 2002: 92). By allowing his diary entry to soon evaporate, Song fashions the stone as a mute confidant who will keep the writer's secrets for ever. Yet, except for his desire for privacy as an individualistic entitlement, why does Song feel the urge to keep his thoughts to himself, even to the point of producing documentaryworks visible for only a few seconds? Is it plausible for us to trace this inclination to remain private to Song's original *public* experience with art censorship in *Another Lesson*, when enlisting a group of students to read wordless textbooks was deemed worthy of a speedy official termination?

Then again, recalling what I analysed in Chapter 5 as Song's Confucian-Daoist-Buddhist outlook, the temporal braid of visibility and invisibility achievable by water as ink might just as well give the artist an opportunity to witness and embrace coexisting opposites. Philosophically inflected, Song's politics operates in, as curator Leng Lin observes, a 'hidden form' (2008: 10, 16).[21] Song himself best illustrates this hidden form in *Tiao/Jump* (1999), a video piece featuring the artist jumping on the same spot in front of Tiananmen Tower, with Mao's portrait staring at him from the back. The original Chinese title for this piece, *Tiao, bu tiao bai bu tiao*, is taken from the first verse of a three-line rhyme Song composed in Beijing's witty vernacular to accompany his action:

21 I adopted the catalogue's English translation for *yin xing shi* (lit., 'invisible form').

Bu tiao bai bu tiao
Tiao le ye bai tiao
Bai tiao ye de tiao

Not to jump is to waste jumping
To jump may still waste jumping
[Even] to waste jumping requires [one] to jump.

(My approximate translation)

Extremely difficult to render into English, these verses convey a sentiment similar to Samuel Beckett's in his oft-cited 'the expression that there is nothing to express, nothing with which to express, nothing from which to express, no power to express, no desire to express, together with the obligation to express' (in Esslin 1965: 17). Whereas Beckett focuses on the linguistic body of a literary expression that, though ineluctably deficient, obliges the writer to still embody it, Song stresses the existential necessity/futility of performing a symbolic action at a historically scarred site. Is propelling one's body up and down, repeatedly, a political action? Is it not? Is 'jumping' a prosthesis for 'being jumped'? Is 'being jumped' an express train to the graveyard from 'jumping'? Isn't jumping merely playing at passing the time?

Replacing the word 'jump' with 'write' in Song's vernacular poem would instantly translocate us to the ambivalent psychosomatic landscape where the artist enacts *Writing Time with Water*. Like the act of jumping, which asserts its energetic presence even as it evokes multiple absent origins, Song's documentary series about temporality functions through both surrogacy and indeterminacy. The series presents an array of prosthetic performances substituting the unseen flow of time with sets of numerical signs that represent a recordable moment. That the given moment is 'recordable' is established by global social consent but what it actually teaches us about the nature of temporality is uncertain. The digits on the face of a watch function as no more and no less than an expedient shareable code for scheduling human societies; the 'hours : minutes : seconds' are the prostheses for an origin whose precise attribute is still open to speculation, whether artistic, philosophical or scientific. Moreover, these prostheses are made with the proviso that they will always be distorted documents. Song's temporary documentary-works about time self-reflexively comment on their own inaccuracy, for his action of document-ing the moment he glimpses from his watch will never synchronize with the actual moment his inscription occurs. The present he records is always already *past*; the duration it takes for his eyes to turn from his watch to his water-soaked brush pen to his moistened writing surface would make his time-record at least a few seconds earlier than the *now* when his wet digits appear. Song's time-marking projects cannot but absorb their inherent documentary liabilities in order to proceed.

It seems easier for us to discern the status of a prosthesis than to ascertain the origin it replaces and the etiology it implies. We know that Song's documentation about time is a pros-thesis, but does this prosthesis refer to the syncopation between the instant the artist raised his brush pen to when he dampened the ground or to a subtext of which even the artist is not fully aware? The many precedents that I raised to contextualize Song's *Writing Time with Water* indicate the difficulty in pinpointing a definitive origin for a prosthetic action which a docu-mentarywork undertakes. Another dilemma derives from the general problem of ephemerality associated with time-based art. Song's water-writ documentaryworks, like Wang Chuyu's blood-writings, depend on another documentary apparatus to record it for posterity. When the artist chooses that *extrinsic* documentary frame as an operating theme, the result is a meta-documentarywork, a technological system of preservation superimposing itself upon an *intrin-sically* self-expiring documentary act.

The most extensive 'extrinsic' documentation that Song has taken for his water-writing-time series happened on the eve of Hong Kong's reunion with China. *1997 nian liu yue sanshi ri zhi 1997 nian qi yue yi ri shui xie shijian yige duo xiao shi / Writing Time for More Than One Hour with Water* (30 June–1 July 1997) produced 96 colour photographs. Each features a frontal shot of the seated Song bending over and writing on a cube placed on top of a switched-on tel-evision set whose screen is turned towards the camera. 'When everyone was watching Hong Kong's return ceremony on TV, I spent an hour (from 11.30 p.m. to 12.30 a.m.) writing time with water.'[22] Facing the back of his TV set, Song listened to the repatriation ceremony without watching it; a momentous nationalistic occasion in China became a soundtrack for his private time-based ritual of producing a serial documentarywork doomed to obsolescence as

22 My interview with Song Dong, 24 March 2009, Beijing.

soon as, if not even before, the document emerges. Is this Song's political gesture of inconsequential civil disobedience or his nonpolitics of philosophical ambiguity? There seems to be a collateral excess of meaning in the artist's water-based documentarywork, timed at a precise historical moment, but what is it exactly? Song hits the notes of mindfulness and indifference at once.

What's more clear-cut than Song's multivalent action is his specific choice in displaying the resulting documentary photographs. I am looking at a reproduction of the 96 colour photographs spreading out across two pages in the catalogue for *Song Dong* (7 September– 5 October 2008), Song's solo exhibition in Shanghai Zendai Museum of Modern Art. Each image, a tiny (2 x 3.5 cm) rectangle, these photographs, placed in an oblong grid-structure (16 images length-wise and 6 across the width, with even margins between each row), create a printed mosaic of time, with Song and his props the measurement system for the duration of his writing time with water (see Shen Qibin 2008: 74–5). While I can't see the records Song does, I can tell from his repetitive but also varied poses that a temporal passage has been crossed, gauged by an alternative imagistic clock. This documentarywork about documenting time shows me a diagram of temporality quantified by a prolonged individual action and directs my attention towards the documenting act more than that which it documents. It is a meta-documentarywork laden with an unspoken semantic heaviness as flighty as the light and sound emanating from Song's television screen.

IMAGE **6.20** *1997 nian liu yue sanshi ri zhi 1997 nian qi yue yi ri shui xie shijian yige duo xiao shi / Writing Time for More Than One Hour with Water* (30 June–1 July 1997) by Song Dong. Image courtesy of the artist and the Pace Beijing Gallery.

Regardless of their divergent purposes and expressions, these Beijing artists' documentaryworks reflect a practice that emerged in the early 1990s in China as an intellectual/cultural response to the heightened political tension and official prohibition of avant-garde art, which its communist government considered a culprit in inciting the students' pro-democratic mass rally. In 1991, Sichuan art critic Wang Lin, seeking to reflect the experimental art activities that had continued underground, organized *Zhongguo dangdai yishu yanjiu wenxian zhan* (*Chinese Contemporary Art Research Document Exhibition*), inventing a display format that treated, in Wang's terms, 'the entire exhibition hall like a giant exhibition catalogue' (Zhang Qingwen 2010).[23] Commenting on Wang's first *Document Exhibition* and its sequels in the following years, art historian Wu Hung notes that they consisted of 'reproductions of recent works by experimental artists and their

23 All citations from Wang Lin in this paragraph come from the same source. I have paraphrased and translated all citations based on Wang's Chinese text.

writings', and that they 'traveled to different cities and provided an important channel of communication [among] experimental artists' (1999: 178). As curator Wang himself explains, crediting his *Document Exhibition* as 'the real beginning of independent curatorial activities' in China, the exhibition's emphasis on documentation 'to a greater extent avoided the official inspection, saved on the budget and included more artists in the exhibition'. Wang's claim is justified by the fact that his first *Document Exhibition* took place right in the capital—on Beijing's Third Ring Road—and featured more than 70 artists: 'Through this kind of convenient and efficient way, using the name of academic research, [*Document Exhibition*], during the most difficult period of Chinese contemporary art, allowed experimental artists to present their transitional artworks to the society.'

Wu Hung cites Wang's *Document Exhibition* as a precedent for what he observes as Chinese contemporary art practitioners' increasing interest in investigating how to exhibit experimental art in the 1990s. In Wu's view, then, *Document Exhibition* is not fundamentally different from other innovative exhibition modes. Thus he adds in a follow-up study that, in the late 1990s, when the government's censorship became less systematic and the technology of dissemination witnessed a qualitative shift, these *Document Exhibitions* 'have been effectively replaced by the "virtual exhibitions," which serve similar purposes in a new period and medium' (2000a: 41). I would slant the argument back towards Wang's analysis and suggest that *Document Exhibition* succeeded as the earliest non-official exhibition mode in the post-Tiananmen period because it benefited from the indigenous cultural status of documentation, which tends to be perceived as scholarly, historical and politically inert, hence more likely to evade official surveillance. Documentation, therefore, lent itself to manipulation by experimental artists, critics and curators who used it to initiate cultural circulations of certain artworks deemed too seditious for public display. The radical xingwei and xingwei-zhuangzhi artworks, presented live to the public, might provoke collective reaction that the government would not tolerate. In contrast, to exhibit these artworks' documents, as mere prosthetic reminders of what was allegedly 'real', was an educational and cultural activity, which the government encouraged—and even funded.

The political context in the 1990s probably persuaded many Chinese time-based artists to regard documentation as both a means of preserving their ephemeral artworks and, before opportunities to exhibit abroad arose, the sole vehicle by which their art might be transferred to the public realm. The mode of 'document exhibition'—whether in actual or virtual venues—

MeiLING
CheNG

addressed the artists' needs to reach more viewers and facilitated their quest for a public outlet. Although this function—public propagation—served by document exhibitions continues to be valid, the kinds of obstacles met and pursuits engaged by the artists have changed, along with China's transformed cultural politics and art exhibition infrastructure. In the twenty-first century, commercialism appears to have outmatched official censorship as the major threat to experimental art. This newly emerged condition of production for Chinese time-based art, however, affects documentaryworks differently. First, documents made for time-based art and displayed or distributed by document exhibitions are not necessarily products of documentaryworks, which conceive of documentation as intrinsic to their art-making process. More pertinently, the cultural reverence for documentation that helped the document exhibitions circumvent official censorship is inherent to documentaryworks whose discursive components, safeguarded with rhetorical perspicacity, tend to protect them from being prime targets for official censorship.

Such a cultural buffer zone is certainly at work in all the documentaryworks analysed in my first round of case studies. Qiu's '*Lantingxu*' pays homage to a venerable calligraphic masterpiece while turning his assiduous xingwei process increasingly into a meditation method to 'xiushen yangxing' (cultivate his body and refine his spirit), as a Chinese folk dictum goes. Both *Within the Fourth Ring Road* and '*Wang Mian Rice Oil Shop*' speak to the socially conscious, learning-by-doing and mass-enlightening ethics of Mao's aesthetic heritage, articulated in his 'Zai Yanan wenyi zuotanhui de jianghua' ('Yan'an Talks on Literature and Art', 1942) (see Li Xianting 1993a: xii–xiii, and Mao Zedong 2011). *Waste Not* demonstrates the emotional familial bond between husband and wife, parents and children, central to the Chinese ethical culture. These documentaryworks are rather strong candidates for the Ministry of Culture's medals of honour!

Some of the documentaryworks in my second round of case studies, however, might not fare so well under the gaze of politically hypersensitive censors. In fact, Yang's *A Hundred Days from 12 May* ran into trouble with the law, anticipating the official prosecution his mentor Ai Weiwei would suffer in 2009 and then again in 2011 for his activism on behalf of the Sichuan earthquake victims (see Ramzy 2009 and Appendix). That the documentaryworks I have annotated here were actually produced and publicized—via multifarious display formats and in divergent locations, both domestic and foreign—indicates a much more diffused and far-reaching exhibition, patronage and proscription environment, which has arisen to integrate contemporary Chinese art into the global marketplace as well as into other noncommercial systems of circulation and evaluation. Most producers of documentaryworks, I believe, desire to stake their claims on the global arena for art historicization, which may better position the artists as those having influences on international cultural formations.

Reading my selections within China's current sociocultural moment, I find these documentaryworks serving multiple epistemic, remedial, pedagogical and pragmatic functions, offering deliberately skewed lenses from which to observe their country's profit-oriented and image-conscious zeitgeist. These largely textualized xingwei projects contemplate sentience, existence and consciousness; report on suppressed human calamities; teach us about our memory's forays into mortality; and leave discursive, imagistic, material and narrative fragments as

provocative—memes-inducive—keepsakes, able to be reassembled and retold. They lean towards what Adrian Heathfield—commenting on the year-long endurance performances of Taiwanese-American artist Tehching Hsieh—aptly calls 'unregulated temporalities (chance operations, contingent forms and improvisations)' to avow 'inassimilable', that is, not easily marketable—values (2009: 21). Being hybrid, however, documentaryworks simultaneously deviate from such temporal randomness to adopt the relative stability of ideographic signs; they embrace both the spendthrift, self-consuming logic of time-based art and what Geremie Barmé—after Milan Kundera—describes as 'the graphomania that has once more made China one of the greatest writing and publishing nations on the planet' (1999: x). For documentary-works bond two kinds of bodies: those made of flesh and those of symbols; they usher in original bodies that are always partially artificial, already prosthetic.

At the one end, documentaryworks join other time-based art genres to variously refract, lament and keep a critical distance from transience and opportunism which, due to rapid mod-ernization and the mobilization of global capital, have become the order of daily urban life in China. Since both modernization and capitalist mobilization aim at building a bright and prosperous *future* for China, time-based art counters this officially condoned mass rally for the future by heightening the existential awareness of the present moment, relishing its onceness. Going against the grain of mainstream economic trends, time-based documentaryworks deviate from the prevalent trend towards conspicuous consumption as status symbol and instant gratification as cosmopolitan cool.

At the other end, a documentarywork complicates time-based art's ecstatic tangle with *now* by teasing out the latter's choreography of the *once-now*. Folding acts of documentation into its intrinsic process, a documentarywork declines to give in to the joy, sorrow, delirium or equilib-rium of engaging solely with the *present* moment, insisting on bringing both the *past* and *future* into its memory-song and history-dance, projecting itself for posterity. As all my examples illustrate, what documentaryworks produce, through both themselves and their extrinsic documentation, amounts to certain culturally relevant yet financially dubious partial or residual document-objects. Like other time-based artworks, documentaryworks promulgate the ethical efficacy of non-monetary alternatives for living/being; unlike their 'purely' ephemeral cousins, documentaryworks refuse to retire into cultural amnesia by archiving time's codification into visual/discursive intelligibility.

The documentaryworks I examine in this chapter sample only a particularly prominent motif—documentation—in the respective prolific *oeuvre*s of Qiu Zhijie, Yang Zhichao, Wang Chuyu and Song Dong. These artists are heirs to China's literati tradition which recognizes an intellectual as a poet, a historian and a philosopher all in one—a 'total writer' of sorts. They all share 'a sense of responsibility towards history,' as Wang Lin sums up in his curatorial intent. Except for Song, the other three write extensively about contemporary experimental art; and all four have published insightful comments on their works. Their writerly interventions create a certain split—or a multiplication effect—in their artistic identities, which have incorporated critical subjectivities in their make-up. These artists are capable of critiquing and historicizing their own art; their self-documentation rivals my critical interpretations of their artworks. Whose prosthetic performance will speak the last word?

Thus my coinage, prosthetic performance, not only qualifies an innate aspect of documentaryworks but also marks the process of negotiation, even competition, between the artist who has authored the source performance and the critic who wilfully authors a subsequent critique. The artist and the critic are then joined in a dialectic struggle and/or alliance to historicize the performance piece. A critic may choose, of course, not to develop any substantial (interpersonal) contact with a living artist who, after all, holds neither authority nor office to issue a critical licence. In analysing the imaginary conspiracy and hermeneutic rivalry between two performance-joined subjects, I am not advocating a professional obligation for a critic to consult an artist. My purpose is, rather, to describe, should such a contact happen in the critic's research, the intersubjective exchanges that may retrospectively transform the live event by re-accessing it. A prosthetic performance—or the kind of documentarywork made by a critic venturing into a time-based artwork—emerges out of such loaded exchanges between two epistemic-emotive subjects to alter, augment and extend the originary live artwork, which is its source and referent, its object of inspiration, contention and quest.

I interweave this essay with eight moments of initiation; each, infused with a sensory hook (a rice paper, a photograph, a table

INTERFACE: LIVE @ THE EVER-NEVER-NOW

of rules, a passport catalogue, etc.) like a hyperlink, transports me to an altered state of mnemonic immersion. These initiatory entries elicit what Alison Lansberg calls 'prosthetic memories', those that one appropriates not through strictly lived experience but from one's empathic involvement with the information culture (1995: 175). Lansberg's analysis focuses primarily on the cinematic experience, which has—as my allegory of the star-seeds and eco-pods earlier in the chapter implies—the capacity to create such an immersive sensorial surrounding that a viewer tends to appropriate the 'fictional' events on the screen as the 'real', or the 'remembered' incidents from his or her personal past. I consider that Lansberg has identified a cognitive phenomenon more pervasive than what the cinematic medium offers, for I often suffer from prosthetic memory when I try to recall a live performance event. By reflecting on the event again, I remember a gesture, a tonal inflection or an accusatory glance that I might or might not have seen then and there. And the reverse also holds true: by searching through documentary traces of a performance, I 'remember' how it happened then and there, even though I had not lived through the event. But thinking makes it so, as Hamlet once said through Shakespeare (or the other way round).

'[Memories] are less about authenticating the past, than about generating possible courses of action in the present,' continues Lansberg (ibid.: 183). By shifting memory from the past to the present tense, Lansberg reinvests the solitary act of reminiscence with the proactive ethical responsibility. Put otherwise, for the one who recognizes memory's property as prosthetic, history is always in the making. Through this epiphany, prosthetic memory merges with and becomes a drive for prosthetic performance; both gravitate towards the agency of a complex, multicentric *now*, permeated as it is by past palimpsests, present contingencies and future imperatives.

Prosthetic performance invites us, those interested in dreaming about the multicentric now of performance, to reconsider what we've termed 'live' in both *enacting* and *recording* time-based artworks. As an adjective, 'live' might signify an emanating flow of sensations, criss-crossing my body and alerting my retinal nerves to vigorous traffic, as my half-aware corporeal responses to emergent stimuli. 'Live', in depicting a performance event, might indicate the contingent dynamics among various perceptual qualities, those identified by Heathfield as 'immediate, immersive, interactive' (2004: 8), each addressing the artist's manipulation and contemplation of temporality, spatiality and corporeality. Taken more broadly as intersectional behaviours, 'live' might highlight the present-tensed co-presence of three-dimensional beings, the conscious or coincidental synchronicity between a perceiver-enactor and other entities, sentient or otherwise. 'Live', technically construed, might refer to one's process of executing a durational task, the condition of presenting that task or the circumstances under which the task is being replicated, reviewed, redone, rejected or recollected by others.

Although all these semantic senses I note for 'live' appear to pivot on the natural-born-and-endowed human perceivers, these provisional definitions do not preclude what Auslander historicizes as the technological inception of the term. Contrasting 'live' with its technological other, Auslander argues that 'the live is actually an effect of mediatization', for 'that category has meaning only in relation to an opposing possibility'. 'It was the development of recording technologies that made it possible to perceive existing representations as "live"'; 'the live can only be defined as "that which can be recorded"' (1999: 51). Multicentric as I am, my wont is to doubt any assertion of an absolute origin. To me, Auslander's claim for the 'live' may be best appreciated in the vein of Raymond Williams' famous *Keywords*—which collects and historicizes numerous culturally loaded words—rather than as a discovery of the term's exclusive technological ancestry (1983). Our failure to name a phenomenon doesn't mean that the phenomenon did not exist before its naming. I might as well argue that the 'live' is simply a shorter spelling for our feeling of being 'alive'; indeed, it is the very quality that persuades us *to live* rather than to die. While I might not feel as alive when I don't record myself living, I can survive as a live organism without being recorded. Moreover, I believe, even with a hi-fidelity apparatus, certain minutiae, nuances and nano-sensitivities underlying my live experiences cannot be recorded while the recording process itself might add an arbitrary experiential layer to my a/liveness.

Even with my reservations, I admire Auslander's ingenious analysis for interrupting the supposed ontological distinction between a live performance and its reproductions via diverse recording mediums (for example, sound recordings, videotapes, films, televisual and digital broadcasting). As Auslander indicates, there are frequently mediatized aspects in a live performance; inversely, a mediatized performance, such as a rock-music recording, or a live performance's mediatized reproductions, may include attributes identifiable as 'live'. To be sure, Auslander's resistance to binarism stands in concert with my complex paradigm for originary and prosthetic performances, for I likewise underscore their reciprocal slippage and imbrication rather than utter division. With the mass media as his implied subject matter, Auslander deals only with recordings and reproductions of live performances transcribed through audiovisual technologies; he excludes writing, or drawing for that matter, as a form of recording. I seek to articulate critical subjectivity, so my concept of prosthetic performance

covers a wide range of documents, from those produced tentatively by the artists prior to their performances to those scrupulously gathered and generated in retrospect by their critics/receivers. In sum, a mediatized performance recording is a prosthetic performance, but a prosthetic performance may be neither mediatized nor a faithful recording of its live source. Besides, a prosthetic performance, just like a mediatized performance, is not necessarily *non-live*.

Re-accessing the live alongside the prosthetic troubles what we habitually presume to be the relations between live performance and documentation, such as their sequentiality and their contrasting standings as producers of primary/original and secondary/prosthetic materials. I contend that sensing and behaving *live* is an experiential dimension happening *both* in creating and in critiquing time-based art. For an artistic subject, being *live* may be a condition first associated with the duration of making/presenting a performance, and then it emerges as a discontinuous, accumulative, repetitive, and perhaps protracted, process in documenting a performance. For a critical subject who missed attending the live event, the sequence of experiencing *live* is somewhat reversed: moving from encountering the prosthetic to producing the meta-original, which is simultaneously originary and prosthetic. The critic's research phase consists of a prolonged, contingent and multi-sourced process of amassing and organizing the originary artwork's prosthetic remnants—coming face to face, as it were, with those evidences and artefacts, perchance even a few post-production embellishments, prepared by the artist's archival procedures. The research will then feed into a writing period, which progresses through some equally durational, emergent, supplementary, fortuitous, chancy and largely theme-directed motions towards making a prosthetic performance, one extending the aesthetic/cultural functionality of the originary performance.

In my Chinese case studies, the live sequences traced thus far become further complicated. These time-based artworks either comprise numerous prosthetic performances, or cannot be witnessed in their entirety by any single intentional viewer. As interested spectatorial others, we can only experience the originary performances doubled as prosthetic performances or imagine the sources via their prosthetic doubles. Thus, if we understand watching a live performance loosely as a documenting process for our mnemonic repertoires, then we may approach examining the documentaryworks collected here as a redoubled process of documentation, a *live* duration in which our experiences with the originary and the prosthetic overlap and through which we may design (*live*) our own prosthetic additions to the original prosthetic bodies.

Is there a contradiction in using documentation to create time-based art? On the surface, I believe, there is. If we take ephemerality as the cost of a time-based artwork, then documenting the artwork itself, or performing the artwork via documentation, may be seen as creating a savings account to offset the expense of forgetfulness. Just as live art spends, so documentation salvages and saves. Underneath the surface, however, ephemerality or the sense of ceaselessly losing touch with the evaporating moment-to-moments is precisely what drives the impulse for documentation. Extravagance inspires and depends on conservation to last.

Peggy Phelan writes, in her charismatic elegiac tone, 'Part of what performance knows is the impossibility of maintaining the distinction between temporal tenses, between an absolutely singular beginning and ending, between living and dying. What performance studies learns

most deeply from performance is the generative force of those "betweens"' (1998: 8). What comes between you—the one who is reading-writing *Beijing Xingwei*—and *me*—the one writing-reading it—is a converging of ever-differentiating temporalities: Which are yours and which mine? Richard Schechner writes, with his penetrating poetic aplomb, 'Performances mark identities, bend and remake time, adorn and reshape the body, tell stories, and allow people to play with behaviour that is "twice-behaved," not-for-the-first-time, rehearsed, cooked, prepared' (1998: 361). In this rehearsal room I share with you, how many times have we behaved as if meeting face-to-face, an actual interface, the skin molecules under our eyelashes shifting towards one another, our dialogues breaking the stiff silence in the air, our co-breathing becoming the ether? Are we not two prosthetic follicles on the hair of time, merging with and splitting from each other to engender wispy ringlets as our artefactual genomic games?

A prosthetic double to live art, documentation reviews, repeats, records, relearns and imagines a partially memorialized past to engender a present-tensed re/encounter with keepsakes from before-now and to enable others from after-now to relive these semi-processed pasts in their own presents. What we call 'live', then, points to a perceiver's present-tensed intertwinement with the fleeting sense of being alive. Documentation offers a storehouse (or, to a more enterprising documenter, a bank) of catalysts, signs, images, origami, mirrors, bells, candles, spells, maps, riddles, expository fragments and other mnemonic prompters for us to simultaneously birth and live in an ever-never-now.

I talk to you at this moment, lingering in our ever-never-now. *Where-when* is this multicentric now? It exists in an active verb, jumping between parallel universes, tense-less and filled with tense to the brim; it sips from a glass of water; it relaxes from a zigzag stroll, round the globe and back again, in 180 nanoseconds, tick tock tick tock bang. I make my xingwei in a Beijing that's ever Los Angeles, and you make your xingwei in a tempo-spatial interstice that we just rename as our Los Angeles–Beijing, through these leaves-pages-screens-neuronal implants we touch-flip-and-click as our re-creative documentarywork (*c.*forever whenever).

(FACING PAGE) IMAGE **6.21** *Beijing Xingwei* (2009), a documentarywork in which the artist Qiu Zhijie enacted his light-calligraphy to inscribe the book's Chinese title, 北京行为, in the air in Beijing's Central Villa district, with stones in the background collected from different provinces of China. Concept by Meiling Cheng. Performance, site selection and photography by Qiu Zhijie. Image courtesy of the photographer.

AI WEIwei—FROM FAKing TO ACtiNG TO BElieVING TO . . .

1 JULY 2011: AN UPDATE FOR A

TEMPORAL DOCUMENT . . .

On 22 June 2011, after 81 days of incarceration in an undisclosed location, Ai Weiwei was released on bail, having allegedly confessed his crimes of tax evasion and pledged to repay the money owed.[1] Ai's release followed a huge international campaign to free him and came just days before the Chinese premiere Wen Jiabao left for state visits (24–28 June) to Hungary, UK and Germany. Ai's emergence from his arrest to reunite with his family opened the second act of a global performance that has been raging since the artist's initial 'disappearance' on 3 April 2011. Undoubtedly, the key players in this global performance, including Ai himself, the CCP leadership and the Western media, art communities and governments, will continue to write the second act with new points of public interest from their ongoing real-life engagements. At this transitional moment, however, no interpretation regarding these key players' motivations, calculations and strategies has convinced me as to how the second act will unfold.

[1] I consulted most news articles in the Western media available online and will cite my source only when there is a direct quotation. I thought about calling some of my Chinese artistinformers to query their assessment of the Ai incident but, without knowing the full extent of China's current crackdown, I decided against potentially endangering them. An abridged version of this Appendix appeared as a Meiling Cheng (2011). I thank Richard Schechner and Mariellen R. Sandford for inviting me to write the comment. I also wish to thank the following colleagues for helping me overcome my fear of personal safety: Winnie Wong, Thomas Berghuis, Jane Chin Davidson, Madeline Puzo, Brent Blair, David Bridel, Stacie Chaiken, Paula Cizmar, Elsbeth Collins, Charlotte Cornwell, Anita Dashiell-Sparks, Debora DeLiso, Velina Hasu Houston, Babette Markus, Oliver Mayer, Natsuko Ohama, Andy Robinson, Eric Trules, Lora Zane, Charlotte Furth, Stanley Rosen and Clay Dube.

In response to Ai's sudden detention in April, I wrote the following character study, tracking the artist's development from a versatile mediator between the Western art establishment and Beijing's emergent experimental art world in the 1990s and early 2000s to an outspoken crusader who, through his new media political art, has championed the causes of his less well-off compatriots and promoted democratic values. Although Ai is now free from the prison cell, his bail condition restricts him from accessing, at least for one year, some of his most efficacious art tools—Twitter feeds, Press interviews and international travel. Ironically, when Ai was shielded from public view, exhaustive media coverage and dedicated art-world mobilization in the West ensured that his vocal political art continued to be heard. Now that he has regained relative freedom of movement, Ai faces the compound challenges of intensified global expectations, unrelenting surveillance by his Chinese government prosecutors and his very recent personal and family experiences of the legal and political consequences to his dissident art. I suggest that Ai has emerged from

a crisis that validated the power of his prior political art only to find himself in another crisis, forcing him to re-evaluate how and where he will conduct his art/life from now on.

These uncertainties made me decide to keep the following comment as a temporary (historical) document, whose multiple versions of updates exist on the Internet and in the media but whose more substantial progress in 'plot' development will likely be unrealized, perhaps even after my document is published in print.

I write with extreme concern for Chinese artist Ai Weiwei, with whom I have had several phone and face-to-face interviews since 2004, when I began working on a *TDR* article that became the prototype for Chapter 2.[2] International Press has covered extensively the circumstances surrounding Ai's latest arrest. In short: On 3 April 2011, as Ai waited to board a plane to Hong Kong and then to Taiwan, two uniformed security agents intercepted him and took him from the Beijing Capital Airport; later that day, police raided Ai's Caochangdi home/studio complex and seized his laptops and computer hard drives. The police also questioned his wife Lu Qing and the staff and volunteers from Ai's company, Fake Design; some of them have since gone missing.[3] On 5 April, after Ai had disappeared for 50 hours, his mother Gao Ying and sister Gao Ge posted on their neighbourhood street a handwritten 'Missing Person' notice, whose photographed version soon went viral online. On 7 April, Chinese foreign ministry spokesman Hong Lei told a news conference that Ai was under investigation for 'economic crimes' and this incident 'has nothing to do with human rights or freedom of expression' (Branigan 2011).

22 APRIL 2011, AFTER AN EXPECTED UNEXPECTED INCIDENT HAPPENED . . .

2 My phone interview with Ai Weiwei, 1 September 2004, Los Angeles to Beijing; interviews with Ai Weiwei, 5 July 2005 and 23 March 2009, Beijing..

3 I cite the company's name from Ai's business card and his company webpage associated with chinese-architects.com. But, according to the Press, the official name for the company is Beijing Fake Cultural Development Ltd. See, for instance, Christopher Bodeen (2011).

As a world-renowned Chinese artist and outspoken social critic, Ai's detention has elicited tremendous overseas response, from high-level foreign (American, European, German, French, Australian, British) government interventions, public demonstrations and performance protests by art communities (including demonstrations in Hong Kong) to online petitions initiated by numerous museums, emulating Ai's prolific 'social sculpture' output by spreading the word via electronic social media.[4] London's Tate Modern, which has been showing Ai's *Sunflower Seeds* (2010)—an installation made up of 100 million individually hand-crafted porcelain sculptures of life-sized sunflower seeds—prominently displays its support for the artist with a rooftop sign that reads, 'RELEASE AI WEIWEI'. Despite global pressure, the Chinese government confirms that it is holding Ai on various alleged crimes (tax evasion, bigamy, Internet pornography, plagiarism, etc.), while warning other countries not to interfere in China's domestic affairs.

4 The EU acted as an entity while certain European countries (UK, Germany, France) acted individually to join the international outcry over the detention of Ai. 'Social sculpture' is a concept first developed by Joseph Beuys, who, I believe, has inspired Ai's naming of his electronic activism as 'social sculpture'. For online petitions, see Guggenheim Foundation (2011).

Given Ai's status as an artist of multiple genres—including xingwei yishu, conceptual sculpture, xingwei-zhuangzhi, photography, architecture, video documentary and politically engaged new media art—his arrest epitomizes the state's infringement on individual artistic freedom. We might share the general abhorrence of any censorship of art and mourn the unjust

treatment of a fellow artist. This reading, at its purest, assumes that unhampered individual freedom of expression is a universal virtue and that public censorship—in whatever form—a condemnable evil.

While my sentiment leans towards this assumption, I am also aware that my emotional response to Ai's plight is itself an ideological construction, resulting from both my acculturation in the democratic West and my immersion in the Western news media's reaffirmation of these values through its coverage of the Ai incident. I proclaimed my politics by signing an online petition calling for Ai's release (circulated by change.org). Nevertheless, the performance scholar in me understands my political choice as an act of belief, validated by an avowal of affiliation that temporarily erases any critical distance between what I accept as true and what I might, given time to reflect, find otherwise. My role as a concerned US citizen, legally endowed with an individual right to free expression, permits, even insists on, my commitment to an immediate action—one guided by and declaring my political agency. In contrast, my role as a student of sociopolitical performance, especially one involving intercultural and cross-national agents, depends on my ability to exercise doubt—towards others as well as towards myself.

The stakes in Ai's case are high; his lawyer and family still don't know his whereabouts and physical condition. When a person's life is potentially in danger, it seems heartless to study his detainment as an episode of sociopolitical performance. But Ai himself made such a reading not only possible but also desirable. Numerous commentators have observed that Ai's arrest may be a shock but not a surprise; the artist has long foreseen, even incited, his detention (see, for instance, Coonan 2011). By blurring the line between art and life, art and politics, Ai has knowingly, if not willingly, accepted the risk of his eventual arrest—which he might retrospectively frame as a political performance. He has done something similar before: when his expensive Shanghai studio was bulldozed by the city government on 11 January 2011, Ai reclaimed the city's destructive act by calling it his performance art piece (see Edward Wong 2011). By a mere cognitive shift, the artist might 'productively' translate his present captivity—as a stretch of existential detritus—into a durational readymade. He might make meaning out of his meaningless suffering (the actual oppression he was forced to endure) by misnaming his subjugation as self-induced confinement, hence, taking away his oppressors' power of harming. Should he do so in the future, then Ai will set the precedent for authoring a conceptual artwork that was predated by an empathic audience response (to his life event as political art). The Chinese government's persecution of Ai—as per the Western media—has established the Beijing artist in the liberal imaginary as a heroic freedom fighter. But the artist deserves a more complex reading.

To me, Ai is a rather intimidating and multifaceted character, more ambivalent than a straightforward dissident. A case in point is the name he chose for his design company, Fake— read in English as that which dissembles and sounds, in Pinyin, close to 'fuck'. This bilingual semantic-sonic punning typifies Ai's impudent series of performative artworks: smashing a valuable Han-dynasty urn; coating vases from the Neolithic age with bright industrial paint; giving the finger to inter/national cultural and political monuments in his performative photographs; repurposing traditional Chinese furniture parts to fabricate witty conceptual sculptures (like ostentatiously counterfeit objects); and jumping in the air, naked, except for his privates which are covered with a stuffed toy horse nicknamed 'Grass Mud Horse', whose Pinyin (*cao ni ma*) is homonymic with an obscene three-word curse (lit., fuck your mother) (see Ai Weiwei

2003 and *China Digital Times* 2011). 'Fake' also reflects Ai's equivocating mix of irreverence, brashness and posturing that characterizes the evolving series of public roles he inhabits.

I first contacted Ai, as the co-curator of *Fuck Off*, via a phone interview, which I still rank among my most challenging remote-communication research experiences.[5] At once brusque and laconic, Ai's phone persona prepared me for my difficult first face-to-face with him, the de facto impresario of Beijing's avant-garde art world, in his home/studio in July 2005.[6] With the benefit of hindsight, I recall that (almost farcical) encounter as Ai's performance of facade, supported by his imposing 'personality architecture'. Countless interruptions—by Ai's assistants, younger artist-visitors and international cellphone calls—punctuated and truncated our one-hour interview. Was Ai showing me that his time was too valuable to focus on one interview by a Mandarin-speaking Taiwanese American female scholar, especially since she was lost on her way and late for the interview? Was he insinuating his disapproval of my analysis in the *TDR* article concerning his 'internal censorship' of the photographic documents of Zhu Yu's xingwei piece, *Eating People* (2000), which he excised from the wall of *Fuck Off*? Was our interactive dynamic preventing him from entertaining me with his reputed gentlemanly magnanimity? Or was Ai demonstrating that his responsibilities to the Chinese art world trumped all other matters?

I requested a second interview with Ai in March 2009 because of my interest in writing about his collective xingwei piece, *Fairytale*. Ai remained somewhat reserved in this meeting, referring me again and again to his sina.com blog archive to answer most of my questions and reading a newspaper throughout our one-hour interview. But this time there were no cellphone interruptions or youngsters grovelling for favours. Ai also allowed me to watch—in his studio, on his assistant's laptop—his newly edited, not-yet-released two-and-a-half-hour digital-video documentary about the making of *Fairytale*. Moreover, Ai volunteered the information regarding his ongoing 'citizen's investigation' of the 2008 Sichuan earthquake victims, asserting that he would keep posting the names of the deceased students one by one on his blog, even though the government censors would erase those postings almost instantly.

Two months after my second meeting with Ai, his blog was no longer accessible, having been shut down by the government. The state's censorious measure forced or inspired Ai to begin using Twitter as art activism, dexterously bypassing the official ban on this social media vehicle. In August 2009, I received a group email from Ai's assistant, stating that Ai and his volunteers were attacked by the police while they were getting ready to leave their hotel room to testify in court for the Sichuan earthquake human rights lawyer Tan Zuoren. One hit Ai on the head. The brutal incident necessitated Ai's emergency cranial surgery about a month later in Germany (Ramzy 2010).

IMAGE **7.1** Grass Mud Horse (cao ni ma): invented by unattributed 'netizens', this neologistic ideogram includes three components: a radical on top representing 'grass'; the component on the lower left indicating a 'horse'; and on the right pointing to 'mud'. Courtesy of the public domain Wikimedia Commons..

5 My phone interview with Ai Weiwei, 1 September 2004, Los Angeles to Beijing.

6 I went to interview Ai primarily to inquire about Zhang Shengquan. We also discussed Ai's general views about performance art in China and the specific 'self-inspection' procedure Ai applied in *Fuck Off*. My interview with Ai Weiwei, 5 July 2005, Beijing.

Based on my understanding of his artistic corpus, supplemented by two distinct interview experiences, I suggest that Ai is a consummate xingwei artist whose most fascinating trait is his play with the grey representational spectrum between seeming and being, simulation and earnestness. In the decade after his 1993 return to China from the US, where he had lived since 1981, with his pedigree as the son of the esteemed poet Ai Qing and his own English-speaking worldly sophistication, Ai assumed the role of a mediator linking government authorities, the Western media, collectors, curators, critics and Chinese experimental art practitioners. This role in turn engendered two mutually reinforcing professional goals: to advance his artistic career; and to foster the growth of Chinese experimental art. Ai's three pioneering untitled, self-published anthologies on xingwei yishu—the so-called Black Cover Book (Ai Weiwei, Zeng Xiaojun and Xu Bing 1994), White Cover Book (Ai Weiwei and Zeng Xiaojun 1995) and Grey Cover Book (Ai Weiwei and Zeng Xiaojun 1997)—and the *Fuck Off* exhibition he co-organized were significant steps towards achieving this goal.

With the design and construction of his austere and elegant home/studio in Caochangdi in 1999, Ai moved into architecture, which brought him the opportunity to serve as a consultant to Herzog & de Meuron, the Swiss firm that designed the Beijing National Stadium, the famous Bird's Nest, for the 2008 Olympic Games. Hosting the Olympics was a momentous 'nationalistic' occasion for China's (geopolitical and economic) capital, a chance to present its brand new state image of cosmopolitan creativity. Beijing embarked on a massive official programme—from the draconian urban clean-up to the extravagant performance ceremonies—to create an icon of post/modern China. Certain incidents that Ai witnessed via his insider's vantage point, I believe, compelled him to shift his performance strategy. In August 2007, Ai very publicly transitioned from his status as an official insider to a socially conscientious outsider, vocally denouncing Beijing's propagandistic promotion of the 2008 Olympic shows as a 'fake smile'.[7] Given that Ai is himself a supreme manipulator of seeming and being 'fake', this denouncement both inaugurated Ai's performance as a rebel against the authoritarian hypocrisy—a role favoured by the democratic West—and marked the drastic narrowing of his representational spectrum between seeming and being.

7 The Chinese phrase *jia xiao* may be translated as a 'pretend smile', as cited in the report by CBC News (2007), or as a 'fake smile', as I translated here. The article also cites Ai as saying, 'I would feel ashamed if I just designed something for glamour or to show some kind of fake image'.

The more Ai performed dissent, the more he found reasons for his dissent; the more he found a solid basis for his critique, the more he reduced the distance between his 'faking' (by ambiguously embracing contradictory positions) and 'acting' (by committing to a unitary position). For Ai, to fake was now more and more to act according to his newfound convictions, which revolved round the individual's democratic right to voice opposition and expose corruption. Ai's tactics in carrying out these convictions included pushing existing sociopolitical boundaries within China and fraternizing with the Western media and contemporary art establishment—he used the former to cultivate his international fame and sought the latter to endorse his political art. Ai applied both tactics in his *Sichuan Earthquake Names Project* (2008–09), the summative title he used for his art activism that involved 'more than 50 researchers and volunteers' in towns across Sichuan province to collect the names of the students crushed to death by shoddily constructed school buildings during the 2008 earthquake.[8] Ai initiated this citizens' investigation for the victimized schoolchildren and their

8 The information collected by the Sichuan Earthquake Names Project inspired Ai's subsequent series of projects using student backpacks to create installations in various exhibitions overseas. See Katherine Grube (2009).

parents; he did it for himself as an artist; he did it for what he hoped would result in a better China. If Ai's previous professional aim was to globally spread good tidings by promoting contemporary Chinese experimental art and his unique position in it, his more recent objective was to alert the global audience by publicizing China's political ills. Despite the shift in modality, however, Ai's creative mission has been consistent throughout his career.

Thus, Ai's performance logic evolved: faking is acting; acting is believing.[9] If Ai used faking to appropriate a range of roles that heightened his personality, then he adopted acting to consciously refine, fit into and further develop these selected roles: an experimental artist; a mentor for newcomers; a mediator; a publisher; an architect; and a curator. When Ai acted a role (as a vocal activist or a political artist) that he found best addressed his intended goal (unveiling hidden sociopolitical problems), he prolonged enacting the role whose performative reiterations over time made the actor believe in the role's efficacy in realizing his self's most socially relevant potential. Belief requires faith; faith pre-empts ambivalence. Ai's belief in his role's concordance with his best self (as an artist who advocates for the downtrodden, for the freedom of expression and for individual human rights) demanded that he overcome the difficulties in continuously enacting this role. The longer Ai inhabited this chosen role, the less able and willing he was to access his inventory of other roles. Now determined in his belief, his 'self' volunteered, even desired, to jettison the potential benefits of playing other roles.

Without distance between seeming and being, performing and living, Ai cut his safety net, which was secured by the theatrical versatility of shifting roles. Nevertheless, I believe that Ai could have been able to play his role as a wired crusader of 'global [democratic] values' a while longer, had there not been a confluence of several sociopolitical events that triggered China's latest large-scale crackdown on political dissidents, civic protesters, human rights lawyers and Internet bloggers—with Ai as the country's most high-profile captive to date.[10]

9 My proposed analysis of Ai's performance logic was inspired by Lope de Vega's play, *Acting Is Believing* (c.1607–08), in which an actor, Genesius, who plays a Christian martyr, gets converted during his acting, surrenders to Christian martyrdom and is later canonized as St Genesius, patron saint of actors. As Genesius prays to God: 'I played my part so well that it seemed real. / "Bravo!" You cried, "since this Genesius dares / To play a saint, we'll hark to his appeal; / He'll have the part, we'll answer all his prayers."' (1986: 101).

10 'Global values' is used as a code phrase to connote democratic values such as 'the sanctity of individual' and 'freedom of expression within a civil society'. See Lionel M. Jensen (2011) and Keith B. Richburg (2011).

Although analysts maintain that it's highly unlikely for something similar to the 2011 'Arab Spring' to occur in China any time soon, the nation's tightened security control reveals its nervousness about possible social unrest (see Euronews 2011 and Zhang Yiqian 2011). Minxin Pei (2011) hypothesizes three reasons for Beijing's current campaign against dissent: One, preemptive strikes against a potential 'Jasmine Revolution'; Two, power jockeying in preparation of the CCP's leadership transition in 2012; Three, punitive response to the 'offence' China perceived regarding the awarding of the 2010 Nobel Peace Prize to its jailed dissident Liu Xiaobo. Add one more: the CCP leadership is bracing for a probable economic downturn in Asia set off by Japan's 2011 earthquake and tsunami-related recession. Since the CCP bases its internal political legitimacy largely on delivering a nonstop economic boom, it cannot risk social instability scaring off transnational investors and curtailing economic growth.

For whatever reason, Ai, along with many other activists lesser known overseas, are casualties of China's latest attack on political nonconformists. Coincidentally, the Chinese government's capture and confinement of Ai has reversed the artist's performance logic: from faking to acting

to believing. In contrast, for the Chinese government, believing is acting; acting is faking. In the past, Ai's reputation offered China both an international cachet for its burgeoning contemporary art scene and an image of tolerance for dissent. The state's present performance of repression, however, reflected its belief that Ai's agitation was no longer an asset. Therefore an immediate action was taken to silence Ai. Now that Ai's case was caught in such an intense global spotlight, the government must produce sufficient criminal charges against the artist (through 'faking', as in inventively assembling evidence or enforcing confession) to staunch international outcry.

Ai's case has garnered so much 'audience' attention from the West because this Chinese artist serves as the perfect poster child for the 'virtues' of Western democracy. Assuming that China's economic prosperity threatens the West's competitive edge, secured for more than a century by intertwining democracy and capitalism, Ai's arrest proves that there is something essentially 'faulty' in China's alternative combination of authoritarianism and de facto capitalism. I do not intend, nor am I equipped, to pass judgement here. My purpose is simply to puncture the ideological self-righteousness performed by much of the Western Press in their coverage of the Ai incident and to acknowledge my complicity in this discursive warfare.

Just for the sake of offering a dissenting opinion: we might reconsider China's largely hybrid socialism-and-capitalism combination through the analogy of bees. Bees are a species of highly organized and collective insects—or, as Jürgen Tautz admiringly puts it: 'A bee colony—surely nature's most wonderful way of organizing matter and energy in space and time' (2009b: v). The common mission of all bees—workers, drones, queen—is to ensure that the beehive not only survive but also thrive as 'a single integrated living organism' (Tautz 2009a: 3). The fate of any individual bee is inconsequential vis-à-vis the sustainability of the entire colony. As a human, like Tautz, I am awestruck by the singular purpose, communal ethos and cooperative economy of the bees. However outrageous it sounds, dare we ask: Is the Chinese leadership's current purge of dissidents following a similar logic?

But then, people are not bees. Arresting Ai is China's show of force to the world and, internally, a strategy to instil fear among critics, including overseas Chinese. When I first heard about Ai's disappearance, my immediate reaction was fear. I have written about Ai, along with other political artists, in this book. Once *Beijing Xingwei* is published, will I be disappeared when I next visit China? Thinking about the danger of political harassment made me feel incredibly sad for Ai and for his family and colleagues. I overcame my sadness and sense of impotence by engaging in a verbal action to reflect on this crisis confronting Ai and affecting many others, including me.

By chance I live in a democratic country, which, in principle, permits dissent and supports diversity. There is a large intellectual space allowed for public debate. Ironically, this means that all opinions—whether or not they diverge from the majority—are out there making noise. A political artist benefits from the freedom of being or not being heard—the risk to the art is inefficacy. Conversely, in China, the available space for dissension is subject to the ruling party's all-powerful discretion. An artist like Ai, who virtually—with his Twitter following as his armoury—assumed the role of a one-man opposition party, risks being heard loud and clear. He hazards the possibility of playing the martyr's role. And only a 'martyr' as internationally celebrated as Ai will have his silencing heard as a global controversy.

GLOssARy of CHinESE TerMS

(Terms in italics refer to titles of artworks, exhibitions, catalogues and books.)

A Chang de jianchi	阿昌的坚持	Chang Tsong-zung	張頌仁
Ai Qing	艾青	Changzheng kongjian	长征空间
Ai Weiwei	艾未未	*Chanpin*	产品
aizibing	爱滋病	*Chao shi*	超市
Anquandao	安全岛	*Cashi riji*	擦拭日记
ba gu wen	八股文	Chen Chuyun	陳竺筠
Baipi shu	白皮书	Chen Kaige	陈凯歌
Bairi wu yi er	百日五一二	Chen Lvsheng	陈履生
bang he	棒喝	Chen Zhen	陈箴
Bao guo	包裹	Cheng, Kaiyi	鄭凱議
Beiqing chengshi	悲情城市	Cheng, Meiling	鄭美玲
Bei yang	背羊	Cheng, Nailing	鄭乃玲
benshengren	本省人	Cheng, Shu-king	鄭書京
biaoyan yishu	表演艺术	*Chi chengshi*	吃城市
Biaozhun dongwu	标准动物	chi de ku zhong ku,	吃得苦中苦,
Bu li bu po	不立不破	fang wei ren shang ren	方為人上人
Bingdong	冰冻	*Chi, he, la, sa, shui*	吃喝拉撒睡
Bing. 96 Zhongyuan	冰. 96 中原	chi nao bu nao	吃脑补脑
Buhezuo fangshi	不合作方式	*Chi penjing*	吃盆景
Bu tiao bai bu tiao /	不跳白不跳	*Chi ren*	吃人
Tiao le ye bai tiao /	跳了也白跳	cho pinang	臭皮囊
Bai tiao ye de tiao	白跳也得跳	*Chongfu shuxie yiqian*	重复书写一千
Cai Guoqiang	蔡国强	*ci 'Lantingxu'*	·次'藍庭序'
Cai Qing	蔡青	*Ciren chusho*	此人出售
Cai Yuan	蔡原	*Cunzai de chidu:*	存在的尺度：
Cang	藏	*He Yunchang zuopi*	何云昌作品
Cang Xin	苍鑫	*Da*	打
Can de VCR	蚕的VCR	*Da jianggang*	大酱缸
Can hua	蚕花	*Dakai xingwei yishu jie*	打开艺术节
Can shu	蚕书	*Daodejing*	道德經
chan	禅	Da Tong Da Zhang	大同大张
Changqi	长崎	*Da xue*	大學

Deng ni	等你	Gao Ying	高瑛
Deng Yuxiang	鄧玉祥	gong an	公案
Dierjie Beijing guoji xianchang yishu jie	第二届北京国际现场艺术节	*Fenbenyixi*	酚苯乙烯
Diyijie yishujia pingtai	第一届艺术家平台	guang shuxie	光书写
Dongba	东坝	guannian sheying	观念摄影
Dongcun	东村	guannian yishu	观念艺术
Dongjing	东京	guan shen bu jing	观身不净
Dong zu	侗族	Guangdao	广岛
Dou Dou	豆豆	Gu Dexin	顾德新
Du	渡	Gu Gong	故宫
Duihua	对话	Gu, Wenda	谷文达
Dui shanghai de milian	对伤害的迷恋	Gu Xiaoping	顾小平
Er-ti-jiao: Zhongguo dangdai yishu zhan	二踢脚：中国当代艺术展	Gu Zhenqing	顾振清
Erwan wuqian li wenhua chuanbo zhongxin	二万五千里文化传播中心	hai gui	海归
		Han	汉
Er wo buxuyao sheme	而我不需要什麽	He Chengyao	何成瑶
25000 *kuai zhuanto*	25000 块砖头	*Heipi shu*	黑皮书
Fa biaoben	发标本	He Qinglian	何清涟
Falungong	法轮功	He Yunchang	何云昌
fangong dalu, zhengjiu Zhongguo	反攻大陆，拯救中國	*Hou ganxing*	后感性
Fan shi—zishen yu huanjing yishu zhan	反视—自身与环境艺术展	Hou Hanru	侯翰如
		Hou Hsiao-hsien	侯孝賢
fei-die	匪谍	Hsieh, Tehching	謝德慶
Fei Dawei	费大为	Huang Zhuan	黄专
Feng	封	Huang Yong Ping	黄永砅
Feng Boyi	冯博一	hu du bu shi zi	虎毒不食子
Feng Weidong	冯卫东	Hui Liangyu	回良玉
Feng Xin-ming	馮欣明	*Huipi shu*	灰皮书
Fen•Ma Liuming	芬•马六明	Hu Junjun	胡军军
Fen•Ma Liuming de wucan er	芬•马六明的午餐二	*Hu shui*	護水
Fen•Ma Liuming he yu	芬•马六明和鱼	hutong	胡同
fu dakuai zai wo yi xing, lao wo yi sheng, yi wo yi lao, xi wo yi si	夫大块载我以形，劳我以生，佚我以老，息我以死	*I Ching*	易經
		Jiangjun Ling	将军令
		Jiaoliu	交流
		jiben daode	基本道德
Fuhuojie kuaile	复活节快乐	*Jidu hanleng*	极度寒冷
Fu Xiaodong	付晓东	jie jing	借景
gaige kaifang	改革开放	jieqi	节气
Gan wen si	敢問死	Ji Lu	季路
Gao Ge	高阁	*Jin*	烬
Gao Minglu	高名潞	*Jinjichuko*	紧急出口
Gao Xiaolan	高小兰	Jing guishen er yuan zhi	敬鬼神而遠之
		Jingzhe	惊蛰
		Jin Le	靳勒

Jiu Guo	酒国	*Man*	缦
ji xing xingwei	即兴行为	Mao Hai	毛孩
Ji yu	祭鱼	*Meili you duojiu?*	美丽有多久?
JJ Xi	奚建军	Meishu tongmeng	美术同盟
Jumin huko bu	居民户口簿	mianbao chong	面包虫
junzi yuan pao chu	君子遠庖廚	ming, sheng si ye	命, 生死也
Kaifang Changcheng	开放长城	*Mingtian*	明天
Kang Mu	康木	*Mokuai*	模块
kongfangxiong	孔方兄	Mo Yan	莫言
Kuangren riji	狂人日记	*Muma Ji*	木马计
lao xiang	老乡	Muyu zhongxue	木鱼中学
Laozi	老子	*Muzhe*	牧者
Leng Lin	冷林	Nanjing	南京
Leung Po-shan	梁寶山	Nanmen Kongjian	南门空间
Liang Shaoji	梁绍基	*Nijialagua Pubu de yanshi yanshi*	尼加拉瓜瀑布的 岩石
Lian ti	连体	*Nongmin Du Wenda de feidie*	农民杜文达的飞碟
Li Hua	李桦	*Nuho ba, Zhongguo!*	怒吼吧, 中国!
Li Jing	黎静	*Nuho ba! Zhongguo*	怒吼吧! 中国
Linghun zhuisha	灵魂追杀	Peng Yu	彭禹
linjiedian	临界点	*Pianzhi*	偏执
linmo	临摹	*Qiangji shijian*	枪击事件
Linshi kongjian	临时空间	Qi Lei	齐雷 / 奇雷
Lin Tianmiao	林天苗	Qi Li	齐力
Liu Ding	刘鼎	qinqing	亲情
Liu Jin	刘瑾	qipao	旗袍
liu min	流民	qin	琴
Liushiwu gongjin	六十五公斤	Qin Ga	琴嘎
Liu Xiaobo	刘晓波	qigong	气功
Liu Yuan	刘源	*Qing hong*	青红
Li Xianting	栗宪庭	*Qingmíngjie de jiyili ceyan*	清明节的记忆力 测验
li yi lian chi	禮義廉恥	Qin Huizhu	秦慧珠
Long yu	龙鱼	Qin Shihuangdi	秦始皇帝
luan	亂	*Qishi lu*	启示录
Luan tan	乱弹	Qiu Zhijie	邱志杰
Lu, Carol Yinghua	卢迎华	*Quanbu zhishi de jichu*	全部知识的基础
Lu Hong	鲁虹	*Quan wu jin*	犬勿近
Lu Jie	卢杰	*Qu to luozi*	娶头骡子
lunhui	轮回	*Ren•Dongwu*	人•动物
Luo	烙	renqing wei	人情味
Luo Zhijiang	羅志江	*Ren you*	人油
Lu Qing	路青	Rujia	儒家
Lu Xun	鲁迅	Rulai Buddha	如来佛
Ma Liuming	马六明		
Ma Qingyun	马清运		

rutu wei an	入土为安
Sama xilie	萨玛系列
San min zhu yi	三民主義
sanpei xiaojie	三陪小姐
shana	刹那
Shanghai shui ji	上海水记
Shenfen huhuan	身份互换
Sheng Qi	盛奇
Shengcun de henji:	生存的痕迹：
'98 Zhongguo dangdai	'98中国当代
yishu neibu	艺术内部
guanmo zhan	观摩展
sheng meng	生猛
Shenlong jian sho bujian wei	神龍見首不見尾
shenti yishu	身体艺术
Shenti fafu, shou zhi fumu,	身體髮膚，受之父母，
bugan huishang,	不敢毀傷，
xiao zhi shi ye	孝之始也
shi	士
Shier pingfang mi	十二平方米
Shijian de xingzhuang	时间的形状
shijian yishu	时间艺术
Shijie zhi wei: Jin Shanri	世界之味：金善日
Shi ren	食人
shiti	尸体
shiti biaoben	尸体标本
Shito Yingguo manyou ji	石头英国漫游记
Shiwan nian	十万年
Shui xie riji	水写日记
Shui xie shijian	水写时间
Shuizuqiang	水族墙
Shuo yingyu	说英语
Sihuan zhinei	四环之内
'Sihuan zhinei'	《四环之内》
chufaqian liuying.	出发前留影。
Sheying: Ai Weiwei	摄影：艾未未
si sheng ming ye	死生命也
Song Dong	宋冬
Song Hui	宋慧
Song Shiping	宋世平
Su Qin	蘇秦
Sun Jing	孙敬
Sun Wukong	孙悟空
Sun Yuan	孙原
Sun Zhenhua	孙振华

Su, Yu-Jen	蘇玉真
Taijitu	太極圖
Tang Song	唐宋
Tang Xin	唐昕
Tan Zuoren	谭作仁
Tiao	跳
tian di	天地
tiandi buren	天地不仁
Tian Haizhen	田海珍
Tian shu	天书
Tian Yanwen	田彦文
Tingzi	亭子
To fa de Kenengxing	头发的可能性
Tonghua	童话
Tu	土
Tuya xilie	涂鸦系列
wai dian	外点
waishengren	外省人
Wang, Ashtin Natshi	王納虛
Wang Chuyu	王楚禹
Wang Du	王度
Wang Gongxin	王功新
Wang Hong	王洪
Wang Jin	王晋
Wang Lin	王林
'Wang Mian liangyou	'王冕粮油
shangdian' dang an	商店'档案
Wang, Nonchi	王弄極
Wang Qingsong	王庆松
Wang Wei	王卫
Wang Wen-hsing	王文興
Wang Xiaoshuai	王小帅
Wang Xizhi	王羲之
Wei lianheguo chengyuan	为联合国成员
suo zuo de 192 ge fang an	所做的192个方案
Wei Xing	魏星
weizhi sheng yan zhi si	未知生焉知死
weizhi si, yan zhi sheng	未知死，焉知生
Wen	吻
Wenhua dongwu	文化动物
Wenhua•Shenghuo	文化•生活
Wenxian zhan	文献展
Wo buxiang likai	我不想离开
Wo de meng	我的梦

Wo yu nvren shangyi sheng haizi de shiyi C	我与女人商议生孩子的事宜C	Yang Jiechang	扬诘苍
Wu Gaozhong	吴高钟	Yang Li	扬荔
Wu Guangyao	吴光耀	Yang Zhichao	扬志超
Wu Hongfei	吴虹飞	*Ye*	夜
wu hua	物化	ye shi	野史
Wu Hung	巫鸿	Yeh Tzu-Chi	葉子啟
Wu jin qi yong	物尽其用	yicixing	一次性
Wu Meichun	吴美纯	*Yige zhuanhuan gean de yanjiu*	一个转换个案的研究
Wu Ming	吴明 无名	*1994 nian 4 yue 30 ri*	1994年4月30日
Wu Shanzhuan	吴山专	*1997 nian liu yue sanshi ri zhi 1997 nian qi yue yi ri shui xie shijian yige duo xiao shi*	1997年六月三十日至 1997年七月一日水写时间一个多小时
wu wei	無為		
Wu Yanguang	吴雁光		
Wuyue ershiba dansheng	五月二十八诞生	*Yi hua de ro shen: Zhongguo xingwei yishu*	异化的肉身：中国行为艺术
xianchang yishu	现场艺术		
Xianfa yuedu	宪法阅读	Yin Xiuzhen	尹秀珍
Xian ji	献祭	yin; yang	陰；陽
Xiao Jing	孝經	yinxing shi	隐形式
xiaokang	小康	*Yi shan*	移山
Xiao Lu	肖鲁	yi sheng er; er sheng san; san sheng wanwu	一生二；二生三；三生萬物
Xiaorenwu de kuangxiang	小人物的狂想		
Xiao Yu	萧昱	*Yishu Dacan*	艺术大餐
Xiangqian	镶嵌	yi zi er shi	易子儿食
Xi he	洗河	you shi wei zheng	有詩為證
xingdong yishu	行动艺术	you/wu	有/無
xingwei yishu	行为艺术	*Youwu zhi wen*	尤物之吻
xingwei-zhuangzhi yishu	行为装置艺术	*You yitangke, ni yuanyi gen wo wan ma?*	又一堂课，你愿意跟我玩吗？
Xingxing meizhan	星星美展		
xingshu	行书	yuan dian	原点
xin xin renlei	新新人类	*Yu Gilbert he George duihua*	与Gilbert和George对话
Xizao	洗澡		
xizi	戏子	'Yu Kong Yi Shan'	愚公移山
xiu shen; qi jia; zhi guo; ping tianxia	修身；齊家；治國；平天下	Yu Gong	愚公
		Yu hai	鱼孩
xiushen yangxing	修身养性	Yu Ji	余极
Xiuzhen shenxue	袖珍神学	Yue Minjun	岳敏君
Xiyouji	西游记	*Yu shui duihua*	与水对话
xuan liang ci gu	悬樑刺股	Yu Zhenhuan	于振寰
Xu Bing	徐冰	*Zai Meiguo yangcan xilie*	在美国养蚕系列
xu shi zai	虚实在	zai xianchang	在现场
Xu Ruotao	徐若涛	*Zai Yanan wenyi zuotanhui de jianghua*	在延安文艺座谈会的讲话
Xunzhang gou	勋章狗		
Xu Yihui	徐一晖	zao chan er	早产儿
Xu Zhen	徐震	Zeng Fanzhi	曾梵志

Zhang Dali	张大力	*Zhongguo renben*	中国人本
Zhang Huan	张洹	*Zhongguo xiandai yishu zhan*	中国现代艺术展
Zhang Jianjun	张健君	*Zhongguo renmin gongheguo xianfa*	中国人民共和国宪法
Zhang Jun	张军		
Zhang Lan	张澜	zhong sheng	眔生
Zhang Shengquan	张盛泉	zhongsheng pingdeng	众身平等
Zhang Xiaogang	张晓刚	*Zhongyao de bushi rou*	重要的不是肉
Zhang Yimou	张艺谋	*Zhu*	铸
Zhang Zhaohui	张朝晖	zhuangzhi yishu	装置艺术
Zhan Wang	展望	*Zhuangzi*	莊子
Zhao Jianhai	赵建海	*Zhuanxingqi de biaoben*	转型期的标本
Zhao Xiangyuan	赵湘媛	Zhu Ming	朱冥
Zheng ba	争霸	Zhu Qi	朱其
Zheng Yuke	郑玉珂	Zhu Xi	朱羲
Zhi Gong	智公	Zhu Yu	朱昱
Zhi pi	植皮	*Zhu Yu wuru shiti an (jiexuan)*	朱昱侮辱尸体案（节选）
Zhong cao	种草		
zhong dian	终点	zibizheng	自闭症
Zhongguo dangdai yishu yanjiu wenxian zhan	中国当代艺术研究文献展	*Ziran xilie*	自然系列
		ziwo dingwei	自我定位
Zhongguo gongfu 2	中国功夫2	ziwo shencha	自我审查
		zou huo ru mo	走火入魔

WORks CitED

ABRAMOVICH, Marina. 2004. *The Biography of Biographies*. Milan: Charta.

ADORNO, Theodor W. 1981. 'Cultural Criticism and Society' in *Prisms* (Shierry Weber Nicholsen and Samuel Weber trans). Cambridge, MA: MIT Press, pp. 17–34.

AI Weiwei (ed.). 2002. *Zhongguo dangdai yishu fangtan lu / Chinese Artists, Texts and Interviews: Chinese Contemporary Art Awards, 1998–2002* (Robert Bernell, Krista Van Fleit and Chin Chin Yap trans). Hong Kong: Timezone 8.

——. 2003. *Ai Weiwei: Works; Beijing, 1993–2003* (Charles Merewether ed.). Hong Kong: Timezone 8.

——. 2007. 'Tonghua 2007' in *Ai Weiwei*. Available at: http://blog.sina.com.cn/s/blog_473-f90ad010009yr.html (last accessed on 26 February 2007; no longer valid).

—— (ed.). 2008. *Yang Zhichao Zuopin, 1999–2008 / Yang Zhichao Work* (Ge Yuanyuan and Wang Yan trans). Exhibition catalogue. Shanghai: Eastlink Gallery.

——. 2011. *Ai Weiwei's Blog: Writings, Interviews, and Digital Rants, 2006–2009* (Lee Ambrozy ed. and trans.). Cambridge, MA: MIT Press.

—— and Yang Zhichao. 2008. 'Fangtan: Ai Weiwei and Yang Zhichao' in *Yang Zhichao Zuopin, 1999–2008 / Yang Zhichao Work*. Exhibition Catalogue. Shanghai: Eastlink Gallery, pp. 1–23.

—— and Zeng Xiaojun (eds). 1995. *Bai pi shu* (White Cover Book). Beijing: Privately published.

—— and Zeng Xiaojun (eds). 1997. *Hui pi shu* (Grey Cover Book). Beijing: Privately published.

——, Hua Tianxue and Feng Boyi (eds). 2000. *Bu hezuo fangshi / Fuck Off*. Exhibition catalogue. Shanghai: Eastlink Gallery.

——, Zeng Xiaojun and Xu Bing (eds). 1994. *Heipi shu* (Black Cover Book). Beijing: Privately published.

ALBEE, Edward. 2000. *The Goat; or, Who Is Sylvia?* Woodstock, NY: Overlook.

ALBERRO, Alexander. 1999. 'Reconsidering Conceptual Art, 1966–1977' in Alexander Alberro and Blake Stimson (eds), *Conceptual Art: A Critical Anthology*. Cambridge, MA: MIT Press, pp. xvi–xxxvii.

——, and Blake Stimson (eds). 1999. *Conceptual Art: A Critical Anthology*. Cambridge, MA: MIT Press.

ALDRIDGE, Alan. 2003. *Consumption*. Cambridge: Polity.

AMINO. 2009. 'He Yun Chang: Touring Project'. Available at: http://www.amino.org.uk/-hyc_info.html (last accessed on 13 March 2009; no longer valid).

—— and Spacex. 2009. 'He Yun Chang: Live Performance, September 2006–January 2007'. Brochure. Available at: http://www.amino.org.uk/ (last accessed on 31 March 2009; no longer valid).

ANTONIOLLI, Alessio. 2002. 'Song Dong's Open Studio at Gasworks' in Christopher W. Mao, Yin Xiuzhen, Song Dong (eds), *Chopsticks*. Exhibition catalogue. New York: Chambers Fine Art.

APPADURAI, Arjun. 1986. 'Commodities and the Politics of Value', introduction to Arjun Appadurai (ed.), *The Social Life of Things: Commodities in Cultural Perspective*. Cambridge: Cambridge University Press, pp. 3–63.

——. 1996. *Modernity at Large: Cultural Dimensions of Globalization*. Minneapolis: University of Minnesota Press.

ARTAUD, Antonin. 1958. *The Theater and Its Double* (Mary Caroline Richards trans.). New York: Grove Weidenfeld.

ASSOCIATED PRESS. 2005. 'Avant-Garde Chinese Artists Defends Fetus-Bird Artwork' (10 August). Available at: http://www.othershore-arts.net/xiaoyuESSAYS10.html#2 (last accessed on 28 May 2010).

ATKINSON, Terry. 1972. Introduction to Ursula Meyer (ed.), *Conceptual Art*. New York: E. P. Dutton, pp. 8–21.

AUSLANDER, Philip. 1999. *Liveness: Performance in a Mediatized Culture*. London: Routledge.

——. 2006. 'The Performativity of Performance Documentation'. *PAJ* 28(3): 1–10.

AVERT. 2006. 'HIV and AIDS in China'. Available at: http://www.avert.org/aidschina.htm (last accessed on 5 April 2006).

AVISE, John C. 2004. *The Hope, Hype, and Reality of Genetic Engineering: Remarkable Stories from Agriculture, Industry, Medicine, and the Environment*. Oxford: Oxford University Press.

BAIDU BAIKE. 2010. *Baidu baike* (A Hundered Degrees Encyclopaedia). Available at: http://baike.baidu.com (last accessed on 15 February 2010).

BAKER, Steve. 2000. *The Postmodern Animal*. London: Reaktion Books.

BARBER, Bruce. 1979. 'Indexing: Conditionalism and Its Heretical Equivalents' in A. A. Bronson and Peggy Gale (eds), *Performance by Artists*. Toronto: Art Metropole, pp. 183–204.

BARBOZA, David. 2007a. 'In China's Revolution, Art Greets Capitalism'. *New York Times* (4 January). Available at: http://www.nytimes.com/2007/01/04/arts/design/04arti.html?partner=rssnyt&emc=rss (last accessed on 4 January 2007).

——. 2007b. 'Zhang Huan in Shanghai'. *New York Times* (3 September). Available at: http://www.nytimes.com/slideshow/2007/09/02/arts/design/20070903_Zhang_FEATURE.html?rf=davidbarboza (last accessed on 28 May 2011).

——. 2009. 'China's Art Market: Cold or Maybe Hibernating?' *New York Times* (10 March). Available at: http://www.nytimes.com/2009/03/11/arts/design/11decl.html?_r=0 (last accessed on 23 May 2013).

BARISH, Jonas A. 1981. *The Antitheatrical Prejudice*. Berkeley: University of California Press.

BARMÉ, Geremie R. 1999. *In the Red: On Contemporary Chinese Culture*. New York: Columbia University Press.

BARRETT, David. 2008. 'Shanghai Biennale 2000'. Available at: http://www.royaljellyfactory.com/david-barrett/articles/eyestorm/eye-shanghai-intro.htm (last accessed on 26 November 2008).

BARTHES, Roland. 1989. *The Rustle of Language* (Richard Howard trans.). Berkeley: University of California Press.

BATTCOCK, Gregory (ed). 1973. *Idea Art: A Critical Anthology*. New York: E. P. Dutton.

BAUDRILLARD, Jean. 1983. *Simulations* (Paul Foss, Paul Patton and Philip Beitchman trans). New York: Semiotext[e].

BAUMAN, Zygmunt. 1998. 'On Glocalization: Or Globalization for Some, Localization for Some Others'. *Thesis Eleven* 54(1): 37–49.

BBC News. 2003a. 'Baby-Eating Art Show Sparks Upset' (3 January). Available at: http://news.bbc.-co.uk/2/hi/entertainment/2624797.stm (last accessed on 13 December 2008).

———. 2003b. 'German Cannibal Tells of Fantasy' (3 December). Available at: http://news.bbc.-co.uk/go/pr/fr/-/2/hi/europe/3286721.stm (last accessed on 3 January 2011).

———. 2005. 'Scarred by History: The Rape of Nanjing' (11 April). Available at: http://news.bbc.-co.uk/go/pr/fr/-/2/hi/asia-pacific/223038.stm (last accessed on 30 October 2010).

———. 2006. 'Japan's Controversial Shrine' (15 August). Available at: http://news.bbc.co.uk/2/hi/asia-pacific/1330223.stm (last accessed on 22 October 2010).

BENEDIKT, Michael. 1966. Introduction to *Modern French Theatre*: *The Avant-Garde, Dada, and Surrealism*; *An Anthology of Plays* (Michael Benedikt and George E. Wellwarth eds and trans). New York: E. P. Dutton, pp. ix–xxxv.

BERGER, John. 1980. *About Looking*. New York: Pantheon Books.

BERGHUIS, Thomas J. 2001. 'Flesh Art-Body and Performance Art in Post-Mao China'. *Chinese Contemporary Art* 4 (November). Available at: http://www.chinese-art.com/Contemporary/volumefour-issue5/flesh.htm (last accessed on 8 October 2003; no longer valid).

———. 2006. *Performance Art in China*. Hong Kong: Timezone 8.

BERGSON, Henri. 2010. *The Creative Mind*: *An Introduction to Metaphysics*. New York: Dover.

BERNSTEIN, Thomas P. 1977. *Up to the Mountains, Down to the Villages*: *The Transfer of Youth from Urban to Rural China*. New Haven, CT: Yale University Press.

BERRY, Christopher J., and Mary Ann Farquhar. 2006. *China on Screen*: *Cinema and Nation*. New York: Columbia University Press.

———, Fran Martin and Audrey Yue (eds). 2003. *Mobile Cultures*: *New Media in Queer Asia*. Durham, NC: Duke University Press.

BESSIRE, Mark H. C. 2003. *Art from Middle Kingdom to Biological Millennium* (Wenda Gu ed.). Exhibition catalogue. Boston, MA: MIT Press.

BEUYS, Joseph. 2004. *What Is Art?* (Volker Harlan ed., Matthew Barton and Shelley Sacks trans). London: Clairview Books.

BHABHA, Homi K. 2006[1994]. *The Location of Culture*. London: Routledge.

BIO-MEDICINE. 2008. Bio-Medicine. Available at: http://www.bio-medicine.org/ (last accessed on 7 May).

BIZART. 2004. 'Biz-Art-Artists—Xu Zhen'. Available at: http://www.biz-art.com/art_artists/xu_zhen-_ch.htm (last accessed on 25 August 2005).

BLAKE, Erin C. 2011. 'Where Be "Here be dragons"?' Available at: http://www.maphist.nl/-extra/herebedragons.html (last accessed on 27 April).

BLANCHARD, Ben. 2010. 'China Stops Prominent Artist Leaving Country'. *Reuters* (3 December). Available at: http://www.reuters.com/assets/print?aid=USTRE6B21ZY20101203 (last accessed on 25 December 2010).

BLECHER, Marc. 2009. 'China in 2008: Meeting Olympian Challenges'. *Asian Survey* 48(1): 74–87.

BOAL, Augusto. 1985. *Theatre of the Oppressed*. New York: Theatre Communications Group.

———. 2002. 'Invisible Theatre' (Susana Epstein trans.) in Rebecca Schneider and Gabrielle Cody (eds), *Re-Direction*: *A Theoretical and Practical Guide*. London: Routledge, pp. 112–21.

BODEEN, Christopher. 2011. 'Chinese Artist Ai Weiwei Released from Detainment'. *Washington Times* (22 June). Available at: http://www.washingtontimes.com/news/2011/jun/22/weiwei-released-from-detention/ (last accessed on 1 July 2011).

BOURDIEU, Pierre. 1986. 'The Forms of Capital' in *Handbook of Theory of Research for the Sociology of Education* (John G. Richardson ed., Richard Nice trans.). New York: Greenwood, pp. 241–58.

BOWRING, Philip. 2009. 'Chinese Exceptionalism'. *New York Times* (22 September). Available at: http://www.nytimes.com/2009/09/23/opinion/23iht-edbowring.html (last accessed on 9 May 2011).

BRADY, Laura. 2010. 'Crush Videos: Animal Torture and Murder as a Fetish'. Available at: http://www.associatedcontent.com/article/230752/crush_videos_animal_torture_and_murder.html?cat=17 (last accessed on 5 May 2010).

BRANIGAN, Tania. 2011. 'China Says Ai Weiwei Detention "Nothing to Do with Human Rights"'. *Guardian* (7 April). Available at: http://www.guardian.co.uk/artanddesign/2011/apr/07/china-suspect-ai-wei-wei-financial-crimes (last accessed on 12 April 2011).

BRONSON, A. A., and Peggy Gale (eds). 1979. *Performance by Artists*. Toronto: Art Metropole.

BROOKS, Richard. 2002. 'Channel 4 Will Show Performance Artist Eating Baby'. *Times* (29 December). Available at: http://www.timesonline.co.uk/tol/news/uk/article806379.ece (last accessed on 11 December 2008).

BROUWER, Marianne, and Chris Driessen. 1997. 'Another Long March' in Chris Driessen and Heidi van Mierlo (eds), *Another Long March*: *Chinese Conceptual and Installation Art in the Nineties*. Exhibition catalogue. Tilburg: Fundament Foundation, pp. 11–31.

BROWN, Leslie (ed.). 1993. *The New Shorter Oxford English Dictionary*. Oxford: Oxford University Press.

BURKE, Edmund. 1998. *A Philosophical Enquiry into the Origin of Our Ideas of the Sublime and Beautiful, and Other Pre-revolutionary Writings* (David Womersley ed.). London: Penguin.

BUSKIRK, Martha. 2003. *The Contingent Object of Contemporary Art*. Cambridge, MA: MIT Press.

BUTLER, Judith. 1990. *Gender Trouble*: *Feminism and the Subversion of Identity*. London: Routledge.

CAGE, John. 2009. 'Experimental Music' (1957). Address to the convention of the Music Teachers National Association, Chicago. Available at: www.kimcohen.com/artmusictheoryassets/artmusictheorytexts/Cage%20Experimental%20Music.pdf (last accessed on 4 October 2009).

CALLAHAN, William A. 2009. *China*: *The Pessoptimist Nation*. Oxford: Oxford University Press.

CANG Xin. 2006. '*Sa'man xilie* / Shamanism Series' in *Cang Xin*. Exhibition catalogue. Hong Kong: Xin Dong Cheng Publishing House / 10 Chancery Lane Gallery / Eastlink Gallery, pp. 204–30.

—— and Su Chen Hsieh. 2008. 'Zhisuoyi fangtan: Interview with the Curator' in Cang Xin, *Cang Xin Shenhua* / *Cangxin's Mythology*. Beijing: Yishu genzong chuban zhongxin, pp. 16–32.

CARLSON, Marvin. 1996. *Performance*: *A Critical Introduction*. London and New York: Routledge.

CARTER, Jimmy. 1979. 'Taiwan Relations Act Statement on Signing H. R. 2479 into Law'. *The American Presidency Project*. Available at: http://www.presidency.ucsb.edu/ws/index.php?pid=32177#ixzz1IOe-HbFO2 (last accessed on 2 April 2011).

CASY. 'Main AIDS Chronology'. Available at: http://www.casy.org/chron/mainchron.htm#2000 (last accessed on 5 April 2006; no longer valid).

CBC NEWS. 2007. 'Artist Behind Beijing's "Bird's Nest" Stadium Boycotts Olympics' (11 August). Available at: www.cbc.ca/news/arts/artdesign/story/2007/08/11/beijing-artist-stadium.html (last accessed on 15 April 2011).

CERTEAU, Michel de. 1984. *The Practice of Everyday Life* (Steven Rendall trans.). Berkeley: University of California Press.

CHANG Tsong-zung. 2001. 'Into the Nineties', introduction to Valerie C. Doran (ed.), *China's New Art, Post-1989*. Hong Kong: Hanart TZ Gallery, pp. i–vii.

CHAUDHURI, Una. 2003. 'Animal Geographies: Zooësis and the Space of Modern Drama'. *Modern Drama* 64 (Winter): 646–62.

———. 2007. '(De)Facing the Animals: Zooësis and Performance'. *TDR* 51 (Spring): 8–20.

CHEN, Aric. 2007. 'The Dream of the Artist' in *Wang Jin*. Exhibition catalogue. New York: Friedman Benda; Beijing: Pékin Fine Arts. Unpaginated.

CHEN, Edward K. Y. 2005. 'Twenty-Five Years of Hyper-growth in China: Is Economics or Politics Taking Command?' in *China 21: Production, Pollution, and Politics*. Claremont, CA: Pacific Basin Institute, pp. 5–12.

CHEN, Lvsheng. 2001. 'Zouhuorumo de qianwei yishu' (Devilish Avant-Garde Art). *Meishu* 4. Available at: http://www.jsmsjy.com/shownews.asp?newsid=102 (last accessed on 16 July 2004; no longer valid).

CHEN Ruoxi. 2008. *Jianchi, wuhui: Chen Ruoxi qi shi zi shu* (Persistence, No Regret: Chen Ruoxi 70-Year-Old Self-Narration). Taipei: Jiuge chubanshe youxian gongsi.

CHEN Xiaoyun. 2001. 'Xu Zhen *fangtan lu*'. Available at: http://www.biz-art.com/art_artists/-xu_zhen_ch.htm (last accessed on 25 August 2005).

CHENG, Li. 2000. 'China in 1999: Seeking Common Ground at a Time of Tension and Conflict'. *Asian Survey* 40: 112–29.

———. 2001. 'China in 2000: A Year of Strategic Rethinking'. *Asian Survey* 41: 71–90.

CHENG, Meiling. 2001. 'Cyborgs in Mutation: osseus labyrint's Alien Body Art'. *TDR* 45 (Summer): 145–68.

———. 2002. *In Other Los Angeleses: Multicentric Performance Art*. Berkeley: University of California Press.

———. 2004a. 'Clandestine Interventions'. *Public Art Review* 16 (Fall–Winter): 26–9.

———. 2004b. 'Performance Art: Double Takes'. Lecture delivered at the School of Theatre, University of Southern California, on 13 April.

———. 2005. 'Violent Capital: Zhu Yu on File'. *TDR* 49 (Fall): 58–77.

———. 2006a. 'Extreme Performance and Installation from China'. *TheatreForum* (Summer): 88–96.

———. 2006b .'Indexing Death in Seven *Xingwei* and *Zhuangzhi* Pieces'. *Performance Research* 11(2): 24–38.

———. 2007a. 'Animalworks in China'. *TDR* 51 (Spring): 63–91.

———. 2007b. 'Catalyst, Praxis, Habitat: Performative Objects in Chinese Time-based Art'. *Performance Research* 12(4): 151–66.

———. 2008. 'Down and Under, Up and Over: Animalworks by Sun Yuan and Peng Yu'. *Performance Paradigm* 4. Available at: http://www.performanceparadigm.net/wp-content/uploads/2008/06/-2cheng-comp.pdf (last accessed on 20 June 2008).

———. 2009. 'De/visualizing Calligraphic Archaeology: Qiu Zhijie's Total Art'. *TDR* 53 (Summer): 17–34.

———. 2010a. 'The Laughing Medusa' in Christine Wertheim (ed.), *Feminaissance*. Los Angeles: Les Figues, pp. 59–69.

———. 2010b. 'Somagraph' in Christine Wertheim (ed.), *Feminaissance*. Los Angeles: Les Figues, pp. 88–99.

——. 2011. 'Ai Weiwei: Acting in Believing'. *TDR* 55 (Winter): 7–13.

——. 2012a. 'Documents of Chinese Time-Based Art: Three Impressions from Three Fragments' in Adrian Heathfield and Amelia Jones (eds), *Perform, Repeat, Record: Live Art in History*. London: Intellect Books, pp. 385–9.

——. 2012b. 'The Prosthetic Present Tense: Documenting Chinese Time-based Art' in Adrian Heathfield and Amelia Jones (eds), *Perform, Repeat, Record: Live Art in History*. London: Intellect Books, pp. 171–86.

CHENG Ziwen. 2006. 'A Shaman in Beijing: The Work of Cang Xin', in *Cang Xin*. Exhibition catalogue. Hong Kong: Xin Dong Cheng Publishing House / 10 Chancery Lane Gallery / Eastlink Gallery, pp. 126–30.

CHIN, Daryl. 1998. 'Beau Geste'. *PAJ* 20(2): 57–61.

CHINA DIGITAL TIMES. 2009. 'Tag: Grass-Mud Horse'. *China Digital Times* (31 March). Available at: http://chinadigitaltimes.net/-china/grass-mud-horse/ (last accessed on 12 April 2011).

CHINA IN BRIEF. 2005. 'Animal Husbandry'. Available at: http://www.china.org.cn/e-china/-agriculture/animal.htm (last accessed on 20 August).

CHINESE ART CENTER. 2006. 'VITAL 06 Closes and Looks Forward to VITAL 07'. Curatorial statement (19 December). Available at: http://www.chinese-arts-centre.org/http:/www.chinese-arts-centre.org/-events/vital-06-closes-and-looks-forward-to-vital-07/ (last accessed on 26 June 2010).

CHINESE-ART.COM. 2000. 'Man and Animal'. Available at: http://www.chinese-art.com/artists/guzhen-qing.htm (last accessed on 3 June 2004; no longer valid).

CHIU, Melissa (ed.). 2007. *Zhang Huan: Altered States*. Milan: Edizioni Charta; New York: Asia Society.

CHOW, Rey. 1998. 'Introduction: On Chineseness as a Theoretical Problem'. *Boundary 2* 25 (Autumn): 1–24.

CHUN, Allen. 1996. 'Fuck Chineseness: On the Ambiguities of Ethnicity as Culture as Identity'. *Boundary 2* 23 (Summer): 111–38.

CIXOUS, Hélène. 1994. 'The Laugh of the Medusa' (Keith Cohen and Paula Cohen trans) in Camille Roman, Suzanne Juhasz and Cristanne Miller (eds), *The Women and Language Debate: A Sourcebook*. New Brunswick, NJ: Rutgers University Press, pp. 78–93.

CLARK, Josh. 2011. 'How Cannibalism Works'. *HowStuffWorks: A Discovery Company*. Available at: http://history.howstuffworks.com/historians/cannibalism.htm/printable (last accessed on 3 January).

CLARKE, Roger, and Wang Xiaoshuai. 2006. 'Screen Dreams'. *Sight and Sound* 16(9): 28.

CNN. 2004a. 'Pentagon: South Korean Hostage Beheaded'. *CNN World* (23 June). Available at: http://articles.cnn.com/2004-06-22/world/iraq.hostage_1_sun-il-hooded-captors-american-businessman-nicholas-berg?_s=PM:WORLD (last accessed on 30 October 2010).

——. 2004b. 'Seoul Defies Iraq Hostage Threat'. *CNN World* (21 June). Available at: http://www.lexis-nexis.com.libproxy.usc.edu/lnacui2api/results/docview/attachRetrieve.do?smi=LOGOS&key=15303&componentseq=1&type=201&inline=y (last accessed on 30 October 2010).

COGGINS, David. 2007. 'Ai Weiwei's Humane Conceptualism'. *Art in America* 95(8): 118–25.

COLONNELLO, Nataline. 2007. 'Ai Weiwei—*Fairytale* at Documenta 12, Kassell, 2007'. Press release by Galerie Urs Meile Beijing–Lucerne. Available at: http://cuids.org/images/uploads/ai_weiwei-_documenta-2.pdf (last accessed on 23 May 2013).

CONFUCIUS 2000. 2000. *Lunyu* (The Analects). Available at: http://www.confucius2000.com/confucius/-lunyu.htm (last accessed on 4 August 2009).

COONAN, Clifford. 2011. 'Ai Weiwei: Seeds of an Iconoclast'. *Independent* (9 April). Available at: http://www.independent.co.uk/news/people/profiles/ai-weiwei-seeds-of-an-iconoclast-2265474.html (last accessed on 12 April 2011).

COTTER, Holland. 2009. 'The Collected Ingredients of a Beijing Life'. *New York Times* (14 July). Available at: http://www.nytimes.com/2009/07/15/arts/design/15song.html (last accessed 29 October 2010).

COWEN, Ruth. 2003. 'Baby-Eating Spectacle Disgusts UK Viewers'. *Globe and Mail* (3 January). Available at: http://www.thefreeradical.ca/Baby_eating_on_television.htm (last accessed on 13 December 2008; no longer valid).

CUMMING, Laura. 2008. 'Fitting Home for a Veteran Collector'. *Observer* (12 October). Available at: http://www.guardian.co.uk/artanddesign/2008/oct/12/art-saatchigallery (last accessed on 10 December 2008).

DAI Yanni. 2001. 'Shi yishu haishi tusha?' (Is It Art or Is It Slaughter?). *Sichuan Zaixian* (17 August). Available at: http://arts.com/Archive/2001/8/17-84854.html (last accessed on 4 June 2004; no longer valid).

DAVIS, Deborah S. (ed.). 2000. *The Consumer Revolution in Urban China*. Berkeley: University of California Press.

DEANS, Jason. 2003. 'C4 rapped over dead baby broadcast'. *Guardian* (10 March). Available at: http://www.guardian.co.uk/media/2003/mar/10/broadcasting.channel42 (last accessed on 11 December 2008).

DELEUZE, Gilles. 1991. *Masochism: An Interpretation of Coldness and Cruelty; and, Venus in Furs* (Jean McNeil trans.). Cambridge, MA: MIT Press.

—— and Félix Guattari. 1988. *A Thousand Plateaus: Capitalism and Schizophrenia* (Brian Massumi trans.). Minneapolis: University of Minnesota Press.

DENG Xiaoping. 1979. 'Uphold the Four Cardinal Principles (Excerpts)'. Speech delivered on 30 March. Available at: http://www.wellesley.edu/Polisci/wj/China/Deng/principles.htm (last accessed on 22 May 2011).

——. 1984. 'Build Socialism with Chinese Characteristics'. Talk with the Japanese delegation to the second session of the Council of Sino-Japanese Non-Governmental Persons on 30 June. Available at: http://english.peopledaily.com.cn/dengxp/vol3/text/c1220.html (last accessed on 22 May 2011).

DERRIDA, Jacques. 1991. '"Eating Well"; or, the Calculation of the Subject: An Interview with Jacques Derrida' in Eduardo Cadava, Peter Connor and Jean-Luc Nancy (eds), *Who Comes after the Subject?* London: Routledge, pp. 96–119.

DIMAGGIO, Paul, Eszter Hargittai, W. Russell Neuman and John P. Robinson. 2001. 'Social Implications of the Internet'. *Annual Review of Sociology* 27: 307–36.

DIRLIK, Arif. 1996. 'Chinese History and the Question of Orientalism'. *History and Theory* 35: 96–118.

DORAN, Valerie C. (ed.) 1993. 'Xu Bing' in Valerie C. Doran (ed.), *China's New Art, Post-1989*. Hong Kong: Hanart TZ Gallery, p. cvii.

DUCHAMP, Marcel. 1989. *The Writings of Marcel Duchamp* (Michel Sanouillet and Elmer Peterson eds). Oxford: Oxford University Press.

——. 1996. 'The Creative Act' (1957) in Kristine Stiles and Peter Selz (eds), *Theories and Documents of Contemporary Art: A Sourcebook of Artists' Writings*. Berkeley: University of California Press, pp. 818–19.

DUTTON, Michael (ed.). 2000. *Streetlife China*. Cambridge: Cambridge University Press.

EHRMANN, Thierry. 2011. 'The Sale of the Ullens Collection Confirms the Strength of Chinese Art'. *Artprice* (12 April). Available at: http://www.artmarketinsight.com/en/11/04/12/The+sale+of+the+-Ullens+collection+confirms+the+strength+of+Chinese+art (last accessed on 6 May 2011).

ELLIS, Anthony. 1984. 'Offense and the Liberal Conception of the Law'. *Philosophy and Public Affairs* 13 (Winter): 3–23.

ELWES, Catherine. 2004. 'On Performance and Performativity: Women Artists and Their Critics'. *Third Text* 18(2): 193–7.

ENTOGENETICS. 2010. 'History and Innovation'. Available at: http://www.entogenetics.com/history.html (last accessed on 10 May 2010).

ERICKSON, Britta. 2001. *The Art of Xu Bing*: *Words without Meaning, Meaning without Words*. Washington, DC: Arthur M. Sackler Gallery, Smithsonian Institution; Seattle: University of Washington Press.

———. 2002. 'The Reception in the West of Experimental Mainland Chinese Art of the 1990s'. Available at: http://www.moma.org/docs/learn/intnlprograms/10.%20CCA_Web_Reception%20in%20the%20 West.pdf (last accessed 22 May 2011).

ERICKSON, Jon. 1995. *The Fate of the Object*. Ann Arbor: University of Michigan Press.

ESSLIN, Martin (ed.). 1965. *Samuel Beckett*: *A Collection of Critical Essays*. Englewood Cliffs, NJ: Prentice-Hall, 1965.

ESTES, Adam Clark. 2011. 'More Theories on Ai Weiwei's Arrest: Nude Photos, Plagiarism'. *Atlantic Wire* (11 April). Available at: http://www.theatlanticwire.com/global/2011/04/nude-photo-plagiarism-ai-weiwei-arrested/36536/ (last accessed on 11 April 2011).

EURONEWS. 2011. 'Jasmine Revolution "Impossible" in China: Analyst'. *Euronews* (30 March). Available at: http://www.euronews.net/2011/03/30/jasmine-revolution-impossible-in-china-analyst/ (last accessed on 16 April 2011).

FARQUHAR, Judith. 2005. *Appetites*: *Food and Sex in Post-socialist China*. Durham, NC: Duke University Press.

FAVAZZA, Amando R. 1996. *Bodies Under Siege*: *Self-mutilation and Body Modification in Culture and Psychiatry*. Baltimore, MD: Johns Hopkins University Press.

FERGUSON, Russell (ed.). 1998. *Out of Actions*: *Between Performance and the Object, 1949–1979*. Exhibition catalogue. Los Angeles: Museum of Contemporary Art.

FEWSMITH, Joseph. 1999. 'China in 1998: Tacking to Stay the Course'. *Asian Survey* 39(1): 99–113.

FIBICHER, Bernhard, and Matthias Frehner (eds). 2005. *Mahjong*: *Contemporary Chinese Art from the Sigg Collection*. Exhibition catalogue. Ostfildern-Ruit: Hatje Cantz.

FOUCAULT, Michel. 2008. 'Of Other Spaces' (1967) in Michiel Dehaene and Lieven De Cauter (eds), *Heterotopia and the City*: *Public Space in a Postcivil Society*. London: Routledge, pp. 13–30.

FREUD, Sigmund 1985. 'On Transience' (1915) (James Starchey trans.) in *The Pelican Freud Library* (A. Richards ed.). Harmondsworth: Penguin, pp. 159–222.

GAASCH, Cynnie. 2004. 'Permanence and Change'. *Artvoice* 4(44). Available at: http://artvoice.com/-issues/v4n44/permanence_and_change (last accessed on 23 May 2013).

GALERIE URS MEILE. 2007. 'Ai Weiwei's *Fairytale* at Documenta 12'. Press Release (25 May). Available at: http://www.artfacts.net/index.php/pageType/instInfo/inst/327/contentType/news//nID/3592/lang/1 (last accessed on 13 March 2009).

GALLAGHER, Mary E. 2002. 'Reform and Openness: Why China's Economic Reforms Have Delayed Democracy'. *World Politics* 54(3): 338–72.

GAO Minglu. 1993. 'The 1985 New Wave Art Movement' in Valerie C. Doran (ed.), *China's New Art, Post-1989*. Hong Kong: Hanart TZ Gallery, pp. c–ciii.

——. 1998a. 'From Elite to Small Man: The Many Faces of a Transitional Avant-Garde in Mainland China' Gao Minglu (ed.), *Inside Out: New Chinese Art*. San Francisco: San Francisco Museum of Modern Art; New York: Asia Society Galleries; Berkeley: University of California Press, pp. 161–3.

—— (ed.). 1998b. *Inside Out: New Chinese Art*. Exhibition catalogue. San Francisco: San Francisco Museum of Modern Art; New York: Asia Society Galleries; Berkeley: University of California Press.

——. 1998c. 'Toward a Transnational Modernity: An Overview of *Inside Out: New Chinese Art*' in Gao Minglu (ed.), *Inside Out: New Chinese Art*. San Francisco: San Francisco Museum of Modern Art; New York: Asia Society Galleries; Berkeley: University of California Press, pp. 15–40.

——. 2004. 'The Great Wall in Contemporary Chinese Art'. *Positions* 12(3): 784–5.

GETZ, Daniel A. 2003. 'Sentient Beings' in *Encyclopedia of Buddhism*, vol. 2 (Robert E. Buswell Jr ed.). New York: Macmillan Reference USA, pp. 760–1.

GIRARD, René. 1979. *Violence and the Sacred* (Patrick Gregory trans.). Baltimore, MD: Johns Hopkins University Press.

GOLDBERG, RoseLee. 1996. *Performance Art: From Futurism to the Present*. New York: Harry N. Abrams.

GOLDSTEIN, Avery. 1998. 'China in 1997: A Year of Transitions'. *Asian Survey* 38(1): 34–52.

GÓMEZ-PEÑA, Guillermo. 1993. *Warrior for Gringostroika: Essays, Performance Texts, and Poetry*. St Paul, MN: Graywolf.

GOODENOUGH, Patrick. 2004. 'Pig-to-Human Organ Transplant Trials Recommended in Australia'. *Cybercast News Service* (14 January). Available at: http://www.cnsnews.com/ViewForeignBureaus.asp?-Page=%5CForeignBureaus%5Carchive%5C200401%5CFOR20040114a.html (last accessed on 17 June 2010).

GOVERNMENT INFORMATION OFFICE, TAIWAN. 2001. 'The Circulated "E-mail Allegations" in the Net—the Rumour/Propaganda of Baby-Eating Story: The Anonymously Circulated Slander through the Net vs the Official Clarification of Taiwan's Government'. Available at: http://888.rockin.net/propaganda-of-baby-eating/rumour.htm (last accessed on 25 November 2008).

GREENE, Brian. 2011. *The Hidden Reality: Parallel Universes and the Deep Laws of the Cosmos*. New York: Alfred A. Knopf.

GRIES, Peter Hays, and Stanley Rosen (eds). 2004. *State and Society in 21st-Century China: Crisis, Contention, and Legitimation*. New York: Routledge.

GRUBE, Katherine. 2009. 'Ai Weiwei Challenges China's Government Over Earthquake'. *ArtAsiaPacific Magazine* 64 (July–August). Available at: http://artasiapacific.com/Magazine/64/AiWeiweiChallengesChinasGovernmentOverEarthquake (last accessed on 20 April 2011).

GU Zhenqing. 2001. 'Ren • Dongwu: Weimei yu Aimei zuopin changshu' (Human•Animal: Aestheticism and Ambivalence Artwork Statement). Available at http://www.csonline.com.cn/gb/content/2001-12/17/content_86169.htm (last accessed on 25 August 2004).

—— (ed.). 2005. *Zhongguo dangdai yishu fangtanlu: Zhongguo dangdai yishu jiang / Chinese Artists: Texts and Interviews; Chinese Contemporary Art Awards*. Hong Kong: Timezone 8.

GUANGDONG MUSEUM OF ART. 2003. *Zhongguo renban / Humanism in China: A Contemporary Record of Photography*. Exhibition catalogue. Guangdong: Guangdong Museum of Art.

——. 2010. 'The Second Quangzhou Triennial'. Press release. Available at: http://www.gdmoa.org/gztri-ennial/second/news-en/news-en.htm (last accessed on 4 August 2010).

GUGGENHEIM FOUNDATION. 2011. 'Call for the Release of Ai Weiwei'. Available at: http://www.change.org/-petitions/call-for-the-release-of-ai-weiwei (last accessed on 12 April 2011).

HAGENS, Guther von. 2003. 'Anatomy and Plastination' in *Gunther von Hagens' Body Worlds: The Anatomical Exhibition of Real Human Bodies*. Exhibition catalogue. Singapore: Asia Academy of Music Arts and Sciences, pp. 9–37.

HARDY, Julia. 'Zen Influences'. Available at: http://www.patheos.com/Library/Zen/Origins/-Influences.html (last accessed on 26 June 2011).

HARPER, Glenn. 2010. 'Substance: A Conversation with Xu Bing'. Available at: http://www.xubing.com/-index.php/site/texts/a_conversation_with_xu_bing1/ (last accessed on 16 April 2010).

HASEGAWA, Yuko . 2004. 'Ma Liuming: The Politics of Non-Differentiation' in *Fen-Ma Liuming*. Exhibition catalogue. Beijing: Xin-Dong Cheng, pp. 40–7.

HE Chengyao. 2004. 'Xianqi nide gaito lai / Lift the Cover from Your Head'. In *Cruel/Loving Bodies* (Sasha S. Welland trans.). Exhibition catalogue. Shanghai: Duolun Museum of Modern Art, pp. 26–33.

——. 2005a. 'Fragmented Words: He Chengyao' in Daniel Brine and Shu Yang (eds), *Zhongguo Xianchang / China Live: Reflections on Contemporary Performance Art* (Carol Lu and Francesca Jordan trans.). London: Chinese Art Centre, in collaboration with Live Art UK, Live Art Development Agency and DaDao Live Art Festival, pp. 42–9.

——. 2005b. 'He Chengyao' in Daniel Brine and Shu Yang (eds), *Zhongguo Xianchang/China Live: Reflections on Contemporary Performance Art* (Carol Lu and Francesca Jordan trans.). London: Chinese Art Centre, in collaboration with Live Art UK, Live Art Development Agency and DaDao Live Art Festival, p. 124.

HE Qinglian. 2006. 'The Hijacked Potential of China's Internet' (Paul Frank trans.). *China Rights Forum* 2: 31–47.

HE Yunchang and Tang Xin (eds). 2004. *Ah Chang de jianchi: He Yunchang zuopin zhan / Ar Chang's Persistence: An Exhibition of He Yunchang's Works* (Carol Lu trans.). Exhibition catalogue. Beijing: Beijing Tokyo Art Projects.

HEATHFIELD, Adrian (ed.). 2004. *Live: Art and Performance*. New York: Routledge.

—— and Amelia Jones (eds). 2012. *Perform, Repeat, Record: Live Art in History*. London: Intellect Books.

—— and Tehching Hsieh. 2009. *Out of Now: The Lifeworks of Tehching Hsieh*. London: Live Art Development Agency; Cambridge, MA: MIT Press.

HEIDEGGER, Martin. 1962. *Being and Time* (John Macquarrie and Edward Robinson trans). London: SCM Press.

HEISER, Jörg. 2011. 'Ai Weiwei in Hospital After Police Brutality'. *Frieze*. Available at: http://www.frieze.-com/blog/entry/ai_weiwei_in_hospital_after_police_brutality/ (last accessed on 18 March 2011).

HEISEY, D. Ray (ed.). 2000. *Chinese Perspectives in Rhetoric and Communication*. Stamford, CT: Ablex.

HESKETH, Therese and Wei Xing Zhu. 1997. 'Health in China: The One Child Family Policy: the Good, the Bad, and the Ugly'. *BMJ* 314: 1685–7.

HEUNG, Jennifer D. 2009. 'Belonging to the City: Cosmopolitanism, Urbanites, and Chinese Cities'. *Vis-à-vis: Explorations in Anthropology* 9(1): 6–12.

HOU Hanru. 2002. *On the Mid-ground: Hou Hanru* (Yu Hsaio-Hwei ed.). Hong Kong: Timezone 8.

Hu Zhen and He Jingfang. 2007. '1001 ge ren de xiandai *Tonghua*' (1001 People's Contemporary Fairytale). Interview with Ai Weiwei. Available at: http://www.bullogger.com/blogs/aiww/archives/-210611.aspx (last accessed on 23 May 2013).

Huot, Claire. 2000. *China's New Cultural Scene*. Durham, NC: Duke University Press.

International Film Circuit. 2009. 'Frozen (*Jidu Hanleng*): A Flim by Wu Ming (Wang Xiaoshuai)'. Available at: http://www.internationalfilmcircuit.com/catalog/frozen.html (last accessed on 30 December 2009).

Irvin, Sherri. 2005. 'Appropriation and Authorship in Contemporary Art'. *British Journal of Aesthetics* 45 (April): 123–37.

Jameson, Fredric. 1982. *The Political Unconscious*. Ithaca, NY: Cornell University Press.

—— and Masao Miyoshi (eds). 2003. *The Cultures of Globalization*. Durham, NC: Duke University Press.

Januszczak, Waldemar. 2003. *Beijing Swings*. Directed by Martin Herring. London: ZCZ Films / Channel 4.

——. 2008. 'Ai Weiwei: Strutting His Stuff'. *Times* (2 November) Available at: http://entertainment.timesonline.co.uk/tol/arts_and_entertainment/visual_arts/article5050070.ece (last accessed on 11 December 2008).

Jensen, Lionel M. 2011. 'Ai Weiwei and the "World of Madness"'. *Asia Sentinel* (14 April). Available at: http://www.asiasentinel.com/index.php?option=com_content&task=view&id=3129&Itemid=258 (last accessed on 18 April 2011).

Jiang Ming. 2008. *The Ability to Exist: He Yunchang Art Works* (Nicolas Raol Bourles trans.). Exhibition catalogue. Jakarta: Vanessa Art Link.

Jones, Amelia. 1997. '"Presence" in Absentia: Experiencing Performance as Documentation'. *Art Journal* 56(4): 11–18.

——. 1998. *Body Art / Performing the Subject*. Minneapolis: University of Minnesota Press.

Kaplan, Janet A. 1999. 'Deeper and Deeper: Interview with Marina Abramovic'. *Art Journal* 58(2): 6–19.

Kaprow, Allan. 1993. 'Nontheatrical Performance' in Jeff Kelley (ed.), *Essays on the Blurring of Art and Life*. Berkeley: University of California Press, pp. 174–5.

Keane, Michael. 2007. *Created in China: The Great New Leap Forward*. New York: Routledge.

Kingston, Maxine Hong. 1976. *The Woman Warrior: Memoir of a Girlhood Among Ghosts*. New York: Alfred A. Knopf.

Kollewe, Julia. 2010. 'China Economic Growth Forecasts Raised by World Bank'. *Guardian* (17 March). Available at: http://www.guardian.co.uk/business/2010/mar/17/china-economic-growth-forecasts-raised-world-bank (last accessed on 24 December 2010).

Kopytoff, Igor. 'The Cultural Biography of Things: Commoditization as Process' in Arjun Appadurai (ed.), *The Social Life of Things: Commodities in Cultural Perspective*. Cambridge: Cambridge University Press, pp. 64–94.

Kosuth, Joseph. 1999. 'Art After Philosophy' in Alexander Alberro and Blake Stimson (eds), *Conceptual Art: A Critical Anthology*. Cambridge, MA: MIT Press, pp. 158–77.

Krafft-Ebing, Richard Freiherr von. 1925. *Psychopathia Sexualis with Reference to the Antipathic Sexual Instinct: A Medico-Forensic Study*. n. p.

Kraig Biocraft Laboratories. 2011. 'University of Notre Dame and Kraig Biocraft Laboratories Create Artificial Spider Silk Breakthrough'. Available at: http://www.kraiglabs.com/Spider-silk-created-9-29-2010.htm (last accessed on 26 June 2011).

KRAUS, Richard Curt. 2004. *The Party and the Arty in China*. Lanham, MD: Rowman & Littlefield.

LACY, Suzanne (ed.). 1995. *Mapping the Terrain: New Genre Public Art*. Seattle, WA: Bay Press.

LANSBERG, Alison. 1995. 'Prosthetic Memory: *Total Recall* and *Blade Runner*' in Mike Featherstone and Roger Burrows (eds), *Cyberspace, Cyberbodies, Cyberpunk: Cultures of Technological Embodiment*. London: Sage, pp. 175–90.

LAOZI. 2011. *Daodejing quanwen ji yiwen* (Daoism: Complete Text and Translated Text). Available at: http://wenku.baidu.com/view/b5254b83ec3a87c24028c42b.html (last accessed on 25 May 2013).

LEE, Pamela M. 2004. *Chronophobia: On Time in the Art of the 1960s*. Cambridge, MA: MIT Press.

LENG Lin. 2008. 'Shui zhong lao yue' (Fishing the Moon from Water) in Shen Qibin (ed.), *Song Dong*. Exhibition catalogue. Shanghai: Shanghai Zendai Museum of Modern Art.

LEUNG, Jenny. 2009. 'Ai Weiwei's New Blog'. *China Digital Times* (1 June). Available at: http://chinadig-italtimes.net/2009/06/ai-weiweis-new-blog/ (last accessed on 18 March 2011)

LEVITT, Noah. 2004. 'Germany's Cannibalism-by-Consent Case: Possible Human Rights Claims'. *CNN World* (13 January). Available as: http://www.cnn.com/2004/LAW/01/13/findlaw.analysis.leavitt.-cannibalism/index.html (last accessed on 3 January 2011).

LEWIS, Ben. 2008. 'A Second Tulip Mania'. *Prospect Magazine* (20 December). Available at: http://www.-prospectmagazine.co.uk/magazine/asecondtulipmania/#.UZ4lJ6RxmRI (last accessed on 28 December 2008).

LeWITT, Sol. 1999. 'Paragraphs on Conceptual Art' in Alexander Alberro and Blake Stimson (eds), *Conceptual Art: A Critical Anthology*. Cambridge, MA: MIT Press, pp. 12–17.

LEYBOLD-JOHNSON, Isobel. 2011. 'Art and Political World Worried for Ai Weiwei'. Available at: http://www.swissinfo.ch/eng/politics/foreign_affairs/Art_and_political_world_worried_for_Ai_Weiwei.html?cid=29948412 (last accessed 8 April 2011).

LI, Conghua. 1998. *China: The Consumer Revolution*. Singapore: John Wiley.

——, and Deloitte & Touche Consulting Group. 1998. *China: The Consumer Revolution*. Singapore: John Wiley.

LI Huang. 2006. 'A Top Ten List of Photographic Works in 2006' (Hu Zhu trans.). Available at: http://www.artzinechina.com/display_vol_aid483_en.html (last accessed on 20 July 2009).

LI Li. 2009. 'World Bank Report Urges Broadening of China's Poverty Reduction Agenda'. Availabe at: http://www.worldbank.org/en/news/2009/04/08/world-bank-report-urges-broadening-chinas-poverty-reduction-agenda (last accessed on 19 March 2010).

LI Xianting. 1993a. 'Illustrated Notes to Major Trends in the Development of Contemporary Chinese Art' in Valerie C. Doran (ed.), *China's New Art, Post-1989*. Hong Kong: Hanart TZ Gallery, pp. lxxii–ic.

——. 1993b. 'Major Trends in the Development of Chinese Art' (Valerie C. Doran trans.) in Valerie C. Doran (ed.), *China's New Art, Post-1989*. Hong Kong: Hanart TZ Gallery, pp. x–xxii.

——. 2000a. 'Da Zhang'. *Meishu tongmeng* 2000. Available at: http://arts.tom.com/look/ysxw/cul_ytxw-zlzz_dazhang1_2.htm (last accessed 5 August 2004; no longer valid).

——. 2000b. 'Overall Prize Winner [CCCA 2000]'. Available at: http://www.othershore-arts.net/xiaoyuESSAYS9.html (last accessed on 28 May 2010).

——. 2003. 'Luo Zidan de xingwei yishu—gei shehui yige jingshi' (Luo Zidan's Performance Art—to Give Society a Warning). Available at: http://www.scitom.com.cn/discovery/tattoo/tat205.html (last accessed on 8 July 2004).

MeiLING
CheNG

——. 2004. 'Li Xianting's Dialogue with Sun Yuan and Peng Yu' (Carol Lu trans.). Unpublished transcript, 7 April.

——. 2006. 'Qiangji shijian de fangtan ji zai jiedu' (Interviews of the Gunshot Event and Reinterpretation). *Jinri.Meishu/Art Today* 1: 42–63.

Li Yumin (ed.). 2004. *Qiu Zhijie: Dangdai yishu yu bantu wenhua* (Qiu Zhijie: Contemporary Art and Indigenous Culture). Fujian: Fujian Meishu Chubanshe.

Liang Shaoji. 1994. 'Guanyu "Ziran xilie"' (Regarding *Nature Series*) in Ai Weiwei, Zeng Xiaojun and Xu Bing (eds), *Heipi shu* (Black Cover Book). Beijing: Privately published, p. 111.

Liang Shaoji. 1999. 'Liang Shaoji'. *Artnews*. Available at: http://www.artnews.com.cn/artist/-artist/0311.htm (last accessed on 2 August 2005).

——. 2002. 'Guanyu "Ziran xilie"—Chuangzuo zaji / About the *Nature Series*—Notes on Creative Work' in Ai Weiwei (ed.), *Zhongguo dangdai yishu fangtan lu / Chinese Artists, Texts and Interviews: Chinese Contemporary Art Awards, 1998–2002* (Robert Bernell, Krista Van Fleit and Chin Chin Yap trans). Hong Kong: Timezone 8, pp. 40–5.

Liao Zhaoxiang. 2001. 'Ying shi cheng jiayao: jing shi zhi zuo laizi zhongguo yishujia Zhu Yu' (Infant Corpse Becoming Delicious Meal: The World-Shocking Piece Comes from Chinese Artist Zhu Yu). *Dongsen xingwen bao* (21 March). Available at: http://210.58.102.66/2001/03/21/91-406577.htm (last accessed on 4 June 2004).

Lincot, Emmanuel. 2004. 'Contemporary Chinese Art Under Deng Xiaoping' (Michael Black trans.). *China Perspectives* 53 (May–June). Available at: http://chinaperspectives.revues.org/2952 (last accessed on 13 Oct. 2008).

Linden, Stanton J. (ed.). 2003. *The Alchemy Reader: From Hermes Trismegistus to Issac Newton*. Cambridge: Cambridge University Press.

Lippard, Lucy R. 1999. 'Postface, in *Six Years: The Dematerialization of the Art Object, 1966 to 1972*' in Alexander Alberro and Blake Stimson (eds), *Conceptual Art: A Critical Anthology*. Cambridge, MA: MIT Press, pp. 294–7.

Liu Kang. 1998. 'Is There an Alternative to (Capitalist) Globalization? The Debate about Modernity in China' in Fredric Jameson and Masao Miyoshi (eds), *The Cultures of Globalization*. Durham, NC: Duke University Press, pp. 164–88.

——. 2004. *Globalization and Cultural Trends in China*. Honolulu: University of Hawaii Press.

Liu Yuan. 2001. 'Zhu de yuanwang: Ping Zhu Yu de "Fuhuojie kuaile"' (A Pig's Wish: Critiquing Zhu Yu's *Happy Easter*). Available at: http://www.xici.net/#d2554646.htm (last accessed on 17 January 2011).

Live Art Development Agency. 2009. 'What is Live Art?'. Available at: http://www.thisisliveart.co.uk/-about_us/what_is_live_art.html (last accessed on 17 April 2009).

Liverpool Biennial. 2009. 'About Liverpool Biennial'. Available at: http://www.biennial.com/content/-Footer/AboutLiverpoolBiennial.aspx (last accessed on 29 August 2009).

Lu, Carol Yinghua. 2009. 'Back to Contemporary: One Contemporary Ambition, Many Worlds'. *e-flux journal* 11 (December). Available at: http://www.e-flux.com/journal/view/102 (last accessed on 22 May 2011).

Lu, Hanlong. 2000. 'To Be Relatively Comfortable in an Egalitarian Society' (Ken K. Liu trans.) in Deborah S. Davis (ed.), *The Consumer Revolution in Urban China*. Berkeley: University of California Press, pp. 124–41.

Lu Hong and Sun Zhenhau. 2006. *Yi hua de ro shen: Zhongguo xingwei yishu / China Performance Art* (Alienated Body/Flesh: Chinese Performance Art). Hebei: Hebei meishu chubanshe.

Lu, Sheldon H. 2001. *China, Transnational Visuality, Global Postmodernity*. Stanford, CA: Stanford University Press.

——. 2008. 'Popular Culture and Body Politics: Beauty Writers in Contemporary China'. *Modern Language Quarterly* 69 (March): 167–85.

Lu Xun. 2006. 'Kuangren riji' (Diary of a Mad Man) (1918). Available at: http://www.tianyabook.com/-luxun/lh/002.htm (last accessed on 5 August 2006).

Lu Yingzhong. 2010. 'Siwan de yishu: tan binzang liyi de jingu bianqian' (The Art of Death: Comments on Funereal Rituals and Their Evolutions). Available at: http://www.thinkerstar.com/lu/essays/-funeral/history.html (last accessed on 15 February 2010).

Ma Guihau. 2002. 'How Children Saved the River'. *New Internationalist* (December). Available at: http://www.newint.org/features/2002/12/01/develop-sustainability (last accessed on 15 August 2010).

Ma Liuming. 2004. '*Guanyu Ma Liuming* / Concerning Ma Liuming', interview with Tang Xin, in *Fen-Ma Liuming*. Exhibition catalogue. Beijing: Xin-Dong Cheng Publication, pp. 78–92.

Ma Qian. 2007. 'Once Upon a Time'. *China Daily* (29 May). Available at: http://www.chinadaily.com.cn/-cndy/2007-05/29/content_882137.htm (last accessed on 13 March 2009).

Ma, Ying. 2009. 'Sixty Years of Backwardness and Suffering'. *National Post* (29 September). Available at: http://yingma.org/2009/09/29/the-uighurs-60-years-of-backwardness-and-suffering/ (last accessed on 31 May 2013).

MacAdams, Lewis. 1981. 'Sex with the Dead: Is John Duncan's Latest Performance Art or Atrocity?'. *Wet* 30(6) (March–April): 60.

Mao, Christopher (ed.). 2007. *The Shape of Time* (Yu Christina Yu trans.). Exhibition catalogue. New York: Chambers Fine Art.

——, Yin Xiuzhen and Song Dong (eds). 2002. *Chopsticks*. Exhibition catalogue. New York: Chambers Fine Art.

Mao Zedong. 2006. 'Yu Gong Yi Shan' (Yu Gong Moves the Mountain) (11 June 1945). *Baidu Zhidao* (11 April). Available at: http://zhidao.baidu.com/question/5963200.html?si=4 (last accessed 6 January 2011).

——. 2011. *Zai Yanan wenyi zuotanhui de jianghua* (Yan'an Talks on Literature and Art, 2 May 1942). Available at: http://news.xinhuanet.com/ziliao/2004-06/24/content_1545090.htm (last accessed on 19 February 2011).

Margulis, Lynn, and Dorion Sagan. 2002. *Acquiring Genomes: A Theory of the Origins of Species*. New York: Basic Books.

Marx, Karl. 1993a. *Capital*, VOL. I, PART I, *Commodities and Money*. Available at: http://www.marxists.org/-archive/marx/works/1867-c1/ch01.htm (last accessed on 18 June 2011).

——. 1993b. 'Commodities' in *Capital*, VOL. I, PART I, *Commodities and Money*. Available at: http://www.-marxists.org/archive/marx/works/1867-c1/ch01.htm#S1 (last accessed on 24 June 2010).

——. 1993c. 'The Fetishism of Commodities and the Secret Thereof'. in *Capital*, VOL. I, PART I, *Commodities and Money*. Available at: http://www.marxists.org/archive/marx/works/1867c1/ch01.htm#S4 (last accessed on 24 June 2010).

Maslin, Janet. 2011. 'Multiple-Universe Theory Made, Well, Easier'. *New York Times* (26 January). Available at: http://www.nytimes.com/2011/01/27/books/27book.html (last accessed on 11 February 2011).

MᴄAꜰᴇᴇ, R. Preston, and John McMillan. 1987. 'Auctions and Bidding'. *Journal of Economic Literature* 25 (June): 699–738.

MᴄGɪꜰꜰᴇʀᴛ, Carola. 2009. 'Chinese Soft Power and Its Implications for the United States: Competition and Cooperation in the Developing World; A Report of the CSIS Smart Power Initiative'. Report for the Center for Strategic and International Studies, Washington, DC (March). Available at: csis.org/files/media/csis/.../090403_mcgiffert_chinesesoftpower_web.pdf (last accessed on 10 May 2011; no longer valid).

MᴄLᴜʜᴀɴ, Marshall. 1994. *Understanding Media*: *The Extensions of Man*. Cambridge, MA: MIT Press.

—— and Quentin Fiore. 1967. *The Medium Is the Massage: An Inventory of Effects*. New York: Bantam Books.

MᴇᴅɪᴀWᴀᴛᴄʜ-UK. 2003. 'Beijing Swings Reprimanded (2003)'. Available at: http://www.media-watchuk.org.uk/index.php?option=com_content&task=view&id=93&Itemid=92 (last accessed on 12 December 2008).

Mᴇɪꜱʜᴜ Tongmeng. 2000. 'Zhang Shengquan'. Available at: http://arts.tom.com/look/ysxw/cul_ytxw-zlzz_dazhang1_1.htm (last accessed on 5 August 2004; no longer valid).

Mᴇʀʟᴇᴀᴜ-Pᴏɴᴛʏ, Maurice. 1976. *Phenomenology of Perception* (Forrest Williams trans.). London: Routledge & Kegan Paul.

Mᴇʏᴇʀ, Ursula (ed.). 1972. *Conceptual Art*. New York: E. P. Dutton.

Mɪᴛᴛᴇʀ, Shomit, and Maria Shevtsova. 2005. *Fifty Key Theatre Directors*. London: Routledge.

Mᴏ Yᴀɴ. 2000. *The Republic of Wine* (Howard Goldblatt trans.). New York: Arcade Publishing.

Mᴏɴᴛᴀɴᴏ, Linda. 1983. 'Chicken Woman' (1972) in Moira Roth (ed.), *The Amazing Decade*: *Women and Performance Art in America, 1970–1980*; *A Source Book*. Los Angeles: Astro Artz, pp. 19–20.

MᴜÑᴏᴢ, José Esteban. 1999. *Disidentifications*: *Queers of Color and the Performance of Politics*. Minneapolis: University of Minnesota Press.

Nᴀᴘᴀᴄᴋ, Jonathan. 2004a. 'Chinese Avant-Garde Art Is A "Social Evil"'. *Art Newspaper*. Available at: http://www.theartnewspaper.com/news/article.asp?idart=5477 (last accessed on 2 June 2004; no longer valid).

——. 2004b. 'The Underground Biennial'. *Art Newspaper*. Available at: http://www.theartnews-paper.com/news/article.asp?idart+3891 (last accessed on 2 June 2004; no longer valid).

——. 2004c. 'Young Beijing'. *Art in America* 92(6) (June–July): 142–5.

—— and Charmaine Picard. 2006. 'Speculation Inflates Chinese Contemporary Art Prices'. *Art News* (13 May). Available at: http://www.sgallery.net/news/05_2006/13.php (last accessed on 22 October 2008).

Nᴀʏᴀʀ, Pramod K. 2004. *Virtual Worlds*: *Culture and Politics in the Age of Cybertechnology*. New Delhi and Thousand Oaks, CA: Sage.

Nᴇᴡ Yᴏʀᴋ Tɪᴍᴇꜱ. 2009. 'Sichuan Earthquake'. *New York Times* (6 May). Available at: http://topics.nytimes.com/topics/news/science/topics/earthquakes/sichuan_province_china/index.html (last accessed on 26 March 2010).

Nᴇᴡᴍᴀɴ, Hayley. 2004. 'Connotations—Performance Images, 1994–1998' in Adrian Heathfield (ed.), *Live*: *Art and Performance*. New York: Routledge, pp. 166–75.

Nᴇᴡᴘᴏʀᴛ Hᴀʀʙᴏʀ Aʀᴛ Mᴜꜱᴇᴜᴍ. 1988. *Chris Burden*: *A Twenty-Year Survey*. Exhibition catalogue. Newport Beach, CA: Newport Harbor Art Museum.

Nᴏᴛʜ, Jochen, Wolfger Pöhlmann, and Kai Reschke (eds). 1994. *China Avant-Garde*: *Counter-Currents in Art and Culture*. Berlin: Haus der Kulturen der Welt.

NURIDSANG, Michel. 2004. 'Xu Zhen' in *China Art Now* (Marc Domage photog., Susan Pickford trans.). Paris: Flammarion, pp. 228–33.

NYE, Joseph S. 2005. 'The Rise of China's Soft Power'. *Wall Street Journal Asia* (29 December). Available at: http://www.iop.harvard.edu/JFKJrForumArchive/transcripts/04192006_The_Rise_of_Chinas_Soft_Power.pdf (last accessed on 10 May 2011).

O'DELL, Kathy. 1998. *Contract with the Skin*: *Masochism, Performance Art, and the 1970s*. Minneapolis: University of Minnesota Press.

O'NEIL, Dennis. 2009. 'Kingdoms of Living Things in the Linnaean Classification System'. Available at: http://anthro.palomar.edu/animal/table_kingdoms.htm (last accessed 24 May 2010; no longer valid).

O'NEILL, Sean, Daniel McGrory and Richard Beeston. 2005. 'Al-Qaeda surfaces to hail 7/7 atrocities'. *Times* (5 August).

OLESEN, Alexa. 2005. 'Chinese Artist Defends Work That Uses Real Fetus'. *Star Tribune and Associated Press Online* (9 August). Available at: http://24hour.startribune.com?24hour/world/v-continue/-story/2621424p-11094158c.html (last accessed on 1 September 2005; no longer valid).

OTHER SHORE ARTS INSTITUTE. 2010. 'Principally Relating to Xiao Yu's Work *Ruan*'. Available at: http://www.othershore-arts.net/xiaoyuESSAYS10.html (last accessed 28 May 2010).

PALMER, Judith. 2007. 'The Body in Hand'. *Realtime* 77 (February–March). Available at http://www.real-timearts.net/article/77/8331 (last accessed on 1 September 2007).

PEH Shing Huei. 2008. 'China's Booming Art Scene Loses Its Lustre'. *Strait Times* (20 December). Available at: http://www.lexisnexis.com.libproxy.usc.edu/us/lnacademic/delivery (last accessed on 16 April 2009).

PEI, Minxin. 2011. 'Three Reasons for Beijing's Current Campaign Against Dissent'. *CNN World* (11 April). Available at: http://globalpublicsquare.blogs.cnn.com/2011/04/11/3-reasons-for-beijings-current-campaign-against-dissent/ (last accessed on 11 April 2011).

PEOPLE'S DAILY ONLINE. 2009. 'Constitution of the People's Republic of China'. *People's Daily Online*. Available at: http://english.peopledaily.com.cn/constitution/constitution.html (last accessed on 30 December 2009).

PEPPERELL, Robert. 2003. *The Posthuman Condition*: *Consciousness Beyond the Brain*. Bristol and Portland, OR: Intellect Books.

PERRY, Elizabeth J. 1993. 'China in 1992: An Experiment in Neo-Authoritarianism'. *Asian Survey* 33(1) (January): 12–21.

PERRY, Gillian, and Paul Wood (eds). 2004. *Themes in Contemporary Art*: *Art of the 20th Century*. New Haven, CT: Yale University Press, in association with the Open University.

PHELAN, Peggy. 1998. 'The Ends of Performance', introduction to Peggy Phelan and Jill Lane (eds), *The Ends of Performance*. New York: New York University Press, pp. 1–19.

POLLACK, Barbara. 2007. 'Art's New Superpower'. *Vanity Fair* (2007): 318–30.

PONTBRIAND, Chantal. 1979. 'Introduction: Notion(s) of Performance' (Peggy Gale trans.) in A. A. Bronson and Peggy Gale (eds), *Performance by Artists*. Toronto: Art Metropole, pp. 9–24.

PUEL, Caroline. 2004. 'Concerning Fen-Ma Liuming' in *Fen-Ma Liuming*. Exhibition catalogue. Beijing: Xin-Dong Cheng, pp. 78–85.

QIAN Zhijian. 1999. 'Performing Bodies'. *Art Journal* 58(2) (Summer). Available at: http://www.zhang-huan.com/ShowText.asp?id=10&sClassID=3 (last accessed on 10 January 2009).

QIU, Jack Linchuan. 2000. 'Interpreting the Dengist Rhetoric of Building Socialism with Chinese Characteristics' in D. Ray Heisey (ed.), *Chinese Perspectives in Rhetoric and Communication*. Stamford, CT: Ablex, pp. 249–64.

QIU Zhijie. 2001. 'Zhongyao de bushi ro' (What's Important Is Not Meat) Available at: http://arts.tom.com/Archive/2001/6/3-43880.html (last accessed on 10 January 2010; no longer valid).

——. 2003. 'Zhongyao de bushi rou' (What's Important Is Not Meat) in *Zhongyao de shi xianshang* (What's Important Is the Live Art Site). Beijing: Zhongguo renmin daxue chubanshe, pp. 76–93.

——. 2004. 'A Travel Guide to Purgatory' in *The Monk and the Demon*: *Chinese Contemporary Art*. Exhibition catalogue. Milan: 5 Continents Editions, pp. 117–23.

——. 2007. '*Jingzhe* (The Awakening of Insects) Phone-booth under the Sihui Bridge, Beijing' in Christopher Mao (ed.), *The Shape of Time* (Yu Christina Yu trans.). Exhibition catalogue. New York: Chambers Fine Art, pp. 40–1.

——. 2009. 'Guan yu "Zuoye 1 hao" de ziwo chenshu' (Self-Narration Regarding 'Assignment 1'). Available at: http://www.qiuzhijie.com/html/calligraphy/lantingxu.htm (last accessed on 21 July 2009).

—— and Wu Meichun. 1999. *Ho Ganxing*: *Yixing yu wangxiang / Post-Sense Sensibility*: *Alien Bodies and Delusion*. Exhibition Catalogue. Beijing: Shaoyaoju Building 202.

RAMZY, Austin. 2009a. 'Ai Weiwei Held in Sichuan'. *China Blog* on *Time.com* (12 August). Available at: http://china.blogs.time.com/2009/08/12/ai-weiwei-held-in-sichuan/ (last accessed on 20 November 2010).

——. 2009b. 'Surgery for Ai Weiwei in Germany'. *The China Blog* on *Time.com* (15 September). Available at: http://china.blogs.time.com/2009/09/15/surgery-for-ai-weiwei-in-germany/ (last accessed on 28 March 2010).

RATNAM, Niru. 2004. 'Art and Globalisation' in Gillian Perry and Paul Wood (eds), *Themes in Contemporary Art*: *Art of the 20th Century*. New Haven, CT: Yale University Press, in association with the Open University, pp. 277–313.

RELIGION FACTS. 2010. 'Chinese Ancestor Worship'. Available at: http://www.religionfacts.com/chinese_religion/practices/ancestor_worship.htm (last accessed on 15 February 2010).

REYBURN, Scott. 2011. 'China's $8.3 Billion Art Market Overtakes UK, Report Says'. *Bloomberg* (14 March). Available at: http://www.bloomberg.com/news/2011-03-14/china-s-8-3-billion-art-market-bests-u-k-as-world-s-no-2-research-says.html (last accessed on 6 May 2011).

RICHBURG, Keith B. 2011. 'Chinese Artist Ai Weiwei Arrested in Latest Government Crackdown'. *Washington Post* (3 April). Available at: http://www.yhumanrightsblog.com/blog/2011/04/03/chinese-artist-ai-weiwei-arrested-in-latest-government-crackdown/ (last accessed on 12 April 2011).

ROBERTSON, Roland. 1992. *Globalization*: *Social Theory and Global Culture*. London: Sage.

——. 1995. 'Glocalization: Time-Space and Homogeneity-Heterogeneity' in Mike Featherstone, Scott Lash and Roland Robertson (eds), *Global Modernities*. London: Sage, pp. 25–44.

——. 2001. 'Globalization Theory 2000+: Major Problematics' in George Ritzer and Barry Smart (eds), *Handbook of Social Theory*. London: Sage, pp. 458–71.

ROJAS, Carlos. 2001. 'Baby-Eating Photos are Part of Chinese Artist's Performance'. *Tapei Times* (23 March). Available at: http://www.taipeitimes.com/News/local/archives/2001/03/23/78704 (last accessed on 12 April 2011).

——. 2002. 'Cannibalism and the Chinese Body Politic: Hermeneutics and Violence in Cross-Cultural Perception'. *Postmodern Culture* 12(3). Available at: http://muse.jhu.edu.libproxy.usc.edu/journals/pmc/v012/12.3rojas.html (last accessed on 24 May 2008).

ROSEN, Stanley. 2004. 'The State of (urban) Youth/Youth and the State in Early 21st-Century China' in Peter Hays Gries and Stanley Rosen (eds), *State and Society in 21st-Century China: Crisis, Contention, and Legitimation*. London and New York: Routledge Curzon, pp. 159–79.

ROSENTHAL, Norman. 1997. *Sensation: Young British Artists from the Saatchi Collection*. Exhibition catalogue. London: Thames and Hudson, in association with the Royal Academy of Arts.

ROTH, Moira. 1983. 'The Amazing Decade' in Moira Roth (ed.), *The Amazing Decade: Women and Performance Art in America, 1970–1980; A Source Book*. Los Angeles: Astro Artz, pp. 14–41.

ROTHSCHILD, Michael L. 2001. Review of *Building Strong Brands* by David A. Aaker. *Social Marketing Quarterly* 7(2) (June): 37.

ROUDOMETOF, Victor. 2003. 'Glocalization, Space, and Modernity 1'. *The European Legacy* 8(1): 37–60.

———. 2005. 'Transnationalism, Cosmopolitanism and Glocalization'. *Current Sociology* 53(1): 113–35.

SACKS, Ruth. 2009. 'Deep Dark Documenta'. *Artthrob News*. Available at: http://www.artthrob.co.za/07/-jul/documenta.html (last accessed on 13 March 2009; no longer valid).

SANDINO, Linda. 2004. 'Here Today, Gone Tomorrow: Transient Materiality in Contemporary Cultural Artefacts'. *Journal of Design History* 17(3): 283–93.

SAVAGE, David G. 2010. 'High Court Strikes Down Cruelty Law'. *Los Angeles Times* (21 April), p. A10.

SCARRY, Elaine. 1987. *The Body in Pain: The Making and Unmaking of the World*. Oxford: Oxford University Press.

SCHECHNER, Richard. 1985. *Between Theater and Anthropology*. Philadelphia: University of Pennsylvania Press.

———. 1998. 'What Is Performance Studies Anyway?' in Peggy Phelan and Jill Lane (eds), *The Ends of Performance*. New York: New York University Press, pp. 357–62.

———. 2002. *Performance Studies: An Introduction*. London: Routledge.

SCHEPER-HUGHES, Nancy. 1998. 'Organ Trade'. *New Internationalist* (5 April). Available at: http://www.-newint.org/features/1998/04/05/trade/ (last accessed on 4 January 2011).

SCHIEFKE, Simone, and Starfruit Liu. 2010. 'Passing Time with Xu Zhen'. Available at: http://www.shang-hart.com/texts/xuzhen.htm (last accessed on 5 May 2010).

SCHIMMEL, Paul. 1998. 'Leap into the Void: Performance and the Object' in Russell Ferguson (ed.), *Out of Actions: Between Performance and the Object, 1949–1979*. Exhibition catalogue. Los Angeles: Los Angeles Museum of Contemporary Art, pp. 17–120.

SCHNEEMANN, Carolee. 1997[1979]. *More Than Meat Joy: Performance Works and Selected Writings* (Bruce McPherson ed.). New Paltz, NY: Documenttext.

SCHNEIDER, Rebecca, and Gabrielle Cody (eds). 2002. *Re-Direction: A Theoretical and Practical Guide*. London: Routledge.

SCHULT, HA. 2009. 'Trash People'. Available at: http://www.haschult.de/trash.html (last accessed on 16 December 2009).

SHANGHAI DAILY. 'High-heeled Kitten Killer Apologizes'. *Shanghai Daily* (16 May). Available at: http://www.chinadaily.com.cn/english/doc/2006-03/16/content_540375.htm (last accessed on 10 May 2010).

SHARP, Willoughby. 1972. 'Lawrence Weiner at Amsterdam: Interview with Willoughby Sharp'. *Avalanche* 4 (Spring): 66–73.

SHARPLES, Sebastian. 2008. *The Opening of the New Saatchi Gallery: The Revolution Continues; New Art from China*. Documentary film. Available at: http://www.saatchigallery.co.uk/blogon/view_video/-849/saatchi_online_tv_at_new_sensations_2008,_the_old_truman_brewery,_brick_lane,_london (last accessed on 16 December 2008; no longer valid).

SHAW, Earl B. 1938. 'Swine Industry of China'. *Economic Geography* 14 (October): 381–97.

SHEN Qibin (ed.). 2008. *Song Dong*. Exhibition catalogue. Shanghai: Shanghai Zendai Museum of Modern Art.

SHIH, Alice. 2006. 'The Days of Frozen Dreams: An Interview with Wang Xiaoshuai'. *CineAction* 69(6): 34.

SHUE, Vivienne. 2004. 'Legitimacy Crisis in China?' in Peter Hays Gries and Stanley Rosen (eds), *State and Society in 21st-Century China: Crisis, Contention, and Legitimation*. London and New York: Routledge Curzon, pp. 24–49.

SIGG, Uli, and Matthias Frehner. 2005. 'Access to China: Uli Sigg in Conversation with Matthias Frehner' in Bernhard Fibicher and Matthias Frehner (eds), *Mahjong: Contemporary Chinese Art from the Sigg Collection*. Exhibition catalogue. Ostfildern: Hatje Cantz Verlag, pp. 15–28.

SMITH, Karen. 2005. *Nine Lives: The Birth of Avant-Garde Art In China*. Zurich: Scalo.

———. 2007. *The Real Thing: Contemporary Art from China*. Exhibition catalogue. London: Tate.

SPALDING, David. 'Priceless Images, Heartless Paintings: The Critical Complicity of Liu Ding' in Nav Haq and Liu Ding (eds), *Liu Ding Products*. Exhibition catalogue. Bristol: Arnolfini, pp. 31–8.

SPIER, Leslie. 2009. 'Ancestor Worship'. *Encyclopedia Americana*. Grolier Online. Available at: http://ea.grolier.es.vrc.scoolaid.net/article?id=0014730-00 (last accessed on 29 May 2013).

STALLABRASS, Julian. 2004. *Art Incorporated: The Story of Contemporary Art*. Oxford: Oxford University Press.

STEIN, Gertrude. 1977[1949]. *Last Operas and Plays* (Carl Van Vechten ed. and introd.). New York: Vintage.

STILES, Kristine. 1993. 'Between Water and Stone: Fluxus Performance: A Metaphysics of Acts' in Elizabeth Armstrong, Joan Rothfuss and Janet Jenkins (eds), *In the Spirit of Fluxus*. Exhibition catalogue. Minneapolis, MN: Walker Art Center, pp. 62–99.

———. 1996a. 'Language and Concepts' in Kristine Stiles and Peter Selz (eds), *Theories and Documents of Contemporary Art: A Sourcebook of Artists' Writings*. Berkeley: University of California Press, pp. 804–96.

———. 1996b. 'Performance Art', in Kristine Stiles and Peter Selz, eds., *Theories and Documents of Contemporary Art: A Sourcebook of Artists' Writings*. Berkeley: University of California Press, pp. 679–94.

———. 1998. 'Uncorrupted Joy: International Art Actions' in Russell Ferguson (ed.), *Out of Actions: Between Performances and the Object, 1949–1979*. Exhibition catalogue. Los Angeles: Los Angeles Museum of Contemporary Art, pp. 226–328.

STRYNKOWSKI, John S. 1995. 'Holy Communion' in Richard P. McBrien (ed.), *HarperCollins Encyclopedia of Catholicism*. San Francisco: HarperCollins, pp. 37–9.

SUN Yuan and Peng Yu. 2007a. Personal website. Available at: http://www.sunyuanpengyu.com/ (last accessed on 18 October 2007).

———. 2007b. 'Yishu wufa xianding' (Art Cannot Be Limited). Interview with Li Qiushi, Wei Xing, Lin Ja. Available at: http://www.sunyuanpengyu.com/ (last accessed on 18 October 2007).

SWIFT, Jonathan. 1729. 'A Modest Proposal: For Preventing the Children of Poor People in Ireland from Being a Burden to Their Parents or Country, and for Making Them Beneficial to the Public'. Available at: http://art-bin.com/art/omodest.html (last accessed on 4 August 2004).

Tang Di. 1997. 'A Frowning Smile' in Chris Driessen and Heidi van Mierlo (eds), *Another Long March*: *Chinese Conceptual and Installation Art in the Nineties*. Exhibition catalogue. Tilburg: Fundament Foundation, pp. 95–131.

Tang Xiaobing. 2000. *Chinese Modern*: *The Heroic and the Quotidian*. Durham, NC: Duke University Press.

——. 2006. 'Echoes of Roar, China! On Vision and Voice in Modern Chinese Art'. *Positions*: *East Asia Cultures Critique* 14(2): 467–94.

Tang Xin (ed.). 2004. *Casting*. Exhibition catalogue. Beijing and Tokyo: Beijing Tokyo Art Projects.

Tatlow, Didi Kirsten. 2001. 'Degenerate Acts'. (*ai*): *Performance for the Planet* (Fall): 62–71.

Tautz, Jürgen. 2009. *The Buzz About Bees*: *Biology of a Superorganism* (Helga R. Heilmann photog., David C. Sandeman trans.). New York: Springer.

Taylor, Alan. 2008. '2008 Olympics Opening Ceremony'. *Boston.com* (8 August). Available at: http://www.boston.com/bigpicture/2008/08/2008_olympics_opening_ceremony.html (last accessed on 26 March 2010)

Taylor, Diana. 2003. *The Archive and the Repertoire*: *Performing Cultural Memory in the Americas*. Durham, NC: Duke University Press.

Teo, Wenny. 2007. 'Gu Dexin–A Survey'. *Shijue shengchan / Visual Production* 4(5): 26–7.

Thakare, Meheer. 2009. 'Branding Quote'. Available at: http://communications.webalue.com/-2009/10/14/branding-quote-a-brand-is-a-set-of-differentiating-promises-stuart-agres/ (last accessed on 16 March 2011).

Thorpe, Vanessa. 2008. 'Record Crowds for China Art Show'. *Observer* (14 December). Available at: http://www.guardian.co.uk/artanddesign/2008/dec/14/saatchi-revolution-continues-china-art (last accessed on 16 December 2008).

Tinari, Philip. 2003. 'What Does Not Stand Cannot Fall: Wang Wei's Temporary Space' in 25000 Cultural Transmission Center, *Linshi kongjian/Temporary Space*. Exhibition catalogue. Beijing: 25000 Cultural Transmission Center. Unpaginated.

——. 2007a. 'Original Copies: The Dafen Oil Painting Village'. *Art Forum* (October): 344–51.

——. 2007b. 'The Real Thing: Contemporary Art from China'. *Artforum International* 46(1) (September): 454–6.

Toy, Mary-Ann. 2008. 'Tibet Uprising Cracks the Face of Modern China'. *The Age* (21 March). Available at: http://www.theage.com.au/news/world/tibet-uprising-cracks-the-face-of-modern-china/2008/-03/20/1205602579501.html (last accessed on 26 March 2010).

Tsing, Anna. 2000. 'The Global Situation'. *Cultural Anthropology* 15(3): 327–60.

Tuan, Francis C., and John Dyck. 1999. 'Structural Change in China's Hog and Feed Industries'. Available at: ipsard.gov.vn/.../Structural_Changes_in_China_s_Hog_and_Feed_Industries_2_060215.pdf (last accessed on 9 March 2010; no longer valid).

US Department of Energy and the National Institutes of Health. 2008. 'Human Genome Project Information'. Available at: http://www.ornl.gov/sci/techresources/Human_Genome/home.shtml (last accessed on 7 May 2008).

Vanessa Art Link. 2008. *Cunzai de chidu*: *He Yunchang zuopi / The Ability to Exist*: *He Yunchang Art Works*. Exhibition catalogue. Jakarta: Galeri Nasional Indonesia / Vanessa Art Link.

Vega, Lope de. 1986. *Acting Is Believing*: *A Tragicomedy in Three Acts, c.1607–08* (Michael D. McGaha trans.). San Antonio, TX: Trinity University Press.

Vergine, Lea. 2000[1974]. *Body Art and Performance: The Body as Language*. Milan: Skira.

Vogel, Carol. 2005. 'Feng Shui in Venice? China Lands at Beinnale'. *New York Times* (11 June). Available at: http://www.nytimes.com/2005/06/11/arts/design/11pavi.html?_r=1 (last accessed on 29 November 2008).

Waldron, Scott, Colin Brown, John Longworth and Zhang Cungen. 2007. *China's Livestock Revolution: Agribusiness and Policy Developments in the Sheep Meat Industry*. Wallingford, UK, and Cambridge, MA: CABI International.

Walsh, Julie. 2002. 'Song Dong—The Diary Keeper' in Christopher Mao, Song Dong and Yin Xiuzhen (eds), *Kuai zi/Chopsticks*. Exhibition catalogue. New York: Chambers Fine Art. Unpaginated.

Wang, Annie. 2006. *The People's Republic of Desire: A Novel*. New York: Harper Paperbacks.

Wang Chuyu. 2007. '"Wang Mian liang yu shangdian dangan" zuopin' (*Wang Mian Rice Oil Shop Document Files* Artwork) (4 August). Available at: www.artronblog.net and http://blog.artron.net/-space.php?uid=65261&do=blog&id=90543 (last accessed on 24 February 2010).

—— and Wang Hong. 2005. '"Wang Mian liangyu shangdian dangan" zuopin jihua' (*Wang Mian Rice Oil Shop Document Files* Artwork Plan) (24 December). Available at: http://www.tianya.cn/publicforum/Content/develop/1/71482.shtml (last accessed on 5 December 2007).

Wang Jin. 2002. 'Wang Jin, *Bing. 96 Zhongyuan*' (artist statement) in Wu Hung (ed.), *Chongxin Jiedu/Reinterpretation: A Decade of Experimental Chinese Art, 1999–2000*. Aomen: Aomen chubanshe, p. 200.

Wang, Jing. 1996. *High Cultural Fever: Politics, Aesthetics, and Ideology in Deng's China*. Berkeley: University of California Press.

——. 2005. 'Bourgeois Bohemians in China? Neo-Tribes and the Urban Imaginary'. *China Quarterly* 183 (September): 532–48.

——. 2008. *Brand New China: Advertising, Media, and Commercial Culture*. Cambridge, MA: Harvard University Press.

Wang Pinpin. 2011. 'Li Xianting: Yishu de shi de manman lai' (Li Xianting: Things About Art Must Be Taken Slowly) (1 February). Available at: http://zqb.cyol.com/html/2011-02/01/nw.D110000zgqnb-_20110201_4-09.htm?div=-1 (last accessed on 27 August 2011).

Wang Wei. 2003. 'Artist Statement' in *Linshi kongjian/Temporary Space*. Exhibition catalogue. Beijing: 25000 Cultural Transmission Center. Unpaginated.

——. 2010. 'Wang Wei'. Available at: http://wangwei.dancingtoasters.com/TemporarySpace.htm (last accessed on 28 July 2010).

Wang, Val. 2000. 'Animal Games'. Available at: http://www.chinese-art.com/artists/animal.htm (last accessed on 3 June 2004; no longer valid).

——. 2003. 'Can Xin'. Available at: http://www.chinese-art.com/artists/Cang%20Xin/cangxin.htm (last accessed on 21 October 2003; no longer valid).

Wang Xiaoying. 2002. 'The Post-communist Personality: The Spectre of China's Capitalist Market Reforms'. *China Journal* 47 (January): 1–17.

Wang Yang. 2009. 'Ba Mama cang de jiuhuo biancheng yishu, Xin shiji zhoukan' (Turning the old Things Saved by Mother Into Art) (26 August). Available at: http://news.sina.com.cn/c/2009-08-26/134518515868.shtml (last accessed on 29 October 2010).

Warhol, Andy. 1975. *The Philosophy of Andy Warhol (From A to B and Back Again)*. New York: Harcourt Brace Jovanovich.

WASIK, Bill. 2009. *And Then There's This: How Stories Live and Die in Viral Culture*. New York: Penguin.

WEBSTER, Robert G. 2004. 'Wet Markets: A Continuing Source of Severe Acute Respiratory Syndrome and Influenza?' *Lancet* 363(9404) (17 January): 234–6.

WEINTRAUB, Linda. 1998. 'Allegorical Persona' in Marketta Seppälä, Linda Weintraub and Jari-Pekka Vanhala (eds), *Animal.Anima.Animus*. Exhibition catalogue. Helsinki: Pori Art Museum, pp. 43–9.

WELLAND, Sasha Su-Ling. 2007. 'Opening the Great Wall' in *Xinling zhi tong: He Chengyao de xingwei yishu ji yingxiang / Pain in Soul: Performance Art and Video Works by He Chengyao*. Exhibition catalogue. Shanghai: Zendai Museum of Modern Art, pp. 59–66

WERTHEIM, Christine (ed.). 2010. *Feminaissance*. Los Angeles: Les Figues.

WHITELAW, Mitchell. 2004. *Metacreation: Art and Artificial Life*. Cambridge, MA: MIT Press.

WILL, George F. 2009. 'Cruelty in the Court: Crush Videos and Foie Gras'. Available at: http://www.thedailybeast.com/newsweek/2009/10/09/cruelty-in-the-court.html (last accessed on 28 May 2013).

WILLIAMS, Raymond. 1983. *Keywords: A Vocabulary of Culture and Society*. Oxford: Oxford University Press.

WIMSATT, William K. and Monroe C. Beardsley. 1946. 'The Intentional Fallacy'. *Sewanee Review* 54 (1946): 468–88.

WITHERS, Josephine. 1994. 'Feminist Performance Art: Performing, Discovering, Transforming Ourselves' in Norma Broude and Mary D. Garrard (eds), *The Power of Feminist Art: The American Movement of the 1970s, History and Impact*. New York: Harry N. Abrams, pp. 158–73.

WOLFE, Cary (ed.). 2003. *Zoontologies: The Question of the Animal*. Minneapolis: Minnesota University Press.

WONG, Edward. 2011. 'Chinese Authorities Raze an Artist's Studio'. *New York Times* (12 January). Available at: http://www.nytimes.com/2011/01/13/world/asia/13china.html (last accessed on 12 April 2011).

WONG, Winnie. 2010. 'After the Copy: Creativity, Originality and the Labor of Appropriation—Dafen Village, Shenzhen, China, 1989–2010'. PhD dissertation, Department of Architecture, Massachusetts Institute of Technology, Cambridge, MA.

WOOD, Daniel. 2008. 'Life imitates art in Beijing's creative 798 Art Zone'. Available at: http://www.straight.com/article-131118/life-imitates-art-in-beijing-s-creative-district (last accessed on 19 March 2010).

WU Ch'eng-en. 1943. *Monkey: Folk Novel of China* (Arthur Waley trans.). New York: Grove Weidenfeld.

WU Hung. 1999. *Transience: Chinese Experimental Art at the End of the Twentieth Century*. Exhibition catalogue. Chicago: Smart Museum of Art, University of Chicago.

———. 2000a. *Exhibiting Experimental Art in China*. Exhibition catalogue. Chicago: Smart Museum of Art, University of Chicago.

———. 2000b. 'Food as Art' in *Exhibiting Experimental Art in China*. Exhibition catalogue. Chicago: Smart Museum of Art, University of Chicago, pp. 191–5.

———. 2000c. 'Wu Hung–Zhang Dali's Dialogue: Conversation with a City'. *Public Culture* 12(3): 749–68.

———. 2002a. '"Vernacular" Post-Modern: The Art of Song Dong and Yin Xiuzhen' in Christopher W. Mao, Yin Xiuzhen, Song Dong (eds), *Kuai zi/Chopsticks*. Exhibition catalogue. New York: Chambers Fine Art, pp. 9–23.

——— (ed.). 2002b. *Reinterpretation: A Decade of Experimental Chinese Art, 1990–2000*. Exhibition catalogue. Guangzhou: Guandong Museum of Art.

———. 2004. *Between Past and Future: New Photography and Video from China*. Exhibition catalogue. Chicago: Smart Museum of Art, University of Chicago; New York: International Center of Photography.

——. 2008. *Making History: Wu Hung on Contemporary Art*. Hong Kong: Timezone 8.

——. 2009. *Waste Not: Zhao Xiangyuan and Song Dong*. Beijing: Tokyo Gallery / Beijing Tokyo Art Projects.

—— (ed.). 2010. *Contemporary Chinese Art: Primary Documents* (with the assistance of Peggy Wang). New York: Museum of Modern Art.

—— and Zhu Yu. 2001. 'Zhu Yu de "Zhi pi" ji qi benwen' (Zhu Yu's *Skin Graft* and Its Original Text). Available at: http://arts.tom.com/Archive/2001/3/18-70946.html (last accessed on 4 June 2004).

XIAO Yu. 2000. 'Xiao Yu', in Ai Weiwei, Hua Tianxue and Feng Boyi (eds), *Bu hezuo fangshi / Fuck Off*. Exhibition catalogue. Shanghai: Eastlink Gallery, pp. 140–3.

XIAO Yu. 2002. 'Xiao Yu *Fangtan*, Interview with Ai Weiwei' in Ai Weiwei (ed.), *Zhongguo dangdai yishu fangtan lu/Chinese Artists, Texts and Interviews: Chinese Contemporary Art Awards, 1998–2002* (Robert Bernell, Krista Van Fleit and Chin Chin Yap trans.). Hong Kong: Timezone 8, pp. 80–93.

XIN Jing Bao. 2005. 'He Yunchang zai Nijala luo piao beibu' (He Yunchang Got Arrested for Naked Floating in Niagara Falls). *Xin Jing Bao* (27 October). Available at: http://culture.163.com/05/-1027/09/212GLA7M00280003.html (last accessed on 23 May 2013).

XU, Ben. 2001. 'Chinese Populist Nationalism: Its Intellectual Politics and Moral Dilemma'. *Representations* 76(1): 120–40.

XU Bing. 1994. '"*Yangzhu*" wenda' (*Raising Pigs*: Questions and Answers) in Ai Weiwei, Zeng Xiaojun and Xu Bing (eds), *Heipi shu* (Black Cover Book). Beijing: Privately published, pp. 84–90.

XU Bing. 2001. 'The Living Word' (Ann L. Huss trans.) in Britta Erickson, *The Art of Xu Bing: Words without Meaning, Meaning without Words*. Washington, DC: Arthur M. Sackler Gallery, Smithsonian Institution; Seattle: University of Washington Press, pp. 13–20.

——. 2009. 'Book from the Sky, 1987–1991'. Available at: http://www.xubing.com/index.php/site/projects/year/1987/book_from_the_sky (last accessed on 5 April 2010).

——. 2010. 'American Silkworm Series, Part II'. Available at: http://www.xubing.com/index.php/-site/projects/year/1995/american_silkworm_series_part_ii (last accessed on 16 April 2010).

XU Yihui. 2000. 'Interview with Xu Yihui, Conducted by Wu Wenguang', in Wu Hung, *Exhibiting Experimental Art in China*. Exhibition catalogue. Chicago: Smart Museum of Art, University of Chicago, pp. 156–60.

YANG Hui. 2003. 'Photograph No. 354, January 2002, Nanbu, Sichuan' in Guangdong Museum of Art, *Zhongguo renban / Humanism in China: A Contemporary Record of Photography*. Exhibition catalogue. Guangdong: Guangdong Museum of Art, p. 49.

YANG Zhichao. 2005. 'Dangan 15: Yang Zhichao xingwei yishu dangan' (Archive 15: Yang Zhichao Performance Art Documents), in Wu Wenguang (ed.), *Document/Xianchang*. Guangxi: Guangxi shifan daxue chubanshe, pp. 6–44.

——. 2008. 'Qishilu Si—Bairi Wu Yier (Revelation 4—A Hundred Days from May 12th)'. Unpublished manuscript.

YEATS, W. B. 1996. *The Collected Poems of W. B. Yeats* (Richard J. Finnera ed.). New York: Scribner Paperback Poetry.

YIN Xiuzhen. 2002. 'Yin Xiuzhen, *Washing the River*, 1995' in Christopher W. Mao, Yin Xiuzhen and Song Dong (eds), *Kuai zi / Chopsticks*. Exhibition catalogue. New York: Chambers Fine Art.

YU Hsiao-hwei (ed.). 2002. 'Interview with Hou Hanru: In the Guise of an Introduction' in *On the Midground*. Hong Kong: Timezone 8, pp. 32–5.

YUE, Gang. 1999. *The Mouth That Begs: Hunger, Cannibalism, and the Politics of Eating in Modern China.* Durham, NC: Duke University Press.

ZENG Renquan. 2004. 'Shibai de zhongguo binzang zhidu' (The Failing Chinese Funereal Regulations). *Da Jiyuan Pinglun Qu* (6 December). Available at: http://www.epochtimes.com/b5/4/12/6/-n738481.htm (last accessed on 5 April 2006).

ZENGZI. 2009. *Xiao Jing: The Classic of Xiao* (Feng Xin-ming trans.). Available at: http://www.tsoidug.-org/Xiao/Xiao_Jing_Comment.pdf (last accessed on 10 August 2009).

ZHANG, Erping. 2005. 'Beijing's Cyber Wall'. *China Rights Forum* 3: 98–101. Available at: http://hrichina.org/-sites/default/files/oldsite/PDFs/CRF.3.2005/CRF-2005-3_GC_Cyber.pdf (last accessed on 27 June 2013).

ZHANG Huan. 2007. 'A Piece of Nothing' in Melissa Chiu (ed.), *Zhang Huan: Altered States*. Exhibition catalogue. New York: Asia Society; Milan: Edizioni Charta pp. 79–80.

——. 2009. 'Family Tree, 2000, New York, USA'. Available at: http://www.zhanghuan.com/ShowWork-Content.asp?id=27&iParentID=18&mid=1 (last accessed on 21 July 2009).

ZHANG Jing. 2010. 'Shenzhen Dafencun: Cheng zhong cun jie youhua zaisheng' (Shenzhen Dafen Village: Village within the City Depends on Oil Painting for Revival). *Xin jing bao* (26 May). Available at: http://epaper.bjnews.com.cn/images/2010-05/26/A28/A28526C.pdf (last accessed on 31 May 2013).

ZHANG Li. 2005. 'Gu Dexin *Fangtanlu*' in Gu Zhenqing (ed.), *Zhongguo dangdai yishu fangtan lu / Chinese Artists, Texts and Interviews: Chinese Contemporary Art Awards, 1998–2002* (Robert Bernell, Krista Van Fleit and Chin Chin Yap trans). Hong Kong: Timezone 8, pp. 59–73.

ZHANG Liujiang. 2001. 'Peng Yu *caifang lu*'. (Peng Yu Interview Record). *Artnews.com*, 2001. Available at: http://www.artnews.com.cn/school/zlj/PY/py01.htm (last accessed on 4 June 2004).

ZHANG Qingwen. 2010. 'Boyi de zhihui: "Yishujia" zazhi zhuanfang Zhongguo dangdai yishu cezhanren Wang Lin' (The Wisdom of Chess-playing: *Artists* Magazine Interviews Chinese Contemporary Art Curator Wang Lin). Available at: http://lijinru.blog.artron.net/space.php?uid=64041&do=-blog&id=648110 (last accessed on 10 November 2010).

ZHANG Xinyu. 2001. 'Shi yishu haishi tusha?—zhuanfang Zhu Yu' (Is it Art or Is it Slaughter?—A Special Interview with Zhu Yu). Available at: http://arts.tom.com/Archive/2001/8/24-15063.html (last accessed on 4 June 2004).

ZHANG Xudong. 1998. 'Nationalism, Mass Culture and Intellectual Strategies in Post-Tiananmen China'. *Social Text* 55 (Summer): 109–40.

—— (ed.). 2001. *Whither China? Intellectual Politics in Contemporary China*. Durham, NC: Duke University Press.

——. 2008. *Postsocialism and Cultural Politics: China in the Last Decade of the Twentieth Century*. Durham, NC: Duke University Press.

ZHANG Yiqian. 2011. 'Jasmine Revolution Failing to Blossom in China?' *Newsy* (23 February). Available at: http://www.newsy.com/videos/jasmine-revolution-failing-to-blossom-in-china/ (last accessed on18 April 2011).

ZHANG Zhaohui. 2001. 'The New Art Community'. Available at: http://www.china-gallery.com/en/-zhang/oth_artcommunity.html (last accessed on 4 June 2004; no longer valid).

ZHANG, Zhen. 2000. 'Mediating Time: The "Rice Bowl of Youth" in Fin de Siècle Urban China'. *Public Culture* 12(1) (Winter): 93–114.

ZHAO Xiangyuan and Song Dong. 2005. 'Jumin huko bu' (Household Register) in *Wu jin qi yong* (Waste Not). Exhibition catalogue. Beijing: Beijing Tokyo Arts Projects. Unpaginated.

Zhao Zhenhai. 2003. 'Photograph N. 138, 1987 Lushen, Henan' in Guangdong Museum of Art, *Zhongguo renban / Humanism in China: A Contemporary Record of Photography*. Exhibition catalogue. Guangdong: Guangdong Museum of Art, p. 45.

Zhong Yiyin. 2007. 'Yishu fufu de pingdan shenghuo' (Art Couple's Placid Life). Available at: http://news.sina.com.cn/c/2005-04-13/12496374826.shtml (last accessed on 15 May 2007).

Zhu Ming. 2007. *Zhu Ming, 1994–2006: Art Works*. Exhibition catalogue. Beijing: Chinese Contemporary.

—— and Li Xianting. 2007. 'Xuhuan de paopao—Zhu Ming he Li Xianting duihualu' (Illusory Bubbles—Zhun Ming and Li Xianting Dialogue Record) in *Zhu Ming, 1994–2006: Art Works*. Exhibition catalogue. Beijing: Chinese Contemporary, pp. 4–11.

Zhu Qi. 2006. 'Cang Xin's Shamanic Visions: Sorcery, Performance Art and Interaction' in *Cang Xin*. Exhibition catalogue. Hong Kong: Xin Dong Cheng / 10 Chancery Lane Gallery / Eastlink Gallery, pp. 8–12.

Zhu Yu. 2009. 'Wo yu nvren shangyi sheng haizi de shiyi C' (I Negotiate with a Woman to Give Birth to a Child, Case C). Available at: http://www.i170.com/Article/35945 (last accessed on 2 March 2009).

Zhuangzi. 1999. *Zhuangzi: Library of Chinese Classics* (trans. into English by Wang Rongpei, trans. into Modern Chinese by Qin Xuqing and Sun Yongchang). Hunan: Hunan People's Publishing House.

Zittrain, Jonathan, and Benjamin Edelman. 2003. 'Internet Filtering in China'. *IEEE Internet Computing* (March–April): 70–7.

INdeX

(Page numbers in italics refer to illustrations.)